THE PELICAN HISTORY OF ART

JOINT EDITORS: NIKOLAUS PEVSNER AND JUDY NAIRN

AMERICAN ART

JOHN WILMERDING

Richard Lindner: Rock-Rock, 1966–7. *Dallas Museum of Fine Arts*

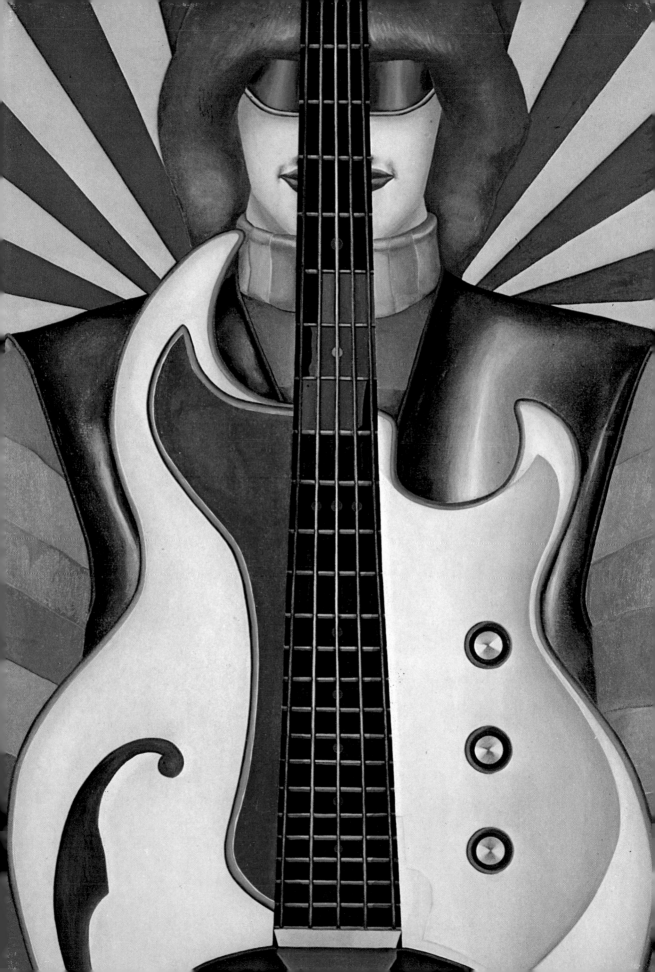

JOHN WILMERDING

AMERICAN ART

PUBLISHED BY PENGUIN BOOKS

Penguin Books Ltd, Harmondsworth, Middlesex, England
Penguin Books, 625 Madison Avenue, New York, New York 10022, U.S.A.
Penguin Books Australia Ltd, Ringwood, Victoria, Australia
Penguin Books Canada Ltd, 41 Steelcase Road West, Markham, Ontario, Canada
Penguin Books (N.Z.) Ltd, 182-190 Wairau Road, Auckland 10, New Zealand

*

Text printed and bound in the United States of America by the Kingsport Press, Inc.,
Kingsport, Tennessee
Plates printed by Balding & Mansell Ltd, London
Set in Monotype Bembo

*

ISBN 0 14 0560.40 8
Library of Congress Catalog Card Number: 75-18755

*

First published 1976

To the memory of
BENJAMIN ROWLAND, JR.

CONTENTS

CONTENTS

Part Three

THE MID NINETEENTH CENTURY
1836–1865

From Nature's Nation to Civil War

Part Four

THE LATER NINETEENTH CENTURY
1865–1893

From Reconstruction to The White City

Part Five

TRANSITION TO THE TWENTIETH CENTURY
1893–1945

From Fin-de-Siècle to World War II

CONTENTS

Part Six
THE MID TWENTIETH CENTURY
1945–1976
From World War II to the Bicentennial

The Plates

ix

LIST OF PLATES

Unless otherwise noted, copyright in photographs belongs to the gallery, library, museum, private collection, or other institution given as the location, by whose courtesy they are reproduced. Where the medium is not specified, it is oil on canvas.

48 Gilbert Stuart: The Skater, 1782. 245·5 × 147·4 cm: 96⅝ × 58⅛ in. *Washington, D.C., National Gallery of Art* (Mellon Collection)

49 Gilbert Stuart: George Washington (The Athenaeum Portrait), 1796. 121·9 × 94 cm: 48 × 37 in. *Boston, Museum of Fine Arts* (Deposited by the Boston Athenaeum, 1876)

50 Gilbert Stuart: Mrs Perez Morton, 1802. 73·8 × 61·3 cm: 29⅛ × 24⅛ in. *Worcester, Massachusetts, Worcester Art Museum*

51 Ralph Earl: Chief Justice and Mrs Oliver Ellsworth, 1792. 192·9 × 220·4 cm: 75⅞ × 86¾ in. *Hartford, Connecticut, Wadsworth Atheneum*

52 Winthrop Chandler: Reverend Ebenezer Devotion, 1770. 127 × 101·6 cm: 50 × 40 in. *The Brookline Historical Society*

53 Joshua Johnston: The Westwood Children, 1807. 104·5 × 114·3 cm: 41⅛ × 46 in. *Washington, D.C., National Gallery of Art* (Gift of Edgar William and Bernice Chrysler Garbisch)

54 William Rush: Tragedy, 1808. Wood. Over life size. *Philadelphia, The Pennsylvania Academy of the Fine Arts* (On loan from the Museum of Art)

55 Henry Sargent: The Dinner Party, c. 1821. 151·1 × 121·9 cm: 59½ × 48 in. *Boston, Museum of Fine Arts* (Gift of Mrs Horatio A. Lamb in memory of Mr and Mrs Winthrop Sargent)

56 Charles Willson Peale: The Staircase Group, 1795. 226·2 × 100·3 cm: 89 × 39½ in. *Philadelphia, The Pennsylvania Museum of Art* (The George W. Elkins Collection)

57 Charles Willson Peale: Exhumation of the Mastodon, 1806. 127 × 158·8 cm: 50 × 62½ in. *Baltimore, Maryland, The Peale Museum* (Gift of Mrs Harry White)

58 Charles Willson Peale: Yarrow Mamout, 1819. 60·9 × 50·8 cm: 24 × 20 in. *Philadelphia, The Historical Society of Pennsylvania*

59 Charles Willson Peale: The Artist in his Museum, 1822. 262·9 × 203 cm: 103½ × 80 in. *Philadelphia, The Pennsylvania Academy of the Fine Arts*

60 Charles Willson Peale: James Peale (The Lamplight Portrait), 1822. 62·2 × 91·4 cm: 24½ × 36 in. *The Detroit Institute of Arts* (Gift of Dexter M. Ferry, Jr.)

61 Rembrandt Peale: Self Portrait, 1828. 48·3 × 36·2 cm: 19 × 14¼ in. *The Detroit Institute of Arts* (Purchase, the Dexter M. Ferry, Jr. Fund)

62 Margaretta Angelica Peale: Still Life, 1828. 23 × 48·6 cm: 13 × 19½ in. *Northampton, Massachusetts, Smith College Museum of Art*

63 Raphaelle Peale: After the Bath, 1823. 73·7 × 61 cm: 29 × 24 in. *Kansas City, Nelson Gallery – Atkins Museum* (Nelson Fund)

64 Charles Bird King: Poor Artist's Cupboard, c. 1815. Oil on wood. 75·5 × 70·5 cm: 29¾ × 27¾ in. *Washington, D.C., The Corcoran Gallery of Art*

65 John Vanderlyn: Death of Jane McCrea, 1804. 81·3 × 67·3 cm: 32 × 26½ in. *Hartford, Connecticut, Wadsworth Atheneum* (E. Irving Blomstrann, New Britain)

66 John Vanderlyn: Marius amid the Ruins of Carthage, 1807. 221 × 174 cm: 87 × 68½ in. *The Fine Arts Museums of San Francisco, M. H. de Young Memorial Museum*

67 John Vanderlyn: Ariadne asleep on the Island of Naxos, 1814. 172·7 × 221 cm: 68 × 87 in. *Philadelphia, The Pennsylvania Academy of the Fine Arts*

68 John Vanderlyn: Niagara, c. 1842–3. 138·4 × 229·9 cm: 54½ × 90½ in. *Kingston, New York, Senate House Museum* (Frick Art Reference Library, New York)

69 Washington Allston: Rising of a Thunderstorm at Sea, 1804. 97·8 × 129·5 cm: 38½ × 51 in. *Boston, Museum of Fine Arts* (Everett Fund)

70 Washington Allston: Diana in the Chase, 1805. 164·5 × 242·6 cm: 64¾ × 95½ in. *Cambridge, Massachusetts, Fogg Art Museum, Harvard University* (Gift of Mrs Edward W. Moore)

71 Washington Allston: Elijah in the Desert, 1818. 123·9 × 184·2 cm: 48¾ × 72½ in. *Boston, Museum of Fine Arts* (Gift of Mrs Samuel Hooper and Miss Alice Hooper)

72 Washington Allston: Moonlit Landscape, 1819. 61 × 88·9 cm: 24 × 35 in. *Boston, Museum of Fine Arts* (Gift of William Sturgis Bigelow)

73 Washington Allston: Belshazzar's Feast, 1817–43. Final version, 365·8 × 527·7 cm: 144 × 192 in. *The Detroit Institute of Arts* (Gift of the Allston Trust)

74 Samuel F. B. Morse: The Old House of Representatives, 1822. 219·7 × 232·2 cm: 86½ × 130¾ in. *Washington, D.C., The Corcoran Gallery of Art*

75 Samuel F. B. Morse: The Muse – Susan Walker Morse, 1835–7. 76·2 × 63·8 cm: 30 × 25⅛ in. *New York, The Metropolitan Museum of Art* (Bequest of Herbert L. Pratt, 1945)

LIST OF PLATES

104 Fitz Hugh Lane: Castine from Hospital Island, 1855. Lithograph. 50·1 × 83·2 cm: 19¾ × 32¾ in. *Newport News, Virginia, The Mariners Museum*

105 Fitz Hugh Lane: The Western Shore with Norman's Woe, 1862. 54·6 × 90·1 cm: 21½ × 35½ in. *Gloucester, Massachusetts, Cape Ann Historical Association* (Richard Merrill, Saugus)

106 Martin Johnson Heade: Summer Showers, *c.* 1865. 33·7 × 67·1 cm: 13¼ × 26⅜ in. *The Brooklyn Museum* (Dick S. Ramsay Fund)

107 Martin Johnson Heade: Approaching Storm: Beach near Newport, *c.* 1867. 71·1 × 148 cm: 28 × 58¼ in. *Boston, Museum of Fine Arts* (M. and M. Karolik Collection)

108 Frederic Edwin Church: Niagara, 1857. 107·4 × 229·9 cm: 42¼ × 90½ in. *Washington, D.C., The Corcoran Gallery of Art*

109 Frederic Edwin Church: Cotopaxi, 1863. 88·9 × 152·4 cm: 35 × 60 in. *Reading, Pennsylvania, The Reading Public Museum and Art Gallery*

110 Sanford Gifford: Catskill Mountain House, 1862. 23·2 × 45·7 cm: 9⅛ × 18 in. *Hartford, Connecticut, Austin Arts Center, Trinity College* (McMurray Collection; E. Irving Blomstrann, New Britain)

111 John F. Francis: Still Life with Wine Bottles and Basket of Fruit, 1857. 63·5 × 76·2 cm: 25 × 30 in. *Boston, Museum of Fine Arts* (M. and M. Karolik Collection)

112 Severin Roesen: Still Life: Flowers, *c.* 1858. 101·6 × 128 cm: 40 × 50⅜ in. *New York, The Metropolitan Museum of Art* (Gift of various Donors, 1967)

113 Ammi Phillips: Harriet Leavens, *c.* 1815. 142·9 × 68·6 cm: 56¼ × 27 in. *Cambridge, Massachusetts, Fogg Art Museum, Harvard University* (Gift–Estate of Harrier Anna Niel)

114 William M. Prior: Nancy Lawson, 1843. 76·2 × 63·5 cm: 30 × 25 in. *Shelburne, Vermont, Shelburne Museum*

115 Edward Hicks: The Peaceable Kingdom of the Branch, 1825–30. Oil on wood. 92·1 × 114·1 cm: 36¼ × 44⅞ in. *New Haven, Connecticut, Yale University Art Gallery* (Gift of Robert W. Carle)

116 Thomas Chambers: Staten Island and the Narrows, *c.* 1835–55. 55·9 × 76·9 cm: 22 × 30¼ in. *The Brooklyn Museum* (Dick S. Ramsay Fund)

117 Anon.: Meditation by the Sea, *c.* 1855. 34·3 × 49·5 cm: 13½ × 19½ in. *Boston, Museum of Fine Arts* (M. and M. Karolik Collection)

118 Erastus Salisbury Field: Historical Monument of the American Republic, *c.* 1876. 276·8 × 398·8 cm: 111 × 157 in. *Springfield, Massachusetts, Museum of Fine Arts*

119 Anon.: Jack Tar. Ship Chandler's Sign, *c.* 1860–70. Wood. H. 108 cm: 42½ in. *Shelburne, Vermont, Shelburne Museum* (John M. Miller)

120 Anon.: Carved figure, Wasco tribe, *c.* 1800–50. Wood. H. 30·5 cm: 12 in. *Chicago, Field Museum of Natural History*

121 Horatio Greenough: George Washington, 1833–41. Marble. H. 345·4 cm: 136 in. *Washington, D.C., The Smithsonian Institution*

122 Hiram Powers: The Greek Slave, 1843. Marble. H. 165·1 cm: 65 in. *Washington, D.C., The Corcoran Gallery of Art*

123 Thomas Crawford: The Indian (the Chief contemplating the Progress of Civilization), 1856. Marble. H. 139·7 cm: 55 in. *The New-York Historical Society*

124 Edmonia Lewis: Abraham Lincoln, 1867. Marble. H. 55·9 cm: 22 in. *San Jose, California, San Jose Public Library*

125 William Wetmore Story: Salome, 1871. Marble. H. 144·8 cm: 57 in. *New York, The Metropolitan Museum of Art* (Gift of William Nelson, 1896)

126 John Rogers: Checkers up at the Farm, 1875. Bronze. H. 50·8 cm: 20 in. *The New-York Historical Society*

127 John Lewis Krimmel: Fourth of July in Center Square, *c.* 1810–12. 58·4 × 73·6 cm: 23 × 29 in. *Philadelphia, The Pennsylvania Academy of the Fine Arts*

128 Richard Caton Woodville: Waiting for the Stage, 1851. 38·1 × 27 cm: 15 × 18⅛ in. *Washington, D.C., The Corcoran Gallery of Art*

129 Jerome Thompson: The 'Pick Nick' near Mount Mansfield, *c.* 1858. 102·9 × 142·2 cm: 40½ × 56 in. *The Fine Arts Museums of San Francisco, M.H. de Young Memorial Museum*

130 Enoch Wood Perry: The Pemigewasset Coach, *c.* 1870. 102·9 × 168·9 cm: 42½ × 66½ in. *Shelburne, Vermont, Shelburne Museum*

131 Albertus D.O. Browere: Rip and Wolf chased

from Home by Dame Van Winkle, 1880.
91·4 × 127 cm: 36 × 50 in. *Shelburne,
Vermont, Shelburne Museum*

132 John Quidor: The Return of Rip Van Winkle,
1829. 101 × 126·5 cm: 39¾ × 49¾ in.
Washington, D.C., National Gallery of Art
(Andrew Mellon Collection)

133 John Quidor: The Money Diggers, 1832. 42·6
× 54·6 cm: 16¾ × 21½ in. *The Brooklyn
Museum* (Gift of Mr and Mrs Alastair
Bradley Martin)

134 John Quidor: Antony van Corlear brought
into the Presence of Peter Stuyvesant, 1839.
69·6 × 87·6 cm: 27⅜ × 34½ in. *Utica, New
York, Munson–Williams–Proctor Institute*

135 William Sidney Mount: Farmers Nooning,
1836. 50·8 × 60·9 cm: 20 × 24 in. *Stony
Brook, Long Island, Suffolk Museum and
Carriage House* (Melville Collection)

136 William Sidney Mount: Cider Making, 1840–
1. 68·6 × 86·7 cm: 27 × 34⅛ in. *New York,
The Metropolitan Museum of Art* (Purchase,
Charles Allen Munn Bequest)

137 William Sidney Mount: Eel Spearing at
Setauket, 1845. 73·7 × 91·4 cm: 29 × 36 in.
*Cooperstown, New York State Historical
Association*

138 William Sidney Mount: Long Island Farm-
houses, 1854–9. 55·6 × 75·9 cm: 21⅞ ×
29⅞ in. *New York, The Metropolitan Museum
of Art* (Gift of Louise F. Wickham in
memory of her father, William H. Wick-
ham, 1928)

139 William Sidney Mount: The Banjo Player, *c.*
1855. 63·5 × 76·2 cm: 25 × 30 in. *The
Detroit Institute of Arts* (Gift of Dexter M.
Ferry, Jr.)

140 George Caleb Bingham: Fur Traders descend-
ing the Missouri, 1845. 73·7 × 92·7 cm:
29 × 36½ in. *New York, The Metropolitan
Museum of Art* (Morris K. Jesup Fund)

141 George Caleb Bingham: Jolly Flatboatmen,
1846. 96·5 × 123·2 cm: 38 × 48½ in. *Col-
lection Senator Claiborne Pell* (National
Gallery of Art, Washington, D.C.)

142 George Caleb Bingham: The County Election,
1851–2. 89·1 × 123·8 cm: 35⅛ × 48¾ in.
The St Louis Art Museum

143 Emanuel Gottlieb Leutze: Washington cross-
ing the Delaware, 1851. 355·6 × 650·3 cm:
140 × 256 in. *New York, The Metropolitan
Museum of Art* (Gift of John Stewart
Kennedy, 1897)

144 John James Audubon: House Wren, *c.* 1834·
Watercolour. 29·2 × 48·6 cm: 11½ × 19⅛
in. *The New-York Historical Society*

145 George Catlin: Wi-jun-jon, The Pigeon's Egg
Head, Going to and Returning from Wash-
ington, 1832. 73·7 × 60·9 cm: 29 × 24 in.
*Washington, D.C., National Collection of Fine
Arts, Smithsonian Institution*

146 Charles Deas: The Death Struggle, 1845.
76·2 × 63·5 cm: 30 × 25 in. *Shelburne,
Vermont, Shelburne Museum*

147 Albert Bierstadt: The Last of the Buffalo,
1889. 181 × 303 cm: 71¼ × 119¼ in.
*Washington, D.C., The Corcoran Gallery of
Art* (Gift of Mrs A. Bierstadt)

148 Albert Bierstadt: Domes of the Yosemite,
1867. 294·6 × 457·2 cm: 116 × 180 in. *St
Johnsbury, Vermont, St Johnsbury Athenaeum*
(Jenks Studio, St Johnsbury)

149 Thomas Moran: Grand Canyon of the Yellow-
stone, 1872. 218·4 × 358·1 cm: 86 × 141 in.
*Washington, D.C., National Collection of Fine
Arts, Smithsonian Institution* (On loan from
the Department of the Interior)

150 Timothy O'Sullivan: Ruins of White House,
Canyon de Chelly, Arizona, 1873. Photo-
graph. *Rochester, New York, International
Museum of Photography, George Eastman
House*

151 Edward Curtis: Princess Angeline, Suguamish
Tribe, Daughter of Chief Siahl, 1899, from
North American Indian (Freeman, London)

152 Eastman Johnson: Life in the South (Old
Kentucky Home), 1859. 91·4 × 114·3 cm:
30 × 45 in. *The New-York Historical Society*

153 Eastman Johnson: The Old Stagecoach, 1871.
92·7 × 152·7 cm: 36¼ × 60⅛ in. *Milwaukee
Art Center*

154 Eastman Johnson: The Cranberry Harvest,
1880. 70 × 139·5 cm: 27½ × 54½ in. *San
Diego, California, Timken Art Gallery* (The
Putnam Foundation)

155 Eastman Johnson: The Hatch Family, 1871.
121·9 × 187·4 cm: 48 × 73⅜ in. *New York,
The Metropolitan Museum of Art* (Gift of
Frederick H. Hatch, 1926)

156 Eastman Johnson: The Funding Bill, 1881.
153·7 × 198·9 cm: 60½ × 78¼ in. *New York,
The Metropolitan Museum of Art* (Gift of
Robert Gordon, 1898)

157 Alexander Gardner: The Home of a Rebel
Sharpshooter, Gettysburg, 1863, from
Photographic Sketchbook of the Civil War.

ton, D.C., Rock Creek Cemetery (David Blume, Washington, D.C.)

184 Daniel Chester French: Lincoln, 1916. Bronze. H. 81·3 cm: 32 in. *Cambridge, Massachusetts, Fogg Art Museum, Harvard University* (Grenville L. Winthrop Bequest)

185 George Inness: The Lackawanna Valley, 1855. 86 × 127·5 cm: 33⅞ × 50¼ in. *Washington, D.C., National Gallery of Art* (Gift of Mrs Huttleston Rogers)

186 George Inness: The Coming Storm, 1878. 66 × 99·1 cm: 26 × 39 in. *Buffalo, New York, Albright-Knox Art Gallery* (Albert H. Tracy Fund, 1900)

187 Homer Dodge Martin: Lake Sanford in the Adirondacks, Spring, 1870. 62·2 × 100·3 cm: 24½ × 39½ in. *New York, Century Association* (Frick Art Reference Library, New York)

188 John La Farge: Maua – Our Boatman, 1891. 119·4 × 96·5 cm: 47 × 38 in. *Andover, Massachusetts, Addison Gallery of American Art, Phillips Academy*

189 Mary Cassatt: Lady at the Tea Table, 1885. 73·7 × 60·9 cm: 29 × 24 in. *New York, The Metropolitan Museum of Art* (Gift of the artist, 1923)

190 Mary Cassatt: Woman Bathing, c. 1891. Drypoint and aquatint in colour. 38·1 × 26·7 cm: 15 × 10½ in. *New York, The Metropolitan Museum of Art* (Gift of Paul J. Sachs, 1916)

191 Childe Hassam: The Flower Garden, 1888. 71·1 × 55 cm: 28 × 21⅝ in. *Worcester, Massachusetts, Worcester Art Museum*

192 Childe Hassam: Inner Harbour, Gloucester, 1918. Lithograph. 19·7 × 28·3 cm: 7¾ × 11⅝ in. *Boston, Museum of Fine Arts* (Gift of Miss Kathleen Rothe)

193 William L. Picknell: Road to Concarneau, 1880. 108·6 × 202·5 cm: 42⅜ × 79¾ in. *Washington, D.C., The Corcoran Gallery of Art*

194 John H. Twachtman: Arques-la-Bataille, 1885. 152·4 × 200·4 cm: 60 × 78⅞ in. *New York, The Metropolitan Museum of Art* (Purchase, 1968; Morris K. Jesup Fund)

195 J. Alden Weir: The Red Bridge, 1895. 61·3 × 85·8 cm: 24⅛ × 33¾ in. *New York, The Metropolitan Museum of Art* (Gift of Mrs John A. Rutherfurd, 1914)

196 Edmund C. Tarbell: Josephine and Mercie, 1908. 71·8 × 82 cm: 28¼ × 32¼ in. *Washington, D.C., The Corcoran Gallery of Art*

197 John White Alexander: Isabella; or, the Pot of Basil, 1897. 191·8 × 90·2 cm: 75½ × 35¾ in. *Boston, Museum of Fine Arts* (Gift of Ernest Wadsworth Longfellow)

198 Clarence H. White: Spring, 1898. Platinum print photograph. *New York, The Metropolitan Museum of Art* (The Alfred Stieglitz Collection, 1933)

199 William Page: Mrs William Page, c. 1860. 153·7 × 92·1 cm: 60¼ × 36¼ in. *The Detroit Institute of Arts* (Gift of Mr and Mrs George S. Page, Blinn S. Page, Lowell B. Page, and Mrs Lesslie S. Howell)

200 William Rimmer: Dying Centaur, 1871. Bronze. H. 54·6 cm: 21½ in. *New York, The Metropolitan Museum of Art* (Gift of Edward Holbrook, 1906)

201 William Rimmer: Flight and Pursuit, 1871. 45·7 × 66·7 cm: 18 × 26¼ in. *Boston, Museum of Fine Arts* (Bequest of Miss Edith Nichols)

202 Elihu Vedder: Questioner of the Sphinx, 1863. 91·4 × 106 cm: 36 × 41¾ in. *Boston, Museum of Fine Arts* (Bequest of Mrs Martin Brimmer)

203 Edward Mitchell Bannister: Approaching Storm, c. 1890. 101·6 × 152·4 cm: 40 × 60 in. *Washington, D.C., Museum of African Art* (Miller Collection; Delmar Lipp, Washington, D.C.)

204 Ralph A. Blakelock: The Poetry of Moonlight, c. 1885–95. 76·2 × 64·2 cm: 30¼ × 25¼ in. *Huntington, New York, The Heckscher Museum*

205 Henry Ossawa Tanner: The Artist's Mother, 1897. 86·4 × 116·8 cm: 34 × 46 in. *Philadelphia, Pennsylvania, Mrs Sadie T.M. Alexander* (Chas. P. Mills & Son, Philadelphia)

206 Thomas Wilmer Dewing: The Recitation, 1891. 76·2 × 139·7 cm: 30 × 55 in. *The Detroit Institute of Arts*

207 Albert Pinkham Ryder: Moonlight Marine, c. 1890–9. Oil on panel. 28·9 × 30·5 cm: 11⅜ × 12 in. *New York, The Metropolitan Museum of Art* (Samuel D. Lee Fund, 1934)

208 Albert Pinkham Ryder: The Dead Bird, before 1880. Oil on panel. 10·8 × 25 cm: 4¼ × 9⅞ in. *Washington, D.C., The Phillips Collection*

209 Arthur B. Davies: Dream, c. 1908. 45·7 × 76·2 cm: 18 × 30 in. *New York, The Metropolitan Museum of Art* (Gift of George A. Hearn)

210 Maurice Prendergast: Umbrellas in the Rain, Venice, 1899. Watercolour. 34 × 52·1 cm: 13⅝ × 20½ in. *Boston, Museum of Fine Arts* (Charles Henry Hayden Fund)

211 Robert Henri: Eva Green, 1907. 61·3 × 76·5 cm: 24⅛ × 30⅛ in. *Wichita Art Museum* (Roland P. Murdock Collection)

212 George B. Luks: Woman with Macaws, 1907. 104 × 88·9 cm: 41 × 35 in. *The Detroit Institute of Arts* (Gift of Miss Julia E. Peck)

213 John Sloan: Gloucester Trolley, 1917. 66 × 81·3 cm: 26 × 32 in. *Canajoharie, New York, Library and Art Museum*

214 George Bellows: The Big Dory, 1913. 45·7 × 55·9 cm: 18 × 22 in. *The New Britain Museum of American Art* (E. Irving Blomstrann, New Britain)

215 George Bellows: Dempsey and Firpo, 1924. Lithograph. 46 × 56·9 cm: 18⅛ × 22⅜ in. *New York, The Museum of Modern Art* (Mrs John D. Rockefeller, Jr, Purchase Fund)

216 Alfred Stieglitz: The Steerage, 1907. Photograph from *Camera Work*, No. 36 (October, 1911)

217 Man Ray: The Rope Dancer Accompanies Herself With Her Shadows, 1916. 132·1 × 186·4 cm: 52 × 73⅜ in. *New York, The Museum of Modern Art* (Gift of G. David Thompson)

218 Stanton Macdonald-Wright: Conception Synchromy, 1915. 76·2 × 60·9 cm: 30 × 24 in. *New York, Whitney Museum of American Art* (Gift of George F. Of; Geoffrey Clements, Staten Island)

219 John Marin: Maine Islands, 1922. Watercolour. 41·3 × 50·8 cm: 16¼ × 20 in. *Washington, D.C., The Phillips Collection*

220 Marsden Hartley: Fox Island, Maine, 1937-8. 54·6 × 71·1 cm: 21½ × 28 in. *Andover, Massachusetts, Addison Gallery of American Art, Phillips Academy*

221 Alfred H. Maurer: Twin Heads, 1930. 67 × 45·7 cm: 26⅜ × 18 in. *New York, Whitney Museum of American Art* (Gift of Mr and Mrs Hudson D. Walker)

222 Max Weber: Chinese Restaurant, 1915. 101·6 × 121·9 cm: 40 × 48 in. *New York, Whitney Museum of American Art*

223 Stuart Davis: Salt Shaker, 1931. 126·6 × 81·3 cm: 49⅞ × 32 in. *New York, The Museum of Modern Art* (Gift of Mrs Edith Gregor Halpert)

224 Joseph Stella: New York Interpreted: The Bridge, 1922. Gouache. 224·2 × 137·2 cm: 88¼ × 54 in. *The Newark Museum*

225 Charles Demuth: 'I Saw the Figure Five in Gold', 1928. Oil on composition board. 91·4 × 75·5 cm: 36 × 29¾ in. *New York, The Metropolitan Museum of Art* (The Alfred Stieglitz Collection, 1949)

226 Charles Sheeler: Rolling Power, 1939. 38·1 × 76·2 cm: 15 × 30 in. *Northampton, Massachusetts, Smith College Museum of Art*

227 Thomas Hart Benton: Arts of the West, 1932. Tempera and oil. 243·8 × 396·2 cm: 96 × 156 in. *The New Britain Museum of American Art* (E. Irving Blomstrann, New Britain)

228 Grant Wood: Stone City, Iowa, 1930. Oil on wood. 76·9 × 101·6 cm: 30¼ × 40 in. *Omaha, Nebraska, Joslyn Art Museum*

229 Ben Shahn: Willis Avenue Bridge, 1940. Tempera on paper over composition board. 58·4 × 79·8 cm: 23 × 31⅜ in. *New York, The Museum of Modern Art* (Gift of Lincoln Kirstein)

230 Jack Levine: Gangster Funeral, 1952-3. 160 × 182·9 cm: 63 × 72 in. *New York, Whitney Museum of American Art* (Geoffrey Clements, Staten Island)

231 Charles Burchfield: Old Farm House (September Sunlight), 1932. Watercolour. 37·9 × 53·3 cm: 14⅞ × 21 in. *Cambridge, Massachusetts, Fogg Art Museum, Harvard University*

232 Morris Graves: Bird Singing in the Moonlight, 1938-9. Gouache. 68 × 76·5 cm: 26¾ × 30⅛ in. *New York, The Museum of Modern Art*

233 Ivan Albright: That Which I Should Have Done I Did Not Do, 1931-41. 246·4 × 91·4 cm: 97 × 36 in. *The Art Institute of Chicago*

234 Edward Weston: Pepper No. 30, 1930. Photograph. *New York, The Museum of Modern Art* (Cole Weston, Carmel, California)

235 Walker Evans: Bedroom Fireplace, Tenant Farmhouse, Hale County, Alabama, 1936. Photograph. *Washington, D.C., Library of Congress*

236 Edward Hopper: Freight Cars, Gloucester, 1928. 73·6 × 101·6 cm: 29 × 40 in. *Andover, Massachusetts, Addison Gallery of American Art, Phillips Academy*

237 Edward Hopper: Office at Night, 1940. 56·2 × 63·5 cm: 22⅛ × 25 in. *Minneapolis, Minnesota, Walker Art Center*

238 Andrew Wyeth: Grape Wine, 1966. Tempera on gesso panel. 65·8 × 74 cm: 25⅞ × 29⅛

in. *New York, The Metropolitan Museum of Art* (Gift of Amanda K. Berls, 1967)

239 Elie Nadelman: Man in the Open Air, *c.* 1914–15. Bronze. H. 138·4 cm: 54½ in. *New York, The Museum of Modern Art* (Gift of William S. Daley)

240 Gaston Lachaise: Torso, 1930. Bronze. H. 29·2 cm: 11½ in. *New York, Whitney Museum of American Art*

241 John B. Flannagan: Triumph of the Egg, I, 1937. Granite. 30·5 × 40·6 cm: 12 × 16 in. *New York, The Museum of Modern Art*

242 Isamu Noguchi: The Family, 1956–7. Granite. H. of tallest statue 487·7 cm: 192 in. *Bloomfield, Connecticut, Connecticut General Life Insurance Company*

243 Arthur G. Dove: Fog Horns, 1929. 46 × 66·4 cm: 18⅛ × 26⅛ in. *Colorado Springs Fine Arts Center* (Gift of Oliver B. James)

244 Milton Avery: Sea Grasses and Blue Sea, 1958. 152·7 × 183·9 cm: 60⅛ × 72⅜ in. *New York, The Museum of Modern Art* (Gift of friends of the artist)

245 Georgia O'Keeffe: Black Iris, 1926. 91·4 × 75·8 cm: 36 × 29⅞ in. *New York, The Metropolitan Museum of Art* (The Alfred Stieglitz Collection)

246 Horace Pippin: Victorian Interior, 1946. 64·1 × 76·2 cm: 25¼ × 30 in. *New York, The Metropolitan Museum of Art* (A. H. Hearn Fund, 1958)

247 Jacob Lawrence: The Migration of the Negro: Panel No. 1: During the World War there was a Great Migration North by Southern Negroes, 1940–1. Tempera on panel. 30·5 × 45·7 cm: 12 × 18 in. *Washington, D.C., The Phillips Collection*

248 Hans Hofmann: Magenta and Blue, 1950. 121·9 × 147·3 cm: 48 × 58 in. *New York, Whitney Museum of American Art*

249 Arshile Gorky: Agony, 1947. 101·6 × 129·5 cm: 40 × 50½ in. *New York, The Museum of Modern Art* (A. Conger Goodyear Fund)

250 Jackson Pollock: Guardians of the Secret, 1943. 123·8 × 190·5 cm: 48¾ × 75 in. *San Francisco Museum of Art* (Albert M. Bender Bequest Fund Purchase)

251 Jackson Pollock: Autumn Rhythm, 1950. 266·7 × 525·8 cm: 105 × 207 in. *New York, The Metropolitan Museum of Art* (George A. Hearn Fund, 1957)

252 Mark Tobey: Edge of August, 1953. Casein on composition board. 121·9 × 71·1 cm: 48 ×

28 in. *New York, The Museum of Modern Art*

253 Franz Kline: Accent Grave, 1955. 191·2 × 131·5 cm: 75¼ × 51¾ in. *The Cleveland Museum of Art* (Anonymous gift)

254 Willem de Kooning: Woman, I, 1950–2. 192·8 × 147·3 cm: 75⅞ × 58 in. *New York, The Museum of Modern Art*

255 Mark Rothko: Green and Maroon on Blue, 1953. 230·6 × 138·4 cm: 90¾ × 54½ in. *Washington, D.C., The Phillips Collection*

256 Barnett Newman: Vir Heroicus Sublimis, 1950–1. 243·6 × 541·7 cm: 95⅜ × 213¼ in. *New York, The Museum of Modern Art* (Gift of Mr and Mrs Ben Heller)

257 Clyfford Still: 1954, 1954. 288·3 × 496·2 cm: 113½ × 156 in. *Buffalo, New York, Albright-Knox Art Gallery* (Gift of Seymour H. Knox)

258 Adolph Gottlieb: The Frozen Sounds, Number I, 1951. 91·4 × 121·9 cm: 36 × 48 in. *New York, Whitney Museum of American Art* (Gift of Mr and Mrs Samuel M. Kootz)

259 Robert Motherwell: The Voyage, 1949. Oil and tempera on paper mounted on composition board. 121·9 × 238·8 cm: 48 × 94 in. *New York, The Museum of Modern Art* (Gift of Mrs John D. Rockefeller, 3rd)

260 Helen Frankenthaler: Interior Landscape, 1964. Acrylic on canvas. 266·1 × 235·6 cm: 104¾ × 92¾ in. *San Francisco Museum of Art* (Gift of the Women's Board)

261 Alexander Calder: Mobile, 1957. Steel. w. 13·7 m: 45 ft. *New York, John F. Kennedy International Airport* (The Port of New York Authority)

262 Simon Rodia: The Watts Towers, c. 1921–54. Steel, concrete, and mixed media. H. of tallest tower c. 30 m: 100 ft. *Watts, Los Angeles* (The Committee for Simon Rodia's Towers in Watts)

263 David Smith: Hudson River Landscape, 1951. Welded steel. H. 190·5 cm: 75 in. *New York, Whitney Museum of American Art*

264 David Smith: Cubi XXII, 1964. Stainless steel. 262·6 × 196·3 cm: 103¾ × 77¼ in. *New Haven, Connecticut, Yale University Art Gallery* (Stephen Carlton Clark, B.A. 1903, Fund; Joseph Szaszfai)

265 John Chamberlain: Dolores James, 1962. Welded and painted steel. 200 × 246·4 × 99 cm: 79 × 97 × 39 in. *New York, The Solomon R. Guggenheim Museum*

266 Richard Lippold: Variation Number 7: Full

Moon, *c.* 1950. Brass rods, nickel-chromium, and stainless steel wire. 304·8 cm: 120 in. *New York, The Museum of Modern Art* (Mrs Simon Guggenheim Fund)

267 Louise Nevelson: Sky Cathedral, 1958. Wood painted black. 344·2 × 304·8 × 45·7 cm: 135½ × 120¼ × 18 in. *New York, The Museum of Modern Art* (Gift of Mr and Mrs Ben Mildwoff)

268 Chryssa: Fragments for the Gates to Times Square, 1966. Neon and plexiglas. 207·7 × 87·6 × 69·9 cm: 81 × 34½ × 27½ in. *New York, Whitney Museum of American Art* (Gift of Howard and Jean Lipman)

269 Sam Gilliam: Horizontal Extension, 1969. Acrylic on canvas with powdered aluminium. 335·3 × 1386·8 × 381 cm: 132 × 546 × 150 in. as hung. *Collection of the artist* (Leroy Woodson)

270 Robert Rauschenberg: Monogram, 1959. Construction. 122 × 183 × 183 cm: 48 × 72 × 72 in. *Stockholm Nationalmuseum*

271 Jasper Johns: Field Painting, 1963–4. Oil and mixed media. 182·9 × 93·4 cm: 72 × 36¾ in. *Collection of the artist* (Leo Castelli, New York)

272 Larry Rivers: Parts of the Face: The Vocabulary Lesson, 1961. 74·3 × 74·3 cm: 29½ × 29½ in. *London, The Tate Gallery*

273 Fritz Scholder: American Indian, 1970. 152·4 × 106·7 cm: 60 × 42 in. *Washington, D.C., United States Department of the Interior, Indian Arts and Crafts Board*

274 Raymond Saunders: Marie's Bill, 1970. 210·8 × 137·2 cm: 83 × 54 in. *New York, Terry Dintenfass Inc.* (John D. Schiff, New York)

275 Richard Lindner: Rock-Rock, 1966–7. 177·8 × 152·4 cm: 70 × 60 in. *Dallas Museum of Fine Arts* (Gift of Mr and Mrs James H. Clark)

276 Romare Bearden: The Street, 1964. Collage. 96·5 × 137·2 cm: 38 × 54 in. *New York, Cordier and Ekstrom*

277 Edward Kienholz: The Wait, 1964–5. Assemblage. 203·2 × 375·9 × 198·2 cm: 80 × 148 × 78 in. *New York, Whitney Museum of American Art* (Gift of Howard and Jean Lipman Foundation Inc.)

278 Marisol: Women and Dog, 1964. Mixed media. 182·9 × 208·3 × 40·6 cm: 72 × 82 × 16 in. *New York, Whitney Museum of American Art* (Gift of the Friends of the Museum)

279 Robert Indiana: The Demuth American Dream No. 5, 1963. Each panel 121·9 × 121·9 cm: 48 × 48 in. *Toronto, Art Gallery of Ontario* (Gift from the Women's Committee Fund, 1964)

280 James Rosenquist: Nomad, 1963. Oil on canvas, plastic paint, wood. 213·3 × 531·4 cm: 84 × 210 in. *Buffalo, New York, Albright-Knox Art Gallery* (Gift of Seymour H. Knox)

281 Roy Lichtenstein: As I Opened Fire, 1964. Oil and magna. Each panel 173 × 142·5 cm: 68 × 46 in. *Amsterdam, Stedelijk Museum*

282 Andy Warhol: 100 Campbell's Soup Cans, 1962. 182·9 × 132·1 cm: 72 × 52 in. *Buffalo, New York, Albright-Knox Art Gallery* (Gift of Seymour H. Knox)

283 Andy Warhol: 5 Deaths 11 Times in Orange, 1963. Acrylic and silkscreen. 220 × 210 cm: 86½ × 82⅝ in. *Turin, Museo Civico* (Giustino Rampazzi, Turin)

284 Claes Oldenburg: Giant Hamburger, 1962. Painted sailcloth stuffed with foam. Approx. 132·1 × 213·3 cm: 52 × 84 in. *Toronto, Art Gallery of Ontario*

285 George Segal: The Gas Station, 1963. Plaster and mixed media. 260 × 730 × 142 cm: 102 × 288 × 56 in. *Ottawa, The National Gallery of Canada*

286 Tom Wesselmann: Great American Nude, No. 57, 1964. Synthetic polymer paint on composition board. 121·9 × 165·1 cm: 48 × 65 in. *New York, Whitney Museum of American Art*

287 Philip Pearlstein: Reclining Nude on Green Couch, 1971. 152·4 × 121·9 cm: 60 × 48 in. *Washington, D.C., The Corcoran Gallery of Art*

288 Chuck Close: Self Portrait, 1968. Acrylic on canvas. 273·1 × 212·1 cm: 107½ × 83½ in. *Minneapolis, Minnesota, Walker Art Center* (Eric Sutherland)

289 Diane Arbus: Boy with a straw hat waiting to march in a pro-war parade, 1966. Photograph. *Cambridge, Massachusetts, Fogg Art Museum, Harvard University*

290 Josef Albers: Homage to the Square: Apparition, 1959. Oil on board. 120·6 × 120·6 cm: 47½ × 47½ in. *New York, The Solomon R. Guggenheim Museum*

291 Richard Anuskiewicz: Between, 1966. Acrylic on canvas. 213·4 × 213·4 cm: 84 × 84 in. *Hanover, New Hampshire, Dartmouth College Collection*

292 Ellsworth Kelly: Green White, 1961. 175·3 ×

PREFACE

Americans continue to think of their country as a young, and youthful, nation. Although now possessing one of the oldest continuing forms of government in the world, America has a history that is comparatively short in relation to civilizations in Europe and Asia. This relative youth has become a deeply ingrained idea, partly real and partly mythic, in the national imagination, even as the country celebrates its Bicentennial in 1976. To be sure, there are many important records of ancient indigenous Indian cultures in the Americas, yet within the boundaries of what came to be settled and organized as the United States a central impulse seemed to be an assault on the past. Both the immigration from Europe and its past on the one hand, and the subduing of the Indians and their past on the other, became forms of declaring both present and future possibility.

The history of art in America, by which we mean in the United States, is also rather young. This presents special inhibitions as well as opportunities. Although the first history of American art might be said to have been written by William Dunlap in 1834, the chronology and substance of much American painting and sculpture are still undergoing reappraisal. Comprehensive modern monographs are yet to appear on several major artists, so that for a time our knowledge about these figures and their role in the evolution of American culture is incomplete. But the inherent value of growth as an idea in American life and the long sustained energy of her arts insure in any case a continuing re-evaluation of the nation's artistic identity. Thus, as American art reflects the constant tension between past and present, her historians will always face the need for definitiveness with the necessity of incompleteness.

The earlier periods of American art especially are in a process of reappraisal. The emergence of heretofore lost documents (such as John Smibert's Notebook), of new technical information, and of generally changing attitudes has widely stimulated current scholarship in the field. Many figures neglected since their lifetime have been brought to light and re-examined within recent years, and some, like Frederic Edwin Church, have emerged as critically important artists. Owing partly to the self-confidence that abstract expressionism brought to American art in the decades after World War II, and partly to the more recently revived interest in forms of realism (e.g., Pop Art and sharp-focus realism), critical and popular taste is turning afresh to earlier areas and movements throughout the nineteenth century.

Since modern American art has been the subject of comprehensive surveys, and since many contemporary artists have been treated in thorough exhibition catalogues or monographs, pro- portionately greater attention here will go to artistic developments prior to the twentieth century. Doubtless, the interested reader will form his own hypothetical list of works he considers most deserving of discussion, and will surely wish for alternatives or additions at certain points in this discussion. But hopefully what is offered here is a structure of ideas that will illuminate the range of issues in a given period or style, and therefore will be applicable even to works or artists only briefly mentioned. The national Bicentennial provides an appropriate point for concluding this survey. This will permit the examination of twentieth-century American art both in the light of its own accomplishments and in the longer perspective and continuities of a national tradition.

PREFACE

Almost entirely, the works of art illustrated are intentionally chosen from public collections. This is to demonstrate the richness and variety of holdings among American museums and also to draw public attention to the direct accessibility of major works of American art. Unlike England or France, America has no one pre-eminent collection of national art (although there are a National Gallery and a National Collection among others in Washington, D.C.). More characteristically, what we might assemble as a sequence of major national objects has through accident and practicality come to repose principally in the two great collections of the Metropolitan Museum of Art in New York and the Museum of Fine Arts in Boston, as well as piecemeal in dozens of smaller institutions across the country. Perhaps this fragmentation is as it should be for a democratic country. De Tocqueville early in the nineteenth century identified such multiplicity as part of the national character.

As a practical people, Americans have often viewed the fine arts as an aristocratic luxury, frequently insisting on a functionalism to make art popularly available and acceptable. Repeated themes in the history of American art are the ambivalent relationships between individual and society, America and Europe, past and present, tradition and revolution. At the same time that the New World sought to cast off the parentage of the Old, it equally aspired to the immediate creation of its own authentic identity. Remarkably, the confluence of a near-messianic national will and a geography receptive to the aspirations of discovery permitted the building of a country whose forces of energy still continue to move with striking determinism.

Just as critical scholarship in American art is now entering a new phase of maturity and seriousness, so too is the teaching of the subject in university curricula. One of the individuals responsible for the vigour and thoughtfulness of work among younger scholars was the late Professor Benjamin Rowland, Jr, of Harvard University. Himself the distinguished author of a book in the Pelican History of Art series, he stimulated a new generation of critics and writers at a propitious time. As one of those former students, I find it a happy and fitting opportunity to dedicate this Pelican volume to his memory.

For invaluable assistance I am indebted to Susan Rose-Smith, who secured the illustrations, Helen Weigle, who prepared the manuscript, and Judy Nairn, who guided the whole to publication. Making my research immeasurably easier were the always helpful efforts of Molly O'Connor and the staff of the Sherman Art Library of Dartmouth College. Finally, I should like to acknowledge the assistance of a fellowship from the John Simon Guggenheim Memorial Foundation during 1973–4, which gave me the opportunity to undertake this work.

J. W.

PART ONE

THE COLONIAL PERIOD
1564–1776

From Discovery to Revolution

THE IMAGERY OF DISCOVERY

AMERICA was an image before she was a fact.

Before the United States came into being there was the uncharted continent of America, but even before that a vision of the New World existed. The very term suggests a bifurcation between two significant words: one (New) emphasizing the substance of discovery, the other (World) implying the context of a vast domain, a geography unto itself. Together, they came to intimate the existence of an unknown landscape beyond the horizon. The concept of a new world emerged partly from the superstitions and religious beliefs of the medieval mind in Europe. The elaborate westworks, for example, of Romanesque and Gothic churches were frequently dedicated to the archangel Michael and massively constructed to face the physical landscape of the setting sun and the spiritual one of the next world. Thus, darkness was associated with the unknown, and the blazing sun disappeared into a metaphorical realm of glory and riches.[1] Likewise, garden imagery was often the subject of artists like Schongauer and Dürer, whose prints enclosed both secular and religious figures in cloisters or courtyards, implying a tempting, unknown world outside the walls of Eden.

As the waning phases of the Middle Ages gradually gave way to the dawn of Renaissance thought, a new spirit arose of intellectual and scientific inquiry. Of all the sciences mathematics was perhaps most at the heart of this new spirit, and measurement seemed the principal aim of the age. During the fifteenth and sixteenth centuries theories of ordering the universe infused every area of learning, from architecture (Alberti) to astronomy (Galileo) to anatomy (Leonardo). Both the development of perspective and the advances in cartography were means of making concrete the undefined spaces of man's experience. So from these various forces accumulated the sense of a world of boundless promise and scale somewhere to the west, an unknown inviting definition. Discovery thus became a form of possession.

This experience of discovery and the effort at rendering the unknown known may be seen in the earliest maps made of the New World. Among the most interesting of these first records are those by John White, one of the first artists to depict the North American coastline and its inhabitants. What do maps such as his *Chart of the East Coast* (Plate 1) tell us? What are its meaning and power as an image? Primarily, of course, a rendering of the portion of land visited by White on the English expedition of 1585, it gives with general accuracy the location of peninsulas, bays, and estuaries along the Atlantic seaboard from the Chesapeake Bay to Florida. At least half the page is taken up by water, a strong and lasting presence in the lives of these explorers. Even before they had reached the shores of the new continent, they had to cross the seemingly endless expanse of ocean. A sense of land and space beyond the horizon was constant. These voyages were challenging and usually perilous, their terminus often unknown or ill-defined.

3

Approaching the New World, therefore, was inherently filled with wonder and determination; this posture would carry into the nineteenth-century charting of the west and the twentieth-century exploration of space.

The sea was at once a physical and a visionary reality to contend with, and it conditioned the imagination of explorers and settlers for centuries.[2] Here was the primal frontier, a vast inviting and inhibiting threshold to the misty lands in the west. Characteristic of many contemporary maps were the coastlines which ran off the edges of the page, and the vague unmarked interiors of continents, signifying where man's first-hand discoveries merged into the conjectural. The mythology of water has deep currents in the history of the European mind, extending back through ancient and medieval literature. In the more immediate background of the Renaissance are the frequent recurrences of visionary sea imagery in the lines of Spenser and Shakespeare.[3] Voyaging into new realms possessed both a mythic and an idyllic character. In 1566 Nicholas Le Challeux described a French expedition of the year previous to an island then known as Florida in the West Indies: 'The rumor spread here that Florida promised an abundance of all that man might desire in the world. For that country had received a singular favor from heaven.'[4]

A century later William Bradford characterized the Puritan attitudes towards coming to the New World. His *History of Plymouth Plantation, 1606–1646* remarks on the sublime terrors of the passage, 'the wonders of the Deepe', which finally culminate through God's will in a safe arrival for his fellow voyagers on 'the firme and stable earth, their proper elemente'.[5] By the eighteenth century travel to the colonial world was proclaimed part of an even grander design. For Bishop George Berkeley and his group headed for Bermuda to found a college (see Plate 25), the New World represented the culmination of western history, the closing drama in the course of empire. 'Time's noblest offspring is the last,'[6] he testified, embellishing a theme that would remain vivid in the American imagination through the nineteenth century. Thus the voyage became as significant as the ultimate arrival throughout the long chronology of exploring the Americas.

John White's chart of 1585 (Plate 1) contains all these elements of discovery. Six three-masted vessels sail both in the open sea and close to the coast, signifying various moments in the approach to land. Whales, dolphins, and fish (which White was to draw in greater detail) populate the waters, indications both of 'the wonders of the Deepe' and of the riches awaiting adventurers to this virgin world. Red dots along the shores of parts of the islands and the mainland denote places where the settlers visited. As if to stamp the imprimatur of the Old World on the New, or to give features to this faceless landscape, White has painted on the continent the arms and crest of Sir Walter Raleigh, instigator of the expedition. Also, running through this map are axial lines from the rose compass and nearby numerical demarcations of latitude. Here were the order and authority of numbers in the service of codifying experience and defining the acts of discovery. In sum, White's image stands as a telling record of time, place, narrative action, even aspiration and ambition. Made visible are measurements of reality as well as acts of imagination. The topographies of land and mind are fused.

4

The period of exploration in the New World stretched over several centuries, from the first discoveries made by the Irish and the Norse around 1000 to the first settlements and colonies of the French, Spanish, and English during the sixteenth century.[7] It is from this latter period that the first American art may be said to date. To be sure, there survive some relics, archaeological sites, and burial mounds of not fully determinate date from indigenous Indian cultures (e.g., Plate 4); and there are earlier charts or records of other expeditions; but it was only with the respective voyages of the French and English in the second half of the sixteenth century that artists came along and sketched their experiences. Their observations were assured firm places in posterity through engravings made by Theodore de Bry and published in various editions during subsequent decades.

Yet before the arrival of the French and the English Columbus had sailed from Spain, and his landfall in 1492 initiated a full century of Spanish colonization in the New World. Bringing with them forms of government and of institutional organization derived primarily from the Catholic Church, the Spanish settled Florida and the Southwest. Their great artistic contribution to the New World was the monumental architecture of the mission churches in Texas, New Mexico, and along the Camino Real in southern California.[8] In the wake of the Spanish the French began sending expeditions to the eastern coasts, although Spanish ambitions were determined to keep their competition short-lived.

With the French vessels that reached Florida in 1564 was the artist Jacques Le Moyne de Morgues. They had come to the same site on the St John River below Jacksonville that a previous French group under Jean Ribaut had reached two years earlier. Ribaut had set up a pillar at the mouth of the river, and now Le Moyne undertook a painting of the monument with René de Laudonnière, captain of this second venture, and Athore, chief of the local Indian tribe (Plate 2). This watercolour is evidently the only one extant of several dozen painted by Le Moyne. Its vivid colouring, the obvious fraternization between European and Indian, above all the rich abundance of floral and vegetable still life, together bespeak an awareness of new-found plenitude. Ribaut had already narrated his optimism and celebration when he described the country as

the fairest, frutefullest and pleasantest of all the worlde, habonding in honney, veneson, wild-foule, forrestes, woodes of all sortes, greatest and fairest vynes in all the wourld with grapes accordingly.[9]

One feels that he could express his delight only through itemizing sequences of flora and fauna, whether 'herons, corleux, bitters, mallardes, woodkockes' or 'gold, silver, pearls, turquoise'.[10] This is a language of well-being. Le Moyne's recollections were more prosaic:

My special duty when we reached the Indies would be to map the seacoast and harbors, indicate the position of towns, plot the depth and course of the rivers.[11]

Le Moyne was later characterized by Richard Hakluyt as 'the skillful painter James Morgues'.[12] He was also an engraver as well as publisher and seller of books. The pre-

cision and detail of his watercolour indicates that he probably had in mind the printing of his own pictures, although he died before ever bringing the project to fruition. This would be left to De Bry.

What proved to be worthy of observation to Le Moyne were various occasions of sailing along the coast or up rivers, building forts, and different Indian ceremonies or customs, such as hunting and going to war. As later engraved by De Bry, most of the figures not surprisingly assume the poses of ideal Renaissance nudes. The sharpness of outlines, generally balanced compositions, and muscular proportions clearly recall the engravings of Pollaiuolo, such as his *Battle of the Naked Men* of about 1470, or Michelangelo's drawings, for example the *Battle of Cascina* of 1504. Ultimately, the stances of these figures go back to Greek and Roman sources like the *Doryphorus* or Imperial fulllength statuary. Le Moyne thus maintains the necessary mixture of practical recording and idyllic vision.

The incident he has chosen to depict in this surviving watercolour is the first meeting ashore between his captain and the Indian chief. With an exchange of gifts and vows of amity, presumably symbolized in the array of full baskets and the sheaf of arrows laid upon the ground, the two leaders visit Ribaut's column, carved with the arms of France and now adorned with wreaths of flowers and leaves. The Indians are kneeling to worship the column; their chief stands proudly in the foreground, himself decorated with elaborate painted designs and 'adorned, after the Indian fashion', as Le Moyne noted,

with their riches: feathers of different kinds, necklaces of a special sort of shell, bracelets made of fish teeth, belts of silver-colored balls, round and oblong, and pearl anklets.[13]

From the beginning the European was to depict the American Indian with a combination of realism and idealism, a blend of the documentary and the romantic that was also to inform the work of John White a few decades later as well as the powerful images of Gustavus Hesselius in the eighteenth century, George Catlin in the nineteenth, and Edward Curtis in the early twentieth (see Plates 21, 145, and 151).

Alas, the promise and possibility suggested by Le Moyne's effulgent imagery were to be reclaimed by the Spanish and eventually passed on to the English. After building his trading post, named Fort Caroline, near the site of Ribaut's column, Laudonnière returned to France for further assistance. His compatriots meanwhile succumbed to stealing and pirating, which naturally drew the angered attention of the Spanish. They pursued and massacred the French colonists, at the same time firmly establishing the dominion of Spain in the area with the founding of St Augustine and the subsequent building of massive fortifications there.

One of the certain incentives to English exploration was the work of Theodore de Bry, whose engravings after Le Moyne's and John White's watercolours both invigorated the European imagination and provided some of the first accurate details about the New World. De Bry's artistic role in the definition of the image of America is consequently an important one. Flemish by birth, he left the persecutions in the Netherlands by Philip II for Germany. In Frankfurt he established himself as an engraver

and goldsmith, and by 1588 was in London attempting to negotiate the publication of Le Moyne's pictures. Of himself he later wrote:

I was the offspring of parents born to an honourable station, and was in affluent circumstances and in the first rank of the more honoured inhabitants of Liege. But stripped of all these belongings by the accidents, cheats, and ill terms of fortune and by the attacks of robbers, I had to contend against such adverse chance that only by my art could I fend for myself. . . . Art restored my former wealth and reputation, and has never failed me, its unwearied devotee.[14]

The engraved print thus not only played a significant part in De Bry's life, but was also central to the transmission of visual information throughout the formative centuries of settling the New World. For some time the reality of America existed foremost as two-dimensional images for Europeans, and later the first attempts at portraiture (see Plates 7–12), gravestone carving (Plate 5), and architecture retained a dominating sense of flatness largely because the experience of form was conveyed by means of prints.

In London De Bry could not persuade Le Moyne to sell his watercolours for engraving, although after the latter's death his widow did permit their publication. During this period Hakluyt was completing his own monumental work, *The Principall Navigations, Voiages and Discoveries of the English Nation*, and probably persuaded De Bry to delay his work on Le Moyne's Florida folio in favour of engraving first the drawings of John White which had been brought back to London from the English voyage to Virginia in 1587. De Bry did publish the Virginia book in several languages in 1590 and the Florida volume a year later.[15]

The English explorations began to surge during the latter half of the sixteenth century from several stimuli: the descriptions of the French, the ambitions of a new mercantile class, the encouragement of Queen Elizabeth I, and the visions of men like Sir Francis Drake and Sir Walter Raleigh. Competition challenged them to take their own part in the discovery and possession of the New World's riches. The artist John White was sent by Raleigh on two of these expeditions, the first in 1585 under Sir Richard Grenville when he made his remarkable group of watercolours, and the second in 1587 when he returned as governor of the Virginia colony and wrote his own account. Also on the first venture was a mineral prospector Joachim Ganz and the noted scientist and surveyor Thomas Hariot. The latter's narrative, *A Briefe and True Report of the New Found Land of Virginia*, was published first in 1588, unillustrated, and then in 1590 with De Bry's engravings after White's drawings. White's and Hariot's records perfectly complemented one another; they form an impressive collaboration of artistic and scientific observation. In this context White's contribution stands out as another landmark in the beginnings of art in the New World.

These two English efforts were not successful in establishing lasting or flourishing colonies in Virginia – that would have to wait until early in the next century with the founding of Jamestown and Plymouth Plantation – but they did produce the signal achievements of Hariot, White, and De Bry. That both the original watercolours and the published engravings have survived lends additional interest.

Not a great deal is known about White's life outside his participation in the Virginia

settlements. He was probably born in the middle years of the sixteenth century, and his Eskimo drawings in the British Museum suggest that he went along with the explorer Martin Frobisher on the latter's voyage to the Arctic in 1577. Scholars agree that he was the John White listed in London in 1580 as a member of the Painter-Stainers' Company.[16] The nature of his artistic training is unknown; all that is clear is that he was a notably talented draughtsman and colourist. His observation of details is astute and his aesthetic sense is evident in the expressive placement of his often strongly silhouetted forms on the page. Comparing the poses of his standing figures with those in Le Moyne's work raises the possibility that he was familiar with the older artist's pictures, Le Moyne having settled in London himself by the early 1580s.[17] Whatever the case, White's perceptions were sharp, his familiarity with artistic conventions sure, and his competence recognizable.

The White watercolours may be conveniently subdivided into several groups: some are maps of the coast (Plate 1) of the areas south of the Chesapeake; others are bird's-eye views of fortifications or Indian towns; a few illustrate Indian manners. Many are filled with a series of narrative incidents, for example, views of their camp sites. In these White often shows the fields fully planted and waters filled with an abundance of life – again the metaphors of plenitude.

Another group of pictures is of individual Indians, some clearly particularized portraits and carefully decorated. One native poses in a contrapposto stance similar to Le Moyne's earlier figures. Another called *The Flyer* by White and *The Conjurer* by De Bry is based on the statue of Mercury by Giovanni Bologna. Finally, there are drawings of a number of individual plants, flowers, fruits, as well as fish, insects, and birds, some identified in Latin with their scientific names. This was probably the influence of Hariot's exacting and methodical mind. Characteristic is the beautiful and expressive rendering of *A Flaminco* (Plate 3), whose head, tail, and feet just reach the edges of the page. By doing so they give the composition a peculiarly effective tension and sinuous grace, so suitable to this elegant and colourful bird.

White surely possessed a refined sense of line and pattern, for his watercolours rise beyond the merely ornithological or ethnological through their feeling for aesthetic design. Accurate as documents, they convey on another level a special delicacy and force that will not be equalled until the early nineteenth-century watercolours of John James Audubon and George Catlin (Plates 144 and 145). American art will retain through much of its history a sense of the practical, and the marriage of art and science displayed here strikes a note that will echo again in subsequent centuries, from Benjamin Franklin and Charles Willson Peale (Plates 57 and 59) to Samuel F. B. Morse, Albert Bierstadt, and William Rimmer (Plates 74, 147, and 200).

In his engravings published from White's drawings, De Bry made a number of subtle changes. Historians have noted his tendency to Europeanize the figures by changing facial features, perfecting anatomical proportions, and classicizing postures. Often, the gestures of several figures are altered, usually in favour of a more rhythmic and harmonious composition. One senses that White's first-hand observations and narrative details are being both idealized and generalized. Presumably more in touch with Renais-

sance style and techniques than White, De Bry attempts to create more unified spatial recession, especially in the landscape views; further, he exploits the nature of the engraving medium to achieve a precision and uniformity of detail. Although this meant that something of White's freshness and immediacy was lost in the translation, the entire process demonstrates how vivid was the transforming and informing power of prints in the European perception of the New World. We might say that America was being both discovered and invented.

John White's colleague, Thomas Hariot, brought to these adventures his own force of personality and vision. The bare facts of his biography – he was born in Oxford in 1560 and educated there – hardly intimate the distinction of his talents. After graduating from Oxford, he became a friend and tutor of Sir Walter Raleigh in astronomy and navigation. Also among his acquaintances were Henry Percy, ninth earl of Northumberland, and the astronomer Johannes Kepler. Raleigh sent him at the age of twenty-five to Virginia with White to make astronomical observations, survey the land and draw maps, and undertake a study of the native Indians and natural resources. All of these he accomplished with scientific thoroughness and accuracy.[18]

His *Briefe and true report of the new found land of Virginia* is methodical in its coverage and organization, with subdivisions for the various commodities of food he found there; for instance, 'I will set down all the goods that we know grow naturally there for food and sustenance of life.'[19] In a mode paralleling White's drawings of different types of fruits, vegetables, fish and birds, and native dress or customs, Hariot itemizes and distinguishes his categories. One plant had additional noteworthiness:

There is an herb called *uppówoc*, which sows itself. In the West Indies it has several names, according to the different places where it grows and is used, but the Spaniards generally call it *tobacco*. Its leaves are dried, made into powder, and then smoked by being sucked through clay pipes into the stomach and head. The fumes purge superfluous phlegm and gross humors from the body . . .[20]

Tobacco was unknown in the Old World and surely a sign of the further riches awaiting discovery in the New. 'May we not expect even more and greater plenty from the inland parts?' concluded Hariot.[21]

The chronicle was published three years after the expedition with the backing of Hakluyt, who included it also within his own publication of *The Principall Navigations*. Subsequent editions appeared in other languages, thus affirming that its voice spoke to the age more than to individual countries. In later life Hariot continued his scholarship, employing the telescope contemporaneously with Galileo to survey the heavens. For him America and the moon were both uncharted spaces which invited measurement and observation. Newly refined instrumentation (besides the telescope, there was the sea compass, the perspective glass, the lodestone and staff) made it possible for the eye, and after it the foot, to cross distant horizons. Hariot's fascination with optics might stand as the central metaphor for his time: to perceive reality was to grasp it.

Hariot also made the earliest known map of the moon,[22] and its significance carries across almost four centuries. From telescopic observations made in 1609–10 he drew the

configurations of the moon's surface with surprising accuracy. Like White's maps of Virginia, it is dotted with numbers as points of reference, a way of translating an unearthly scale into the comprehension of the human mind and body. Once, he reported that the Indians in Virginia regarded the moon, sun, and stars as minor divinities.[23] For all his measurements, did he come himself to imagine the moon as some godly presence?

The pioneering exploration of space by Americans in the latter half of the twentieth century has been the inevitable extension of discovery in our own time. The experience of newness, the beckoning horizon, the fear and exhilaration, the sense of beauty and of technology echo again out of the chambered nautili of modern ships of space. In 1969 the astronaut Edwin Aldrin spoke of the moon's 'magnificent desolation', and Neil Armstrong declared that 'It has a stark beauty all of its own. It's like much of the high desert of the United States.'[24] Journeying to an unknown frontier came to be identified with the image and impulse of America, whether in the sixteenth, nineteenth, or twentieth centuries.

Along with the romantic similes were the constant technical language and scientific data, the code names, the precision of navigation, the numbers.[25] With no discontinuity one can turn back to the beginnings of scientific observation in the early Renaissance and re-read the lists of Hariot, the charts of White, with a sense of familiarity. As if pulled by some psychic gravity, these travellers moved towards America's definition, holding in Norman Mailer's phrase 'a dream of the future's face'.[26] In crasser terms perhaps progress, expansion, and growth were the operative motivations, then as now. Nineteenth-century America defined it as Manifest Destiny. The point is that with the accomplishments of Le Moyne and White the image of the New World was subtly, but forever, transmuted into the fact of America.

CHAPTER 2

THE FIRST ARTS

THE drawings of the early European explorers in America make clear the existence of native Indian cultures, with their own colourful and refined artistic traditions. Long before the period of discovery man had settled on the North American continent. It is thought that tribes probably migrated from northeastern Asia into Alaska and thence southward; possibly too there was migration across the Pacific, as recent evidence suggests provocative similarities between some artifacts of the pre-Columbian civilizations in Central America and the arts of Polynesia and the Orient.[1] Arguments continue over whether these tribal influxes came primarily from Mongolia during the Stone Age, and developed gradually their own sophisticated but isolated civilization, or whether they came from multiple geographical backgrounds in sequential periods, bringing infusions of successively advanced achievements. Not surprisingly, these two theories speak to the traditional American impulse to define its identity: is it indigenous and hermetic or is it an amalgam of external influences?

Whatever the demarcations of these ancient migrations, several distinct areas of tribal settlement and development had emerged by the time of the European arrivals in the sixteenth century. Historians of these Indian cultures divide the areas into some half dozen, stretching across most of North America.[2] Each produced a distinctive culture based on local needs and customs, available materials, and technical abilities. For example, prevalent in Alaska were objects of stone and ivory, wood of course throughout the Central Woodlands, extensive architectural complexes carved in the earth and mountains of the Southwest (see Plate 150), unusual basketry in California, and monumental wooden totems in the Northwest.

The history of these native arts may be generally divided into three periods of interest, the first of which concerns us at this point: Prehistory, of long and hazy duration, from which not a great deal survives; the flourishing and relatively well-documented Modern age prior to 1900;[3] and the Contemporary period, with its serious resurgence of interest in the Indian identity and tradition (see Plates 120 and 273). Remarkably, a few carved works do survive from as early as the first century, among them an Eskimo pipe stem of ivory now in the Smithsonian Institution, Washington; and pipes in the form of men and birds found respectively at the Adena and Tremper Mounds in Ohio (Ohio State Museum, Columbus).

One of the most expressive of these stone carvings, and appealing particularly to modern eyes, is the effigy pipe in the shape of a crouching man (Plate 4). Carved of red bauxite and standing about ten inches high, it possesses a substantial character, given warmth by its dark colour and texture. The compactness of the whole recalls the mass of stone from which it was hewn. The form balances between naturalism and abstraction, suitable to its ceremonial and magical functions, while the few surface

incisions equally set off the flowing volumes of the torso. Seemingly bulky and monumental on the one hand, yet intimate and personal on the other, the piece strikes a chord which we recognize will resound in twentieth-century works by John Flannagan, William Zorach, Elie Nadelman, and others (Plates 241 and 239). Above all, we should keep in mind that much Indian art is carved and strongly three-dimensional. This is an important difference from the two-dimensional character of most Colonial art, whether painting, engraving, stone carving, or architecture. This pipe is indicative of a rich legacy of sculpted forms that include masks, totem poles, bowls and baskets, shields and headdresses, jewellery, burial mounds, and cliff dwellings.

The art of carving in the first colonies provides us with a number of suggestive comparisons. Although craftsmen were active early in producing ship figureheads, furniture, silverware, and occasional architectural decorations, the first and most pervasive sculptural form in the European settlements of the seventeenth century was the gravestone. A reflection of the God-fearing ethics of the Puritans, these simple slabs of stone were carved with economy and directness. With Indian artifacts they share a common stress on functionalism and the symbolic imagery of divinities. But the austere flatness of the Colonial gravestone is its distinguishing feature, one explained by several facts: the inhibitions of Puritanism, strictly functional needs, primarily graphic sources, the provincial conditions of wilderness, and an archaic style characteristic of all early forms of art.[4]

Stone markers from as early as the mid seventeenth century still survive in New England; the oldest known decorated gravestone is believed to be that of John White in Haverhill, Essex County, dated 1668.[5] Ornamented with predominantly religious imagery, the later stones mirrored the mission, 'errand' as Perry Miller has defined it for us, of the Puritans in New England. Escaping persecution at home, they sought to establish a holier order for God's world in an uncorrupted landscape. Even in Virginia, where mercantile aspirations overshadowed any religious aims, conversion of the Indians was implicit in King James' Charter of 1606, which set forth 'Propagating of Christian religion to such people, as yet live in darkness and miserable ignorance of the true knowledge and worship of God'.[6] Man's life, therefore, was to be conducted in covenant with God and his fellowman.

It followed that death would also be surrounded by images joining this world to the next. Even though iconoclasm was a strong strain running through Puritan theology, figures of life, death, and resurrection were prolific in gravestone carving. Both the permanence of stone and the drawing of symbols were modes of making concrete the relationship between man and God. The most frequently appearing emblems were those suggesting death (skulls, coffins, skeletons, candles about to be snuffed out) and the promise of new life (trees, garlands, grapes, trumpeting figures, peacocks). These two themes were further amplified through references to voyaging, cyclic transformation, time and eternity, as in the winged death's heads, angels, the sun and moon, and hourglasses.[7] Such reminders of mortality would also appear in seventeenth-century painting, such as the *Self Portrait* of *c.* 1690 of Captain Thomas Smith (Plate 13).

The gravestone of John Foster* (Plate 5) in Dorchester, Massachusetts, is one of the

* Dates of artists' birth and death are given in the Bibliography, pp. 283-302.

best and most characteristic surviving from the seventeenth century. Dated 1681, it modifies the form and imagery of another stone carved for Joseph Tapping four years earlier at King's Chapel in Boston.[8] In the Tapping work the figures of Time and Death are enclosed within a square panel in the lower half of the stone, while geometric forms, a winged death's head, and an hourglass fill the more elaborate scrolled pediment above. The Tapping marker is one of several attributed to the so-called Charlestown Carver,[9] who was active in Boston during this period. Possibly the Foster carving is his work too, although the deceased himself had been accomplished as a local artist and engraver ('The ingenious Mathematician and printer' proclaims the inscription), and may have been responsible at least for designing his own gravestone.

The carving of the Foster stone is somewhat deeper and richer, though the differences in relief between the lower and upper decoration suggest either later reworking or two hands responsible for the original execution. Whatever the case, it is a more harmonious and economical design than its predecessor. The allegory within the central arch vividly expounds the inevitability of human mortality. To the right the figure of Time, with scythe and hourglass, attempts to stay the hand of Death, the skeletal figure in the centre who in turn reaches across to snuff out the candle burning above the globe. The hair both of Death and of Time seems carved as if to flow into the rays of the sun above, thus linking the interlocking symbolism of these various images. Further, the globe has added to it handles resembling the body of a snake with the head of a bird and the tail of a fish – fused emblems of regeneration. The entire motif was not original with these gravestones, but rather derived directly from printed sources, in this instance an engraved illustration in Francis Quarles' *Hieroglyphiques of the Life of Man*, published in London in 1638.[10]

In fact, most of the images for Colonial carving of this sort may be traced back to broadsides, engravings, or book illustrations. These were usually copied from English originals and sometimes also reflected the craftsmanship of expatriate artisans in England from the Low Countries. In the same way much of seventeenth- and eighteenth-century American portraiture derived details, postures, or entire compositions from English or Anglo-Dutch models, just as most medieval and Georgian forms of architecture in the Colonies reflect identifiable European prototypes.[11] Nonetheless, the Colonial craftsmen modified their sources in response to indigenous requirements, which during this period included straightforward functionalism and directness. Thus, contemporaneous portraiture strove primarily to create likenesses for posterity (not works of art for themselves); and architecture, particularly of the early medieval phases, often starkly expressed its protective and strictly functional nature. So these gravestone illustrations simplify their narratives in the process of translation, and in their very form as slabs sticking up directly from the soil state austerely their legible role as markers.

Something of their formal clarity may be understood by noting how the Foster gravestone carver echoes the balanced placement of the globe, Death, and Time with the tripartite arches of the stone itself. In addition, there is an intuitive feeling for repeated circular forms – in the two heads, globe, sun, arches, and border decorations – all of which help to unify the whole. Finally, the architectural character of the marker's overall shape was intentional, whether alluding to a triumphal arch, a doorway, or on a

lesser scale an altar triptych; here the symbolism of the gravestone as a mark of passage from one life to another was made complete. 'Death is the portal to eternity, and carries men over to an unchangeable state,' explained the Boston minister Samuel Willard.[12] And on these dark slates his contemporaries marked their wishes for duration and permanence, their qualities of restraint and determinism, their consciousness of dread and glory.

Interestingly, it is John Foster to whom the first prints made in the American colonies are attributed. There is an early view of New York, dated 1626–8, but it was printed in Holland, and Foster himself evidently sent to be engraved in London a view of Boston (no longer extant) he had drawn in the 1670s.[13] Besides Foster, only a couple of other seventeenth-century printers in the colonies have been identified: the unknown engraver of *The Harp Player* (1680s, Massachusetts Historical Society), and the Boston silversmith John Coney, who engraved Massachusetts currency in the 1690s.[14] More prints were not made because setting up presses and dispersing engravings were subordinate to the imposed hardships of exploration and settlement.

Foster was born in Dorchester in 1648, and lived a short but productive thirty-three years. His father was town brewer and captain in the militia. After graduating from Harvard, the young Foster taught school for several years, but gave this up in 1675, and with the encouragement of Increase Mather and John Eliot ('apostle to the Indians') he set up a printing press in Boston. With his background, taking up such a trade must have been an unusual step at the time,[15] and it gives evidence of the emerging respect for artistic careers and production. His first print was the woodcut portrait of *Richard Mather* (Plate 6), believed to be dated 1670 and printed in Cambridge, which then had the only available press. It conceivably was intended as a frontispiece to the 1670 pamphlet *Life and Death of that Reverend Man of God, Mr Richard Mather*, although this cannot be proved. The head and torso were carved on separate blocks (why is unclear); in later printings the uneven expansion of the wood caused a break in the shoulder line, and a title was added at the bottom.[16]

For all the uncertainties surrounding this print, it is still one of rugged force. Striking are the bold contrasts of black and white, both between the overall silhouette and the background and among the details within the figure. Clear rhythmic curves outlining the head and two elbows create an imposing sense of mass, even with the minimal modelling and shading across the form. Characteristically, most of the detailing and the sense of individuality belong to the head, yet this is evenly counterpointed by the two white areas of the hands. Just as head and torso were separately drawn on different blocks, one senses the flat, clearly defined parts that constitute the whole. This decorative strength would also typify the first colonial paintings (Plates 7–11).

Foster's graphic career also included minor broadsides as well as important early maps and charts. His largest and most decorative work was *A Map of New England* (1677, John Carter Brown Library, Providence, R.I.); to the title he added a long and ambitious caption:

A Map of New-England, Being the first that was ever here cut, and done by the best pattern that could be had, which being in some places defective, it made the other less exact, yet doth it

sufficiently shew the Scituation of the Countrey, and Conveniently well the Distance of Places.[17]

Besides numerous attractive drawings of trees, vessels, animals, hunters, and houses (to denote settlements), it also has a compass rose and frequent reference numbers, calling our attention to the intellectual and perceptual links with John White's renderings of a century earlier. Moreover, in the year of his death Foster drew an astronomical chart of *The Copernican System* (Massachusetts Historical Society) and wrote an essay on 'Comets, their Motion, Distance and Magnitude'.[18] Like reverberations from Thomas Hariot (a man far-seeing in terms both of time and of distance), these efforts at fixity focus the colonial vision with renewed sharpness.

From the same period as the earliest surviving prints and gravestones also date the first paintings produced in the Atlantic colonies. Fragmentary evidence gives us the names of a few known individuals who listed themselves as painters of one sort or another in the Boston area before the end of the seventeenth century: John Gardner, Daniel George, Henry Sharpe, and Thomas Child.[19] Occasional bills, inventories, town lists, and other documents yield tantalizingly incomplete information about the activities of these artists and craftsmen, although somewhat more emerges about individuals after the turn of the century.

Similarly in New York (New Amsterdam until 1664) the names of portraitists and some of their work have survived from the latter part of the seventeenth century, among them Evert Duyckinck, Jacob Strijcker, Augustine Herrman, Jan Dirckzen, and Hendrik Couturier. Most of them were recent arrivals from the Netherlands and brought with them a modified Dutch Baroque style.[20] (Historians hasten to point out that elsewhere in the colonial world, most notably in the Spanish settlements in Mexico, prints and paintings were being produced throughout the preceding century.[21]) Little conclusive documentation about the first American portraits is extant, and scholars remain challenged over the attribution, authenticity, and quantity of these works. Estimates of the number of identifiably American pictures from the seventeenth century range from fifty to four hundred.[22]

More clear are the stylistic antecedents in English and Dutch painting. From East Anglia came many of the settlers in New England, bringing with them the strong influences of Holland in their own cultural background. During the sixteenth century the linear and ornamental style of Holbein had impressed itself on English art; in the first quarter of the seventeenth century this decorative mode merged with the more vigorous modelling and realism of the Dutch Baroque. These two elements in turn contributed to the manner of painting by the English in the colonies. Not surprisingly, this style was common both to provincial America and to provincial England, and numerous parallels exist between the portraiture of East Anglia and that of early New England, both areas strongly Puritan in temperament.[23] The linear decorativeness which appeared especially in the rendering of costumes (see Plate 9) was partially a legacy from late medieval forms, seen equally in the tracery of English Gothic architecture, manuscript illumination, and ornamental miniatures by Nicholas Hilliard. By contrast, the concerns for

light and shadow, sense of volume, and tentative spatial definition derive rather from Dutch sources, whether known from originals or through English interpreters such as Sir Anthony van Dyck, Sir Peter Lely, and Sir Godfrey Kneller.

Beyond supplying their immediate needs for food and shelter in the wilderness, the colonists generally attempted to model their life and surroundings (with the exception of religious beliefs) on the society they left behind in England. Some paintings, furniture, and silver they brought with them; others they executed with remembered European styles in mind. The harshness of life in these settlements, the restraints on art as a luxury reflected in Puritan thought, and the special ambitions of the colonists in the New World, all may have contributed a distinctive character to their first paintings. Nonetheless, their attitudes, environment, and cultural forms remained provincial extensions from the mother country until the time of the Revolution.

Why should portraiture have been the principal subject for these early artists? Several interrelated reasons have been advanced: the painter was engaged foremost in a craft, rather than in art for its own sake, to fulfil the function of recording accurately a likeness for posterity. In a larger sense he was creating images of ambition, status, or aspiration, as the world in which he worked constantly stressed the individual and reliance on self for survival. Later, portraiture surely also came to be associated with refinement and patronage, further reflections of Old World habits and practices.[24] But for the most part his efforts were functional and pragmatic, responding directly to the needs at hand. We have already noted how gravestones and prints were similar expressions of functional requirements. Contemporary town planning also responded to practicalities; in Boston, for example, the old cow paths gradually became with use meandering and otherwise unplanned lanes on the city's seventeenth-century maps. And dwellings in the medieval phase of architecture were functionally organized around a large central hearth, with a lean-to added as wanted.[25]

In painting, as in the other arts, we become aware of a certain vigour and roughness, assertions of minds carving security and order out of the wilderness. The first dated paintings in the colonies are of 1664, and herald a flourish of artistic activity during the next few years. Because the name of Augustine Clement (sometimes Clemens) has been circumstantially linked with the authorship of one of these portraits, *Dr John Clark* (Plate 7), some word about the possible artist is in order. Clement was born in England about 1600 and apprenticed in 1613 to Jonathan Miller of Reading. After learning heraldic and decorative painting for seven or eight years, he completed his training with Edward Newman of Eton. On his own by 1625, Clement practised glass painting in Reading, but with competition increasing he probably decided to seek new opportunities in New England. He sailed with his wife and his servant Thomas Wheeler in 1635, settling first in Dorchester, later in Boston's North End. A deed of 20 March 1652 signifies him as 'Painter' and lists his purchase from John Capen of 'one peece: of ground . . . in Boston', which was bounded to the north by the property of Dr Clark.[26] It is this association which has led to the tentative attribution of Clark's likeness to the hand of his neighbour.[27]

Clark was an almost exact contemporary of Clement, and had himself emigrated to

Newbury, Massachusetts, before taking up his medical practice in Boston. The inscription above indicates his age as sixty-six, and the obvious attention to his surgical profession (he holds two of the tools used in bone operations on the skull) suggests a man at the culmination of his distinguished career. The crisp rendering of the skull and the sympathetic treatment of Clark's face recall the strength of Dutch realism. In fact, the general portrait format and presentation of the skull and instruments as still-life elements bring to mind Rembrandt's portraits of individuals as well as group pictures such as *Dr Tulp's Anatomy Lesson*. Indifferent as parts of this picture may be, the striking details and sharp silhouetting of forms generate an image of individual will. While there are faint touches of colour in the beard and flesh tones, the general tonal structure relies on contrasts of dark and light both physical and metaphysical in nature. Here ultimately is a figure aware of mortality, his own and that of others.

Also inscribed with the date of 1664 is the three-quarter-length portrait of *Elizabeth Eggington* (Plate 8). Relying like the Clark image on a balanced juxtaposition of light and dark patterns, this painting belongs to an artist with a somewhat harder style and a stronger sensitivity to colouristic details, as may be seen in the touches of yellow which highlight her lace and ribbons. Characteristic of this whole early group is the frontal and central situation of the figure against a flat dark background; the insistent linear outlines which contain the figure and component details; the rather wooden stance with head slightly averted to one side or the other, the eyes usually looking at the spectator; and in the figure's hands some associational object, in this instance a fan and ribbon. The unknown author, like so many gravestone carvers, has wrought an image that combines delicacy with strength, refinement with crudeness.

Surely one of the most colourful and memorable of colonial paintings is the portrait of *Mrs Elizabeth Freake and Baby Mary* (1674) (Plate 9), paired with a likeness done at the same time of *Mr John Freake* (Worcester Art Museum, Worcester, Mass.). The husband was born in England in 1635 and came to Boston about 1660, where he established himself as a prosperous merchant and attorney. He married Elizabeth Clarke, a native Bostonian several years younger than himself. Their daughter Mary was born in 1674, the eighth child, and was six months old at the time these portraits were undertaken. The following year John Freake was killed in an explosion in Boston harbour. Before his untimely death he had settled his family into a well furnished 'dwelling house ould & new' at the corner of Fleet and Moon Streets in Boston's North End.[28]

Befitting his status, Mr Freake wears an elaborate Venetian needlepoint collar and Persian waistcoat with silver buttons, and holds long elegant gloves. Except for subdued touches of red in the face, the picture remains basically graphic in character, reliant as were the works of 1664 on black and white areas and on crisp linear outlines. Particularly expressive are the decorative patterns made by the lace collar and cuffs and by the extended fingers of the sitter's hands and gloves. Much of this sensitivity to ornamental design and tonal contrast is further intensified in the companion painting of mother and child. The extraordinary achievement of this work is its rich colourism, surprising both for an artist of evidently not much training and for a generation thought so God-fearing and unworldly.

Mrs Freake's bodice and skirt are a vibrant combination of red, gold, and green, set off by the white lace Netherlandish collar and bunches of red and black ribbons. She sits in one of the 'Turkie workt Chaires' listed in the inventory of the house's furnishings. Being steadied on her lap with both hands is the upright figure of Baby Mary, clothed in a bright yellow dress and cap. A dark red curtain fills the upper left corner, and barely visible is a table. This emphasis on material belongings and the directness of observation doubtless reflect Dutch sources, but this must stand as probably the first American picture to include more than the figure in the composition. While the individuals still remain close to the picture surface and rather flattened out, there is an appealing sense of un-pretentiousness and informality here.

The artist had some difficulty in painting the hands; x-rays show that he made changes in their placement as he proceeded, while also removing what appears to have been a small glove held by the child. But he depicted the faces with sympathetic feeling and employed the touching gestures of mother and daughter's hands to convey an intimate expression of maternal tenderness. The sure identity of the artist has been lost to us. Opinions range from questioning whether he was American or foreign born to suggesting that he may have been Samuel Clement, Augustine's son, who like his father was a painter-stainer and lived near the Freake family.[29] Whoever this imaginative and observant individual was, he instilled in his pictures an image of familial piety, so much a part of the communal world of Puritan New England. The well known lines of Anne Bradstreet come to mind:

> If ever two were one, then surely we.
> If ever man were loved by wife, then thee ...
>
> Then, while we live, in love let's so persever,
> That when we live no more we may live ever.[30]

Her poetry equally mirrored the forms and images of Elizabethan literature, transplanted to the circumstances of the New World.[31] The painter of the Freake portraits found in his sitters evidence of self-reliance, sobriety, and humanity: what auspicious qualities for the first American efforts at establishing a self-identity.

Because of a similarity in style and subject, the 1670 portraits of the Gibbs children – Henry, Margaret, and Robert (Plate 10) – have been attributed to the painter of the Freakes. In this group occur the same overall flatness, background drapery, touches of bright colour, and stance of the figures. The preference for children's portraits further ties these works together. The floor of black and white tiles in each of the Gibbs pictures seems taken directly from Dutch examples, such as the portraits of children by Paulus Moreelse or interior scenes by Vermeer and others. Again the figures have in their hands some object appropriate to age and sex: Henry holds a toy bird, Margaret a fan, and Robert a pair of gloves. Some aspects seem more tightly drawn than in the Freake pictures (for example, the clothing); others more wooden, notably here Robert's awkwardly turned right wrist. Still, the rounded face and ruddy flesh tones are quite consistent.

Even more problematic is the painting of *Alice Mason* (Plate 11), also dated 1670 and

similar in composition. Painted at the same time was a larger picture of three other Mason children – David, Joanna, and Abigail – (Collection Nathaniel Hamlen, Wayland, Mass.), which presents them in near-identical costumes, each with slashed sleeves. Because of the closeness in inscription on these two paintings to those in the Gibbs portraits, and the similarity in modelling of the forms to the Freakes, this entire group has been ascribed to a single hand.[32] At the same time close comparison points up subtle but significant differences. *Robert Gibbs* is a miniature adult, and stands in a more legibly defined space; *Alice Mason* has quite clearly a child's face and demeanour. The tiles on which she stands are smaller and fade into an indistinct setting. The bright red apple she holds, set off in front of her white pinafore, is an individualistic touch in contrast to Robert Gibbs's more formal and traditional gloves. That she emerges more sharply as a personality has led to the alternative and more persuasive conclusion that two different artists executed the Gibbs and Mason works.[33] This tangled skein of authorship, however, should not obscure our appreciation of the appropriateness of these youthful images to the beginnings of life in the American colonies.

With the figure of *Elizabeth Paddy Wensley* (Plate 12) we have a noticeable shift in style. Although the costume somewhat resembles that of Mrs Freake, and an essential flatness of figure and space remains, this work moves even further from the ornamental medieval manner of provincial English portraiture towards the fuller modelling, richer gradations of lighting, and more convincing spatial ambience of seventeenth-century Dutch and Flemish art. Wooden as the figure is, there are now efforts to surround her with solid furniture, the handsome floral still life, and the cutaway view into the distant landscape at the upper left. The picture's component details still appear distinct and separable from one another – the whole is assembled from adding together adjacent parts. Yet the greater complexity in rendering the clothing, extending the setting, and in shaping the face with shadow bespeak both an awareness of a more recent European style and the ambition to translate that style into colonial terms.

The portraiture of Captain Thomas Smith carried this development one step further. Surviving examples of his work include *Captain George Curwin* (c. 1675, Essex Institute, Salem, Mass.), *Major Thomas Savage* (c. 1679, Estate of Henry L. Shattuck, Boston), and his own *Self Portrait* of c. 1690 (Plate 13). Like the artist himself, Curwin and Savage were born abroad; they emigrated to New England in the 1630s, while Smith is believed to have arrived from Bermuda about 1650. Doubtless of mutual interest between the artist and his sitters were their respective military careers and mercantile interests. A record in the Harvard College account books for 1680 provides one of the few documentary fragments of the period: 'Colledge Dr to money pd Major Tho. Smith for drawing Dr Ames effigies pr Order of Corporation. 4.4'.[34] The institution was commissioning one who was obviously trained in a more up-to-date style than that employed by the limners of the 1670s.

The Savage portrait is of particular interest for its inclusion of an early view in the background of Boston Harbour and Beacon Hill. Smith repeats the device in his own portrait, presumably depicting a naval battle (not specifically identified) in which he had participated. The colours flown by the vessels are those of the English and Dutch, and

the flags on the fortifications may signify Barbary pirates.[35] In the lower left-hand corner his hand rests upon the vanitas symbol of a skull and a poem signed with his initials:

> Why why should I the World be minding
> therin a World of Evils Finding.
> Then Farwell World: Farwell thy Jarres
> thy Joies thy Toies thy Wiles thy Warrs
> Truth Sounds Retreat: I am not sorye.
> The Eternall Drawes to him my heart
> By Faith (which can thy Force Subvert)
> To Crowne me (after Grace) with Glory.

The sentiments of Puritan piety, human frailty, and moral judgement are those echoed on early gravestones, yet the general impression of this picture is one of sober force and accomplishment. But its most important contribution was the new Baroque palpability of form and space. For the first time the painter attempts to turn his figure diagonally slightly away from the picture plane. The table and fort recede convincingly into depth. The eye senses an ambience of light and atmosphere both in defining the volume of the head and in filling the distant landscape. There is now a more organic unity both within the figure itself and in the pictorial space as a whole. An impressive and singular personality emerges.

The decisive change that has taken place is the imprint of Rubens' and Van Dyck's style, first felt in English art during the sixteen-twenties and thirties, and in turn transmitted to New England via the fashionable precedents of Lely and engravings after his work. The heightened realism and illusionism evident here appear in American painting with increasing frequency during the next decades, culminating with the American career of John Singleton Copley (see Plates 34–9).

At the very end of the century comes the portrait of *William Stoughton* (Plate 14), in the compositional format of the Smith pictures but more naive and crude in execution. Stoughton was born in 1631, possibly in England, although by the next year he was in New England. He graduated from Harvard, and travelled abroad at least twice. He had a notable career as chief magistrate for the Salem witch trials of 1692 and as Lieutenant Governor of Massachusetts for a number of years thereafter.[36] With his hand open as if in presentation, he sits before a rendering of Stoughton Hall, his gift to Harvard. (The hills beyond are an imaginative conceit.) The balanced and geometric façade is in the fashionable manner of Inigo Jones, just as the portrait style and iconography reflect the newer mode of painting. In this very period the influence of Jones and his successor Sir Christopher Wren was making itself felt in the change of architectural style from the medieval to the Georgian. Thus Stoughton's portrait, however unskilled and *retardataire*, expresses the rising prosperity of painter and sitter alike. Likewise, Thomas Smith is among the first artists to emerge with known professional careers. Not only did the year 1700 mark a transition of centuries, but it also calls attention to the evolving change in the style of painting, sculpture, and architecture. Above all, it coincides with a transformation of the stature of art and artists in America.

CHAPTER 3

NATIVE CRAFTSMEN

AFTER 1700 the names of active artists and records of their careers become increasingly available. For example, announcements in the Boston gazettes during the first quarter of the century give us the names of dealers in artist's supplies as well as of the painters at work in the area: Zabdiel Boylston, Nehemiah Partridge, Samuel Robinson, Daniel Lawrence, Jr, and John Gibbs. Elsewhere, rising prosperity in the other colonies along the Atlantic seaboard began to attract aspiring painters and artisans. Henrietta Johnston came to Charleston, South Carolina, in 1705, where she was known for her small pastel portraits done over the next couple of decades.[1] In New York the various members of the Duyckinck family typified the direct importation of Dutch Baroque portrait styles and the emergence of an active artistic group there.

The first in the family to be identified as a painter in New York was Evert Duyckinck, who came from Holland with his father and brother in 1638. Both he and his son Gerrit are listed as limners in the New York directories. Gerrit's son, Gerardus I, in turn continued various artistic pursuits, including painting, gilding, japan work, glazing, as well as dealing in looking-glasses and painter's colours. Gerardus Duyckinck II learned the same trades from his father, and upon the older man's death in 1746 took over the family business, expanding it substantially, and selling prints and giving lessons in drawing as well.[2]

During this century of activity over several generations colonial painters gained greatly expanded resources, at the same time liberating art from its narrow early confines and transforming it into a flourishing profession. In the mid-Atlantic states the name of Justus Engelhardt Kuhn figures as the most prominent early practitioner of the Baroque style. Coming from Germany to Maryland, he filed a petition for naturalization in 1708, and changed his name from Ketclon. Until his death nine years later he was an active portraitist in the Annapolis area, painting mostly the members of the Carroll, Darnall, and Digges families.[3] His portrait of *Eleanor Darnall* (*c.* 1710) (Plate 15) exhibits his favoured format: a single child standing in the midst of an elaborate architectural fancy, with a balustrade behind and a view of gardens beyond, on one side a bird or animal, and on the other a pedestal holding a sculpture or vase. The chequered floor and the miniaturist appearance of the figure are reminiscent of the Gibbs and Mason paintings, but the divisions of space and garden perspective testify to the newer Baroque sensibility. Richness of colouring, animated contrasts of dark and light forms, and attempt at movement into depth are all hallmarks of seventeenth-century painting in northern Europe. This portrait approaches the character of genre or of conversation painting. Various precedents suggest themselves: for example the figure compositions of Rubens and mezzotints done in the 1690s by John Smith after Sir Godfrey Kneller's fashionable oils. Specifically, the Smith print of *Lord Buckhurst and Lady Mary Sackville* (1695, Henry

Francis du Pont Winterthur Museum, Winterthur, Del.) might have served as a likely source for Kuhn.[4]

This mezzotint was certainly the basis for a number of New York pictures painted around 1730. In New York, Albany, and along the Hudson River lived a prospering mercantile group of Dutch patroons, many of whom wanted portraits of themselves and members of their families. As in New England, the identity and number of artists at work remain controversial. What is clear is that this large group was painted primarily between 1715 and 1740, several distinct hands are evident, and a penchant is shown for fanciful architectural and landscape settings. Naturally, patroon painting was as a whole closer in style and iconography to Dutch sources, although one can distinguish varying degrees of adherence to the painterliness, luminosity, and plasticity of European Baroque art. These artists relied more consistently on mezzotints for their compositions, and while the results of their work are sometimes more sophisticated than the New England counterparts, they could also be less interesting.

The largest group of pictures from the Albany area to share a common manner is the one most in dispute. Alike in composition – often three-quarter- or full-length standing figures filling the composition and offset by an architectural view – they are specifically noted for the Latin inscription *Aetatis Suae* followed by the sitter's age and the date of completion. Opinions differ, some giving all portraits so inscribed (about twenty-three) plus another similar group (about sixty) to the so-called *Aetatis Suae* Limner, others attributing the unsigned works to three different hands.[5] Until more technical analysis is accomplished and further evidence uncovered in old family records, town directories, accounts of sale, and the like, a decisive judgement cannot be made.

The *Aetatis Suae* Limner was active between 1715 and 1725, painting likenesses of members of the Schuyler, Van Vechten, Van Alstyne, and Van Schaik families. An impressive example in this manner is the portrait of *Mrs David Ver Planck (Ariantje Coemans)* of *c.* 1717 (Plate 16). In 1716 she had inherited her father's fortune and began building an imposing manor house on the Hudson. This may have been the occasion for the portrait commission with its elaborate architectural rendering (taken from a mezzotint after Kneller) prominent in the background.[6] In 1723, at the age of fifty-one, she was married for the first time to David Ver Planck, who was twenty-four years younger than she. Depicted here as an awkwardly tall figure with a strong face, the subject conveys the pioneer values of frankness, ambition, and determination. Characteristic of this artist's style are the focused attention on the bright collar, the strips of highlighting along the creases of the clothing, and the often angular definition of forms. For all its rough directness, however, there are ameliorating touches of colour, such as the gold fringe along the hem of the tablecloth and the red rose which Ariantje Coemans holds up before us. Later paintings in the *Aetatis Suae* manner (whether from the same or another hand) have been placed in Newport, Rhode Island, around 1721; in Virginia during the following year; and again in Albany around 1724.[7]

Among other identifiable styles appearing in the Upper Hudson area at this time was that of the Gansevoort Limner, believed by some to be Pieter Vanderlyn. Born about 1687, he came from Holland to New York in 1718. He was known to be working in

Albany and Kingston between 1720 and 1745, although his first dated works are of 1730. Picking up where the *Aetatis Suae* Limner left off, Vanderlyn shifted his attention from the earlier artist's patrician clients to the expanding middle-class merchants with business on the Hudson. His portraits of *Adam Winne* of Albany[8] (Henry Francis du Pont Winterthur Museum, Winterthur, Del.) and *Pau de Wandelaer* (Plate 17) display his personal mode of painting. Figure and landscape are simplified into clean, rhythmic patterns. The obvious two-dimensional quality harks back to the medieval tradition at the same time that Vanderlyn's love of colour and his use of the landscape vignette strike a more modern balance. Particularly attractive are the personal accents he introduces, such as the one-masted vessel in the background (associated with the Wandelaer trading activities) and juxtaposed in the foreground a small bird in the young man's hand.

Also painting in the Albany area was the Wendell Limner, and further south along the Hudson the Van Rensselaer Limner. In New York one prominent figure was the de Peyster Limner, thought to be responsible for an engaging group of portraits of de Peyster and Van Cortlandt children in the 1730s. One of the most colourful and interesting of these is that of *Pierre Van Cortlandt* of *c.* 1731 (Plate 18). Based directly on John Smith's mezzotint after Kneller, it loosely varies the format employed twenty years earlier by Kuhn. Like the contemporaneous *De Peyster Boy with Deer* (New-York Historical Society), *John Van Cortlandt* (The Brooklyn Museum), and *Boy of the de Peyster Family* (New-York Historical Society), this picture presents the youth standing at the centre of a decorative floor, gesturing to one side, with a dog or a deer on the other. As in most American portraits deriving from English mezzotints, the transforming process here was one of simplifying the source. This was a reflection both of the sometimes unsure skills of the copyist and of the need to clothe the American subject in a more appropriately down-to-earth environment.

The limner of *Pierre Van Cortlandt* had a special eye for colour. Here as in his other works he favoured ordering his compositions around basic colour juxtapositions of redgreens and blue-yellows, concentrating the strongest hues in the costume of the figure and their complementary tones in the background architecture and landscape. Now colour plays the crucial unifying role of organizing the contrast of tonal values throughout the picture. This particular portrait gains additional liveliness through the play of various diagonal rhythms, for example, the boy's forward step, turn of the dog's head, pattern of the floor, brightly coloured floral arrangement balanced by the cloud-filled sky, and curving balustrade. The charm of this rendering, however, barely forecasts the unusual career that lay before young Cortlandt, as a leader of the American Revolution, legislator and first Lieutenant Governor of New York, and elder statesman to the age of ninety-three.[9]

If Cortlandt's image is one of youthful optimism and promise, that of *Anne Pollard* (1721) (Plate 19) embodies the triumph of age and longevity. The muted colours (dark reds and browns) and frontal presentation of the figure make this the culmination of early New England painting. Produced on the occasion of her hundredth birthday, it conveys the remarkable strength of her years. The rough forms seem almost hewn out of the dark backdrop; the eyes stare with life even as the lids droop down and creases

furrow the face. She was literally one of the last links with the past – said to be among Governor Winthrop's first settlers in the Bay Colony. The crudeness of the execution was itself a reminder of Boston's first likenesses, although the strong modelling of the face and upper torso hint of later Baroque developments. What is haunting is the power of nearly abstract forms which constitute this image, as if abstraction itself was the concretion of timelessness. With Anne Pollard the survival of colonial life in America was demonstrated. Only the pious Puritan temperament and the rocky New England coast could have produced such an expression of endurance as this.

A softening of those features, however, was to come. Like ice cracking on the Connecticut River in spring, artistic change was everywhere felt with new force during the second decade of the eighteenth century. Silverware, for example, which had during the seventeenth century relied strongly on English and Dutch forms for the sturdy and functional objects that were produced, was gradually modified during the closing years of the century by Baroque styles. The simple, straightforward cups and tankards wrought in the 1670s were succeeded in the nineties by objects with more tapered shapes, embellished surfaces, and rhythmic movement throughout the whole. During the William and Mary period (about 1690–1720) these tendencies increased, and silver pieces took on a new sense of surface animation, plastic mass, and rich effects of light and shadow. A new stylistic turning point came in the early 1720s with the emergence of light and elegant Queen Anne forms. Now younger silvermakers worked in a manner stressing abstract geometric shapes, proportional relationships among the parts of a piece and across its surfaces, and generally fluid effects.

The same delicacy appears in contemporary furniture, with graceful cabriole legs supporting Queen Anne pieces, curving slats subdividing chairbacks, and finials counterpointing the rich grained woods of highboys – all this in contrast to the heavy, rough benches and tables of mid-seventeenth-century dwellings, with basic horizontals and verticals unequivocally stating their weight-bearing functions. Architecture, too, reflected the changed spirit. By the end of the seventeenth century the first Georgian styles had begun to replace the dark, practical, usefully asymmetrical houses put up from the sixteen-thirties to eighties. Wren-inspired buildings were built in the prospering areas of Virginia, first in the state capitol at Williamsburg in the 1690s, then during the first quarter of the eighteenth century along the James River. Balanced and orderly divisions characterized the plan of the city itself as well as the design of façades and interior spaces of the great manor houses. Proportional subdivisions, interest in effects of texture and light, and overall harmony and elegance were apparent in architecture, silver, and furniture alike.

These new values in turn expressed the dramatic increases in population, notably in the major artistic centres of New York, Boston, and Philadelphia, but generally throughout the colonies as well. The battle for survival and security in the wilderness, so engrossing in the preceding century, was now largely won, and increases in wealth and ambition called for suitably fashionable and refined forms of art. Painting during this period took several new directions. Most notable was the variety of new subjects that began to appear: historical, mythological, and religious paintings, landscape and marine

views. Portraiture remained dominant, though it gained further in technical sophistication and self-confidence. More artists emerged with established professional reputations. While some, like John Smibert, were born abroad and pursued successful careers in the Colonies, others, like Robert Feke, were native-born and equally accomplished.

Contemporary with patroon portraiture in upstate New York is an unusual group of religious pictures (twelve are in the Albany Institute of History and Art), all dating from the first quarter of the eighteenth century. They include *The Finding of Moses*, *The Adoration of the Magi*, and *Christ at Emmaus*. No artist is known for these, and the style is relatively primitive. Nonetheless, they are colourful early examples of new artistic interests. Their two-dimensional character attests their likely source in Dutch Bible illustrations, but they must have made striking decorations for New York's manor houses. Said one visitor to Albany in 1744, 'They affect pictures much, particularly scripture history, with which they adorn their rooms.' [10]

Among the portraitists gaining recognition at this time was Gustavus Hesselius, who was one of the first to undertake both mythological subjects and Indian portraits. Quite remarkably, no signed paintings by Hesselius are known, and only a few are confidently attributed to him. Born in Sweden in 1682, he came to Philadelphia in 1712 after receiving some instruction in England from Michael Dahl. Until his death in 1755 Hesselius worked in the Philadelphia area, except for the decade of the twenties when he was in Annapolis.

During this Maryland stay he executed a scene of the Last Supper for St Barnabas' Church in Prince George's County.[11] Also from this earlier part of his career was his *Bacchus and Ariadne* (c. 1720) (Plate 20), a canvas both ambitious and awkward. Baroque movements, contrasts of light and dark, and painterly effects fill the composition. But the placement of figures in space is not always clear (witness the tumbling Amor in the middleground), and a certain crudity becomes evident in the articulation of background space and details. It is likely that such a picture was a type of exercise for the aspiring artist, who would work from engravings after European originals for his own practice. Two aspects of its style consistently recur in Hesselius' later work: the generally sombre colouring and the concentrated focus of lighting on the central subject.

Most of his portraits likewise rely on a dark, usually reddish-brown, ground, on which the figure is built up in still darker areas of colour, with the face set off in the strongest light and clarity of detail. This is the case with the paintings of himself and his wife of 1740 (Historical Society of Pennsylvania, Philadelphia) and the two handsome Indian portraits of 1735, *Lapowinsa* and *Tishcohan* (Plate 21). For these last two Hesselius was paid sixteen pounds. The chiefs he depicted participated in negotiations at Pennsbury with Pennsylvania leaders over a land controversy,[12] and are among the most sympathetic and sensitive portraits surviving from that period. The painted oval format was a common Baroque device to enhance a sense of illusionistic depth. The positioning of the two Indians differs only slightly; both wear hung around the neck at the centre of the chest a hide pouch; a blue sash is wrapped around the waist and over the right shoulder of one, the left of the other; and a lock of hair falls down each one's draped shoulder. Lapowinsa bears more striking facial markings, while Tishcohan has the focal

interest of a white pipe silhouetted against his chest. The chief seems to emerge with mysterious force out of the dark red background, only his head sharply detailed and intensely lit. Appropriately, it is the face which receives Hesselius' most confident and painterly brushwork, such that he forcefully conveys a feeling of individuality, one here that is both questioning and dignified.

Along with these relatively new subjects treated by Hesselius and his generation, painters and engravers alike were giving increasing attention to landscape views. To some degree the concern for recording prospects of towns, cities, and harbours was a logical extension of earlier mapmaking activities, but in a larger sense it was also an expression of rising prosperity and urban expansion. Among the first established print-makers to come from abroad to work in New England were Francis Dewing, William Burgis, and Peter Pelham. Dewing and Burgis both arrived in Boston about 1717; the former worked there for about five years, while Burgis was active in both Boston and New York for the next two decades. Credited to Burgis are the first view of Harvard College (1726), a panorama of New York (*c.* 1721) noteworthy for its unusual dimensions (it is over six feet long, printed from four plates), and several prospects in Boston harbour, including *Fort George*, *Boston Lighthouse*, and *A South East View of ye Great Town of Boston in New England in America* of 1743 (Plate 22).

This engraving is over four feet long and was drawn on three separate copperplates. Its bird's-eye vantage and the cluttered repetition of miniature vessels are legacies of the map tradition, in which topography is laid out below us and marked with recognizable emblems of reference. Burgis here is giving us a repertory of activities; every size of vessel is represented, some under sail, others not, and two in the foreground firing their cannon for sheer pictorial effect. The attention to light and shadow, the broad spatial vista, and the animated surface design (particularly the rhythmic diagonal lines of wharves, ensigns, and vessels) are all Baroque mannerisms. But Burgis' record of the many spires on the horizon and of the lively movements across Boston's waters is purely contemporary in its ambitious spirit.

Burgis and Peter Pelham share the honours for producing the first mezzotints in America. Burgis printed his *Boston Lighthouse* (The Mariners Museum, Newport News, Va.) in 1729; Pelham's portrait of *Cotton Mather* (Plate 23) dates from two years earlier. The mezzotint was a form of engraving, enhanced by burnishing or scraping the already roughened surface of the metal plate. This permitted an enlarged range of textural effects. But its greatest contribution to American art proved to be in the area of por-traiture, where copies were made after countless English originals, primarily by Sir Godfrey Kneller and his followers, thus offering to aspiring Colonial artists an *au courant* repertory of poses and compositions for their provincial clients.

Pelham was born in the closing years of the seventeenth century and his artistic work began in London in 1713 when he was apprenticed to one of the best established printers of the day, John Simon. During the early 1720s Pelham successfully produced a couple of dozen engravings. Precisely why he emigrated to Boston in 1727 is not clear, although he may well have had in mind the example of Dewing and Burgis, who had departed a decade before. If he initially expected ample opportunities for selling his mezzotints, he

must have been disappointed, for the principal market in portraiture was in oils. He did take up painting, in part to provide himself with a basis to make mezzotint copies. This was the case with *Cotton Mather* (Plate 24), which, like the print, ultimately derived from Kneller's style and format of the half torso in a Baroque oval. Kneller's own training in Holland and Rome gave his work a sense of lively colour and brushwork that usually became dry and hardened in his followers. Not surprisingly, Pelham's training as a graphic artist moulded his more linear and tonal approach to painting, where he stresses contrasts of light and dark patterns, especially in the wig surrounding Mather's head and the sharp rectangular collar against his coat.[13]

Over half a century intervenes between this image and John Foster's woodcut of an earlier Mather (Plate 6); the more sophisticated style tells much about the development of American art in this time. Not least, it emphasizes the extent to which the graphic arts provided such a firm and influential basis for the tradition of painting which now began to flourish. In fact, competent as Pelham was as an artist, his lasting significance was more in his role as the stepfather of John Singleton Copley, later to become the towering figure in American Colonial art. In fact, one of the young Copley's first artistic efforts was a mezzotint of *The Rev. William Welsteed*, 1753 (Yale University Art Gallery, New Haven, Conn.), which was almost identical in execution to *Cotton Mather*.

CHAPTER 4

PROFESSIONAL ARTISTS

JOHN SMIBERT's arrival from England in 1729 was a major artistic benchmark of this period, for his talents would raise the level of painting in America markedly. He was born in Edinburgh in 1688, making him a near contemporary of Gustavus Hesselius. Following a youthful apprenticeship as plasterer and house painter, he set off for London in 1709, where he took up coach painting and copying pictures for dealers, a practice that was to serve him well in future years. Not only did it bring him sufficient income to undertake further travelling, but it also encouraged him later to make copies after old masters which would prove to be useful models of instruction for himself and for others. Determined by this time to be a portrait painter, he left for Italy in 1719, and, once in Florence, directly took up making copies after works by Titian and Raphael, among others,[1] for which he was paid modest sums. After an excursion to Rome, Leghorn, and Siena, Smibert was back in London in August 1722, ready to paint portrait commissions in earnest and to keep a formal account in his record book.

Settled in London, Smibert was kept busy with a succession of sitters from various classes, including a number of title.[2] His list suggests a certain artistic and commercial success, although clearly his output did not approach, perhaps intentionally, that of Kneller and his shop. At the Piazza, Covent Garden, where he lived from 1725 to 1728, Smibert's studio was 'the rendezvous of the most celebrated artists';[3] some were friends with whom he kept in touch later on in Boston. Among those in Kneller's circle who were doubtless competitors of Smibert were Michael Dahl and Thomas Hudson. Although solidly established in London, Smibert must have had frustrated aspirations 'to be lookt on as at the top'.[4]

An opportunity for change came from Dean George Berkeley of Derry, who had met Smibert travelling in Italy and sat for him at Covent Garden in June 1726. Berkeley told Smibert of his plan to found a 'Universal College of science and arts in the Bermudas'[5] 'for the Better Supplying Churches in our Foreign Plantations and for Converting the Savage Americans to Christianity',[6] and invited the artist to join the group to teach drawing, painting, and architecture. Parliament gave its approval but delayed the financial backing. Despite satisfactory business and the dissuasions of friends, Smibert was lured by the prospects of brighter successes abroad, and sailed with the Berkeley entourage late in 1728. After putting in at the York River, Virginia, they pushed on to Rhode Island, arriving in Newport in January 1729. While the Dean waited, vainly as it turned out, for funds to arrive from Parliament, Smibert set off for Boston, where he began work a few months later. His Boston list commenced in May 1729 with a portrait of no less a personage than Mrs Hutchinson, wife of the Governor.

The picture that literally and symbolically bridges Smibert's London and Boston careers is also his major work; *Dean George Berkeley and his Family (The Bermuda*

Group) of 1728-9 (Plate 25). Some argument remains over its precise dating and the identity of all the figures, but this would appear to be the painting Smibert recorded in his London list in July 1728 as 'A Large picture begun for Mr. Wainwright 10 ginnes recd in pairt'.[7] In the adjacent margin the artist later added 'at Boston' and the figure of thirty guineas, indicating that he had completed the work and received his balance due after arriving in America. Probably this was the same work he was accounting for in the entry on the American list of November 1730, which gives the following individuals as sitters: 'John Wainwright Esqr., Revd. Dean Berkeley, his Lady, and son, John James Esqr., Ricd. Dalton Esqr., Ms. Hendcock, John Smibert.'[8] The date on the canvas itself is unclear today, but appears to read 'Jo. Smibert fecit 1729', possibly marking the time of completion, while its entry in the *Notebook* the following year was occasioned by Wainwright's final payment.[9]

The picture was the first professionally painted group portrait in America, and it was to have a strong influence on succeeding generations (see Plates 27 and 33). Its immediate impact lay in its up-to-date style, and it firmly established Smibert as the pre-eminent artist of the period. Dean Berkeley stands to the right, the one figure shown frontally and full length, which directly conveys his authoritative position. Grouped next to him behind the table in a graceful pyramidal arrangement are his wife and eldest son Henry, Miss Handcock, and John James of Bury St Edmunds. Balancing Berkeley on the left are Richard Dalton, the secretary seated at the table, John Wainwright (it is thought) looking over his shoulder,[10] and at the far left the artist himself, who glances directly out at the spectator.

Suitably to a family group, the women are at the centre of the composition, while the principal male figures stand imposingly around them, echoed by the three pillars of the porch behind. Berkeley is linked further to his secretary by the books each holds, and by their glances: the Dean seems to be pausing in the midst of some remarks he is dictating to Dalton. Thus through composition and gesture Smibert is able at once to individualize and to unify his sitters. Something of Berkeley's stature and resolve emanate equally from his firm bearing and from details such as the hand surely gripping the upright book. In fact, the entire composition is constructed around interlocking horizontal and vertical forms, including the table and the pattern of the rug covering it as well as the standing figures and pillars. Yet the overall effect is not one of rigidity, for there are subtle modulations throughout, among them the picturesque landscape in the background, Dalton's relaxed position and angular placement, the different gestures of hands and arms which lead the eye throughout the figural arrangements, and the varied views of the heads, from frontal to three-quarter to profile. In this respect the artist, by looking out at us, metaphorically mediates between his subject and the viewer, emphasizing his creative role as artificer. His presence is unpretentious, however, in keeping with Horace Walpole's description of him as 'a silent, modest man who abhored the finesse of some of his profession'.[11]

Recent cleaning of the Berkeley canvas has revealed a picture of sensitive and subtle colouring, organized around the three primaries of red, yellow, and blue. These appear together in the tablecloth pattern, and are then repeated in the rich red of Dalton's robe

and the various blues of Berkeley's coat and the background landscape. Equally subtle is the artist's control of light and shadow, which both focuses attention on critical details and softly models subordinate forms.

A similar handling of light and colour is evident in another group portrait of the same time, that of *Daniel, Peter, and Andrew Oliver* (1730) (Plate 26). Smibert is sometimes criticized for a relative inability to differentiate the characters who sat before him, and indeed at first glance one might think his depiction of the three Olivers monotonously repetitive as they sit in balanced formation around the table. Yet there are enlivening differences among their postures, placement in the overall composition, and relationship to the spectator. Again Smibert employs variants of the three primary colours for the clothing of each figure, while also framing the dark-haired younger Oliver at the centre with his white-wigged elders on either side.

Smibert's early years in Boston were a mixture of personal unhappiness and public success. After being happily married in July 1730 to Mary Williams, who was half his age, there followed over the next few years the deaths in infancy of five of his nine children. At the same time, he had important commissions to paint a number of notable Bostonians, including *Francis Brinley* and *Mrs Brinley with her son Francis* (both Metropolitan Museum of Art). Mr Brinley's portrait is appealing for its landscape view of Boston seen from Datchett House in Roxbury; the companion painting of his wife and son draws for its format on copies after Sir Peter Lely and after a Raphael Madonna and Child composition. In works such as these the artist brought from abroad the fresh brushwork and full modelling of the most up-to-date European styles.

Not long after his arrival he drew further attention to his practice by holding an exhibition of recently completed works along with a number of his Italian copies. Mather Byles described his reactions in a long poem published anonymously in the London *Daily Courant* of 14 April 1730. This included the first mention of the portraits of Samuel Sewall, Nathaniel Byfield, and Jean Paul Mascarene, as well as the copies of Van Dyck and Rubens, and the following tantalizing passage: 'Landskips how gay! arise in every Light,/And fresh Creations rush upon the Sight'.[12] The celebration continued:

> Thy Fame, O *Smibert*, shall the Muse rehearse,
> And sing her Sister-Art in softer Verse.
> 'Tis yours, Great Master, in just Lines to trace
> The rising Prospect, or the lovely Face,
> In the fair Round to swell the glowing cheek,
> Give Thought to Shades, and bid the Colours speak.[13]

During the following years the prices that Smibert commanded fluctuated with the market, and in October 1734 he advertised in the *Boston News-Letter*:

John Smilbert, Painter, sells all Sorts of Colours, dry or ground, with Oils, and Brushes, Fans of Several Sorts, the best Mezotints, Italian, French, Dutch and English Prints, in Frames and Glasses, or without, by Wholesale or Retail at Reasonable Rates: at his House in Queen Street, between the Town-House and the Orange Tree, Boston.[14]

Here was a means both of new income and of a continuing supply of artistic sources for his own painting. For example, he ordered a set of prints from Lemprière, stating that

These ships I want sometimes for to be in a distant view in Portraits of Merchts etc who chuse such, so if there be any better done since send them. but they must be in the modern construction.[15]

Smibert made profitable trips to paint in New York and Philadelphia in 1740, but his later work relied ever more directly on mezzotints for inspiration, and as a consequence his style was often dryer and flatter than in his earlier paintings. He presumably gave up portraiture with the conclusion of his list in 1746, his eyesight by this time weakened. To Arthur Pond he wrote in 1749:

I need not tell you that I grow old, my eyes has been some time failing me, but [I'm] stil heart whole & hath been diverting my self with somethings in the Landskip way which you know I always liked.[16]

In 1738 he noted painting 'a vew of Boston', but this and whatever later landscapes he undertook are no longer known. In his last years he also attempted a few full-length portraits, which are generally weaker than his familiar half- and three-quarter-lengths. These new efforts conclude a remarkably varied and talented career, which had set new standards for American art. Possibly his most influential contribution had been the sophisticated group portrait, with its finest expression in *The Berkeley Family*. His art dominates the middle decades of the eighteenth century, and his accomplishment was surpassed only with the emergence of John Singleton Copley during the decade following Smibert's death in 1751.

Smibert's trip to New York and Philadelphia points up the artistic activity under way in areas outside New England. Contemporaneous with Smibert's, for example, is the work of Charles Bridges, who was active in Virginia from 1735 to 1740. His paintings of the Byrd family, for instance *Maria Taylor Byrd* (Metropolitan Museum of Art), display a similar familiarity with fashionable London portraiture in the manner of Kneller and Lely, but possess more fluid and sparkling effects in the rendering of clothing than most Smibert figures. Because he arrived late in life and returned to England after such a short period, Bridges did not stamp the course of American painting so strongly.

One artist felt by many to rival Smibert is the native-born Robert Feke. Successive generations of art historians have attempted to piece together the facts of his life and career, yet much still remains obscure. It is generally believed that he was born in Oyster Bay, Long Island, about 1707, and evidence exists that he died probably on Barbados around 1752.[17] Some records suggest he may have made a youthful voyage to Europe as a mariner; his career as a painter does not begin until 1741 and lasts for little more than a decade. Within this period he executed some pictures as impressive as Smibert's, though quite different in character.

Contacts between Oyster Bay and Rhode Island were close during the period of Feke's youth, and he himself was married in Newport in 1742.[18] We are not sure whether he first saw Smibert's work there or in New York, but he certainly had the opportunity to study Smibert's portraits in either place, and his own early works testify

31

THE COLONIAL PERIOD: 1564-1776

to his having borrowed some compositional elements from the Boston artist. The major work of his early career is his painting of *Isaac Royall and His Family* (1741) (Plate 27), which owes its general conception and two of the poses to Smibert's *Bermuda Group*. Like the earlier canvas, this too presented an image of aspiration and achievement. Just as Smibert sought to convey the impressive stature and grand vision of Dean Berkeley, Feke was responding to the young Royall's rise to wealth and social position. He was just twenty-two and graduated from Harvard. Recently married and the father of a child, he was also the beneficiary of a handsome inheritance from his father. Feke's balanced forms and harmonious design embody Royall's new familial stability and self-possession.

But there most of the debt to Smibert ends, and Feke's individual style begins to assert itself. Unlike the more complex spatial arrangement of the Berkeley group, the figures in the Royall family stand or sit in a single plane along the back edge of the table. Their silhouettes are much stronger and the landscape behind barely draws our attention into depth. Feke more strongly emphasizes the decorative patterns of tablecloth, colour areas of the clothing, and details such as lace cuffs or Royall's gold braid trim. Indeed, a hallmark of Feke's style hereafter will be his striking decorative sense of colour and line, discernible in his treatment of two-dimensional designs on clothing and in the crisp contours of the figures on the canvas. This feeling for the ornamental surface is in obvious contrast to Smibert's more sculptural handling of form and space – a manner associated with the older artist's recent familiarity with fashionable English painting – and derives from the earlier colonial traditions of American art as first seen in the Freake and Gibbs portraits (Plates 9 and 10).

Feke's insistence on surface pattern is further evident in his placement of the adult figures within four equal vertical divisions of the canvas. In addition, the amount of the table top visible is equal to the portion shown of the child's body and to the distance from each woman's bodice to the top of her head. Finally, Royall must have intended that special attention be given to his child, as Feke has placed him virtually in the centre of the composition, at the crossing of the horizontal and vertical lines as well as of the diagonals. Paradoxically, it is thus both more naive and more imaginative than Smibert's model.

Feke's sensitivity to contour and pattern in the service of defining his figures continued over the next few years. In 1746 he journeyed to Philadelphia, and there undertook a series of major portraits, all noticeably advanced in technique over his previous work. Although these show a more sculptural treatment of the figure than in the *Royall Family*, Feke still basically relied on strongly lit ornamental details as his primary visual effects. Not surprisingly, the poses came from mezzotints,[19] but Feke made the models his own by simplifying the background and having his sitter fill up most of the canvas surface.

By 1747 he was back in Newport and the next year in Boston. Smibert had of course by this time given up portraiture due to weakened eyesight. Joseph Badger and John Greenwood were not comparable talents (see Plates 31 and 32), and Copley was yet to emerge. As he had earlier in Philadelphia, Feke moved in to fill the artistic vacuum. Among his finest Boston works from the late forties were his renderings of *Mrs James*

Bowdoin (Bowdoin College Museum of Art, Brunswick, Maine), a more understated and graceful version of his recent Philadelphia pictures; the monumental full-length *Brigadier-General Samuel Waldo* (also at Bowdoin), who is shown appropriately with elaborately braided frock coat and sweeping landscape behind; and the dignified *Isaac Winslow* (Plate 28). In this last Feke displays his now fully developed colouristic and decorative sensibilities. As in his portraits of Francis and Waldo, he employs the uninterrupted curving lines of the coat, buttons, embroidery, outstretched arm, and foreground contour to pull the various elements together and lead our attention to Winslow's head. While the landscape still remains largely a flat backdrop, it is now better integrated with the figure by means of repeated shapes and colours. Some touches, such as the bright gold braid, recall the central ornamental design of the rug tablecloth in the *Royall Family*; others, like the illusionistic chip in the stone plinth at the left or the highlighted fingertips of Winslow's left hand, are telling strokes of Feke's mature brush.

The artist made a second visit to Philadelphia in 1749, but was back two years later in Newport, where we have the last concrete evidence of his whereabouts. Although he disappeared after this, possibly to Barbados, his influence on the younger generation of painters kept his style alive in New England and the mid-Atlantic Colonies. Greenwood, Badger, Copley, and John Hesselius were all in differing ways indebted to Feke artistically. Although English mezzotint prototypes continued to serve as sources for this generation, Feke's increasing inventiveness and technical ability helped to initiate a thriving school of American painting. It remained only for artists of the second half of the eighteenth century to bring the Colonial period to its culmination.

In fact, just about mid-century a varied group of both native and foreign-born artists began their work or arrived in the colonies. Their talents were uneven; their periods and places of work differed considerably; but they form an important picture of activity between the end of Smibert's and Feke's careers and the rise to prominence of Copley and West. Most noteworthy in the South was Jeremiah Theus, who had emigrated from Switzerland to South Carolina in the later 1730s. He advertised in the local paper in 1740 that he had established himself on Market Square

where all Ladies and Gentlemen may have their Pictures drawn, likewise landskips of all sizes, Crests and Coats of Arms for Coaches or Chaises. Likewise for the Convenience of those who live in the Country he is willing to wait on them at their respective plantations.[20]

Although he was active until his death in 1774, his best portraits date from the middle fifties, and include unaffected but graceful renderings of men, women, and children. His use of pale colours and silvery tones in *Elizabeth Rothmaler* (1757) (Plate 29) was perfectly suited to expressing the polish and elegance of Charleston's genteel tastes. While his formats generally continued those of his predecessor in the south, Justus Kuhn (see Plate 15), Theus had the lighter, more refined touch characteristic of his age.

John Wollaston's work in New York, Maryland, and Virginia is contemporary with that of Theus, and possesses a similar Rococo lightness. But in contrast, Wollaston's canvases were often larger, his sense of form more monumental. The son of John Woolaston, a London portraitist active in the first quarter of the eighteenth century, the

younger Wollaston was himself painting in England from the 1730s up to 1749, when he departed for New York. It was evidently at this time that he changed the spelling of his name. He was enormously successful in New York – he painted nearly one hundred portraits during his three or four years there – partly because there was little competition. By 1753 he had left for Maryland and Virginia; in addition, he was painting in Philadelphia in 1758 and Charleston in 1767.[21]

Typical of his work is the portrait of *Mrs Fielding Lewis* of c. 1756 (Plate 30). It is a variant on a compositional pose he regularly favoured: the three-quarter-length figure in a tall pyramidal format with a rather perfunctory background. This formula obviously enabled him to accomplish his successful and prolific production; he eschewed the full-length pose and group portraits. Another mannerism identifying his American work is the almond shape of the eyes, slanting inward slightly, of almost every sitter. In *Mrs Lewis* he repeats this form in the lines of the eyebrow and face, while echoing Rococo curves are evident in the scrolled table leg and in the folds of the dress.

Along with Wollaston, Lawrence Kilburn and Thomas McIlworth were also at work in New York during the 1750s. Elsewhere, John Hesselius carried on the manner of both Feke and Wollaston, two early influences on his painting, throughout the mid-Atlantic Colonies, from Philadelphia to Delaware, Maryland, and Virginia. By 1763 he had married well and settled down at a country plantation near Annapolis, where he subsequently gave lessons in painting to the young Charles Willson Peale, soon to become the dominant artist of the area (see Plate 56). Thus, Hesselius, who had begun under the tutelage of his father Gustavus (see Plate 21), and then drawn on the best talents among his own contemporaries, stands as an interesting figure of transition to a new generation. His own pictures – the best known perhaps being that of *Charles Calvert and his Servant* (1761, Baltimore Museum of Art, Maryland) – are stamped with Rococo refinements: flickering effects of light, pastel colouring, and more informal arrangements. His attention to rich costuming, as well, projected both his own well-being and the tastes of the southern aristocracy.

During the same period New England saw a number of artists with differing training and ability. Among those taking advantage of the release from competition after Smibert had given up portraiture in Boston was Joseph Badger. Born in nearby Charlestown, he moved into Boston proper in 1731 to work as a glazier and house painter. About 1740 he took up portraiture, remaining active for the next twenty years and providing during that time some sources for Copley's first works. One of his most ambitious pictures was the full-length portrait of *Captain John Larrabee* (c. 1760) (Plate 31), although it falls short of the felicitous achievement of Feke's *Isaac Winslow* (Plate 28) owing to the ambiguities in the relation of the figure to his setting. Badger is a less effective colourist, too, and his modelling of form tends to be dry and uniform. Yet through his realistic detailing and emphasis on the stark outlining of his figure against the background Badger is able to convey an intuitive sense of Larrabee's stature. Badger's hard and forthright style seems well matched to the position his subject held as the commanding officer of Castle William in Boston harbour.[22]

Another native Boston artist of some accomplishment is John Greenwood, born in

1727, and apprenticed as a youth to the engraver and sign painter Thomas Johnston. Aged eighteen, Greenwood began his own career as a portraitist and remained active in Boston and Portsmouth, New Hampshire, until 1752. Besides his numerous portraits, often rather wooden in character and, appropriate to his name, painted in greens, he also produced an unusual mezzotint, *Jersey Nanny*, in 1748 (Museum of Fine Arts, Boston). This print is interesting as an image of an ordinary figure of the streets, Ann Arnold, shown in an almost anecdotal manner. Its suggestion of genre found full expression in one of the period's most distinctive works, *Sea Captains carousing in Surinam* of 1758 (Plate 32). Greenwood, who had moved to the Dutch colony in 1752, painted a large number of portraits there before going to the Netherlands later in the decade, and then in 1762 to London for the remainder of his career. His *Sea Captains* must be one of the first genre paintings in American art, although it is equally a large and informal group portrait of the artist's friends. Most of the figures are identifiable as mariners from Rhode Island; included were a future Governor of the colony, commander of the Continental Navy, and signer of the Declaration of Independence.[23] Others are smoking pipes, staggering drunkenly, playing cards, or drinking wine. The artist himself is departing the scene with a candle in hand. The whole is animated by the variety of candle-lit faces and gestures. Although presumably done from a memorable first-hand experience, Greenwood may also have found his inspiration in the contemporary printed caricatures by Hogarth.

Just as Greenwood was leaving Boston, Joseph Blackburn arrived from London via Bermuda. He brought with him the full Rococo style of Thomas Hudson and Joseph Highmore, which had now fully replaced the heavy painterly Baroque manner of the Kneller and Lely shops. In Newport during 1754, Boston from 1755 to 1760, and then Portsmouth, New Hampshire, for two final years before returning to London, Blackburn found plenty of commissions for his delicate and elegant productions. Something of this lightness is apparent in his rendering of *Isaac Winslow and his Family* (1755) (Plate 33). There were of course several American precedents he could have assimilated, from Smibert's *Berkeley Family* and Feke's *Royall Family* (Plates 25 and 27) to John Greenwood's group portrait of the *Greenwood-Lee Family* of about 1747 (Museum of Fine Arts, Boston). But Blackburn's arrangement of the figures is notably more informal and asymmetrical, replacing the stable compositional form of the central table in the earlier pictures. There is also a shimmer to surfaces and textures, an attenuation and undulation of forms that are new. Of all this generation, his influence was to be especially marked on the early work of John Singleton Copley,[24] then just beginning to try his own hand at art.

THE COLONIAL TRIUMPH

COPLEY's beginnings were humble. He was born in Boston in 1738, the son of parents just emigrated from Ireland. His father died not long after, and his mother continued to run the family's tobacco shop. In 1748 she married Peter Pelham, who brought into Copley's life his world of artistic experience, which included a studio filled with his own prints and mezzotints after the works of others. As a contemporary and colleague of John Smibert, Pelham doubtless acquainted his impressionable stepson with the older painter and his work.

Although Pelham also died three years later, he left behind a library of books and prints that stimulated the young Copley to make his first attempts at art at the age of fifteen. The decade of the 1750s was largely a period of self-education for him, and his early works – prints, portraits, and history pieces – reflect the resources at hand. His first mezzotint of the *Reverend William Welsteed* (1753) was based both on an oil by Badger of the subject and on a print by Pelham of the *Reverend William Cooper* (cf. Plate 23), which Copley modified on the metal plate. His first history paintings of the next year express an early and continuing interest in European art, discovered initially in his stepfather's collections. Portraits from this period were directly based on English mezzotints, or modified from versions painted by Greenwood, Feke, and Smibert. Blackburn's influence on Copley's early style consisted in providing not only poses but also a manner of Rococo colouring and flickering highlights to imitate.[1] During this time, too, Copley essayed his first group portraits, something he would not do again until the end of his American career some fifteen years later (see Plate 38). The most familiar are *The Brothers and Sisters of Christopher Gore* of c. 1755 (Winterthur Museum, Delaware) and *Mary and Elizabeth Royall* of c. 1758 (Museum of Fine Arts, Boston); the former owes a multiple debt for its poses to the precedents of Smibert, Badger, Feke, and Greenwood, while the latter at once recognizes and rejects Blackburn's sophisticated colouring.

Copley's maturing artistic style was firmly grounded in the graphic tradition, which led him throughout most of his career to organize his paintings around strong tonal contrasts and precise draughtsmanship. All the more remarkable, therefore, was the rich colouristic sense he gradually acquired. Some measure of his reliance on graphic clarity is evident in one of his most forceful early portraits, *Epes Sargent* (1759–61) (Plate 34), which is a nearly monochromatic picture contrasting various browns and greys with the white flesh tones, hair, and cuffs. It is a pose Copley reworked from a portrait begun the year before of *Thaddeus Burr* (City Art Museum, St Louis, Mo.), which in turn recalls precedents by Feke, Badger, and others (compare Plates 28 and 31). But Copley has given his subject new strength and informality, suitable to Sargent's prosperous suburban position as a Gloucester merchant. The powerful pyramidal composition, echoed by the interior triangle of head and right forearm, the massive figure and stone pedestal,

all evoke a person of resolve and a down-to-earth, self-possessed character. Copley's convincing sense of weight and volume was the result of anatomical studies he had begun a few years before. His portraits possess an unequalled realism in rendering the structure of the human body, along with telling surface details, as here the thick touches of paint for the texture of Sargent's hair and the rough skin of his right hand.

Henry Pelham or the *Boy with a Squirrel* (Plate 35), painted in 1765, is Copley's early masterpiece, and a significant milestone in colonial American art. It stands as the first major work painted by an American artist for himself, rather than on commission, and it also became the first American picture to be exhibited abroad. This intimate and personal work further represents Copley's final break with English and American precedents. His sense of palpable mass and spatial ambience, even within this narrow setting, now far surpasses the modelling of Smibert, the linear designs of Feke and Greenwood, the virtuoso textures of Blackburn. The very informality of pose and organization was new both for Copley and for American painting. Pelham sits casually but preoccupied at a plain table turned obliquely to the viewer. His loosely diagonal posture is echoed in the stance of the squirrel; their almost unconscious playing with the chain is another link. Yet Copley makes subtly clear the differing degrees of thought and action between boy and animal.

Unifying the whole are the exquisite sheen of light and softness of textures, from the central attention to the youthful face and bright satin colour to the rich drapery behind and the polished mahogany table in front. Particularly beautiful are the half-shadows falling across Pelham's chin and right hand and the reflections of light within the glass and on the wood surface. The colour scheme is appropriately unaffected, with pinks, whites, and yellows in the shirt repeating the facial tones, and in turn finding deeper sonorities in the dark red drapery and warm brown mahogany. Even the simple, uncarved table seems to express the purity of youth. Most of all, this is a serene vision of youthfulness, an embodiment of that age between childhood's unknowingness and maturity's self-awareness. Copley conveys as much his own familial affection as an understanding of a moment of timelessness. One almost feels a psychological suspension in Pelham's reverie. Such profound thoughtfulness would not be expressed again in American art until Thomas Eakins' moving portraits of his family (see Plates 166 and 169) over a century later.

This picture follows in the long tradition of portraits of youths, going back to the Mason limner and Justus Kuhn (compare Plates 11 and 15) and continuing with Charles Willson Peale (see Plate 56). Copley himself was to paint other fine examples in subsequent years. But the *Boy with a Squirrel* remains unmatched for its perception and sensitivity. In addition, the picture had a singularly interesting history following its completion. Copley was already intrigued by the standards and opportunities of painting in England. To gain some measure of his artistic worth in relation to European art, he determined to send his stepbrother's portrait to London for exhibition at the Society of Artists.

He despatched it to his friend Captain R. G. Bruce, who arranged for its exhibition and subsequently reported back on its favourable reception by Sir Joshua Reynolds and

Benjamin West. Bruce began by stating that 'It was universally allowed to be the best Picture of its kind that appeared on that occasion';[2] the President of the Royal Academy remarked

that in any Collection of Painting it will pass for an excellent Picture, but considering the Dissadvantages . . . *it was a very wonderfull performance*. . . . It exceeded any Portrait that Mr. West ever drew.[3]

West was to succeed Reynolds as head of the Academy. He was Copley's exact contemporary and the first major American artist to go abroad to study. He had left Philadelphia a few years before, and his own success in London was to be one of the factors encouraging Copley to follow. He added his own positive appraisal of the portrait, but like Reynolds found the style 'too liney, which was judgd to have arose from there being so much neetness in the lines'.[4] The phrases Reynolds used were 'Hardness in the Drawing, Coldness in the Shades, An over minuteness'.[5] What both were reacting to we now recognize as qualities peculiar to American art: the preference for factuality, the almost scientific concern for the physical world,[6] and the early graphic tradition characterized by such linear and tonal sharpness. This manner was in distinct contrast to English Baroque and Rococo painting with its fluid touches and flickering atmospheric effects. Nonetheless, this initial approbation gave impetus to Copley to consider a career abroad.

He had now established himself as a consummate observer of personality. For the next ten years his portraits would capture with objectivity and sympathy a remarkable range of human types, male and female, old and young, prosperous and humble. His achievement in delineating convincing physical form as well as inner character was what decisively lifted him above his predecessors. Following the *Boy with a Squirrel* he undertook similarly composed portraits of *Nathaniel Hurd* (*c.* 1765, Cleveland Museum of Art) and *Paul Revere* (1768–70, Museum of Fine Arts, Boston). Both were informal, showing each man from the waist up seated before a highly polished table with tools of their trade before them. These were men who like Copley himself had risen from modest backgrounds to positions of professional and highly respected craftsmen. In this sense we may read them as artistic tributes, testaments to the elevated and now independent status of the American painter, architect, cabinetmaker, and silversmith. In the portrait of Revere he expressed the man's capacities for action and thought in a specially felicitous way by contrasting his hands, one holding a teapot, the other his chin. Thus we are given unobtrusively an image of an individual pausing thoughtfully in the midst of his work.

Major commissions flowed to Copley during these years; not least of them was the portrait of *Jeremiah Lee* of 1769 (Plate 36) and its companion of his wife. Copley had done full-length portraits only infrequently before, the most notable example being *Colonel Nathaniel Sparhawk* of 1764 (Museum of Fine Arts, Boston). Here he pulled off a bold stroke by painting his subject in a striking red costume which dominates the elaborate architectural background. With *Lee* he reversed the basic colour scheme, now setting the sombrely clothed merchant within a richly hued interior. Copley also repeats a device he had successfully used several times before and which also recalls the com-

positions of Feke (see Plate 27), that of highlighting the bright rows of gold braid and buttons so that their sweeping arcs carry our attention directly to Lee's head.

Lee was one of Marblehead's most prominent businessmen, and his success was mirrored not only in Copley's canvas but in his entire surroundings. His house in the latest manner after James Gibbs was one of the most costly and splendid late Georgian buildings outside of Boston, and duly reflected its owner's powerful and influential status in the years prior to the Revolution.[7] Just as its emphasis on formal purity and classical proportions brought a unity to the whole environment, enhanced by elegant furnishings, so did Copley's paintings possess harmony and internal consistency. The imagery of confidence we see here was in keeping with the new self-respect gained after the mid-century by artists such as Copley or architects such as Peter Harrison and William Buckland.

Copley was equally capable of severe and unembellished pictures. In 1770 he portrayed *Samuel Adams* (Museum of Fine Arts, Boston) in three-quarter pose with sombre colouring and strong lighting, befitting the dramatic confrontation between the radical Whig and Governor Thomas Hutchinson. The next year he painted *Mrs Humphrey Devereux* (Plate 37) in an equally austere and effective manner. An extensive series of lavish half-length female portraits had preceded this, but compared to them the image of Mrs Devereux is spare and uncontrived.

The occasion for this portrait was unusual. An old friend and colleague, John Greenwood, had written Copley from London asking if he would paint Greenwood's mother, who was then living in Marblehead. 'I am very desirous of seeing the good Lady's Face as she now appears, with old age creeping upon her.'[8] Copley has recorded her appearance and more. As with *Henry Pelham*, the table is obliquely placed, and her glance is turned away, lending a relaxed manner. Her chin rests on her supporting hand, reminiscent of *Paul Revere*, but the trim posture, alert eyes, and crisp modelling mirror the strength and self-possession of age. Perhaps most striking is the emphatic economy of design and the near abstraction of Copley's composition. In this regard it was both a commissioned portrait and an artist's utterance to a peer.

During the next few years tensions mounted between the colonists and the English government, and Copley found himself increasingly pressured by events. His clients were splitting into opposing factions, his family became subject to political threats, his own sympathies were torn, and his artistic energies taxed. Renewed correspondence with West as well as concern for success at more than portraiture (he had meanwhile done exceedingly well on a trip to New York and Philadelphia) led him to decide finally to leave.

Among his last pictures completed in Boston was the double portrait of 1774 of *Mr and Mrs Isaac Winslow* (Plate 38), an image that seems to bear the weary lines of the sitters' age and that year's troubles. One similar composition of the year before, of *Mr and Mrs Thomas Mifflin* (Historical Society of Pennsylvania, Philadelphia), anticipated this. But Copley replaced the earlier vertical and more complex format with a balanced horizontal arrangement. Through the astute placement of the table and hanging drapery behind he distinguished between the two individuals, at the same time that their mirrored positions and adjacent hands speak to their marital unity. Mr Winslow has obviously aged from the time Feke painted him in 1748 and Blackburn in 1755 (Plates

28 and 33). But this was his second wife, and Copley perceived a note of grace and re-newal in her gentle face.

Shortly after, Copley sailed for England; his wife and family joined him six months later. Now began an even longer artistic career in London, of some forty years. He first set off after arrival for Italy, where he studied antiquities and made copies after the old masters. His brushwork began to loosen up as he became more conscious of contem-porary English painting, and he successfully exhibited his work at the Royal Academy. Now familiar at first hand with prominent examples of history painting, considered to be the highest branch of art, in 1778 he took the proffered opportunity of a commission to make a major attempt himself. The subject, *Watson and the Shark* (Plate 39), was based on an event of twenty-five years earlier. The notable London merchant Brook Watson, later to become Lord Mayor, had been attacked by a shark while swimming as a youth in Havana harbour. He lost part of his leg in the incident, but was rescued from death at the last gasp. This vivid moment Copley chose for his large canvas.[9]

Its significance lay in the bold, but not unprecedented, representation of recent instead of ancient history. The figures were in contemporary dress; the participants were ordinary, though their actions were heroic. Copley here had the immediate examples to follow of his compatriot Benjamin West, who had completed his *Death of General Wolfe* in 1770 and *Penn's Treaty with the Indians* in 1772 (Plates 43 and 44). Both painters informed their pictures with an immediate sense of realism, and Copley particularly in-fused the grand tradition of history painting with his basic talent for portraiture. For *Watson and the Shark* is really a group portrait in action. In contrast to West's reliance on Poussin and other classical sources for his style and composition, Copley has turned to Rubens for the more dramatic torsion of his arrangement.[10] Here the essentially pyrami-dal design is counterpointed by the tensions of action and gesture, the generally zigzag organization of forms back into space, and the active silhouette of the figural group. Copley's ability to model form with light and shadow now serves the human drama of life and death in the balance. As such, the painting is an unexpected first signal of the coming romantic movement in Europe and America, anticipating most familiarly Géricault's *Raft of the Medusa* of 1815 (Louvre, Paris), but also John Vanderlyn's *Death of Jane McCrea* and Thomas Cole's early landscapes (Plates 65 and 90).

The exhibition of *Watson* brought Copley new success and reputation, along with full membership in the Royal Academy. The picture is a turning-point in his career, marking the actual and figurative conclusion of his American style, while also inaugurat-ing his subsequent ventures into grand history painting in England. There followed, for example, *The Death of Chatham* in 1779–81, *The Death of Major Pierson* in 1782–4 (both Tate Gallery, London), and *The Siege of Gibraltar* in 1788 (Guildhall Art Gallery, London). His portrait style changed decisively, as well, to a more flamboyant and dash-ing manner. Old age overtook his long life of two extraordinary careers with a stroke in 1815.

Before Copley's departure for London American artists had already shown occasional interest in historical subjects. One of them whose portrait he had completed in 1770 was

Paul Revere, a silversmith of the highest artistry, who shortly produced the most memorable popular image of events during the Revolutionary period. Revere was but three years older than Copley. His father was Apollos Rivoire, a French Huguenot émigré from the Isle of Guernsey, who began an apprenticeship in Boston under the noted silversmith John Coney early in the century. Anglicizing his name, young Paul Revere followed in the trade just as the graceful and abstract Queen Anne style was beginning to appear.[11] The practice of engraving prints was a natural extension of his work in silver, and during the Revolutionary years he was active in producing broadsides, bookplates, trade cards, paper currency, and other miscellanea. Among his larger engraved views the best known are *A Westerly View of The Colledges in Cambridge New England* of 1767 and *A View of Part of the Town of Boston in New England and British Ships of War Landing Their Troops! 1768* of 1770, both strongly indebted to Burgis' previous versions (see Plate 22).

Also of 1770 was the famous *Bloody Massacre perpetrated in King Street Boston* (Plate 40), which Revere copied from a print by Henry Pelham,[12] who immediately wrote a strong letter expressing his displeasure. But the damage was done; Revere's print was already in the streets. While Pelham's version was the better drawn, Revere's had an incendiary quality in its very crudeness and in the captions which made it the more forceful. He made other changes as well: in the position of the moon, the details of the skyline, and, on the right, the pointed addition of the sign 'Butcher's Hall'. Even his alteration of the title, from Pelham's *Fruits of Arbitrary Power* to *The Bloody Massacre*, expressed a more provocative tone. Its vigour and directness followed in the tradition of John Foster's first woodcuts (Plate 6), but more importantly it crystallized contemporary ideology in popular form, so much so that copies and facsimiles appeared regularly over the next several decades.

The pioneering figure of history painting, however, and the individual primarily responsible for attracting Copley to London was Benjamin West, his exact contemporary. West's background was equally modest: he was born into a Quaker family in Springfield Township, Pennsylvania. He evidently showed an early talent for drawing, which was enlarged by his first glimpses in Philadelphia of prints and occasional oils by European masters. But the major formative influence of his youth came when he was nine through meeting William Williams, a portrait painter born at Bristol in England, who had come to Philadelphia about 1747. Said West later, 'Most undoubtedly had not Williams been settled in Philadelphia I shd not have embraced painting as a profession.'[13]

Although Williams is believed to have painted a large number of portraits during his American years, much of his career has been obscured by confusion with other artists named William Williams in both America and England. West's teacher was also later known for his published narrative *Journal of Llewellin Penrose, a Seaman*. The long friendship between the two men began in the later forties in Philadelphia, when Williams loaned the aspiring youth his copies of the books on art theory by Charles du Fresnoy and Jonathan Richardson. Williams also must have impressed him with his manner of painting in the current Rococo style, as exemplified in his portrait of *William Hall*

of 1766 (Plate 41). This work is characterized by bright colours, rather hard drawing, and flat modelling, but its lightness and charm were similar to the contemporaneous work of Blackburn and Wollaston (compare Plates 30 and 33).

Wollaston was another early influence on West's youthful career. West's portrait of *Thomas Mifflin* of 1758 (Plate 42) illustrates that he was aware of and able to master rapidly the style of both Wollaston's and Williams' painting. What continued to stimulate him most were his readings in ancient history and study of historical works by old masters. A generous subscription and letters of introduction from friends made possible West's departure for Italy in 1760 at the age of twenty-two. In Rome he met the most prominent connoisseurs and dilettanti and had his first opportunity to examine Renaissance and ancient works close up. Two figures especially dominated artistic thought of the day: the German philosopher Johann Winckelmann and the painter Anton Raphael Mengs. The one propounded, and the other demonstrated, the rules of antique classicism as models for contemporary art and society. Following the Scottish painter Gavin Hamilton, West took up the neo-classical style in its first wave and made it the major expression of his early maturity.

The picture best embodying this style – and one leading him ultimately to the positions of history painter to the King in 1772 and President of the Royal Academy after Reynolds' death in 1792 – was *Agrippina landing at Brundisium with the Ashes of Germanicus* (1768, Yale University Art Gallery, New Haven, Conn.). West took a subject of Roman stoic courage and clothed it in layers of classicism, showing that he had studied profitably the theories of Winckelmann and also the paintings of such other classicists as Poussin. It further exemplified the teachings of Reynolds on the eclectic choice of the best in past styles. Indeed, West borrowed from several different classical sources for this one picture. What better fulfilment of his views that art should dignify and instruct man by presenting the noble body in noble action?[14]

But not only ought art to emulate classical examples; the painter must also follow classical artistic principles by stressing careful drawing, proportion and perfection of the parts in relation to the whole, and the ideal standards of the human form:

Correctness of outline, and the justness of character in the human figure are eternal; all other points are variable, all other points are in a degree subordinate and indifferent – such as colour, manners and costume; they are marks of various nations; but the form of man has been fixed by eternal laws, and must therefore be immutable. It was to those points that the philosophical taste of the Greek artists was directed; and their figures produced on those principles leave no room for improvement, their excellencies are eternal.[15]

Archbishop Drummond had commissioned *Agrippina*, and its immediate success led to a meeting with George III, who in turn favoured the painter with his patronage and friendship over the next forty years. West was to introduce a much more radical transformation of history painting with his *Death of General Wolfe* in 1770 (Plate 43). Here were the values of ancient history updated and applied to recent events. The scene had taken place on the plains of Quebec at the close of fighting between the French and English in 1758, and West insisted on contemporary costumes and setting instead of

Roman togas and allegorical format. Resisting the counsel of the King, Archbishop Drummond, and Reynolds, West finally won them over. Reynolds admitted that 'West has conquered',[16] and the King commanded a copy for himself. The picture was not without its moral allusions: the crouching Indian was in the spirit of ancient statuary and the entire composition of Wolfe's dying figure surrounded by attendants was taken from Baroque renditions of Christ's Descent from the Cross and the Pietà. West had made even more immanent the truths of noble sacrifice and suffering.

In 1772 West carried this combination of classical eclecticism and realism a step further with his painting of *Penn's Treaty with the Indians* (Plate 44). The planar disposition of the figures across the canvas foreground probably came from Poussin and from Raphael's Stanze frescoes, while the central group standing in an S-shaped configuration may well have derived from Masaccio's *Tribute Money*. Although the event itself had occurred in 1682, West did not hesitate to clothe the participants in eighteenth-century costumes and to include portraits of his father and half-brother standing next to Penn. He wrote in 1805 to a friend that his intention was to create an image of harmony and benevolence; so well did he succeed, that subsequent artists including Edward Hicks (see Plate 115) made innumerable copies.

Like Copley he continued to produce pictures combining history and portrait painting, but in the later 1770s his style began to graft new dramatic colour and feeling on to his calculated classical draughtsmanship and modelling. The best example of this increased emotionalism and expressive power is *Saul and the Witch of Endor* (1777, Wadsworth Atheneum, Hartford, Conn.). By the next decade West's art had undergone a profound shift in this direction, largely stimulated by his attentive reading of Edmund Burke's *Philosophical Enquiry into the Origin of our Ideas of the Sublime and Beautiful*. First published in 1756, this influential essay defined the two polarities in art, characterizing the sublime by such qualities as vastness, darkness, privation, and obscurity. Their appearance in painting instilled feelings in the beholder of terror, wildness, isolation, and overwhelming power. Much of West's later style and subject matter manifested his interpretation of Burke's ideas.

The single major work which most embodies these principles is *Death on the Pale Horse*, begun about 1787 and reworked in several versions up to 1817 (Plate 45). Instead of his early spatial clarity and balanced compositions, we have intentional confusion, movement, and violent energy. Light and shadow, colour and brushwork are vigorous. Figures seem to crush one another as much by gesture as by the compacted crowding. Death crowned rides the white horse at the centre; his bolts of lightning strike a lover dead to the left, and Roman soldiers plunder the temple at Jerusalem on the right. These are but a few details meant to inspire the appropriate reactions of awed reverence and astonishment. The unstable stances of the figures and their explosion forward towards the viewer also contribute to the total effect. And West both physically and figuratively conveys sensations of vastness by the staggering size of his forty-six-foot-long canvas.[17]

The range and authority of West's work were to have a far-reaching impact on subsequent American art. He at once forecasts the coming neo-classical and romantic movements, as his influence on John Vanderlyn and Washington Allston (see Plates 65 and 70)

43

among others confirms. Even more important were his critical roles as pioneer of a new type of history painting and as teacher of several generations of American painters. His pictorial innovations were perfectly suited for a country that would soon require celebration of contemporary national history and heroes. His students included most of the major figures of late-eighteenth- and early-nineteenth-century American art: Matthew Pratt, John Trumbull, Henry Benbridge, Charles Willson Peale, Gilbert Stuart, Thomas Sully, Washington Allston, Samuel F. B. Morse, William Dunlap, and Robert Fulton. He was able to offer advice, shelter, financial support to such an extraordinarily varied list because of his own intelligent understanding of eclecticism. Rather than imposing a stamp on those who entered his studio, he had a liberating effect which encouraged their aristic individuality. In addition, almost all returned home to pursue their careers. National soil was now called the United States, and the political changes had been no less profound than the artistic ones.

PART TWO

TRANSITION TO THE NINETEENTH CENTURY
1776–1836

From Federalism to Nationalism

CHAPTER 6

AN AMERICAN SCHOOL

Two years after he came to London, Benjamin West persuaded Elizabeth Shewell to leave Philadelphia to marry him. In 1765 she arrived, accompanied by her cousin Matthew Pratt, who was to stay on after the wedding to enrol as West's first American student.[1] That same year Pratt undertook a large canvas showing himself and other pupils in West's studio, ambitiously titling it *The American School* (Plate 46). West is probably the younger figure dressed in green standing on the left, looking over the shoulder of Pratt (who was four years his senior) and giving him instruction. None of the other figures is securely identified, although the painter prominently shown in profile at the right may have been Abraham Delanoy, already established in New York and another of West's early students.[2] The fully modelled forms and the clear spatial organization are close to West's own compositions of this period. In the informality and graceful ease of the postures Pratt, like his teacher, carries the group portrait well beyond the seemingly stiff contrivances of its colonial precedents (compare Plates 27 and 33) to a new level of sophistication.

Among the most distinguished of West's visitors were John Trumbull and Gilbert Stuart. The former was born in Lebanon, Connecticut, in 1756; his father was governor of the state during and after the Revolution, and this background was to give him comfortable access to some of the major political personalities of the day. While at Harvard during the early 1770s, he visited Copley, and examined as well the paintings of Smibert and Blackburn. With the outbreak of hostilities he became an officer in the Continental Army and served briefly as Washington's aide-de-camp in Boston.

The unfolding events and emerging heroes of the Revolutionary War soon called for appropriate artistic record and interpretation. Trumbull's experiences on the battlefield and in the studio were to converge in establishing him as the pre-eminent painter of this period's most notable actions and its participants. In June 1775 he was stationed in Roxbury, where he was able to follow the Battle of Bunker Hill on the north side of Boston. This occasion provided the first subject of a series Trumbull was to devote to dramatic incidents in the War.

Acquaintance in Boston with the future consul general of Great Britain to the United States led Trumbull to plan a trip to England for study with West. Carrying a letter of introduction from Franklin, he set off via Paris for London in 1780. West's first wish was to see what sort of work Trumbull had done, and not having anything with him to show, Trumbull received instructions to 'go into that room, where you will find Mr. Stuart painting, and choose something to copy'.[3] Trumbull's success at copying and his further study under West were shortly interrupted by his arrest for alleged spying and eight months imprisonment in retaliation for Major André's hanging. Following this he returned to America and was variously occupied, including painting occasional portraits

and landscapes. With the signing of the Treaty of Paris, he determined once again to study with West and arrived in London early in 1784. This time he attended the school of the Royal Academy, and under the urging of both Jefferson and West, he now began his best-known series on national historic events.

The Death of General Warren at the Battle of Bunker's Hill, 17 June 1775 (Plate 47) was 'finished March 1786' in West's quarters. Its vivid touches of red, strong contrasts of light and dark, and the emphatic diagonal movements of the figures were directly indebted to the recently completed history pictures of West and Copley, most particularly the latter's *Death of Major Pierson* of 1784 (Tate Gallery, London). Trumbull also had West's *Battle of La Hogue* of 1778 (Metropolitan Museum, New York) in mind. Further, the mortally wounded figure of General Warren is based on the composition of *The Death of General Wolfe* (Plate 43) while the vigorous brushwork and the intense moral drama of life and death are in the spirit of *Death on the Pale Horse* (Plate 45), which was just beginning to occupy West's attention at this time.

The historian William Dunlap deprecated Trumbull's works in contrast to his models,[4] though the fact is that the American painter had successfully adapted West's techniques for the new national sentiments. He had drawn on the moral seriousness and clarity of West's earlier art; equally, he recognized the need for expressive romantic feeling, which was better satisfied through the vocabulary of the sublime. Indeed, Trumbull's art stands at an interesting transitional moment between eighteenth-century classicism and nineteenth-century romanticism, using a language of forms that looks at once backward and forward. In this regard, his painting is in the same spirit as the writing of the Declaration of Independence, with phrases such as 'Life, Liberty and Pursuit of Happiness' recalling past ideals while also announcing down-to-earth practicalities for the future. Similarly, the contemporaneous Federal style of American architecture was an intermediary manner between the refined and intellectual classicism of colonial Georgian and the solid, three-dimensional geometries of the coming neo-classical orders.

Actually, Trumbull's long life was itself divided almost equally across the two centuries. His forty-three years in the nineteenth were unevenly spent in working on versions of his history paintings and attempting portraiture.[5] The nineties saw Trumbull back in the United States, only to return to London in 1794 as John Jay's secretary. After the turn of the century, he continued to travel, facing increasing personal and professional difficulties. The ambivalences of style, resolved in his best early work, now seem to extend ironically into all his later affairs. The major financial and artistic commissions to paint murals for the new Capitol Rotunda in Washington went to him, yet the results were hollow and bombastic repetitions of earlier versions; he became president of the American Academy of Fine Arts, which was founded in 1802, only to become so dictatorial and conservative that its collapse was assured when the younger members resigned in 1825 to form the National Academy of Design. He did branch out into new activities, including the painting of several views done between 1806 and 1808 of Niagara Falls, which temper his other failures by forecasting the most significant subject matter for the next generation of American artists.

Some of Trumbull's instincts were also forward-looking. In December 1826 he wrote

to President John Quincy Adams 'to call the attention of the government to the fine arts', urging that eminent artists be called upon to record important national events. 'The history of the United States already abounds in admirable subjects for the pencil and the chisel,' he went on, implying that such subjects were more uplifting than foreign 'expensive mirrors and all the frivolous and perishable finery of fashionable up-holstery'.[6]

Trumbull's art both reported consciously the great actions and revealed unconsciously the underlying attitudes of his day. Gilbert Stuart's accomplishment was to record as faithfully and tellingly the faces of that period's principal personalities. His life was equally full of contradictions and countercurrents,[7] and his art moved from the formulas of academicism to the spontaneity of romantic naturalism. His father had emigrated from Scotland and operated a snuffmill near Newport, Rhode Island, where he was born in 1755. When he was fourteen the Scottish painter Cosmo Alexander arrived in New-port, bringing with him the latest style practised by Reynolds in London. Alexander gave Stuart some instruction, and in 1771 persuaded the youth's parents to permit him to embark on a painting trip, first to the southern colonies, then on to Alexander's native Edinburgh. In one of those unexpected turns of fortune which were thereafter to punc-tuate Stuart's life, his patron soon died, and the young man had a miserable time working his way home.

Back in Newport he painted a number of rather dry and stiff portraits in the colonial limner tradition, although his often flattened, tightly contained figures were softened by occasional luminous textures and colours. Just as his artistic aspirations were on the rise, the same circumstances that had driven Copley to London forced Stuart's hand. Portrait commissions were increasingly hard to come by, and his close friend Benjamin Water-house had recently departed for London. The Battle of Bunker Hill in June 1775 brought the war close, and now Stuart also decided to leave. Proud and determined at first in London, he soon became destitute and aimless. As Waterhouse later recalled, 'with Stuart it was either high tide or low tide. In London he would sometimes lay abed for weeks, waiting for the tide to lead him on to fortune.'[8] It came at last through a meeting he managed with West, following which Stuart humbly but self-pityingly peti-tioned the older artist for help.[9] Hard work and released talent soon made him West's principal assistant.

By 1780 Stuart had mastered the currently fashionable style of Georgian portraiture as exemplified by Gainsborough and Romney. His brushwork loosened and his palette lightened; self-confidently he presented his work at the annual exhibition of the Royal Academy in 1779. It was not long before he thought himself – and probably was – a better portrait painter than West. Stuart's first critical acclaim justifiably came with *The Skater* in 1782 (Plate 48), a portrait traditional in its derivation, but original in fulfilment. The picture portrayed William Grant of East Lothian, who had requested a full-length, the artist's first. The day set for the initial sitting was cold, as Stuart noted, better suited for skating than painting, and the two agreed to take a turn on the Serpentine, where West had drawn some notoriety skating several years before.

When artist and client returned to the studio, Stuart suggested the informal portrait

be set in a skating scene. He was familiar with a cast of the Apollo Belvedere in West's gallery, and now modified the figure for the pose of *The Skater*. The approach was one regularly preached by Reynolds and West, but Stuart has transformed his model with fresh imaginativeness and spontaneity. He has shown Grant at the pause in a turn, with the lively silhouette and spiralling axis of the body perfectly conveying the graceful motions of skating. In the background two figures walk to the bank, another pair leans over to tie on skates, while others turn in a group on the ice. Stuart thus unobtrusively sketches in the very sequence of activities he and his sitter had personally enjoyed. The colours of the painting are luminous greys and cool greens and blues appropriate to the season and setting. Yet this is not entirely a picture of physical movements or sensations. Stuart's use of a classical source for the figure's posture suggests that he sought to temper the real with the ideal, the immediate with the timeless, the active with the contemplative. Indeed, the precise, full modelling of Grant's thoughtful face serves as a culminating focus among the animating lines and forms in the rest of the picture.

Stuart was seldom comfortable painting full-length figures, and his best work was ordinarily in delineating faces (and the psychological presences they revealed) with sensitivity and unrivalled perception. *The Skater* made his reputation in London, but his quixotic, egotistical nature led him to excesses and to irresponsible behaviour. Finally, his self-indulgences brought his creditors down upon him, and he was forced to flee to Ireland in 1787. There, introductions to the wealthy and powerful brought him important new commissions, followed once again by an unfortunate pattern of extravagance and indebtedness. This time, after five years in and near Dublin, failures forced his return to America. Arriving in New York, he moved on to Philadelphia, with new resolve to paint President Washington, the equivalent of royalty in America. His artistic reputation in England had made him well known; to this he once more joined his remarkable powers of resilience, charm, and gaiety. (Were Dunlap's words a bit double-edged when he wrote of Stuart, 'His colloquial powers were of the first order, and made him the delight of all who were thrown in his way'[10]?) John Jay assisted in making the arrangements for a sitting with Washington, and in 1795 Stuart began his first life portrait of the President.

He painted three principal versions, and numerous copies of each were made in the studio over the following years. So popular did they become that they were referred to as Stuart's 'hundred dollar bills', and virtually from the moment of their execution these images defined a lasting national icon. The first painting Stuart completed was the Vaughn type, so called from one of the prominent subscribers for a copy. In bust-length format, this showed the right side of Washington's face in three-quarter view. The artist has caught in the President's features a suitable aura of calm intelligence and noble bearing. Its immediately enthusiastic reception brought Stuart a long list of orders and advance payments for copies, but as he proceeded to work on these, he lost his touch and interest.[11] Partly because of this and partly on the suggestion of one subscriber, in 1796 he sought a new sitting with Washington. This time he decided to paint the left side of his sitter's face, but the passage of a year had noticeably aged the President.

The *Athenaeum Portrait* (Plate 49) of Washington (named for its original owner) is a

deftly painted image; it and the companion canvas of Martha Washington remained intentionally unfinished so that the artist might keep them for making further replicas. With sure brushwork and colouring Stuart has built up the solid planes of the face, cast a strong light on the broad brow and firmly set cheek, and stressed the dark, strong glance of the eyes. It is this very directness of vision which lends the result such force and authority. Stuart's brushstrokes are most precise, and the colour most intense, around the eyes and nose, for these were the features he considered the most critical.[12] An area of opaque grey encircles the head, setting it off in relief, while looser-textured brushwork fills part of the remaining canvas with a sense of tone and mood. For the flesh tones Stuart employed complementary tints of blue and pink to enhance the sense of vibrancy. In fact, he cared much about the handling of colour. Once, arguing against West's use of arbitrary streaks of colour, he claimed that 'Nature does not colour in streaks. Look at my hand; see how the colours are mottled and mingled, yet all is clear as silver.'[13] Stuart was at his best, and he knew it, when he worked from nature, and he felt that the most convincing way of painting facial features was with pure tones overlaid and fused together. 'Good flesh colouring partook of all colours, not mixed, so as to be combined in one tint, but shining through each other, like the blood through the natural skin.'[14]

Technically, this helps to explain the triumph of this *Washington*, but artistically and spiritually it was more: a figure caught between myth and mortality, between ideal and real presence, between national symbol and burdened human being. Motivated by further requests from patrons and still elevated ambitions, Stuart went on to paint a third version, the Lansdowne type, with the President shown full-length in a posture adapted from French royal portraits and Roman imperial statuary. It is as if Stuart were seeking to peel away his sitter's identity through the actual act of sequential paintings; and the significance of his unfinished portraits lies not merely in practicality, but in a more profound intuition about the transience and mutability of human character.

This is nowhere more apparent than in the beautiful late portrait of *Mrs Perez Morton* (Plate 50), painted after the turn of the century when the fortunes of the artist seemed more uneven than ever. With the removal of the national capital from Philadelphia to Washington, Stuart gradually felt a decline in patronage and was himself impelled to follow in 1803. During this time he had met Sarah Wentworth Apthorp Morton, wife of a prominent Massachusetts politician, known for her poetry as the 'American Sappho'. She sat for him now as well as after both had moved to Boston. Her own past was filled with personal troubles, including a marital scandal involving her sister and her husband. For the first time Stuart was separated from his family, when he sent his wife and children on to New Jersey en route to Boston. An affair has been mooted between painter and poet; one feels even more concretely the ambience of sadness and poignance evoked by this canvas.[15]

The first version was more prosaic and finished, with Mrs Morton's arms folded across her waist. As circumstances drew them together, Stuart revealed in this subsequent image a tentativeness and irresolution, as much in his life as in hers. The colour is fresh and vibrant, the brushwork lively and suggestive. Mrs Morton appears to lift or lower – we cannot be sure – a veil over her head, responsive to Stuart's insight into feelings both

revealed and concealed. Surely more than physiognomy, these half defined features hint of love and loss, the creative sensibilities of sitter and seer, human possibility as well as frailty.

Sarah Morton touched on some of these feelings herself when she wrote:

> E'en me, by no enlivened grace array'd,
> Me, born to linger in affliction's shade,
> Hast thou, kind artist, with attraction drest,
> With all that Nature in my soul express'd.[16]

The canvas, though unfinished, could not be more complete. It stands as a telling image of the unstable tensions running through Stuart and through the larger events of American life in the Federalist era. Significantly, Stuart did not bring many of his later pictures to completion, and an improvisatory spirit is evident in all his best work. He was an artist in and of a transitional age, mirroring the self-confidence along with the search for identity that were his and the country's.

Another figure in West's circle and portraitist of the Federal period was Ralph Earl, perhaps the foremost painter among a group flourishing in Connecticut in the post-Revolutionary period. Born in western Massachusetts in 1751, he learned to paint early, although it is uncertain whether or not he had formal instruction.[17] On the eve of the Revolution he was established in New Haven, where he met the engraver Amos Doolittle. Together, they collaborated on painting and publishing some of the first scenes of Revolutionary events, including views of Concord and Lexington and the battles which occurred there. But Earl's sympathies were with the Tories, and when put in an increasingly embattled position, he was forced to sail for England in 1778.

Like Stuart and Trumbull in the same years, Earl made his way to West's rooms, and worked in England until 1785. Under the influence of West, and less directly of Reynolds, Gainsborough, and Romney, his manner of painting evolved gradually out of its early stiffness and rugged simplicity into a more colourful and decorative style. When he returned to America with his second wife in the spring of 1785, he settled in New York for a few years to paint some of the notable participants in the Revolutionary War. In the late eighties and during the nineties he was active painting numerous portraits of eminent Connecticut citizens. In Windsor he completed one of his few group portraits and one of his finest works, *Chief Justice and Mrs Oliver Ellsworth* (Plate 51).

Ellsworth had a distinguished career both during the Revolutionary War and in the national government afterward.[18] The large size of the canvas and the well furnished interior intimate something of this impressive personality, but his further interests in agriculture are indicated by the sweeping landscape out of the window. Earl also calls our attention to other significant biographical details. Ellsworth and his wife are sitting in the room where they had previously received a visit from General Washington, and their handsome house is shown again on the distant hillside. Of equal importance is the copy of the Constitution prominently held by Ellsworth, signifying his participation in the drafting of that document. Earl's painting confidently informs us that a new age of ambition and achievement has arrived. The forthright touches in rendering textures

of drapery and clothing and in modelling the faces fully with light reflect Earl's tutoring in the English school; yet he still retains a distinctively American sense in the colourful patterning and emphatic linearism in the treatment of rug, bookcase, and landscape.

At the same time as Earl, a sizable number of portraitists were working in this mode throughout central Connecticut, among them Reuben Moultrop, John Brewster, Joseph Steward, and William Jennys.[19] Generally, they shared a preference for placing the figure in a room lined with books, decorative wallpaper, tablecloth, or rug, and a window or doorway view to one side. The drawing tends to be tight, the patterns of clear colour flat, and the total effect one of directness. Characteristic of the Connecticut school is the portrait of the *Reverend Ebenezer Devotion* of 1770 (Plate 52) by Winthrop Chandler, a native of Woodstock. This and its companion painting of the minister's wife were the artist's first known commissions, undertaken at the age of twenty-three. Both in the austere modelling and in the almost abstract arrangement of books the portrait conveys an apt image of order, thoughtfulness, and piety. Although Chandler was active for over a decade more, he was 'poor, and diseased, insolvent' at his death in 1790.[20]

This decorative instinct is also an appealing element in the style of Joshua Johnston, born in 1765 of West Indian and Negro ancestry. Active in Baltimore during the last decade of the eighteenth century and the first quarter of the nineteenth, he may have had some instruction from Charles Willson Peale, as his works bear definite resemblances to those by several of the Peales (see Plates 56 and 58).[21] Whether painting single bust-lengths or full figures in group compositions, Johnston showed a special ability for expressive linear design and rather wistful faces in most of his sitters. This is true of *The Westwood Children* of 1807 (Plate 53), a picture of touching charm with the slightly over-sized heads, whimsical stares, and amusing dog. Typically, Johnston leaves his background for the most part empty; he relies on ordering and varying his format through the play of silhouetted forms, repeated shapes, or simple asymmetries in the placing of figures and in the definition of interior space. This particular canvas is both a perceptive record of youth and an interesting indicator of the well-to-do circles in which the artist moved. His art, along with that of Earl and the Connecticut group, stands as a lively link between earlier colonial portraiture and the full flourishing of the indigenous folk tradition (see Plates 10 and 114) during the first quarter of the nineteenth century.

CHAPTER 7

FEDERAL IMAGES

FASHIONED at the same time as Johnston's painting was William Rush's pair of pine carvings, *Comedy* and *Tragedy* (Plate 54). American painting was not alone in arriving at a new level of variety, richness, and informality by the beginning of the nineteenth century; sculpture had also grown beyond its colonial limitations of function and necessity. Even the form of gravestones was changing from the earlier simple flatness to new three-dimensional geometric masses. Carvers were active, of course, during much of the eighteenth century in embellishing furniture and architecture, and producing occasional shop signs or ship's figureheads. In Boston members of the Skillin family were the dominant artisans during the latter half of the century. As we might expect, their figures were often inspired by the delicate classicism of illustrations in contemporary furniture manuals.[1]

Both the elegance and the naturalism of Rush's figures are part of the spirit which, as we have seen, informs the style of painting in the Federal era, as well as its graceful architecture by Charles Bulfinch and Samuel McIntire. Like his contemporaries, Rush expectedly retains an awareness of his engraved sources – these wooden personifications are not carved fully in the round, and their surfaces are busy with convoluted linear designs. But the lightness and grace of his forms in turn come from their conscious attenuation and the use of proportion, so much a part of all the arts in this period. Rush was almost the exact age of Stuart, Trumbull, and Earl. His father taught him wood carving in Philadelphia. After a further apprenticeship and service in the Revolutionary War, he established himself in subsequent years as the leading figurehead carver of the area. In later life he also worked in plaster and terracotta; whether carving or modelling, he possessed a sure understanding of three-dimensional form. His sensibility is evident in these wood figures, prepared for niches in the façade of a Philadelphia theatre by Benjamin Latrobe.[2]

Rush often carved his allegorical figures from live models, thus again fusing those familiar polarities in Federal art of the ideal and the immediate, the symbolic and the personal. To be admired as well is his mastery of technique and material, to a point, for example, where the bend of a knee, an elbow, or a crease of drapery, is coincident with a knot or turn in the grain of wood. Whether carving Hercules, Virtue, Schuylkill Freed, or George Washington, Rush exhibited an elegance and polish that glossed both the outer manner and inner life of the young American republic.

The features of American art during the Federal period were delineated in individuals as much as in their environment. Henry Sargent's paired paintings in the Museum of Fine Arts, Boston, of *The Tea Party* and *The Dinner Party* (Plate 55) were executed in the 1820s, but display interiors of the turn of the century, when Boston architecture favoured the slender, chaste lines of the English Adam style. In fact, the rooms Sargent shows

could well be ones in Bulfinch's recently erected Tontine Crescent.[3] Both Bulfinch and Sargent were very young at the outbreak of the War, and made their respective tours to England in its aftermath. Sargent was a native of Gloucester, Massachusetts, and following four years' study with West and Copley in London in the 1790s, he returned to Boston to carry on both political and artistic careers.

The strong illusionistic space and clear balancing of light and dark planes in *The Dinner Party* owe as much to contemporary architectural taste as to Sargent's admitted borrowing from a popular French neo-classical painting of *The Capuchin Chapel* (Metropolitan Museum, New York) by François Granet. Sargent was also known for his more ambitious historical canvases in the manner of West, but it was in pictures like *The Dinner Party* ('a specimen of the extraordinary power of light and shade,' wrote Dunlap[4]) that he most successfully mirrored contemporary taste and manners.

The artist, however, who best embodies this early period of the young nation is Charles Willson Peale of Maryland. Like his contemporaries Franklin and Jefferson, he was an individual of many talents – painter, patriot, inventor, naturalist, and museum founder – a personification of the Age of Enlightenment in a new place and time. He headed a remarkable family which itself became a dynasty of talented artists and scientists. Appropriately, his own children bore the names of Raphaelle, Angelica Kauffmann, Rembrandt, Titian, and Rubens, by his first wife; and Linnaeus and Franklin, by his second; names given less out of presumption than an ardent sense of expectation and promise. Peale's birth in Queen Annes County in 1741 was the beginning of a long life marked by that rare blend of the thinker and the doer. Generous in his manner, he saw into the lives of others close to him with unmatched insight and devotion. In the same summer as the Declaration of Independence John Adams visited Peale's studio, and described some of these facets of the painter: 'He is ingenious. He has vanity, loves finery, wears a sword, gold lace, speaks French, is capable of friendship, and strong family attachments and natural affections.'[5]

As a youth Peale was apprenticed in the saddler's business, but very early, he later recounted, 'the idea of making Pictures [had] taken possession of his mind'.[6] From John Hesselius at nearby Bellefield plantation he received some instruction in 1763, and in the same year advertised as a sign painter. Two years later he sailed to Boston, where he saw Smibert's paintings and paid a visit to Copley; in 1766 with letters of introduction he left for England and two years of study with West. Unlike many of his contemporaries, time abroad made Peale all the more anxious to return home. Settled in Maryland, his family and his career began to flourish. Among his favourite portrait subjects was the family group, and of the many he painted in these years none was more harmonious in substance and design than the canvas he completed in 1773 of his own family (New-York Historical Society, New York). Characteristically, Peale arranged his group around the wife and youngest child, and brought together several generations in a picture of domestic felicity. In this and other paintings to come he included references to the family's artistic life, with statues or paintings shown in the background, a carefully composed still life on the table, or one of the figures holding painter's tools in hand.

Throughout his career Peale's greatest works are portraits of his family as artists, and

as such are really about the nature of art itself. The first masterpiece of his mature career is *The Staircase Group* of 1795 (Plate 56), which compares with the illusionism of Sargent's *Dinner Party* but ultimately is more stunning as a *trompe l'œil* in its own right. This lifesize portrait of his two sons (Raphaelle with palette in hand ascending the stairs and Titian above turning to look down) was mounted with a real step at the bottom to extend the illusion into the viewer's space. But it is more than a picture of marvellous visual magic, for in its very calling of our attention to its optical accomplishments it stresses its subject as art and its maker as artist. The play between the real and the illusory is part of other balances Peale sets up in this picture, between informal poses and formal structure, diagonals crossing one another, palpable presence of the youths and implied presence of the spectator. By signing his name on the painted calling card on the lower step, the artist makes this both portraiture and personal history, both genre painting and a figural still life.

It is this new inventiveness and imagination that Peale brings to traditional forms of painting that so enliven the course of American art at this point. Yet one might well argue that a continuing characteristic of American artists is this penchant for original subjects or unexpected compositions, as is also evident in the work of Copley, Stuart, and John Neagle (see, for example, Plates 39, 48, and 77).

That Peale identified his life and art with one another, and in turn his own aspirations with those of the nation, may be seen in another remarkable picture, the *Exhumation of the Mastodon* of 1806 (Plate 57). In part, this was a pictorial account of his many years' engagement in establishing a museum of natural history and fine arts. As early as 1782 Peale had contemplated an addition to his house for the exhibition of portraits of national figures; within the next couple of years he had borrowed a collection of excavated bones and made life-sized drawings of them. As Trumbull had seen, the founding of the new republic stimulated a need for a national history and art. By 1786 Peale had conceived of his museum, which was to be a 'great school of nature . . . to bring into one view a world in miniature'.[7]

In 1790 Peale published a broadside *To the Citizens of the United States of America*, announcing his hopes for the museum and soliciting support. A few years later his galleries had so expanded that he negotiated moving the exhibitions to Philosophical Hall. The next step was the formation in 1794 of the Columbianum, a related Academy of Fine Arts, the antecedent of today's Pennsylvania Academy of the Fine Arts. The culmination of Peale's efforts came with another move in 1802 to the upper quarters of Independence Hall, in whose revered chambers past and future history might at last be fused.

Concurrently with all these activities ran Peale's relentless impulse to collect suitable pictures and artifacts for exhibition. Early in 1800 he saw the first news announcement of the excavation of some giant bones in upstate New York. The event excited his interest; it might yield a potentially major centrepiece for his natural history collections. He hastened to book passage up the Hudson to Newburgh, sketching the hilly scenery with enthusiasm. After some negotiation with John Masten, who owned the farm where the skeleton fragments were found, he acquired the bones and sent them back to his

museum. Subsequent digging on nearby property also turned up two other partial skeletons of 'the great unknown'. It is a composite of these activities, along with the portraits of additional relatives, friends, and distinguished scientists, that Peale depicts in the *Exhumation of the Mastodon*.

Appropriately enough, the great contrivance of wooden tripod and buckets to excavate the muddy hole occupies the centre of the canvas. Although President Jefferson offered the assistance of equipment from the military, the undertaking expresses foremost Peale's ingenuity and inventiveness. Beginning his picture in 1806, he continued to add portraits for another two years, until the composition included nearly seventy-five figures, of whom almost two dozen were identifiable. In the immediate foreground the farmer Masten climbs from the pit to look back at Peale, who stands prominently with his family in the right foreground. Peale holds up a large drawing of the mammoth's thighbone and points towards the real thing; he stands before us as both artist and scientist. (On the other side of the machinery the naturalist Alexander Wilson watches with arms crossed.) A thunderstorm threatens in the background, calling our attention to nature's dramatic voice in this occasion, though the artist is also referring to his fortune that it did not rain during his efforts to empty the swamp. The various activities of the remaining figures make this, in addition, an early example of American genre painting. Thus Peale has succeeded in imaginatively bringing together the various branches of painting. While making history, he has also recorded it.

Jefferson wrote his congratulations to Peale

on the prospect . . . of obtaining a complete skeleton of the great incognitum, and the world on there being a person at the critical moment of the discovery who has zeal enough to devote himself to the recovery of these great animal monuments.[8]

Meanwhile, in the firm belief that the New World had a natural history estimable in its own right, fragments of the second skeleton were assembled for a tour through Europe to be managed by Peale's son Rembrandt. The entire enterprise characteristically intertwined patriotic goals and personal history.

Although in later years Peale's administrative activities increasingly preoccupied him, he did complete some portraits of great strength and feeling. The best of these were of figures who, like the artist, had gained new vitality in old age. One almost senses a bond between sitter and painter reflected in the features of *Yarrow Mamout* (1819) (Plate 58), so direct is the glance, so warm and wise the expression. Mamout was reputedly one hundred and thirty-four years old and known as Billy Lee, onetime servant to Washington. A Mohammedan who lived in Georgetown, he was described by Peale as 'healthy, active and very full of fun'.[9] The predominant colours of this canvas are dark greens and browns, and the lighting is mellow, both so fitting for capturing the resonance of age.

Peale's self portrait in *The Artist in his Museum* (1822) (Plate 59) is even more an image of self-possession. The full-length picture was commissioned by the trustees of his museum, and the artist thought of it as 'a lasting monument of my art as a painter', which would express his efforts at bringing 'into public view the beauties of nature and art'.[10] He stands before us, positioned between his museum gallery and his audience, one

hand lifting the curtain on his past life's work, the other welcoming us as present and future spectators. Nearby are the emblems of his interests: a stuffed bird and taxidermist's tools at the left, bones of the mammoth and artist's palette at the right; both the objects for collection and the means of interpretation are present. In the background, rows of portraits and cases of birds fill the Long Room of Independence Hall. Visitors respond with a variety of reactions: one man studies the birds thoughtfully, another explains the exhibits to his son, and the woman raises her arms in a gesture of astonishment at the mammoth skeleton.

Preparatory to this picture Peale began a careful watercolour study of the Long Room, which was finished by his son Titian.[11] He also made some smaller oil studies in bust-length format, primarily to experiment with the lighting effects. He explained to Jefferson,

The light I have chosen for my portrait is novel, and before I made a beginning of the large picture, I made a trial on a small canvas to know if I could make the likeness sufficiently striking. My back is towards the light, so that there is no direct light except on my bald pate, the whole face being in a reflected light.[12]

The results are innovative, technically and conceptually. But above all Peale's image of the artist is an embodiment of the American traits of idealism and practicality.

In the same year he completed the portrait of his brother, *James Peale* (' *The Lamplight Portrait*') (Plate 60). The smaller size of the canvas and the dark, ruddy tonalities suggest a mood of intimacy and introspection. The sitter had also led an accomplished life as a painter and patriot, and both aspects are noted here. On the lampshade Peale listed the battles of the Revolutionary War in which his brother had served, while under the glow of light James studies a miniature painted by his daughter Anna of Rembrandt Peale's daughter Rosalba, who was in turn just beginning her own artistic studies.[13] Thus, in a subtle and touching way Peale alludes to the creative life of his family across three branches and over three generations. The miniaturist's palette on the desk once more joins the painter to his picture in that now familiar linking of thought and action. The lighting in this canvas shows Peale at his most unusual and original. Yet this virtuosity is fully in the service of conveying his brother's self-absorption in art. As such, it is both an affectionate fraternal tribute and a quiet celebration of the life of painting.

After his death in 1827, Peale's children continued many of his activities, in painting, running the museum, and natural science. Of those pursuing artistic careers, several were especially successful in painting portraits, still lifes, and deception pieces. Rembrandt, who was born in 1778, was among his father's favourite pupils, and actually influenced the elder's painting techniques in his later years. During his tour of Europe with the mastodon bones he came to know West in London and the French neo-classicists in Paris. His establishment in 1814 of the Peale Museum in Baltimore carried on another of his father's interests in that city. As a painter he was best as a portraitist, and made much of the porthole formula for his version of Washington. His own *Self Portrait* of 1828 (Plate 61) has the thoughtful glance, soft textures, and glowing light which had characterized his father's picture of James Peale. He made numerous other portraits of himself,

including one by candlelight, an indication of that strong Peale tradition of forthrightly examining oneself as well as others.

Rembrandt's cousin, Margaretta Angelica Peale, was taught to paint by her father James. In contrast to the prolific Rembrandt, who had three sets of twins among his ten children, Margaretta and two of her sisters never married. But her artistic interests were typical of the family; one of her paintings was a *trompe l'œil* depicting the catalogue of Peale's Museum. Her *Still Life* (Plate 62) exemplified the many variations of this subject painted by her relations in the 1820s. Refined and carefully balanced, highly conscious of contrasting surfaces and near-geometric forms, these delicate and often elegant compositions reveal the essence of the Federal style. Even the sense of systematic order belongs to the same philosophic world expressed in the educational structure of Jefferson's University of Virginia, the architectural masses of Bulfinch's state houses, or the political checks and balances of the United States Constitution.

Raphaelle Peale was also a painter of still lifes in this same manner, with foods and flowers shown at their purest and freshest. The tables on which these spare arrangements appear are pushed forward to allow us no view below or around them: we are forced to concentrate on the formal composition itself, a reminder that in still life we have an artist's most abstract subject matter. Artifice for its own sake is evident first in the arranging of a still life and secondly in the painting of it. Peale brought together his concerns with still-life composition and with illusionistic deception in his *tour de force*, *After the Bath* of 1823 (Plate 63). It was characteristic of him to have originated this design as a practical joke on his prudish wife, who was supposed to have been fooled into believing that Raphaelle had hung a real linen cloth across a presumably indecent subject. It was like the story that Washington had been momentarily deceived when he passed by *The Staircase Group*; such anecdotes are more revealing for their artistic than their historical truth.[14]

Raphaelle appears to have been playing constantly, both in comic and serious ways, with the perception of his images. In another instance he advertised under still-life subjects that he could paint portraits of the deceased.[15] It is an irony that a painter so noted for the rendering of food and fruit arrangements should have suffered terribly from gout. Nonetheless, beyond the whimsy and cleverness is a serious fascination with both realism and abstraction that makes *After the Bath* particularly appealing to modern eyes.

Charles Bird King was a still-life painter outside the Peale dynasty, but his pictures were often equally ironic and autobiographical. Born in Newport, Rhode Island, in 1785, he was eleven years younger than Raphaelle Peale, and much longer-lived. About 1800 he studied with Edward Savage in New York, and from 1805 to 1812 with West in London, where he also struck up close friendships with Washington Allston and Thomas Sully. Later he painted in various cities along the mid-Atlantic coast, usually returning to Newport for the summers. He settled in Washington during his later years, and on several occasions painted vivid portraits of Indians visiting the capital. He tended to treat these portraits as enlarged figural still lifes, and it was in this latter subject that he was most inventive.

One of his finest compositions is *The Poor Artist's Cupboard* of about 1815 (Plate 64),

which is a theme he, like Peale, later varied. It is filled with inner meanings and partially concealed allusions to his own career and to the life of art generally. By enclosing the shelf with a shallow niche, King is able to amplify the traditional table-top arrangement. His composition intentionally hovers between chaos and order, just as the objects suggest possibility and frustration, and the lighting reveals as much as it hides. Peculiar to King's style are the strong contrasts of light and dark, the ambiguous background space, and the rich play of shapes, textures, and edges. Cluttered here are mementos of a painter's struggles: a sheriff's notice of sale of an artist's property, an open book called the *Advantages of Poverty*, another nearby on the *Pleasures of Hope* torn through its title, the humble loaf of bread and glass of water. Other volumes or scraps refer to vanity, criticism, and philosophy, even artistic commissions which King lost to his competitors.[16] On this shelf, as on the doors, tables, bookcases, and letter racks that William M. Harnett and John F. Peto later painted (see Plates 171 and 172), lie the fragments of an artist's dreams, whether tattered or whole, imaginary or tangible, attained or unattainable.

This generation of artists, with the Peales taking a central role, greatly expanded the possibilities for art in America. Their high technical competence and distinctive imaginativeness opened up new subjects for artists to paint, and treated familiar categories with fresh ingenuity. For the most part they chose a decisively different course from their colonial predecessors; although they went abroad for study, their careers developed and frequently flourished in America. We have underestimated their concern for art and for their country. To both they brought old ideals and new informality. In so doing, they spoke with a clear sense of self, place, and time.

CHAPTER 8

THE GRAND TOUR

JOHN VANDERLYN and Washington Allston are often, and appropriately, discussed together. Both were born during the American Revolution (Vanderlyn in Kingston, New York, in 1774; Allston in Georgetown County, South Carolina, four years later). As near-contemporaries, they grew up with national memories of the war and attainment of independence still fresh, but they had not participated in these great events at first hand; their generation rather viewed them with the nostalgia and romanticism of retrospection.[1] At the beginning of their careers both men went to Europe for study, joining one another in Paris, and each later passing time at work in Italy.

There does not appear to be one precise moment at which study in Europe became de rigueur for American artists. Copley and West, of course, had considered it necessary in the later eighteenth century to further their careers abroad. Now a younger generation felt a similar pull, although Peale returned after a short while, and Allston left England despite great success abroad and the fervent urgings of his English colleagues to remain. Later Thomas Cole and several of his followers in the Hudson River School repeated variations of the Grand Tour, but as national sentiment became more self-confident during the first half of the nineteenth century, others like William Sidney Mount determinedly remained at home to paint. With the crises of the Civil War, technological expansion, and a new internationalism in American affairs after the mid-century, another wave of artists that included Sargent and Whistler left for study or careers abroad. For each generation, however, the lure of Europe often involved mixed sentiments – to seek advancement in foreign academies and in a long tradition of art non-existent at home, while also remaining faithful to one's national impulses and aspirations.

Vanderlyn is of singular interest because he was the first major American artist to go to Paris for study and thus to break from the influential tradition of history painting established by West in London. Perhaps Vanderlyn and Allston are too readily categorized as the respective American exemplars of the emerging neo-classical and romantic movements. It is true that Vanderlyn adopted the prevailing modes of neo-classical painting as practised by David and Ingres, but, like the latter, Vanderlyn presided over the romanticizing of pure classicism.

He was the grandson of Pieter Vanderlyn, the Dutch patroon painter (see Plate 17) in the Albany area in the seventeen-twenties and thirties. His own interest in art emerged early. When he was fourteen, he made drawings after Dutch prints, and two years later he filled a carefully composed 'Drawing Book' with figure studies after Le Brun.[2] Thereafter, his artistic education accelerated, first with an apprenticeship to Thomas Barrow, an art dealer in New York, then with classes at the Columbian Academy of Painting, and finally, in 1795, with an assistantship to Gilbert Stuart in Philadelphia for a year.

The association with Stuart came about because he had left two of his portraits at Barrow's for framing, and Vanderlyn had requested permission to copy them. His version of Aaron Burr's portrait was sufficiently good to gain the sitter's admiration and further patronage, including the backing for Vanderlyn to go to Paris in 1796 for additional study. During the next four years he worked in the studio of François-André Vincent and looked profitably at the old masters in the Louvre. Together they provided Vanderlyn with a solid initiation in classical forms and discipline.

His first major picture, the *Death of Jane McCrea* of 1804 (Plate 65), owes much to the prevailing French manner; for example, fresh in Vanderlyn's mind must have been such recently influential works as David's *Oath of the Horatii* of 1785 and *The Battle of the Sabines* of 1795, along with *Achilles and the Ambassadors of Agamemnon* by Ingres, which had brought him the coveted Prix de Rome in 1801. Like his French contemporaries, Vanderlyn alluded to antique statuary for his figures and grouped them parallel to the foreground edge. The clear outlining and the generally balanced format further suggest the more distant sources of Greek pedimental sculpture and vase painting. Also present is an awareness of Poussin's classical Baroque compositions, from which David consciously borrowed and which Vanderlyn copied as well. The screen of trees especially seems to derive from Poussin.

The subject of the painting was drawn from recent history, in the modern manner of both West and David. The immediate impetus had come from Joel Barlow, who had commissioned the painter to illustrate his epic poem, the *Columbiad*, about the discovery and founding of America. In ambitious Miltonic couplets Barlow described the incident during the Revolutionary War when Miss McCrea was shot and scalped while on her way to marry an officer serving under General Burgoyne. Since Indians were then in Burgoyne's employ as his army was moving south, the massacre soon became the symbol of anti-Tory sentiment and other moralistic propaganda. Here in vivid reality was the confrontation of civilization and barbarism, virtue and evil, innocence and brutality.[3]

> They seize her hands and thro her face divine
> Drive the descending ax . . .[4]

The message was clear, and it was now a function of art to act as a critical voice for moral and patriotic conduct.

It is significant that Vanderlyn did not choose a moment of heroic action, such as David's Heraclia stepping forward to separate the warring Romans and Sabines, or the sons of Horace joining in a commitment of sacrifice and fraternity; or the noble deaths of leaders painted by West and Trumbull. Clearly the appeal here is more to the emotions than to the intellect. A sense of near-melodrama is borne out by the expressive role of colour and lighting, the tensions of gestures and musculature, the strong diagonal forms which challenge the basic classical schema, the would-be rescuer running in the distance, and the mysterious brooding aura of the darkened woods. It is Vanderlyn's achievement to have transformed the neo-classical precedents of French painting to suit the romantic needs of American history in the making.

He carried the implications of this solution a step further in *Marius amid the Ruins of Carthage* (Plate 66), painted three years later. Again he assembled both classical and romantic elements, but in a new combination that gave stronger emphasis to the tragic feelings of loss and the poignance of failure. Quite distinct from his preceding work was the lack of movement and action. Now, as the artist himself wrote, 'C. Marius [is] sitting on the ruins of Carthagena, in sombre melancholy, reflecting the mutability of Fortune.'[5] The real subject was to be essentially one of thought and idea. Marius in defeat has fled to Africa, where he pauses to contemplate his misfortune. His brooding visage is accompanied by threatening storm clouds in the background, the blood-red toga which dominates the foreground, and ruins all around. Indeed, Vanderlyn confirmed his intention to associate fallen man with fallen civilization:

I thought that subject a picturesque one on account of the ruins which might be properly introduced in the background . . . the man and position combined, was capable of showing in two great instances the instability of human grandeur – a city in ruins and a fallen general.[6]

Prior to painting this picture in Rome, Vanderlyn had returned for a short time to the United States between 1801 and 1803, when he renewed his friendship with Burr. Once back in Italy, Vanderlyn heard the tragic sequence of events that overtook his patron: the mortal duel with Hamilton in 1804, Burr's farewell to the Senate the following year, and in 1807 his trial for treason. There is good reason to believe that the painter had in mind this more immediate history of power turned to ashes as he composed his canvas.[7] Vanderlyn modified other classical rules in his interpretation of the theme. For example, he borrowed from a number of disparate sources: the posture of Marius is based on a statue of Mercury at Pompeii, and visible in the background are portions of the Parthenon, the Villa of Hadrian, and the Claudian aqueduct from, of course, different sites in Greece and Italy. Even the frontality of Marius is tempered by the draperies sweeping across his body and by his asymmetrical position in the landscape.

The picture established Vanderlyn's reputation in France. Out of some twelve hundred entries in an exhibition at the Louvre, the *Marius* gained the gold medal from Napoleon, who also sought to acquire it for the state. At the same time, Vanderlyn, now back in Paris, worked on a copy of Correggio's *Antiope* in the Louvre, said to have been favourably judged by his peers.[8] It in turn suggested to him the subject of his next important canvas, *Ariadne asleep on the Island of Naxos* (Plate 67), begun in 1809 and finished three years later, although dated 1814.[9]

He asserted that his intention was to paint 'female beauty', a sort of companion piece to 'the strongest, most masculine characteristics' of the *Marius*.[10] From Correggio came the figure's reclining position and raised arm, as well as the warm light caressing the flesh. Although horizontal in format, the picture continues from *Marius* the distant view into a landscape at the right, the dark red drapery on which Ariadne reclines, and the overall mood of contemplation. Vanderlyn seems to have been conscious of such Renaissance prototypes as Giorgione's *Sleeping Venus* (Dresden, Gemäldegalerie) and Titian's *Venus of Urbino* (Florence, Uffizi). In fact, the rich colourism of this work is probably owed foremost to Vanderlyn's scrutiny of works at hand in Paris by Titian

and Correggio. Nonetheless, his American background seems to assert itself, almost unintentionally, in the pristine landscape setting with its blooming wild flowers crisply delineated in the foreground.

At this point Vanderlyn hoped that he might find popular acceptance and patronage for his type of history painting at home. Returning in 1815, he undertook during the next few years the painting of enormous panoramas of the *Palace and Gardens at Versailles* (Metropolitan Museum, New York), which he exhibited in a specially constructed rotunda in New York. While panoramic paintings were to become increasingly popular during the next decades, large-scale views of landscape appealing to a later generation, Vanderlyn's efforts seemed out of step with his time. His ventures into grand history painting did not suit the changed tastes in America for local scenery, and his later years were increasingly marked by controversy, frustration, and failure.

He fought with Trumbull over commissions to decorate the national Capitol, and finally won the opportunity to work on a large *Landing of Columbus* in 1838; but for the most part it was a dry and contrived work, and sadly anachronistic. Critics of the day called rather for 'views of our battles, such as Chippewa, Erie, New Orleans, Lake Champlain . . .' as not only 'highly national and popular, but exceedingly profitable'.[11] Difficult and combative, Vanderlyn alienated fellow artists, and was advised to 'imbibe daily a reasonable quantity of strong beer'.[12] Even so, in his later years he did have the vision to propose a National Gallery of Art. And he continued to work on versions of views begun long before of *Niagara Falls*.

He made his first visit to the Falls in 1801, and during the next couple of years worked on paintings to be taken to London for engraving. He revisited Niagara again in the late twenties and thirties, and produced a number of views attractive for their first-hand freshness and directness. The final canvas in the series (Plate 68) was apparently not finished until 1842–3. It is a large-scale work which retains some of the sweep and power of the smaller studies done on the spot, but is also overlaid with certain obvious didactic details. A farmer with his cart to the left and a pair of Indians in the right foreground indicate men living in harmony with each other, while the village to the right sits at the edge of the falls, emblematic of the balance achieved between civilization and nature. Rising out of the foreground is a great dead tree with a raven perched against the sky, but it is surrounded with the lush greenery of new young shoots. Perhaps unknowingly, Vanderlyn had articulated the language of natural regeneration which in these same years had become triumphant in the hands of younger painters in the Hudson River School.

Vanderlyn's colleague, Washington Allston, came north from his native South Carolina as a youth, his interest in art already stimulated. In Newport he met the painters Samuel King and Edward Greene Malbone, and at Harvard in the late 1790s he cultivated an ability for sketching. As an undergraduate he was equally impressed with the classics and contemporary Romantic literature. In 1801 he sailed for England, where his artistic education culminated with two years' study under Benjamin West. Then with Vanderlyn he set off for Paris, where in the Louvre his own tastes led him, not yet

to the Venetians, but to the dramatic seascapes and shipwrecks of the eighteenth-century painter Joseph Vernet. If he owed the subject of an important early work, *Rising of a Thunderstorm at Sea* (1804) (Plate 69), to Vernet, its grandeur and visionary sublimity also reflected the imprint of paintings he had known previously in London by Salvator Rosa, Fuseli, and West.

The small vessel in the foreground tosses on the crest of a foaming wave, caught in the midst of the sweeping cross-currents of water and clouds. The vastness and emptiness of the ocean, save for one other distant vessel, pictorially express the theories of Edmund Burke as they would have been interpreted to Allston by his teacher West. Man is made to feel insignificant before the infinite power of nature, yet this is not an image of threatening terror, for a clearing sky is evident overhead and on the horizon. In short, life is an adventure, man must rely on his will and faith, nature is an awesome presence but full of promise. Unlike West, Allston draws on no specific literary or historical framework for his picture; while a moral content remains implicit, meaning is now transmitted primarily through the mood of nature rather than the actions of history.

It is this transformation that has confirmed Allston's place at the beginning of the Romantic movement in American art. In 1804 he left Paris for Rome, travelling into Italy across the Alps. This proved an indelible experience, and Allston merged actuality and memory in several related oils begun at this time. One of the largest and most characteristic was the luminous *Diana in the Chase* of 1805 (Plate 70). Baroque drama and Rococo delicacy still linger in this work, but one feels that the classical figures and their activities in the foreground are fully subordinated to the rich landscape itself. Allston gives us nature full of contrasts: rough and smooth textures, crisp details and broad masses, dense pockets of shadow and glowing areas of transparent light. Allston's allusions to the past were but excuses for lyrical meditation on nature's magnificence. It had struck a responsive chord in his soul, and increasingly he summoned light and colour to express his feelings in paint. In Rome he was drawn to friendships with Washington Irving and Samuel Taylor Coleridge, whose imaginative and romantic temperaments reinforced his own.

Irving described how they wandered around Rome together, enjoying the landscape and examining works of art with enthusiasm: 'His eyes would dilate; his pale countenance would flush; he would breathe quick and almost gasp in expressing his feelings when excited by an object of grandeur and sublimity.'[13] Although he sailed from Italy for America in 1808, his experience in Rome left a strong mark on his style. Back in Boston he painted recollections of scenery in the Alps and along the Mediterranean shore, all suffused with glowing light and colour appropriate to their lyrical mood. Portraits of his family also done in this period similarly possessed a poetic and introspective character. In 1811 he left for a second stay in England, this one lasting seven years. It was a period of mixed fortunes. He revived his friendship with Coleridge and met Wordsworth; and he began a number of major religious and historical canvases, now closer to the manner of West.

Allston seemed most comfortable when he could adapt historical drama to a landscape setting, as in the *Elijah in the Desert* of 1818 (Plate 71). West was himself then

working on pictures of Christ healing and the raising of Lazarus, probably Allston's immediate inspiration, but his biblical subject matter becomes fused with the larger power of a rugged landscape. In part the painting belongs in a context of melancholy arising from his wife's death three years before. Its mood of isolation and solitude was an extension of Allston's innermost feelings. Likewise, in his portraits of Coleridge and West he enveloped the sitter with an aura of mysterious sadness.

Technically, the canvas reveals Allston's mature handling of colour glazing, a method he had developed from successive examinations of Venetian painting. By means of underpainting and layers of varnish he was able to create a luminous transparency through his colours that often suggested light glowing from within. In this instance he said he mixed his colours with skim milk and completed the painting within three weeks.[14] Returning to Boston (to the distress of his English friends) shortly after its completion, Allston brought his colouristic ideas to fulfilment in one of his most beautiful and serene works, the *Moonlit Landscape* of 1819 (Plate 72). Now his reverie on experience, recollection, and imagination fused completely the outlines of an Italian town with the animating presence of the moon. Light, both poetic and tangible, from its dominant position pervades the entire composition.

The moon and its reflection form a central vertical axis linking together the various horizontal zones of landscape receding into the distance. Both structurally and thematically, then, the design is harmonious. Twenty years later the Transcendentalist Margaret Fuller sympathetically understood Allston's achievement when she wrote, 'The calm and meditative cast of these pictures, the ideal beauty that shone *through* rather than *in* them, and the harmony of coloring were unlike anything else I saw.'[15] Allston himself lectured on the need for unity of composition and idea through 'one of the mightiest ministers of the Imagination, – the great Law of Harmony'.[16] Of all his paintings, this one, with its implied union of man and nature and of outer world and inner spirit, had a special appeal to the coming generation. On exhibition in Boston during Allston's later years, it directly influenced similar canvases by Robert Salmon and Fitz Hugh Lane. Its illumination of the soul and imagination spoke directly to the luminist painters who followed at mid-century, and later found poignant reincarnation in the moonlit marines of Albert Ryder (see Plates 105 and 207).

Before he left Europe for the last time, Allston began a composition which came to symbolize the frustration of his later career and the irresolution of the Romantic sensibility. The subject of *Belshazzar's Feast* (Plate 73) had preoccupied a number of artists in the seventeenth and eighteenth centuries. An admired version by Rembrandt was in an English collection; West, John Martin, and others had treated aspects of the story from Daniel in the period of Allston's time in London.[17] Belshazzar's vision of the writing on the wall once more found Allston attempting to paint miraculous historical events. But after his final return to Boston, the changes in taste and setting seemed to sap his interest in finishing the work.

He did successfully complete lyrical landscapes and literary subjects in the spirit of *Moonlit Landscape*, but his will for monumental history pictures had ebbed. He procrastinated, worked on small studies, took bad advice on the big canvas from Gilbert

Stuart, repainted, and gave up. But it would not release him, as friends and patrons raised subscriptions to underwrite his costs, only to result in further indecision. Re-married and settled in Cambridgeport, he lived on to be one of the elder statesmen of American art, visited by Thomas Sully, Samuel F. B. Morse, and Horatio Greenough. At his death in 1843, he was still working on the crowded composition, unable to re-solve nagging problems of scale or relationships of figures to each other and to the set-ting. Like Stuart, Allston was unable to finish a number of later works. One of his last drawings was of Belshazzar's clenched hand, more an image of frustration than Allston realized.

Accompanying Allston on his second trip to London in 1811 was Samuel Morse, who was twelve years younger and had graduated from Yale the year before. In London he studied with West and attempted his first ambitious painting, a huge canvas of *The Dying Hercules*, which he accompanied by a plaster sculpture (both Yale University Art Gallery, New Haven, Conn.), that owed its inspiration partly to Renaissance sources and partly to Allston's recent religious pieces. When not successful, he turned for support to portraiture, though not long after his return to America in 1815, he conceived of a new major history painting.

In 1821 François Granet's *Capucin Chapel* was exhibited in the United States to quite a stir. Some ten orders for replicas were placed with Granet, Thomas Sully made his own copy, and we have already noted that Henry Sargent used it as a basis for his com-position of *The Dinner Party* (Plate 55).[18] Morse was inspired in 1822 to attempt a large interior scene, illuminated by artificial lighting, of *The Old House of Representatives* (Plate 74). The chamber (now Statuary Hall outside the present House) had recently been completed in the latest classical manner by Benjamin Latrobe. With the backing of President Monroe, Morse laboured on the picture for over a year, several times rework-ing the difficult perspective of the spacious view and taking individual portraits of each Congressman in an adjacent room. The result was of course American history in action, its democratic institution deliberating in a setting of suitable nobility.

But Morse himself intimated that his aim was the illustration of an ideal as well as a reality:

The primary design of the present picture is not so much to give highly-finished likenesses of the individuals introduced as to exhibit to the public a faithful representation of the national hall, with its furniture and business during the session of Congress.[19]

To this end the picture is a composite, including visitors sitting in the gallery, other figures conversing in the foreground, and Justices of the Supreme Court stand-ing on the raised dais. A page lights the central chandelier, which the artist with characteristic precision of observation noted was 'brass, and contains 30 Argand's lamps'.[20]

At the end of the decade Morse went abroad again, this time with commissions to paint copies after the old masters. He was anxious to visit Paris, and once in the Louvre he determined to essay another interior scene on a large scale. His friend James Fenimore Cooper urged him on,[21] but the optimism and enthusiasm went unfulfilled, and Morse

again turned to portraiture and to his new interest in science. Among the most touching and lovely of his late pictures is *The Muse – Susan Walker Morse* (Plate 75), which he did between 1835 and 1837 when he was Professor of the Literature of the Arts of Design at New York University. Its fully neo-classical manner heralds a new phase in all the arts, although Morse's attention was now diverted to his invention of the telegraph and to the introduction of the daguerreotype process to America, both in 1839. One might say he had not given up art entirely, merely turned to other forms of communication. His combined interests in art and science placed him in the same tradition as Charles Willson Peale before him and Frederick Law Olmsted after him. We should also remember that he played a crucial role in founding the National Academy of Design in 1826 and remained its president until 1845. His place in American aesthetics, in the development of an American *vision*, is on various accounts assured.

FROM FACE TO PLACE

MORSE was not the only portraitist active in the eighteen-twenties and thirties. Whether out of necessity or inclination, a number of painters were making careers of varying success in the major cities of the country. Handed down to them was the solid tradition of Federal portraiture established by Trumbull, Peale, and Stuart, and by Charles B. J. F. de Saint-Memin, who left during the French Revolution for America and became known for his crayon and watercolour profile portraits. A strong group worked in Philadelphia, carrying on Stuart's style while adapting it to the newer tastes for informality and realism. The dominant figure was Thomas Sully, who was born in England in 1783 and came to Charlestown, South Carolina, nine years later. He received training from his older brother and other local artists. During the early 1800s he undertook his first portrait efforts in Norfolk, Virginia, New York, and Philadelphia, before deciding in 1809 to seek help from West in London.

There he fell strongly under the influence of Sir Thomas Lawrence, who encouraged a style of fluid brushwork, contrasting textures, and expressive contrasts of light and dark. Returning to Philadelphia, Sully soon became a popular and prolific portraitist of important politicians and prominent merchants. He crowned his second trip to England in 1838 with a vibrant portrait of the young Queen Victoria. During his long career he produced over two thousand portraits, which he recorded in his Register;[1] seemingly most comfortable with the informal bust-length format, he was fully capable of treating the full-length pose or the large-scale historical setting as well.

One of Sully's most appealing pictures is *The Torn Hat* of 1820 (Plate 76), for which the artist's son served as the model. In a similar manner his daughter later posed for several versions of a painting he called *The Student* (Metropolitan Museum), and in each of these Sully was especially interested in capturing the subtle effects of half lights and soft shadows as they fall across the face under a floppy hat. With gentleness and affection he has caught the soft textures and open glance of youth. It also demonstrated his personal approach to painting, which he later described in *Hints to Young Painters*, first written in 1851 though not published for another twenty years. Sully stressed the usefulness of knowledge of anatomy (and of perspective where needed) in order to place a form solidly in space. Ordinarily, he urged sketching a figure in pencil, and then working up to darker and lighter tones, adding colour, drapery, and background details next. The figure should be clearly contrasted in tone with the setting behind. From both Lawrence and Allston he learned the technique of scumbling and glazing: 'it will give softness and depth of effect'.[2] Above all, strive to retain the improvisatory touch of one's initial impressions, for 'if the refinement of a portrait is carried too far, the identity of the sitter may be lost'.[3]

Born in 1796 in Boston but brought up in Philadelphia, John Neagle had artistic and

family ties to Sully. A variety of artists gave him occasional instruction, including Edward Petticolas in Richmond, Virginia; Pietro Ancora, Thomas Wilson, and Bass Otis in Philadelphia; and Gilbert Stuart in Boston. He began portrait painting in Philadelphia around 1818 and thereafter sought commissions as well in Lexington, Kentucky. The work which established his reputation then and since is *Pat Lyon at the Forge* of 1829 (Plate 77).[4] Certain aspects owe their inspiration to these older painters whom Neagle admired: for example, he must have been familiar with the *Interior of a Smithy* by Otis (Pennsylvania Academy of the Fine Arts, Philadelphia), which was exhibited to popular approval in 1819; from Stuart and Sully came the lively brush-work, warm colouring, and imaginative lighting, as well as the imposing full-length format. But Neagle has decisively transformed the Lansdowne Washington or the standing Queen Victoria into a democratic setting and character. It is a painting depicting personal history – Lyon was a successful blacksmith and engineer, and visible in the background is the tower of the Walnut Street Jail in Philadelphia, where he was unjustly imprisoned on a false accusation. But in a larger sense this image conveys the powerful energies of the young republic, alluding both to individual determination and to coming industrial power.

New York could also count on several talented portraitists in this generation. John Wesley Jarvis was three years older than Sully, though also English-born and brought to the United States as a youth. During the War of 1812 he travelled and painted actively in the South, but thereafter established himself in New York as a highly productive and popular painter. Another near-contemporary was Samuel Lovett Waldo, who grew up in Connecticut and learned painting from Joseph Steward, one of the portraitists active in Ralph Earl's circle. Elsewhere in New England, Chester Harding rose from simple beginnings in northern New Hampshire to a successful career as portrait painter in the mid-West and South. He followed Sully to London and to the studio of Sir Thomas Lawrence; he later pursued almost as prolific a career as Sully in Boston and Springfield, Massachusetts. Jeremiah P. Hardy was a little younger, born in 1800; also from rural New Hampshire, he spent much of his life around Bangor, Maine. Although occasional genre pictures have been mistakenly attributed to him, he was an able portraitist who relied on the clear draughtsmanship and careful observation of details favoured at that time.

Henry Inman's birth dates from the following year. A native of upstate New York, he took up apprenticeship in his youth with Jarvis. With Morse, Waldo, Dunlap, and others, Inman was a founding member of the new National Academy of Design. His portrait of *Georgianna Buckham and her Mother* (Plate 78), painted a couple of years after Morse's interpretation of his daughter as *The Muse* (Plate 75), has a similar neo-classical quality in its tightness of drawing and balanced forms, though Inman's work borders on the edge of pure sweetness and sentimentality.

Completing this interesting and active group are Charles Loring Elliott and George P. A. Healy, born in 1812 and 1813 respectively, thus making them a full generation younger than Sully, Jarvis, and Waldo. Healy began his career in Boston, passed the middle years of the century in Paris, and succeeded in rendering faithful likenesses of

well-known American statesmen from the 1850s onward. Elliott's background, in con-
trast, consisted of brief work with Trumbull and with the genre painter John Quidor.
His style more logically was the heir to Inman's romantic manner, now turned towards
a sharper realism. This was in part due to the rising influence of the daguerreotype,
which Elliott knew and used as a basis for his work. Consequently, some of his portraits
have an unimaginative, monotonous character; others like that of *Mrs Thomas Goulding*
of 1858 (Plate 79) possess a meticulous realism and sense of immediacy. His best work
displayed a force of clarity and personality which made him one of the foremost
American portraitists at mid-century. 'There is nothing in all nature like a fine human
face,'[5] he said, and in the faces of his sitters we can see the self-possession and prosperity
of America before the Civil War.

Even stronger was the daguerreotype image itself, and one of the most powerful
examples of the medium may be seen in the half plate of *John Quincy Adams* (Plate 80),
probably made in 1843. The artist was Albert Sands Southworth, who with Mathew
Brady had learned the new technique of image-making from Samuel Morse. Morse had
been in Paris at the time that Louis Daguerre unveiled his process, which involved
sensitizing a silver-plated sheet of copper with iodine vapour. After exposure to an
image in a camera obscura, the 'latent image' was developed by contact with heated
mercury vapour, which clung to those areas most exposed to light. Morse sought a
meeting with the French inventor, and following their discussions the American artist
brought home details of the procedure, and was among the first to begin production of
daguerreotypes in the United States.[6]

Morse was acting in part out of necessity. He needed the income from instruction, and
he hoped to employ his prints as a basis for portrait commissions in oil. More significant
was his intuitive sense of the profounder intellectual and artistic implications of the
new medium: 'The daguerreotype is undoubtedly destined to produce a great *revolution*
in art, and we, as artists, should be aware of it and rightly understand its influence.'[7] He
saw the appeal to Americans of the new and the mechanical, impulses that run deep
through the national character. Morse had introduced a medium to his countrymen that
responded to many of their deepest aspirations. Here was an art form that was docu-
mentary and factual; it embodied ingenuity and technology; above all, it celebrated in-
dividuality, whether of the humblest soul or most familiar national figure. Relatively
inexpensive as well, it perfectly served the practical and spiritual needs of a democracy.
It comes as no surprise to learn that daguerreotype soon became more popular, success-
ful, and creative in America than in any other country at the time. In its heyday before
the Civil War, estimates list dozens of parlours in business in New York, Boston, and
other major cities, and between fifteen and twenty million pictures taken in the period
from 1840 to 1860, with an annual output of three million in some years.[8]

Such popularity confirmed its democratic appeal. But it may be that the daguerreo-
type succeeded for even more subtle reasons. Peculiar to the process was the fact that it
created a unique image (unlike other printmaking techniques and later photographic
developments); and it also appeared in reverse. In other words, the image was the one a
sitter saw in his mirror, not the one seen every day by the eyes of others. We do not

think of this, but our mirror image is unique to our own eyes, and this revealing psychological truth may help to account for the fact that over ninety-five per cent of America's daguerreotypes were portraits.[9] For a country seeking national identity through its leaders and its landscape, Morse and the new process brought a crucial mode of expression. The goals of art and science were fused in common cause. (We should remind ourselves that these were also the concerns of Robert Fulton, George Catlin, and John James Audubon; see Plates 144 and 145.) Whether cataloguing the particularities of species or looking for stays against mortality, the artist made individual presence concrete and palpable.

Southworth was a native of Fairlee, Vermont. Born in 1811, he was schooled in Massachusetts. After hearing some lectures on daguerreotype in Boston, he went to New York for instruction with Morse in 1840. The next year he returned to Massachusetts to set up a daguerreotype business with Joseph Pennell, who left in 1843. Two years later Josiah Johnson Hawes joined the partnership and established one of the outstanding firms of the day.[10] Because convincing evidence suggests a date of 1843 for the Adams daguerreotype, it seems most likely to be the work of Southworth alone.[11] He had positive views about approaching his work:

What is to be done is obliged to be done quickly. The whole character of the sitter is to be read at first sight . . . Nature is not at all to be represented as it is, but as it ought to be, and might possibly have been.[12]

On first reading, the role of immediacy and of interpretation suggested here seems to contradict the careful preparation and execution of a daguerreotype. But Southworth believed in both the documentary and interpretative capacities of his medium, that is, in recording what the eye saw as well as what the mind felt.

To this end he (later with his partner Hawes) stressed three primary aspects in making images: 'the disposition of light and shade, the arrangement of the sitter, and accessories for the design and composition of the picture'.[13] All of these elements are brought to bear in the picture of Adams. An ageing ex-President, now a member of the House of Representatives, he was near the end of a long life. He sits among the familiar furnishings of the family house in Quincy, Massachusetts, with full light modelling the strong features of his head against a bare wall. The spare forms of mantel, chair, pile of books, and table lamp set off his self-composed but weary countenance. As Southworth (with Hawes) had later found a special drama in the ageing figures of Lemuel Shaw and Daniel Webster, here he recorded the physical details of a great public individual along with a symbolic sense of his inner strength and endurance. Immediately accessible to the viewer were the picture's, and the sitter's, qualities of honesty, authority, and directness. Clarity of form and of mind were equated.

This portrait makes a fine contrast with an equally remarkable one done in plaster of his father *John Adams* (Plate 81), also in his last years. The sculptor was John H. I. Browere, who lived only to the age of forty. He had learned painting early from Archibald Robertson in New York, and then went to Europe to study sculpture in 1816–17. On his return he travelled around the United States until his death in 1834, making life

masks of distinguished citizens for his 'Gallery of Busts'. Jefferson's famous description of the artist's methods is worth full repetition:

I was taken in by Brower [sic]. He said his operation would be of about 20 minutes and less unpleasant than Houdon's method. I submitted therefore without enquiry but it was a bold experiment on his part on the health of an Octogenary, worn down by sickness as well as age. Successive coats of thin grout plaistered on the naked head, and kept there an hour, would have been a severe trial of a young and hale person. He suffered the plaister also to get so dry that separation became difficult and even dangerous. He was obliged to use freely the mallet and chisel to break it into pieces and get off a piece at a time. These thumps of the mallet would have been sensible almost to a loggerhead. The family became alarmed, and he confused till I was quite exhausted and there became a real danger that the ears would separate from the head sooner than from the plaister. I now bid adieu forever to busts and even portraits.[14]

Fortunately, the procedure was neither so difficult or alarming for Adams, who was then in his ninety-first year.[15] As a type of facsimile, the plaster was capable of the intense realism and immediacy of a daguerreotype, but in addition its solidity and three-dimensionality enhanced the sense of heroic permanence. (Compare the re-use of the technique by George Segal, Plate 285, in the twentieth century.) To Browere the combination of the documentary and the ideal, in the Roman manner, perfectly fulfilled contemporary artistic needs.

Another native-born sculptor was John Frazee, the exact contemporary of Browere and an accomplished carver of marble busts that combined individualized detail with idealized form.[16] The third sculptor in this group, Hezekiah Augur, was one year younger, born in 1791, and got his first taste of sculpture through making furniture. He also worked in marble during the mid twenties, often with classical sources in mind. His best known group is *Jephthah and his Daughter* (c. 1828–30) (Plate 82), whose refinement of surface carving and linear detail reflect likely inspiration from recently published engravings or Rococo terracottas;[17] at the same time the strong, simple planes of the heads forecast the purer forms of full neo-classicism. The work of Augur and his colleagues thus stands half way between the carvings of Rush at the beginning of the century and the marbles by Hiram Powers, Horatio Greenough, and their generation in the forties and fifties (compare Plates 54 and 122).

This period saw the flourishing of all the arts as they adapted to national needs. The wish to record both the actual presence and the symbolic force of notable individuals has been equally apparent in painting, sculpture, and the graphic arts, and that same wish carried over into the first responses of American artists to their landscape. During the first quarter of the nineteenth century surveyors, engineers, and artists made the first extensive excursions into the wilderness, to the west and to upstate New York and northern New England. The decade of the 1820s especially consisted of events signifying a period of transition between old values and new. In 1825 the Erie Canal was opened, and soon America's first steam railways would be built. 1828 saw the deaths both of Jefferson and of John Adams and the election of Jackson to the Presidency. His name was to be linked with an unfolding age of national optimism, expansion, and self-determination.

During the years after the American Revolution peace and opportunity attracted a new wave of immigrants from Europe, and following the second round of hostilities with the British in the War of 1812 an even livelier period of trade and population growth took place. During the 1790s a number of European artists arrived to carry on full and long careers in America. Usually specializing in local views, Archibald and Alexander Robertson emigrated from Scotland to New York; from England William Groombridge settled in Philadelphia, painting also in New York and Baltimore; and Michele Felice Cornè came from the island of Elba to Salem, Massachusetts.[18]

In 1795, at about the age of thirty, Francis Guy made his way from England to the United States, where he was active painting views in Brooklyn, New York, Philadelphia, and Baltimore. In lower Manhattan he did *The Tontine Coffee House* as early as 1797 (New-York Historical Society, New York), and some twenty years later he returned to the New York area to execute *Winter Scene in Brooklyn* (Plate 83), known in several versions. He was a resourceful painter, employing devices such as a tent with a glass opening so that he might work out of doors in bad weather; or a piece of gauze stretched across a window on which he might accurately sketch the scene below for subsequent transfer to his canvas.[19] This Brooklyn view, for example, was from his house at 11 Front Street, looking out on James and Fulton; as a contemporary described it, 'Guy, as he painted, would sometimes call out of the window, to his subjects, as he caught sight of them on their customary ground, to stand still, while he put in the characteristic strokes.'[20] While evoking Northern Renaissance and Baroque precedents, for example Breughel's crowded winter panoramas, Guy's painting has a naive charm and enthusiasm of its own. Some figures indeed do look out at the artist (and spectator), while others go about their daily activities. This is at once a catalogue of ordinary human affairs and a celebration of season and place.

Two other artists recorded the excitement and action of American cities in the 1820s: Thomas Birch in Philadelphia and New York, and Robert Salmon in Boston. It is not surprising that both painters favoured views of harbours dotted with vessels, shorelines crowded with houses, and wharves filled with people. Birch was fifteen when he arrived from England in 1794. His father William was an engraver, painter, and collector of seventeenth-century Dutch paintings. Under him the younger Birch received instruction and doubtless studied the examples of Dutch art, for his own style would emulate the low horizons, deep thrusts of space, and the alternating bands of light and dark as compositional devices. By the War of 1812 he was well established, and its major naval engagements afforded him many subjects, as did the harbour shorelines of Philadelphia and New York.

Birch succeeded where Vanderlyn had not, in seeing the popularity and profit of dramatizing the heroes and history of the nation's most recent adventure. His seascapes of both narrative action and scenic views drew on the various Dutch precedents he knew and on the shipwreck compositions of the eighteenth-century French painter Joseph Vernet.[21] More original, because based on first-hand observation, were his open vistas such as *New York Harbour* (*c.* 1830) (Plate 84), with Castle William in the background and an intentional variety of six different vessels crossing the water. Here were

made visible the energetic impulses of Jacksonian Democracy, with the commerce of an eager nation animating its busy shorelines.

Robert Salmon belonged to the same generation, and when he sailed from Liverpool for Boston in 1828, he was already fifty years old with a mature career behind him in England and Scotland. Unlike his contemporaries he did little travelling during his twelve years in America, and found sufficient subjects to paint within the city and greater harbour area of Boston. Many of his subjects were imaginary, a large number were re-membered views from his years of travel around the coast of Great Britain, and an equal group were devoted to views of the Boston wharves, the vessels traversing the harbour, the outer islands, and the myriad daily activities of the area. His style brought together elements that were already strong in English painting during his formative years, namely the dramatic atmospheric qualities of seventeenth-century Dutch painting and the crystalline sharpness of light and detail introduced into England by Canaletto in the middle of the eighteenth century. Salmon's penchant for moonlight scenes during his American years suggests that he knew well Allston's glowing picture of 1819.

He was capable of painting on both a very small scale and in panoramic dimensions. Shortly after his arrival he executed several enormous theatre backdrops showing scenes of the Algerian Fleet in stages of battle. He employed this format for his sweeping view of *Boston Harbour from Mr Greene's House, Pemberton Hill*, in 1829 (Plate 85). Apart from the familiar façade of Faneuil Hall in the foreground, the very breadth, density, and grandeur of this view convey Salmon's recognition of the city's exuberant expansion and prosperity. His special attention to precise draughtsmanship and clear illumination fixed an attitude towards recording nature that carried directly into the work of Fitz Hugh Lane and the luminist painters of the next generation (see Plates 105 and 99).[22]

Another English-born artist of interest is Joshua Shaw, who arrived in Philadelphia in 1817, like Salmon already well trained. He travelled extensively along the east coast making local views according to the formulas of the beautiful, picturesque, and sublime. Many of these were engraved in a series by John Hill in 1820 as *Picturesque Views of American Scenery*, whose introduction began by exclaiming, 'In no quarter of the globe are the majesty and loveliness of nature more strikingly conspicuous than in America.' One of his larger oils in this spirit was *On the Susquehanna* of 1839 (Plate 86), which has the soft light, bright flowers, and fuzzy foliage characteristic of his best work. His careful drawing of the Indians and the rocky setting along with the serenity of mood are a fusion of his direct observation and imaginative interpretation of nature. To a high tech-nical ability he brought perceptive insight in recording American scenery, for he was among the first to grasp its moral significance. The introduction to *American Scenery* went on:

The vast regions which are comprised in or subjected to the republic present to the eye every variety of the beautiful and sublime. . . . Striking however and original as the features of nature undoubtedly are in the United States, they have rarely been made the subjects of pictorial delineation. . . . America only, of all the countries of civilized man, is unsung and undescribed.[23]

Here was a clarion call for the American artist, and painters linked under the name of the Hudson River School answered that call.

CHAPTER 10

THE FOUNDING OF THE HUDSON RIVER SCHOOL

THE decade of the 1830s was a watershed. George Catlin spent eight of those years studying the Indian tribes of North America. In 1838 John James Audubon completed twelve years of supervising publication of his *Birds of America*. Thomas Cole wrote his important *Essay on American Scenery* in 1835, and the next year finished his summary series on *The Course of Empire*. Emerson's central essay on *Nature* appeared then, and was followed in 1837 by the Phi Beta Kappa address at Harvard on *The American Scholar*. At the beginning of the decade Alexis de Tocqueville made his tour of the United States, and as a result published his celebrated volumes on *Democracy in America* in 1835, with observations that are still convincing today. The year before brought an equally important publication, William Dunlap's *History of the Rise and Progress of the Arts of Design in the United States*.

Dunlap was sixty-eight in 1834 (he died but five years later), and his volumes are filled with philosophical retrospection as well as anecdotal details about the lives of American artists to date. He himself had grown up in New Jersey, travelled to London for study with West, became a portraitist of modest ability, and then in later life turned to playwriting and his history. In the section devoted to his own biography he began by stating

I have endeavoured, by the examples of West and Copley, to show the road to eminence which a painter ought to follow, and shall hereafter exhibit Trumbull, Sully, Allston, Morse, Leslie, and others, as examples of industry . . .[1]

A friend of Dunlap's expressed the sentiments of many when he claimed, 'The subject is of deep interest to all who feel a becoming pride in the talents which our native artists have so amply displayed.'[2] Like his contemporaries, Dunlap spoke to profoundly shared desires for defining a national consciousness. The very words of his title assume that the new republic had a worthy history. Concepts like 'rise' and 'progress' were fundamental to the spirit of Jacksonian America. The term 'design' also filled a necessary role, in practical terms permitting Dunlap to discuss all of the arts (painting, sculpture, engraving, even ornithological illustration) as they helped to shape a native aesthetic; but in symbolic terms, too, alluding to the belief in harmony and order. It is an eloquent document of its time and the first major primary source of American art history.

It was during this same period that nature came to be identified with American history. Now landscape painting assumed the former language of history painting, becoming the new vehicle for moral imperatives, spiritual inspiration, and didactic formulas. The experience of the wilderness, with its purity and beauty, was associated with pride in a new political order and in a regenerative power believed distinct from the corruptions and age of European civilizations. American painters went out into

nature with the reverential attitude of pilgrims; their mission was to define for their public the native character of American geography and its revelation of God's presence. One therefore sketched directly from recognizable locales, while imaginatively selecting portions of nature for a compositional synthesis that would illustrate a higher, spiritual 'design'.

In articulating this purpose a group of artists, now known as the Hudson River School, sought fitting subjects to paint along the upper Hudson valley, through the Catskills, Adirondacks, and White Mountains, and along the unsettled portions of the New England coast. Thomas Doughty was the senior member by his birth in 1793. A native of Philadelphia, he painted that area for much of his life. For a brief time in school he received some training in draughtsmanship, and at the age of fifteen he was apprenticed in the leather business. To Dunlap he later wrote: 'I attempted three or four paintings in oil during the latter part of my apprenticeship, but they were mere daubs, inasmuch as I had never received any instruction in oils.'[3] By 1820 he was married and determined to be a full-time professional painter. During the next years he made copies after the old masters in Robert Gilmor's collection, began to exhibit regularly at the Pennsylvania Academy, and counted a number of contemporary painters among his friends, including Thomas Sully, Alvan Fisher, Chester Harding, John Neagle, and Joshua Shaw.[4]

In 1828 Doughty went to Boston, where he worked for the next few years. He painted several commissioned views of country estates and a number of imaginary Italianate scenes; most of his pictures were exhibited under such categories as 'from nature', 'from recollection', or 'compositions'.[5] By the time he had done *Mill Pond and Mills, Lowell, Massachusetts* (Plate 87) around 1833, Dunlap could conclude that 'Mr. Doughty has long stood in the first rank as a landscape painter.'[6] This painting was clearly done from nature, although Doughty has carefully arranged its major components. Typical of his work is the small figure in the middleground who focuses our attention on the central area and lends scale to the surrounding elements. Normally, Doughty liked to emphasize him with an area of light, though here he contrasts the highlighted individual against the dark tree and its reflection, in turn framed by the mirror-still water. In fact, the entire canvas is a sequence of contrasts, such as trees and architecture, light forms and dark, moving and placid water. This is a lyrical and poetic view of nature, and the mills in the background are evidence of the romantic attitude Americans initially took to industrial technology. But it would not be long before the intrusion of the steam engine into the wilderness was more apparent and more ambivalent. (Compare, for example, its treatment by Cropsey, Inness, Eakins, and Weir in Plates 97, 185, 164, and 195.)

Doughty frequently blurred his categories of subject matter, as was the case with his treatment of *Mount Desert Lighthouse* (1847) (Plate 88). He had first painted this view in 1836, making him one of the first artists to venture that far along the rugged Maine coast,[7] and two years later it was engraved in Nathaniel Parker Willis' *American Scenery*. This gave the image wide circulation and may have been a partial stimulus for Thomas Cole's trip to Mount Desert a few years later. Doughty has taken some liberties in his

composition. Mount Desert Rock and its lighthouse (built in 1830 as one of the first off the Atlantic coast) are twenty-five miles offshore, with the mainland nowhere near so prominent in the background. Moreover, coastal sailing would not have been undertaken in such open waters. The rocky ledge that Doughty does show (although it did not get a light station until the 1870s) is Egg Rock at the southern end of Frenchman's Bay, which is in just this location in relation to the mountains on Mount Desert behind.[8] In short, Doughty has made a composite of his travels in the area, to maximize the balance of human and natural drama in his subject.

The artist who most influentially articulated the polarities in American painting between recording and interpreting nature was Thomas Cole. Born at Bolton, Lancashire, in 1801, he had a youthful zest (according to his later friend and biographer Louis L. Noble) for walks in the country and for reading. Both could have first stimulated his taste for picturesque scenery. At the age of seventeen he emigrated with his family to Philadelphia, and for the next few years travelled around western Pennsylvania and Ohio, attempting his first landscape sketches. He returned to Philadelphia in 1823 determined to be a professional artist, and two years later took up residence in New York, by then established as the major literary and artistic centre of the country. The often cited turning point in his career came when he placed three Hudson River views for sale at G. W. Bruen's shop, where they attracted the favourable attention of no less than Trumbull, Dunlap, and Asher B. Durand.[9]

Acceptance and recognition came to Cole in the following years. He now made more frequent excursions to sketch in the countryside, and his pictures found willing purchasers. His early style is laden with a strong literary character. This was not surprising in a milieu influenced by the presence of William Cullen Bryant, James Fenimore Cooper, and Washington Irving. Through his close friendship with Bryant and association with other poets and writers, Cole entered a circle of enthusiastic artistic activity. Many in this group collaborated on publishing projects, especially illustrated narratives on American scenery, belonged to lively social clubs, and together established in 1839 the Apollo Association.[10] This later became the American Art-Union, an organization imitated elsewhere, which arranged annual art exhibitions and sales for more than two decades.

Cole's oils of the late 1820s often drew on narrative subjects from the Bible or from Cooper's novels, as, for example, the *Scene from 'The Last of the Mohicans'* (Plate 89). Cole chose the moment of high drama when Cora kneels before Tamenund within the encircling tribe of Indians. At the same time he has translated the incident into his own pictorial terms, by subordinating the human figures and literary action to the primal forces of nature around them. A great rock teeters threateningly above the figures; trees to the right have burst into autumnal flames; rough stumps and boulders fill the foreground; while towering cliffs in the hazy distance convey a sense of vastness and inaccessibility. In short, the elements of landscape itself embody Cole's message.

In fact, so cogent was Cole's artistic vocabulary that other landscape views were just as effective without specific written sources. *Sunny Morning on the Hudson River* of about 1827 (Plate 90) contains many of the aspects of American nature that Cole defined a few

years later in his *Essay on American Scenery*. The panoramic view and centrally isolated rock platform are related to the composition of the *Mohicans*, but now nature is the only actor on stage. First of all, the scene fulfilled the belief that

the most distinctive, and perhaps the most impressive, characteristic of American scenery is its wildness.

It is the most distinctive, because in civilized Europe the primitive features of scenery have long since been destroyed or modified.[11]

Foremost in constituting that wildness were the mountains. 'American mountains are generally clothed to the summit by dense forests, while those of Europe are mostly bare.'[12] Almost as expressive was the presence of water, which allowed a complete range of moods, from the contemplative placid lake to the active coursing stream to the sublime force of a waterfall, 'the voice of the landscape'.[13] Foliage, particularly in the autumn, was capable of calling attention to degrees of age, the passage of time, or the singular glory of divine handiwork. Finally, the sky could speak to many feelings, 'whether it be the serenity of summer's blue, or the dark tumult of the storm'.[14] Cole's vision was to unveil the beauty of American nature, for he saw an 'inseparable connection between the beautiful and the good'.[15] All the viewer need do was learn to 'read' the language of nature to discover a 'source of delight and improvement'.[16] In Cole's hands American landscape painting had fully taken on the mantle of moral instruction from the history painting of Benjamin West and the philosophical terminology of Burke's theories.

Cole's first period of work came to a close with his determination to visit Europe in 1829, to study the art and scenery of that older world. Bryant marked his departure with his famous ode of cautionary lines:

> Thine eyes shall see the light of distant skies:
> Yet, Cole! thy heart shall bear to Europe's strand
> A living image of thy native land . . .
> Fair scenes shall greet thee where thou goest – fair,
> But different – everywhere the trace of men . . .
> Gaze on them, till the tears shall dim thy sight,
> But keep that earlier, wilder image bright.[17]

In England for two years, Cole became acquainted with the work of Turner and John Martin, among other artists, the poetry of Wordsworth, and the aesthetic theories of Archibald Allison. He then moved across Europe on to Italy for a few years, commenting on works in the Louvre and the Vatican, but responding most ardently to the landscape of the Rhine, Volterra, Florence, and Rome. While he especially admired Claude, it was the architectural monuments in varying states of ruin and preservation – the Coliseum, Pantheon, Paestum, aqueducts on the Campagna – that elicited his emotions. Here he was 'on the seashore of history' confronting 'the bones of empire',[18] facing the lessons of past civilizations, learning man's place in the larger currents of time.

At this point in his work architecture naturally began to assume a more significant role in his compositions, associated as it now was with evidence of man's hand, his

achievements as well as his failures. In the poignant contemplation of these ruins Cole conceived of a series of canvases on the *Course of Empire*, in which he was aided by a commission from the noted New York collector Luman Reed. He envisaged the group illustrating the progress of man to a civilized state, followed by downfall through vainglory and a return to the wilderness of nature. Rather than a single picture, a series would strengthen the cyclical evolution of the narrative. It consisted of five paintings, of which the third was the largest and thus appropriate for the culmination of empire. Cole used the device of a central mountain, symbolizing nature, to focus each composition; we see it from a slightly different vantage point from canvas to canvas in recognition of its changing state. In addition, the light shifts accordingly, from early dawn to hot noontime sunlight to evening.

Cole thought of the first image as emblematic of creation: the day, the season, time, man's work, all beginning. Here the mountain is most angular, the contrast of light and dark sharpest. Savages and wild animals roam the landscape. In the second man and day have reached a more advanced, pastoral condition. The third, *Consummation of Empire* (Plate 91), 'must be a noonday, – a great city girding the bay . . . all that can be combined to show the fulness of prosperity: the chiaroscuro broad'.[19] For this he most clearly was conscious of Turner's and Claude Lorraine's similar paintings of ancient seaports bathed in golden light. Because man had intruded finally on his harmonious balance with nature, *Destruction of Empire* followed (Plate 92). Based more on the precedents of John Martin for its design, this was 'a tempest, – a battle, and the burning of the city . . . there should be fierce chiaroscuro . . . this is a scene of destruction or vicious state'.[20] The last Cole initially conceived as a sunset scene, but Noble described it when finished as moonrise, 'the funeral knell of departed greatness'.[21]

Cole completed the great series in New York in 1836, a year that also saw the death of Reed, the artist's marriage, and the real beginning of his close friendship with Asher Durand. At this time he was working on another major canvas, *The Oxbow (The Connecticut River near Northampton)* (Plate 93). Where the *Course of Empire* demonstrated Cole's more abstract, philosophical treatment of landscape, *The Oxbow* spoke to the soul by consecrating a real place. At the same time, this was unlike Doughty's calm and meditative stance (Plate 87), with its intimate scale and distance. Rather, Cole gives us a vast opening across the valley, all the more marked by the diminutive presence of the artist with his easel in the foreground. In the background a storm is passing, leaving the landscape cleansed physically (and spiritually), while in the foreground is another prominent device of Cole's, the blasted tree trunk surrounded by verdant young growth – more signals of nature's regenerative power. Man has a harmonious place in this setting, but greater forces than he have created the order and beauty before him. Nearby are reminders of a chronology greater than his own. Thus, in being uplifted by the past, 'the mind's eye may see far into futurity'.[22] In a parallel to Transcendentalism Cole saw the union between 'the silent energy of nature'[23] and of mind.

During the following years he planned and partially executed other series on similar themes, though none possessed the totality or originality of the *Course of Empire*. In 1839 Samuel Ward commissioned an ambitious sequence to be called *The Voyage of Life*.

Cole completed one version the following year and another during a second trip to Rome in 1842. This comprised four views from infancy to old age, with parallel handling of light, foliage, and dramatic action. *Youth* (Plate 94) was the second in the series and perhaps the most beautiful, partly because its vision was one of imagined possibility and opportunity. Even though Cole persistently saw the dangers of self-destruction and the melancholy of life's passing, his imagery of youth predominates more out of pride than warning, and speaks for himself as well as for his age.

With Cole's early death in 1848, leadership of the Hudson River School passed to Asher B. Durand. Although he was five years older than Cole, Durand came to landscape painting later in his career. Born and raised in rural New Jersey, he was apprenticed in 1812 to the engraver Peter Maverick, where his training instilled in him a lasting sense of working in line, sharpness of detail, and composing with tonal contrasts. After five years with Maverick, Durand became a partner for another three. His reputation was secured with the engravings he made after Trumbull's *Declaration of Independence* and Vanderlyn's *Ariadne*. He painted a number of portraits, and some history pieces, during the 1830s; his artistic education was completed with a trip to Europe in 1840. Active in the National Academy of Design since its founding in 1825, Durand served as its president from 1845 to 1861.

His best known work is *Kindred Spirits* (Plate 95), a large oil painted in 1849 on commission from Jonathan Sturges as a memorial tribute to Cole, and given to Bryant in appreciation of his Funeral Oration. Durand shows the two nature poets standing on a precipice in harmony with their woodland surroundings. The composition itself, as well as details such as the broken tree, contrasting rock forms, and waterfall, all pay homage to Cole's art, although Durand's technique is more closely based on drawings from nature and on the tighter draughtsmanship of an engraver's hand.

Indeed, if Cole may be generally representative of the imaginative and idealistic approach to nature, then Durand expresses best the related polarity of recording the actual and the specific. Cole's views compare with the generalized and more symbolic language of Emerson. In the latter's essay on *Nature* we find: 'The lover of nature is he whose inward and outward senses are still truly adjusted to each other; who has retained the spirit of infancy even into the era of manhood.'[24] Cole wrote that in the American forest were 'trees in every stage of vegetable life and decay'.[25] Both speak of nature in terms of evolutionary cycles and symbolic relationships. By contrast, Thoreau, and Durand, uncovered the spiritual content of nature through attention to its factual presence. Throughout *Walden*, the *Journals*, and his other writings Thoreau takes nature's measurements, whether the time of day and season, the depth of Walden Pond, or the types of birds and shrubs he sees.

For Durand it was drawing that counted first. Oil sketching was too loose, too general. He urged that painters

draw with scrupulous fidelity the outline or contour of such subjects as you shall select, and . . . choose the most beautiful or characteristic of its kind. If your subject be a tree, observe particularly wherein it differs from those of other species.[26]

As if following that advice, Thoreau noted, while canoeing in Maine, that the 'hore-hound, horsemint, and the sensitive fern grew close to the edge, under the willows and alders, and woolgrass on the islands'.[27] This care for the particularity of forms is evident in Durand's *Landscape with Birches* of 1855 (Plate 96) – even its title states an individuality quite different from Cole's *Sunny Morning on the Hudson River* (Plate 90). While we know that both artists were painting from first-hand experience in nature, Durand's precision of imagery and execution gives his interpretation a more concrete sense of place. By mid-century American landscape painting had helped to define and ennoble the national consciousness. Through several decades artists and public alike chorused their assent.

PART THREE

THE MID NINETEENTH CENTURY
1836–1865
From Nature's Nation to Civil War

THE FLOURISHING OF THE HUDSON RIVER SCHOOL

AMONG the followers of Thomas Cole and an interpreter of his ideas in the younger generation was Jasper F. Cropsey. Viewing his pictures, one critic summarized the landscape artist's role:

The axe of civilization is busy with our old forests, and artisan ingenuity is fast sweeping away the relics of our national infancy . . . Yankee enterprise has little sympathy with the picturesque, and it behooves our artists to rescue from its grasp the little that is left, before it is forever too late.[1]

This expresses something of the zeal and reverence that the American painter brought to his work, but it also indicates the increasingly tenuous balance between the pristine virtues of wilderness and the encroaching agents of civilization. By mid-century the power and possibility of the steam engine had been felt across much of the continent, but what began as the romance of technology was shifting towards a growing disquiet with the destructive capacity of the machine. Even a popular term like 'industry' was ambivalent in its reference at once to hard work and to commercial manufacture.

Cropsey's generation was probably the last which could view the steam engine with a certain nostalgia and poignance. For example, his *Starrucca Viaduct* of 1865 (Plate 97) draws our attention to a train steaming through the middle distance. Man's industry (in both senses) is evident here still as an emblem of American power and growth. The machine for now embodies and confirms possession of the wilderness. It remains a small and romantic counterpoint to the surrounding natural beauty, as is clear from the contemplative distance imposed between the small figures in the foreground and the rail viaduct, and from the proximity of the train's puffs of steam to the clouds crowning the mountain above. The energies of train and landscape are for the moment in harmony. Cropsey ultimately acknowledges his indebtedness to Cole in framing this scene with trees and in giving central position to the distant mountain.

Cropsey was born on Staten Island, New York, and its rural farm lands provided the subject for a number of his early oils.[2] The turning point in his early career came in 1847. By then he had solidly established himself as a faithful painter of nature; in that year he married and set off with his wife on a trip to Europe. For a time in Rome he was, appropriately, in Cole's former studio. His artistic horizons were broadened by contact with other American and German painters then working in Italy.[3]

By the time of Cropsey's return to New York in 1849, Cole had died; like Durand and the other younger landscapists, Cropsey now began sketching extensively in upstate New York and New England. During the next few years he took on several pupils who were to make significant careers of their own: the San Francisco-based artist Norton Bush; David Johnson, another New Yorker who produced some of the strongest and

most refined drawings of the Hudson River School; and George Inness, whose art makes an important transition from this early landscape group to the Impressionists later in the nineteenth century (see Plates 185 and 186).

This period of activity culminated in 1856 with a second voyage to England, where Cropsey remained for the next seven years. This time he familiarized himself with contemporary English and French painting, taking particular note of the work of the Pre-Raphaelites and of Constable and Turner. From the former group Cropsey gained a strengthened sense of nature's minutest details, while the latter confirmed his own increasing fascination with light and atmosphere as expressions of personal feeling. His return to America in 1863 marked the beginning of his mature style of painting and vision of nature. His early work was firmly within the formulas practised by Cole. Most of his views were emphatically literary or allegorical; they stressed narrative detail and obvious symbolic allusions. Gradually, his compositions opened up, becoming more spacious and panoramic. The immanence of light became as important as the presence of physical geography. The didactic elements of picture-making remained, but by the 1860s for Cropsey and his contemporaries these aspects were less strident and explicit, more evocative and poetic.

Starrucca Viaduct exemplifies this self-confident praise of American nature along with the progress of native ingenuity. The bridge, a celebrated engineering achievement, carried the Erie–Lackawanna Railroad across the Susquehanna river near Lanesboro, Pennsylvania. Contemporary eyes equated man-made with natural beauty; as one critic wrote: 'Certainly our bridges over rivers and valleys, and from mountain to mountain, are among the finest specimens of *fine arts* which the world has to show.'[4] Cropsey became known for favouring autumn scenes in brilliant colour, and the intense hues of the foliage here add to the picture's celebratory tone. Painted at the close of the Civil War, it was also an implicit statement of thanksgiving after adversity and belief in renewed progress. Although Cropsey's later work continued to be even lusher and more expansive, the profound breaks in American life eventually made such laudatory attitudes seem tarnished and hollow. After 1870, one might say this style was living on borrowed time, and the autumnal flares of Cropsey's later canvases proved to be less attuned to changing tastes than the starker metaphor of Indian summer uncompromisingly clarified by Thomas Eakins in *Max Schmitt in a Single Scull* (Plate 164) of 1871.

The other members of the Hudson River School were linked by closeness in both style and age. John W. Casilear's birth in 1811 and John F. Kensett's in 1816 gave them a few years' seniority, but the rest were born in the decade of the twenties: Worthington Whittredge and George Durrie in 1820, Cropsey and William Hart in 1823, Frederic Edwin Church in 1826, David Johnson in 1827, James M. Hart and Jervis McEntee in 1828.[5] Many of them were close friends, teachers, or students of one another, and travelling companions, whether to the hills of New England, the western mountains, or the Italian Campagna. Durrie was one who travelled little from his home area of New Haven, but established himself as the pre-eminent recorder of New England winter scenes.

Elsewhere, there were numerous talented artists who, while not formally members of

the Hudson River School, practised a similar approach to painting. A notable example was Robert S. Duncanson of Cincinnati. Born in New York of a Black mother and a Scottish Canadian father, Duncanson grew up in Canada and came to Ohio probably in 1841 when he was twenty. Feelings about Abolition ran strong there, and his race often made life awkward, but largely through self-training Duncanson won for himself some notable portrait commissions and the patronage of Nicholas Longworth. Two trips abroad in 1853 and 1863 enlarged his ambitions as a landscape painter; on the first excursion he was accompanied by William Sonntag, whose misty Italian landscapes appear to have influenced the direction of his later style.[6]

In 1851, at the height of his career, Duncanson painted *Blue Hole, Flood Waters, Little Miami River* (Plate 98). The small fishermen in the foreground, placid water, and enveloping trees are reminiscent of Doughty's compositions, although the precision of drawing and attention to details of rocks and foliage are closer to the manner of Durand (see Plates 87 and 96). The picture comes at an important transitional moment in American painting, recalling the poetic reveries of nature painted by the preceding generation while anticipating the coming interest in expansive lighting and atmospheric effects.

The art of John F. Kensett followed a similar direction, from tight, dark, and closed compositions to more open, luminous, and almost abstract designs. Kensett's family was settled in Cheshire, Connecticut, and he first learned the techniques of engraving and drawing in his family's publishing firm in New Haven. As for so many American artists (e.g., Copley, Durand, Lane, Homer, Bellows), training in the graphic arts would provide a solid foundation for his later painting. All his best pictures were to possess a powerful clarity of line and tonal contrasts. In 1840 he went to Europe for seven years, struggling further with printmaking, making copies after the old masters in the Louvre, drawing frequently from nature, and trying original oils. Later he admitted, 'My real life commenced there, in the stately woods of Windsor, and the famous beeches of Burnham, and the lovely and fascinating landscape that surrounds them.'[7] This indeed proved to be a period of expanding artistic ideas, abilities, and associations.

Like Cropsey on his return to New York, Kensett during the summers of the later forties and fifties undertook regular painting excursions into the countryside. Often with Casilear he ventured across New York and New England, and in the late fifties made trips along the Missouri River and from Baltimore to Wheeling, West Virginia. Periodic travel filled his later years as well: there were other voyages to Europe in 1856 and the mid sixties, as well as a particularly productive trip to Colorado and the Rocky Mountains with Sanford Gifford and Worthington Whittredge in 1870. Among the areas eliciting Kensett's strongest sentiments and most indelibly striking works were Newport and Narragansett Bay, Rhode Island.

This part of the New England coast was one – Cape Ann in Massachusetts and Mount Desert in Maine were others – that had a special appeal for a sizable number of painters. During the middle decades of the century these places became relatively more accessible by carriage and rail. Increased wealth and leisure time stimulated the building of hotels and summer cottages. The picturesque contours of rocky shorelines and the invigorating

climate stimulated unusual pictorial interest. The exploring artist discovered an alluring balance between civilization and wilderness. From the fifties to the seventies Newport also attracted Whittredge, Heade, William Stanley Haseltine, and Alfred Thompson Bricher, some of whom worked on Cape Ann and in Maine as well.

A local view painted often by Kensett was Beacon Rock, Newport, the subject of *Marine off Big Rock* of 1869 (Plate 99). His earlier work had favoured a darker palette, rather crowded woodland scenes, and the forms of nature in motion – dense rustling foliage, turbulent skies, and waterfalls. By the end of the fifties he had distilled his design and pigments to more restrained and measured effects. He tended to balance carefully the areas of sky, water, and land, along with parallel contrasts of light and dark silhouettes. Instead of the physical forces of nature seen in action, now water and air are stilled – mirrors of the soul. As if by plane geometry, one feels a vast new expanse of space created through measurement, precision, and logic. This equilibrium is an affirmation of nature's transcendent harmony and the rightness of man's place in this order, even with his figural presence barely intimated. To this end Kensett applies paint thinly and evenly, as if its very translucence was a metaphoric vehicle for the painting's pure and placid vision.

Paradoxically, the more exacting Americans were in recording place, the closer they came to articulating the spiritual content they perceived in their landscape; for painter and spectator alike recognized that the process of refinement itself revealed the specific and the momentary as clues to the universal and the timeless. Henry Tuckerman observed, 'It is rarely that . . . we can *locate* a landscape so confidently as Kensett's; the vein of rock, perhaps, identifies the scene . . .'[8] At the same time we 'instinctively recognize a transfusion of the natural sentiment and a tone of mind into and through the mechanical execution, design, and spirit of a pictorial work'.[9]

Arriving at a similar solution about this time was Kensett's friend and colleague, Worthington Whittredge. Whittredge had been born on the Little Miami River in Ohio, not far from where Duncanson had painted *Blue Hole*. The Whittredge family had moved there a few years earlier from Massachusetts, where the painter's father had been a life-long sea captain. Whittredge later recounted, 'Of course I was doomed, when a child, to hear much about the sea and of all the wonderful things in New England.'[10] The salt water in the veins of his ancestry drew him back to paint some of his most contented views on the coasts of Cape Ann and Newport.

He was largely self-educated as an artist, and his ambition to paint emerged early in the face of parental disapproval. From house and sign painting he went on to learn daguerreotypy and portraiture; by the early 1840s he was determined to be a landscapist. From Nicholas Longworth, who had commissioned murals from Duncanson, Whittredge also received artistic assistance. His youthful aspirations concluded with a trip to Europe in 1849 that lasted for ten years. Spending some time in Belgium and France, he profited from seeing the contemporary paintings of the Barbizon artists Diaz de la Peña and Corot, but it was at Düsseldorf that his style was firmly stamped. There a popular school had formed, stressing tight draughtsmanship and detail, dramatic narrative subject matter, and meticulous finish.

Under the leadership of Andreas Achenbach, Carl Lessing, and Emmanuel Leutze, a handful of notable American painters studied in Düsseldorf between the late forties and early sixties, the most important being the genre painters Richard Caton Woodville, George Caleb Bingham, and Eastman Johnson, and the landscapists Albert Bierstadt, J. M. Hart, William Stanley Haseltine, and William Trost Richards.[11] The German manner had a strong impact on their work, and some never recovered from its influence. Whittredge's responses to the Düsseldorf teachings were mixed. He loved the landscape and the surroundings, and his own pictures at this time reflected the prevailing style, even though he claimed a critical stance:

Many of these works were in the hardest German style, colorless and with nothing to recommend them except their design. This was to be sure often a compensation for lack of color and the charm of handling but it was not enough and never will be enough to satisfy us in the realm of art.[12]

Eventually, the lure of Rome fired his imagination even more. Once there, he again made the acquaintance of prominent countrymen: Hiram Powers, who was then finishing his *Greek Slave* (Plate 122), as well as the sculptors Harriet Hosmer and Thomas Crawford; Nathaniel Hawthorne, engaged there in writing *The Marble Faun*; and the painters Gifford, Haseltine, and William Beard who accompanied Whittredge on a painting excursion around Lake Nemi.[13]

But possibly the most affecting experience for Whittredge was the voyage into Italy across the Alps, for their soaring ruggedness suggested a new sense of scale to him, an impression of space extending laterally as well as vertically.

I had been accustomed to measure grandeur, at the most, by the little hills of Western Virginia; I had never thought it might be measured horizontally as on our great Western plains. In fact, I believe it is the accepted idea that all grandeur *must* be measured up and down.[14]

When he did return to the United States in 1859, and began to travel into the Catskills and to the Western plains, the same impression of spaciousness struck him. On his first trip to the West in 1866 he talked again about the significance of viewing distant mountains accentuated by vast plains:

Often on reaching an elevation we had a remarkable view of the great plains. Due to the curvature of the earth, no definite horizon was visible, the whole line melting away, even in that clear atmosphere, into mere air. I had never seen any effect like it, and it was another proof of the vastness and impressiveness of the plains.[15]

These sentiments inform Whittredge's handling of *Home by the Sea* (1872) (Plate 100), one of a series done at Newport. In contrast to his earlier preference for close-up views and dark, forest interiors, he has now chosen a sweeping and distant vantage point looking out over the sunlit landscape towards the sea. The warmth and clarity of light convey his perception of nature's generosity. What he discovered as the grandeur of horizontal space perfectly matched contemporary assumptions about the destiny of America.

Samuel Colman, a student of Durand in his youth, was another who travelled abroad

for study. Between his two trips to Europe in the early sixties and again in the early seventies, he painted his stirring vision of *Storm King on the Hudson* (1866) (Plate 101). Known for its dramatic storms, the area lends fitting backdrop to the new energies of steam power. An American pendant to Turner's *Fighting Temeraire* of 1838, it juxtaposes the ages of sail and steam through the dark billowing clouds generated by nature and by machine.[16]

Virtually the exact contemporaries of Colman were William S. Haseltine, William T. Richards, and Alfred Thompson Bricher, all born in the early 1830s. Haseltine was a native of Philadelphia, where he began his first artistic education before going to Düsseldorf in 1854. Four years in Germany instilled in him a familiarity with the favoured style of sharp realism, which he brought to all his oils of the New England coast painted in the 1860s. Richards was also from Philadelphia, travelled abroad, and turned to marine painting in the same period. He, too, based his style on strong, clear drawings of the coastal geography, and emphasized the stark silhouettes of rocky configurations against deep expanses of water.[17]

Bricher came from Portsmouth, New Hampshire, where he received some early lessons in painting. By 1858 he had joined Haseltine sketching on Mount Desert Island in Maine. Also in Boston the following year, Bricher probably knew the work of Fitz Hugh Lane (see Plate 105), who had also been painting at Mount Desert throughout the 1850s and exhibiting his pictures regularly in Boston. Not surprisingly, the crisp and crystalline style evolved by all these painters reflected both exchanged ideas as their paths crossed and shared attitudes towards nature. Travelling regularly in the summer months to the coast, Bricher painted first at Newport, then Mount Desert, and finally at Grand Manan Island on the Canadian border. The development of his style paralleled that of Kensett, Whittredge, and the other second-generation Hudson River painters, moving steadily towards the open formats and fully illuminated views characteristic of many painters from the mid sixties onward. As the southerly New England resorts became more popular and crowded, these artists tended to seek subjects further afield, places still retaining some sense of raw and pristine forces.

Frederic Church painted at Grand Manan in the early fifties, and was followed not long after by Gifford, William Bradford, and William Hart, among others. One of Bricher's most forceful views done there in the seventies is his *Morning at Grand Manan* (Plate 102), which unveils the quiet drama of a colourful northern sunrise over the towering headlands, in turn pronounced by the rushing tidal change (some fifty feet) at the southern end of the Bay of Fundy.[18] Although such scenes were now outside the territorial limits of America, they continued to hold for the artist the desired qualities of an ever fresh, sublime frontier.

For the same reasons Church and Heade went to paint in South America, while James Hamilton and Bradford sought subjects in the Arctic. Hamilton, born in 1819 in Ireland, came to Philadelphia as a youth, adding yet another interesting figure to that city's group of marine painters. An ardent follower of Turner, Hamilton created canvases often more imaginative in conception and turbulent in handling than those of his American contemporaries. During the early 1850s he accompanied Elisha Kent Kane on

expeditions to the Arctic in search of the lost British explorer Sir John Franklin, and provided drawings subsequently engraved to illustrate the published accounts of their ventures.[19] Bradford, even more so, became an established painter and explorer of 'Nature under the terrible aspects of the Frigid Zone'.

Bradford was born in Fairhaven, Massachusetts, and grew up in nearby New Bedford, with its active port and whaling industry. There stirred the beginnings of Melville's *Moby Dick*, as well as a rich tradition of painters fascinated by the sea, from Albert Bierstadt and R. Swain Gifford to Albert P. Ryder. The Gloucester artist Lane was in New Bedford on at least two occasions during Bradford's youth, and helped to form the local painter's early style of careful draughtsmanship, cool lighting effects, and active narrative records of local views.[20] The arrival of a Dutch artist, Albert van Beest, in 1845 modified Bradford's approach towards a looser handling of paint and more dramatic seascapes. With his artistic training complete, Bradford became increasingly excited by the lure of the Arctic, in part fired by the publication of books about recent expeditions.[21] In 1861 he equipped the first of several extensive ventures to the north. The most ambitious occurred in the summer of 1869 and led to a large book illustrated with his own photographs, published in London as *The Arctic Regions* in 1873.[22]

Here were art and science fused, religious experience and natural history joined. The awesome magnificence of the icebergs and the eerie northern light invited comprehensive physical documentation, while inspiring exultant moral interpretation. The written language used by all was intensely euphoric, employing grand metaphors and frequent exclamation points. Bradford and his contemporaries carefully observed the Esquimaux, the Arctic animals, and the peculiar characteristics of the landscape, but it was the iceberg in its many manifestations that transfixed their attention. It was a Greek temple, a Gothic cathedral, a Chinese pagoda, a Saracenic mosque. This protean geology belonged to the history of the earth itself, and to nineteenth-century sensibilities such mountains of ice were floating counterparts of the Alps and the Andes, visions

Wonderful to behold! it was only a fair field for the steepled icebergs, a vast metropolis in ice, pearly white and red as roses, glittering in the sunset. Solemn, still, and half-celestial scene! . . . I said aloud, but low: 'The City of God! The sea of glass! the plains of heaven!'[23]

Possibly more than any other medium, photography suited Bradford's aspirations. Although he made countless pencil and wash sketches for use in oil paintings for the rest of his life, in a style that became increasingly bombastic, repetitive, and exaggerated, he and his assistants took photographs that have retained their original immediacy and force. It was the camera (guided by the mind and aided by the hand) that he recognized as possessing the capacity for capturing momentary phenomena as well as unchanging truths. The 'sun-given powers of the camera'[24] made it a seer in more senses than one.

In his photographs Bradford often chose the distant or elevated vantage point. He consciously contrasted the immense scale of the icebergs with the small figures of his companions, or the belching black smoke of a steamer against a glistening white wall of ice and snow. Silhouettes, mirrored reflections, sharply detailed textures, and the pervasive dominance of light were crucial elements in his 'instantaneous views', such as

Schooners in Arctic Ice (Plate 103), as much as they were in the painted equivalents by his contemporaries. In fact, he thought of recording nature in terms of tonal contrasts:

On one side would be a towering mass in shadow, on the other a majestic berg glistened in sunlight; so that without leaving the vessel's deck I could study every variety of light and shade.[25]

This perception is consistent with the content and method we have seen in the canvases of Cropsey, Kensett, Whittredge, Bricher and their generation. Together, they can be grouped under the term luminism. In stopping time the photographer saw what the painter felt: the timeless.

CHAPTER 12

THE LUMINIST VIEW

THE third quarter of the nineteenth century coincided with the emergence of a distinctly indigenous style of painting now called luminism. Relying on light as its primary expression, this mode of painting flourished from about 1850 to 1875, with perhaps its supreme accomplishments coming in the decade of the sixties. This period also saw the culmination in popularity as a critic of Ruskin, whose ideas received wide circulation in *The Crayon*.[1] First published in 1855, this magazine carried the writings of Durand, Bryant, and other nature enthusiasts, and exerted a strong influence on American taste in the following years. Evidence indicates that Fitz Hugh Lane was acquainted with Ruskin's *Modern Painters*; Frederic Church owned a copy, and his paintings owed a noticeable debt to Ruskin's ideas about nature and to the art of Turner, so stoutly defended by the English critic.[2]

Ruskin's linking of art, nature, and morality found immediate acceptance with Americans. Perceiving the spiritual authority of art and of nature was an uplifting and edifying experience. The writings of Andrew Jackson Downing and James Jackson Jarves further promulgated Ruskin's theories. Downing sought to articulate the moral content of nature and architecture. The preface to his third volume, *The Architecture of Country Houses* (1850), pointedly began by stating that 'a good house . . . is a powerful means of civilization . . . there is a moral influence in a country home . . .'.[3]

Jarves was an equally influential follower of Ruskin, although the American also had in mind Darwin's recently published beliefs concerning progress and perfection, which seemed readily adaptable from human to artistic evolution.[4] More pointedly, Jarves grasped the central interest of artists at that time: 'The thoroughly American branch of painting, based upon the facts and tastes of the country and people, is the landscape.'[5] Although he was critical, he realized even more that 'the highest aim of the greater number of the landscapists seemingly is intense gradations of skies and violent contrasts of positive color'. Not fully approving, he nonetheless identified some of the major luminist painters of the period and the characteristics of their art.[6]

The 1860s was their triumphant decade, and the notion of moral landscape is to be seen not only on canvas but in the great parks of Frederick Law Olmsted, Downing's worthy successor, whose finest work dates from these years. First in Central and Prospect Parks in New York City and subsequently in Golden Gate Park in San Francisco and the Back Bay development in Boston, he created three-dimensional Hudson River landscapes for both the spiritual and physical recreation of the public. This generation also had its historian in Henry T. Tuckerman, whose *Book of the Artist, American Artist Life* appeared in 1867.

Tuckerman also took note of the special qualities we now associate with luminist painting. Regarding a Newport scene by Heade he stated that 'the effect of a thin

overflow of water on the glistening sand of the beach is given with rare truth. None of our painters has a more refined sense of beauty, or a more delicate feeling of color.'[7] Luminism is indeed characterized by refinement of means and effect. An oft-quoted statement by Emerson is perhaps the philosophical headwater of the movement:

Standing on the bare ground – my head bathed by the blithe air, and uplifted into infinite space – all mean egotism vanishes. I become a transparent eyeball; I am nothing; I see all; the currents of the Universal Being circulate through me; I am part or parcel of God.[8]

Luminist pictures convey this sense of the maker's individuality totally absorbed by a crystalline universe. The painter applies his pigments uniformly and thinly, as if the smooth veil of paint was one with his pictorial vision. Foremost attention goes to the expressive presence of light, which seems to saturate these landscapes, and the awareness of horizon, which suggests a near infinity of space and corresponding suspension of time. Most luminist canvases are emphatically horizontal compositions, but there are some of vertical design which succeed by virtue of the central radiance of light or atmosphere unifying foreground with distant horizon.[9]

Like the physiology of the body, luminism has two sides – one bright, still, and intimate; the other dark, dramatic and expansive.[10] More profoundly, perhaps, this duality belongs to the tensions of the age. In one respect we may regard luminism as the culmination of Jacksonian optimism and promise, the sense of national unity and expansion, with progress and fruition visible in spacious, serene landscapes. At the same time the Civil War brought deep psychic shock to the country, challenging the concept as well as the actuality of geographical union and harmony. Throughout the sixties and even into the seventies the former mode was predominant (see Plates 99–106), although the tense undercurrents surfaced occasionally in powerfully surreal or explosive images (compare Plates 107 and 109).

Contributing to the luminist vision was a technical fact, the introduction of new cadmium pigments during this period, making possible the painting of sunset and twilight scenes in hot reds, yellows, and oranges.[11] Jarves complained, 'We are undergoing a virulent epidemic of sunsets.'[12] What was true was that luminist pictures concentrated on open areas of sky, cloud formations, and a full range of light effects. But theirs was as much a meteorology of feeling as of weather. In most respects, then, American landscape painting at mid-century differed in important ways from concurrent developments in Europe. A notable contrast is French Impressionism's attention to optics and the scientific rendering of retinal impulses, which ultimately led Monet and his colleagues to the dissolution of form on the canvas. For the American painter the image remained precise, measured, and enduring.

The founding figure of luminism is Fitz Hugh Lane. Born in Gloucester, Massachusetts, in 1804, he was the almost exact contemporary of Cole and plays a parallel role in the formulation of this variant of Hudson River painting. Partially crippled as a child, he had some difficulty travelling and spent much of his life around Gloucester or Boston, with periodic summer cruises to the Maine coast. His career began with an apprenticeship at Pendleton's lithography shop in Boston during the early 1830s. There he worked

alongside Benjamin Champney, David Claypoole Johnston, and other young would-be artists. Their training included lithographic music sheet covers, trade advertisements, and eventually full-scale scenic views.

The art of lithography was relatively new, having been invented in Germany in the 1790s and introduced into America during the first quarter of the nineteenth century. As a method of printmaking it differed in significant respects from the earlier techniques of engraving and etching. Instead of having to bite into a metal plate either with a sharp tool or with acid, and then press paper into its inked surface, in lithography one could draw on a polished stone with a greasy crayon. After the surface was lightly moistened with water, the grease-based ink would adhere only to those drawn areas, and with the lightest pressure the paper would pick up the image. This meant that one could work on much larger sheets with greater ease, and also print many more copies, since there were no incised lines to wear down. The whole process was more economical in terms of time, effort, and expense. Lithography thus provided inexpensive and widely accessible illustrations of familiar city prospects and landscape scenery. Like daguerreotypy in the same years it literally revealed the energy and prosperity of Jacksonian America.

Lane's first work in lithography, and later in oil, was characteristic of his generation – elaborately descriptive and narrative, although not so literary as the early Cole (Plate 89) or so anecdotal as the early Mount (Plate 136). His earliest views are of Boston; between 1835 and 1845 he also drew on stone prospects of a dozen other cities in New England and the northeast.[13] These tend to be filled with local shoreline and harbour activities; the emphasis is on figures and vessels usually in action, in the tradition of those lively cityscapes painted a few years before by Guy, Birch, and Salmon (see Plates 83–5). Lane's first canvases are similarly crowded, sometimes dramatic, as his methods of drawing and composing carried over directly from his graphic work into his painting.

He returned to Gloucester in 1848 to settle down, built his own house overlooking the harbour, and commenced an energetic professional career. That year marked a crucial turning point in his art, for he made his first summer visit to Maine. The clarity of air and light, along with the rugged coastal topography, deeply impressed him. Following a few years behind Cole, Doughty (Plate 88), and Fisher, Lane at Mount Desert soon took a radically different approach to interpreting the wilderness. After 1850 his mature work possessed a new openness of design and feeling.

Perhaps his most beautiful lithograph is the 1855 view of *Castine from Hospital Island* (Plate 104), which summarizes his technical and stylistic advances to that date. In his day Lane was unique in his dual accomplishments as printmaker and painter. Distinctive about the *Castine* view is its detached and spacious quality. With the two small figures in the foreground the spectator looks out across the water, punctuated by a few sailing vessels for scale and interest, to the far shore. Almost two-thirds of the composition are given to the thin clouds of a fair-weather sky. A mood of quiet contemplation confirms the Emersonian vision of man's union with nature.

Human presence is even less obtrusive in *The Western Shore with Norman's Woe* of 1862 (Plate 105), a classic of the luminist canon. Painted along the Gloucester shoreline in Lane's best years, the water is mirror-still, accented by nearly geometric rocks. Distant

space is evident in the three-master just visible on the horizon. A sense of vacuum pre-vails, as Lane distils and finally suspends time itself. From careful drawings that he made on the spot he gradually refined his composition on canvas, purifying it through the translucence of memory and reverie. His pale skies and glassy surfaces of water are elements of a material and spiritual universe which we – now indeed 'bathed by the blithe air, and uplifted into infinite space' – at once look at and look through.

By the time of his death in 1865 Lane had clearly drawn, in every sense, the outlines of American luminist painting. During this decade and into the next Martin Johnson Heade, Frederic Church, and Sanford Gifford amplified the movement within the dimensions of their individual stylistic developments. All three were a generation younger than Lane, although Heade's dates (1819–1904) made him the oldest and most long-lived of the group. Near his native Lumberville, Pennsylvania, he received artistic instruction in his late teens from Edward and Thomas Hicks, before making an early journey to Europe in 1838. The next few years found him travelling in America, seeking portrait commissions and attempting his first genre paintings. This pattern repeated itself with a second trip to Rome in 1848, followed by further moves to Chicago, St Louis, and back to the east coast. Such constant restlessness would be reflected in the un-usual variety of his subjects and in the frequent echo of lonely introspection through so many of his landscapes.

Heade's first views of nature, of the early 1850s, are in a manner close to Kensett and Whittredge at the same time. Although his handling of paint is looser than theirs, he chose similar compositions of foreground trees framing dark woods with a stream and path leading the eye through a tunnel of light into glimpses of distant sky.[14] By 1860 a decisive shift had occurred in his style. This was in keeping with general changes in American painting that we have observed elsewhere, but it could have more precisely resulted from acquaintance with Lane's work. Heade had evidently been introduced to the Newburyport area about this time by friends, and in 1862 began painting the marsh scenes of coastal Massachusetts – a subject that preoccupied him also in Rhode Island, New Jersey, and Florida to the end of his life.

Summer Showers of c. 1865 (Plate 106) shows these tidal wetlands in the formula synonymous with Heade's name: consciously lateral format, zones of clear sunlight alternating with dark clouds or shadow, perfect symmetries of salt haystacks displaced across the meadow like an architectural elevation, their rhythmic silhouettes marking off the landscape's horizontals like notes on a bar of music, and gentle harmonizing curves of the winding stream. These were not just records of nature and personal soli-tude, but also highly intellectual exercises, as Heade's few refined and tightly controlled charcoal studies show. It is no accident that his contrast of tones and shapes in such a picture so closely resembles Lane's process of abstraction in the same period (compare Plate 105). In fact, there is much evidence to indicate, certainly during 1863, an exchange of stylistic ideas between the two painters.[15]

The mysterious tension of luminism's dark side – a paradox related to the camera and the mirror, too – finds stark fulfilment in *Approaching Storm: Beach near Newport*, c. 1867 (Plate 107). Despite the sailing-boats, it is an unearthly landscape of brooding terror.

Almost without precedent,[16] this image gives unknowing voice to the end of Eden in a nation now at war with itself.

Heade's energies, and those of luminism, would not be so intense again. Three times between 1863 and 1870 he went to South America to paint, in flight and pursuit. Like his friends Church and Gifford, he found compelling the last undiscovered frontiers. From his experiences in Brazil came an extensive series of lush tropical pictures that depicted pairs of orchids and hummingbirds. The results were half still life, half land-scape, an invention of Heade's. His peripatetic travels continued through the seventies and eighties; only with marriage at the age of sixty-four did he settle down in Florida for his last years. His later career produced, with generally ebbing powers but occasion-ally stunning technical displays, familiar subjects along with a new series of enlarged floral still lifes. These cut sprays of giant magnolias on velvet cloths are strangely sensual, until we consider the sexual repressions of the Victorian age itself, or the erotic exuberance of an artist like Picasso as he aged.

Heade's close friend Frederic Edwin Church brought American landscape painting of this period to its apogee. Not fully a luminist painter himself, he did make an important contribution. Of an old Hartford family, in 1844, thanks to the assistance of the promi-nent collector Daniel Wadsworth, he became Thomas Cole's only pupil. After two years with Cole, he travelled through the Berkshires and began his first views of New England scenery. These paintings were strongly in Cole's debt, but already were more tightly drawn, more expansive in design, and more scientific in observation. His mantle was Cole's ideas; his achievement was their transformation for a new age of national deter-minism. Where Cole looked to the past with melancholy, Church addressed the future with optimism.[17]

It was almost ordained that one of Church's most influential and monumental early works would be *Niagara* of 1857 (Plate 108). Had not the master himself written:

And Niagara! that wonder of the world! – where the sublime and beautiful are bound together in an indissoluable chain . . . At our feet the floods of a thousand rivers are poured out – the contents of vast inland seas. In its volume we conceived immensity; in its course, everlasting duration; in its impetuosity, uncontrollable power.[18]

During the first half of the nineteenth century almost every major American artist had gone to paint Niagara (see Plate 68), but Church's version struck a fresh chord that seemed uniquely to capture the contemporary imagination. What was crucially new were the aggressively horizontal proportions (the device Heade soon learned); the spec-tator's vantage point on the very edge of the turbulent precipice, yet elevated enough to look across a vast panorama; the water at the sides and the clouds in the far distance, which intimate a powerful geography extending beyond our frame of sight; and the animated brushwork, varied to coincide with the different textures of rock, sky, and flowing or foaming water.

Thus, technically and conceptually, Church has recorded the face of geology with new accuracy while investing its meaning with augmented power. As in Constable's late *plein-air* landscapes, the rainbow confirms the mood of uplifting hope. Church goes

further to invoke an image of thunderous ovation; appropriately, the picture was celebrated on tour at home by President Fillmore and throngs of admiring Americans, and abroad by Ruskin and Léon Gérôme.[19]

Where so many of Church's contemporaries travelled to the American west in search of the wilderness frontier, he found its myth and reality in Maine, the Arctic, and South America. As we have already seen, Alvan Fisher was an early visitor to the Maine coast, Doughty painted at Mount Desert (Plate 88) as early as 1836, Cole in 1844, and Lane in 1848. The latter exhibited in New York in 1849 an incandescent wilderness view called *Twilight on the Kennebec*, which appears to have prompted Church to make his own visit to Maine the following year.[20] He and Lane both returned to Mount Desert in several of the same summers during the next decade,[21] with the result that Church now undertook his own series of resplendent sunset landscapes, painted with the same hot cadmium colours. These culminated in the apocalyptic *Twilight in the Wilderness* of 1860 (Cleveland Museum), Church's summary of North American heroic landscape.[22]

Twice during the 1850s Church went to South America, and at the end of the decade to the Arctic. These were extensions of his perception of a national geography, for in the mountains of both ice and lava he again found a cosmic vision that unveiled scientific as well as spiritual links to a timeless history. Both the Monroe Doctrine and Manifest Destiny were kindred political assertions of the New World's territorial rightness, and even the ageing Jefferson could state that 'America, North and South, has a set of interests distinct from those of Europe, and peculiarly her own'.[23]

Church found special inspiration in the writings of Alexander von Humboldt, the German scientist who explored much of northwestern South America between 1799 and 1804.[24] His accounts, published over the following decades, were enormously popular, and Church owned several volumes himself. Humboldt was the first man to climb Chimborazo in Ecuador, and now Church followed his footsteps as a fellow devotee to natural history and science. A sequence of gigantic canvases came from these experiences, equal to the magnitude of Church's ambitions and beliefs. One of the most overwhelming is *Cotopaxi* (Plate 109),[25] characterized by meticulous botanical details and a vast prospect across (in Humboldt's words about a similar sight) 'a sea of verdure, the misty horizon . . . illuminated by the rays of the setting sun'.[26] Church used a similar language of description:

Cotopaxi is represented in continuous but not violent eruption. The discharges of thick smoke occur in successive but gradual jets . . . so that the newly risen sun flares with a lurid fire through its thick volumes.[27]

Intentionally, he juxtaposes sun and volcano as the central protagonists within this half terrestrial, half celestial, arena, just as he interlocks molten sunlight and placid lake, explosive plumes of smoke and quiet blue sky, or dense vegetation and vaporous waterfall. The cyclic forces depicted here derived from the very origins of the solar system – now we can grasp how much Church has transformed Cole's *Course of Empire* (Plates 91 and 92) – and it was America's providence to fulfil this new creation. Thereafter, Church made pilgrimages to other monuments of history – Baalbek, the Parthenon,

Jerusalem, and Petra – and invested them with similar associations. Collaborating in the 1870s with Calvert Vaux, one of the architects of Central Park, he built Olana, his 'place on high' overlooking the Hudson, and there created a microcosm of his worldly and spiritual experiences.

Sanford Gifford, three years Church's senior, was born into a large family in upstate New York in 1823, and was better educated than many of his contemporaries. He mostly taught himself to paint through excursions in the New England mountains and close study of Cole's art. In 1855 he left for two years in Europe, and for a time travelled with Albert Bierstadt in Italy. Upon his return to New York he moved into the new Tenth Street Studio Building, which was to bring together a large number of notable American painters during the next decade or so.[28] A second trip abroad in 1868 took Gifford to many of the places visited by Church in the Mediterranean and the Middle East, followed in the early seventies by two excursions out west.

Of all the places Gifford loved to paint, Whittredge stated that a favourite was the region of the *Catskill Mountain House* (Plate 110).[29] Late summer and autumn found Gifford regularly there, and in this picture of 1862 he gently joins the golden haze of Indian summer with the sparkling foliage of fall. Its almost aerial viewpoint and sense of breathtaking distance are familiar luminist marks. With other fellow artists like Cole and Cropsey, Gifford offered his own praise to nature.[30] Climbing the Catskills or Cotopaxi was an occasion of transcendence. Listen to Thoreau at the summit of Kadahdin:

Talk of mysteries! Think of our life in nature, – daily to be shown matter, to come in contact with it – rocks, trees, wind on our cheeks! the solid earth! the actual world! the common sense! Contact! Contact![31]

Somehow it was fitting that the luminist painter seemed most evocative with autumn scenery, for the glory of both was transient. A friend's remark that 'Gifford loved the light'[32] might have been applied to any of this group.

NATIONAL WELL-BEING

LUMINISM was a distinctly American style of painting, notable as an early and major indigenous expression. But the exuberance and self-confidence associated with Jackson's administration and the years after did not only find voice in the rise of landscape paint- ing: still-life subjects also conveyed a sense of fruition and fulfilment, as the paintings of John F. Francis and Severin Roesen testify. Coincidentally, both artists spent much of their careers in Pennsylvania. Francis was a native of Philadelphia, born in 1808; his early career was largely devoted to portraiture. By the 1850s still-life painting had be- come his principal preoccupation, and *Still Life with Wine Bottles and Basket of Fruit* of 1857 (Plate 111) shows one of his favourite arrangements. Glasses and bottles are lined up like miniature organ pipes, each filled to a different level, while fruit and crackers overflow from the basket and plate respectively. In comparison to the restraint and refined elegance of Federal still-life paintings (compare Plate 62), this is an imagery of secular praise and thanksgiving.

Roesen, a German porcelain painter who came to the United States about 1848, presents an equally effulgent composition in his *Still Life: Flowers* of *c.* 1858 (Plate 112).[1] There is a German quality in the hardness of outline and precision of crowded details. Yet the very abundance and density of flowering forms were directly in tune with current American tastes. These thick and colourful floral arrangements are visually and intellectually akin to Victorian rug and wallpaper designs as well as to Church's lush landscapes (see Plate 109). Appropriately, Roesen's fruits and flowers were always at their ripest and frequently heightened by glistening drops of water, not unlike the clear waters that cleansed the views of nature's larger bounty.

Equally revealing of the national temperament was the impressive flourishing of folk art, of genre painting, and of neo-classicism in sculpture and also in architecture. It is no accident that these other artistic forms developed concurrently during the middle quarters of the nineteenth century. Together, they reflected the fervent interest in the lives of ordinary citizens and the equally fervent belief in the establishment of a moral order, both inspired by democracy. Folk painting of this period did have antecedents in the flat, linear images of the colonial limners and in the decorative portraits of the Con- necticut school from the late eighteenth century.

Yet the lingering medieval tradition had well run its course before the emergence of nineteenth-century folk art, and the strong planar character of this later revival has to be understood in a new context. One obvious stimulus was the radically changed role of art in American life from the colonial to the republican period. The nineteenth century's association of art with national well-being encouraged artists of all persuasions and talents to participate in this democratic self-expression. As a consequence, for the first time we see a groundswell of art produced not just by the trained and travelled artist, but by the

untutored and self-taught amateur as well. Terms such as 'naive' and 'primitive' are often interchangeably employed for this art, but do little justice to work that is often highly sophisticated and intellectual. The American impulses towards craftsmanship, practicality, and gadgetry also now emerged in response to needs both practical and artistic.

A marvellous production of whirligigs, weathervanes, shop signs and figures, carrousel animals, decorated furniture, and illuminated documents resulted. That many of these combined utilitarian ends with aesthetic qualities makes an important link to Horatio Greenough's theories about the functional beauty of the clipper ship and the trotting wagon. The folk artist also blurred distinctions between painting and sculpture. Shop signs, painted furniture or picture frames (see Plate 115), and brightly coloured carved figures brought the two arts together. Expressive pattern belonged as much to incised lettering and weathervane silhouettes as to painting, watercolour, and drawing.

To be sure, folk art is primarily distinguished by its non-illusionistic and abstract perception of form and space. In painting especially the artist conceptualizes his image; that is, he reduces an object or figure to its basic shape, posture, or silhouette. To this end he has no interest in optical spatial recession or in a single source of light to model form. Thus he can assemble an additive sequence of discrete patterns into a rhythmic and harmonious whole.[2] Often his composites are of both form and subject, as in Hicks' *Peaceable Kingdom* (Plate 115), which joins the imagery of Isaiah's prophecy with a view of the Natural Bridge in Virginia and under it the central group from Benjamin West's *Penn's Treaty with the Indians* (Plate 44).

Yet, the line separating folk and academic art is not so sharp as it is sometimes drawn. For example, there are provocative similarities between *Meditation by the Sea* and Kensett's luminist views (Plates 117 and 99). Moreover, Lane's earliest work in lithography and watercolour possesses the same graphic flatness and linearism.[3] William Prior was capable of painting either modelled or decorative forms, and advertised the distinction: 'Persons wishing for a flat picture can have a likeness without shade or shadow at one quarter price.'[4] Likewise, the portraits of Erastus Salisbury Field evolved from a style of bright patterns in the thirties and forties to a later one of academic realism strongly influenced by daguerreotypes.[5]

A vast number of these painters and carvers are unknown to us by name. Some individuals with a large production or recognized professional ambitions have been identified as singular artistic personalities. One of the more prolific was Ammi Phillips, who was born in northeastern Connecticut in 1788. Previous portraitists in the state, for instance Reuben Moultrop, helped to form the basis of his early style, which was rather stiff in character and dark in colour. About 1811 Phillips moved to western Massachusetts, where the lighter tonalities and full-length designs of a local painter, J. Brown, now remoulded his style.[6] Exemplary of Phillips' new manner is his portrait of *Harriet Leavens* of c. 1815 (Plate 113). His colour scheme is simple yet elegant: against the large areas of pale pinks and greens used for the dress, background, and floor is set the bright red and green bag at the subject's side. These notes find further echoes in the red lips, earring, and necklace stone and in Harriet's dark green eyes. Her columnar form, and indeed the rather architectural character of the picture's repeated horizontals and

verticals, gives some hint of emerging neo-classical tastes. The wide eyes and slightly up-turned corners of her lips create a dreamy expression, and the viewer is ultimately caught between the directness of Harriet's glance and the mysterious reserve of colour and detail.

During the 1820s Phillips abandoned this mode for stronger tonal contrasts and greater realism of detail that probably came from his acquaintance with the work of the Albany painter Ezra Ames. Thereafter, working through upstate New York and western Massachusetts, Phillips stressed intricate patterns of lace and sharp figural silhouettes. In this long and varied career, however, he never surpassed the soft but compelling evocativeness of his early achievement.

William Matthew Prior was a portraitist of equal versatility. A native of Bath, Maine, he was born in 1806 when that city was establishing itself as one of the most active ship-building ports on the coast. Prior's first artistic efforts at ship and sign painting, as well as portraiture, reflect the various opportunities with which local trade must have provided him. During the 1830s he travelled through New England, settled for a time in Portland, and painted as far south as Baltimore. He lived for his last thirty years, from 1841 on, in his 'Painting Garret' in Boston. When train travel made the itinerant painter's life easier after mid-century, Prior would pack his equipment in a chest for temporary storage at a local depot, while he set off on foot with what he needed, in search of portrait work in the surrounding countryside.[7]

His likeness of *Nancy Lawson* of 1843 (Plate 114), paired with a canvas of her husband the *Rev. William Lawson* (Shelburne Museum, Vermont), displays his special abilities in rendering both partially modelled form and well organized flat patterns. His decorative design gains simple strength through contrasting and repeated linear motifs; for example, the crossing diagonals of the black neck ribbon find initial echoes in the silhouetted white collar, and subsequent ones in the edges of the drapery and Mrs Lawson's sleeve. Similarly, the crossing window grid reinforces other light and dark horizontal lines in the costume, just as the hanging curtain-pull complements the circular forms in the sitter's face and bonnet. The result is a portrait sympathetically drawn from life but modulated through the artist's imaginative mode of composition.

Landscape subjects provided no less interest for the folk artist. Significantly, some of them were also amateur scientists, like the itinerant Rufus Porter who painted murals in houses along the upper Connecticut Valley and dabbled in scientific inventions; others were ministers, like Jonathan Fisher of Blue Hill, Maine, who painted landscape views as well as individual flowers and birds,[8] once more weaving together the threads of art, natural science, and morality. Another notable minister-artist was the Pennsylvania Quaker Edward Hicks. Born in 1780, he lost his mother a few years later and was brought up by neighbours. He learned carriage and sign painting in his youth. 1803 might be called the beginning of his life's work, for in that year he married, joined the Society of Friends, and began his professional careers as artist and preacher.

Income was a problem. There was none from the Friends ministry, and to compensate he continued painting signs, a practice he used to embellish a number of his landscape and religious scenes. Based on the example of a British artist and on the words of Isaiah, his favourite subject was the *Peaceable Kingdom*, which he painted in dozens

of versions.[9] The *Peaceable Kingdom of the Branch* (Plate 115), one of his earliest (1825–30), is decoratively framed with the title and biblical lines (in shaded letters): 'The wolf also shall dwell with the lamb, & the leopard shall lie down with the kid; & the young lion & the fatling together; & a little child shall lead them.' Hicks had great admiration for the seventeenth-century peacemaker William Penn, so it was natural in many of these variants to join the famous scene from West's painting with his own imagery of biblical amity. The further inclusion here of the Natural Bridge in Virginia adds a recognized national landmark and symbol of harmony. In later treatments of the theme Hicks gave larger prominence to the animals. A division within the Quaker community prompted him to interpret the beasts as gentle human personifications redeemed through spiritual conversion.

Pure landscapes of native scenery also drew the self-trained artist's attention. Thomas Chambers was born in England in 1815 and was attracted to the United States about the same time as Robert Salmon. Primarily a marine painter, Chambers was listed in the New York directories during the early thirties as a landscape painter as well, and in the Boston directories in 1850 as a portraitist. Because his works are seldom dated or signed, the number attributed to him has varied.[10] His style is unmistakable in *Staten Island and the Narrows* (Plate 116), dated loosely at mid-century. He delighted in especially bright colours, here flat areas of greens and blues highlighted by repeated touches of white for waves and clouds. Chambers also usually achieved a uniformly glossy finish with his pigments. Although views such as this were from first-hand experience, optical accuracy is submerged in a highly fanciful and vivid design.

Contemporary with Chambers' marine is one of the most compelling folk paintings in American art, the delightful and mysterious *Meditation by the Sea* (Plate 117). Part of its mystery is no doubt due to the anonymity of its maker, but part derives from a peculiar surreality as well. Small in size, vast in implied space, it shares with Lane's work (see Plate 105) its attitude toward nature and a not too different technical approach. Yet there is a whimsical fancy at work here in the strange rock configurations at the end of the beach, and not least in the diminutive figure with crossed arms who stares at the waves. One wonders whether the turbulence in the water before him is the cause or the result of his fixed glance.

Still another painter of great imaginative powers was Erastus Salisbury Field of Leverett, Massachusetts, an almost exact contemporary of Prior. Samuel Morse's diary indicates that Field spent brief time in the New Yorker's studio in 1824,[11] though what he seems to have learned from Morse was not so much academic techniques as an interest in portrait and American historical subjects. The style of his early portraits is closer to the mature work of Phillips and Prior and is, if anything, more colourful and intricately linear in decorative organization. Having travelled in southern New England for a time, he returned to New York in the 1840s and began experimenting with daguerreotypy. Thereafter, his art showed the mixed influences of photographic realism and his own inventive abstractions. He settled in western Massachusetts after 1848, and continued portrait painting through the next decades, but also turned his attention increasingly to topics of historical interest, often based on contemporary prints.

Field's most ambitious conception was his *Historical Monument of the American Republic* (Plate 118), occasioned by the country's centennial in 1876 (though added to on the anniversary of national independence in 1888). Actually, the idea first came to him from his one-time teacher. Field was mindful of Morse's deep discouragement, first over the indifferent reception of his grand interior scenes in Congress Hall and the Louvre, and secondly over the failure to secure commissions for decorating the U.S. Capitol rotunda. With Morse's death in 1872 Field adapted the older artist's idea for a painting on the subject of *The Germ of the Republic*,[12] but in the manner of the folk artist he transformed his theme from a single historical time to a panoramic composite of events and personalities. The scale of his canvas itself (over nine by thirteen feet) was suitable for such a sweep of history and for the grandeur of a national celebration.

Its multiplicity of architectural styles was intended to demonstrate the individuality and variety of democracy, but of course also indicated the current prevalence of eclecticism. Depicted in the lower levels (the firm foundation of the country) were the earliest incidents of national progress. In the upper arcades were illustrations of subsequent historical glories. Major statesmen, generals, and heroes were shown carved in high relief or placed as statues in the round between the columns. Metaphorically crowning the upper sections were vignettes of contemporary life. In a final blaze of futuristic technology steam engines cross aerial trestles connecting the principal towers.

As an image of collective determinism, orderly evolution, and heroic achievement, Field's canvas is a worthy successor, in grandeur of form and subject, to the precedents of West, Trumbull, Vanderlyn, and Cole (see Plates 43, 47, 65, and 91). To some extent it possessed a timeliness that the late ambitions of Trumbull and Vanderlyn did not achieve, and its optimistic panoply coincided with the exaggerated rhetoric of later canvases by Church and Bierstadt (compare Plates 108 and 148). What such visions overlooked were the sobering realities of the Reconstruction period. A nation, like an individual, in its youth has little concept of its mortality. What the aftermath of the Civil War finally showed was the end of America's adolescence, and the deepest questions for the second half of the century would concern human and institutional endurance. Thus, where Field completed the final chapter of a century-old vision, Thomas Eakins at the same moment (see Plate 165) was drawing the lineaments of the future.

In a comparable way the folk sculptor's heyday also came during the middle decades of the century. Exuberance in American life expressed itself through a constant playfulness of forms, carnival colours, and whimsical distortion of scale. That carved objects were primarily utilitarian made them no less concerned with the expressive properties of abstract design. A witty example is *Jack Tar* (Plate 119), an over-lifesized ship chandler's sign. Like many cigar-store Indians or other symbols of trade, such forms were often enormous in scale in order to be immediately recognizable and engaging emblems. Such gigantism and isolation of a single shape were, appropriately, to become devices for Pop Art in the 1960s (compare Plates 284 and 286) with its renewed interest in mundane imagery and commercial advertising.

Significantly, the nineteenth century was the period for the great flourishing of America's other major indigenous arts, those of the Indian. For a culture so often viewed

in contrast to the European aesthetic of the settlers, it is ironic that the American Indian believed equally, or even more strongly, in the spiritual power of the land. It was not the romance of conquering the wilderness or shaping the national destiny with the steam engine, but a more mystical reverence for the earth:

The ground says, The Great Spirit has placed me here to produce all that grows on me, trees and fruit. The same way the ground says, It was from me man was made. The Great Spirit, in placing men on the earth, desired them to take good care of the ground and to do each other no harm . . .[13]

Harm was their portion nonetheless. With the arrival of the Europeans the Indians were gradually displaced from the east coast to territories westward and finally to isolated reservations by the end of the nineteenth century. Each tribal group responded differently to the forces of acculturation and assimilation. The Cherokee, for example, and some of the other tribes of the southeast tended to adapt readily, while the Pueblos in the southwest remained zealous in their efforts to retain their traditional culture.[14] The often savage confrontation of opposing energies scarred the western plains and mountains during the century, with reality itself often made mythic.

The close identification of the Indians with nature may explain their foremost artistic achievements in the three-dimensional arts, such as cliff dwellings, monumental burial mounds, and various sculptural forms in wood and clay. There have survived fine examples of painting on wood, bark cloth, hides, or walls. Most familiar are decorated shields, drums, tents, clothing, and of course painting the body for warlike or ceremonial purposes. Both more prevalent and more expressive, however, are the carved and modelled works developed in each tribal area: basketry in California, clay pottery and woven materials throughout the southwest, beadwork across the Plains, totem poles in the northwest, and masks in the Arctic.

Making something palpable directly from the materials of the earth seems to possess a power different from painting. Whether this derives from the sense of posterity in solid forms and permanent materials, from the physical and environmental involvement of the maker, or from the impulse of creating a presence as real as oneself – who can say? What is evident is the spiritual or magical authority associated with the strongest Indian sculpture. Such is the case with the carved wood figure from the Wasco tribe (Plate 120) of the Great Plains area between the Rockies and the Sierra Nevada. The Wasco lived along the Columbia River in Oregon, and cultivated what is known as the 'X-ray' style, so called from the serrated patterns suggesting exposed ribs.[15] Such attention to geometry and symmetry is characteristic. A Sioux, one of the Indian graduates of Dartmouth College in 1887, explained that his people

possessed remarkable powers of concentration and abstraction, and I sometimes fancy that such nearness to nature as I have described keeps the spirit sensitive to impressions not uncommonly felt, and in touch with the unseen powers.[16]

That idea of spirit into substance is as old as prehistory (see Plate 4): no less has it appealed to twentieth-century artists as culturally diverse as Jackson Pollock and Fritz Scholder (see Plates 250 and 273).

STORIES IN PAINT AND STONE

THE sweeping neo-classical revival, which dominated American sculpture for the half-century between Horatio Greenough's departure for Italy in 1825 and the nation's Centennial in 1876, reflected American aspirations as fervently as did landscape painting. Both were concerned with moral and spiritual content, even upon occasion with specific questions of Christian ethics. Neo-classicism as it appeared in both sculpture and architecture was equally concerned with the romance of science, specifically archaeology, which paralleled the landscapist's reverence for botany and meteorology; while both relied on the metaphors of mathematics in stressing measurement, proportion, and harmonious order. Both cared deeply that art have an edifying role and a nationalist character. It is significant that a number of sculptors took subjects from English romantic poetry. Nature served as the universal model of order, and was equated with the organization of architecture as well as the human body. In this connection it is appropriate to note the large number of neo-classical figures carved for fountains, parks, malls, and cemeteries.

American neo-classicism (especially in architecture) was nationalist in style, function, and form. Stylistically, it rejected the book-derived Palladianism of English forms in favour of direct inspiration from the original Greek and Roman sources. Functionally, it perfectly served the individual in a democracy. The basic rational orders were recognized by all at the same time that they allowed flexibility for adaptation to individual needs. Thus, the temple form equally accommodated churches and banks, government buildings and private dwellings, waterworks and universities, and so unified every working facet of democracy. Formally, the classical revival provided a desired sense of permanence, both in the use of stone (which now replaced wood in earlier architecture and sculpture), and in the new solidity of three-dimensional mass. Aggressive and bold as Jacksonian individuality, Greek forms and figures stood with components clearly defined and the whole confidently self-contained.[1]

In another parallel with painting, this sculptural movement evolved through two phases from a more philosophical stance to an increasing naturalism and exoticism in the later work. The older generation led by Horatio Greenough and Hiram Powers created powerful rhetorical symbols in the same spirit as Cole's literary landscapes, while a younger group emerging at mid-century turned to foreign themes, such as the Near East, which attracted William Wetmore Story as it had Church and Gifford. Greenough and Powers are interesting figures to compare. They were born in the same year, 1805, and spent their careers in Florence (in contrast to the larger group working in Rome), but came from opposing backgrounds, the former a Boston Yankee, the latter a rural artisan. They were the pioneering intellects of the movement, and together created the two summary pieces of neo-classical sculpture: *George Washington* and *The Greek Slave*

(Plates 121 and 122); at the same time the first major portrait busts were, characteristically for Greenough, of John Adams and John Quincy Adams, and for Powers, of Andrew Jackson and John Calhoun.[2]

Early 1832 saw a historic moment in the passing of a resolution in the House of Representatives – 'Resolved, that the President of the United States be authorized to employ Horatio Greenough, of Massachusetts, to execute, in marble, a full length pedestrian statue of Washington . . .'[3] – for this was the government's first important commission of sculpture to a native artist.[4] Greenough's friend Washington Allston had assisted in bringing him this honour; so had James Fenimore Cooper, who offered further advice directly to the sculptor: 'Make the figure as servant and simple as possible. . . . Aim rather at the natural than the classical.'[5]

At work on the large marble (Plate 121) from 1833 to 1841, Greenough was and still is criticized for neither following Cooper's advice nor in fact satisfactorily resolving the dilemma posed between idealism and realism. (Of course, this tension was a similar one for the work of Cole and Durand.) The truth was that even Cooper sought certain classical allusions, and others virtually in the same breath complained about the piece being both too classical and too literal. The collector and former mayor of New York Philip Hone observed that

It looks like a great herculean Warrior – like Venus of the bath, a grand Martial Magog. . . . Washington was too prudent, and careful of his health, to expose himself thus in a climate so uncertain as ours . . .[6]

Yet Greenough's intention was precisely to join, as contemporary taste required, classical allusions (here the pose of the *Zeus* by Phidias) and recognizable immediacy, as in the realistic facial features and the veins on Washington's upraised arm. In fact, he described his Washington as 'a conductor between God and Man'.[7] Such mediation between opposites is further evident in details such as the relief panel on one side of the chair showing allegorical figures of North and South America, and the small carved figures of Columbus and an Indian atop the chair's back who represent the European and indigenous aspects of the New World.[8] In all his subsequent portrait and allegorical pieces Greenough continued to elaborate on these two interrelated strains in his style.[9]

Almost more problematic for historians have been his theories on art: seemingly remote from his overtly ideal sculpture are his famous lines defining 'Beauty as the promise of Function; Action as the presence of Function; Character as the record of Function'.[10] Significantly, it was in forms of folk architecture, so to speak, that Greenough most clearly perceived his idea of functionalism:

The men who have reduced locomotion to its simplest elements, in the trotting wagon and the yacht *America*, are nearer to Athens at this moment than they who would bend the Greek temple to every use. I contend for Greek principles, not Greek things.[11]

We might argue that he did not recognize how truly a Greek principle as well as thing was the Greek temple for every use – in the context of America. At the same time he did make an intellectual link between his art and his ideas. The connecting metaphor and reality was the human figure; for like the yacht or wagon, and by extension pure Greek

revival architecture, the human body was 'the most beautiful organization of earth, the exponent and minister of the highest being ... a many-sided response to the call for many functions'.[12] Nakedness was the exposure of truth.

Greenough's friend Hiram Powers was in his own way equally interested in the elements of idealism and naturalism in his art. Powers grew up in the frontier community of Woodstock, Vermont, and moved to Cincinnati, Ohio, in 1818, where he worked in a clock factory ('some of my happiest days'[13]) and later in a local museum. There he first learned to model in wax and saw on exhibition a plaster cast of Houdon's *Washington*. Soon Powers himself accomplished a successful series of commissioned portrait busts. Former President John Quincy Adams was so pleased with his that he responded with lines of poetry, not unlike those penned by Bryant to Cole a few years before:

> Artist! may fortune smile upon thy hand!
> Go forth and rival Greece's art sublime.
> Return, and bid the statesmen of thy Land
> live in thy marble through all after time.[14]

Powers set off for Italy in 1837, where he continued to model strong, well-received portrait busts. At first he had difficulty translating the plaster casts into marble; eventually he found talented assistants, and later with the so-called pointing machine was able to transfer his designs accurately to the stone.[15] Powers' ambitions soon prompted him to undertake a major imaginative piece, *The Greek Slave* of 1843 (Plate 122), perhaps the essential sculpture of American neo-classicism.

Mindful of contemporary interest at home in the issue of slavery, and of the sympathy on both sides of the Atlantic for the Greek War of Independence, Powers imagined an 'embodiment of enslaved Greek womanhood'.[16] An ideal conception, but modified by a hint of repressed sensuosity in the softly modelled flesh, the figure ultimately is less Greek than Victorian. The essential romanticism which inhabits this classical frame is a clue to the work's pre-eminent popularity and influence. Greenough anticipated the response of prudery by declaring that his figure 'is too deeply concerned to be aware of her nakedness. ... It is not her person but her spirit that stands exposed.'[17] The appeal to morality was confirmed by contemporary sermons, one of which declared: 'The *Greek Slave* is clothed all over with sentiment, sheltered, protected by it from every profane eye.'[18]

The work was a sensation at the Crystal Palace in London in 1851 and at its successor in New York two years later. Powers had orders for several marble replicas in full and half size. In terms of idea, emotion, and form *The Greek Slave* was a definitive embodiment of American taste. It inspired other busts and full-length figures in the prolific years that followed, by Powers as well as by younger sculptors like Erastus Dow Palmer, Chauncey B. Ives, and William Henry Rinehart.[19]

Only a few years younger than Greenough and Powers was the New Yorker Thomas Crawford, who was the first important American sculptor to be active in Rome. Born in 1813, he worked as a youth for John Frazee and attended drawing classes in anatomy

at the National Academy of Design. He left for Rome in 1835, and there enrolled in the studio of Bertel Thorvaldsen. By 1850 he had gained a major commission from the city of Richmond, Virginia, for an equestrian statue of Washington.[20] Consequent upon this, he was given in 1853 the opportunity to decorate the recently extended Capitol wings.

When the House of Representatives moved into its new space, the former chamber (see Plate 74) was designated Statuary Hall, another indication that this generation required memorials with the solidity and permanence of marble. Before his early death in 1857 of a brain tumour, Crawford completed the monumental figure of *Armed Liberty* for the top of the Capitol's dome, a sculptural group for the pediment of the Senate wing, and designs for bronze doors at the entrances to the House and Senate. The pedimental group included some dozen pieces illustrating 'The Progress of Civilization'; flanking the central figure of America were the pioneers and settlers on one side, an Indian family on the other.

Crawford duplicated one figure in marble, *The Indian* (*the Chief contemplating the Progress of Civilization*) (Plate 123). Like that of Greenough and Powers, Crawford's imagery was a mixture of elements fusing reason and emotion, past and present, symbolic and specific. Even the carving of the Indian adds native details of dress to the classicized torso.

This basic ambivalence is discernible in most neo-classical sculpture, including that by the one major individual who remained in America throughout his career: Erastus Dow Palmer. However, with the second generation of carvers who travelled to Rome about mid-century, various elements of the style became more exaggerated. This younger group, whose careers often stretched to the end of the century – William Randolph Rogers, William Wetmore Story, William Henry Rinehart, Harriet Hosmer, and Edmonia Lewis – favoured greater degrees of realism and emotionalism.

This is immediately evident in comparing Edmonia Lewis' portrait bust of *Abraham Lincoln* done in 1867 with Greenough's *Washington* (Plates 121 and 124). Born in 1845, Lewis was the youngest of what Henry James called 'the white marmorean flock'. If Harriet Hosmer was the most independent-minded of the women sculptors in Rome,[21] Edmonia Lewis was the most interesting. Her mother was a Chippewa Indian, her father a Black; her early education included study at Oberlin College and some instruction from the sculptor Edward Brackett. In Rome during the 1860s, she produced pieces related to her Indian and African ancestry as well as to current issues.[22] Thus, her *Lincoln* is dressed in contemporary clothing, a figure still marked by the dignity and idealism of neo-classical precedents, but now a more accessible and humane individual, author of the Emancipation Proclamation.

Like Greenough, Story was a well-educated Bostonian; at the age of thirty-seven he gave up law practice permanently for a sculptural career abroad, and in 1856 joined the flock in Rome. His preference for strongly romantic and dramatic subjects emerges in his best known marbles of *Cleopatra* (1858, Metropolitan Museum) and *Salome* (1871) (Plate 125). The earlier was the better known at the time, although the partially covered front of *Cleopatra* evolved in the *Salome* to a fuller, more erotic exposure. Now, too, pure classicism has yielded to Egyptian revival details and an asymmetrical composition

that suggest a mystery and instability quite changed from Greenough's seated figure. Hawthorne saw the new sensibility in the *Cleopatra* (though his words apply equally to *Salome*) when he called it 'a work of genuine thought and energy, representing a terribly dangerous woman; quiet enough for the moment, but very likely to spring upon you like a tigress'.[23]

Story himself wrote a long poem about the earlier work, but again his lines aptly describe the recurring theme in *Salome*:

> I will lie and dream of the past time,
> Aeons of thought away,
> And through the jungle of memory
> Loosen my fancy to play . . .[24]

Memory, danger, imagination, sexuality – these were all digressions in the course of later neo-classical sculpture. After mid-century other interests developed as well, such as explicitly realistic anecdotes and the expressive possibilities of bronze casting, most notably in the respective careers of John Rogers and Augustus Saint-Gaudens (Plates 126 and 182). Neo-classicism in sculpture outlasted the movement in architecture by about a decade, primarily because sculptural form could sustain narrative moral content, whereas the utilitarian and psychological needs of architecture eventually found other styles and methods of construction more compatible.

The sculpture of John Rogers makes a unique transition between the literary imagery of the neo-classicists and the popular homilies of genre art. From a solid Yankee background Rogers was to pursue an artistic course entirely different from those of his fellow New Englanders Greenough or Story. Born in Salem in 1829, he learned basic drawing in a Boston high school, but with the onset of eye trouble he took up clay modelling. This was followed in the 1850s by mechanical pursuits in Manchester, New Hampshire, and Hannibal, Missouri. He continued to sketch and model, and by 1858 was convinced of the need for professional artistic training abroad. But neither Paris nor Rome could hold him. Having had no education in classics, he saw little merit in copying antique casts; more compelling was his interest in storytelling.

Within a year he was back in the United States, and after a small plaster group received favourable publicity in Chicago, he seized upon the idea of making bronze casts of his subjects which might in turn be replicated inexpensively in plaster for popular sale. By 1863 he had commenced a prolific and successful career that was to last for thirty years.[25] Through his happy combination of publicity, multiple copies, low cost, and ordinary subject matter, his art was unparalleled in its day in reaching a wide American audience. Through anecdote and sentiment Rogers' themes celebrated Civil War leaders, moralistic incidents from novels and plays, and mundane vignettes from the lives of every citizen. In imagery and method the Rogers groups were utterly democratic.

His assertion that 'home scenes interest *everybody*'[26] is realized in *Checkers up at the Farm* of 1875 (Plate 126), one of the most popular pieces he ever marketed. Its price was

fifteen dollars and sales amounted to five thousand copies.[27] Using his wife and child as models, a frequent practice for him, Rogers arranged the group in a compact but visually interesting pyramidal design. He had made a number of previous versions in 1855, 1859, and 1860, as well as a related pair of card players in 1862. Ultimately, all of these derived from pictorial sources familiar to him in the 1850s; for example, he owned a collection of engravings after Sir David Wilkie, from which the specific subject came; and he also knew from his stay in Missouri the various card-player groups on river flat-boats painted in the same years by George Caleb Bingham, whose balanced arrangements of a few figures were similar in format and feeling.[28] In the imagery of game-playing, taken up as well by William Sidney Mount, A. D. O. Browere, Eastman Johnson, Seth Eastman, and Richard Caton Woodville (see Plates 128 and 141), was yet another metaphor of praise for democratic America.

The reference to genre painting is apposite in confirming the common ideas in many of the arts during these years. From the twenties to the seventies a large and varied group of painters concentrated on subjects from popular literature and everyday life. They gave the common moments, musings, and pleasures of the ordinary citizen symbolic importance, in the belief that individual lives mirrored the larger strengths of the nation. One of the earliest genre painters was the German-born John Lewis Krimmel, who came to Philadelphia in 1810. Before his death from drowning in 1821 at the age of thirty-two, he completed a sequence of observant local scenes.

Among the first is *Fourth of July in Center Square* of *c.* 1810–12 (Plate 127), with its fashionable assemblage of the citizenry on a national holiday. Quite pointedly, Krimmel associates this celebration with the young country's artistic and technical accomplishments. Occupying centre stage is William Rush's carved allegorical figure of the Schuylkill, the *Nymph with Bittern*, and looming behind is the massive form of Benjamin Latrobe's Central Pump House for the Fairmount Waterworks. The engine pump inside signals its romantic power by the plumes of smoke issuing above, giving to the neo-classical forms and to the narrative scene a nationalist identity little different from Church's vision of *Cotopaxi* (Plate 109).

Born in 1825, Richard Caton Woodville of Baltimore died equally young, also after a productive career of only ten years. By the age of sixteen he had learned to draw with great facility, a talent which served him well when he left in 1845 for Düsseldorf. During the next six years he studied at the Academy and with the genre painter Carl Ferdinand Sohn. Both helped him to strengthen his style of precise draughtsmanship and meticulous detailing. He became especially adept at recording telling portrait features, even intimating qualities of character, and at placing his figures within sharply defined interior spaces.[29] All these elements are brought together at their best in *Waiting for the Stage* of 1851 (Plate 128). The careful control of lighting and displacement of objects almost suggest an image caught within a camera obscura. The three figures are at once unified and isolated within their world of thought and action. As the title indicates, it is time suspended, punctuated only by sparkling highlights of such details as the burning coals, decanter, and spectacle frames. Within this miniature theatre Woodville manages to create a balanced drama of physical and psychological presences.

Both Jerome Thompson and Enoch Wood Perry show the gradual transformation of genre painting during the middle decades of the nineteenth century. From the more elaborate anecdotal works favoured initially, painters increasingly moved to open, sun-filled landscape settings. Thompson's life spanned the middle two quarters of the century, and though he was based for most of his career on Long Island, New York, he painted extensively in northern New England, and probably knew recent English painting through engravings. In the 1850s he undertook a series of canvases in Vermont, of which *The 'Pick Nick' near Mount Mansfield* (Plate 129) is a fine example. Characteristically, Thompson arranges a group of figures, some seated, some standing, on a rising knoll in the foreground, with a far-reaching luminous landscape view visible beyond them. This format served him well in other variants on the subject, one that appropriately held in radiant balance man and nature.

Perry was a younger artist; in 1852, at twenty-one, he went to Düsseldorf for study with Leutze. During the next decade he moved frequently around the United States, although he was settled in New York by 1866. He was capable of artfully composing figures in an outdoor setting, an ability seen to advantage in his large canvas of *The Pemigewasset Coach* (Plate 130). Although dated by some to much later in his career,[30] this does not possess any characteristics definitive of his late work; on the contrary, the gesturing youths, bright colours, luminous landscape setting, and the carriage subject itself are much closer in spirit and style to the very similar work of the early 1870s by Perry's friends Eastman Johnson and Winslow Homer (compare Plates 153, 159, and 160).[31] All three of them occupied neighbouring quarters during the seventies in the Tenth Street Studio Building in New York, and through Düsseldorf associations or recent American prints their work of this period, and notably this oil, reflects an awareness of similarly silhouetted figures in earlier compositions by Bingham, Leutze (see Plates 141 and 143), and David Claypoole Johnston.

Applying the same balance of figures and landscape to imaginary subjects, the New York painter Albertus D. O. Browere was typical in his fascination with the Rip Van Winkle story. Son of the sculptor John H. I. Browere, he painted primarily in the Catskills, but made two long trips to California during the 1850s. Several large views of the western mountains, as well as at least one of gold-miners playing cards, resulted. His painting of *Rip and Wolf chased from Home by Dame Van Winkle* (Plate 131) was one of a series he did late in his career, but treats the literature with the same gusto and immediacy as real life. America actual or imagined was cause for self-confidence.

CHAPTER 15

CELEBRATIONS OF EXPERIENCE

IN recording the daily life of ordinary people, genre painting in its own way expressed the exuberant sense of national consciousness in mid-nineteenth-century America. Chronologically, Krimmel and his contemporary D. C. Johnston might be considered precursors of the movement, which unfolded in two sequential phases. The first included a group of artists born between 1812 and 1815, among them Browere and Thompson, James G. Clonney, William Ranney, and David Gilmore Blythe. Although younger by ten years, Woodville produced pictures which coincide directly with those of this generation.

A younger group of genre painters, led by E. W. Perry and J. G. Brown (both born in 1831), lived into the twentieth century, with their mature work emerging in the 1870s. Generally, genre paralleled landscape painting in its early focus on literary or strongly narrative content, and in its later attention to more spacious, sunny landscape settings with less active figural arrangements. Often more contemplative and serious, it was these younger painters who in turn provided the background, and in some instances precedents, for the early work of Eastman Johnson, Winslow Homer, and Thomas Eakins. Light as both an optical and metaphysical presence, an increasing concern in mid-century landscape painting, often became an equally expressive device for the contemporary genre artist (see Plates 129, 138, and 140).

The three major genre painters of the first half of the nineteenth century are indisputably John Quidor, William Sidney Mount, and George Caleb Bingham. Quidor and Mount particularly, by their respective births in 1801 and 1807, were artistic contemporaries of Thomas Cole in the Hudson River school and Fitz Hugh Lane in the luminist movement. Quidor came from upstate New York, and most of his highly imaginative pictures reflected either his own recollections of the region or its description in the romantic tales of Washington Irving.

Quidor's family moved to New York City in 1811, and for a time between 1814 and 1822 he studied as a pupil under the portraitist John Wesley Jarvis. Henry Inman was a fellow student, and biographers have noted how little Quidor must have been affected by his associates. Yet, subjective and expressive as his painting was, it is pertinent to note that in 1827 he was listed as a portraitist himself in the city's directory, and that three years later the one pupil he took on, Charles Loring Elliott, was also to be known as a portrait painter. Another friend, John H. I. Browere, frequented Quidor's studio for discussions of his life masks (Plate 81). Thus, a strong picture emerges of Quidor's interest in painting people. One friend later recalled that 'John Quidor was the only avowed figure painter then in New York.'[1]

It was not the objective world of traditional portraiture that appealed to him, but rather the inner whimsies of the human situation and personality. To this end he turned

for subjects in the late 1820s to romantic literature by Cervantes, Cooper, and, more than any, Washington Irving. A point of interest here is the fact that Cole settled in New York in 1825, and shortly after undertook his own paintings from stories by Cooper (Plate 89) and Irving. Quidor seems, therefore, very much a part of contemporary artistic currents, independent of mind, but by no means isolated from outside influences and ideas.[2]

Quidor's first significant works date from 1829, when he painted at least two themes of apparition taken from Irving's *Sketch Book*, the most evocative being *The Return of Rip Van Winkle* (Plate 132). Irving's humorous and magical tales were also painted by Cole, Durand, and Quidor's colleague Inman,[3] as well as by Browere much later (compare Plate 131). However, Quidor was the least interested in illustration of an incident, and conversely most intrigued by the essential inner psychological drama. Attesting to his reputation as a figure painter, his figures here constitute the strongest part of the painting. With great control of colour – the most intense blues and reds are in the foreground – and of drawing – the exaggerated gestures and profiles of the three central figures are the sharpest – Quidor concentrates our attention on the confrontation of Rip with his present and past identities.

The crucial moment in Irving's story, which Quidor takes to interpret, is one of confusion for Rip:

I'm not myself – I'm somebody else – that's me yonder – no – that's somebody else got into my shoes – I was myself last night, but I fell asleep on the mountain, and they've changed my gun, and everything's changed, and I'm changed, and I can't tell what's my name, or who I am![4]

The basic subject, then, is the question of reality itself. Quidor saw that the essence of art, whether literature or painting, was posed in this very moment of the tale, where the ambivalent truths of time, dreams, and imagination all emerge from the framework of the narrative. The technique of painting reinforces the scene's imaginative power: as if in a dream the background figures, buildings, and landscape fade into an undefined hazy ground, while the doubting town fathers who cause the immediate anxiety appear most precisely. To the side is a slouching figure, an alter-ego as real or not as one wills or fears or believes him to be. In the same mysterious way this isolated figure reappears in several later Quidor oils, sometimes observing the scene with detachment, at others in the distance fleeing from the action.

No one is certain of Quidor's pictorial sources, although some originals, as well as engravings and copies, of seventeenth-century Dutch genre paintings were on view in New York during this period. Engravings of works by eighteenth-century English artists (for example, Hogarth and Wilkie) were also widely circulated, as we know from their impact on the work of Mount and Bingham.[5] Casts of classical sculptures were in collections such as that of the Pennsylvania Academy of the Fine Arts, and were commonly used as fundamental resources for an artist's training. One wonders if Quidor here had in mind copies of Michelangelo's marble of the *Bound Slave* for the figure against the tree along with the image of *God the Father* for the hoary profile and pointing arm of Rip.

An even more eerie and dramatic apparition from Irving's *Tales of a Traveler* is the basis for *The Money Diggers* (Plate 133), painted three years later. Here, at the moment of discovering the chest of gold, Wolfert to the left, Knipperhausen in the centre, and Sam climbing from the pit, all respond to the 'grim visage of the drowned buccaneer, grinning hideously' from the cliff above. Irving goes on to state that 'panic communicated itself . . . all was horror and confusion'.[6] Now the colour scheme is intensely dark, with all the physical action and psychological tension conveyed by the central fire at the pit's edge casting highlights on crucial details nearby. Even the trees respond with suitably expressive contortions. (At the same time, such a language of gestures for both figural and landscape forms appears in the work of Quidor's contemporaries, most notably Allston and Cole; see Plates 71, 73, and 90.)

Quidor was also a master colourist. Much of the visual impact of *The Money Diggers* relies on the strong oppositions of light and dark, along with the animated repetitions of basic reds, yellows, and blues which at once distinguish and relate the various figures. By the end of the thirties Quidor was able to unify even more effectively his range of tones, gestures, compositional organization, and psychological elements. *Antony van Corlear brought into the Presence of Peter Stuyvesant* (Plate 134) is at first glance a picture of wild activity, highlighted by the mad facial expressions and gesturing limbs. Like the staccato rhythms of music, all these forms are a visual expression of the trumpet's noise.

This is one of Quidor's most deftly composed canvases. As a framework (and foil) for the sinuous and agitated figures, the room is a measured stage of planar surfaces, each subdivided into smaller rectangular blocks, for example the floor pattern, door panelling, window panes, and framed picture on the wall. There seems to be an intentional counterpoint of the world within and without, intimated in the landscape views out of doors as well as on the wall. Once more the detached observer is present, in the soldier standing guard at the door. Quite rightly, the question has been asked if this might not be a personification of the artist himself, the outsider;[7] perhaps more pointedly he is the one individual who stands on the threshold between reality and illusion. With Quidor mystery always blurs the edges of mirth and ribaldry.

Throughout much of the next decade Quidor's whereabouts and painting activities are unclear, and speculation has raised the possibility of a trip to the west. He returned to Irving subjects in the fifties and sixties, but with a new emphasis on sketchy calligraphy, hazy definition of form, and suffusing golden tonalities. Thereafter, the power waned from this extraordinary career.

Where Quidor turned to his inner imagination, William Sidney Mount of Setauket, Long Island, looked to the objective world of people and farm lands near his home. After some local instruction, he went to New York in the mid twenties to work as a sign painter with his brother Henry. During 1826 he enrolled in the school of the National Academy of Design. Still impressive as exemplars for would-be artists were the history paintings in the grand manner then on view by Trumbull and West, from whom Mount borrowed directly for his own first efforts in oil.

By 1830 his first portraits and genre scenes had lost some of the early hardness of colour

and drawing. His interest in genre was stimulated by Dutch painting, which he had ample opportunity to see in New York. Allston in particular urged him to emulate Ostade and Steen, and Mount later noted his familiarity with Teniers.[8] The wide circulation of engravings after Hogarth and Wilkie also played a role in popularizing anecdotal subjects, and examples by some of Mount's older colleagues, such as D. C. Johnston, Durand, and Allston, would have confirmed his interest. In addition, he knew Cole and Bryant among others in New York, and with Quidor shared a mutual association with Henry Inman. It is not surprising that the practitioners of landscape and genre painting found much in common.

In 1836 Mount moved back to eastern Long Island, where he remained for the rest of his career. His relief at leaving the city is reflected by his first major work set out of doors, *Farmers Nooning* (Plate 135), with 'the canopy of heaven for my paint room'.[9] Concentrating foremost on a narrative moment expressed through the figures, Mount felicitously balances them with the peaceful landscape background. Colour and lighting likewise combine bright details and mottled shadows with the pervasive warm glow surrounding the foreground group. All these devices well suit the contrasts of active and passive, above all suggesting a pleasure, both delighted and serious, in the American scene.

Four years later Mount found an even more gracious solution for relating these various pictorial elements in *Cider Making* (Plate 136). The painting shows a sequence of related moments in the process of making and enjoying cider, from the youths who ride the wheel crushing apples and the men turning the press (central to the operation and to the composition), to another group of youths seated by barrels in the foreground and a second trio of men (including Mount with his sketchbook) conversing at the far right. Each one of these groups has both an animal and an echoing inanimate form nearby. Thus, the boys and girl sit next to cider barrels in the foreground; the children behind are associated with the wooden wheel, itself framed by the blue hillside beyond;[10] the men in the centre stand beneath the mill's roof; while on the right the men by the fence have an adjacent counterpoint in the hayrick up the hill. Furthermore, Mount ties these various episodes together visually by glances carrying from one group to the next and to the spectator himself.

Mount has created an optimistic metaphor of America's abundance. The sun is high, the season is Indian summer, and cider is yielded from sweet apples, all testifying to the warm and productive relationshp between man and nature. But the picture had a more immediate relevance as well. Charles Augustus Davis, who commissioned it, was a prominent New York merchant who belonged to a powerful circle of Whigs involved in fighting President Van Buren's re-election in 1840. Appealing to popular emotions with phrases such as 'Tippecanoe and Tyler too', the party publicized General William Henry Harrison's presumed preference for a log cabin and a barrel of cider to the White House. That imagery carried the election for Harrison, and occasioned Davis's commission to Mount. A contemporary newspaper description of the painting noted that because the barrels of hard cider were 'of choice quality, the old squire had marked it "1840" – a year ever famous, he said, for "hard cider", and he intended it as a present

to "*Old Tip*" '.[11] This would account for Mount's dates of 1840 on the barrel and of 1841 in the left-hand corner; the former was a time of harvest (in several senses) as the latter was of fruition.

That Mount should have been interested in politics, like Bingham, who actually ran for office in Missouri, is not surprising, for involvement in the crucial daily affairs of one's fellow citizens was a natural extension of genre subject matter itself. Mount's fundamental interest was people, and this is nowhere more indelibly recorded than in his familiar *Eel Spearing at Setauket* of 1845 (Plate 137). Characteristically, the individuals were familiar faces to the artist (the boy and dog may well be the ones in the foreground of *Cider Making*), and he places them before a landscape he knew well, 'a view of the Hon Selah B. Strong's residence in the distance during a drought at Setauket, Long Island'.[12]

Although Mount described, and painted, his view with an almost scientific precision, he attains a metaphysical level of allusion. He remembered the moment as 'calm, and the water as clear as a mirror, every object perfectly distinct . . .'.[13] With the clarity of a camera he captures the dry, early morning light, and so fixes the strong silhouettes of boy, woman, and boat in a stable pyramidal design that we hardly observe other figures rowing beyond them. Through the clear light, limpid water, and concentration of thought in these faces, the attendant pause is released from the immediate and (in a proto-luminist vision) stilled beyond time.

Mount had a highly inventive mind; he adapted musical instruments to practical needs, and he was fascinated by perspective. Along with many in his day he became immersed in spiritualism. While *Eel Spearing* embodies none of these pursuits singly, it reflects the overlapping ideas of art, science, and religion that appealed to Mount and to his age.[14]

As a record of place, such a picture possesses a sense of praise similar to that of his fellow Long Islander, Walt Whitman. This 'Isle of sweet brooks of drinking water – healthy air and soil!/Isle of the salty shore and breeze and brine!'[15] was for the poet equal occasion to celebrate America's variety and harmony. Indeed, many in Whitman's generation believed with him that 'there is no imperfection in the present, and can be none in the future'.[16] This tone of celebration in both Whitman and Mount later took a more contemplative direction, as is evident in two works by Mount of the late 1850s, *Long Island Farmhouses* and *The Banjo Player* (Plates 138 and 139).

In the former the golden glow of *Eel Spearing* has evolved into the hazy thin warmth of a late autumn afternoon. Mount's composition is as deft as ever. Always mindful to relate figures, buildings, and landscape, he here unifies our view of the several farm-houses from foreground to distance by means of the dominating tree's dark branches and its shadows, which carry our eyes through the composition.

This elegiac and meditative mood suffuses *The Banjo Player*, too. This picture is sup-posedly unfinished, but one must feel there was some deep impulse towards incomple-tion, for it is in keeping with Mount's de-emphasis on the number and activity of figures in several later canvases. This particular subject was the conclusion of a series going back to the early 1830s that depicted barn dancers and musicians. With each succeeding

version the physical activity diminished, the composition was made more economical, and the subject turned more from a descriptive accounting to the quiet inner voice. A musician himself, Mount, like Eakins, saw and felt music's power as an emblem of creativity. Just as the barn setting here is half inside, half outside, so *The Banjo Player* evokes a song as much to himself as to us.

Although Mount's midwestern counterpart, George Caleb Bingham, was born in 1811 in Augusta County, Virginia, he moved to Missouri at the age of eight, and was thereafter always associated with his adopted region. When young, he learned to draw and to copy engravings; by 1854 he had completed some rather stiff and awkward portraits. The critical time of change for him was a period of study in Philadelphia in 1838 and a likely side visit to New York. Besides studying American paintings at the Pennsylvania Academy, Bingham also bought engravings and casts for future use. The works on view of Philadelphia artists such as Birch, Neagle, Sully, and Shaw had a special impact on the formation of his own first essays at landscape and figure painting.[17]

With little question the most significant stimulus in his taking up genre was the example of Mount, whose works he had the opportunity to see in the east both first hand and through engraved copies. Bingham employed several similar methods, among them the use of instruction books on composition as exemplified by the old masters, and the adaptation of subjects or designs from Hogarth and Wilkie. Mount's own pictures were well regarded by the public by 1830, and a number provided themes which Bingham reinterpreted in his paintings during the 1840s.[18] While stylistic evidence confirms Bingham's debt to Mount on various occasions, the picture most often brought forward to prove it is paradoxically the Missouri artist's first major work of real originality.

Although *Fur Traders descending the Missouri* (Plate 140) was completed in the same year – 1845 – as *Eel Spearing at Setauket*, Mount's picture was not exhibited until a year later.[19] Drawing on similar sources and techniques, both painters arrived at a comparable vision of rural life. Bingham's original title for exhibition was 'French Trader and his Half-Breed Son', an indication of the exoticism he saw in the people and landscape of the frontier. Borrowing a device Mount occasionally used of having figures look out at the spectator, Bingham here turns all the glances outward.[20] This mode of fixation is also reminiscent of the daguerreotype, whose influence may further account for the stillness of mood and of design.

Bingham was to continue painting for over thirty years more, but this picture began the most productive and imaginative decade of his career. In the *Fur Traders* he established methods of composition and colouring which were to characterize his best work of the next few years. He favoured the balanced arrangement of forms parallel to the picture surface, and often he framed the figural shapes with similar contours of a landscape screen behind. He also relied on pure primary colours of red, yellow, and blue for the clothing of the principal figures, with paler variants repeated throughout the rest of the scene. This was but another means of harmonizing the human and natural subject matter. Remarkably, he achieves a sense of motion stayed. The water is at once mirror-

clear, yet nonetheless moving leftward across our frame of vision. Through vertical and diagonal shapes Bingham evokes a feeling of forward motion so imperceptible as to seem perpetual. Physical action becomes fused with reverie, as even the spectator is engaged in thought by the direct gaze of eyes meeting his own.

A marvellous series of flatboatmen paintings followed during the later forties and early fifties. Their gentle humour, treatment of the landscape almost as a personality, and anecdotal details of local colour find striking parallels in the descriptions of life on the Missouri and Mississippi rivers by Mark Twain. Possibly Bingham's most refined yet animated picture of this group is the large *Jolly Flatboatmen* of 1846 (Plate 141 and front cover), more complex than the *Fur Traders* in its organization of figures in depth, but equally expressive of movement within the classical design. Within a complicated but lucid structure of intersecting horizontals, verticals, and diagonals Bingham carries our eye from the unmoving stability of the platform and seated figures through increasingly dynamic forms above to the dancing boatmen at the apex. When Bingham repeated himself, as he did after this work and in several other cases besides, his later versions, unless markedly changed, were invariably weaker and more contrived.

The appeal of politics drew Bingham into running for State Representative, and, naturally, into painting subjects drawn from first-hand experience. The culminating series of his early maturity was a group of big canvases on episodes in campaigning for office, including *The County Election* of 1851-2 (Plate 142). By this date he was extensively adapting sources for overall compositions, as well as individual postures, from engravings after old masters and casts of antique statuary. Here, for example, one can see quotations from Claude, Poussin, and Hogarth in the total design; Wilkie's *Village Politicians* and Raphael's *School of Athens* for the crowd of figures; and sculptural poses for specific individuals.[21] But such pictures also reflect the fascination for Bingham and many of his contemporaries of phrenology. This interest in surveying varieties of physiognomy, anatomy, or psychological types was a mode of perceiving democracy itself.[22]

Upon completing this series Bingham decided to go abroad, ostensibly to supervise engravings to be made from his paintings in Paris, but surely also to experience more directly the artistic precedents he considered to be the foundation of his own work. In Düsseldorf from 1856 to 1860 he learned from Leutze the prevailing style of hard modelling, harsh colour, and exact rendering of detail. Even more, the German training accentuated his tendency towards isolating eye-catching gestures and postures. His canvases thereafter were drained of their earlier freshness and unpretentiousness. He was still capable of strong paintings during his later career at home, but the overriding direction of the post-Düsseldorf years was towards melodrama and sentiment.

As one of those responsible for the strong influence of the Düsseldorf School, Emmanuel Leutze forms an important artistic link between nineteenth-century German and American art. Born in Germany, he grew up in Philadelphia, but then returned to Düsseldorf to study in 1841. His most famous picture, *Washington crossing the Delaware* of 1851 (Plate 143), is an archetype of the school, with densely crowded

details, meticulously finished textures, dramatic lighting, and boldly silhouetted figures. Worthington Whittredge posed for hours as Washington and as the helmsman:

Clad in Washington's full uniform, heavy chapeau and all, spy-glass in one hand and the other on my knee, I was nearly dead when the operation was over. They poured champagne down my throat and I lived through it.[23]

The overwhelming size of the canvas alone (more than twelve by twenty-one feet) reveals something about mid-century ambitions in America, but such exaggerations could not last for very long, either in the imagination or in reality.

PART FOUR

THE LATER NINETEENTH CENTURY
1865–1893

From Reconstruction to The White City

THE ARTIST AS SCIENTIST

THROUGHOUT the nineteenth century, and especially during its middle decades, the American artist repeatedly found himself venturing into the wilderness as a scientist exploring new terrain. Reminiscent of the New World's earliest explorers, these nineteenth-century successors equated the vast plains with crossing the ocean, as they voyaged west in 'prairie schooners' (just as twentieth-century adventurers visit the 'seas' of the moon). More often than not the artist went on expeditions as a surveyor, of land as well as of human and animal species.

The impulses to measure and categorize reflected democratic notions about individuality within a total system. In addition, the western frontier embodied the continuing identification of the American republic with its geography. After the divisiveness of the Civil War, the completion in 1869 of the first transcontinental railroad symbolized a new national unity in territorial terms.[1] Science was to serve the philosophy of exploration, in providing a framework of methodical identification, measurement, and quantification, as well as its means, in providing refined instruments for seeing, such as the telescope, microscope, and, of course, the camera.

The first major expedition of the century was that of Lewis and Clark in 1804; others followed over the years, often with painters and photographers in their company. We may distinguish four principal groups of artist-explorers documenting the changing frontier: in the early 1830s, George Catlin, Karl Bodmer, and Alfred Jacob Miller;[2] between the mid forties and mid fifties, Charles Deas, Seth Eastman, and the Düsseldorf-trained Carl Wimar, Leutze, and Bingham; in the decade following the Civil War, the painters Albert Bierstadt and Thomas Moran, and the photographers Timothy O'Sullivan, William H. Jackson, and William Bell; finally, during the century's closing years, Frederic Remington, Charles M. Russell, Henry Farny, and Charles Curtis.

The art of John James Audubon belongs at the beginning of this long development in American painting. Born out of wedlock in Haiti in 1785 to a French sea captain, but brought up in France, he entered as a youth the studio of the dominant French neoclassicist, Jacques-Louis David. From the start Audubon's paintings displayed a marked preference for the profiles and silhouettes of forms; in short, for a strongly linear mode of delineation which could well have reflected the influence of his teacher's style.

In 1803 Audubon made his way to Philadelphia, and a few years later to Kentucky, where he married. When his business failed, he took up portraiture, primarily bust-length profiles, but soon was consumed with interest in drawing birds in their natural settings. By 1820 he had determined to undertake a comprehensive record of every species in North America. That fall he commenced the first of several trips through the country in search of subjects. For several months he sketched while descending the

Mississippi River, the continent's most abundant flyway, and in early 1821 established a base for himself in New Orleans that would serve as home for the next six years.

By 1826 Audubon had a sufficient number of watercolour drawings in hand to go to England with the thought of publishing his portfolio. He finally found a talented engraver in Robert Havell, Jr, who was equal to the task of printing the originals with fidelity. As the artist learned more about ornithology in his stay abroad, he realized that many of his initial sketches would have to be redone. So three times in the next ten years he returned to America to make additional drawings and replacements. For much of the time, too, he had assistants who specialized variously in drawing floral details, particular habitats of birds, or landscape backgrounds for him.

When his *Birds of America* was finally published in 1838, it included four hundred and thirty-five plates. In remarkably few did the economical design or delicate balance of forms in the original watercolour become laboured or crowded in the engraved version. In a manner related to folk art, Audubon preferred to view his birds from eye level, depicting them in their most characteristic profile or silhouette. He employed the classical device of a quadrant system for drawing – squaring off his sheet of paper and placing another set of drawn squares behind the subject, then transferring details from one corresponding pattern to the other.[3]

Audubon's birds, seen collectively, give an extraordinary range of types, and even personalities. Generally, he was determined to record noteworthy details of a species, and frequently showed birds of both sexes, often with identifiable seasonal plumage. Yet something more raises his work from a level of technical ornithological illustration to one of aesthetic quality – his intuitive sense of scale, and for finding the right foliage forms to complement the birds environmentally and visually. More striking is his power of abstraction, apparent even in a watercolour as intimate and unpretentious as the *House Wren* (Plate 144).

Whenever possible, he drew from life, and many times from very close up. Once, for example,

a pair of House Wrens built a hole in the wall, within inches of my drawing room. . . . I threw [the male] some flies and spiders that he seized with alacrity. . . . One morning I took him in to draw his portrait, quickly closed the window, easily caught and held him in my hand.[4]

On another occasion, when he found a nest of wrens in an old tree, he reluctantly decided to retrieve it in order to obtain a more accurate drawing: 'I hope all will believe that when I resolved to sacrifice the nest, it was as much on your account as on my own.'[5] In this watercolour the mother feeds the babies, while the father stands sentinel above. Forms, colours, and textures throughout are restrained and crisp, as appropriate to the size and movement of the species. (On the other hand, intense colour contrasts and strong rhythmic patterns, often placed in tension with one another or an edge of the page, were more suited to larger or more savage birds.)

This sense of rightness and subtle balance between utter realism and abstract design characterizes Audubon's best work. He is usually set apart from the mainstream of American painting; yet his concern for expressive two-dimensional pattern is close in

spirit to the folk artists of his day, his interest in typology had parallels in Cole's land-scapes and Bingham's figures, and his subject matter involved aspects of both portraiture and narrative genre painting. Lastly, his approach to art has a familiar moral tone: 'I marveled at Nature as the dawn presented her – in richest, purest array – before her Creator. Again I was full of desire to comprehend all I saw!'[6] The artist was transcribing nothing less than the immediate details of a transcendent grand design.

George Catlin's art presents a similar combination of artistic and philosophical ele-ments. He was eleven years younger than Audubon, although also born in the last years of the eighteenth century. Fishing and hunting were part of his boyhood in rural New York, and his interest in Indians was stirred early, not least by the story of his mother's capture in 1778 during a massacre in Pennsylvania. At twenty-one, on his father's urging, he studied law, but his attention became increasingly diverted to painting: 'A stronger passion was getting the advantage of me.'[7] In 1823 he moved to Philadelphia to take up art seriously, and soon made a success of portraiture. A visit of western Indians en route to Washington fired his imagination

to rescue from oblivion so much of their primitive looks and customs as the industry and ardent enthusiasm of one lifetime could accomplish . . . nothing short of the loss of my life shall prevent me visiting their country, and becoming their historian.[8]

With little formal training Catlin began in 1830 six arduous years of travel through the Plains, at first making half-length portraits, but soon executing full-lengths and also descriptive views of the landscape, Indian ceremonies, hunting, and other daily activi-ties. His feelings alternated between a sense of awe ('The strange country that I am in – its excitements – its accidents and wild incidents . . . startle me at almost every moment'[9]) and the need for close factual observation ('It is from the observance of a thousand little and apparently trivial modes and tricks of Indian life, that the Indian character must be learned.'[10]).

In a number of cases Catlin combined aspects of portrait and genre painting, as for example, *Wi-jun-jon, The Pigeon's Egg Head, Going to and Returning from Washington* of 1832 (Plate 145). The divided composition aids the sense of narrative, one that in fact had moral overtones. In Catlin's words,

We-jun-jon (the Pigeon's Egg Head) was a brave and a warrior of the Assinneboins – young – proud – handsome – valiant, and graceful. . . . He was dressed in his native costume, which was classic and exceedingly beautiful.[11]

His stay in Washington had the results we can see, and on returning to his tribe he was eventually killed as a demonic medicine man. Catlin's style, like Audubon's, combines carefully accentuated details, strong simplified patterns, and clear areas of colour. In approach and technique his art makes an interesting parallel to both folk and academic expressions of the same period. With a collection of over five hundred paintings Catlin began exhibiting his Indian Gallery in 1837, often accompanied by lectures, and two years later he took it on successful tour to Europe. Debts finally overwhelmed him in the early fifties, forcing him to sell the group. His last years were spent at work in rooms at

the Smithsonian Building in Washington, to which by happy fortune a countryman, who had acquired his Indian pictures, eventually donated them.

Charles Deas, a Philadelphia-born artist, was a generation younger than Catlin, and did not begin to paint extensively west of the Mississippi until the 1840s. His images revealed less interest than those of Catlin or Seth Eastman in recording 'the trivial modes of Indian life', and more in the dramatic contests of man and nature that he considered symbolic of the frontier environment. *The Death Struggle* of 1845 (Plate 146) is such an example, with its interlocking torsion of horses and men at the brink of a mountain precipice. In its literary content, suggestion of deep space, and turbulent action, the picture draws on a pictorial vocabulary popularized by Cole and Church (compare Plates 89 and 108).

The artist who brought to an apogee the combination of scientific observation and symbolic grandeur in recording the west was Albert Bierstadt. Born at Solingen in Germany in 1830, he was brought by his family to New Bedford, Massachusetts, two years later. During the 1840s he began to sketch landscape, and stimulated by the opening of the Düsseldorf Gallery in New York in 1849, decided to study at Düsseldorf himself. Contributing to his decision was the fact that his mother's cousin was a painter and teacher there. Like his friends Leutze, Whittredge, and William Stanley Haseltine, he learned the prevailing style of tightly finished detail, colour and texture.[12]

Returning to New Bedford after two years, he made plans for a trip to sketch American scenery, and in 1859 went on the first of three major journeys to the west, especially the Rocky Mountains.[13] On this excursion he made quick but forceful oil sketches of single and grouped Indians, as well as landscape views to be amplified later in the studio. Generally, these remained modest in scale and reserved in treatment, although they showed close observation of light and atmosphere.

His second western excursion in 1863 was to inspire his greatest canvases. Accompanying him was Fitz Hugh Ludlow, a hashish eater, who described the journey in *The Heart of the Continent*.[14] Ludlow's language of description was not quite hallucinatory, but it had the same qualities of exaggeration and exclamation that we find in Humboldt's accounts of South America or Church's and Bradford's of the Arctic. On the one hand he regularly specified the course of their travel as if he were reading from a map, and just as often referred to flora and fauna by Latin names; on the other hand he was equally attentive to the symbolic meaning of their experience.

For example, herds of buffalo seemed as vast and powerful to him as icebergs had to others; they represented a force of nature:

I remember my first and my succeeding impressions of Niagara; but never did I see an incarnation of vast multitude, or resistless force, which impressed me like the main herd of buffalo.[15]

Bierstadt made hasty sketches of these creatures, in battle, stampede, and death. Years later they formed the basis of a major canvas, *The Last of the Buffalo* (Plate 147), an image summarizing the artist's awareness of a breed of man and animal both vanishing. Using the strongly horizontal format favoured by Church and others, he contrasts the hulking animal forms in the foreground with the spacious open landscape in the distance. In

opposition are the tension of violence and the peaceful beauty of river and far mountains. But more than a panorama of breathtaking nature, it is also one of mortality, giving us at close range the full cycle of life, dying, present and past death, and by implication re-birth in the fullness of nature and the herd beyond. As an image of indiscriminate slaughter and of plundering the land's resources, it acquires a sharpened poignance for America a century later.

From the sixties onward Bierstadt began to paint his spectacular experiences on ever larger canvases, as if their enormous size could somehow convey the physical scale of the western landscape and his own perception of its symbolic importance. Ludlow was constantly stymied in finding means to measure this scenery. 'Arithmetic is . . . petty to the task. . . . When nature's lightning hits a man fair and square, it splits his yardstick.'[16] Bierstadt made use of photography, most notably the stereograph: this camera had two lenses which opened simultaneously and thus created a sense of spatial depth in binocu-lar vision. Just as the intimacy and individuality of the daguerreotype had served an earlier generation's needs, now stereoscopy matched the wish to capture the dramatic spatial quality of the western wilderness.

Bierstadt painted a number of important oils based on his crossing through the Rocky Mountains, though he was shortly to find equally grand subjects in the Yosemite Valley of California. The group pressed on to San Francisco, where Bierstadt met Carleton Watkins, by then established as the foremost photographer of Yosemite.[17] Along with Jackson, Watkins was a pioneer in the use of large (eighteen-by-twenty-inch) wet-plate photography, which permitted the camera to record another kind of size in the printed image. Impressed with his views, Bierstadt went into Yosemite, with the expectation (as Ludlow described it) of 'going to the original site of the Garden of Eden'.[18]

The *Domes of the Yosemite* of 1867 (Plate 148) was the result, one of his largest and finest achievements. The viewer observes the scene, as the artist first did, from a great height; he stands on the brink of pure wild nature of an almost incomprehensible scale, with a rushing cataract nearby – not unlike the image Bierstadt may have had in mind of Church's *Niagara* (Plate 108). To the visitors the valley was

the tenth foundation-stone of John's apocalyptic heaven. . . . Far to the westward, widening more and more, it opens into the bosom of great mountain-ranges, – into a field of perfect light, misty by its own excess, – into an unspeakable suffusion of glory created from the phoenix-pile of the dying sun.[19]

Here was a consummate emblem of national celebration, geology and metaphysics joined in common service. Bierstadt's German training ably suited his need for accurate detailing and theatrical presentation. For another decade pictures of this sort brought him the highest prices and popularity of the day. With Church his effusive visual rhetoric matched the nation's assumptions about its destiny, until the parlous divisions of the Civil War cast dark shadows over those views. Bierstadt continued to travel abroad in the later sixties, and went to California again in the early seventies. Changes in taste finally brought debt and unhappiness. His art really represented the culmination of ideas

once exuberant and fresh in the early Hudson River school, but the nation beginning its second century held out realities for Americans no longer so absolute.

Thomas Moran, younger than Bierstadt by seven years, was also born abroad (near Cole's birthplace in Bolton, Lancashire) and brought to the United States as a child. During the 1860s Moran made two visits to Europe, spending time in England in admiration of Turner's oils, and travelling through Italy, with Venice as his most memorable experience. In 1871 he and W. H. Jackson were invited to join Ferdinand V. Hayden's surveying party in the Northwest Territories, one of several expeditions during the decade that brought together the artist, photographer, and government geologist.

Moran's triumphant achievement of this journey was the twelve-foot-wide canvas *Grand Canyon of the Yellowstone* (1872) (Plate 149). Its grandeur of scale and beauty, in combination with simulated photographic realism of the terrain, had an immediate impact on the public back east. The mythic and the substantive power of this geography was real. Disbelieving eyes now believed. Congress that same year passed legislation setting aside the area as the country's first national park.[20]

But the photographs of Jackson, Bell, and O'Sullivan also played a critical role in shaping the public's vision. Sometimes working with glass plates as big as twenty by twenty-four inches, and cameras of necessity large enough to hold them, they carried the heavy, cumbersome equipment up to staggering sites for a dramatic vantage point. Now the possibility of making duplicate prints from the glass negative permitted wide, and consequently influential, dissemination of their impressive images. Their pictorial devices were similar to those of the painter: juxtaposition of foreground with hazy distance, minutely scaled figures seen adjacent to towering cliffs, and contrasts of light and dark to illuminate nature's visible surface and invisible power. The camera saw geography but revealed cosmology.

Timothy O'Sullivan was born in 1840 (Jackson three years later), and apprenticed during the mid fifties in the photographic studio of the master daguerreotypist and early Civil War photographer, Mathew Brady. During the War O'Sullivan worked in association with Alexander Gardner, another Brady assistant, to produce some of the most compelling images of the period (see Plate 157).[21] O'Sullivan recognized that the immediate power of the camera was stark factual truth, but he further perceived its capacity to frame, crop, highlight, isolate, sharply focus, or luminously dissolve – in short, to define deeper truths about people and their environment.

Beginning in 1867, he joined for three years Clarence King's geological survey of the fortieth parallel; in 1870 he was photographer for an expedition in the tropics of Panama; and the following years found him accompanying Lieutenant George M. Wheeler in the southwest. Thus, his itinerary, intentions, and imagery were little different from those of Heade, Church, or other artistic contemporaries. From the Wheeler expedition came his stunning photograph of the *Ruins of White House, Canyon de Chelly, Arizona* (Plate 150). He chose a point of view sufficient to capture the angle of light expressively falling across the rock walls and revealing its geological character, but also distant enough to suggest the sweeping magnitude of form. Barely visible atop each

level of the geometric cliff dwellings is a pair of men with rope lines hanging between them. The cliffs, once sacred, had been abandoned by Indians in the thirteenth century. One comes to feel that while O'Sullivan's picture is of the moment, it has also excavated the work of men and nature beyond a wider frame of time.

In the closing decades of the nineteenth century it became clear that the Indian way of life was vanishing. As settlers moved into the frontier, the cowboy became the new romantic hero for artists such as Frederic Remington and Charles M. Russell. Their lively pictures did not go unaffected by photography; after Eadweard Muybridge's sequential photographs of galloping horses (Plate 168) were published in 1878, Remington borrowed their action poses directly for his own compositions. Of all those recording America's last frontier, however, perhaps appropriately the most moving and profound was the photographer Edward Curtis.[22] Born in Wisconsin in 1868, he cultivated an early interest in photography, and first began taking pictures of Indians during the 1890s in Oregon. By 1900 he felt called by a mission similar to Catlin's, to document in another medium the extant Indian tribes west of the Mississippi. Six years later he had the active encouragement of President Theodore Roosevelt and the financial support of J. P. Morgan. During the 1920s he continued to amass his photographs and to publish them in what became twenty volumes of some twenty-two hundred prints.

With sympathy but directness he looked at Indian land and faces. The level of quality that endured throughout the project was evident in his first pictures taken in the 1890s along the northwest coast, where he encountered Indian groups closest to extinction. *Princess Angeline* (Plate 151) of the Suguamish tribe was the daughter of Chief Siahl, after whom the city of Seattle is named.[23] As an image of age and endurance, this face recalls those of *Anne Pollard* and *Yarrow Mamout* (Plates 19 and 58). At the same time the Indian voice of loss has its own place in time:

I am tired; my heart is sick and sad. . . . We are like birds with a broken wing. . . . My eyes are growing dim – I am old.[24]

The consciousness of individual mortality was joined to a sense that an entire age and way of life for America at large were passing. The same burdens of flesh and spirit weigh on the sitters of Thomas Eakins (Plates 169 and 170). Yet we see in the lines furrowing the faces of both *Princess Angeline* and the *Canyon de Chelly* the features of America's most distant past.

CHAPTER 17

PHYSICAL REALISM

THE decade of the 1870s was a critical one of transition in American life and culture. Reconstruction after the Civil War was a failure in human terms. At the same time American architects succeeded in laying the foundations for the modern skyscraper. Technology was the reason. Somewhere in these years the order of the machine seemed to replace the order of nature as the dominant vision of the age. The great Brooklyn Bridge was crossing the East River, and the giant Corliss Engine was the centrepiece of the Philadelphia Centennial Exposition.

The period saw the founding of new cultural institutions: land grant colleges, state universities, town libraries (H. H. Richardson's best date from this decade), and museums. In 1870 both the Museum of Fine Arts in Boston and the Metropolitan Museum of Art in New York were incorporated, the latter with a number of prominent American artists among its founding members. Harder to separate are the conflicting currents of stylistic change in the arts. Humour and nostalgia in earlier genre continued in the plasters of Rogers while anxious brooding and tension appear in the bronzes of William Rimmer. The celebratory optimism associated with the Hudson River School survived in the increasingly meditative views of the luminists as well as in the declarative histrionics of Bierstadt and Church. Yet where the light of luminism was associated with national destiny, light in Eakins now illuminated individual human survival.

In sum, the innocence and single-minded idealism of the pre-Civil-War decades were giving way to a new sobriety and seriousness,[1] driving some artists further inward, others to starker reassessments of the physical world. This complicated process of change is visible in the painters responsible for carrying American art to its maturity, most notably Eastman Johnson, Winslow Homer, and Thomas Eakins. Johnson was the oldest of the three, born in Lovell, Maine, in 1824. In 1841 he spent a year of training in Bufford's lithography shop in Boston. He developed an early facility for drawing portraits in charcoal, and during the late forties made a success of sketching eminent faces in the nation's capital. By 1849 he was persuaded to go to Europe for study in Düsseldorf. Under the guidance of the Germans, and particularly Leutze, his style of drawing became more refined, as he gained ability in rendering modulations of light and dark and a subtle variety of delicate textures.

Had he returned home after his two years in Düsseldorf, his work thereafter could well have been marred by the hardness and theatricality manifested in Bingham's and Bierstadt's later years. Johnson found the Germans particularly lacking in feeling for colour,[2] and went on to The Hague, where he studied the Dutch genre masters who were then so popular through engravings in the United States. But of equal impact were the portraits of the great seventeenth-century figures Hals and Rembrandt; in them Johnson sensed the expressive possibilities of brushwork, colour, and lighting, a feeling for

monumental composition, and the psychological ambience of a subject. In 1855 he completed his European sojourn with several months of work in the studio of Thomas Couture in Paris. There, too, he learned new ingredients for his art through Couture's insistence on exacting procedures of composition and preliminary studies of a subject. During Johnson's remaining career one can find these various elements combined in his approach to painting.

The work which announced his artistic maturity and established his popularity was *Life in the South* (*Old Kentucky Home*) of 1859 (Plate 152). It is reminiscent of several precedents which Johnson could have known: Dutch paintings of tavern or family groups (for example, Jan Steen's *Dancing Couple*), the widely known engraving after Wilkie's *Blind Fiddler*, and the barn scenes of Mount (see Plate 139). From Mount Johnson took the example of a typically American subject, combined interior–exterior setting, and arrangement of the figures into sequential anecdotal groupings. He also re-used characteristic Mount details, such as farm tools lying on the ground or standing against a wall, the attentive dog in the foreground, and the pose of the banjo player.

The picture is more a demonstration of Johnson's mastery of his European training and of the sentimental tradition of American genre painting, than an original statement in its own right. During the following decade he began to paint more out of doors, especially scenes of maple sugaring in Maine. The summer of 1870 marked a new phase in his work; recently married, he made a visit that year to the island of Nantucket. His first major canvas completed there (although conceived the year before in the Catskills) was *The Old Stagecoach* of 1871 (Plate 153).

Johnson's palette has now markedly lightened. By comparison to his work of ten years earlier, his composition is more open and less contrived, his brushwork at once more fluid and self-confident. The strongly silhouetted figures culminating in the central boy waving his hat are a lingering legacy of the Düsseldorf manner, and directly recall similar details painted earlier by Bingham (Plate 141) and Leutze.[3] The theme of playful youths is only in part a continuation of the optimistic genre tradition of Mount and Bingham. It is more a contemporary reflection (seen also in the writing of Charles Dudley Warner and Mark Twain) of the nostalgia for rural and farm life in an age of urbanization, corruption, and hypocrisy.

Throughout the seventies Johnson painted a *plein-air* series of groups cranberry-picking on Nantucket. The largest and most finished canvas of the sequence was *The Cranberry Harvest* of 1880 (Plate 154). Beneath a clear, deep blue sky and across the rolling moors, turned reddish by the berries and the first hints of autumn colouring, large numbers of figures are at work in this golden moment of sunlight and season. Johnson maintains a compositional clarity by increasing the sharpness of detailing as the eye moves towards the foreground figures, and by giving central prominence to the standing woman in the foreground. Her strong vertical form anchors the entire design, not least as the focus of the surrounding individuals arranged as if on the spokes of a wheel, a nice echo of the windmill on the horizon. The strong raking light of the after-noon sun is equally important in defining these forms in space, as its touch brightens the edges of critical details.

Johnson discovered during this period that light could define psychological as well as physical presence. We do not sense this at first in *The Hatch Family* of 1871 (Plate 155) because the definition of furniture, individuals, and accessories is so precise. This tightness of handling in brushwork and design was a reminder of his basic indebtedness both to his German instructors and to Couture, and possibly to contemporary portrait photographs as well.[4] Yet throughout, light has a softening and focusing capacity, as it models faces or crisply sets apart some detail. The single source of illumination through the window literally defines the family and their possessions in this room, but it further tells us something about the separateness and relatedness of people.

This and the monumental *Funding Bill* (Plate 156) painted ten years later are also images of the Victorian world in America, the wealth of prominent businessmen, the comfortable surroundings, clothing, and possessions money could buy. In this regard the emphasis in these works on physical textures and on the accumulation of worldly things is close to the elaborate materialism of Richardson's library interiors and the still lifes of Peto and Harnett (Plates 171 and 172). In *The Funding Bill* Johnson abandoned his long-held preference for painting groups of people, and concentrated close-up on a scene of discussion between two individuals he knew well: on the left his wife's brother-in-law Robert W. Rutherford, on the right Johnson's friend Samuel W. Rowse. Johnson's best later works were individual portraits, whose success derives from elements he found in Dutch art, particularly largeness of form and awareness of inner human strengths: he liked to render the late afternoon light, which in *The Funding Bill* stretches across the room to catch the important details of hands and faces. In these deepening shadows and weighty furniture are the outward signs of physical age, but they also glow as embers of intelligence, experience, and self-possession.

Concern for the human condition most dramatically emerged as a subject for the artist during the Civil War. The eye of the camera, especially in the hands of Mathew Brady, saw what people accepted as actuality, and the awful facts it recorded had the greater impact for being laconic and unembellished. Brady received his first artistic training from the portraitist William Page, followed around 1840 by instruction in daguerreotypy from Samuel Morse. Subsequently, Brady established the most successful daguerreotype business in the country, with a well-equipped studio in New York. At the beginning of the War he opened a second in Washington, under the direction of the Scottish-born Alexander Gardner, a man the same age as himself and Eastman Johnson.

Brady is best known for his photographs of Lincoln during the war years; he was also present at Gettysburg and several other major engagements. But Gardner and his fellow-assistant O'Sullivan produced possibly the most moving and memorable pictures of the war. Limited in part by cumbersome equipment and the time that the camera's lens had to be open to register an image (about a minute), photographers concentrated on the aftermath of battles: architectural ruins as photographed by George N. Barnard or soldiers fallen dead in fighting as Gardner and O'Sullivan showed them were grim reminders enough of the actual ferocity.

Gardner's most enduring contribution was the two-volume publication in 1866 of

his *Photographic Sketch Book of the Civil War*. Of the hundred photographs in it, O'Sulli-van had assisted with nearly a half. The plate most often associated with Gardner's achievement is *The Home of a Rebel Sharpshooter, Gettysburg* (Plate 157), taken a day after the ill-fated battle. The intimacy of the close-up vantage point is in wrenching contrast to the empty and lonely death implied by the open slabs of rock. There is further pathos in the juxtaposition of the man's rifle propped against the stone wall and his own fallen body. The blanket placed beneath his head and the disarray of his clothing bring home to us the fact that his death was neither swift nor painless.[5]

This form of neutral and uncompromising illustration also appears in the Civil War work of Winslow Homer, whose pictorial style both paralleled and reflected the camera's way of seeing. A native of Boston, he was born in 1836, and apprenticed at Bufford's lithography shop about a decade later than Johnson. Although he did not like the work, Homer did learn a basic feeling for draughtsmanship and composing in clear patterns of black and white.[6]

After leaving Bufford's in 1857, he drew illustrations for *Ballou's Pictorial* in Boston and two years later for *Harper's Weekly* in New York. When the War broke out *Harper's* sent Homer to the front, and the artist returned regular illustrations to be en-graved in the magazine. He also took up oil painting about this time, and one of his first major canvases was *Prisoners from the Front* (1866) (Plate 158). Its lack of narrative action, straightforward presentation of the subject, and reliance on the sharp silhouetting of the figures against a neutral background invoke a new pictorial vision, associated, as we have seen, most radically with the camera's eye.[7]

The style of this picture, like the photographs of Brady and his assistants, marks a fundamental break with earlier American genre painting. Painters and photographers alike required a gravity of means equal to their vision of this subject matter. Gardner had introduced his *Sketch Book* by stating that 'verbal representations . . . may or may not have the merit of accuracy; but photographic presentments . . . will be accepted by posterity with an undoubting faith'.[8] Actually, changes were occurring in American literature as well. In his poem 'Eighteen Sixty-One' from *Leaves of Grass* Walt Whit-man called for a new language, grave, heroic, and durable enough to convey the national and individual shock of war:

> Arm'd year – year of the struggle,
> No dainty rhymes or sentimental love verses for you
> terrible year . . .[9]

Equally vivid were Whitman's first-hand experiences as a hospital volunteer, recounted later in *Specimen Days*.[10] His descriptions accumulate, not unlike the photograph, the observed facts of injury, sickness, misery, and death.

In 1867 Homer sailed for France; he spent much of the following year in Paris. Ostensibly he went to view *Prisoners from the Front* and another of his paintings in-cluded in the Universal Exposition, but evidence suggests that he saw something as well of the Japanese prints also shown, the old masters in the Louvre, and examples of current French painting.[11] Whether influenced by the flat tonal contrasts of Manet's canvases

then shocking the French public or by the bright decorative patterns of Japanese prints, Homer's own work showed new feeling for asymmetrical design, strongly silhouetted forms, and a lightened palette.

During the 1870s he occupied a studio not far from Eastman Johnson and Enoch Wood Perry in the New York University building. In 1873 Homer spent the first of several summers in Gloucester, Massachusetts, and there painted a number of his most familiar oils and watercolours. In spirit his subjects of youths at play were similar to works of the same period by Johnson and Perry (compare Plates 130, 153, and 159). Works like *Breezing Up* and *Boys Wading* (Plates 159 and 160) are evocations of leisured America, reactivated by new diversions and energies after the Civil War. For the most part these are pictures of lively gestures and animated shapes, strong lighting and bright colours.

Breezing Up is an image of wonderful vigour, in colouring, brushwork, and composition. Homer enhances a sense of immediacy by the diagonal movement of the catboat, its mast and sail angling out of the picture frame itself, and by the active silhouettes of the figures against the sky. Thus his very means of painting contribute to the optimism and exuberance in life which are part of his subject. At the same time there are clues present to the more serious and thoughtful themes of his later years. For example, as was the case with occasional other works of this decade,[12] there is a meditative note which underlies the whole, manifested in faces which look in different directions. More and more during this period Homer glimpsed the mystery of isolation and self-reliance.

Although watercolour, a medium he now took up seriously for the first time, afforded him a more intimate and informal method of painting, we find the same hints of considered reflection both in his increasingly spare designs and in figures with backs or faces averted from us. An example is *Boys Wading* of 1873 (Plate 160), part of a series he completed showing the children gathering clams or passing the hours in play near the Gloucester wharves. The rather tight drawing and opaque colouring are typical of his first watercolours, although the more fluid handling of reflections on the water indicates his developing abilities. Homer took great care in linking his figures compositionally with their surroundings, as here he counterpoints the pair of boys with the masts on the fishing schooner and the two cranes in the background.

By the end of the seventies his watercolours were even more open and sparkling, as he grasped the possibilities of the medium for capturing the translucent effects of light and atmosphere. More often now he depicted figures in pairs or alone, less physically active and more absorbed within themselves. As if in search of new, at least more profound, subject matter – he had after all mastered the imagery and techniques of traditional American genre – he made a second trip abroad, this time to England. From the spring of 1881 to the fall of 1882 he settled in a small fishing village near Tynemouth on the rugged coast overlooking the North Sea.

He painted watercolours almost exclusively, and *Inside the Bar, Tynemouth* (Plate 161), based on sketches made there, illustrates the major changes of mood and handling in his work of this time. With the pounding storms and rough seas for backdrop, he

saw in the lives of these sturdy fisherfolk, not the exhilaration of life of the Gloucester summers, but the drama of human survival. His delineation of both men and women is now more heroic; they assume statuesque poses almost larger than life, and their massive forms find complementary shapes in the rugged boats putting out to sea nearby. The weather also plays a more expressive role – no longer the glowing fullness appropriate to images of youth, but the heavy, brooding presence of nature's confronting forces. Frequently, isolated individuals must struggle across a rocky shore against the power of stormy gales, metaphoric of the conflicting elements in man's relationship with nature.

During his stay in England Homer passed through London more than once. Very likely he had opportunities to see examples of English art which might have contributed to this transformation in his style, such as the atmospheric watercolours of Constable and Turner, or the naturalistic drawings of classical figures by the Pre-Raphaelites. An even more imposing stimulus could have come from the monumental marble sculptures from the Parthenon pediments housed in the British Museum.[13] But, characteristic for Homer, he must have found his major source of inspiration in contemporary illustrations in the weekly *Illustrated London News* and *Punch*.

These magazines had a wide circulation at the time, and, very much like *Harper's* or *Every Saturday*, *Our Young Folks*, and *Scribner's Monthly*, which Homer knew well from his own contributions, they regularly carried engraved illustrations. Among the best known drawings in *Punch* were those by George du Maurier, who regularly showed the hefty Scots herring girls at work with the fishing fleets each summer. So familiar were his images of these women with bare arms, bulky dress and kerchiefs, big baskets at hand, and arms resting on their hips, that it is hard to imagine that Homer did not see and respond to them with logical artistic interest.[14]

After returning home in 1882, Homer moved for good to Prout's Neck, Maine, whose rocky ledges and quiet isolation provided him with a similar setting of natural drama, which he continued to paint for the rest of his career.[15] He made numerous trips to Bermuda, Florida, and the Caribbean in the winter, and to Canada or the Adirondacks in the later summer and fall. On these excursions with his brother or friends he combined watercolour painting and his love of hunting and fishing. Now more fluid, economical, and expressive than ever in his handling of the medium, he reserved the brighter and more intense colours for the brilliant light and heat of the southern climate, and cooler, more sombre hues for northern woodland scenes.

But the coast outside his studio and house at Prout's Neck, particularly during the long winter months out of season for most visitors, provided him with some of his greatest subjects. During the eighties and nineties he continued to examine what he felt were the profound themes of life, death, and survival, in an impressive sequence of major works. *The Fox Hunt* of 1893 (Plate 162) is typical of several later pictures in which man himself is absent; the questions of mortality and humanity are simply implicit in this winter drama of the fox and crows each seeking prey. Homer's familiarity with photography and Japanese prints has aided him in creating this stark pattern of contrasting light and dark forms, emblematic of life and death in all of nature's

universe. In one of his most poignant touches Homer makes us see the cruel beauty even in the thorny sprigs and berries, red as blood against the snow.

The contrast of opposites and the pairing of forms, devices Homer used often in his mature work, were nowhere more powerfully employed than in one of his last oils, *Right and Left* of 1909 (Plate 163). The title initially refers to the shells fired from a double-barrel shotgun, each finding its mark. But it also leads us to consider the other less obvious balances within this work: not just the hunter and the hunted, but the men firing at the birds from the background and the viewer looking at them from in front, one duck rising and the other falling, a sense of the momentary and of the universal, mortality illuminated by showing these creatures at the juncture of life and death.

The date of this picture places it literally in the twentieth century. But conceptually and stylistically too it approaches those concerns of twentieth-century painting, pure form and subjectivity; its flattening of figure and ground, and its intimation of personal meaning, for example, must be viewed as truly contemporary with the later works of Harnett and Ryder in America (Plates 172 and 208) and Monet in France, as they mark the threshold of modern art.

CHAPTER 18

PSYCHOLOGICAL REALISM

LATE in his own career Thomas Eakins called Homer the best living American painter,[1] although it is Eakins himself who ultimately ranks as America's greatest artist. The two men had much in common, as well as some important differences. They were near-contemporaries (Eakins was six years the younger), and both lived into the twentieth century, withdrawn into themselves through much of their later lives. But in contrast to Homer's Yankee background, Eakins spent his life in his native Philadelphia. While Homer remained a bachelor, Eakins was married but had no children; both relied on the deep affection of family and close friends. The two young men separately went to Paris in the fall of 1866, though Eakins remained abroad four years and returned via Spain. Later each took photographs and made use of the camera's vision in his work.

For Homer and Eakins their personal life was subordinate to their art. Said the former, 'the most interesting part of my life is of no concern to the public',[2] and the latter, more pointedly, 'for the public I believe my life is all in my work'.[3] In his own way each artist arrived at a broadly compassionate view of mortality, but where Homer increasingly perceived humanity through the natural world, Eakins looked ever more closely at the individual human presence.

From his schooling in Philadelphia Eakins learned a love of languages and mathematics. He studied anatomy at Jefferson Medical College and drawing in life classes at the Pennsylvania Academy. As with Horatio Greenough, the link between Eakins' scientific and artistic interests was the human body. During his years in Paris in the late sixties he studied at the École des Beaux Arts under Jean-Léon Gérôme, who strengthened Eakins' abilities in careful draughtsmanship and perspective. Both of these techniques were part of Gérôme's emphasis on achieving the right balance and contrast of forms within pictorial space. Late in 1869 Eakins went to Madrid and Seville for several months. At the Prado he responded with enthusiasm to Velázquez and Ribera, who, with Rembrandt, were to be a liberating inspiration for his art. 'O what a satisfaction it gave me to see the good Spanish work so good so strong so reasonable so free from every affectation. It stands out like nature itself.'[4] In a parallel way to Eastman Johnson, Eakins now drew on the principles of drawing and composition he had learned in France, along with the strong brushwork and force of feeling conveyed by light in the seventeeth-century realists.

Returning to Philadelphia, he painted during the early seventies two interrelated series of pictures, one of his sisters in subdued interior settings, the other of outdoor scenes showing his friends boating or hunting along the Schuylkill River and Delaware Bay. His early masterpiece is *Max Schmitt in a Single Scull* of 1871 (Plate 164). Like Homer, Eakins loved outdoor exercise, and included himself here rowing off in the

middle distance. This was a symbolic signature, both referring to first-hand experience, and signifying the artist's literal embodiment of self in his art.

As with almost every picture he painted, the human figure is central, and light is always the defining agent of form and feeling. For this work Eakins characteristically made careful perspective drawings to place his friend Max Schmitt explicitly in space, but implicitly as well in a coherent metaphysical structure. The total sense of pause and balance, along with the warm, clear lighting, convey the artist's praise for human and natural promise. Sculling as a sport surely appealed to Eakins for its particular qualities of self-discipline, in which rhythm, order, and sequence became more than physical requirements. While perhaps reminding us of the full sunlight falling across man and landscape in the paintings of Mount (see Plate 136), Eakins' is finally a more thoughtful, even melancholy work.

For within this structure he has so analytically marked out, there emerges the aware-ness of time's passage. Evidence of the momentary appears foremost in Max Schmitt's glance outward, as if called and caught by a photographer, in the distant puff from the steamboat, and in Eakins shown half way through a stroke. But the moment alludes both to time's suspension and to its continuation. The imagery of change and flow is present in the unseen currents of the river and the bridges crossing it. Eakins first calls attention to biological age – the fullness of maturity implies the inevitability of ageing – and links it to larger cycles of change. Thus, the warmth of late afternoon will yield to evening, Indian summer to autumn, even one century to another, as the new iron and steel bridges indicate the coming of another way of life.

Eakins' most heroic vision of the human condition, and very possibly the greatest picture ever painted by an American artist, is *The Gross Clinic* of 1875 (Plate 165). Its nominal subject was one of the most distinguished surgeons of his day, Dr Samuel Gross, conducting a thigh operation before his class. There are several precedents Eakins could have had in mind, most obviously Rembrandt's two great clinic pictures, the *Anatomy Lesson of Dr Tulp* of 1632, and the *Anatomy Lesson of Dr Joan Deijman* of 1656, and possi-bly closer at hand Washington Allston's *Dead Man Revived by Touching the Bones of the Prophet Elisha* of 1811–13 in the Pennsylvania Academy.[5] Although not a religious painting, *The Gross Clinic* does evoke a spiritual power. It is unique in raising genre to the level of myth.

Careful observation and studies preceded the final canvas. Eakins worked from photographs and from vigorous oil sketches blocking out the major masses of light and dark. From these it is clear that he intended the principal glare of attention to fall on the head and hand of Dr Gross and on the limb of the patient. Through light alone we contrast and associate the professional man with his work. Gross is at once intelligent and active, pausing, like Max Schmitt, in a moment between inner thought and outer action. The connection of mind and body was always important for Eakins, and here they are joined by the strongest light and colour and by the pyramidal composition.

Eakins' proclamation of individual worth had its counterpart in the poetry of his contemporary and friend, Walt Whitman, who began *Leaves of Grass* with

One's-self I sing, a simple separate person,
Yet utter the word Democratic, the word En-Masse.
Of physiology from top to toe I sing . . .[6]

For Eakins, too, this was a hymn in praise of a person in relation to society around him, and physiology referred to the health and wholeness of the individual as well as to the nation. In the amphitheatre are all degrees of physical and cerebral involvement in this drama, from the central calm and gravity of Gross to the actions on either side of him – the operation itself and the turning aside of the mother of the patient in a response we can read only through her clenched hands – and finally the differing levels of attention in the figures behind.

Eakins varied the thickness of his paint and the intensity of colour and light accordingly. The red blood on the hands of Gross and his assistants is all the more vivid for being the one strong colour at the centre of a dominantly black and white composition. Yet such opposing tonalities are essential to this transcendent drama of life and death. Eakins identified with Gross's assertion of accomplishment and integrity. Beginning with an objective record of surgery in America before antiseptic medicine, he probed the essence of human will and capability.

Painted for the Centennial Exhibition of 1876 in Philadelphia, the picture was refused a position in the art building, because genteel taste found the blood too offensive and the patient too awkwardly placed. So it hung in the medical section. Another painting Eakins finished in time for acceptable exhibition in the art galleries was *The Chess Players* (Plate 166). The canvas is small in size and sombre in colour, its brooding introspection a measure of Eakins' withdrawal after the rejection of his boldest accomplishment. Where he had formerly painted the salvaging of the flesh, now he contemplates the indices of its decay. The artist's father stands at the apex of this group, joined with two elderly friends in turning all concentration inward.

In contrast to the leisure activities, such as card games and checkers, favoured by the generation of Woodville, Mount, and Bingham (compare Plates 128, 135, and 141), the subject of chess itself invokes the stillness of thought, the energies of intelligence rather than physical movement. Eakins includes reminders of former experience with the faintly visible globe and framed landscape behind; of the fragilities of age with the slender furniture, water glasses, and carved chess pieces; and of mortal change with the clock on the mantel.

In this year he also began teaching classes at the Pennsylvania Academy, and by 1882 had become Director of Instruction. The early eighties was a period of great activity and experimentation for him. A few years before he had begun modelling small figures in wax as preparatory studies for paintings. Now he completed in bronze more elaborately finished reliefs of individuals and of horses, and he began to take photographs.[7] Both were a means of more accurately measuring the human anatomy – its weight, motion, and placement – within the space surrounding it. An important example composed from such models and photographs was *The Swimming Hole* of 1883 (Plate 167). In this picture Eakins and his dog Harry are swimming in from the lower right, while his pupils posed in varying positions complete the familiar pyramidal

design. It is at once an ordinary shared experience and a timeless arcadian vision. The immediate is expressed through the momentary positions of some figures. Yet an ideal stasis is inherent in the classical balance, fullness of light, and harmonious relationship implied between man and landscape.

The stopped action of the diving figure was doubtless inspired by Eadweard Muybridge's photographs of animals in motion taken during the preceding decade. Eakins acquired a set of Muybridge's photographs about this time, and lectured from lantern slides of them.[8] Muybridge had emigrated from London in 1852, and not long after he learned photography from Carleton Watkins in San Francisco. Like Bierstadt, he was strongly impressed with Watkins' photographs of Yosemite, and during the sixties extensively photographed the area himself. His name is chiefly associated with Leland Stanford's commission in 1872 to prove photographically that a galloping horse at one point in its stride has all four hooves off the ground. This Muybridge did with a row of cameras lined up along a track, each shutter opened in split-second sequence. Throughout the seventies he compiled a series of photographs of humans and various animals (Plate 168) in motion. As his imagery became known to Eakins and other artists, they developed a new visual consciousness for informal and instantaneous poses.

Thereafter Eakins occasionally depicted a hand casually gesturing, a mouth opened in song, or a head tilted in some idiosyncratic response, but these were usually expressions of doubt, hesitation, or insecurity. Fundamentally, he was interested in the human being at rest, for then he was able to probe and unveil self-awareness. Certainly the failure of *The Gross Clinic* affected him deeply. Its almost inevitable sequel was his dismissal from the Academy in 1886, for removing a loincloth from a nude model to demonstrate musculature and bone structure to his life class. His methods of seeking objective truth ran counter to Victorian gentility, and increasingly he concentrated on painting portraits of single individuals, in search of psychological truth.

In 1885, the year after marrying Susan MacDowell, he painted her seated in a corner of his studio as *Portrait of a Lady with a Setter* (Plate 169). It is a warm scene of orderly disarray, suggested by the diagonal turn of the rug, by the comfortable poses of his wife and Harry, whose glances look outward with open alertness, and by the portions of Eakins' works visible on the walls. Yet in the lines of red around those wistful eyes and in the set of the mouth are to be read the pressures and unhappiness intruding into the shared life of artist and subject. Only the mellow colours and lighting convey the human strength and affection at the heart of this picture.

Deeply troubled by the rejection of his work and of his methods of teaching art, Eakins sought relief and change in a trip west during 1887. When he returned, a friend introduced him to Whitman, then across the Delaware River in Camden, New Jersey. Eakins painted the white-bearded poet, the first of many portraits he was to execute during his later career of individuals with shared creative or inner power: painters, architects, musicians, singers, teachers, and priests. In his likeness of the pianist *Mrs Edith Mahon* of 1904 (Plate 170) he recorded a countenance of aching sadness and spiritual pain. On many previous occasions he had placed his sitters in the chair that is barely visible here, sometimes framing a head as with a halo, other times closing around

the figure with its back and arms, as if it were an outward sign of willed or imposed order.

Eakins was the equal of Degas in using light, brushwork, detail, and pictorial design to reveal the deeper character of his sitters. The harsh lighting on the face and chest of *Mrs Mahon*, the scroll-back of the chair so detached as to belong to another material world, and the reflections in the liquid of these eyes, are all clues to the burdening weight of an individual life. Eakins' searching vision was turned as much into himself as it was into the faces before him. This is one reason why they could look out so directly. His great triumph was in not succumbing to despair, for remarkably, as much as he saw human frailty and failing, he also saw human possibility and achievement.

More generally, the elegiac sense of loss present in Eakins' later works was an index of a *fin-de-siècle* mood that some of his contemporaries also caught, for example, John F. Peto, Augustus Saint-Gaudens, and Henry O. Tanner (see Plates 171, 183, and 205). Peto, although a still-life painter, informed his images with a significance and feeling altogether rare and original. In this respect his life and art are comparable to Eakins', with rejection and trouble cumulatively pressing in. Peto's art was a similar struggle to discover integrity and order behind ordinary surfaces and within physical presences.

Born in Philadelphia in 1854, Peto in his twenties studied at the Pennsylvania Academy, where the Peale tradition of realist still-life painting was still strong and where Eakins' artistic power was first being felt. At first Peto tried photography and commercial work to support himself, while submitting pictures for regular exhibition. When he committed himself fully to painting around 1880, his first pictures showed an admitted debt to the work of his friend and contemporary, William M. Harnett, in the choice of some motifs, particularly the pipe, mug, and newspaper arrangements on a table top.[9] But the mood of seriousness and mystery, the looser brushwork, and the use of light as a means of expressing feeling were much closer to the philosophical temperament of Eakins.

Peto's titles are indicative of his sensibility for nostalgia, introspection, and irony: *Old Friends, Old Souvenirs, Abandoned Treasures, Old Reminiscences, Lamps of Other Days, Ordinary Objects in the Artist's Creative Mind*. During the 1880s he transformed traditional still-life motifs with an inventiveness quite his own. One distinctive contribution was his painting of illusionistic office boards or rack pictures. Intended for places of business, these deceptive panels displayed crossed tapes tacked to them, with portions of letters, signs, newspaper clippings, calling cards, and other notations arranged across the worn surface. While Peto was certainly concerned with formal design and pure artifice, he could also call attention to some corporate or individual existence implied within. To this end he favoured torn labels, partially legible signs, and visual ambiguities, such as the card which reappears in several works stating 'Important Information Inside'.

Equally imaginative were his arrangements of books on old shelves, which preoccupied him during the last decade of his career. From the late eighties on, Peto settled in rural New Jersey, withdrawn much like Homer and Eakins, painting the world of

objects closest to him. *Still Life with Lard-Oil Lamp* (Plate 171) is on the surface a familiar image of Victorian materialism, but more personally a mirror of the unravelling order both in Peto's own life and in America at the turn of the century. Thus these piles of books and homely accessories are heavy with the weight of use and the wear of experience.

Superficially chaotic, Peto's composition suggests a yearning to salvage order out of fragmentation. As in Eakins, one feels the imposition of individual will as a stay against the advancing confusions and multiplicity of twentieth-century life. Partly because these objects were so intimately a part of Peto's house and studio, they possess the presence of humanity and always refer back to their arranger. The restlessness and isolation are his, but so is the evidence of thought and intelligence. Typical of his mature style are the gritty textures, which both describe and physically approximate the objects to which they belong, and the strong illumination, whose sombre shadows assist in revealing as well as concealing. This power of light and dark is the same tragic force as in Eakins' pictures. Together these forms embody the life of the artist as well as the life of art.

Peto is the most significant of the large group of later-nineteenth-century painters of still-life deception pieces. Most often compared to him is his slightly older contemporary William M. Harnett, who was born in Ireland but also grew up in Philadelphia. Coming from a family immersed in the crafts, Harnett himself began by engraving silver, a technique of demanding precision which appears to have carried over into the linear clarity of his subsequent painting. He and Peto became friends while studying at the Pennsylvania Academy in the 1870s, though Harnett spent time at the Cooper Union and the National Academy of Design in New York as well.

Beginning in the late seventies, Harnett painted an extensive series of pipe and mug still lifes. These follow squarely in the tradition of earlier compositions by the Peale family and by John F. Francis and Severin Roesen respectively in the first and second quarters of the century. Yet there are very revealing differences among the images of these three periods. Where a Peale still life evokes the delicacy and gentility of Federal America, and the compositions of Francis and Roesen the optimism and well-being of mid-century attitudes (compare Plates 62, 111, and 112), Harnett's *Old Cupboard Door* of 1889 (Plate 172) characteristically belongs to a bourgeois world of material gain and worldly possessions. In comparison to Peto, Harnett was generally a more prosaic and derivative artist, his debt to American predecessors and to earlier Dutch prototypes more obvious.

During the early 1880s he worked in Munich, where his work gained a heightened intensity of meticulous textures and jewel-like detail. Some arrangements took on a miniaturist quality, while others expanded into a scale of larger objects seen against old doors. Significantly, the best known examples of this type, the series *After the Hunt*, were based on contemporary German photographs.[10] In his last major works, for example *The Old Cupboard Door*, Harnett joins the table-top motifs of his first years with his later wall deceptions. His most distinguishing achievements are an extraordinary technical dexterity, often stunning in its creation of illusionistic effects, and a refined sense of formal order and variety. Here the eye may delight in the subtle modulations

of vertical, horizontal, diagonal, and circular forms, appropriately augmented by the several musical references.

The works of Peto and Harnett received criticism in their day for being apparently concerned with legerdemain rather than moral worth, a now familiar nineteenth-century complaint. A sermon commented about a Harnett, 'There is nothing whatever in the picture to please or instruct or elevate you. . . . The picture is unworthy, because its purpose is low and selfish'; while another columnist deemed a *trompe l'œil* by Peto an 'original freak of the brush'.[11] What later eyes can see is the modernism of these painters in their concerns with formal abstraction and with the nature of visual perception itself.

One may view variations of these themes and techniques in the work of several contemporaries, most notably Joseph Decker, Victor Dubreuil, George Cope, Jefferson David Chalfant, Alexander Pope, and Richard LaBarre Goodwin. Possibly the most whimsical was John Haberle, a native of New Haven, Connecticut, and resident there most of his life. As a youth he worked with scientific exhibitions and illustrations in the Yale paleontological museum. This may partially account for the uncanny precision of his deceiving images, such as *Grandma's Hearthstone* of 1890 (Plate 173), but the anecdotal humour seems all his own. Its environmental scale, attention to utterly familiar and banal objects, and affinity with photographic illustration make striking antecedents to both sculpture and painting by Pop artists in the 1960s. The great flourishing of *trompe l'œil* painting at the end of the nineteenth century seems, in retrospect, a culmination of the desire to define the outer world, at the same time that it initiated the new century's examination of pure artistic form and process.

CHAPTER 19

FASHIONABLE ART

'I'd rather go to Europe than go to heaven' are the words of William Merritt Chase,[1] but the sentiments were shared by many of his friends and contemporaries. Repeating the course of West's and Copley's careers a century later, a new wave of American painters felt impelled to absorb current styles abroad. On some of this generation, for instance Homer, European influences were slight; on others, for example Sargent and Duveneck, they were substantial. Several travelled abroad briefly, others repeatedly, while yet others passed most of their careers as expatriates, retaining nonetheless an American character in their work.

Duveneck and Chase are often paired as artists of similar age (born respectively in 1848 and 1849), background, and development. Duveneck came from Covington, Kentucky, Chase from near Indianapolis, Indiana. Both worked for local painters in their youth, and went to Munich for further study in the early 1870s. There they shared a studio and learned the new methods of direct painting on the canvas with vigorous brushwork and broad accents of light. During the later seventies Duveneck was himself a highly influential teacher in Munich for other Americans, while Chase at the same time initiated his own long and productive career of teaching in New York. Around the turn of the century each man turned his attention to bright outdoor landscapes, Duveneck at Gloucester, Massachusetts, and Chase on eastern Long Island.[2]

The Munich school in the seventies flourished under the leadership of Wilhelm Leibl and Wilhelm Trübner. Directly, and through intermediate influences such as Courbet and Manet, it looked back to the inspiration of the seventeeth-century realists, especially Hals. Among the moderns Courbet's commonplace subjects, inelegant colours, and seemingly coarse brushwork attained additional notoriety in shocking contemporary critical and popular tastes.

The Old Professor of 1871 (Plate 174) is a model of the Munich style. The subject looks straightforwardly out at the viewer, establishing immediate contact; the head seems almost carved in thick planes of paint; and strong focal light brings the form out of dense surrounding shadow. The broad, rough brushstrokes indicate that Duveneck worked swiftly to set down his initial impression, so that the textural marks convey both palpable physical form and a total impression of vibrancy. Henry James could be astringent but telling in his observations on Homer and Duveneck. While disliking what he considered the raw ugliness of their subjects, he admired the breadth and energy of their vision. About Duveneck's picture he wrote:

A third is a head of a German professor, most grotesquely hideous in feature and physiognomy, looking a good deal, as to his complexion and eyeballs, as if he had just been cut down after an unpractical attempt to hang himself.[3]

144

Yet he was also willing to admit 'great quality . . . extreme naturalness . . . unmixed, unredeemed reality'.[4]

In Munich both Duveneck and Chase mastered a style of exceptional fluency and dash, which at its best matched the more prolific output of Sargent. What was generally lacking was any probing psychological truth. After his return to America in 1878, Chase's style and interests began to shift. He started teaching at the Art Students League, and joined the Society for American Artists (serving as its president from 1885 to 1895), both organized in response to the inbred conservatism of the National Academy.

During the later eighties he settled in Brooklyn, where the pastoral landscape of Prospect Park stimulated numerous pictures. In the next decade he built a house on eastern Long Island, and regularly summered there, while continuing to teach his classes in studios built nearby. Throughout this period his palette lightened markedly, as he established himself as a leading exponent of Impressionism in America. Among his loveliest later works are the *plein-air* landscapes around Shinnecock. Related were a series of interior scenes painted in his New York studio and townhouse, including *A Friendly Call* of 1895 (Plate 175).

This picture is filled with bright, intense colours; warm sunlight is present both as it softly floods the room and as a concrete part of the design, evident in the patterns of the window seen in the mirror. As an image of its time, Chase's work tells us about the importance of costume and elaborate furnishings, of manner and manners, of the stuffs and textures of Victorian taste. The composition is loosely indebted to Velázquez's *Las Meninas*, which Chase had admired in the Prado,[5] and to his friend Sargent's bold emulation of the Spanish work in the *Daughters of Edward Darley Boit* of 1882 (Plate 179). Chase's attention to formal order also links his work to Whistler as well as to Harnett, though the lightness of touch is closer to Sargent. At the centre of several artistic developments at the end of the nineteenth century, it still retains Chase's own personal radiance of affection for the world about him. More significant for the future was his widely influential teaching career,[6] and specifically the legacy he left to the young Robert Henri, who came to teach at his New York School of Art early in the new century.

William Morris Hunt was another painter whose work reflected a certain eclecticism: he was variously attracted to portrait, landscape, and allegorical subjects; to oil painting, charcoal drawing, and plaster sculpture; and to styles of realism and Impressionism. Though born in Vermont in 1824, he and his brother, the architect Richard Morris Hunt, soon became a part of fashionable, cosmopolitan circles. He left Harvard for study with the sculptor Henry Kirke Brown in Rome, followed in 1846 with training he found distasteful at Düsseldorf, and finally lessons with Couture in Paris. When Couture's emphasis on careful drawing and composition did not appeal either, Hunt became one of the first American artists to discover and popularize the landscape school working in the countryside around Barbizon.

After more travel, he settled down during the 1860s in Boston, where his lectures on art were well received and helped in stimulating substantial local patronage of the

Barbizon painters. Hunt's own style gradually shifted from clear dependence on the Barbizon manner to one of more incisive realism. During the summer of 1876 he sketched with his students on Cape Ann, and enjoyed it so much that the following year he bought a house. Earlier he had constructed a painting wagon, equipped for convenient travel and work in the countryside.[7] This now went into active service, as Hunt constantly worked along the Magnolia and Gloucester shorelines as well as through the woods inland.

His happiest achievement of the summer was *Gloucester Harbour* (Plate 176), a painting he completed in one afternoon. Enthusiastically, he claimed, 'I believe that I have painted a picture with *light* in it!'[8] One senses in the rapid execution and hazy atmosphere his record of the moment. But like most American works, in contrast to the improvisatory character of French Impressionism, this is a rather carefully constructed composition, with solid forms balanced in the foreground and horizon line equally dividing the surface. Still, Hunt's awareness of the subtle nuances of outdoor light, his technique of bright patches of pure colour, and his intuitive struggle between conveying feeling and optical sensations, place him at the forefront of those Americans caught up in both the fashion and substance of French art.

Immersed far more radically in avant-garde art abroad was the personality and art of James McNeill Whistler. He was born in Lowell, Massachusetts, in 1834, though when the whim suited him, he claimed other birthplaces for himself. His father, an engineer, took his family to Russia, where he was engaged in building a railroad from St Petersburg to Moscow. Whistler was sent to West Point, from which he was dismissed for failing chemistry. At that time he drew his first sketches and lithographs, and in 1854 he served for several months in the U.S. Coast Survey. This work also had little appeal for him, although he did master the technique of etching in producing charts of the coast, and the introduction to this medium provided an important foundation for his subsequent achievements as a printmaker.

He left for Paris in 1855, and during the next few years involved himself in the developments of contemporary French art – the rise of realism, interest in Spanish and Dutch painting of the seventeenth century, and examination of formal and perceptual issues. He knew Fantin-Latour and Courbet, and developed artistic interests parallel to those of other younger painters like Degas and Manet. Among his own first endeavours was a strong group of etchings known as The French Set. By 1859 he had decided to settle in London, where he continued to make prints and to paint in an atmosphere he felt might be more congenial. The Paris Salon of the year before had rejected a picture of his which was now accepted for exhibition at the Royal Academy.

At the same time Whistler began a series of canvases which he titled 'Harmonies' or 'Symphonies', of which *Symphony in White No. 2: The Little White Girl* (1864) (Plate 177) is an important example, for in it are to be seen a fusion of all the formative elements in his style: the wistful, virginal figures painted by the Pre-Raphaelites; the bold realism of Courbet and Manet; the neo-classicism of his English friend Albert Joseph Moore, who in turn stimulated Whistler's interest directly in original Hellenistic sculpture; and Oriental art. This last was a widespread vogue among this generation;

among American artists Whistler and John La Farge were ardent collectors of Oriental screens, Chinese porcelain, and Japanese prints. Not only did these arts offer a world sufficiently exotic to contribute an aura of romanticism and nostalgia, but they also possessed a formal richness – in the flat, sometimes cropped designs, asymmetrical balances of form, and juxtapositions of colour patterns – which had enormous appeal. There is an additional precedent of which Whistler was conscious: that of Vermeer, in whose spirit are the clear profile of face and body, the pearl earrings, and conscious rectangular division of the composition.[9]

Whistler's Irish mistress Jo Heffernan posed for this and numerous other works of this period. The artist's friend Swinburne composed a poem which was attached to the frame. But what is most significant, finally, is Whistler's transformation of his subject beyond both portraiture and literary content into an aesthetic of primarily formal values. The perceptual ambiguity in the mirror, itself revealing a picture within a picture, is an aspect to which Swinburne's lines also alluded:

> Art thou the ghost, my sister,
> White sister there,
> Am I the ghost, who knows?[10]

During the summer of 1865 Whistler worked at Trouville near Courbet and Monet, exchanging ideas with them and concerning himself more with shoreline views of the sea. The next year he took a voyage to South America, which further confirmed his artistic interest in painting expanses of water as expressions of mood and feeling. Why he left in February 1866 and remained away for nine months is still obscure, but he spent much of this time on the coast of Chile, especially at Valparaiso. Perhaps actually and symbolically he felt closer to the Pacific and the evocative art of the orient. Increasingly he painted harbour shoreline and ocean surface at dusk in pictures he called 'Nocturnes', again with conscious musical analogies. Within a relatively narrow range of colours (usually blues, greens, and greys) he varied tones and accents to achieve a total rhythmic harmony. The silhouettes of boats often played across the horizon line, like notes on a sheet of music, with a visual power of abstraction all their own. Indeed, music offered an abstract artistic language perfectly suited to embody personal sensation as well as forms independent of representation.

The notorious work which brought on the widely publicized trial with Ruskin was *Nocturne in Black and Gold: The Falling Rocket* of *c.* 1874 (Plate 178), whose nominal subject was exploding fireworks over Cremorne Gardens. The influential critic was offended by Whistler's 'ill-educated conceit' and 'willful imposture' in asking 'two hundred guineas for flinging a pot of paint in the public's face'.[11] In the libel suit which followed Whistler asserted the artist's creativity as the true subject and artistic insight as the most knowledgeable critic. He won a farthing for damages, but was forced into bankruptcy by the publicity. The trial represents a watershed in nineteenth-century art between traditional values and modernism. Where the former viewed a work of art as a vehicle for didactic or moral content, Whistler treated it as an expression for its own

sake. To the Attorney General he had explained regarding one portrait: 'It is the picture and not Mr Irving that is the arrangement.'[12]

Whistler's principles are evident in all his later work: the decorations for F. R. Leyland's Peacock Room, the large portraits, and the shimmering economies of his Venice etchings. Already a patron and friend of the artist, Leyland called on Whistler in the mid seventies to decorate the dining room of his recently acquired house, No. 59 Prince's Gate. The painter conceived of the space as a harmonious and consistent environment, suitable for the inclusion of particular pictures by himself, Burne-Jones, and others, and for the display of the owner's porcelain collection, but the room also possessed an ambience of feeling as rich and self-contained as any of his individual Nocturnes or Symphonies. Furthermore, the room – now reassembled in the Freer Gallery in Washington, D.C. – stands as an important antecedent of the later surge in large-scale decorative and mural art in America around the turn of the century.

The artist's best known portraits of this period are undoubtedly his *Arrangement in Grey and Black No. 1: The Artist's Mother* of 1871 (Louvre, Paris) and *No. 2: Thomas Carlyle* (Glasgow Art Gallery and Museum) painted shortly after. In each instance the order of the title indicates the principal role he assigns to formal design and abstract conception. Within the square formats both figures sit in profile, absorbed in thought and isolated as well by the severe geometries of a few framed prints and the empty wall behind. Rendered as monumental still lifes, these figures seem transposed to some more enduring world beyond flux and transience. Partially reminiscent of Degas's group portraits, such as the *Bellelli Family* of 1859, which Whistler knew from his earlier years in Paris, *The Artist's Mother* and *Carlyle* evoke even more the powerful physical and psychological realism of Velázquez, that master's strong silhouetting of a figure against a spare background, and broad handling of the paint.

Whistler's younger countryman John Singer Sargent also took up residence in London during the last quarter of the century. He, too, received his first important teaching in Paris, came to admire Hals and Velázquez, was influenced by the early developments of Impressionism, moved comfortably between France and England, and visited Venice in the eighties. But where Whistler nettled, Sargent flattered, London society. The former catered to his own artistic taste, the latter to that of others. Sargent was a generation younger, born in Florence in 1856, of a family constantly travelling across Europe with the changing social seasons. Enrolled in the studio of Carolus-Duran in 1874, Sargent learned to paint directly from the live model and from first impressions of the landscape. He rapidly developed his great technical abilities in both drawing and painting form with enormous vitality.

Following a period of travel in the late seventies and early eighties to Spain, Tangier, and Venice, he painted a series of shadowy interior scenes, which culminated in his first major canvas, the *Daughters of Edward Darley Boit* of 1882 (Plate 179). The large scale of the work and the direct contact of the figures with the viewer were partly an expression of Sargent's esteem for Velázquez's *Las Meninas*, while the dark receding space and half lights were related to his recollections of moving through the arcades and piazzas of Venice. It is one of his most inventive designs, in playing with the mystery

of light and shadow, spatial definition, contrasting size of figures and porcelain jars (leading one critic to call this 'his family of pots' [13]), two- and three-dimensional geometries, and animate counterpointed with inanimate.

Shortly after, he began the equally striking portrait of *Madame X* (*Madame Pierre Gautreau*) (Plate 180), which became the scandalous failure of the 1884 Paris Salon. 'She had the most beautiful lines,' Sargent wrote,[14] and through a series of charcoal drawings of her profile pose he abstracted her provocative character and feminine hauteur with expressive restraint and refinement. The full-length pose, sober colouring, and shadowy background again recall Velázquez. Sargent's intense care with the evocative silhouette, and with the formal repetition of the subject's pose and the table legs, results in a memorable image he was not to surpass.

Sargent was the perfect artist for his increasingly aristocratic patrons on both sides of the Atlantic. He was a brilliant painter of surfaces and textures in a gilded age that believed that beauty was skin deep. His revival of an eighteenth-century style (reminiscent of the English Copley or Reynolds) was as much a reflection of the late Victorian era as was the veiled pain which Eakins perceived. At his weakest (for example, in his watercolours) Sargent represented the triumph of superficiality, though in his sheer handling of paint he frequently attained a grandeur and confidence that is overwhelming. Sargent's friend Henry James had much in common with him: a cosmopolitan dignity, easy familiarity with travel abroad, and a special talent for portraying women.[15] James strongly praised the painter on numerous occasions, seeing the early force of the *Boit Daughters* and *Madame X*. But more pointedly he noted the 'spectacle of a talent which on the very threshold of its career has nothing more to learn . . . he knows so much about the art of painting that he perhaps does not fear energies quite enough'.[16] Sargent saw characteristics but not character, and consequently he seldom feared the energies which Eakins did.

The art of Cecilia Beaux may be placed somewhere within the compass points of Sargent, Whistler, Chase, and Eakins. A well received and honoured painter in her day, she was a year older than Sargent and a portraitist of a similar aristocratic American clientele. However, she was born in Philadelphia and for the most part educated privately. Her family kept her out of the 'untidy and indiscriminate' but nonetheless 'magic circle' of Eakins' students.[17] Study in Paris during the late eighties brought her in contact with developments in contemporary French painting and the seventeenth-century masters in the Louvre. She was capable of the dashing brushwork of Sargent; like him and Chase, she adopted the bright palette and improvisatory manner of the Impressionists, as is evident in *Dorothea in the Woods* of 1897 (Plate 181). At the same time there are parallels to Whistler in the flattening of space, asymmetrical placement of the figure, and colourful floral pattern, as well as to Eakins in the sense of mystery and meditation.

A figure who was as popular as Sargent throughout this period was the sculptor Augustus Saint-Gaudens, one of America's great talents of the nineteenth century. Born in Dublin in 1848, he was brought to the United States as an infant, and grew up in New York. At thirteen he worked for a cameo cutter, and later learned drawing at Cooper Union. His sense of line and of conceiving form in relief would carry into all

his subsequent portrait sculpture.[18] In 1867 he went to France for study at the École des Beaux Arts, followed by a trip to Rome and return to New York in 1872. The following year he met H. H. Richardson, who gave him work alongside John La Farge in Trinity Church in Boston; soon after, he met Stanford White, who was to become a close friend and artistic collaborator on several projects.

Richardson helped in securing the commission of the *Shaw Memorial* (Plate 182) for Saint-Gaudens in 1881, although the contract was not signed for another three years and the bronze was not finally completed in place at the head of Boston Common until 1897. Robert Gould Shaw was a Bostonian who was killed leading a Black Union regiment in the middle of the Civil War. Saint-Gaudens worked from portrait photographs of Shaw, Black models he recruited from New York streets to pose for the soldiers, and iconographical precedents such as Velázquez's *Surrender at Breda* and Roman triumphal arches. Within an architectural frame designed by White, Shaw on horseback and his troops march across this pictorial stage, with details cropped photographically at either side. To stay the relentless forward movement of rifles and marching legs Saint-Gaudens has the horse's head sharply pulled back, Shaw's upright form ('as lean as a compass-needle', wrote Robert Lowell[19]) countering the varied diagonals, and the personification of victory hovering above. Altogether, it is an extraordinary blending of high and low relief, clarity and condensation, balance and movement, realistic transcription and ideal symbolism.

In continuing to fuse the ideal and the real Saint-Gaudens was drawing on deeply felt currents of nineteenth-century taste, and these elements inform all his work in some combination or another. His greatest sculpture, the *Adams Memorial* in the Rock Creek Cemetery in Washington (Plate 183), was begun while work was still under way on the *Shaw* piece. Marian Hooper Adams, wife of his friend Henry Adams, committed suicide in 1885, and two years later Saint-Gaudens was asked to design a commemorative sculpture. At first he was at a loss for an image, but while Adams and John La Farge went off for inspiration to the Far East, Saint-Gaudens brought together several disparate but harmonious ideas. Seated before a simple stone slab, with ornamental cornice contributed by White, is a slightly larger than lifesize figure recalling a classical Greek pediment figure, Hellenistic tomb stele, Chinese buddha, and Japanese kwannon. The eyes appear neither open nor closed, but caught in suspended reverie. The hand raised to the face suggests an immediacy that is in turn made remote by the partially shrouded head. In the large simplified forms of the drapery is a powerful play of nearly abstract rhythms. Adams himself could only interpret the work's sense of mystery as 'the Peace of God'. Its gravity of means and feeling form a sculptural elegy, comparable to Eakins' late portraits, marking not just individual mortality but the disquiet of an age itself slipping away.

Daniel Chester French, only two years younger than Saint-Gaudens, carried this combination of realism and allegory in monumental sculpture into the early twentieth century, although seldom with his competitor's depth of meaning or originality. His best known image is the eighteen-foot *Seated Lincoln* carved under his guidance in 1922 for the Lincoln Memorial in Washington. A final three-foot study of 1916 (Plate 184)

in bronze gives a clearer idea of its detail. French based the head on life masks, but placed the figure within an idealized Roman chair to complete the synthesis of immediate humanity and noble symbol, in a manner he followed from Saint-Gaudens' earlier versions of the subject. This classicism is a culmination of the style and imagery initiated decades before by Greenough, Powers, and Crawford. As the carving took its place in the national capital, new sculptural ideas were emerging (see Plates 239 and 240), and the first great war of another century was under way.

CHAPTER 20

IMPRESSIONS OF EYE AND FEELING

Two forms of Impressionism emerged during the last quarter of the nineteenth century, one largely concerned with the optical issues, *plein-air* subject matter, and broken-colour brushwork of the French movement; the other also using colour, light, and texture, but directed towards the expression of subjective feeling more than recording objective form.[1] Impressionism in America followed the French movement only after a full generation, at a time when the latter was already fragmenting into the different directions of its individual practitioners. Unlike the situation in France, where the artists associated under the banner of Impressionism pursued their largely theoretical ideas in defiance of official salon art and the jury system, the American artists tended to be rather practical and literalist followers in their established footsteps, and in fact constituted a loose academy of their own.

In the art of George Inness one can follow almost the full range of transition from landscape problems of the forties to those of the nineties. His birth in 1825 made him the almost exact contemporary of Church and Cropsey, yet the direction of Inness's art was entirely different, and appealed to tastes that were flourishing, rather than waning, during the post-Civil War decades. Church himself recognized, unappreciatively, the deep distinctions between their approaches to art when he said of Inness: 'His theory is "Subject is nothing, treatment makes the picture."'[2] Of primary concern to Inness was the important role of the artistic process itself, such that his resulting images were highly personal, even otherworldly.

Inness moved when he was very young from Newburgh, New York, to Newark, New Jersey, and got some early instruction in art from local painters. During the forties he studied with the accomplished landscapist Regis Gignoux in New York City, and began to use engravings after seventeenth-century landscapes as models for his own first canvases. His early compositions reflect not only Dutch precedents but also the philosophical landscapes of Thomas Cole and Washington Allston. In 1854 he went to France; like Hunt he was profoundly influenced by the Barbizon school, which now stimulated a major transformation of his style towards openness of design, more suggestive brushwork, and a brighter range of colour.

The finest view of his early maturity is *The Lackawanna Valley* of 1855 (Plate 185), with its lingering debt both to panoramic Dutch pictures and to spacious vistas by Cole like *The Oxbow* (Plate 93). However, the informal placement of the tree on the left in counterpoint to the receding planes of land beyond breathes the newer spirit of Barbizon. Inness's picture was a commission from the first president of the Delaware, Lackawanna, and Western Railroad, and was supposed to portray the recently built roundhouse complex at Scranton, Pennsylvania.[3] The company's buildings are there, but pushed into the distance, and the several puffs of steam issuing from the industrial

machinery are to enhance the fundamentally romantic interpretation of American scenery. As with Cropsey's *Starrucca Viaduct* (Plate 97), the machine in the national garden is still more of a productive than a destructive intrusion. Yet the cut tree-trunks across the foreground intimate an irony and ambivalence towards the changing relationship between countryside and industrial progress. In this regard Inness was expressing sentiments shared on both sides of the Atlantic at mid-century.[4]

He continued to elaborate on these themes during the next decade and a half, painting extensively in Medfield, Massachusetts, in the early sixties, and thereafter in New Jersey. Here he was a neighbour of the painter William Page, whom he had first met a decade earlier in Europe. Page was an ardent exponent of Swedenborgianism, and now introduced Inness to its spiritualist principles. When Inness returned to Italy during the early seventies, his work underwent another stylistic change. Concentrating on views of olive groves and the rolling Campagna, he organized his compositions with a new decorative strength of flat contrasting shapes. Back home in the later seventies, first in Boston and New York briefly and then settled for good in Montclair, New Jersey, Inness sought to develop his notions of pictorial order and harmony, as creative applications of his religious and philosophical principles.

The Coming Storm of 1878 (Plate 186) exemplifies some of these ideas as he codified them in his later career. For example, he took great care to subdivide horizontally both the picture's surface and its spatial recession into rhythmic parts, in this instance gently but carefully tied together by the two small bare trees at the right. These carry the eye upward and backward from the immediate foreground to distant sky. Figures and animals often appear in his views, but they are usually unobtrusive, serving to lend interest to some part of the whole, rather than to become a distracting subject of interest in their own right. While there is no question of Inness's meteorological accuracy, his storm is ultimately subordinated to the controls of pictorial organization. Likewise, the varied textures of pigment and rich colour harmonies (here of pale greens, browns, yellows, and greys) seem to acquire a Whistlerian life all their own.

This is also a transitional work to Inness's late style, which became even denser in atmospheric and textural effects. Superficially, his work approached French Impressionism, which he disdained. His landscapes were, by contrast, neither scientific, optical, nor transient, but rather shrouded in the mist and mystery of an immaterial world. 'Whatever is painted truly according to any idea of unity', he argued, 'possesses both the subjective sentiment – the poetry of nature – and the objective fact.'[5] This attitude and style also characterized Inness's friends and followers Alexander Wyant, Dwight Tryon, and Homer Dodge Martin, whose artistic developments were roughly parallel to his own.

Martin, for example, was eleven years younger than Inness, and grew up in Albany, New York, where he began painting under the guidance of the Hudson River landscapist James M. Hart. During the sixties he looked to Cole's pictures for inspiration and particularly to the open compositions of Kensett, whose influence lies behind *Lake Sanford in the Adirondacks, Spring*, of 1870 (Plate 187). Yet the expansive view typical of the Hudson River manner is somehow softened by a meditative mood and hazy

atmosphere closer to Inness. The forms are in fact without the charged symbolism of Cole's prototypes (compare Plate 90); they reflect instead a view which Church would have found lacking, but which Inness proclaimed, that 'a work of art is not to instruct, not to edify, but to awaken an emotion'.[6] Not surprisingly, Martin subsequently went to Europe and found especially appealing the art of Whistler and of Corot.

John La Farge occupies a place many find awkward to pinpoint in the evolution of American art, yet his work joins several of the currents that preoccupied his contemporaries. Born in New York in 1835, he went through college and began law school, but gave that up to visit Europe in 1856. In France he acquired an admiration for Corot, and in England for the Pre-Raphaelites, both of whom were to find echoes in his subsequent approach to art. During the next decade he joined the studio of William Morris Hunt in Newport, where he met William and Henry James. His landscapes of this period are similar to Hunt's, atmospheric, softly textured, and richly painted, but more abstract and simplified.

In the seventies La Farge turned to other media, partly out of disappointment at the unfavourable reception of his landscapes and partly out of his inherent impulses to explore and experiment.[7] Whatever the reason, he now took up woodcut book illustration, watercolour, mural decoration (most notably for Richardson at Trinity Church), and stained glass. Like his watercolours, they glowed with light, and ranged from transparent to opaque. He further extended his artistic vocabulary by venturing into new subjects, such as still life, allegory, and religious painting.

The impulse to escape the advances of industrialism at the end of the nineteenth century finally motivated La Farge and Henry Adams, as it did Gauguin in France, to leave for the Far East in 1886. Their trip to Japan, and then to Samoa and Tahiti during 1890–1, was a common expression of romantic interest in the exotic, seen on a less ambitious scale in Homer's frequent visits to the Caribbean in the same period. It is relevant to recall that Homer's own fascination with Japanese prints was in large part due to the collecting enthusiasm of his friend La Farge. Travel of this distance may also be seen as the culmination of those drives that impelled other American artists, for example Whistler, Church, Heade, Gifford, and O'Sullivan, to seek undiscovered territory. La Farge felt he was 'in presence of the remotest past'.[8]

During his long excursion through the South Pacific he kept seeing European art transformed. His bright Polynesian sketches looked like Corot in the tropics. 'I have seen every morning upon which I have waked early enough, innumerable Corots, here, however with intense greens.'[9] Or, on another occasion in Samoa he exclaimed that 'Rembrandt would be happy here, especially in the evenings, when the cocoanut fire . . . makes a centre of light.'[10]

What clearly impressed him and his painting most forcibly was the awareness of colour and light, and his best watercolours of the voyage seem ignited by fire from within. *Maua – Our Boatman* of 1891 (Plate 188) was done on La Farge's last day in Samoa, late in the afternoon.[11] The painter is at his best in combining effects at once intimate and monumental, cool and warm, scientific and romantic, living and timeless. Previously he had described how another

Samoan youngster who rose shining from the sea to meet us, all brown and red, with a red hibiscus fastened in his hair by a grass knot as beautiful as any carved ornament, was the Bacchus of Tintoretto's picture, making offering to Ariadne.[12]

La Farge was capable of observing scientifically, as Audubon, Catlin, and Curtis had done, while also putting on paper or canvas feelings as personal as those of Whistler or Inness. Yet *Maua* bears La Farge's stamp alone, in its singular combination of his various interests in figure painting, landscape, and still life.

The attention to media other than oil was shared by Mary Cassatt, Childe Hassam, John Twachtman, J. Alden Weir, and of course Whistler. This generation was responsible for a vigorous revival of etching, and to a lesser degree lithography. Cassatt was probably closest to the Impressionist movement, although it was the more classical aspects of the human figure, careful drawing and composition, and social observation which attracted her. Born near Pittsburgh the same year as Thomas Eakins, she too entered classes at the Pennsylvania Academy in the early sixties, and left for France in 1866 for several years. Emphasis on drawing and life study led her in the early seventies to Italy, where she looked closely at the figural compositions of Correggio and Parmigianino. The imagery of Madonna and Child was to offer a formal and iconographical source for her own more personal and secular interpretations later.

Following in Eakins' path, she went on to Spain and was deeply impressed by Goya and Velázquez. By the mid seventies she was settled in Paris, and except for a few trips home, remained in France for the rest of her life. Her work soon reflected the influence of Manet, Courbet, and Monet, but it was Degas whom she most admired and who invited her formally to exhibit with the Impressionist group in 1877. That year marks the beginning of her most productive and successful years. 'I took leave of conventional art. I began to live.'[13] Through Degas especially she learned the aesthetic possibilities of photographs and Japanese prints. Between her and Whistler there developed a mutual admiration, but Sargent she came to ignore.

In 1877 her parents and sister Lydia moved to Paris, and during the following years some of her strongest portraits were of the family. One of these was *Lady at the Tea Table* of 1885 (Plate 189), for which her aunt Mrs Robert Moore Riddle posed.[14] Cassatt was ordinarily less inclined than Degas to exploit the most visually provocative aspects of photographs, such as extreme juxtapositions of foreground and background, harshly cropped or awkwardly imbalanced forms; and generally she did not attain his psychological power. Her work always seemed to retain a subconsciously American strain in its hard realism and palpability of mass and space.

Here one finds her acknowledgement of Japanese prints in the assiduously controlled patterns of interlocking circular and rectangular shapes. The conception is even more strongly reminiscent of Degas' *Bellelli Family* of 1859 in the Louvre, in which the severe silhouette of the older woman is reinforced by the sharp edges of a nearby picture frame. Mary Cassatt achieves a comparable, and for her unusual, sense of inner character. The figure dominates her surroundings at the same time that she is locked into the orderly arrangement of familiar objects. Possibly because the painter showed such insight into

the settled habits and fragile toughness of age, her family was exceedingly displeased with the result.

Mary Cassatt's most original achievement was her graphic work, highlighted by her set of twelve colour prints exhibited in 1891. These were ingenious combinations of drypoint, soft ground, and aquatint, and include some of her most familiar and successful images.[15] *Woman Bathing* (Plate 190) displays her consummate economy of design and means. The flattened forms and surfaces attest to her creative use of Japanese models, although there are subtle touches all her own: the rhythmic play of curved silhouettes; ambiguity of mirror and wall; contrasting floral, striped, and plain areas; and a refined sensibility in the muted colour range of soft pink, green, blue, and ochre. Stylistically, these prints summarize many late-nineteenth-century interests; technically, they are unsurpassed by any of Mary Cassatt's contemporaries.

Two years later, at the invitation of Mrs Potter Palmer, Cassatt executed a major mural (regrettably now lost) on the theme of *Modern Woman* for the Women's Building at the Columbian Exposition in Chicago. Thus she joined in an activity of large-scale decoration which was engaging the attention of numerous contemporaries, such as Sargent, Whistler, Vedder, La Farge, and Saint-Gaudens. In addition, she made an important contribution to American taste by stimulating her friend Louisine Elder Havemeyer (whom she first met in 1879) to acquire French Impressionist works as well as neglected old masters like El Greco. Cassatt toured Europe with the Havemeyers in 1897 and 1901, helping them assemble the eminent collection eventually bequeathed to the Metropolitan Museum.

While Mary Cassatt was living out her life in France with advancing blindness and unhappiness, a group of American Impressionists at home formed a closely knit group called The Ten. The most accomplished in this circle included Joseph de Camp, John Twachtman, J. Alden Weir; along with the Bostonians Frank Benson, Childe Hassam, Willard Metcalf, and Edmund Tarbell; plus Thomas Dewing, the most original painter of the group, although stylistically much more subjective than the rest.[16] Several were also members of the Society of American Artists, which had earlier separated itself from the conservative strictures of the National Academy. Together these painters remained active and exhibited together up until World War I. Of their better known contemporaries not in the organization were Lilla Cabot Perry, who remained more directly associated with her French colleagues, and Theodore Robinson, whose short life ended in 1896.

The Ten represented a common artistic sensibility for good reasons. They were all very much of the same generation, born within the ten-year period 1852–62, and lived on the average well into the first quarter of the twentieth century. Their training was similar: except for Weir who left for France in 1873, the rest arrived in Paris around 1883, when the Impressionist movement was at its zenith. After travel for some to Holland, Spain, the French countryside, or Venice, most returned to work in New York during the winters and painted in New England or Europe during the summers. Gloucester, Massachusetts, with its picturesque shoreline and special ambience of luminous atmosphere, understandably appealed to several of this generation, for example

Twachtman, Hassam, and Perry. As it had earlier for Lane, Homer, Hunt, Duveneck, and Beaux, this region had a notable lightening effect on their manner of painting.[17]

Although commonly favoured, the mature later work of the American Impressionists tended to be the weakest and least original, primarily because it adhered (despite disclaimers to the contrary) most closely to European precedents.[18] This was especially so with Robinson, Hassam, and Twachtman. But American artists generally were too deeply ingrained with a national aesthetic tradition of realism and narrative to be able to perceive or accept fully the intellectual and formal implications of the French theories. Some tended to retain a tonal structure of contrasting low and high values, while the French wherever possible eliminated the darker ranges. Others clung to anecdotal subject matter or portraits, and correspondingly they preferred to render the figure as a palpable entity. It was counter to their perceptions and inclinations to allow touches of broken colour to dissolve their subjects, however much their brushwork might emulate the loose and improvisatory mode of their French models. In the same way, Americans usually maintained balanced compositional structure and convincing pictorial space, in contrast to the increasing fusion of figure and ground, surface and space, in pictures by Monet and others. In sum, American artists on the whole gave priority to the substance of their subject matter, over its perception (retinally or optically), rather than the reverse.

Hassam's *Flower Garden* of 1888 (Plate 191) exemplifies a characteristically American understanding of Impressionism: the popular theme of flowers in sunlight, bright complementaries of reds and greens; at the same time a formal composition with little sense of the momentary, and a full scale of light and dark contrasts. Hassam's early training had been in printing, and a significant achievement of his career was also in etching and lithography. *Inner Harbour, Gloucester*, of 1918 (Plate 192) exploits the soft textures and swift notations possible in the lithographic medium, as well as the white surface of the paper, to suggest the brilliance of sunlight and its shimmering reflections across the water. The economic and almost abstract division of the design is technically and conceptually worthy of Whistler.

The fishing port of Concarneau near Pont-Aven in Brittany attracted Benson, William Picknell, and other American Impressionists. Picknell's *Road to Concarneau* of 1880 (Plate 193) is a work of unusual strength, both in colour (the sky is an intense blue) and in design (such perspectival recession could have been painted only by an American). Five years later, Twachtman's *Arques-la-Bataille* (Plate 194) reflected his personal response to the French movement. He had been a colleague of Duveneck's in Munich during the preceding decade, and his broad, vigorous brushwork here recalls that style (see Plate 174) at the same time that the markedly lightened palette and bold patterns reflect his exposure to Impressionism and Japanese prints respectively. This is a record of both sight and feeling, with a mood of calm melancholy familiar to this period, and shows Twachtman at his best. An equally strong decorative structure holds together J. Alden Weir's *Red Bridge* of 1895 (Plate 195), which contains as well complex balances of reds and greens, water and sky, nature and industry. As a romantic image of

technology, this bridge marks an interesting point of transition between the images by Cropsey thirty years earlier and Joseph Stella thirty years later (Plates 97 and 224).

Other painters of this generation remained more consistently concerned with the human figure; some closer to Impressionism, like Edmund Tarbell, Joseph de Camp, and the photographers Clarence H. White and Gertrude Käsebier; others, such as George de Forest Brush, Abbott Thayer, and John White Alexander, devoted to painting classicized, idyllic women. Tarbell at his strongest was capable of rendering strong but delicate pictorial spaces, inhabited by figures often separated physically as well as psychologically. In *Josephine and Mercie* of 1908 (Plate 196), for example, the furnishings seem to frame the figures, just as the softly filtered light and pale colours envelop the mood of self-absorption. John Alexander's *Isabella; or, The Pot of Basil* of 1897 (Plate 197) carries such introspection into a different realm of physical sensuosity and inner mystery. Now at the end of the century the lingering whispers of Whistler, the Pre-Raphaelites, Munich, and tonalism still reverberate.

Shortly after the formation of The Ten, Clarence H. White, along with Gertrude Käsebier, Edward Steichen, and others, founded the Photo-Secession movement with similar ideas in mind: 'Light, light, always light! . . . See and record its delicacy and daintiness in the upper ranges . . . Ever and always use light to express your thought.'[19] White's prints, such as *Spring* (1898) (Plate 198), took partial inspiration from Whistler's Harmonies and Symphonies, but now achieved through soft-focus effects of the photograph. A new gum-nitrate process permitted the brushing or washing of sensitized salts on the plate, while in some instances gauze or drops of water were placed on the camera's lens, all to create the hazy and evocative qualities seen in painting. Here more than anywhere were the inner and outer eye made one.

PART FIVE

TRANSITION TO THE TWENTIETH CENTURY 1893–1945

From Fin-de-Siècle to World War II

CHAPTER 21

THE INNER EYE

THE nineteenth century turned a number of artists deeply inward, and in its closing years some had created a subjective art more associated with the twentieth century. Poetic and personal as this work was, science often played a central role, in the concern with anatomy or with mathematics. Although more than one group began by drawing from antique casts, and others from nature, they all drew a veil of reverie across their subjects, turning the specific into the general, the immediate into the timeless. Often their own lives were punctuated by periods of isolation, no less in New York City than the American or Italian countryside. The colour of Titian, as it had years before for Allston, was an appealing exemplar, and most emulated his methods of scumbling and glazing layers of paint. Frequently, pictures took long periods to complete, as the artist strove to create a single, harmonious feeling, and as the work of art seemed to become inseparable from his individual psyche.

The brooding melancholy and foreboding so prevalent at century's end reflected an uneasy perception of changing order. Although this mood was strongest in the eighties and nineties, there were some precursors in an earlier generation, most notably William Page and William Rimmer. Both had difficulties in finishing works, and their artistic frustration is to be seen in their small and uneven oeuvres. Neither Page's personal nor his artistic life ever seemed sure of itself: he married three times, shifted styles and subjects, and moved uneasily between Europe and America.

Born in Albany in 1811, he moved to New York as a child, and briefly studied law in 1825 before turning to art. He began artistic training at the American Academy, but moved to the new National Academy of Design under Morse in 1827. From his teacher Page gained an admiration for the colour-glazing techniques of Allston and Titian, and during the next two decades developed his own elaborate theories about art. One of his notions concerned the 'middle tint', whereby a picture should be constructed upon strong colours kept within a middle range of tonal values.[1] In 1850 he went to Europe for much of the decade, first studying in the Louvre and then proceeding to Italy. There he copied works by Titian, whom he compared favourably to Raphael on the basis that art required 'design in lines [as well as] chiaroscuro, and colour combined'.[2] By this time a fervent enthusiast of Swedenborg's spiritualist teachings, Page believed the proportions of the human body to derive more from spiritual revelation than mathematical rules. Thus the antique past became useful to him only as it was transformed by more modern feeling.

When he returned to New York for good in 1860, he was working on paired portraits of himself and his third wife, Sophie Candace Stevens, the finest accomplishments of his career. For the composition of *Mrs William Page* (Plate 199) he made a careful drawing ruled off into quadrants, to ensure the proper subdivisions of the anatomy and the exact

placement of the figure within the setting. In the background of his own portrait he included a faintly visible cast of Theseus from the Parthenon pediment; here the Colosseum acts both as backdrop to his wife's figure and as a reminder of the past's perfection. Page doubtless found its measured subdivisions perfectly attuned to the modern spirit. Indeed, the tall dark silhouette of Sophie Page seems intentionally echoed in the tiered arcades behind. Figure and architecture are further balanced by their positions respectively just to the right and left of centre.

Finally, Page invests the whole with a dreamlike detachment, by flattening out the curved wall slightly, leaving rather vaguely defined the fallen columns, and cutting the figure off at the bottom of the canvas, which has the curious effect of suggesting that she stands in an extension of the viewer's space. Through glazing Page achieved a luminous atmosphere, with the figure as the dominant note of his restrained colour scheme. In fact, the final phase of his procedure was the heightening of colour in the figures, so that 'they shall "stand out rounded and alive" before long'.[3]

Five years younger than Page, William Rimmer seemed even more consumed by spiritual obsessions. His life's vision was conditioned by the belief, neither proved nor disproved, that he was the son of the pretender to the throne of France. This explains why the royal imagery of lions and gladiators is so recurrent in his work. In 1826 he emigrated with his family from his native Liverpool to Boston, where his father brought him up with extensive instruction in languages, science, and music. During the mid thirties he worked in the lithographic shop of Pendleton's associate Thomas Moore, with Lane, Benjamin Champney, and D. C. Johnston, although Rimmer's scientific bent took him in an entirely different direction from his contemporaries. Through study in the medical collections and dissecting rooms of the Massachusetts Medical College he virtually taught himself to be a physician.

'Anatomy is the only Subject' became the credo of his vocation and avocation.[4] In the late fifties he also began to carve his first figures in pieces of granite quarried in nearby Quincy. He found useful poses in various sources: the figure drawings of Allston and William Blake, prints after the work of John Martin, and casts in the Boston Athenaeum, including the figures of *Night* and *Day* from the Medici tombs in Florence. The next fifteen years saw Rimmer's period of greatest artistic activity. During the sixties he began a popular career teaching art anatomy in Boston and later in New York. His pupils included artists as diverse as Hunt, La Farge, D. C. French, and Frank Benson. Hunt remained a competitive friend and teacher himself, responsible for cultivating local interest in the animal bronzes by the French sculptor Barye.

Rimmer's sculpture of the *Dying Centaur* (1871) (Plate 200) reflects some awareness of Barye's work, although Rimmer cared less about the romantic conflict among animals themselves and more about the troubling physical and psychic passions within man's own nature. A decade earlier he had completed his largest piece, a full-size figure of the *Falling Gladiator* (Museum of Fine Arts, Boston), and here he compressed in more compact form a similar conflict between aspiration and collapse. One feels an anguish of both soul and body, a duality seen in the image of a creature half man, half beast. The cut arms are particularly expressive in their various allusions to fragmented classical

statuary, the immediacy of photographic cropping, and the imagined pain of amputation. The suffering that Rimmer put into his art was equally personal and artistic, for in the preceding years his three sons died in childhood, and his first important public work, a statue of *Alexander Hamilton* for Commonwealth Avenue, was severely criticized.

The artist's drawings and paintings are just as haunted with personal meaning. His most compelling picture, *Flight and Pursuit* of 1871 (Plate 201), also poses a set of ambivalences, in the title, and in the perpendicular crossing of endless hallways, solid and transparent figures, shadow and substance. Rimmer's original title for the subject was *Oh, For the Horns of the Altar*, a reference to an Old Testament story about one of David's sons usurping the throne which should have rightfully gone to Solomon. Altars were also decorated with horns, and were places of sanctuary. Thus, Rimmer had in mind his own imagined plight in losing the throne of France as well as fleeing a possible threat of assassination.[5] Eakins would have appreciated Rimmer's argument that 'a work of art should be something more than the solution of a problem in science'.[6] The surrealism of Rimmer's figures emerges out of his extraordinary capacity for putting the flesh of feeling on the anatomy of visions.

The decade of the fifties also found Elihu Vedder roaming through Italy like Page, impressed with the large figures of Michelangelo like Rimmer. Vedder was a generation younger, born in New York in 1836. In his twenties he met J. J. Jarves, who encouraged him to study the painters of the early Renaissance. He first went to France in 1857, but as he later wrote, 'Fate, the stupidity of drawing from casts, the roving instinct and the opportunity, and [his friend] Rhodes's need of a companion combined – drew me to Italy.'[7] He was very moved by the ancient rocks and Etruscan ruins near Volterra, and 'at Venice I absorbed colour like a sponge'.[8] Coincidentally with Page he also returned to New York in 1860, with memories and images of the past germinating in his mind. Impoverished and alone in New York, Vedder turned increasingly inward for the sources of his art.

Once thinking of Goya, he recalled, 'on the floor, huddling in my single blanket, I too had dreams of angels and devils . . . It was there I conceived "The Questioner of the Sphinx"'.[9] His picture (Plate 202) comes not long after Page's portrait of his wife, and is akin to it in its dreamlike mystery and surreal clarity. The idea is a combination of experience and invention, recalling his recollections of the haunted landscapes of ancient Europe, the monumental fresco figures of Michelangelo, the rich colourism of Titian, and his vision of the great ruin still half buried in the sands of time. Much of the picture's force comes from the sharp definition of form and vivid blue sky in contrast to the nagging enigmas of the buried skull, discordant scale of carved and human figures, and sense of imagined voices in this vacuum of air and space. Half mockingly, he wrote of another painting that he 'drew it all out of my own head with a common lead pencil'.[10] How fitting that here he should have placed his signature (and presence) on the block of stone in the foreground surrounded by sand.

A couple of years later Vedder met La Farge and Hunt in Boston ('If Hunt was comforting, La Farge was inspiring'[11]), and as a consequence his style somewhat softened. In later years, too, spent mostly in Rome, he borrowed from the mannerisms of the

Pre-Raphaelites. During the 1890s he joined several contemporaries in undertaking architectural decoration, and contributed important murals to the Library of Congress and the art gallery at Bowdoin College.

Although widely divergent in age and background, another group of painters produced pictures in the nineties that were less patently symbolic, though equally subjective, and on the whole more experimental technically. Born in New Brunswick, Canada, in 1828, Edward M. Bannister settled in Boston, where he felt a Black might most congenially pursue art. Two circumstances seemed to have played a decisive role in determining his career: study with Rimmer at the Lowell Institute in the early sixties, and a New York newspaper's slur that 'while the Negro may harbor an appreciation of art, he is unable to produce it'.[12] Nonetheless, Bannister successfully established himself as a landscape painter, and refused to allow racial subject matter to promote or hamper his reputation.

By 1871 he was sufficiently independent to move to Providence, where he was a founder of the Art Club, forerunner of the Rhode Island School of Design, and five years later won a gold medal at the Philadelphia Centennial Exposition.[13] His best work, such as *Approaching Storm* of c. 1890 (Plate 203), is a personal transformation of the Hudson River tradition, rather parallel to Inness, and similarly tempered by an awareness of Barbizon art. Although Bannister did not visit Europe himself, he was in Boston during the crucial years when Hunt and La Farge were promulgating this style. The drama of man struggling against an oncoming storm recalls Homer's themes of the same years, while the loose brushwork and thick impasto share an expressive spirit with the work of Blakelock and Ryder.

Actually, the art of Ralph Blakelock evolved in a very similar way out of the relatively tight handling identified with the later Hudson River School, and its subsequent mellowing by Barbizon influences, into a resonant world of contemplative landscapes. Blakelock was a full generation younger than Bannister, born just before mid-century, but he painted his most imaginative works in the eighties and nineties, after which time a mental collapse forced him into a sanatorium. He grew up in his native New York with a precocious interest in art and music, and his pictures reflected associations analogous to those of Whistler. His earliest work, mostly of scenes in the Catskills in the late 1860s, is close in feeling and technique to the style of Cropsey, William Sonntag, and George Loring Brown, though soon his paintings were to take on the evocative softness of Inness and Wyant.

During the early seventies Blakelock travelled in the west and southwest, visiting Indian camps and then going down through Central America before returning home. For a while his canvases included scenes of Indian settlements set on the plains or deep within woods, but by the eighties most narrative or genre subject matter was absorbed into generalized landscapes whose dominant themes were the glow of sunsets or moonlight.[14] *The Poetry of Moonlight* (Plate 204) is a classic example of his later period. As Blakelock rarely dated and irregularly signed his pictures, their chronology remains inexact; in addition, his wife confirmed that 'his best work took a long time to complete and in the meantime he had to live'.[15]

While perhaps initially derived from Barbizon art, Blakelock's feathery trees surrounding a full moon have become the most recognizable features of his work. Largely self-taught, he tended to experiment with applications of pigment, varnish, and sometimes other incompatible substances, which have since led to the serious deterioration of several canvases. When he did have time to resolve a picture over a period of time, he built up on a silvery ground his various forms, often flattening details with a palette knife or wiping them away. As layers of paint or glazes accumulated he rubbed the surface, which exposed hints of the silver interior.[16] His colour was highly original, most often structured around dark blues, greens, and blacks, in counterpoint with the yellows and whites. By these means the genesis and process of image-making became fused for Blakelock through the passion of dreams.

In contrast to the predilection of Bannister and Blakelock for pure landscapes, Henry O. Tanner and Thomas Dewing used similar means but focused on the human figure. Although both were born in the 1850s and arrived at a similar mood of introspection in their work at the end of the century, their training and associations were markedly different. Tanner was one of the first Black American artists to gain an international reputation with his election to the French National Academy. He was trained at the Pennsylvania Academy under Eakins, who remained a friend and helpful colleague through later years. Eakins was largely responsible for turning Tanner's attention to genre and portrait painting, and the older man's influence is seen in the deeply touching portrait of *The Artist's Mother* of 1897 (Plate 205). Light from an unknown source falls across the crucial surfaces of the sitter's face and arm, while the surrounding darkness confirms a mood of pensive calm and tenderness. Tanner's placement of the figure to the right of the composition succeeds in charging the remaining darkness with the power and mystery of thought.

From the 1890s on Tanner spent most of his time in Paris, where he flirted unsuccessfully with recent French styles at the same time that he won a solid reputation for himself.[17] His paintings after the turn of the century tended towards religious and landscape subjects with interesting parallels to Ryder's work, but without the technical or conceptual strength of his earlier achievements.

Dewing also favoured the rendering of women seated alone in a room, caught up in the reverie of inner voices. He, too, had been to Paris, though it was as a student in his twenties during the formative years of his style. His much lighter touch and tonalism in a characteristic work like *The Recitation* of 1891 (Plate 206) reflected his more fashionable association with the other American Impressionists and their participation in the Society of American Artists and The Ten.[18] Dewing developed two related types of composition – single individuals at rest within spare interiors, and a couple of figures floating in gauzy landscapes. Both were painted in a manner partially indebted to Whistler, for example the single colouristic atmosphere (usually pale green), compression of space into a nearly abstract surface design, occasional musical allusions, and formal arrangements reminiscent of Vermeer. Dewing gently manipulates a subtle ambiguity between refined material elegance and forms nearly dematerialized by the surrounding vapours of light, textures, and imagined sounds.

Dewing is one of those figures who summarize an age, and in his art may be seen an original distillation of many later nineteenth-century tastes and preoccupations: Victorian idealism and illusion, *fin-de-siècle* nostalgia and wistfulness, an aestheticism joined to poetic and musical sensibilities, and shapes of the real world treated as vehicles of either personal or universal meaning. Yet his exquisite images define more than the terminus of one century, for his impulses towards abstraction and subjectivity equally prepare us for the artistic questions younger painters were to address during the coming decades.

Comparable to Dewing in depth of originality and expressive personal poetry was Albert Ryder. Born in New Bedford, Massachusetts, in 1847 of an old Cape Cod family, he grew up conscious of the sea and of the far-flung shipping and whaling activities centred in his home port. In 1870 he moved to New York, where he received some artistic help from a local portraitist, and a few years later took courses in drawing from life and from antique casts at the National Academy.[19] Historians are quick to stress the lonely isolation in Ryder's life and art, which tends to obscure his personal and artistic associations with J. A. Weir during the eighties. The two painters were among the co-founders of the Society of American Artists, and remained friends in later years.

The nature of Ryder's several trips to Europe also gives an idea of his individual temperament. He went first in 1877 to England, but stayed only a month. Five years later, however, he spent from late spring to fall making a conventional grand tour of the continent. Weir said that his colleague's more memorable experiences included crossing the Alps and seeing 'the great art treasures' before gladly returning home.[20] Again in 1887 and 1896 Ryder made the ship crossing, but now (rather like Whistler journeying to Valparaiso) it was just for the experience of the open ocean and sky. These became fragments in the voyage of life which he celebrated in lyrical and poetic form on his canvases. Likewise, he drew extensively on religious and literary subject matter for some pictures, transforming his themes into personal and pictorial terms. As we have seen, such impulses were not unique, as the various manifestations of spiritualism and narrative sources among his contemporaries make evident.

With his romantic inclinations Ryder was attracted above all to Shakespeare, as well as to Chaucer, the Bible, and many of the English romantic poets. He shared with others a deep feeling for music; in Wagner's operas he discovered not only inspiration for subjects but also a total expression of exuberant rhythms and powerfully articulated emotions. Yet it was not narrative action or literary descriptions that he used; rather it was the generalized forms of nature and their capacity for symbolizing the more sublime abstractions of tragedy, heroism, mortality, and eternity. Partly because of these visionary compulsions and partly because his actual eyesight gave him lifelong trouble, Ryder said

my colors were not those of nature . . . There was no detail to vex the eye. Three solid masses of form and color – sky, foliage, and earth – the whole bathed in an atmosphere of golden luminosity.[21]

Although most of his canvases bear no dates and were worked on over many years like Blakelock's, Ryder's subjects moved from recollections of familiar landscapes around coastal New England to metaphoric seascapes frequently given the title *Moonlight Marine* (Plate 207). Usually small in size and vast in scale, they rely on internal rhythms of repeated shapes and melodic tonal contrasts of glazed yellows and dark green-blues. Ryder used to walk through New York's streets and parks 'soaked in the moonlight',[22] though the colour in his paintings rarely specifies time of day any more than source of illumination. There is seldom any shore, wind, or man – only the emblems of mortal passage. Ryder's approach is best compared with the equally hermetic and symbolic poems of Emily Dickinson.

Perhaps the pathos and fragility of such dreams most eloquently emerge in the tiny panel, *The Dead Bird* (Plate 208). Ryder sensed in this small creature of nature something of his own humanity. This perception, along with the virtually abstract treatment of space and ground, would have relevance for twentieth-century painters like Morris Graves (see Plate 232) and Ryder's younger friend Marsden Hartley. Another visible recognition of Ryder's modernism was the inclusion of ten of his paintings in the Armory Show of 1913. Homer and Eakins were not represented at all in that watershed event announcing the beginning of twentieth-century art in America.

APPROACHES TO MODERNISM

IN one of the principal organizers of the Armory Show, Arthur B. Davies, may be found many of the paradoxes characterizing the emergence of avant-garde thought during the first decade of the twentieth century. His own painting was deeply rooted in art of the past, at the same time that Walter Pach could speak of 'the quickness and rightness of his appreciations'[1] in choosing contemporary works for the exhibition in New York. He was eclectic in his sources, yet as a leader of his colleagues he was single-minded, even 'severe, arrogant, implacable'.[2] Besides conducting his careers as artist and administrator, and maintaining a family in upstate New York, he carried on a secret affair with another woman under a pseudonym.[3]

Davies was born in Utica, New York, in 1862, and his early landscapes are rather dreamy views somewhat akin to Wyant's and Blakelock's. He was fascinated with painting figures in landscapes partly real and partly imaginary. Increasingly he became concerned with the linear rhythms of a composition, along with loosely brushed areas of paint and vaporous nuances of soft colours. *Dream* (Plate 209) is typical in its evocation of the elegant figures of Botticelli and of Piero di Cosimo; the classicism equally of Greek vases and French painting; and the dream worlds of Davies' American predecessors, Vedder, La Farge, and Ryder.[4] After his exposure to cubism and related movements at the Armory Show, he attempted for a few years with only marginal success to adapt its fragmentation of forms to his own painting. His greater achievement was in helping to introduce modern European art to America.

Joining Davies in the modernist cause was Maurice Prendergast, who was three years older and a native of St John's, Newfoundland, though much of his life is associated with Boston. A stay in France in the early nineties resulted in his close association with the Canadian painter James W. Morrice, who stimulated Prendergast's awareness of Japanese prints and the work of various Impressionists and post-Impressionists, most particularly the Nabis. Returning to New England later in the decade, Prendergast settled into a routine of painting watercolours of nearby coastal resorts and parks in a holiday mood.

When he went to Italy in 1898 for a year, he responded with special sympathy and excitement to the shimmering beauty of Venice. His work there reflected enthusiasm for both the distant past – the bright, strong mosaics of Padua and Florence – and the Renaissance still alive in the paintings of pageants and processions by Carpaccio.[5] Venice itself was an imaginary and actual playland, a rich composite of east and west in its architectural and cultural inheritance, an improbable city seemingly constructed of water and sunlight. This charmed world was a perfect subject for Prendergast's imagery of affection and affirmation – the last before the decisive disruptions to art and social order respectively in the Armory Show and World War I.

Even poor weather takes on a carnival air in *Umbrellas in the Rain, Venice*, 1899 (Plate 210), as Prendergast uses the muted tones of architectural surfaces and water reflections as a screen for the brightly coloured circles of open umbrellas. With a full understanding of his medium, which establishes him as a worthy successor to Homer in the American watercolour tradition, Prendergast cleverly equates the spontaneity, luminosity, and fluidity of his means with his subject. The sense of decorative structure and the exploration of colour patterns as indices of feeling both parallel and reflect the work of Whistler and Bonnard.

After 1900 Prendergast concentrated on painting watercolours in and near Boston, but now he also took up oil painting seriously. His canvases achieve a similar hermetic indulgence in sensuosity of paint and colour, though seldom with the originality or full realization of his watercolours. After 1914 he was based in New York, associating himself with Davies and others pressing for artistic reform, though he continued to paint in New England during the summers. He enriched his paintings with a growing knowledge of older art, attained through his various visits to Europe and from his extensive collection of scholarly journals and illustrated books. His library included works on Egyptian, ancient, Indian, and Renaissance art. The accompanying illustrations often served as both indirect and direct sources for poses, gestures, and figural or compositional arrangements in his own pictures.[6]

Thus for Prendergast the art of the past had an abiding life in the present, as he sought to make timeless and significant the fleeting simplicity of the moment. The pastoral charm of his subjects, though limned from immediate experience, gained philosophical depth through a searching creative imagination. Like Davies, he seems paradoxically to look forward and backward; his art is both a culmination of American Impressionism and a forecast of formal and colour abstraction later in the twentieth century.

The group in New York which Prendergast joined under the collective title of The Eight was led by Robert Henri, a magnetic personality and teacher, who attracted other friends and students to his cause. Among them were William Glackens, Ernest Lawson, and Everett Shinn, each too dependent on various aspects or masters of French Impressionism ever to develop original styles of their own. Two other Philadelphians, George Luks and John Sloan, followed Henri to New York; Davies completed their number. Except for the senior members Davies and Prendergast, the rest were close contemporaries, born between 1865 and 1876.

Henri came from Cincinnati, and grew up in Ohio and Nebraska conscious of the values of individualism, nature, and the frontier. Already at the age of fourteen he could note, 'I love to write and draw',[7] and a few years after the family had moved to Atlantic City, New Jersey, Henri enrolled in the Pennsylvania Academy. Eakins had only recently been forced to leave, but his ideas continued in the teaching of his ablest follower Thomas Anshutz, who urged that one paint not so much 'by outlines . . . get the big things first, then the little ones'.[8] Expectedly, Henri gained an appreciation for the human figure through study of anatomy. When he encountered *The Gross Clinic* at the Jefferson Medical College, he called it 'the most wonderful painting I had ever seen',[9] and later urged his own students to look closely at Eakins' work.

In 1888 Henri went to France for three years. At the Académie Julian he learned a new sense of artistic freedom, and like Prendergast in the same years had his first exposure to the new ideas of the future Nabis who were also associated with the school. Other developments proved even stronger stimulation to his artistic maturity: the discovery of Rembrandt in the Louvre, reading Emerson with an emerging sense of his own independence and self-reliance, and visiting Concarneau where he began to paint directly from nature under the influence of the Impressionists. When he returned to Paris at the end of the nineties, his enthusiasm for the great realists of the seventeenth century was confirmed, and his own manner of painting began to change accordingly.

Back in Philadelphia in the closing years of the century, Henri made his decisive move to New York in 1900. There he found a new subject matter appropriate to the recent changes in his style. Seizing on life in the city, he championed it as embodying progress and modernism. This would be the landscape of the new century. During his first years in New York, Henri taught in Chase's art school, but soon outstripped his elder in popularity. In 1908 Henri gathered his friends and colleagues together in protest against the conservative and restrictive exhibition policies of the National Academy. Called The Eight by critics, the group planned its own exhibition at Macbeth's Gallery, which gained great attention through publicity and a subsequent tour around the country.

The machinery was now set in motion for another similar project, the Exhibition of Independent Artists organized by Henri and Walt Kuhn two years later. Then in 1911 the dissidents joined under the banner of the Association of American Painters and Sculptors with the purpose of holding what it was hoped would be the first of regular major exhibitions of advanced contemporary art. J. Alden Weir was elected president, but declined office before efforts got under way, and Davies became his successor. This action brought about an important shift in the group's plan, for the focus of the upcoming exhibition was now broadened to include modern European art as well as American. Kuhn left for Europe to make some preliminary choices, and Davies followed; guided by Walter Pach, they visited various avant-garde artists and collectors, including the Duchamps, Brancusi, and the Steins. When the vast exhibition of over twelve hundred European and American works of art opened in the 69th Regiment Armory on lower Lexington Avenue in February 1913, little did Henri, Davies, or others realize how crucially the course of American art was to be changed.

Although Henri in the years following the Armory Show became involved with quasi-scientific methods of colour application and of composition, such as the Maratta colour system and Jay Hambidge's theory of 'dynamic symmetry', his approach to painting and teaching remained relatively consistent. *Eva Green* of 1907 (Plate 211) shows the quickness and breadth associated with the several seventeenth- and nineteenth-century precedents he had studied. He argued that a form should be 'rendered according to its nature, but it is not to be copied'; and that 'gesture expresses through form and colour the states of life. Work with great speed . . . Get the greatest possibility of expression in the larger masses first.'[10] As for his subject, Henri saw the future in youth. 'Children are greater than the grown man.'[11] For all his assertions of modernism,

however, Henri's painting tended, like that of Chase and Duveneck before him, to lack psychological depth. His principal contributions to American art lay rather in his dynamic capacity as teacher,[12] exponent, and catalyst.

Two of those who followed Henri from Philadelphia to New York were George Luks and John Sloan, both born in rural Pennsylvania, and educated at the Academy during the eighties, along with Glackens and the future collector Albert C. Barnes. Taught by Anshutz, each retained the strong influence of the Eakins tradition.[13] Also drawn to Henri, they felt his influence and that of seventeenth-century painting. Like Shinn and Glackens, they began their artistic careers as newspaper illustrators, eventually bringing to their painting a sense for the immediate, for forms seen in black and white, and for the telling gesture or pose. After his training in Philadelphia, Luks studied further in Düsseldorf, Paris, and London. This European experience solidified his appreciation for the powerful realism, tonal strength, and broad brushwork of Hals.

He made several copies and variations based on the Dutch master's work, one of which was *Woman with Macaws* (1907) (Plate 212). Luks' personal life was turbulent and exuberant: he was married several times, but no one knows precisely how many; he drank heavily – and he painted with similar energy. Almost sculptured in paint, the solid masses of the woman, dark blue bird at her shoulder, and red and green one in front emerge out of this darkness with a deliberately crude power. Luks must have seen aspects of himself in many of his subjects – the waifs, cabbies, cooks, cleaning women, and clowns, often coarse or dishevelled, yet self-possessed and robust. His sense of humour and social conscience set his best oils somewhat apart from those of his colleagues.

During the early nineties Sloan moved from his work on the Philadelphia *Inquirer* into Henri's orbit, going on to New York himself in 1904. In his work over the next decade he reflected Henri's influence in the dark palette, vigorous brushwork, and local subject matter. This identifiable style of those around Henri caused them to be called The Ash Can School, a recognition of their rejection of Impressionism's light and airy themes in favour of the rough vitality of urban life. In 1914 Sloan's style shifted somewhat in response to two principal events: the Armory Show, which he claimed made him more conscious of expressive colour, as well as of greater plasticity and geometry of form; and summers in Gloucester over the next few years, which did indeed stimulate a lighter colour scheme.

Gloucester Trolley of 1917 (Plate 213) comes at this important transitional moment in his career. Earlier in New York, Sloan had loved to walk everywhere, especially at night. He found subjects in people crossing streets or seated in cafés, although the real personalities of his pictures were the emblems and structures of the urban age, street lights, steamer ferries, and the elevated railway. (Such imagery would later reappear regularly in Edward Hopper's long career, and have renewed appeal for artists in the 1960s; see Plates 236, 279, and 285.) Sloan wandered around the picturesque streets and environs of Gloucester, celebrating city life on a more intimate scale. Here he makes the new trolley line through Rocky Neck and East Gloucester the central presence of his canvas.

Later in Santa Fe, New Mexico, he pursued his sense of abstract form in nature,

defined by the strong light and atmosphere. From the thirties on he experimented with semi-scientific theories of clarifying form, not very successfully, by a technique of drawn linework over his figures. As with Henri, his artistic ideas seem more enduring than his painting. Sloan came close to understanding the achievement of cubism, although he felt that it incorrectly put primacy on craftsmanship, 'the grammar and composition of art . . . the skeleton of tradition'.[14] He and many in his generation continued to feel, in spite of the Armory Show's revelations, that one should choose a subject at hand. 'Look down the road and use your imagination. Get some excitement from the reality in front of you.'[15] Above all, 'an interest in things is and always was at the root of art'.[16] But that was a premise that the avant-garde art shown in New York directly challenged.

The finest painter of the Ash Can group, and Henri's best student, although not a member of The Eight, was George Bellows, also born in Ohio. Almost twenty years younger than Henri, Bellows as a child copied pictures in his native Columbus, although his first success came as an accomplished and promising baseball player. In 1904 he determined to leave Ohio State half way through his college years, and 'arrived in New York', he said, 'I found myself in my first art school under Robert Henri having never heard of him before . . . My life begins at this point.'[17] Sloan was also there at this time, and together they were introduced to Henri's insistence on freedom from orthodoxy and traditional academic restraints.

Like Sloan, Bellows roamed the city for subjects, finding them in the steamers on the river, youths swimming off the wharves, excavation for the old Pennsylvania Railroad Station, and crowds watching the combat at boxing clubs. Having been taught an appreciation for Goya, Manet, and Hals, Bellows sought to capture these scenes of action and movement with the familiar method of directness and breadth. His acquaintances included fellow realists Eugene Speicher and Rockwell Kent; following in Kent's and Henri's footsteps, Bellows also went to Maine for several summers of painting. Among the favourite haunts of these artists were the isolated islands of Monhegan and Matinicus, both well off the coast.

This rugged landscape was the setting for Bellows' *Big Dory* of 1913 (Plate 214), in which he was able to transfer the boldness and vigour of the Ash Can manner to his wilderness subject. The painting is full of turbulent energies, well controlled and orchestrated, including the massive clouds, looming headland set against the sea, and men straining to launch the boat. The brushstrokes are thick and almost sculptural, the contrasts of dark and light appropriately stark, and the colours strong blues, reds and whites.

Bellows was much impressed both by the exhibition of The Eight at Macbeth's in 1908 and by the Armory Show, as his own aggressive style demonstrated. From his earlier experience he had an enduring interest in sports, and among his most popular works have been his several boxing scenes, sketched and painted throughout his career from 1907 to 1924. Sometimes neglected is his notable accomplishment as a lithographer; his prolific output included some sixty prints in 1921 and over thirty more two years later.[18] One of the most memorable scenes he witnessed was the Dempsey–Firpo

fight in 1923, which he put on canvas and on stone. The lithograph (Plate 215) captures but one highpoint in the rousing drama. During the course of the short match Dempsey floored his opponent seven times before finally knocking him out, but not without being sent at one point through the ropes himself. Later, Bellows described the moment to Henri:

When Dempsey was knocked through the ropes he fell in my lap. I cursed him a bit and placed him carefully back in the ring with instructions to be of good cheer.[19]

Bellows fully appreciated the capacity of his graphic medium for tonal strength and linear expressiveness. In this instance his lithograph was one of his best, and far better than his oil version. Belonging to the Eakins tradition, it recalls the master's own boxing pictures of the late nineties, but with a quite different emphasis on intensity and immediacy of action. Bellows was a superior draughtsman among his contemporaries; he knew how to model form effectively, catch salient details, and exploit dramatic contours. Here the close-in viewpoint, accentuation of light forms against dark background, and interlocked diagonal and horizontal lines convey with vigour the impact of opposing forces.

Paralleling the efforts of The Eight and their followers was the creative and administrative vision of Alfred Stieglitz. He belonged to the same generation; born in Hoboken, New Jersey, in 1864, he went to Berlin for training in engineering in his twenties, when he began photographing. On his return to New York in 1890, he made use of the new hand-held camera to take pictures easily around the city. His subjects of this period were often similar to those of the Ash Can group: horse-drawn trolleys and coaches, railroad yards, wharves, humble workers, the city lit up at night or covered with snow, and the Flat Iron Building, which he described as 'like a bow of a monster ocean steamer – a picture of new America still in the making'.[20]

He also held common attitudes with these painters in fighting the jury system, competitions, and prizes, although 'when it came to a showdown, I could not see anything truly revolutionary or searching in their paintings'.[21] Partly out of competitive spirit, one suspects, and partly from critical discrimination Stieglitz concluded that their social realism never lifted their art above 'mere literature'. In these same years he was extraordinarily busy, joining camera groups and editing magazines; his best known activities are his leadership from 1902 of the Photo-Secession movement, and his publication of *Camera Work* from 1903 to 1917. He also opened his first gallery, which after 1908 was familiarly known as 291. In the later twenties he went on to found The Intimate Gallery, and from 1929 until his later life ran An American Place.

During the same year (1908) that The Eight was mounting its first independent show at Macbeth's, Stieglitz commenced his own revolutionary exhibitions of avant-garde European and American art.[22] Through these he helped to introduce artistic ideas of far-reaching consequence for the American scene. Meanwhile, he remained equally committed to advancing the acceptance of photography as a fine art. At 291 he displayed the work of other Photo-Secessionists, and later at An American Place that of younger photographers such as Paul Strand, Eliot Porter, and Ansel Adams.

173

At the same time he continued his own work. The acknowledged masterpiece of his early career was his photograph *The Steerage* (Plate 216), an image he came across while seeking relief from the boredom of his first-class accommodation to Europe in the summer of 1907.

The scene fascinated me: A round straw hat; the funnel leaning left, the stairway leaning right; the white drawbridge, its railings made of chain; white suspenders crossed on the back of a man below; circular iron machinery; a mast that cut into the sky, while completing a triangle. I stood spellbound for a while. I saw shapes related to one another – a picture of shapes, and underlying it, a new vision that held me.[23]

Indeed, its awareness of pattern and coherent visual design bears interesting comparison with Seurat and Prendergast. But this was also an image of 'deepest human feeling' for immigrants willingly or unwillingly returning to Europe, with the Statue of Liberty behind, not in front of them. The eye observes how the cold metal forms both contain and separate people in an uncompromising but deeply compassionate vision.

In 1916 Stieglitz first exhibited the work of Georgia O'Keeffe, whom he married in the early twenties after his unhappy first marriage broke up. A new phase of his own work also began with summers spent at Lake George, where he photographed clouds and sections of sky, titling them 'Equivalents'. Like the studies of Constable or the Nocturnes of Whistler, these were intended as expressions of pure feeling and as isolations of form as abstract as music. The creative forces of both Stieglitz and the Armory Show generated fundamental changes in American artistic consciousness, at a time when wider human affairs were also undergoing the upheaval of a world war.

CHAPTER 23

CUBISM IN AMERICA

The decade and a half between the Armory Show and the stock market crash in 1929 was a period of excitement and confusion in art, of consolidation for some artists, experimentation for others. While a few of The Eight struggled to deal with cubism and other avant-garde developments in recent European art, most ignored the challenge, preferring to continue their established forms of realism. For Henri and his friends it was difficult to believe that the ideas of progress they had championed were not so modern after all. Another group, however, mostly in the orbit of Stieglitz, attempted to adapt in their own work the ideas of modernism they saw at the Armory Show as well as at first hand in Paris.

This modernist group benefited from the Armory Show's strengths and suffered from its weaknesses. As the first major survey of recent European art in America, the exhibition did help to promote some acceptance and sales of contemporary work. Although Americans during the following years rarely approached the originality or importance of their European colleagues, this event might be seen symbolically as the beginning of a new internationalism in twentieth-century styles and of America's eventual emergence into the artistic forefront. At the same time, coming in 1913, the show could only present the earlier phases of cubism. Even at that, Braque was under-represented, and the movement was seen predominantly through figures like Picabia and Gleizes working on its periphery. Davies also attempted to over-categorize both later-nineteenth-century and contemporary developments, defining cubism as a descendant of classicism and the futurists as 'feeble realists'.[1] Consequently, there was bound to be a certain misinterpretation and confusion of styles compounding the larger shock of newness.

American artists who did respond to cubism or fauvism often inspired the same critical hostility that the Show did, for presenting art apparently contemptuous of traditional imagery, colour, and execution.[2] While some awkwardly distorted the integrity of recognizable shapes or colour for expressive effects, others eschewed imagery altogether for nearly complete abstraction. Similarly, improvisatory or automatic techniques, along with the foreign materials of collage, represented aspects of the assault on academicism. The Armory Show only made visible at a singular moment on a wide and sensational scale what many painters were already confronting on their own. Almost all those responsible for introducing and developing modernism in American art spent several years in Paris during the crucial period when fauvism, cubism, and their off-shoots were being defined. It would be symptomatic of many Americans in subsequent years to work with often divergent styles, different subjects, and sometimes irreconcilable formal problems.

Duchamp's *Nude Descending the Staircase* (Philadelphia Museum) acted as the principal

lightning rod for public derision. This work became the most notorious example of the new cubist and proto-futurist tendencies, and Duchamp's arrival in New York two years later signalled the presence at hand of an anarchic and iconoclastic spirit. Although he was to spend much of his life thereafter in America, he remained a Frenchman in temperament and intellect. The fundamentally cerebral and sophisticated nature of his art drew on French literature, especially symbolist poetry, and his closest associates included Picabia, Apollinaire, and Breton. Duchamp was one of the first Europeans to invigorate American art during the twentieth century, and his artistic attitudes were to gain in influence over the years.[3]

Most immediately affected was Man Ray, who became a life-long friend and collaborator. A near-contemporary, Ray was born in Philadelphia in 1890. With some experience as a would-be artist by the time of the Armory Show, he was strongly influenced by cubist and fauvist examples there, although Duchamp had an almost immediate liberating impact on his work. *The Rope Dancer Accompanies Herself With Her Shadows* of 1916 (Plate 217) is only vaguely reminiscent of pure cubism in the overlapping angular forms and the interchange between shadow and substance. More akin to Duchamp is the idea, rather than representation, of a figure in motion, suggested by the rope turning with the various positions of the dancer in space; the emphasis on pure artifice as embodied in the sequence of spectrum colours (orange, green, red, blue, yellow, and brown) across the canvas; and the inventive whimsy in the imitation of collage and enigmatic inclusion of the title.

Partly from Duchamp's stimulation, partly from his own fertile imagination, Ray went on to work in the Dada and surrealist aesthetics, and made some distinctively original contributions as an improvisatory film-maker and creator of 'readymades'. Although in Paris during much of his later career, Ray retained a hold on the physical world of objects – a more American quality, in contrast to Duchamp. Both men indulged in the gesture, the pun, the perplexing transformation, but Ray's stance was always more practical and palpable than theoretical or mental.

Only a few other Americans pushed beyond orthodox cubist painting to such advanced and independent solutions. Among them was Stanton Macdonald-Wright, who was the same age as Ray and who, in collaboration with his friend Morgan Russell, was responsible for developing a style of colour abstraction which they called Synchromism. A native of Charlottesville, Virginia, Wright went in his youth to California; he attempted to leave school and go even further, to Japan, but only reached Hawaii. Many years later he returned to the west coast, as well as travelling again to Hawaii and Japan. Thus, in his art and life there was a special confluence of east and west.

He first went to Paris in 1907; three years later he met Russell, who drew his attention to the work of Seurat and Cézanne. At this time, too, he read the colour theories of Chevreul, and discovered Oriental art. Together, these various activities stimulated his first Synchromist paintings in 1912 and their exhibition the following year. Typical of his work at this time is *Conception Synchromy* of 1915 (Plate 218), at once paralleling and influenced by the orphist works of Robert Delaunay in Paris. Central to both the French and American movements was the role of colour alone in defining form, space, and

feeling. Initially these works are indebted to Cézanne's late landscapes, where facets of pure colour brushed in juxtaposition to one another on canvas or paper build up masses as well as the surrounding space. By their relative visual weights different areas of colour established fixed positions on the canvas's surface and in pictorial space. Further, in the tradition of Whistler colour is modulated as a vehicle of pure feeling.

I strive to divest my art of all anecdote and illustration and to purify it so that the emotions of the spectator can become entirely 'aesthetic', as in listening to music.[4]

Wright saw his art as 'abstract in both content and form',[5] as expressive as Oriental calligraphy or decorative colour designs. With consistency and confidence he enlarged on these ideas through his later career of painting, teaching, and writing. By the late 1960s he recognized the ways in which his painting was (and was not) a forerunner of the new flourish of interest in colour abstraction in that decade (see Plates 293 and 295). Outlived, but not outdated, his pioneering role was now confirmed.

Both John Marin and Marsden Hartley were somewhat older. The former was born in Rutherford, New Jersey, in 1870, the latter in rural Maine in 1877. Both reached New York around the turn of the century, and were influenced by the combined traditions of Munich and Impressionism as taught by Chase. Marin went to Paris in 1905, Hartley seven years later; on their return they entered Stieglitz's circle. Both found subjects of great strength in Maine, and less extensively in New Mexico. The impulses of each artist towards subjectivity and abstraction drew respectively on the late-nineteenth-century examples of Ryder and Homer, while forging a link to the basic forms of Abstract Expressionism in the mid twentieth century.

In Paris Marin associated with other young Americans, Alfred Maurer, Max Weber, Edward Steichen, and Arthur Carles, all interested to differing degrees in the current styles of fauvism, cubism, and Neo-Impressionism. Returning to New York in 1909, Marin exhibited at 291 in the next couple of years, and at the Armory Show, his recent watercolours of New York's buildings and skyline, fragmented into turbulent lines and masses. Following from Delaunay's orphist abstractions of the Eiffel Tower, and echoing the futurists' ideas about the dynamism of the city, Marin explained, 'I try to express graphically what a great city is doing. Within the frames there must be balance, a controlling of these warring, pushing, pulling forces.'[6]

Beginning in 1914 and for numerous summers thereafter, Marin painted in Maine. Perhaps his most resolved series of watercolours dates from 1922, when he stayed in Stonington on Deer Isle. About this time he developed his device of a frame within a frame, as seen in *Maine Islands* (Plate 219). The vigorous slashing lines and glistening white of the paper seen through his transparent washes convey something of the brilliant Maine light and the sparkling contrast of evergreen islands dotting the water. The conscious fragmentation and ambiguity of form and space ultimately reflect Marin's cubist inheritance, a process of abstraction and formal analysis he was never fully capable of reconciling with his instincts for representation or expression of personal feeling. That he was ambidextrous had both physical and psychological implications; often he worked with brushes in both hands, but more significant are the other signs of conflict

that always seemed to threaten to pull his work apart: surface versus space, representation versus abstraction, pure form versus emotional content, nature versus the studio, even Europe versus America.

Hartley's first-hand exposure to contemporary European movements came slightly later than Marin's. He had seen some examples at 291, where he had his own exhibition in 1909; with help from Stieglitz and Davies he went to Europe from 1912 to 1914. Almost immediately he was painting large decorative works in the synthetic cubist idiom, but these were imitative and without full understanding of the original. Like Marin he had a strong desire to express personal feelings, which ran counter to the dispassionate and independent examination of structure or form. Hardly had he returned to America when he began travelling again, almost compulsively for the rest of his life, back to Europe; to Mexico, Nova Scotia, and Bermuda; and to New England, especially Gloucester and his native Maine.

He moved from a style based on post-Impressionism and fauvism to the more symbolic and mystical expressionism of Kandinsky and the Blaue Reiter group. Seemingly in constant search for a sense of permanence, Hartley found powerful images of continuity and ancient strength in the mountains of Mexico, Switzerland, and Maine, and in the glacial rocks of Dogtown on Cape Ann, Massachusetts. Appropriately, these images appear as massive geometries of pyramids, cubes, or cylinders. He treated landscapes and figures alike as timeless large-scale still lifes, often immobilized within large rhythmic shapes heavily outlined with solid borders, and weighted down beneath thick textures of paint. Even water, sky, and clouds become heavy and viscous, as in *Fox Island, Maine* (Plate 220). Drawing incongruously on Cézanne as well as on Ryder, Hartley brought to the transient and insignificant a stillness and monumentality as the only means of coming to grips with his own lonely mortality.

Unhappiness was also a part of Alfred Maurer's life, which ended in his suicide in 1932 at the age of sixty-four. It came shortly after the death of his aged father, himself an artist for Currier and Ives, and a life-long supporter of young Maurer's activities. Maurer left New York for Paris at the turn of the century and remained until the start of the first World War. Cézanne and Matisse were among the formative influences of his maturing style. His first exhibition at 291 with Marin elicited characteristic remarks of irritation and incomprehension: 'But his pictures! There is no understanding them . . . here is one which has in the foreground a great gob of color; what is it? A bursted tomato?'[7]

Gradually, his work began to assimilate the influences of Picasso's synthetic cubism and of African sculpture. Not only does his later style show a richer sense of colour and geometric structure, but he devoted increasing attention to the formal problem of centrality, balance, and symmetry. During the late twenties he took up figure and portrait subjects, and in the last years of his life sought to synthesize these with cubist abstraction. *Twin Heads* (Plate 221) was one of an extensive series of what might be called figural still lifes. How much the dualities of form and content have psychic ties to the artist's ambiguous relationship to his father is hard to estimate. Like Marin, the conflict between formal issues and expressions of emotion preoccupied him

to the end; unlike Marin, Maurer's problem ultimately became more personal than artistic.

Along with Maurer, Max Weber and Stuart Davis were perhaps the closest and most consistent followers of the cubist movement. Weber, a Russian born in 1881, grew up in Brooklyn, where he got his first artistic training. Paris offered him the familiar artistic precedents, which he tended to fuse with his youthful recollections of Russian folk art, Byzantine icons, and colourful religious ceremonies. When his semi-cubist work in the manner of the late Cézanne and Picasso's *Demoiselles d'Avignon* was shown in New York, echoes of Ruskin appeared in the reviews; his work was 'an insult to the public'.[8]

Chinese Restaurant of 1915 (Plate 222) in its richness of textures and complex formal harmonies comes as close as any American work to the original spirit of its French counterparts. Yet Weber, too, betrayed his distance in his instincts for partial representation:

On entering a Chinese restaurant from the darkness of the night outside, a maze and blaze of light seemed to split into fragments the interior and its contents . . . oblique planes and contours took vertical and horizontal positions . . . the life and movement so enchanting! To express this, kaleidoscopic means had to be chosen.[9]

A few years later Weber gave up abstraction for figure painting, often with equally great strength but without sureness of direction. If insecurity marked artists in the period after the great war, so too did it trouble America and the world at large.

Stuart Davis's experience generally paralleled that of his contemporaries, but because of his youth (he was born in 1894) in a later sequence. His father was a colleague of The Eight; he was a pupil of Henri in New York. His first strong response to modernism came at the Armory Show, 'the greatest shock to me – the greatest single influence I have experienced'.[10] He found especially impressive the examples of Post-Impressionism and fauvism, 'because broad generalization of form and non-imitative use of color were already in my own experience'.[11] As he admitted, he sought to pursue these ideas in his own work over the following years.

Cubist elements became increasingly important to his pictorial construction, first through the influence of Léger, and later of Picasso. By the time he left for Paris for a year in 1928, his mature style was clear: large, simplified forms; often a visual collage of letters, textured patterns, and flat colours; and oscillations between figure and ground, solid and shadow. Painted after his return, *Salt Shaker* (Plate 223) comes at the height of his career. While the suggestion of a personage recalls the whimsy of Klee's art, echoes of Picasso are stronger in the vernacular subject matter and assembled fragments of synthetic cubism. Davis was one of the first Americans to exploit so fully and inventively the play between positive and negative, along with the role of lettering in its visual (as well as verbal) capacity. His painting belongs to the American still-life tradition of Peto and Harnett, at the same time that it stands as an important antecedent to Pop Art of the 1960s (see Plates 199 and 282).

Like Max Weber, Joseph Stella was a foreigner (born in southern Italy in 1877) who came to the United States at the end of the nineteenth century. After brief study with

Chase, he made his way to Paris at the time of the Armory Show, and was more strongly influenced by futurism than by any of the other contemporary movements. He had read the futurist manifesto praising modern industry and machinery for its dynamic beauty, and the image of the Brooklyn Bridge as a subject 'had become an ever growing obsession ever since I had come to America'.[12] He painted his first version in 1919, and over the next few years incorporated it into a larger scheme of five related canvases on the theme of *New York Interpreted*.

Together the series showed the New York skyline at night; the final picture on the right was of *The Bridge* (Plate 224), partly indebted to cubism and futurism, though without the latter's celebration of violence and motion. Combining the romantic power Stieglitz saw in the Flatiron Building with the pulsing energy Marin found embodied in the Woolworth Building, Stella forged his own image of 'the flux of the metropolitan life'.[13] But his is a more mystical vision than theirs, as he also talked of the 'bells of a new religion . . . the predella of my composition . . . the stained glass fulgency of a cathedral'.[14] Indeed, his format was a conscious recollection of Italian altarpieces. But for all his derivation from past and present Italian art, Stella's work exudes a fundamental American romanticism and optimism. He wandered the streets at night like Ryder, and he 'appealed for help to the soaring verse of Walt Whitman'.[15] And his series of five canvases, the middle one the largest, makes a fully appropriate comparison with its nineteenth-century predecessor, Cole's *Course of Empire* (Plates 91 and 92). In addition, his work had a worthy literary equivalent in Hart Crane's poem, *The Bridge*, which took shape in these same years:

> Again the traffic lights that skim thy swift
> Unfractioned idiom, immaculate sigh of stars,
> Beading thy path – condense eternity:
> And we have seen night lifted in thine arms.[16]

Stella's subsequent painting was a continuing mixture of European and American elements: nostalgic imitations of Italian Renaissance art, yet collages more abstract than Davis's, botanical studies paralleling those of Charles Demuth and Georgia O'Keeffe, and other industrial views similar to Niles Spencer's and Charles Sheeler's. Demuth's work was almost as protean. After the familiar sequence of the Pennsylvania Academy, Paris, and association with 291, he undertook figure drawings reminiscent of Rodin and watercolours of flowers with the demonic fire of Nolde. Also well known are his haunted illustrations of stories by Zola and Henry James, especially the latter's *Turn of the Screw*. Duchamp's presence in New York after 1915 inclined Demuth towards a group of architectural views, painted with transparent cubist planes.

About 1920 Demuth turned to working in oil and tempera, which presumably he felt more suitable to the large, impersonal landscape of industrial growth. With titles like *My Egypt* and *Home of the Brave* given to images of grain elevators, silos, and water tanks, it is plain that Demuth was following Stella and others in reverence and praise for modern America. At the same time he was at work on a related group of so-called 'poster portraits' of his friends. The finest of these is '*I Saw the Figure Five in Gold*' of 1928

(Plate 225), in honour of William Carlos Williams and his poem of that title.[17] Williams was on a New York street en route to see Marsden Hartley, when a fire engine suddenly and noisily passed by, prompting him directly to write down his lines: 'Among the rain/and lights/ I saw the figure 5/ in gold/ on a red/firetruck/moving/tense/unheeded/ to gong/clangs/siren howls/and wheels rumbling/through the dark city.'[18]

Demuth includes within his picture the first and middle names of Williams, his own and the poet's initials, and the cropped words 'Art Co.' at the right, ambiguously referring to a fire engine company and to the different arts involved. Williams was a vigorous and outgoing personality, and a doctor as well: how appropriate to associate him with the clanging mission of protection and rescue of a fire engine. On several levels here was another American combination of art and science, presented in the gleaming precision of machine-like shapes while calling attention equally to the signs of poetry and painting.[19]

Sheeler shared with Demuth his first name (Charles), age (born in 1883), state of birth (Pennsylvania), training (at the Academy and in Paris), and eventual interest in machine forms tempered by a cubist background. Sheeler settled in New York in 1919, and during the next decade began to take photographs as a means of support. The subjects of his camera and his canvas were, like Demuth's, the great industrial plants of American industry; for example, his views of the Ford River Rouge plant in Michigan bear titles like *American Landscape* or *Classic Landscape*. The cool neutrality of tone, factual clarity of detail, and sharp illumination of photography carried over into Sheeler's style of painting,[20] as is evident in *Rolling Power* of 1939 (Plate 226). Forecast by Stella, this style has been well termed 'precisionism' (sometimes also immaculate or cubist realism), a concept relating both to the technique of execution and to the mechanical subject matter.

The machine as art had a wide appeal for many of this generation, including notable foreigners like Duchamp and Picabia who were known in the United States, and for such other American painters as Man Ray, Preston Dickinson, Morton Schamberg, and John Covert. Machine imagery provided both still-life forms for detached intellectual examination and emblems of larger power, order, or functionalism. *Rolling Power* in this latter regard is at once real and abstract, its visual harmony one of form as well as of represented function. The detached clarity and organic unity of parts issue out of the earlier artistic traditions of American luminism,[21] neo-classicism, and *trompe l'œil* still life. Sheeler is the worthy heir of Lane, Greenough, and Harnett no less than the forebear of the realist movements of the 1930s and 1960s.

CHAPTER 24

REGIONS OF THE MIND AND COUNTRY

THE Depression years between the stock market crash of 1929 and America's engagement in the second World War in the early forties stimulated a renewed period of national self-examination. Somewhat like the period between the War of 1812 and the Civil War there emerged a strong impulse to define the nation's cultural identity. Significantly, the decade of the thirties saw the rise to new prominence of landscape and genre painting based on consciously native subject matter. Once again, a group of American artists associated artistic enterprise with national consciousness, now encouraged by the government itself through the Federal Arts Projects and other employment programmes of the New Deal.[1]

The isolationist mood in both politics and art was to an extent one of those recurring American reactions to Europe. To the painter Thomas Hart Benton the modernist painters in Paris, and by extension in New York, represented an intellectualism, urbanity, and aestheticism that he felt foreign to the American temperament:

Modern art became, especially in its American derivations, a simple smearing and pouring of material, good for nothing but to release neurotic tensions. Here finally it became like a bowel movement or a vomiting spell.[2]

Along with John Steuart Curry of Kansas and Grant Wood of Iowa, Benton was one of the Regionalist painters who celebrated the countryside and modes of life of their native midwestern states. Benton was born in 1889 in Missouri, into a family well known for government service. The joining of interests for him in art and in contemporary political and social issues revived a tradition going back to George Caleb Bingham.

Around 1907 Benton began several years of artistic study and training, not always to his liking, first at the Art Institute of Chicago and then in Paris. He returned to New York for good in 1913, stimulated by Renaissance art, working in distemper and egg-tempera, and

setting up multiple-figure groups in voluminal and three-dimensional arrangements and their extension in the perspectives of an illusory picture space – a space of my own creation.[3]

For many of his larger compositions Benton now made sculptural models of his figures, and during the mid twenties he actively took up mural painting. All these developments confirmed his dislike of cubism's flatness and dissolution of realistic form. In 1932 he received a commission to paint murals in the library of the old Whitney Museum on the theme of 'The Arts of Life in America'.[4] His series depicted familiar scenes of everyday life in different regions of the country, including *Arts of the West* (Plate 227); the pictures variously recall the monumental figure compositions of Tintoretto,

182

Michelangelo, and El Greco. This combination of visual narrative, social observation, and enthusiasm for the local scene formed the basis for the colourful style which Benton carried into his work of subsequent decades.

Grant Wood was Benton's junior by two years, and spent most of his life in his native Iowa. Like Benton he travelled to Europe early and found a passing appeal in late Impressionism. But the critical formative influence for him was to be the German, Flemish, and French primitives of the early Northern Renaissance, especially Memling: from them Wood derived his preference for sharp detailing and meticulous clarity of form, severe poses and hard staring eyes, as well as techniques of glazing. His style came to combine precise observation with intuitive feeling for pure design.

In the rolling landscape, folk architecture, and the faces of his neighbours he found the essential imagery for his first major pictures and for most of his work thereafter. 1930 saw his reputation solidly established with the appearance of his well known *American Gothic* (Art Institute of Chicago) and *Stone City, Iowa* (Plate 228). The latter was a nearly abandoned town, founded by an Irishman, J. A. Green, who had built a large mansion on the hill out of local stone. In Wood's youth the area was an active quarrying centre, but the cranes had been stilled – only one is partially visible in the left middle distance – and Green's stone house with its single gothic window at the left edge of the picture is now empty.

Wood has consciously chosen an elevated viewpoint, and given the whole a greenish cast, both in the manner of sixteenth-century northern landscapes.[5] The dominant aura of nostalgia and ghostly stillness provides an ambiguous overlay of past and present. Wood once claimed that 'all the good ideas I ever had came to me while I was milking a cow'.[6] Yet, too easily are Wood's ideas and art seen as expressions of a charming and innocent realism; we are mistaken to overlook the strong presence of feeling and of abstraction in his art.

The term Regionalism is usually associated with the midwestern art of Benton, Wood, and Curry, but it can more generally be applied to the painting of the rural scene elsewhere in the country during this period.[7] The art of Ben Shahn is an example, though he often shifted between sympathetic observation and pungent social commentary. An almost exact contemporary of Benton and Wood, Shahn was born in Lithuania, and, much like Max Weber, grew up in Brooklyn, strongly conscious of his Jewish heritage. Probably the crucial factor in his artistic development was his early graphic training. He also travelled to Europe during the 1920s to make his own confrontation with the past and with the avant-garde. But as Benton described it for this group, 'salvation [was] in the home experience'.[8]

Shahn, too, was impressed with the early Renaissance masters, though new artistic influences came during the thirties in New York through his friendship with the photographer Walker Evans and the Mexican muralist Diego Rivera. Shahn completed a number of mural projects for government agencies, and by the end of the decade was well established. In 1940 he painted *Willis Avenue Bridge* (Plate 229), with figures also incorporated in a large fresco he began at this time for the Federal Security Building in Washington. Together, the subject and style embody most of Shahn's artistic

interests: the large figural forms of Renaissance painting and of Mexican murals, intensity of facial expressions and exaggerated postures (first seen in his Sacco and Vanzetti series of the early thirties), a sense of surrealist space, and selective attention to realistic details. His sympathetic awareness of humble humanity is close to Evans's photographs (see Plate 235), while the strong linear design is a result of his own graphic sensibility. From Rivera probably came the bold colouring as well as the counterpointing of figural and architectural forms against spatial depth.

Most important is always to have a play back and forth, back and forth. Between the big and the little, the light and the dark, the smiling and the sad.[9]

Irony, satire, and social comment were also the tools of William Gropper and Jack Levine, modern descendants of Woodville, Blythe, and Quidor. Born in Boston in 1915, Levine and his colleague Hyman Bloom studied together under Denman Ross of Harvard, who helped deepen their acquaintance with major artistic figures of the past. Levine found himself looking especially to Titian and Rembrandt among the old masters, and to Goya, Daumier, and Rouault among the moderns, as precedents for the scrutiny of character and social types in his own art.

Levine's mature style from the forties onward is characterized by unerring draughtsmanship, slightly disquieting angles of vision or compressions of pictorial space, and a lively sense of pigment, animated by flickering highlights or swift touches of brushwork. He delighted in caricaturing the exemplars of social and professional types, often exaggerating their forms by enlarging their heads and torsos, while compressing overall proportions as well as the surrounding space. This is readily apparent in his best known painting, *Gangster Funeral* of 1952–3 (Plate 230). The group portrait composition reflects his study of Baroque art, although the ironic and even sympathetic awareness of mortal flesh in decay recalls the American vision of Eakins. While there is comedy in figures like 'the police chief, porcine and acute',[10] Levine ironically implies the closeness of the spectator, whose attention is drawn in by the emphatically foreshortened casket. In subsequent years Levine continued his uncompromising observations of human beings, whether from Jewish history, ancient mythology, the streets of New York, or the beaches of Miami.

In contrast, Charles Burchfield and Morris Graves created an art more of inner visions and mysteries. Burchfield's birth in 1893 in Ohio loosely aligns his background with those of Benton and Wood. His training at the Cleveland School of Art and youthful sketching in the countryside instilled in him a lifelong nostalgia for small-town life and rural scenery. In 1916 he visited New York briefly, with the mixed results of overwhelming homesickness and the first successful sales of his paintings. Working for most of his life in watercolour, Burchfield developed a style of decorative rhythmic shapes, calligraphic notations, and a personal imagery based on reality but full of allusions and occasional symbolism.[11]

His images were embodiments of childhood sensations and memories – fear, wonder, excitement, loneliness; he drew equally for inspiration on children's book illustrations and Oriental art. Reading Sherwood Anderson's *Winesburg, Ohio* in 1919 turned his

interest more towards contemporary life, and with his move to Buffalo, New York, two years later he increasingly painted old buildings as emblems of subjective moods. *Old Farm House (September Sunlight)* of 1932 (Plate 231) was one of a series attempting to capture the personality of a place, time, and season. The sagging roof and dark windows suggest the shadowed facial features of some hidden human presence. Not long before the artist had noted his delight in the 'rich odors of September',[12] as well as in the textures, colours, and sounds of nature. Burchfield's deep interest in music found its way often into his pictures as he sought to paint visual equivalents of sound as well as states of pure feeling. In later decades his watercolours became ever richer and denser in both pictorial effect and meaning.

The work of Morris Graves is similarly charged with symbolic power and inner thought. Born in 1910 in Oregon, he travelled frequently, most notably to the Orient as a youth and again in the 1940s, and to Ireland, where he lived during the mid fifties. But most of his life was passed in, and his inspiration derived from, the Pacific Northwest, with its orientation towards Far Eastern art and culture. Of strong influence on Graves were Chinese and Japanese art and Zen Buddhism. With a lean frame, thin face, and contemplative cast to his eyes, he created from the start an art of introspection, hermetic quiet, and touching fragility. Whether on a rugged island in Puget Sound, a moor in Ireland, near Chartres Cathedral off-season, or in the mountains of Nepal, Graves drew a mantle of physical isolation around himself as he sought liberation in a transcendent spiritual world.

Much of his art reflects the raw beauty and rough textures characteristic of his northwest landscape. But it was in the small-scale world of birds that he most consistently and evocatively found expression for his own migratory instincts and sense of human mortality. Even his preference for painting with gouache on tissue paper contributes to his frail images of tragedy and possibility. His titles evoke a mystical and private world descended from Albert Ryder: *Spirit Bird, Consciousness Achieving the Form of a Crane, Little-Known Bird of the Inner Eye, Bird Maddened by the Length of its Own Winter.* During the late thirties another major Pacific coast painter, Mark Tobey, had an important impact on Graves' style. Tobey had just returned from Japan, and was working with his compositions of so-called 'white writing' (see Plate 252).[13] Graves was uninterested in the formal abstraction, but did take over for his own expressive use the delicate calligraphy for a series of paintings which included *Bird Singing in the Moonlight* of 1938-9 (Plate 232). Like the birds of the 'inner eye' series which followed, some wounded or blinded, this solitary creature was in part an emblematic extension of its creator, each weaving a silent song of his own existence.

Others of this generation, such as Peter Blume and Philip Evergood, moved much closer to a style of pure surrealism. Ivan Albright's painting is concerned with such meticulous detail and rich paint surfaces that his canvases acquire a heightened intensity, and even mystery, that make them almost surreal. Because of his birth in Chicago in 1897, one might think to associate Albright with the other regionalists, but his artistic background was rather that of the Eakins tradition. Albright's father was an Eakins student and passed on the methods of life drawing to his son. Albright received more

formal instruction at several art schools, including the Pennsylvania Academy. His long obsession with the human figure as a still-life object may be viewed as in part derived from the nineteenth-century *trompe l'œil* painters of the Philadelphia school and from the scientific examination of anatomical detail taught by Eakins (see Plates 165 and 172).

The human presence is but partially visible in *That Which I Should Have Done I Did Not Do* (Plate 233), an extraordinary mirage of dense and painstakingly laboured highlights, details, and textures. Albright's pictures ordinarily consumed years in the execution, during which he would walk around his subject and paint it from different angles. In the course of this intense concentration one almost feels the processes of life, growth, and decay evolving before one. Forms change but do not move: 'I cannot paint motion, so all the things around me are deadly still, so still that they hurt the eye.'[14] The predominantly sombre colouring and exquisitely controlled illumination also reflect Albright's preference for working with forms in the median range of subtle half-lights, the 'twilight world of shadow',[15] where visual mystery and magic paradoxically might be strongest.

Edward Weston and Walker Evans were two photographers who also did some of their finest work in the thirties, and transformed their realism with intense feeling and abstraction. Weston was of Benton's generation; though born in Illinois, he moved to California at twenty and remained on the west coast for most of his life. During the twenties he met Stieglitz, Sheeler, and Paul Strand, and travelled extensively in Mexico, where he knew the muralists Orozco, Siqueros, and Rivera. Already in his portraits he preferred to concentrate on close-ups of the head or sections of the figure, just as he might frame only fragments of a landscape, clouds, or a steel mill.

In the early thirties began a special preoccupation with vegetables, in which he found a heightened presence of abstract form. *Peppers* (Plate 234) provided a subject which elicited particular enthusiasm:

Peppers never repeat themselves . . . always excitingly individual . . . It is classic, completely satisfying, – a pepper – but more than a pepper: abstract, in that it is completely outside subject matter . . . this one, and in fact all the new ones, take one into an inner reality – the absolute – with a clear understanding, a mystic revealment.[16]

Using varying combinations of artificial and natural light, and experimenting constantly with extreme close-ups and shifting vantage points, Weston so isolates his subject as to create a powerful play between large and small scale as well as organic and abstract form. Irony and wit frequently tempered his serious and incisive perceptions, even through the war years and his last images made at Point Lobos.[17]

Walker Evans was a good deal younger. Born in 1903, he grew up in Chicago, went to college in the east, but left for study in Paris in 1926. Mostly out of frustration he began photographing a few years later. The middle thirties, when he worked for the Farm Security Administration, represented a period of almost unsurpassed creative energy and success for him. Out of these years came his striking images of ante-bellum architecture in the South, his first important exhibition and publication of the prints in

American Photographs, and the famous collaboration with James Agee on *Let Us Now Praise Famous Men*.

Both text and photographs were documentary accounts of rural life and poverty in the South, each direct, clear, and sharp in form.[18] Dorothea Lange was another forceful interpreter of the Depression years, but she focused primarily on people with a more romantic attitude. Yet the caption of one of her best known pictures – 'If you die, you're dead – that's all' – caught the laconic, simple, and forthright character of their art. Documentary photography became a modern descendant of nineteenth-century genre painting, only tougher in its rendering of everyday life, the hardships of work, and survival itself.

While many sought to dramatize the lives of the poor by illustrating the deprivations of the Depression, the very title of Agee and Evans's book indicates an ultimate sense of reverence and celebration. Among Evans's most familiar images are the haunting faces of the sharecropper families whose direct glances were equal to his camera's eye. Yet throughout his career from this first prolific period into the 1970s Evans found equal interest in the austere forms and simple details of folk architecture. Whether photographing exteriors or corners of rooms, he makes us conscious of the human presence. In *Bedroom Fireplace, Tenant Farmhouse, Hale County, Alabama*, 1936 (Plate 235), the small ordinary fragments of everyday life seem to align themselves as if personages posing for the camera. By framing the fireplace to the left of centre, Evans reveals not rigid or confining symmetries but rough purity and order in this environment. Humble reminders of human mortality animate these spare surfaces – the pair of shoes, photographs tacked to the wall, and the handprint stamped on the wood – with a formal order and mysterious life force similar to a Peto still life (compare Plate 171).

This visual accounting of plain and worn surroundings is matched by Agee's text, also an inventory of people's lives through a narrative close-up of accumulated details. Agee equally came to apprehend a picture of human endurance and redemption.

Enough lines, enough off-true, that this symmetry is strongly yet most subtly sprained against its centers, into something more powerful. . . . A look of being most certainly hand-made, as a child's drawing, a thing created out of need, love, patience . . .[19]

This collaborative production has emerged as one of the central works of art from the 1930s, with a profound eloquence no less human than artistic.

One of the major artists to bridge most of the important phases of realism in twentieth-century American art is Edward Hopper. Born just north of New York City in 1882, he was a student of Henri in the early 1900s and went to Paris on a couple of occasions in the next few years. When he returned to New York, he increasingly sought subjects to paint in Gloucester, and later along the Maine coast and on Cape Cod. More concerned with rigorous formal design than his Ash Can colleagues, Hopper saw in the angles and rhythmic silhouettes of old wooden houses both picturesque interest and a source of compositional structure.

Unlike Reginald Marsh and Raphael Soyer, two other realists carrying the traditions of the Ash Can school into later decades of the century, Hopper usually eschewed

painting people in action as genre subjects, preferring rather 'to paint sunlight on the side of a house'.[20] Indeed, light became a fundamental component in both his water-colours and his oils, as much a source of illumination and definition as of mystery and melancholy. A restrained man who led a frugal life, he produced paintings of compar-able order and economy, using careful methods of preparatory drawings. *Freight Cars, Gloucester*, of 1928 (Plate 236) is typical of the order he found in the rhythmic forms of the urban landscape. Both subject and format make it a worthy descendant of Fitz Hugh Lane's earlier luminist canvases (compare Plate 105). Hopper enjoyed the many juxtapositions of different architectural styles and forms, such as the nineteenth-century church spire and anonymous modern roof tops. Many of his paintings convey an aura of loneliness, as this does, through the cold lighting and absence of figures; yet he equally favoured the imagery of transportation and communication as emblems of human con-tact as well as separation.

Hopper's designs classically employed a dominant horizontal base, on which he built strong vertical forms, and then subordinate diagonal or angular embellishments. He retained this sense of geometric organization of pictorial space into his last works of the early sixties, moving in some towards greater austerity of design, in others towards new richness and complexity. *Office at Night* of 1940 (Plate 237) offers some idea of both impulses. The greater reliance on diagonal planes and various geometries of office furniture contrasts with the parallel clarity of *Freight Cars*, at the same time that Hopper now stresses new plainness of surface and vacuum-like tension in the space. In fact, a picture on the office wall and other details in the preliminary drawings were eliminated from the final canvas.

Other significant changes occur, too: the man becomes progressively younger in each version, while the two figures who were initially looking at one another are here glancing in different directions, lost in their separate worlds within this confining space. Hopper thus makes us aware of obvious sexual differences, but more importantly of the distances between human beings even in close proximity. His best art allows us reserved glimpses into psychological states which calls to mind Eakins and Eastman Johnson. But Hopper's art is not only an extension of past traditions in American real-ism; his everyday subject matter and sharp forms are quite comfortable in the company of a younger generation's work, whether that of the Pop artists or of the hard-edge colour painters of the 1960s (compare Plates 285 and 292).

Like Hopper, Andrew Wyeth was an artist who pursued his own form of realism through the middle decades of the twentieth century, independent of the major waves of abstraction and formalism which preoccupied others. He was born in 1917, the son of a famous illustrator, N. C. Wyeth, who in turn was a pupil of Howard Pyle. Like William Sidney Mount and Charles Burchfield before him, Wyeth felt no interest in travel abroad. His entire career belongs to two small rural worlds in the Northeast: Chadds Ford, Pennsylvania, and Cushing, Maine. Coming to artistic maturity in the thirties, Wyeth chose familiar themes of isolation and nostalgia, the realism of the ordi-nary, and the world of feeling it possesses. Mistakenly admired for the apparent photo-graphic literalness in his temperas and dry-brush watercolours, he has rather sought an

economy of design often approaching abstraction, expressive angles of vision, selective focusing of detail, and intimations of psychological presences which relate his art to the several currents of realism practised by his generation.[21]

Wyeth soon moved away from the illustrational character of his father's art, and increasingly subordinated tendencies towards sentiment and narrative content, in favour of sparer designs and more evocative poetic content. Probably better known for his landscapes, a major preoccupation from the 1940s onward, he began to turn concentrated attention in the sixties to painting the human figure. One of his most compelling works is *Grape Wine* of 1966 (Plate 238), a successor to the reflective portraits painted by Peale, Tanner, and Eakins (see Plates 58, 205, and 170), the latter greatly admired by Wyeth. The strength of this picture emerges through the rich ambiguous space, almost monochromatic tonality, and gentle shifts of the figure's outline away from the central axis. One's eye must adjust to the narrow range of colour and fragile highlights as if viewing a darkened room or late autumn landscape. The sitter was Willard Snowden, a solitary drifter who worked nearby for a time. His solitude is one of flesh and of spirit, with the rustle of inner voices passing as silently as breath through the parted lips into the surrounding stillness.

CHAPTER 25

TOWARDS ABSTRACTION

UNDERLYING the concern of artists maturing in the 1930s with various aspects of realism was an increasing attention to the aesthetics of abstraction and pure form. Elie Nadelman is one of the first prominent figures in America to represent the transition in sculpture from late-nineteenth-century academicism to the new expressive formalism. Born in 1882, he left his native Warsaw at the turn of the century and by 1904 had made his way to Munich. After six months he went on to Paris, his home for the next ten years. In that time he studied examples of classical sculpture, most notably the Slaves of Michelangelo in the Louvre; among the moderns the work of Rodin and Seurat impressed him most strongly. Together, these precedents offered a solid foundation for his own emerging style. With the outbreak of war in 1914 Nadelman finally left for London and then New York. Not long after, Stieglitz gave him a small exhibition at 291.[1]

From this period dates one of Nadelman's most elegant and memorable pieces, *Man in the Open Air* (Plate 239), his only full-length bronze of a male figure. Behind it lies much of the artist's sensitivity to the classical tradition, from the indebtedness to the Greek prototypes of Phidias and Praxiteles for the general form and posture, to the balanced play of contours and volumes taken from the art of Ingres, Degas, and Seurat. But ultimately he is closer to the modern spirit of Modigliani, Brancusi, Maillol, and Matisse. With finesse and whimsy he parodies traditional styles of elegance (compare Gilbert Stuart's *Skater*, Plate 48), while inventing his own formal refinement.

Nadelman collected folk art, too, and in his work we see his distinctive taste for blending the naïve and the sophisticated. Equilibrium and fluency were his guiding principles, as may be seen in the internal echoes of near-geometric forms, such as the man's arms, legs, and tree branches. As he had once argued,

each expression of sentiment is made by a movement which geometry governs. . . . I have adopted this principle in building up my statuary, simplifying and restraining always in organizing the parts so as to give the whole a greater unity.[2]

The figure is neither nude nor clothed; only the tied bow on the chest and the bowler hat suggest that he is some actor or dancer. Indeed, Nadelman delighted in portraying performers, for in a sense such subjects were themselves engaged in the metamorphoses of art. How appropriate, then, that his figures, in referring to the life of the model, even more refer to the life of art.

Nadelman and Gaston Lachaise stand as a bridge between Saint-Gaudens and Isamu Noguchi (compare Plates 182 and 242), or more broadly between Hiram Powers and David Smith (Plates 122 and 264). Lachaise was the same age as Nadelman, though born

in Paris, the son of an accomplished cabinetmaker. He was interested in sculpture by the age of thirteen, and his first training was in the solidly academic tradition of Beaux Arts schooling. Falling in love with a visiting American, Lachaise followed his future wife to Boston in 1906. He made his way to New York, where he secured work under the academic sculptor Paul Manship. During this time Lachaise was refining his own classical vision of form, which included fully modelled volumes, bulging but sensuous contours, and smoothly polished surfaces.[3]

Lachaise's series of standing nude women was the consuming preoccupation of his career, and *Torso* of 1930 (Plate 240) well illustrates his credo of 'simplify and amplify: amplification and simplification'.[4] Finding inspiration in ancient Hindu carving as well as in the recent sculpture of Brancusi and Nadelman,[5] Lachaise always exploited his refinements and distortions of form to obtain a heightened emotional power. Most of his pieces began as generalized images of his wife, idealized and transformed into female earth figures not unlike the late figures of Gauguin or Renoir. They are suggestive images of sexuality and physicality, though equally assertions of pure sculptural form. *Torso*, in its magnification and isolation of a part of the human figure, recalls both the anatomical fragments of Rodin and the devices of enlargement and abstraction in the paintings of Georgia O'Keeffe (see Plate 245). Like O'Keeffe, Lachaise engages us through his play on figural scale: this seemingly massive and monumental *Torso* is but thirteen inches high.

John Flannagan was an American-born artist who crossed the Atlantic in the other direction for his first inspiration. A decade younger than Nadelman and Lachaise, he came from North Dakota and schooling in Minneapolis, Minnesota, to New York just after World War I. There he met Arthur B. Davies and had his first exhibition. On a Guggenheim Fellowship in 1932 he spent a year in Ireland, where he cultivated his love for nature. Among the fields and hillsides then and later at home he sought out stones with suggestive shapes for carving. He had for a time worked in wood, but found the material too yielding: stone, especially ordinary fieldstone and granite, possessed a grainy roughness evocative of the earth itself. Seeking the permanence of ancient geology, Flannagan hewed out of stone his solid and self-contained forms, such as *Triumph of the Egg, I* of 1937 (Plate 241). 'Its very rudeness seems to me more in harmony with simple direct statement,' he wrote. 'The rude rock is partly protest against Art as mere ornament, and rather an affirmation of vigour.'[6]

Decorative values were of little interest to Flannagan. Instead, he wished to draw from the resistant strength of his stone some evidence of duration, usually an image of re-generation or renewal. Like Morris Graves he made the world of small, often fragile, animals his own. With their expressive crudeness of shape, surface, and mass, Flannagan's 'monumental miniatures' seem at once primal and poetic, personal and timeless. An in-tense and brooding individual, he variously sought relief in drinking and in psychiatric treatment. His life of ill fortune culminated with an automobile accident in 1939, which left him injured and suffering until he killed himself three years later.

Another Guggenheim Fellow whose period of study abroad proved to be a turning point in his sculptural career was Isamu Noguchi. Born in Los Angeles in 1904 of a

Japanese father and a mother with part American Indian blood, Noguchi grew up in Japan, but returned to the United States when he was seventeen for further schooling. Eventually, he was apprenticed to the sculptor Gutzon Borglum, who 'told me I would never be a sculptor, so I decided to . . . become a doctor'.[7] Still he continued to try further study and efforts at work in traditional styles, but felt listless and discouraged.

He had made a point of visiting the galleries of Stieglitz and other dealers; in 1926 he encountered an exhibition of Brancusi's work, and there Noguchi's real artistic education began: 'I was transfixed by his vision.'[8] Shortly after, he got the opportunity to go to Paris ('the heart of all that mattered'[9]) for two years of study, and was able to work for a while with Brancusi himself. Besides this influence, Noguchi also felt the impact of the Constructivists and Picasso's recent wire assemblages. Not surprisingly, in his own work Noguchi experimented with simplified geometric volumes as well as with tensile wire constructions. After returning to New York, he travelled in the other direction to the Orient, where he rediscovered the beauty of Japanese gardens and something of his own past. Almost twenty years later he returned to Japan again, and thereafter travelled around the world on other occasions, often visiting Greece and the Orient on the same trip. As East and West merged in his own background, they also combined in his concepts and forms of sculpture.

The forties were a period of experiment and inventive development for Noguchi; he designed playgrounds, illuminated sculpture, and marble slab pieces. During the following decade came the first of many commissions for major public and institutional gardens, as well as opportunities for stage-set designs. Noguchi called his sculpture for the lawns of the Connecticut General Life Insurance Company (Plate 242) 'my first perfectly realized garden'.[10] Like ancient monoliths or heroic Greek kouroi, these stone figures complement both the classical spirit of Skidmore, Owings, and Merrill's architecture nearby and the open landscape setting. Noguchi was always conscious of the spatial context:

I say it is the sculptor who orders and animates space, gives it meaning . . . it is the point of view that sanctifies; it is the selection and placement that will make anything of a sculpture . . .[11]

His interest in sculptural images of permanence at once summons up the spirit of ancient Indian burial mounds and their artifacts, while preparing for the environmental forms and earthworks of a later generation (compare Plates 4 and 300).

Likewise, there were several painters of this generation who form a link between the avant-garde at the beginning of the century and the emergence of abstract expresssionism after World War II. Arthur Dove and Milton Avery, for example, stand as important transitional figures between Marsden Hartley and Mark Rothko. From upstate New York, born in 1880, Dove made his way to New York and Paris during the first decade of the century. By the time Stieglitz gave him his first exhibition, Dove's art had moved through the influence of post-Impressionism to increasingly abstract imagery. Although he knew many of the Ash Can group, the illustrational and narrative

aspects of painting held little interest for him. In this regard he said, 'I don't like titles for these pictures, because they should tell their own story.'[12]

The style that Dove evolved during the 1920s stressed simplified and generalized forms derived from nature, often relying on rhythmic repetitions of broad silhouettes and discrete patterns of earthy colours. He moved out of New York to Connecticut, and subsequently began spending time on board a houseboat, which the Doves would sail around Long Island Sound in all varieties of weather. The large forms of rocks, shore, water, sun, and moon provided him with unending motifs, 'simplified in most cases to color and force lines and substances, just as music has done with sound'.[13] Both his process of transformation and his sense of musical analogy are present in *Fog Horns* of 1929 (Plate 243): the muted colours, soft overlapping edges, and shifting circular densities convey the visual and aural impressions of the horn blasts echoing towards us through the fog, while a dimmer answering repeat is seen and heard on the far horizon. In Dove's later years, especially as he became sick in the forties, his forms tended to become even more abstract and primordial, sometimes symbolic, as he sought to make concrete both the outer and inner reality of his experience in nature.

Milton Avery also evolved a style of simplified patterns taken from landscape and human forms, although with even flatter and more opaque areas of colour, in generally brighter harmonies and closer to the effect of large-scale still lifes. Younger than Dove by thirteen years, Avery also came from rural New York, but moved when young with his family to Hartford, Connecticut. Farm and country life, and summers in Gloucester from 1925 on, influenced his long artistic interest in the seashore as a subject. Like other artists in Gloucester before him, he found appealing the smooth curving beaches and bold rocky promontories of Cape Ann, as well as the strong sunlight giving definition to rolling hillsides and expansive views of water. Avery's admiration for the art of Matisse further stimulated his special sensibility for bold colour designs and linear rhythms.

Ordinarily, too, Avery preferred combinations of closely related hues, as he does in *Sea Grasses and Blue Sea* of 1958 (Plate 244). He employs only a pale blue for the broad foreground and thin stretch of cloudless sky, and a darker blue mottled with patches of black for the expanse of sea between. Thinly brushed strokes of pigment hint at textures of grass on the beach and pale clouds on the distant horizon, while more irregular strokes and contours are used for the shifting reflections on the water's surface. But ultimately Avery's work holds interest less for its particular abstraction of reality than for its evocative tensions between space and surface, large and small forms, and restrained chromatic variations. His art remained remarkably consistent in its development from the forties to the sixties, though his later canvases tended towards bigger shapes and larger dimensions, rather in the spirit of the abstract expressionist work of his friends Adolph Gottlieb and Mark Rothko (compare Plates 255 and 258).

Belonging to the same generation and coming from a similar background in the midwest was Georgia O'Keeffe. After the turn of the century she studied at the Art Institute of Chicago and the Art Students League in New York, but found little interest in the prevailing manner of Chase and his followers. Intermittent periods of further study and

some teaching experience followed, but without as yet any firm direction set for her art. Then several winters in Texas began to suggest the presence of abstract form and space in the landscape: 'That was my country – terrible winds and a wonderful emptiness.'[14] In 1915 she met Stieglitz, who arranged her first major exhibition two years later; thereafter, they summered together at Lake George, and were married in 1924.

Her increasing preference for the isolation of forms in nature was in keeping with Stieglitz' approach to his photographs, especially his cloud 'equivalents' of this period. O'Keeffe, too, sought almost continually in her painting that ambiguous life of shapes on the border between abstraction and representation; *Black Iris* of 1926 (Plate 245) is an example. Here she employs her favourite devices of dislocation and magnification. The subject fills the surface, detached from its original setting and assuming the power of an enlarged scale. O'Keeffe controls the viscosity and texture of her pigments, so that her forms seem to flow from opacity into transparency, and density into pure vapours. Her flower becomes a microcosm of the universe, at once a landscape itself and a scientific cross-section.

Her image has much in common both with the art of her time and with the American tradition. The fascination with frontality recalls Weston, the near-symmetry Evans, interlocking contours and silhouettes Dove, purity of formal design Peale and Peto, and implicit sensuality the flower paintings of Heade. At its best O'Keeffe's work challenges us with its nuances of power versus grace, precision versus softness, decorativeness versus volume, minuteness versus grandeur. From the thirties on she spent her winters in New Mexico, moving there permanently after Stieglitz' death in 1946. Her later work increased in scale, size, and abstraction. Active well into her eighties, O'Keeffe created an art that was contemporary in both spirit and age with the exaggerated realism of Chuck Close on the one hand and the poured veils of colour of Morris Louis (see Plates 288 and 295) on the other.

Horace Pippin evolved an even more personal and intuitive style of colouristic and decorative richness. Born a year after Georgia O'Keeffe, in 1888, he moved as a child from his native West Chester, Pennsylvania, to Goshen, New York, where he grew up with an interest in art but no opportunities for professional training. He was consequently a self-taught painter, whose conscious primitivism recalls the long American folk tradition extending back to the colonial limners and flourishing in the nineteenth century. To support his artistic inclinations Pippin took various jobs until World War I broke out, when he joined a Black unit sent to fight in France. The war left a strong mark on him, psychologically and physically. The violence and suffering deeply moved him, and the fighting left him with a crippled right arm.[15]

In spite of his disability he struggled to paint, and during the thirties recognition came rapidly through the interest and support of N. C. Wyeth, Holger Cahill, and Albert Barnes. Generally, Pippin's narrative subjects are less successful than his still lifes or interior scenes, which have an independent strength of colour and ornamental pattern. An example of his most elegant works is *Victorian Interior* of 1946 (Plate 246). A blend of memory and observation, this near-symmetrical composition is full of bright areas of colour with selected concentrations of intricate linear designs. As such, his art

happily mediates between the abstractions of folk art and modernism (compare with Plates 115 and 244).

Jacob Lawrence developed for himself a similar style combining vigorous silhouetted patterns and narrative subject matter. Born in Atlantic City, New Jersey, in 1917, he grew up in Pennsylvania. In 1930 he moved to New York, studied there at various schools, and by the end of the decade had gained employment with the Federal Arts Projects. From the forties on he engaged in an active career of teaching, travel, and work. More consistently than Pippin he committed himself to images of Black history in America, with particular attention to scenes and events from contemporary life.

1941 marked the occasion of Lawrence's first major exhibition in New York. Shown were the more than two dozen temperas in a series entitled *The Migration of the Negro*, which met with wide critical success.[16] The first panel, *During the World War there was a Great Migration North by Southern Negroes* (Plate 247), is typical, with its precise repetition of angular and compressed forms. Like Avery, Pippin, and Shahn (compare Plate 229), Lawrence exaggerates or simplifies shapes for the sake of expressive force. Also to achieve emotional impact he would vary the size, number, and crowding of his figures; the constriction or tilting upward of pictorial space; and the harsh colours within often jagged outlines. Soon after, Lawrence entered service in World War II, a happier and more productive experience for him than the earlier war had been for Pippin. He produced new series on the war years and other topical aspects of national and racial history, always maintaining a creative balance between realistic and abstract form, as well as between protest and sympathy.

Two artists who decisively assisted in carrying American art through the critical transition during the 1940s from representational to non-representatinal art were Arshile Gorky and Hans Hofmann. Hofmann's birth in 1880 made him a close contemporary of Nadelman, Lachaise, Dove, and O'Keeffe, though both he and Gorky were born abroad, and brought with them to America a strong sense of modern developments in European art. Hofmann spent his youth in Munich, but went to Paris in 1904 for ten years. During this critical period he met Matisse, Picasso, and Delaunay among other pioneers of the French school. Through them he came to terms with neo-Impressionism, fauvism, and cubism. His own art would draw on the independent expressiveness of colour from fauvism and on the intellectual analysis and construction of pictorial structure from cubism. As a teacher, too, he articulated a philosophy of universality, which encouraged the spontaneity, improvisation, and emotion of French and German Expressionism, especially Kandinsky, along with the impersonal and structural organization of cubism and de Stijl, especially Mondrian.[17]

Hofmann began his long and influential teaching career in Munich in 1915: 'I opened my school . . . to clarify the then entirely new pictorial approach.'[18] As he expounded his theories to several generations of students there, and in the United States after 1930, a number of related pictorial ideas emerged strongly: he stressed the mysterious process of creation itself, the pictorial tension between the two-dimensional surface and three-dimensional space, the idea of counterforces held in equilibrium, colour as a 'means of creating intervals', and depth established not by traditional perspective (that is, 'the

arrangement of objects one after another toward a vanishing point') but by 'the creation of forces in the sense of *push and pull*'.[19]

During the late thirties Hofmann was able to give increasing attention to his own painting, which became a demonstration of his artistic ideas. Throughout the next decade and continuing until his death in 1966, his work simultaneously explored the implications of cubist structure and expressionist colour; for example, *Magenta and Blue* of 1950 (Plate 248) contrasts a number of interlocking colour complementaries (reds and greens, yellows and blues) within a large cubist grid that at once suggests a table still life, interior scene, and fractured landscape. Forms exist both as discrete shapes and as images in process of change; the eye finds almost interchangeable figure and ground, volume and void, line and plane. Here was a total compendium of artistic grammar which Hofmann himself continued to elaborate through his remaining career and which provided a basic syntax for most younger artists of the abstract expressionist movement (see Plates 250–60).

Hofmann's canvases and those of Arshile Gorky present the world of the artist, a personal 'universe in action',[20] for them not so much a voyage of psychological self-discovery as a revelation of corners of the creator's studio. Gorky was a full generation younger, born in 1905, and a refugee from Armenia. His given name was Vosdanig Manoog Adoian, but he changed it after his arrival in New York in 1920, intentionally using the Russian novelist's name to take on a new personal and artistic identity. In a similar way he devoted himself to past artists with an intensity of identification that often seemed to approach slavish imitation. In the late twenties and thirties, Gorky said, 'I was *with* Cézanne for a long time, and then naturally I was *with* Picasso.'[21] During this period he was foremost a follower learning the language of the masters, and there are hints in Gorky's work of Léger and Miró, as well as of other surrealists whom he knew at this time, André Breton and Matta Echaurren. Gorky also studied closely Uccello and the drawings of Ingres, to try to understand the capacity of line for pure musical form.

In 1935 Gorky was employed with the Works Progress Administration, and completed his large mural for the Newark airport. By the end of the thirties he had fully liberated his art from apprenticeship to others, and there followed an intensely productive decade of work before his death in 1948. Largely through Matta he had learned to mix his pigments with turpentine to create gauzy atmospheric effects and ambiguous, impermanent images of flux.[22] Now living in Connecticut, he was keenly conscious of the rolling fields, birds, and insects around him, and these became transformed into his interior landscapes on canvas. Partial anatomies and organisms fuse with their surrounding setting of vaporous colours and textures, figures and environment becoming inseparable. 'I do not paint in front of, but from within nature.'[23]

Agony (Plate 249) is such a picture. As in Hofmann's later work, colour and line begin to exist independently of form; images hover mysteriously beyond representation. Almost secret inventions, these are emblems of strong artistic passion and consciousness. The title also refers to the misfortunes of real life, for a year earlier Gorky's studio and contents had been completely burned, and at the same time he was operated

on for cancer. His anguish is apparent in the smouldering reds and charred blacks of this painting. In 1948 he suffered a broken neck in an automobile accident, and, leaving a note 'Goodbye My Loveds', he committed suicide. Gorky's agony was certainly personal, but it also belonged to his age. From the late Depression through the war years America and the world experienced a wider sense of disquieting change, as well as violence and suffering. Flannagan's death had occurred but a few years before, and Jackson Pollock's was not far in the future.

THE MID TWENTIETH CENTURY
1945–1976
From World War II to the Bicentennial

CRISIS OF THE EASEL

THE explosion of the atomic bomb in 1945 marked a turning point in modern history: for the first time the human race possessed the ability to destroy itself totally. Man's affairs seemed to assume a heroic and tragic scale. Not surprisingly, so did the art of the period. Working primarily in New York was a group now associated under the title of abstract expressionism.[1] Its members were close in age – most were born between 1903 and 1915 – and also had isolation in common. Recognition and success were slow in coming, triumphs lonely and hermetic. The seeds of abstract expressionism were sown during preceding decades, by cubism and expressionism respectively, and nurtured by the practitioners of surrealism during the war years. With the fall of France in 1940 a number of prominent European artists, many of them surrealists, moved to the United States.[2] They stimulated among American artists a heightened interest in psychoanalysis, mythology, and the techniques of automatism. Symbolically, the centre of artistic authority and innovation had moved from Paris to New York.

Part of the energy of abstract expressionism derived from the fusion of recent European ideas with a consciousness of the scale and power of the American landscape. The central figure of this generation, for example, Jackson Pollock, was born in Cody, Wyoming, moved to Arizona as a child, and grew up in southern California. After high school he participated in a geological survey of the Grand Canyon; his awareness of southwest Indian art, especially sand painting, was also to contribute to the emergence of magic imagery in his own art during the early 1940s. Another significant influence on the formation of his style was his association with Thomas Hart Benton, with whom he studied in New York from 1930 to 1932. ('My work with Benton was important as something against which to react very strongly, later on.'[3]) In 1935 Pollock was given work with the W.P.A., an experience of dual importance: it provided a reassuring sense of artistic community and work on a mural scale.

Social realism, then, was something of a provocation, at once to draw from and to reject. Other interests of Pollock's at this time included the paintings of Albert Ryder (Plates 207 and 208), with their aura of mysticism, intense subjectivity, and incrusted layerings of paint, and – in the late thirties – the Mexican muralists. His synthesis of these elements informs much of his work during the early forties, as exemplied by *Guardians of the Secret* (Plate 250).

The picture variously recalls the subjective graffiti of the surrealists, the compositional structure of cubism, the stark expressionism of Picasso's *Guernica* (a strong stimulus to Pollock), the ritual themes of Indian masks and totems (Pollock had travelled west several times in preceding years), and the murals of Benton (see Plate 227) with their large scale, undulating figures, and overlapping spaces. The power of ancient mythology is part of the secrets guarded here, as Pollock's cryptic writing fuses the two totemic

figures at either side with the central dream landscape. Whether primal signs of some lost language or molecular organisms, these marks of bright colour and rough brush-work suggest a crude life force all their own.

Within the next few years signs and symbols disappeared altogether from his work, as the ritual of the process itself, the energy and duration of creativity, acquired primary importance. During the relatively short and intense time from 1947 to 1951 Pollock made his boldest breakthroughs and most original statements. *Autumn Rhythm* (Plate 251) is one of the major canvases belonging to this culminating period, marked by his complete liberation of line and colour from preconceived form, and by a new environ-mental scale appearing to envelop the spectator. Now the free-flowing gesture takes over, as Pollock began to drip, throw, and pour paint onto his canvas, filling the entire surface with his bodily involvement. He had taken the critical step of making the very act of painting its own subject.

By this time Pollock had moved to eastern Long Island, and nominally the muted colours of this and related pictures – russets, greys, and blacks – reflect that area and the environs of New York City. In another sense these grand and dynamic images are pictorial equivalents of the scientific conceptions of the mid twentieth century, which have given us the theories of relativity and the expanding universe, and the equations of mass and energy, time and space. Of course, in no sense is Pollock's painting any longer illustrational or representative; even more significant, it is also not figurative. Colour belongs only to the pulsing motions of line, and line now has neither inside nor outside, having transcended its former function as contour or edge.[4] With these webs of paint on bare canvas, image and ground become interchangeable. Therefore seeing or rendering an object against a surface or an implied horizon is no longer of interest.

Pollock's radical technique is at the heart of abstract expressionism's signal contribu-tion to the course of modern art. In his own words:

My painting does not come from the easel . . . I prefer to tack the unstretched canvas to the hard wall or floor. I need the resistance of a hard surface. On the floor I am more at ease. I feel nearer, more a part of the painting, since this way I can walk round it, work from the four sides and literally be *in* the painting.[5]

Thus he makes a critical break with the long tradition of the easel picture from the Renaissance to cubism, in physically approaching his canvas from a new vantage and in treating it conceptually in a new way – not as a window of framed space but as a surface continuum recording subjective activity.[6] Now the entire area of the canvas equally receives the artist's gestures, his controlled accidents of moving paint, and his modulated tracery of colour harmonies.

The fundamentally American character of Pollock's art is apparent in comparing it to the work of his French contemporary Georges Matthieu, who, for all his active whorls of paint, basically approached his canvases as oversized easel pictures. Likewise, Matthieu's densities of line coalesce into figures ultimately perceived as separable from their background. In addition, Pollock's environments of energy belong to a native tradition of heroic and dynamic landscape, as celebrated earlier by Church, Bierstadt

(see Plates 108 and 148), and Whitman, and in the 1950s by Beat writers like Jack Kerouac and Lawrence Ferlinghetti. Their novels and poetry found a comparable form of expressing personal energies in stream-of-consciousness narration and impulsive travel across America.[7]

The art of Mark Tobey makes an interesting comparison with that of Pollock. A full generation older, Tobey was born in 1890 in Wisconsin. He grew up in the midwest, and spent much of his life in the Pacific northwest, but travelled on several occasions to Europe and to the Orient. Also his early conversion to the Bahá'í faith and subsequent interest in Zen instilled a strong spiritualist character into his art. Abroad he studied Persian miniatures, and in Seattle he was introduced to examples of Chinese calligraphy and scroll painting. All these elements were to temper his approach to painting with a distinctively contemplative quality, apparent in his familiar manner of 'white writing', first developed in the 1940s.

His work tended to be more intimate and restrained than Pollock's, often employing the subtler nuances of watercolour or tempera, more intricate gestures, and emphasis on white as symbolic of enlightenment. But his paintings were also subjective landscapes, for example *Edge of August* (1953) (Plate 252), which drew on a number of personal experiences: the intimacy of Japanese gardens ('this small world almost under foot . . . which must be realized and appreciated from its own level in space'), a summer field of 'matted grasses, delicate thread-like structures', and the magical transition of a season, 'the thing that lies between two conditions of nature, summer and fall'.[8] The solid edge of colour at the lower left also suggests that we are looking over a fragment of the earth's contour itself into a universe both personal and cosmic. Tobey's age, training, and west-coast orientation never forced on him the urgency experienced by the New York school, a fact seen in his less brutal and physical art, although he shared in the impulses towards formal abstraction, subjectivity, and revelation.

Franz Kline and Willem de Kooning are the two other major action or gesture painters in the movement. Kline came from the coal country of central Pennsylvania, and sustained throughout his career a recollection of the powerful industrial and machine forms dominant in that landscape. A solid grounding in academic art training, especially in draughtsmanship, helped to shape his mature work. He also cultivated a deep appreciation for the great artists of chiaroscuro: Dürer and Rembrandt among the old masters; Goya and Daumier among modern Europeans; Ryder and the Ash Can School from the American tradition. From this background emerged Kline's own graphic sensibility of vigorous drawing and tonal contrast.

He settled in New York in the late thirties, and his scenes of the city increasingly stressed opposing masses of light and dark, along with the motion of forms and brushwork, tensely pushing against the framing edges. By the late forties he had moved almost fully to abstraction, enlarging his former improvisatory sketches into bold canvases of colliding strokes of black and white paint. He asserted that he was 'painting experiences . . . I'm not painting bridge constructions, sky scrapers'.[9] Nonetheless, these pictures convey the impact of urban largeness and dynamism, the explosive energy, and even violence, of post-war America. They possess the spirit of steel-girder architecture,

wherein the interlocking tension of parts in cage construction allows a new exchange between space and mass, as well as inside and outside.

Consider *Accent Grave* of 1955 (Plate 253). It is first a visual pun on the French accent, along with a felicitous allusion to a gravity of scale and gesture. In using a wide house-painter's brush and black enamel paint, Kline rejected (as Pollock did) working from the wrist, and instead recorded swaths of movements by his full arm and body. His lines of energy are so thick as to read simultaneously as planes, in tension with the adjacent fields of white. Kline implies the motion of paint coursing beyond the edges of his canvas, much as Church had sought to suggest the uncontained forces of *Niagara* (see Plate 108), although the abstract expressionist work is more an embodiment than a representation of energy.

In some regards de Kooning seems the most conservative of this group, with his strong academic training, familiarity with the European precedents of cubism and de Stijl, and recurring use of the easel convention and the human figure. Therefore his reconciliation of these factors with the radical advances of abstract expressionism makes his art all the more complex and original. He sailed from his native Rotterdam for New York in 1926, and in the next few years became a friend of Gorky. Work for the W.P.A. in the mid thirties provided temporary employment, but soon de Kooning turned more to the automatism and biomorphic imagery of surrealism.

By the late forties he had moved towards an aggressively physical brushwork and strident colouring, treating painting, much as Pollock and Kline did, as a form of auto-biographical record. About this time, too, he began work on his series *Woman*, which evolved into one of the central themes of his career. The figurative subject appealed for several reasons, not least because it was central to the history of European painting, 'the vulgar and fleshy part' of western art.[10] But *Woman, I* (Plate 254) also embodies the artist's response to the violence and energy of the American city, the garish colours and magnified scale of its billboards, and more particularly the cult of movie queens and sex goddesses in the post-war period. With the eyes of an arriving foreigner de Kooning saw a ferocity and indulgence in this American vision, and painted it with deserved intensity.

Along with distant hints of cubist fragmentation and ambiguity, expressionist distortion, and surrealist improvisation, de Kooning's painting possesses its own inventions. Present are his favoured combination of fleshy pink with lurid yellows and greens, the repeated use of oval motifs for different anatomical parts, and the long slashes of pigment alternatively reading as interior walls or furnishings and exterior foliage. His equal directness of form and of means results in an acute image of comedy and horror.

In contrast to the linear gesturalism of this side of abstract expressionism, the expressive capacity of colour fields was the primary concern of another group of painters. Mark Rothko, Barnett Newman, and Clyfford Still most notably treated their expanses of canvas as environments of pure feeling, states of mind or consciousness, revelations of transcendent harmony. Just as the age itself produced political concepts such as the Cold War, with its ambivalence of calm and anxiety, so the aggressive energy in some painting had a parallel expression in other expansive canvases ranging from the sensuous to the sacramental.

Rothko, for example, moved through the biomorphic figuration and automatic calligraphy of surrealism during the 1930s into large simplified rectangles of colour fused on a single plane. His surfaces are as physically rich and suggestive as Pollock's, and equally enveloping in scale, but rely rather on subtle nuances of colour shifts and subdued textures to convey an emotional impact. His soft hovering forms, as in *Green and Maroon on Blue* of 1953 (Plate 255), fill the surface almost to the framing edges, thus in their own way equating figure and ground. While not so immediately personal as Pollock's or Kline's, Rothko's paintings nonetheless bear the evocative imprint of the artist's brush in the scumbled surfaces and frayed edges. They are visionary landscapes of environments, partly owing to their vague references to horizon lines and zones of earth, water, and sky, or to times of day – we can almost feel the heat of noontime sunlight, the glow of twilight, the absorbent cool of evening – but they are also 'measures' (Rothko's word) of feeling.[11]

Even more austere and monumental were the paintings of Barnett Newman, who had similarly worked with surrealist and primitive imagery before turning in the late forties to expansive fields of colour and severe gestures of contrasting lines. Newman had a strong Jewish consciousness which led him to make an almost mystical association of Genesis and other biblical events with the artist's act of creation. 'My drawing declares the space,' he said, much as 'man's first speech was an address to the unknowable,'[12] a first marking (and making) in the void. The few vertical lines of raw colour in his canvases are intended as an appearance of light or man giving both metaphoric and formal power to the remaining surface.[13]

Such is the effect of *Vir Heroicus Sublimis* of 1950–1 (Plate 256), with its Latin title conferring a tone of historical authority. This was Newman's first painting on such a scale (eighteen feet wide), and he intentionally chose a ratio of over two to one in width to height, to increase the effect of sweeping breadth.[14] Such panoramic grandeur, as well as the effulgent radiance and transcendent order, is descended, not superficially, from the luminist proclamations of Church and Gifford a century earlier (compare Plates 109 and 110). Newman's vertical divisions further define the space by creating an exact square in the centre, while visually pulling at that symmetry with different values of colour and imbalanced placement in the outer sections. Adventurous and pioneering in form, his work contains both personal and universal meaning, related ultimately to the heroic tradition of sublime landscape and history painting descending from Benjamin West (see Plate 45).[15]

Clyfford Still's paintings expressed a similar largeness of vision, though not so demonstrably mystical. Born in North Dakota, growing up in the state of Washington and in Alberta, Canada, and later teaching in California, he carried the ruggedness and sweep of the western American landscape into his canvases. After rejecting the structures of cubist and constructivist art, and working through figurative inventions allied to surrealism (even though he denied the association), he evolved during the forties a style of rough, irregular patches of interlocking colours. Through control of scale and tonal opposites, figure and ground became interchangeable. By the middle fifties his painting (Plate 257) had become much larger in size; his islands of colour were fewer but more

intense, and often confined to jagged vertical tears along the pictorial field. He enjoyed relying on severe opposites of closely valued colours – combinations of black and purple versus yellow and orange; in this instance it is black, red, and white – to which were sometimes attached the allusive power of metaphysical dualities. One thinks of night and day, sun and earth, male and female, good and evil,[16] much as one detects similarly contesting forces in Church's interpretation of *Cotopaxi* (Plate 109).

In fact, Still's vast landscapes belong to the romantic tradition of Allston and Ryder (see Plates 72 and 207) with their visionary themes and thick glazes of pigment. At the same time Still shares with Rothko and Newman the idea of painting as an open terrain across which the artist inscribes his presence. Still wrote of the

journey that one must make, walking straight and alone. . . . Until one had crossed the darkened and wasted valleys and come at last into clear air and could stand on a high and limitless plain.[17]

The abstract expressionist viewpoint was summarized in an oft-quoted letter to *The New York Times* of 13 June 1943, written by Rothko and Adolph Gottlieb with Still's editorial assistance, and including the following assertions:

To us art is an adventure into an unknown world, which can be explored only by those willing to take the risks. . . . This world of the imagination is fancy-free. . . . We favor the simple expression of the complex thought. We are for the large shape because it has the impact of the unequivocal. We wish to reassert the picture plane. We are for flat forms because they destroy illusion and reveal truth . . . we profess spiritual kinship with primitive and archaic art.[18]

Several abstract expressionists, including Gottlieb himself, Robert Motherwell, and Helen Frankenthaler, staked out stylistic positions within the broad range of the movement's two major currents, fusing aspects of both gesture and colour-field painting.[19]

A native New Yorker, Gottlieb began his artistic career studying with Sloan and Henri during the twenties. In the next decade he travelled abroad, worked for the W.P.A. in Gloucester, and spent some time in Arizona. On the sands of the western desert and the Cape Ann beaches he became fascinated with the forms of dried grasses, bones, and shells. These appeared in somewhat surrealist paintings combining landscape and still life. At first Gottlieb arranged these objects on shelves or in compartments, as if in some rite of mental archaeology. During the forties his awareness of Indian artifacts and the starkness of the war years together prompted him towards an increasing primitivism.[20] To this end he used increasingly flattened shapes and thick impasto roughly applied, now regulated within a large irregular grid system across the surface.

By the end of the forties his images had transcended all illustrational or narrative functions, and assumed a purely visual presence of cryptic and mythic force. During the fifties he further evolved these so-called 'pictographs' into 'bursts' of paired monumental shapes on raw fields of canvas. *The Frozen Sounds, Number 1*, of 1951 (Plate 258) falls during the critical period of transition between these two phases of Gottlieb's career. While recalling the potent hieroglyphs of preceding pictures, it is moving towards both the larger fields of colour and the gestural brushwork of pure abstract expressionism.

Perhaps the most articulate and intellectual artist of the movement was Robert Motherwell, who was born in Washington and grew up in California. He studied

philosophy at Stanford and later in graduate school at Harvard, followed by a period at Columbia with Meyer Schapiro. More conscious of art history than his colleagues, he also had important experience as a teacher, writer, and editor. Taking up art full time in the early forties, he felt the combined influences of surrealist automatism and synthetic cubist construction. As with many of his generation, the momentum of war in Europe made a lasting impression on Motherwell, and in 1949 he began the first of his series (eventually numbering more than one hundred versions) entitled *Elegy to the Spanish Republic*.

Also dating from this year and closely related to the drama of the Spanish Civil War was *The Voyage* (Plate 259). In this and the *Elegy* series Motherwell drew on the collage forms of Picasso, figural shapes of Miró, and decorative strength of Matisse to effect a mural sequence of magnified shapes. Sometimes organic or phallic in suggestion, and usually alternating in dark–light and round–angular rhythms, these forms evoke 'the contrast between life and death, and their interrelation'.[21] On another occasion Motherwell referred to 'a chapter in *Moby Dick* that evokes white's qualities as no painter could, except in his medium'.[22] In addition, the sere yellows appearing in this and some other works recall the western landscape of his background. Thus he brings together his complex searches through culture, history, and personal consciousness.

In 1958 Motherwell married Helen Frankenthaler, whose art also draws on the two major currents of abstract expressionism. A younger artist (born in 1928), she characterizes the developments pursued by the second generation of painters in the movement.[23] Her struggles to find a personal style began with study under Rufino Tamayo in New York and Paul Feeley at Bennington College. She acquainted herself with the examples of Cézanne and Matisse, as well as the American precedents of Dove, Hartley, and Marin. Her own creative vision found a clear sense of direction in the early fifties, when she studied in the summers at Provincetown with Hans Hofmann, and visited exhibitions in New York of Gorky and Pollock. She suddenly felt herself in a foreign country, but 'I wanted to live in this land; I *had* to live there, and master the language.'[24]

From Pollock particularly she developed a technique of gestural colour staining, which soon became much broader in execution and effect, as may be seen in *Interior Landscape* of 1964 (Plate 260). By both pouring and brushing her thinned paints onto the raw canvas, she was able to soak the bright colours into the material itself, and thus now literally, as well as conceptually, fuse colour, form, and field into one. The new use of acrylic pigments allowed a heightened intensity of colour (in this instance greens, yellow, and blues) and a broader range of fluid and atmospheric effects. Both her grandeur of chromatic vapours and her transformation of the painter's methods of working demonstrated an articulate and eloquent mastery of her pictorial language, as, among others, Morris Louis, Jules Olitski, and Kenneth Noland (see Plates 295 and 296) recognized.

CRISIS OF THE PEDESTAL

'WHAT do we call "American" . . . ?' asked Arthur Dove, and answered, 'Inventive-ness, restlessness, speed, and change.'[1] Already seen in post-war painting, these qualities are also discernible in concurrent developments in American sculpture. In the twentieth century artists created a new form of sculpture in the history of art, neither carved nor modelled, but assembled or constructed.[2] Thanks to cubism and constructivism, frag-ments of form and pre-existing materials might be brought together in unexpected juxtapositions with each other and with surrounding space. Interest in new materials and objects, such as various metals and junk, combined with new techniques of welding, made possible work on a scale larger than ever before. Related to this was the active and positive treatment of both interior and surrounding space as itself a malleable material to be enclosed, punctured, manipulated, or otherwise animated. One of the crucial accom-plishments of American sculpture during the post-war decades was the embodiment of process as a new ingredient, whether in the introduction of motion into sculpture, in the calling attention to an object's transformation, or in the expressive evidence of the artist's hand left on its surfaces.

Alexander Calder, David Smith, and Louise Nevelson are the towering figures among a prolific and inventive generation of artists at work through this period. Calder, along with George Rickey, made the special contribution of introducing actual motion and the element of time into modern sculpture. Born in Philadelphia in 1898, Calder was to follow an illustrious father and grandfather into the field of sculpture. He completed engineering school before studying at the Art Students League during the early twenties. Attracted by artistic developments abroad, he went to Paris in 1926, and thereafter travelled back and forth between France and America throughout his career. In the late twenties he began an elaborate group of wire figures as part of a toy-sized circus. Some were intended to stand on the ground, while others were balanced on, or hung from, wire strings. At the same time he was carving simplified animal forms in wood, with formal emphasis on the stance and gesture of limbs. Together, these suggested to the artist the eventual evolution of his familiar mobiles and stabiles.

Calder's work bears the imprint of the two artistic cultures he has known. During his first years in France he became a close friend of Miró; he knew Léger somewhat less well, and he made a visit to Mondrian's studio that had a strong impact on him. With the Spanish surrealist Calder came to share a delight in whimsy, bright cheerful colours, suggestive organic or natural shapes, and the idea of drawing in space. From Mondrian he grasped a sense of equilibrium and reduction to essentials, as well as the idea that artistic form need not be representational. His own work subsequently relied primarily on interrelationships between line and plane and on combinations of the basic colours, red, yellow, and blue, plus black and white. By 1932 Calder had created motorized

mobiles, and this soon led him to conceive of animating his assembled forms by currents of air.[3]

During the course of his career his pieces grew larger and bolder. The large mobile commissioned for the International Arrivals Building at New York's Kennedy Airport in 1957 (Plate 261) illustrates the essential Calder at his best. Apart from its genesis in the earlier European styles he had known, it demonstrates even more those characteristics Dove named as American. While very much recalling the nineteenth-century craft tradition of weathervanes, whirligigs, and hanging shop signs, it also speaks to a mid-twentieth-century context of flux, energy, and movement. Although non-representational, his forms always suggest the contours or skeletons of animals, or constellations of floating birds, fish, clouds, and heavenly bodies.

Likewise, his titles often refer to marine and insect life or to foliage and trees. Indeed, the idea of growth is visible in both his leaf-shaped plates and in forms branching off a central core. And while made of metal and wire, they obey and display the basic physics of nature. Revolving within often extensive systems, interrelated in hieratic order, Calder's lines and planes draw endlessly in the space around them, with no single view or moment in time ever defining the whole completely. The fourth dimension of duration is the final shaping element. Calder's work is seen to best advantage in spaces of circulation: staircases, foyers, fountains, and plazas. Certainly no more felicitous setting could be imagined for a Calder mobile than a major American airport.

If Calder's work reaches harmoniously into architectural space, Simon Rodia's Watts Towers in Los Angeles (Plate 262) actually become a form of sculptural architecture, blurring any clear distinction between the traditional boundaries of the two art forms. Rodia, born in 1879, was an Italian emigrant and a tilesetter by trade. He lived in Los Angeles much of his mature life, and 'wanted to do something in the United States because I was raised here you understand?'[4] For over three decades, from the early twenties to the mid fifties, he worked alone on a small corner between two city streets and a railroad track to erect the several towers, adjacent benches, terraces, and surrounding walls. On a scaffolding of steel rods and wire screen, he massed concrete, into which he embedded all manner of junk fragments from nearby streets.

Like a folk artist, Rodia had an intuitive sense of ornamental design. With pieces of stone, bottle glass, shells, and mirror he assembled a varied array of colours, textures, and surfaces, further embellished by areas of geometric design that he incised in the plain concrete. As one drives across the flat dreary landscape of southern Los Angeles, with gas stations, stores, and houses rarely over one story high, these weightless spires seem all the more remarkable in that they endow the commonplace with beauty. Non-functional in any practical sense, their tensile tracery nonetheless evokes a force of imagination and a touching sense of aspiration. Like some secular Beauvais, the Towers rise up from their surroundings as a sustained assertion of human will.

During the late forties and fifties metal and junk assemblages preoccupied a large group of American sculptors,[5] of whom David Smith was pre-eminent in the prolific originality and power of his achievement. He was born in Indiana in 1906 and moved after college to New York, where during the mid twenties he studied under John Sloan

at the Art Students League. In this period, too, he was exposed to other widely diverse influences: the work of the Russian constructivists and of Picasso, friendship with Stuart Davis, and in 1925 a summer job in an automobile plant, where he first learned techniques of welding.[6] Gradually Smith added objects and materials to the surface of his canvases, always retaining in his subsequent sculpture an underlying pictorial sensibility:

The first constructions that grew off my canvas were wood, somewhere between 1930 and 1933. Then there was an introduction of metal lines and found forms. The next step changed the canvas to the base of the sculpture. And then I became a sculptor who painted his images.[7]

Smith's welded metal sculptures of the next few years were mostly figures influenced by the recent constructions of Picasso and Gonzalez and the surrealist *Palace at 4 A.M.* by Giacometti. But though he drew on these traditions in his formative years, Smith sought to move in an entirely independent direction, basically by rejecting rather than modifying the cubist and surrealist assumptions about an object's central core.[8] Expressing qualities of ambiguity and paradox that were as much a reflection of the age as of surrealism specifically, his work developed an abstract figural imagery while denying any single vertical axis or unifying point of view.

Like Pollock, Smith sought to redefine the nature of figuration by shifting line and surface away from their role of defining form to an objective life of their own. Around 1950 he was working on a series of open grilles in a critical phase of this sculptural pursuit. *Hudson River Landscape* (Plate 263) characteristically suggests something of the cubist forms and open linework of Stuart Davis's painting (see Plate 223). Spaces appear to be alternatively substantial and empty, and lines oscillate between defining negative shapes and embodying motions of energy.

In 1940 Smith had moved from New York City upstate to Bolton Landing, and on one level this piece alludes to the sweeping vistas and craggy forests of the upper Hudson valley area. Its emphatic reference to the planar format and consciousness of framing edges further denote a pictorial convention and the idea of landscape (compare Plates 90 and 101). But Smith also causes us to see the forms for themselves, as well as the surrounding context, which is framed and thereby made a part of the work itself. In other words, figure and ground are actively interrelated, much as they are in works by de Kooning and Gottlieb from the same period (compare Plates 254 and 258).

Smith brought his sculpture to maturity largely in self-sustained isolation on his Adirondacks farm. Throughout the fifties his figures became increasingly monumental and totemic. Even as his forms retained a human touch in their finish and stance, they were approaching an environmental scale, both in the industrial grandeur of their materials and in the raw landscape objectified around their surfaces. In addition, from the late thirties onward the mixed imagery of sexuality and war, especially the phallic metaphor of the cannon, was a central theme in his work. Although he probably drew on a variety of sources,[9] the iconography of Picasso's *Guernica* appears to have had a marked impact on Smith, as it did on his contemporaries. Between such images and his materials he saw an expressive link:

Possibly steel is so beautiful because of all the movement associated with it, its strength and functions. . . . Yet it is also brutal: the rapist, the murderer and death-dealing giants are also its offspring. . . . The iron element I hold in high respect.[10]

During 1962 Smith went to Voltri in Italy, where he was given an abandoned steel plant in which to work. So productive was this period for him that one critic said, 'Vulcan came to Voltri.'[11] Following this stay Smith turned to his *Cubi* series (Plate 264), which were to be the summary works of his last few years. Despite the heroic presence of strength and mass, pictorial values remained evident in the still linear forms, planar composition, framing character of the outer elements, and record of the artist's hand across the surfaces. In a number of later pieces Smith actually painted some components in bright primary colours, a direct reference to the formal language of painting, while in most others he burnished the stainless steel with broad rough gestures. He clearly had in mind, by such finishing and by placement of his sculptures across the fields of Bolton Landing, the incorporation of the environment as a formal element in his art:

I made them and I polished them in such a way that on a dull day they take on a dull blue, or the color of the sky in the late afternoon sun, the glow, golden like the rays, the colors of nature.[12]

In form and technique Smith's sculpture emerges from a context of twentieth-century industrial power, equally capable of beauty and strength, grace and brutality. That he defined his essentially romantic vision in the landscape of the northern Hudson River valley returns us once again to that deeply ingrained metaphor of the machine in the garden, employed from the time of Cropsey and Inness (see Plates 97 and 185) onwards. The paradox of creative and destructive force in Smith's art culminated with his death in a truck accident in 1965.

The American automobile, with its familiar violence and mortality, held a common appeal for artists as different as John Chamberlain and Andy Warhol (see Plates 265 and 283). Interestingly, Chamberlain, like Smith and the painter Robert Indiana, was born in Indiana, a state known for flat open roads, dangerously high speed limits, and the Indianapolis raceway, where every Memorial Day the 500 provides an opportunity for Americans to indulge in tallying the holiday weekend's death rate. Along with Jason Seley, Chamberlain worked principally with junked car bumpers and chassis fragments. Both belong to a group of sculptors a full generation younger than Smith and indebted to his precedent.[13] Where Seley preferred to use unpainted bumpers, in order to exploit the surface textures and sheen as well as the expressive preformed shapes, Chamberlain often chose parts already painted and crushed, which he then further compacted together.

A work like *Dolores James* of 1962 (Plate 265) thus alludes to a car crash, not in any specific illustrative way, but in its past and present brutality to the forms. Like most other assemblages, his imply a personal history or life in time, a context to which they once belonged, and a sense of the process by which they were given a new identity and a new context. Like Smith's work, Chamberlain's sculpture has a certain pictorial character, not simply in the modulation of light, colour, and texture, but also in the

generally planar composition intended for placement on the wall rather than the floor. Partly indebted to abstract expressionism, *Dolores James* invites comparison with the savage aggressions of de Kooning and the exploding collisions of Kline (see Plates 253 and 254).

Closer in age to Smith was another midwesterner, Richard Lippold, a native of Wisconsin who studied industrial design at the University of Chicago and carried his knowledge into his work as a sculptor. During the forties he concentrated increasingly in his metal constructions on the wire lines that contained or defined forms. By the end of the decade his intricate repetitions and symmetries of polished wires combined to suggest planes and geometric solids in space, in the tradition of Naum Gabo's later constructivist work. More mathematical than Calder's, Lippold's work also demarcated metamorphic galaxies in space, with titles often referring specifically to a sun or moon. Even though fixed in place, *Variation Number 7: Full Moon* of *c.* 1950 (Plate 266) is typical in its dissolution of solid surfaces and volumes and the near-complete penetration of space and light throughout.

Physically, Lippold makes visible a series of interdependent tensions, as taut as they are delicate, which respond to the subtlest nuances of the human presence nearby. Any stirring of the air causes the wires to vibrate with a shimmering light like some distant star. 'Once installed, nothing can disturb it except the most delicate of matter,' said Lippold, though he also thought of his work in the larger context of fragile world balances and order:

We must remember that a slip of paper in the wrong place – someone's desk or a portfolio – can now destroy mankind. It is not the main tensions we must fear, it is the little delicate relationships we must control.[14]

Although a central development of the fifties, work in metal was not the only avenue of expression open to sculptors. Somewhat overshadowed have been the more intimate assemblages in wood by Louise Nevelson, Joseph Cornell, Varujan Boghosian, and others.[15] Where Cornell and Boghosian created small surrealist theatres of found objects, endowed with poetic allusion and feeling, Nevelson progressively moved through her career from single carved pieces to large-scale architectural environments, through which one moves visually and often physically. Born in Kiev in 1899, she emigrated with her family a few years later to Rockland, Maine, where she grew up conscious of the rugged coastal landscape of rocks and trees. Once determined to be an artist, she went to Munich in 1931 to study painting under Hans Hofmann, although six months later Nazi pressures forced the closing of his school. Even so, a sense she acquired of the carefully structured two-dimensional surface always remained in her art.

A reinforcement of this experience was a period of work in New York, along with Ben Shahn, under Diego Rivera. Subsequent interest in archaeology took her to Mexico and Central America, where she found especially impressive the solid geometric forms of pre-Columbian sculpture. She herself collected African sculpture, and these various art forms had a combined impact on her own taste for large, simplified, quasi-geometric shapes. Finding stone too resistant to her improvisatory touch and her wish for gentle

poetic metaphor, she chose wood for most of her work. Exhibiting an awareness of cubist wood constructions, her early pieces were dark blocky forms with arresting silhouettes.

Conscious of seeing shapes as surfaces and edges, she combined natural and invented objects in façades of gradually increasing scale. During the later forties she began to place her figures on extended horizontal pedestals, which by the mid fifties had become platforms for a lateral arrangement of several forms. Now painted totally black in order to unify the range of grained or polished textures, and the resulting subtlety of light transitions across and around surfaces, they call attention to the playful rhythms of both mass and spatial interval. Nevelson also thought of such pieces as part of a larger group of related constructions, all sharing a common poetic theme and exhibited as a richly metaphoric environment. Both in terms of form and concept, then, her work arrived at a conscious sense of ambivalence between still life and landscape.

Paralleling the work of numerous artists of her generation (for example, Pollock, Gottlieb, and Smith), Nevelson's sculpture moved towards a totemic scale and imagery. By the late fifties her single or aligned figures had become large walls, subdivided into boxes and shelves of overlapping objects in varying degrees of relief. A summary work of this time was *Sky Cathedral* (Plate 267), which maintains and augments the paradox of scale between the intimate and the environmental – on the one hand suggesting small cupboards or bureau drawers, on the other a metropolitan street plan or skyline. Indeed, most of Nevelson's mature life and career is associated with New York City, whose grids and densely massed volumes constantly surrounded her. This rough grandeur and the compact rhythms of energy are American characteristics of her art, which Jean Arp perceived on first seeing this work at the Museum of Modern Art: 'This is America and I will write a poem to the savage.'[16]

At the same time Nevelson felt that her

works are definitely feminine. . . . Men don't work this way, they become too affixed, too involved with the craft or technique. They wouldn't putter, so to speak, as I do with these things. . . . My work is delicate; it may look strong, but it is delicate. True strength is delicate.[17]

She arranged fragments from junkshops and elsewhere of old furniture and architectural decoration, modified so that we may appreciate their purely formal abstraction as well as their hint of some former identity. Her art obscures as much as it reveals, reflecting both the secret recesses and the outer idiosyncrasies of the human personality itself. Her assemblages have a reflective and meditative character, paradoxical for objects so physical. Reminiscent of the work of Peto and Walker Evans (see Plates 171 and 235), they bear witness to an ordering intelligence and individual humanity.

With the later work of Nevelson, Smith, and Calder we have reached a point where American sculpture has pushed well beyond traditional limits and forms in several new directions. During the sixties and seventies other younger artists were to pursue the implications of forms in motion, in an architectural or environmental framework, and in an expanding variety of materials and processes. Two artists born in 1933, Chryssa and Sam Gilliam, in very different ways represent some of the radical modifications of

sculptural form in the post-abstract-expressionist period. The Greek-born Chryssa, who uses only her first name, studied in Paris and San Francisco during the mid fifties before coming to New York. Immediately fascinated by the large billboards and illuminated advertisements, she sought unsuccessfully for a job sign-painting, and turned instead to creating art forms derived from the advertising world.

Beginning with large reliefs of letters or signs in metal, she moved in the early 1960s to the use of neon tubing in three-dimensional assemblages. Usually limited to a few bright contrasting colours, and enclosed in plexiglass boxes which also reveal the electric circuitry below, her designs of light are frequently programmed to blink on and off at intervals. A work like *Fragments for the Gates to Times Square* of 1966 (Plate 268) thus calls attention to itself in process. Sometimes her shapes are legible letters, but they are generally more successful as abstracted hieroglyphs, at once recalling their original commercial context and announcing a purely formal language of their own. Her work serves as a link between construction sculpture of the fifties and subsequent concerns with commercial imagery in Pop art, and colour structures in op and systemic art (see Plates 279 and 293).

The pictorial impulses of colour perception and sign-making in Chryssa's work indicate the extent to which painting and sculpture had become joined in much work of this period. In Sam Gilliam's art we find another fusion of means, wherein his hanging canvases actually assume sculptural form in space. Coming from a large Baptist family in Black Mississippi, Gilliam made his way through school, college, and graduate school in Louisville, Kentucky. After Army service and a period of civil rights activity in the sixties, he settled in Washington, D.C., where he was exposed to the strong local school of colour-field painters (see Plate 295), and began to establish an increasingly independent reputation of his own. His first exhibited works were watercolours, and these were followed in the mid sixties by large acrylic paintings of geometric colour. Out of a procedure of crumpling or rolling his still wet watercolours, to achieve vaporous and spatial effects that seem to challenge the picture's surface and framing edges, he evolved his technique of similarly staining and shaping large canvases.

Characteristic is *Horizontal Extension* of 1969 (Plate 269), which had paint poured and dripped on to its surface, was then rolled or folded, and finally hung without stretchers, literally moulded in space. Sometimes Gilliam draped paintings from rods or nailed them to a wall or beam, in each instance confronting the nature and limits of pictorial structure.[18] Black activists, conscious foremost of social and racial awareness, have understandably criticized Gilliam for not addressing more explicitly through art issues of Black identity and aspiration. He admits that as one possible and important route, though prefers for himself instead

to make it in terms of being the best black painter. . . . Underneath, what's important to me is to do what I want to do . . . concerned with the quality of your existence as an artist.[19]

That his work speaks directly to the processes of art itself gives forceful testimony both to his own creative innovations and to his integrity.

ENERGY AND IMAGERY

THE single-mindedness and fervour that seemed to characterize the dialectic of abstract expressionism gave way in the later 1950s to an attitude of irony and scepticism. A number of younger artists sought to question the philosophical absolutes and auto-biographical dynamics of action painting with an intentional equivocation and detachment. Thus, they deliberately worked in an area of conceptual and formal ambivalences, posing rather than solving problems about the nature and identity of objects, and challenging further the distinctions between pictorial and sculptural form. Robert Rauschenberg and Jasper Johns were the leading figures, with perhaps the most inventive and fertile imaginations, in giving new directions to the artistic language of abstract expressionism.

Of similar age and background – Rauschenberg was born in 1925 in Port Arthur, Texas; Johns was five years younger and from Allendale, South Carolina – they occupied neighbouring studios and shared ideas during the later fifties. Rauschenberg recalled of Johns: 'It would be difficult to imagine my work at that time without his encouragement.'[1] They also had mutual friends in the dancer Merce Cunningham and the composer John Cage, and owed a common artistic debt to Marcel Duchamp. Rauschenberg moved around in the southern and western United States during his youth, ending up at the Art Institute in Kansas City, Missouri, in the mid forties. In 1947 he left for Paris, where he met his future wife and studied at the Académie Julian. Hearing about Josef Albers, he left to study under him the following year at Black Mountain College in North Carolina. There he was 'disciplined by Albers [and] worked hard but poorly'[2] for him.

Although Rauschenberg came to New York not long after, and was briefly enrolled at the Art Students League under Morris Kantor, his artistic interests were moving in different directions through acquaintance with modern dance, theatre, and music. At this time, too, he began working on a series of so-called white canvases, followed by sequences of black and of red paintings, all severely reductive, in part stimulated by Albers (see Plate 290). Though not concerned with the older artist's ratios of related colour values, they are similarly austere and disciplined in their attention to essentials.[3] Most notably, Rauschenberg's work exhibited from this period on an underlying structure of generally rectangular forms. He also sought to discover the nature of colour, paint, and texture for their own sake. These early works call attention to the physical presence of pigment along with the intruding touch of the artist.

Next Rauschenberg began to enrich his enigmatic surfaces with newspaper 'to activate a ground', as he said, such that 'the printed material became as much a subject as the paint'.[4] By the mid fifties he was attaching found objects to his canvases, in the manner of cubist collages, but with the incongruities and inconsistencies of surrealism or Dada.

He called the results, for example *Monogram* of 1959 (Plate 270), 'combines' – appropriate for the fusion of various pictorial, graphic, and sculptural techniques. But these were equally metaphoric combinations of urban detritus, in a manner akin to Nevelson's assemblages (compare Plate 267), bringing together forms of disparate and unexpected scale, association, or personal history. His own experience of New York made him conscious of 'a city where you have on one lot a forty-story building and right next to it, you have a little shack'.[5]

Rauschenberg's aesthetic is also concerned with the transformation of objects: 'the fact that the material is re-used is, in truth, the paradox. It ceases to be waste.'[6] But in contrast to Nevelson's his forms undergo a metamorphosis more conceptual than physical; he seldom fragments or obscures their original function or identity, preferring rather to provoke fresh tensions between the real world and the arena of art. His celebrated statement that 'painting relates to both art and life ... I try to act in that gap between the two'[7] is borne out here by objects like the stuffed goat and tyre, which challenge us less with their vulgarity than with the fact that that vulgarity refuses to be subsumed into an expected artistic context.[8] At the same time Rauschenberg challenges the formal limits of art, by breaking the traditional framed rectangle of a canvas; in this instance it is actually two joined wood panels, placed on the floor instead of on a wall, with thinner pieces of wood and the found objects added on. (In other cases he opened up holes within the field to expose the wall behind, or extended objects across the framing edges to an adjacent surface or floor.) The artist's presence is witnessed in a variety of ways: the free gestures of paint on the goat's nose, the broadly brushed or scumbled rectangles, the pieces of stencilled signs with the capital letters R and A suggesting part of the artist's name, a sequence of footprints, and the heel of a shoe.

In fact, Rauschenberg's art has a notably autobiographical cast. Like the abstract expressionists he records his physical participation in process across an environmental field, often spilling or dripping paint like an action painter,[9] and he also employs photographs and memorabilia from his past or his present. During the sixties he added complexity to his techniques by transferring photographs and newspaper images via silkscreening to his canvases and via rubbing to his drawings (especially the series illustrating Dante's *Inferno*). Numerous reproductions of past art appear; some – for example Velázquez' *Venus and Cupid* with its mirrored figure – recur more often, in literal as well as metaphorical layerings of printed, drawn, reversed, and superimposed images. By such means Rauschenberg constantly refers to the life of art and to personal experience. In 'that gap between the two' he extends our perceptions of both.

Jasper Johns arrived in New York in 1949, and after a couple of years away in the army, joined Rauschenberg's circle of friends. During the fifties Johns also developed an approach to his art that both exploited and contradicted abstract expressionist techniques. Drawing on the nonsensical dislocations of images by Dada art, and Duchamp particularly, the surrealist juxtapositions of conscious and dreamed visions in Magritte's painting, and the gestural surfaces of the abstract expressionists (for example Rothko and Newman), Johns fused together a compendium of modern aesthetics. After some early collage constructions, he turned to several sequences of field paintings, the best known

being the American flag, target, alphabet, and number series of the mid fifties. In these the image fills the entire surface, confusing reality with artifice, even representation with abstraction; for we are made aware of pigment, total optical design, and artistic process as much as of original object.

Johns asserted, 'I'm certainly not putting the numbers to any use, numbers are used all the time, and what's being done is making something to be looked at.'[10] He supported this approach with his use of encaustic, that is, heated wax with pigment colours mixed in. This medium dries swiftly, but retains a rich, fluent character and makes even more palpable the gestural involvement of the artist. During the later fifties and early sixties Johns' work shifted towards a larger scale, both more environmental in allusion and sculptural in form, certainly due in part to the stimulus of Rauschenberg's recent combines: *Field Painting* of 1963–4 (Plate 271) is an example, although characteristically it is a more cerebral and systematic work than any by Rauschenberg.

Field Painting embodies the heart of Johns' continual examination of what might be called the linguistics of art and vision. His title recalls the precedents of abstract expressionism, with attention directed to activity across the entire surface, though his painting is more a microcosm of the artist's studio. Appended to the centre are a paint brush, mixing can, and other accessories, as well as hinged letters spelling out the primary colours. But Johns also incorporates the paradoxes of what we see and know. The letters appear in relief, casting shadows of themselves, as well as painted in reverse and stencilled, sometimes in colours other than those which they spell. (For example, the 'o' in YELLOW is blue in cut-out, red on one side, and barely an outline around its central shadow on the other.) He has fashioned a dictionary of artistic syntax, much like Duchamp's *Tu m'* (Yale University Art Gallery); a wall of his creative life, reminiscent of Peto's *Still Life with Lard-Oil Lamp* (Plate 171). As modern *trompe l'œil*, much of Johns' work deals with transformations and ambiguous perceptions. He engages us in the serious game of art itself, literal but mutable. In his sketchbooks he noted, 'Take an object. Do something to it. Do something else to it. Ditto.'[11] The multiple readings of form in *Field Painting* literally illustrate such modifications in progress.

Two years older than Rauschenberg, Larry Rivers was another contemporary who forged a link between abstract expressionist techniques and the reintroduction of ordinary objects and realist images. Rivers was a native New Yorker, and his training was in music before he turned to painting in 1945. Association with Nell Blaine, subsequent study with Hans Hofmann and William Baziotes, and a strong awareness of de Kooning's style (see Plates 248 and 254) combined to shape Rivers' own interest in gestural immediacy and figural representation.

Some of his work of the early fifties retains the specificity of portraiture, with a corresponding solidity of form and spatial articulation, but increasingly his active touches of brushwork begin to acquire an independent life. Figures appear in multiple exposure, fragmented and floating across a non-illusionistic field. Rivers added familiar imagery such as the American flag (about the same time as Johns), repainted clichéd icons such as *Washington crossing the Delaware* (see Plate 143), and like Rauschenberg and Johns assembled encompassing panoramas of references to the experience of life and

art.[12] During the early sixties Rivers began a series of illustrated vocabulary lessons in different languages (Plate 272), which were also of course lexicons in the vocabulary of art. We are reminded of Stuart Davis in the presentation of words as visual objects as well as verbal information, and of the individual techniques of de Kooning and Kline (see Plates 223, 253, and 254). However, Rivers' deliberate allusions to contemporary mass media – the stencilled letters of billboards, the imagery of textbook illustrations – belong especially to the vulgar consumerism ascendant in the America of the 1960s and celebrated mercilessly by Pop art.

Rivers, Johns, Rauschenberg, and also Richard Lindner decisively modified abstract expressionism with a new irreverence in attitude and execution, elevation of commercial objects and techniques into the context of art, and complex questions about the nature of sight and perception. Pop art carried further the celebration of popular images and mass-media techniques by rejecting altogether the personal dynamics of earlier abstract painting (see Plates 279–86). Meanwhile, other younger painters continued to explore styles mediating between the legacy of abstract expressionism and the emergence of Pop art's aggressively banal realism. Fritz Scholder and Raymond Saunders in particular fashioned styles synthesizing these elements, but with a sharply focused sense of individuality.

Scholder, born in Minnesota in 1937, was of part Indian descent; his father belonged to the Luiseno tribe in California, headed a local Indian school board, and for a time worked in the Bureau of Indian Affairs. Scholder's family moved in the early fifties to South Dakota, where he received his first artistic training from Oscar Howe, a Sioux Indian painter recently returned from Paris, who introduced him to modern artistic developments. He continued his study of art at Wisconsin State College, and later in the decade spent an important two years working under Wayne Thiebaud at Sacramento City College in California.[13] During the sixties Scholder moved to Arizona, completed a graduate degree, and began teaching in New Mexico. With a heightened consciousness of his background, he actively collected Indian artifacts, went to see tribal dances, and became convinced 'that it was time for a new idiom in Indian painting'.[14] The final shaping experience of his maturing style was a trip in 1969 to England, where he was deeply impressed with the expressionist portraits of Francis Bacon in the Tate Gallery.

Scholder's Indian paintings reflect aspects of this background. *American Indian* of 1970 (Plate 273) is characteristic in reflecting the example of Thiebaud, an artist on the periphery of the Pop movement, in the creamy and corpulent treatment of paint and in the immediate familiarity of its image. Thiebaud's noted predilection for painting rows of desserts on table tops also found echoes in Scholder's occasional rendering of an Indian with an ice-cream cone or beer can. There is obvious humour and irony here, as the figure actually and figuratively wraps himself in the flag. As such, it offers comment on what the artist terms the 'sad history' of the American Indian in relation to his land and the white Federal government. Beyond this, the image of the flag generated singularly intense controversy for artists and public alike throughout this period, and Scholder joined in addressing some of its multiple meanings and perceptions. The striking exaggerations of colour and form recall the work of Bacon but also suggest the harsh

figurations of de Kooning. Interestingly, the large simplifications of the human frame seem to have been long a part of the Indian's artistic instincts (see Plates 4 and 120). But Scholder's work is contemporary in all its looming ambivalences: terror and endurance, lost power and acquired pride, certain identity and uncertain future.

Three years older than Scholder, Raymond Saunders also imprinted personal experience and racial history onto his canvases, but with a similar breadth of humanity. Born in Pittsburgh, Saunders pursued most of his artistic education in Pennsylvania (at the Carnegie-Mellon Institute, the Barnes Foundation, and the Pennsylvania Academy) before doing advanced work in California and Rome. Travel in the Middle East, Japan, and Russia exposed him to landscapes of exotic colours and images, which seem occasionally blended into his work like textures of memory. Conscious of the Black ghetto in America, he has painted pictures reflecting (in no explicit way) that urban environment.

Saunders' work combines the loose brushwork and broad colour fields of abstract expressionism with the popular imagery of the street, such as the comic figure of Mickey Mouse with the printed word GOD repeated nearby (in *Doctor Jesus*), and various stencilled numbers or alphabets. *Marie's Bill* (Plate 274) possesses the rougher improvisations and bright colours of graffiti on subway cars or city buildings.[15] Its personal gestures announce the distant affections and declarations of named but unknown persons, as well as the recording presence of the artist, fused together with humour, warmth, and mystery.

Richard Lindner and Romare Bearden also exploited the popular imagery of the 1960s, in ways related but not central to Pop art itself. Rather than working out of abstract expressionism, they formulated styles based on earlier precedents in cubist collage, expressionist distortions of colour and form, and surrealist disjunctions of scale and space. This was not surprising, for Lindner was himself German, and Bearden had studied at the Art Students League with George Grosz, who introduced him to the work of Kollwitz and Daumier. Moreover, different as their backgrounds were otherwise, both formed their artistic and social outlook during the 1930s in New York, against the background of Depression and the threatening shadows of war.

Born in 1901, Lindner fled his native Bavaria for the United States in 1933. He brought with him a multitude of memories which would eventually find their way into his art: the circus, dressing up, members of his family who were variety artists, his youth in the medieval city of Nuremberg, the legends and fantasy surrounding the mad king Ludwig II, Nietzsche's brooding philosophy, and the consciousness of an exile in a new homeland.[16] The artist as performer and outsider is a continuing theme in twentieth-century art, from Picasso and Man Ray to Federico Fellini and Bruce Nauman (see Plates 217 and 298), and Lindner in New York was especially drawn to the carnival artifice of the urban environment. In Times Square and Broadway particularly he saw modern man masked, costumed, and mechanized.

From the time he began painting in the early fifties, Lindner's style moved steadily towards flattened forms and sharply outlined rhythms of glaring colours. *Rock-Rock* of 1966–7 (Plate 275 and frontispiece) typifies the strong frontality and near-symmetry of

his mature work, with occasional surfaces highlighted by metallic modelling in the manner of Léger. The garish tonalities and strident patterns aptly suit the intense pitch of noise, barrage of advertising, even hallucinatory pressure of life in the age of amplified rock music. The figure presses close to the picture surface, oppressive, domineering, yet ironically lifeless within all these implied visual and aural energies. The guitar cleaves musician and picture in two, as if diagramming schizophrenia, certainly alluding to the androgyny cultivated in the lifestyles of many rock stars during this period. The slender moustache hints at vulnerable but violent adolescence; neither male nor female, the face becomes part of an inert mask dominated by reflecting sunshades and wig-like hair. There is the magic power of the rock idol, almost a totemic presence, but also before us is man savage as an animal and, like Ernest Trova's highly polished bronzes of futurist automatons, impersonal as a machine.

Romare Bearden also captures the compacted sights and sounds of New York, albeit more explicitly the Black world of Harlem that he knows best. Born in 1914 in Charlotte, North Carolina, he moved north for schooling in New York and Pittsburgh. During the 1940s he knew Jacob Lawrence and other Black artists in Harlem, and in the sixties was instrumental in organizing a group concerned with defining and promoting the Black artistic identity. After service in the Second World War, which heightened his awareness of racial inequalities, he worked in Paris. During the next few years he explored various aspects of modernism, including abstract expressionism, to which several large canvases bear witness, but by the early sixties had found that the technique of collage best suited his artistic aims and experiences.

For example, the assembled fragments of *The Street* (1964) (Plate 276) are appropriate to the multiple sensations of urban life, its crowding, disparateness, shifting history, and restless energy; to the artist's own varied background of work in Harlem, Greenwich Village, and Paris; and to the mixed feelings Blacks have known of suffering, hope, triumph, survival. But Bearden's work further contains his reflections on Black history, his own education, and daily life around him. The titles of his compositions reveal references to art (*La Primavera, Illusionist at 4 P.M.*, and *Three Folk Musicians*), the distant and recent past (*Cotton, Train Whistle Blues*, and *Jazz 1930s*), and biblical literature (*Baptism, Destruction of Sodom and Gomorrah*, and *Expulsion from Paradise*). Of course, these last are also allegories for the present. Bearden put it simply: 'This work represents some consolidations of some memories, of some direct experiences from my childhood on to the present.'[17] Like Saunders, he creates an art of genre rather than propaganda, always direct and humane in its vision.

In sculpture Edward Kienholz and Marisol similarly joined commonplace objects and everyday realities with the methods of assemblage. Kienholz was born in 1927 in Washington, and thereafter remained largely associated with the art life of the west coast. His family were farmers, and from them he learned carpentry, plumbing, mechanics, and engineering – useful trades for his later large-scale constructions. He went through various colleges and jobs before settling in the early 1950s in Los Angeles, where he ran a succession of art galleries. At the same time he began to work with heavily painted wood panels, which soon evolved into more three-dimensional pieces

with objects attached in relief or on hinges. Frequently these made witty references to contemporary events – a fantastic assemblage of camera and lantern parts with other objects, *God Tracking Station*, emerged in response to the Russian orbiting of the first sputnik. By the mid sixties Kienholz had carried his sculptural ideas to full life-sized environments or 'tableaux', combining found and constructed forms.

Some works, for example *The Illegal Operation* and *State Hospital*, confront the viewer with a sordid horror and pathos, others, like *Back Seat Dodge* and *The Beanery*, with satirical irony, but all force our involvement visually and psychologically. *The Wait* of 1964-5 (Plate 277) stirs a mixture of these sentiments. As sculpture, it is no longer separable from real life; it is set up as an extension of the viewer's space and equipped both with familiar accessories and with a live bird.[18] Thus other senses in addition to our sight are engaged; the work of art does not allow itself simply to be looked at.

Technically, Kienholz gains our uneasy participation by his decision to 'work close to the floor; to consume the space between where paintings hang and the ground'.[19] In other words, these objects metaphorically come to fill a corner of our own lives. The figure waiting is surrounded by fantasies and memories, as are we all. Around her neck hangs a chain of bottles filled with trinkets and toys. The large bottle that is her head bears on its cap a photograph from her youth, contrasting with the animal skull contained within and the skeleton limbs below. Kienholz's work is a meditation on the mortality of people and things. As he said, 'all the little tragedies are evident in junk'.[20]

The work of Marisol (Escobar) poses similar combinations of wit and gravity, individuality and universality, actual and imagined realities. A Venezuelan born in Paris who does not use her full name, she studied first at the École des Beaux Arts and then during the early 1950s in New York under Hans Hofmann. His influence was strong and pervasive in her subsequent wood constructions, such as *Women and Dog* of 1964 (Plate 278), in the emphatic frontality of forms, total structural coherence, tension of opposites (for instance line and mass), and full range of techniques. There is painting, drawing, stencil, collage, relief, assemblage, and carving; cubist simultaneity and surrealist contradictions.

Her immediate precedents lie in the work of Johns and Rauschenberg (Plates 270 and 271), although some of the deliberate geometry of form derives from an awareness of the pre-Columbian sculpture of Central America.[21] Her whimsy and sense of craft belong as well to the tradition of nineteenth-century American folk art, such as toys, shop sign figures, and carousel carvings (see Plate 119). Frequently her own face appears repeated in her pieces, on a light note as insouciant vanity, on a more serious level as a familiar emblem of the artist made part of his work. On occasion Marisol took as subjects contemporary popular images – figures of Heads of State or moguls of the art scene in the sixties – but it remained for others to exploit fully the commercial mechanics and visual language of mass media, central features of the Pop art movement.

CHAPTER 29

MONUMENTAL REALISM

POP ART was one of the consummate expressions of the decade of the 1960s in America. It cannot be separated from the culmination of affluence and prosperity during the post–World-War-II era. America had become a ravenously consuming society, packaging art as well as other products, indulging in commercial manipulation, and celebrating exhibitionism, self-promotion, and instant success. During the early sixties Pop art seized on these elements and exploited them with a brazenness that seemed offensive both for its discomforting insinuations and for its assault on the elevated hegemony of abstract expressionism. Roy Lichtenstein noted that

everybody was hanging everything. It was almost acceptable to hang a dripping paint rag, everybody was accustomed to this. The one thing everyone hated was commercial art . . . the most brazen and threatening characteristics of our culture.[1]

Pop artists chose to replace the individuality of technique and feeling in abstract painting with a mechanical neutrality of means and image. Yet their rejection was not without its indebtedness to the older generation. Pop continued, for example, the environmental scale, all-over treatment of the picture field, context (now made explicit) of the urban industrial landscape, and fundamental New York orientation. In addition, Cage, Rauschenberg, and Johns had shown how everyday sights and sounds might expand the vocabulary of abstract art.

Pop art was a magnified form of genre painting, reflecting America's optimistic determinism in the years of the Kennedy presidency, much as genre in the 1850s or the 1930s had been associated with national values. Pop's mass-media orientation may further be related to the acceleration of uniformity in most aspects of national life, whether restaurants or regional dialects.[2] Shared by all Americans were the principal preoccupations of Pop art – sex, the automobile, and food. These became almost interchangeable, as Americans increasingly blurred distinctions between bathroom, highway, supermarket, and kitchen. Another interconnecting theme was a concern with the nature of visual information itself, whatever the subject, in an age of pervasive confusion between the substance and the image of reality.[3]

In addition to quoting the treatment of commonplace and mechanical objects earlier in European art by Picasso and Léger, as well as Duchamp's influential readymades, we may note a number of antecedents to Pop art in the American tradition. These include nineteenth-century *trompe l'œil* paintings, folk art, John Rogers' mass-produced genre sculpture; in the twentieth century the commercial images painted by Stuart Davis and Gerald Murphy, the American scene depicted by Hopper, Sheeler, and Evans, and of course every format of contemporary advertising.

Many of the elements incorporated in Pop appeared in the work of Robert Indiana,

who declared himself 'an American painter of signs'.[4] Born Robert Clark in 1928 in Indiana, he adopted the name of his native state, one at the heartland of the country in character and geography. His art reveals a fascination with words as visual design and verbal information, recalling both nineteenth-century tavern signs and modern industrial emblems. When he settled in New York in the mid fifties, two important influences on the formation of his style were his decision to move into a studio at Coenties Slip in lower Manhattan, and his subsequent association with Ellsworth Kelly, Jack Youngerman, and others working with hard-edged intense colour abstractions (see Plate 292).

Much of his early work consisted of assemblages constructed with abandoned forms found in the old buildings, such as stencils or signs once used by the original ship chandlers occupying the premises. Meanwhile, he was equally impressed with the prospect of modern commerce visible from the slip. Strongly conscious of American literature, he based several paintings in the early sixties on lines from Whitman or Melville, while others derived from various themes of past or present American culture. His painted forms soon took on the flat bold colours and clear silhouettes of stencilled trade signs; letters, numbers, or words were increasingly magnified, until they assumed a monumental scale and near-abstract power of design. Often figure and ground reverberated with each other because of nearly equal claims on the picture's surface and evenly saturated contrasting colours.

One of Indiana's major works from a series occupying him for much of the early 1960s was *The Demuth American Dream No. 5* (Plate 279), a complex assemblage of multiple associations. Of course, it is foremost a work of deliberate art historicism, an intended homage to Demuth's original (Plate 225). Indiana always enjoyed coincidences, especially of numbers, for they often became signals to him of personal and historical conjunctions, as if with the power of astrology. So he learned that Demuth painted his picture in 1928, the year Indiana was born, and this later picture was painted thirty-five years afterwards, a number divisible by five.[5]

While retaining Demuth's general colour scheme of yellows, reds, dark blues, greys, and blacks, Indiana displaced the earlier cubist transparencies and fragments of fire-engine and building forms with opaque graphics carrying new meanings of their own. He played, for example, on the different formal manifestations of the number five; in fact, there are five: the numeral itself, five-pointed star, repetition of words in outer circles, the number of colours and of panels. Other numbers acquired comparable significance for him – highway routes, gas station signs, birth and death dates. As if marks on a calendar, they denote embodiments of time, history, and geography. Thus the imagery of *The American Dream* also alludes to the country's highways, restaurants with juke box and pinball machines, the uniform shapes and colours of road signs. Whether in the sequence of numbers or in the cycle of ERR, HUG, EAT, DIE, Indiana saw a twentieth-century voyage of life.

Most of Indiana's colleagues in the Pop art group were born between 1925 and 1935, and were therefore in their early thirties when the movement gained its full momentum. Jim Dine was one whose art emerged out of abstract expressionism and the Happenings

of the mid fifties. As such, his continued sense of personally painted surfaces and attachment of incongruous objects to his canvases put him along the creative edge of pure Pop, closer to the work of Rauschenberg and Johns. James Rosenquist felt a parallel impact from the work of Pollock and Sam Francis,[6] although the panoramic breadth and intense gigantism of his work gained even greater force from his experience as a billboard painter during the mid 1950s in Minnesota and later in the decade in New York. Soon he met Rauschenberg and Johns, and joined Indiana, Kelly, Youngerman, Agnes Martin, Charles Hinman, and others in studios at Coenties Slip.

From his work on billboards Rosenquist carried over into his painting such devices as highly enlarged forms (often cropped or simplified to a point of abstraction), garish, glossy colours, and an imitated slickness of commercial illustration techniques. His vantage points, often high up on buildings, yet near to his painted image, made him conscious of both close-up angles of vision and distant aerial views. His paintings are collages of these multiple glimpses of the environment, but are also equivalents of the shifting densities of images transmitted by mass media.[7] *Nomad* of 1963 (Plate 280) presents us with a sample array of familiarly seen objects – picnic bench, open wallet, sunlamp, microphone, ballet dancers' legs perhaps from a televised film, and advertising signs. Rosenquist explained,

I'm amazed and excited and fascinated about the way things are thrust at us, the way this invisible screen that's a couple of feet in front of our mind and our senses is attacked by radio and television and visual communications, through things larger than life . . .[8]

Thus his work was a reaction to aspects of contemporary American culture, 'the extreme acceleration of feelings', 'a glimmer, a flash of static movement', 'the action that goes on in this free society'. He remembered his colours in even more immediate terms, as 'T-shirt yellow . . . Man-Tan suntan orange . . . Franco-American spaghetti orange, I can't forget it.'[9] But ultimately neither individual colours nor specific images constituted his subject; rather, 'the content will be something more, gained from the relationships'.[10] Alternately optimistic and overwhelming, his images together express something of American energy and expansiveness in an advanced technological age.

Violence, long an undercurrent in the national character, became increasingly commonplace during the decade, and appeared repeatedly in cool detached fragments in newspapers and on television screens. Roy Lichtenstein addressed the subject, as well as the issue of our perception of it, in 1964 in *As I Opened Fire* (Plate 281), one of a series consciously emulating the comic book, news photo, and television screen. Lichtenstein was a native New Yorker, studied at Ohio State University, and began painting in the fifties in an abstract expressionist manner. He then used the style for rendering common objects and, by the early sixties, large-scale cartoon figures. His repertory of subjects came from comic strips, magazine advertisements, and commercial illustrations, and he accentuated their character by borrowing their techniques as well. Among those he used were the Ben Day dots from mechanical printing processes, generalized and readily legible forms, photographically projected images, limited colours (usually the basic primaries with black and white) in the manner of inexpensive colour separations, and stencilling.[11]

More importantly, Lichtenstein's processes of accentuation amounted to transformation. By isolating the form, draining it of its narrative context, and then drastically changing its scale, he endowed it with new visual presence. In addition, his images are not literal translations but subtle modifications of the original.[12] In *As I Opened Fire*, for example, there is a conscious harmonizing of rectangular, circular, and flamelike shapes, as well as a formal consistency between the placement and scale of words and of nearby images. Lichtenstein replaces verbal narrative with visual continuity, as here the strong diagonal forms are the principal means of carrying the eye across the panels from left to right. Movement is confirmed by the shifting viewpoints, evident in the changed colour of the sky and the zoom lens effect of moving closer to the gun nozzles in each frame. These underlying formal distillations are close in spirit to the hard-edge abstractions of Ellsworth Kelly and Frank Stella (compare Plates 292 and 293) done in the same period.[13]

Much of Lichtenstein's work is devoted to the imagery of reproductions, which goes to the heart of seeing itself, a century-long issue in modern art. Thus he painted *Magnifying Glass*, *Image Duplicator*, and the word ART; he made mechanical copies of Picasso, Mondrian, and Monet, views of Greek ruins and Egyptian pyramids (as seen by most people only in coffee-table book illustrations); and he painted magnified brushstrokes and picture stretcher frames – all questioning the identity and perception of art.[14]

Likewise, Andy Warhol took for subjects graphic images, such as labels of cans, newspaper headlines or photographs, currency, and stamps; with these he raised contradictions about their techniques by painting what had been originally engraved or otherwise printed. Or he undertook to represent famous movie stars (*Marilyn Monroe*, *Elizabeth Taylor*), public faces (the best known being *Jackie*), works of art (*Mona Lisa*, *Thirty Are Better Than One*), and the F.B.I.'s *Most Wanted Men*; all were known and experienced foremost through the public media of movies, magazines, posters, or television. The replicated image was more real than the individual human being. As Warhol explained, 'In the future everybody will be world famous for fifteen minutes.'[15]

His family were Polish immigrants named Warhola living in Pittsburgh. He grew up in the Depression years, held a job decorating shop windows, and studied at the Carnegie Institute of Technology, before moving to New York in 1949. For several months he shared an apartment with his fellow Pittsburgher Philip Pearlstein, beginning a sequence of jobs doing commercial magazine illustrations and design which lasted through the fifties. His exposure to commercial methods and images during this period well prepared him for the introduction of banal themes into his first paintings of the early sixties. He moved steadily over the next couple of years to full emulation of mass-media processes, first selecting and reworking commonplace subjects, next painting them to approximate mechanical means, finally using actual mass-reproduction devices such as photomechanical silkscreening. Master epigrammatist of the Pop scene, he referred to his studio as The Factory and asserted that 'machines have less problems. I'd like to be a machine, wouldn't you?'[16]

100 Campbell's Soup Cans of 1962 (Plate 282) is from one of his best known series, and possesses a visual strength that is at once optical and ideational. As a flat system of red, yellow, white, and black patterns it is akin to much of the systemic and op art of the

same years (see Plate 291); but it is also a sign of individuality in the modern industrial world of the later twentieth century. 'Everybody's plastic. I want to be plastic,' he said. 'The Empire State Building is a star!'[17] Warhol, who sprayed his hair silver, lined his loft with foil, and used silver in his paintings, was truly a mirror of his time.

With President Kennedy's death a good deal of Pop took on a darker tone. Warhol worked on several 'Disaster' series, of car crashes, suicides, the electric chair, race riots, and hospitals. Silkscreened in lurid orange, *5 Deaths 11 Times in Orange* of 1963 (Plate 283) conveys his observation that 'when you see a gruesome picture over and over again, it doesn't really have any effect'.[18] Like a broken newsreel, high-speed printing of a newspaper, or replayed videotape, the edges overlap in a flickering image of depersonalized violence. Not surprisingly, the next step for Warhol was to declare an end to painting and turn his energies to film.[19]

Another logical extension of the Pop sensibility was into sculpture, where the three-dimensional realities of life and art might be even more sharply counterpointed. Here the leading figures were the Swedish-born Claes Oldenburg and the New Yorker George Segal.[20] Oldenburg grew up in Chicago, and after graduating from Yale, studied art and anatomy at the Art Institute of Chicago, a combination that would be central to much of his later work. When he moved to New York in the mid fifties, he met Segal, Dine, Kaprow, and Red Grooms, who were variously involved in extending the improvisatory and environmental implications of abstract expressionism through Happenings or lifesize sculptural assemblages. Oldenburg's first major efforts followed similar lines with construction of such tableaux (all but *vivants*) as *The Street* and *The Store*. The former consisted of rough-textured paintings and wood reliefs, reflecting the raw immediacy of both abstract expressionism and the literal urban background of New York City. For the second project he fashioned painted plaster replicas of supermarket objects for actual sale in his store/studio.

Punning on the materialism of art in several senses, Oldenburg announced in Whitmanesque lines that he was for an art 'that does something other than sit on its ass in a museum'.

I am for Kool-art, 7-UP art, Pepsi-art, Sunshine art, 39 cents art, 15 cents art, Varonol art, Dro-bomb art, Vam art, Menthol art, L&M art, Exlax art, Venida art, Heaven Hill art, Pamryl art, San-o-med art, ℞ art, 9.99 art, Now art, New art, How art, Fire sale art, Last Chance art, Only art, Diamond art, Tomorrow art, Franks art, Ducks art, Meat-o-rama art.[21]

During the mid sixties his sculpture steadily evolved from plasters of clothing articles and foods in actual size to household utensils made of canvas or vinyl and stuffed with kapok. These in turn he enlarged to absurdly oversized scales, often with effects equally comic and disturbing. Such is the *Giant Hamburger* (1962) (Plate 284) of painted canvas filled with foam rubber. Ever and again Oldenburg confronts us with dislocations in size, viewpoint, texture, hardness or softness. With a bow to Marcel Duchamp he contradicts most of the physical properties of an object, presenting to us an ambiguous image equivalent to *trompe l'œil* painting in three dimensions.

By different methods George Segal achieved similar juxtapositions of artifice and

reality. He grew up in New York City and nearby New Jersey, and received his training in art at New York University and Rutgers. His career began during the later fifties with expressionist landscapes, though he soon began making plaster figures. Full-sized and placed in real surroundings, these dominated his career from about 1960 on. Made of plaster moulded over live models, then cut in sections and reassembled, the outer surfaces of course were subject to modelling adjustments at various points, and approximated (rather than replicated) the inner figure.

The apparitional and often contemplative character of his work has led several critics to see Segal as only tangentially related to the deliberate vulgarity and irony of pure Pop: on the one hand his lonely effigies seem extensions of Hopper's American scene painting of the thirties, on the other early inhabitants of the hyper realist art ascendant in the later sixties (see Plates 237 and 287). Yet he often situates these figures in the commercial and mundane settings of Pop: a bus interior, counter of a diner, butcher shop, movie-hall entrance, *The Gas Station* (Plate 285). He forces similar 'shocks and encounters' [22] with our recognition of questioned identities, both in form (sculpture cast, modelled, found, assembled) and content. The results include doubletakes on Greek marbles, Degas bronzes, and ourselves.

Tom Wesselmann worked with both painting and sculpture, as well as assemblage environments combining the two. Born and educated in Ohio, he joined in the manufacture of Pop icons from the early 1960s onward. Like Rosenquist he emulated the billboard format and employed collage compositions of enlarged photographic images. Like Lichtenstein he flattened and isolated his subject, and like Warhol relentlessly asserted the bogus or dehumanized features of contemporary life. Using brash glossy colours and moulded plastic, he cited even more than Oldenburg the cosmetic indulgences and sexual fantasies of Americans. The most celebrated series of Wesselmann's career, entitled *Great American Nude* (Plate 286), explored these themes through sequential variations. Those of the early sixties depicted the full reclining nude in the manner of the sleeping Venuses of Giorgione and Titian, Manet's *Olympia*, and the odalisques of Matisse, whose paintings Wesselmann knew and occasionally quoted in his backgrounds.[23] Featureless, save for the mechanically generalized pubis, nipples, and mouth, these figures are embodiments, literally flat and artificial, of how both women and art are perceived.

Paralleling and growing out of Pop art during the 1960s was the resurgence of a new realism intent on restoring fully the human figure as an alternative subject to formalist abstraction. Sculptors like John de Andrea and Duane Hanson employed cast polyester and fibreglass in conjunction with live models to strain even further than Pop the juncture between the real and the made. Similarly, painters – among them John Clem Clarke, Richard Estes, Chuck Close, and Philip Pearlstein – exploited or referred to photography to execute their deft illusions. After moving from Pittsburgh to New York with Warhol in 1949, Pearlstein did some industrial design work before turning to painting landscapes in a vigorously gestural manner. A trip to Italy in the late fifties drew his attention to the structural solidity of the stony landscape and ancient architecture he saw there.

Around 1961 he began painting the nude, as stilled and substantial as Roman ruins or the Amalfi cliffs. At first he made wash drawings of his models, which he then translated into oil on much larger canvases, but soon he was painting them directly from life. Composed and arranged as carefully as still lifes, his figures (Plate 287) are isolated as pure forms, and in comparison to Wesselmann's nude we are made to look at the form, rather than what it represents. Pearlstein often crops a head, limb, or shape, as here the leg and sofa are severed by the canvas edges. Foreshortening, cold lighting, and muted green and flesh tones all serve to dramatize the weight and substance of human physicality. The seriousness and intensity of vision look back in the American tradition to Thomas Eakins and Ivan Albright (compare Plates 167 and 233). Yet photographic as Pearlstein seems, he considers it important that we understand his comment that 'I see more than a camera does, and it takes me more time than a camera.'[24]

Lack of emotion and of social comment also characterizes the work of Chuck Close, who wishes to retain the neutrality of the camera's eye, while augmenting its revelations of textures or unscrutinized details. A good deal younger than most of the Pop artists – he was born in 1940 in Monroe, Washington – he has examined the issues they raised with even greater sharpness. Working from eight-by-ten-inch photographs magnified onto canvases nine feet high, he meticulously deposits his image (Plate 288) on the expansive surface with an airbrush and the most limited amount of paint.[25] The disturbing power of his paintings is impossible to comprehend fully through reproductions, for the uncanny illusions of his technique and representation partly reside in their sudden unexpected scale.

To move from Close to Diane Arbus presents the contrasting paradox of an artist seeking instead through her camera 'what you can't see in a photograph'.[26] She was born in 1923 in New York, where her entire creative life was concentrated. For several years she worked with her husband in fashion photography, and in 1959 studied under Lisette Model, a documentary photographer. Two Guggenheim Fellowships in 1963 and 1966 provided the time to release her energies fully on her own work. She began photographing freaks and misfits, seeing in them a certain ordinariness. By implication she forced her viewers to consider that 'normal' people possess malaises not so far removed. In fact, she argued that 'most people go through life dreading they'll have a traumatic experience. Freaks were born with their trauma. They've already passed their test in life. They're aristocrats.'[27]

In 1966 she found subjects in the derelicts of Washington Square. 'They were like a lot of sculptures in a funny way,'[28] she observed, and she got them to pose, like Pearlstein's models, with patient endurance and self-possession. Yet it was the unexpected, the peculiar, the obscured that she sought. Correspondingly, she felt there was a power of magic in the camera also in the processes of development, which contributed finally to the revelation of inner mysteries and psychological truths. Thus we view her recurring attention to masks, veils, and costumes; façades of individuals and buildings; and the deceptive character of identical twins, and matching raincoats or bathing suits.

She saw emptiness in cluttered rooms, and eloquent meaning in bare walls or naked flesh. Nudes, she noted, 'seem to wear more clothes than other people'.[29] During the

later sixties she photographed individuals at patriotic parades, in a period of enflamed but contradictory passions. Yet in faces such as *Boy with a straw hat waiting to march in a pro-war parade, N. Y. C.,* 1966 (Plate 289) there is an inner silence, naivety, even innocence. Dressed in clothing appropriate for a man much older, he too is in a costume of sorts. Perhaps it was inevitable that such recognitions would become unbearable for Arbus, for she took her life in 1971, and inevitable also in these years that the American vision should turn inward once again.

FORMALIST ART

By the late 1960s Pop art was no longer a recognizable movement. Some of its expon-
ents continued to work in their familiar styles, augmenting and intensifying aspects of
their work, while others sought to shift directions. Contrary to partisan critical asser-
tions, both realism and abstraction continued to flourish during the sixties and seventies,
each weighted with some of the central intellectual issues of the age.

Whether dealing with representational imagery or not, many artists following
abstract expressionism narrowed their investigations to discrete components of artistic
form: the nature of line, figuration, colour, pictorial surface or structure, materials, pro-
cesses and concepts for their own sake. Appropriate to such concentration on essentials
were the reductive terms given artistic expressions in this period – op, minimal, systemic,
primary.[1] To an extent these were continuing developments in the tradition of art
examining itself since the middle of the nineteenth century. But the marked withdrawal
into cerebration may also be seen in the context of an outer world drawing closer to
chaos, violence, and uncertainty. It cannot be an accident that in two periods of extreme
disequilibrium, the immediate aftermath of World War II and the years of America's
divisive involvement in the Viet Nam war, art turned to abstraction seeking possible
metaphors of order.[2]

Consequently, two older masters who had an obvious appeal for many younger
painters during the sixties were Ad Reinhardt and Josef Albers. Reinhardt derived his
severely geometric designs from Malevich and Mondrian, but worked within strict
restraints of symmetry and colour values so close as to be barely discernible. His large
canvases carried the meditative power of abstract expressionism's colour-field painting,
but now dealt more with the mechanics of seeing than conditions of feeling. Albers
(born in Germany in 1888) in turn brought from his Bauhaus training a tradition of
theoretical design, systematic order and execution, and purity of formal issues.

His creative investigations as teacher and artist culminated with *Homage to the Square*,
a series which he pursued from the 1950s onward. He used only three or four colours,
each defining one of the modular units that concentrically occupied his format. Part of
his visual effect of balance and tension derived from a planned set of ratios involved. For
example, in the variant subtitled *Apparition* (1959) (Plate 290) the units reading across are
1, 1, 1, 4, 1, 1, 1, and from the bottom up $\frac{1}{2}$, $\frac{1}{2}$, $\frac{1}{2}$, 4, $1\frac{1}{2}$, $1\frac{1}{2}$, $1\frac{1}{2}$.[3] This means that at
first glance the eye might not sense the subtle shift of colour relationships from the two
sides to the top, as readily as the more visible intensity of contrasts at the bottom. Most
importantly Albers was able to invest and maintain vitality in his design by his deliberate
device of symmetry in appearance but in fact only on the vertical axis. As he explained,
'This semi-concentric configuration avoids complete four-sided symmetry which
would result in static fixation.'[4]

Of equal, if not greater, interest to him was the charged ambiguity we read in surface flatness versus stepped movement forward and backwards into space. This is due, of course, to his choice of colours (here yellow at the centre, surrounded by two shades of blue and green), whose relationships with one another change in each area of the field. In words and work he reiterated: 'We do not see colors as they really are. In our perception they alter one another.'[5] In Albers' eye and hand seemingly mechanical and fixed laws became agents in creating elusive and mutable meditations on art.

That Albers' theories provided an important background for the development of systemic and optical art in the 1960s is evident in the work of Richard Anuskiewicz. Born in 1930 in Pennsylvania, he received his first artistic training at the Cleveland School of Art. There he responded to the prevailing styles of regionalism, with his own paintings of the late forties and early fifties closely resembling the moody street scenes of Burchfield and the painstakingly detailed still lifes of Ivan Albright. In the mid fifties he went to Yale, and under Albers' influence began methodical colour studies of optical versus pigment mixing of hues. By the early sixties he was using acrylic paints for their heightened intensities, and composing large simple geometric abstractions out of very limited colours, usually powerful complementaries and one related hue, such as red, green, and blue. In pre-calculated order his diverging, converging, or intersecting lines of colour appeared not only to force optical mixtures of additional hues, but also the perception of advancing or receding planes in different sections of the canvas. Such works deliberately strained the retina, often achieving shifts in visual effect the longer one looked, as well as powerful after-images when the eye turned elsewhere.

During the later sixties Anuskiewicz began a related series of works, reducing his means even further to just black and white. One of these was *Between* (1966) (Plate 291), which served as a modular unit that he repeated in a number of more complicated combinations. By this time he had refined his technique to one combining liquitex and thin strips of masking tape. First the ground was painted, in this instance white, and then the tape laid across it in the predetermined pattern. (If there was to be an additional colour, that section also would have been painted on beneath as part of the primary field.) On top of the grid of tape the final layer of paint, here black, is applied, and the tape subsequently peeled away. Thus the vivid optical pulsations emerge only in the final stage, when, as here, the eye perceives both an invented range of tonal values and the illusion of bending across the picture surface. Much as in a photograph we confront an interchange of positive and negative, both in the process and in the effect.

Anuskiewicz's work is related to an extensive field of systemic and optical art in this period. Pursuing an idea first evident in abstract expressionism – that the image was no longer a unit within pictorial space, but coextensive with it and capable of extension beyond its boundaries – both painters and sculptors engaged in repetition and thematic serialization, whether realist or abstract (compare Plates 279, 282, 291, and 294).[6] These ideas have also been extended into the area of advanced technology, as artists have taken advantage of contemporary electronics, from simple electric lighting to videotape and computer programming.[7] They have analogues in the developments of electronic music

and concrete poetry,[8] but ultimately they reflect the larger impulses towards standardization and codification in American life. Such developments also provided the logical precedents for the emergence of conceptual art during the late sixties, in which the preconceived idea assumed primacy over a work's fabrication or execution.

Within the turbulent currents of American art during the fifties and sixties Ellsworth Kelly defined a style related to his time, yet of distinctive individuality. His interest in reductive geometry is related to the minimalists, enlarged fragments of the environment to Pop, pure colour and form to systemic art. At the same time his rather different background and training conspired to give a personal character to his art (despite the suppression of an individual hand in his hard-edge forms, shared with numerous contemporaries), which is revealed most in his repeated return to sources in the observed world. Kelly was a close contemporary of the Pop artists; he was born in 1923, the same year as Lichtenstein, and was a friend of Robert Indiana on Coenties Slip in the later fifties.

Other salient details that contributed to his artistic sensibility were: growing up in New Jersey, often bird watching in the marshes as a youth; Army service from 1943 to 1945, first making posters for propaganda and working with a unit on camouflage, later being stationed in France; after the war two years in Boston studying at the Museum School and visiting local museums; finally, returning to Paris in 1948 for six years to study art and begin a career.[9] During this last period he began to move towards extreme simplification, and then abstraction, of observed architectural shapes or details, such as a window, stone revetment, handrail on a stairway, awning, or wall. An observant photographer himself, he concentrated on views of Paris bridges and the reflections of their arches in the water, as he later photographed barns on eastern Long Island. In such cases, the edges and silhouettes of geometric shapes, along with the contrasting areas of light and dark, chiefly appealed to his eye.

Thus from the time of his return to New York in 1954 his work explored the gentle tensions of shapes, whether in two contrasting colours, black and white, figure and field, curving and straight lines, or bending and flat planes. *Green White* of 1961 (Plate 292) incorporates some of these elements, with four points of its stretching central form just touching the framing edges. The figure both pushes against the frame and is held in by it. The bright green background and the organic shape can be related to Kelly's longheld admiration for Audubon's paintings, with their similar sense of flat pattern often set in deliberate counterpoint to the total format. As such, this calls to mind even more the distant ancestors of Audubon's watercolours, those by John White (compare Plates 3 and 144). Also related were Kelly's periodic pencil drawings of plant forms and leaves, here generalized and enlarged into an environment of both objective and allusive vitality.

In contrast to Albers, both Kelly and Frank Stella accorded precedence to shape over colour. The Massachusetts-born Stella was educated in the mid fifties at Princeton, where he met the painter Darby Bannard and the future critic Michael Fried, and studied under the art historian William Seitz. Through his college associations and visits to New York galleries Stella's formative stimulations came from abstract expressionism: 'What I saw, what I liked, was the openness of the gesture, the directness of the attack.'[10] He had also

seen Jasper Johns' just completed flag and target paintings, and, moving into New York to work, he now gradually weaned himself from the influence of action painting. While he retained its large scale and all-over character, he began to replace the accidental with the predetermined and the personal with the matter-of-fact.

He undertook a series of generally monochromatic canvases filled with parallel stripes and occasionally a central rectangular form. Increasingly, his unitary configurations covered the pictorial field more uniformly, and the evenly repeated bands became more integrally related to the supporting frame.[11] Around 1960 he began to notch the edges of his canvases or cut out small central rectangles. The notching became larger in the next series, until the removed areas were in balance with the painted surface, and the painting appeared to be either a frame or a large portion of the structural support itself. His still-geometric contours combined equally indentations and projections.

During the mid sixties Stella's work underwent several logical changes. He started to develop irregular geometric formats, counterpointing symmetry with asymmetry; he made surface design partially independent of framing support; and, now using epoxy and fluorescent paints, he effected combinations of bright colour. His 'protractor' series of the late sixties and early seventies was the culmination of these changes. *Agbatana III* (Plate 293) was one of an elaborately worked out group of thematic variations, suggested by interlocking protractor arcs and titled with the names of cities in Asia Minor.[12] While not literal references, the scale, size (often ten by twenty feet), and design of these works did allude to the architectural character of these cities' circular plans, as well as to the arches and decoration of Islamic monuments. But Stella's paintings also approach the status of shaped objects, and as such define further correlations among the forms of modern art.

Tony Smith brought to his sculpture a similar reductive geometry and monumental scale, although (in contrast to Stella) with a sense of the organic and unexpected. Born in 1912 in New Jersey, he attended the Art Students League in New York and the re-founded Bauhaus in Chicago during the thirties. For two years he worked on several projects designed by Frank Lloyd Wright, and he continued to practise architecture during the forties and fifties. Long pursuing painting and sculpture for himself as well, he turned full time to a career in sculpture around 1960. Not surprisingly, his forms had the compactness of architectural models and bore witness to the lessons of engineering. But rather than being impersonal and mechanized abstractions, they suggest the organic growth and structure of a molecular system.

Thus *Gracehoper* (1961) (Plate 294) seems to stretch its limbs across the floor, possessing the symmetries and individualities of some figural presence. Its playful title, too, intimates both an insect as well as abstract charms. Smith's use of primary forms has placed him in some minds with other minimalist sculptors such as Ronald Bladen, Donald Judd, and Larry Bell. But through his inventive extensions and interlockings of polyhedral modules, his pieces acquire (where the others reject) human associations. As with the work of his friend Barnett Newman (compare Plate 256) we confront, in these modern dolmens and megaliths, man – heroic and sublime.[13]

Contrasting with these variously mathematical and constructivist approaches to pure

form were the advances in colour-stain painting by Morris Louis and Jules Olitski. Louis was born in Baltimore in 1912; he held various jobs and did some painting during the Depression years, including work for the W.P.A. in New York during the late thirties. He then moved back to Baltimore, and in the early fifties settled in Washington, D.C. Shortly after, he met Kenneth Noland, and in 1953 the two painters visited the critic Clement Greenberg in New York. Greenberg took them to see Helen Frankenthaler in her studio, where both were strongly impressed with her first stained canvases in which paint had been poured and rubbed directly into the weave (see Plate 260).

Louis's own work by this date was close to the actively gestural manner of abstract expressionism, especially the precedents of Pollock and de Kooning. Both he and Noland returned to Washington to pursue the implications of their encounter with Frankenthaler's work, and over the next few years each worked on related sequences of paintings, staining in the pigments in different formats and degrees of improvisation.[14] Using thinned acrylics in bright colours, and unprimed, unsized canvases which he partially stapled to a scaffold, Louis poured the paints on one edge and lifted the canvas to direct the rivulets of colour across its surface. The results were variously called Veils, Florals, Unfurleds, or Stripes – sensuous translucencies and screens of colour lying actually in (rather than on) the texture of the material. First implied by Pollock, now decisively stated, figuration and colour existed as one.

In *Theta* (Plate 295), completed two years before Louis's death from lung cancer in 1962, we see the results of two balanced rows of colour (though one of high-keyed values, the other darker) poured separately across adjacent corners of the field. However, unlike most of his preceding series, the starting and terminal areas of these fluid columns are cropped at the edges, thus enhancing the mystery of their origin and substantiality. Following Barnett Newman's lines or 'zips' across his colour fields, these too are marks in a void, the artist's declaration of life, like Arctic flowers blooming in a snowy tundra.

Ten years younger, the Russian-born Olitski was brought to New York at the age of one. He enrolled in art classes, visited local museums, and worked in relatively traditional styles during the 1940s. At the end of the decade he went to Paris for two years, and gradually his work moved towards abstraction. During the fifties his paintings were gestural fields of heavily layered pigment, often with spackle and resin added. About 1960 he felt the crucial impact of Frankenthaler's example and the influence of Louis's and Noland's work. For the next few years he used sponges and rollers to stain quasi-geometric or organic forms into his canvases. By the mid sixties he had reduced these generally circular motifs to small marks hovering near the framing edges.[15]

About this time he also shifted to a technique of spraying his colours, either directly on the surface or just above it so that the fine mist of particles settled down like a diaphanous veil, as in *High A Yellow* of 1967 (Plate 296). Yellow, shifting slightly in literal as well as visual saturation throughout, occupies most of the surface, with only a pale tinge of a pink vapour fused in at the lower left, and traditional gestures of brushwork reinforcing the upper and right edges. The colour field appears to be purely optical, with the insubstantiality of tinted steam, existing in provocative counterpoint to the physical support beneath and around it. While acknowledging the formal achieve-

ments of both Louis and Olitski, not least as masters of such radiant atmospheres, we may also view their beautiful inner landscapes as romantic reveries in the tradition of earlier American luminism and tonalism (see Plates 106 and 206).

In a comparable way Eva Hesse sought a sculpture of personal feeling, one that challenged the traditional limits of form, while working forward from some of the premises of abstract expressionism. Born in Nazi Germany in 1936, she came to New York three years later, and was educated under Albers at Yale in the late fifties. Then she spent a few years in Germany before returning to New York in 1965, a point that marked the beginning of her mature work. In it were embodied the frustrations and sufferings of her personal life: the separation of her parents, her mother's death when Eva was a child and her father's remarriage, his death in 1966, and in the same period the break with her own husband.[16] From circular tubes or breast-shaped forms extruded long strings or rubber piping with veiled sexual associations. Consciously she avoided the lack (to her) of mystery in Marisol and the cerebral geometries of the minimalists, preferring instead the rough improvisations of Pollock.

'Chaos can be as structured as non-chaos. That we know from Jackson Pollock,'[17] she claimed, and favouring as her materials papier-mâché, plastic, latex, and fibreglass, she constructed wall reliefs and free-hanging environmental works. In the later sixties and 1970 (the year of her death from a brain tumour) her imagery evolved more into suggestions of vascular systems and intravenous tubing associated with her final illness. Of course, her pieces were never so literal or parochial; nor were they really 'anti-form', as some proposed, but unfamiliar form. *Right After* of 1969 (Plate 297), a reference to returning to work following an operation, is a hanging fibreglass network which crisscrosses an all-over field in three dimensions. As a clotted jungle it was 'much closer to soul or introspection or inner feelings'.[18] In concept and substance it extended the freeforms of Richard Lippold and Sam Gilliam (Plates 266 and 269), and brought sculptural expression close to process art of the 1970s.

Indeed, as American art moved through the decade of the country's Bicentennial, conceptual and process art emerged as one of the principal coherent movements of the period. The primary forms of expression were in two related arenas, the environment (earth works) and the human being (body art); one was an extension of minimalist sculpture onto a terrestrial scale, the other of autobiographical gestures in art from abstract expressionism on. At the heart of both was the insistence that the artistic statement exists less in the finished result than in the initial act of imagination. One of the most active figures, Douglas Huebler, commented on the key issues:

The world is full of objects, more or less interesting; I do not wish to add any more. I prefer, simply, to state the existence of things in terms of time and/or place.[19]

These attitudes arose partly in resistance to the treatment of art as a commodity to be bought, sold, or stored in museums. Thus a number of works existed only on paper as diagrams or explanations in print. Others, if executed as performances and actions, were no longer extant after the gesture, unless recorded in film or photographs. Still others were merely proposals of ideas or definitions of situations. Most of the artists were close

in age, born around 1940, as well as approach. Among the more notable body artists were Vito Acconci, Chris Burden, Barry Le Va, and Bruce Nauman, who concentrated on physical activities to or by themselves. Nauman in particular had a background in the California variations of Pop art, and had experimented widely in the minimalist aesthetic with different new media, including fibreglass, video, and neon lighting. From both emerged his taste for conceptual, visual, and verbal punning. His *Self Portrait as a Fountain* (Plate 298) was one of several works devoted to questions of his artistic and physical identity.[20] This acknowledges debts to Duchamp and Johns, in both comic parody and serious reinterrogation of the artist defining art.

Other artists, such as Michael Heizer, Eleanor Antin, Edward Ruscha, and Dennis Oppenheim, executed actions or designs in the landscape, calling attention to themselves and a specific environment, along with the process of interaction between the two. Fundamentally, body art reflects some aspiration for renewed humanity in a techno-logical world, while earth art has spoken to the still existing beauty in an increasingly ravaged landscape. It is hardly accidental that such expressions should arise at about the same time that America (and other industrially advanced nations) first felt the decisive pressures of pollution, overpopulation, and the consequent prospect of limited resources. In addition, America's ideas of growth and expansion, so long associated with its geography, now met with the first serious limitations of military, economic, and poli-tical power. Conceptual art in part represented the withdrawal of artists from the physical world of conspicuous consumption to the inner commerce of thought.

Earthworks in their concreteness are not considered by some as pure conceptual art, yet usually this art involves impermanent gestures, albeit in vast new terrains. The Bulgarian-born Christo and Robert Smithson produced some of the most ambitious and grand examples of the movement. Christo had studied art in Sofia and then in Paris during the fifties. With surrealist overtones he began wrapping forms and objects in packages, dealing with ideas of concealment and revelation, much like his contem-poraries Nevelson and Segal. He covered sometimes in cloth, sometimes in plastic, other containers (bottles, cans, boxes) or paradoxically cut-off instruments of communica-tion: a camera, television set, magazine, traffic light, or telephone. Later he cut off views through streets with stockpiled oil drums, or through façades by first proposing to cover and then actually wrapping entire buildings.

Christo moved to New York in 1964. By the end of the decade he had wrapped the Museum of Contemporary Art in Chicago and a one-mile stretch of the Australian coast near Sydney.[21] All these projects, one must keep in mind, were less to hide than to allow a fresh perception of form and space. During 1971 he planned, and the following year carried out, the hanging of his *Valley Curtain* (Plate 299), an enormous synthetic canvas some thirteen hundred feet wide, on steel cables stretching across Rifle Gap, Colorado. After many months of legal negotiations and engineering logistics, the bril-liant orange curtain finally went up against a vivid blue sky. Before billowing and rip-ping in subsequent gusts of wind,[22] it for a time cut the space of the valley in two, drawing the eye to itself and the surrounding frame of landscape, as if an artist's canvas now truly on nature's scale (compare Plates 109 and 269).

Robert Smithson, by contrast, did leave most of his earthworks intact, but he preferred sites that were desolate or inaccessible. A native of New Jersey, he attended the Art Students League; by the mid sixties he was engaged in conceptual work. Yet his years in New York made him conscious of Frederick Law Olmsted's monumental achievement with his landscape of Central Park. Similarly, Smithson saw the possibility of discovering new power, creating new beauty, in the rubble of raw earth and stone. During the later sixties and early seventies he designed landscape ramps and hillside displacements: 'glacial reveries', he called them. He also talked of returning to 'the origin of materials' and of his sites showing 'the effect of time'.[23]

A work of powerful eloquence, Smithson's *Spiral Jetty* of 1970 (Plate 300) is just such a meditation on geological time and history. About fifteen hundred feet long, it projects into the Great Salt Lake in Utah, like an elevated roadbed of compacted rocks. Smithson had in mind the geometric earth mounds of prehistoric Indian burial sites in Ohio and elsewhere, but his organic form also embodied nature's own configurations. In this respect the grandeur he revealed in the American landscape makes a striking and not inappropriate comparison with Thomas Cole's *Oxbow* (Plate 93) of 1836. (Coincidentally, both artists also died young, Smithson in a plane crash in 1973.)[24] But *Spiral Jetty* is a form of large-scale drawing as well, and what Smithson termed an 'earth map' takes us back, full spiral, to the very beginnings of American art, when the New World itself (see Plate 1) was an image awaiting materialization as fact.

NOTES TO PART ONE

CHAPTER 1

p. 3 1. See Howard Mumford Jones, *O Strange New World, American Culture: The Formative Years* (New York, 1964), 4.

p. 4 2. See Roger B. Stein, 'Seascape and the American Imagination: the Puritan Seventeenth Century', *Early American Literature*, VII, 1 (Spring 1972), 17–37.

3. *Ibid.*, 22–3.

4. Stefan Lorant, ed., *The New World, The First Pictures of America* (rev. ed., New York, 1965), 88.

5. Quoted in Stein, *op. cit.*, 22.

6. Alexander C. Fraser, ed., *The Works of George Berkeley, D.D.* (4 vols., Oxford, 1901), IV, 364–5. Quoted in Patricia Hills, *The American Frontier, Images and Myths* (exhibition catalogue, Whitney Museum of American Art, New York, 1973), 5.

p. 5 7. A compact and informative summary of this subject may be found in the writings of Samuel Eliot Morison, dean of American historians, especially his *Oxford History of the American People* (New York, 1965), 18–20, 39–46. The comprehensive account is his *European Discovery of America, The Northern Voyages, A.D. 500–1600* (New York, 1971), especially chapters XIX and XX.

8. This topic receives its most eloquent and perceptive treatment in William Pierson's *American Buildings and their Architects, The Colonial and Neo-Classical Styles* (Garden City, N. Y., 1970), chapter V. See also Morison, *Oxford History, op. cit.*, 23–8, 34–9.

9. Lorant, *op. cit.*, 7. See also Morison, *Oxford History*, 41.

10. Lorant, 7.

11. *Ibid.*, 36.

12. *Ibid.*, 30.

p. 6 13. *Ibid.*, 38.

p. 7 14. Foreword to De Bry's *Icones quinquaginta virorum illustrium* (Frankfurt, 1597); quoted in Lorant, 30–1.

15. See Lorant, 31; and Morison, *The European Discovery, op. cit.*, 560–1.

p. 8 16. Paul Hulton, introduction to the Dover edition of Thomas Hariot, *A Briefe and True Report of the New Found Land of Virginia* (New York, 1972), ix; also see Lorant, *op. cit.*, 180.

17. Hulton, introduction to Hariot, *op. cit.*, xii.

18. Lorant, *op. cit.*, 225; Hulton, viii–ix; and p. 9 Muriel Rukeyser, *The Traces of Thomas Hariot* (New York, 1971), 3–5.

19. Lorant, 234; and Hariot, *op. cit.*, 6. See also Morison, *The European Discovery, op. cit.*, 666–9.

20. Lorant, 246.

21. *Ibid.*, 276; and Morison, *The European Discovery, op. cit.*, 669.

22. Morison, *The European Discovery*, 654.

23. Rukeyser, *op. cit.*, 219–24. p. 10

24. Neil Armstrong, Michael Collins, Edwin E. Aldrin, Jr, *First on the Moon* (Boston, 1970), 325, 323.

25. See Norman Mailer, *Of a Fire on the Moon* (Signet edition, New York, 1970), 17.

26. *Ibid.*, chapter 5.

CHAPTER 2

1. See Daniel M. Mendelowitz, *A History of* p. 11 *American Art* (2nd ed., New York, 1970), 3–4.

2. See the maps in Mendelowitz, 4; and in Norman Feder, *American Indian Art* (New York, 1971), 20.

3. See Mendelowitz, part one; also Norman Feder, *Two Hundred Years of North American Indian Art* (New York, 1971); and Frederick J. Dockstader, *Indian Art in America* (Greenwich, Conn., 1961).

4. See Allan I. Ludwig, *Graven Images, New* p. 12 *England Stone-carving and its Symbols, 1650–1815* (Middletown, Conn., 1966), 428. This is pre-eminently the most thorough and comprehensively illustrated discussion of the subject.

5. *Ibid.*, 283–5, 237, and 358.

6. See Alexander Brown, *The Genesis of the United States* (Boston, 1890), 53; quoted in Perry Miller, *Errand into the Wilderness* (Harper Torchback ed., New York, 1964), 101; see also *ibid.*, 100 and 11.

7. For a complete survey of this imagery and its meanings see Ludwig, *op. cit.*, chapter II:ii, 'The Repertory of Symbols'.

239

p. 13 8. *Ibid.*, plates 14, 15, 55, 151; and see Mendelo-witz, *op. cit.*, 124–5.

9. See Ludwig, *op. cit.*, 287–96.

10. *Ibid.*, 276.

11. Ludwig's book is a model of thoroughness in analysing convincingly the American gravestone forms and their English sources; see especially his chapter III, 'Sources and Definitions of the Major New England Styles'. The pioneering research in the area of painting is Waldron Phoenix Belknap, Jr's *American Colonial Painting, Materials for a History* (Cambridge, Mass., 1959), especially part VI, 'The Discovery of the English Mezzotint as Prototype of American Colonial Portraiture'. In architecture William H. Pierson, Jr's *American Buildings and Their Architects, The Colonial and Neo-Classical Styles* (Garden City, N.Y., 1970) demonstrates parallel relationships; see especially part I, 'Colonial America'.

p. 14 12. Quoted in John Warner Barber, *Massachusetts Historical Collections* (Worcester, Mass., 1839), 100; and in Ludwig, *op. cit.*, 139.

13. Sinclair H. Hitchings, 'Graphic Arts in Colonial New England', in John D. Morse, ed., *Prints in and of America to 1850* (Winterthur Conference Report, 1970, Charlottesville, Va., 1970), 78.

14. Richard B. Holman, 'Seventeenth-Century American Prints', in Morse, ed., *Prints in America, op. cit.*, 45–8.

15. See *ibid.*, 25; and *American Printmaking, The First 150 Years* (exhibition catalogue, The Museum of Graphic Art, New York and Washington, D.C., 1969), 16.

16. See Holman, *op. cit.*, 26 ff.

p. 15 17. *Ibid.*, 39; and *American Printmaking, op. cit.*, 16.

18. See Holman, *op. cit.*, 43.

19. See Abbott Lowell Cummings, 'Decorative Painting in Early New England', in Ian M. G. Quimby, ed., *American Painting to 1776, A Reappraisal* (Winterthur Conference Report, 1971, Charlottesville, Va., 1971), 90–101.

20. See R. Peter Mooz, 'Colonial Art', in John Wilmerding, ed., *The Genius of American Painting* (London and New York, 1973), 27.

21. See Richard E. Ahlborn, 'American Beginnings: Prints in Sixteenth-Century Mexico', in Morse, ed., *Prints in America, op. cit.*, 1–22; A. Hyatt Mayor, preface to *American Printmaking, op.*

cit., 7; and Jules D. Prown, *American Painting, From its Beginnings to the Armory Show* (Cleveland, Ohio, 1970), 18.

22. See for example, Prown, *op. cit.*, 18, who cites the more conservative figure; and John McCoubrey, 'Painting', in *The Arts in America: The Colonial Period* (New York, 1966), 154, who takes a more generous standpoint.

23. Mooz, *op. cit.*, 28; and Samuel M. Green, 'English Origins of New England Painting', in Quimby, ed., *American Painting, op. cit.*, 15–69.

24. Neil Harris, among recent scholars, has given p. 16 the most balanced and complete explanation of these factors in his 'Keynote Remarks', in Quimby, ed., *American Painting, op. cit.*, 10–13; and in his *Artist in American Society* (New York, 1966), chapter 1, 'To the Aid of Necessity'.

25. On these topics see John W. Reps, *Town Planning in Frontier America* (Princeton, N.J., 1969); and William H. Pierson, Jr, *op. cit.* (Note 11), especially chapter II, 'The Atlantic Seaboard in the Seventeenth Century'.

26. See Abbott Lowell Cummings, 'Decorative Painting in Early New England', in Quimby, ed., *American Painting, op. cit.*, 88–9; and Mooz, *op. cit.*, 28.

27. A more conservative argument holds that the evidence of a link between Clark and Clement is too tenuous, and that it is strange for the painter to have resumed portraiture so many years after his youthful work. Still, it must be acknowledged that the picture is sufficiently sophisticated to have been done by a studio-trained artist. See *American Art at Harvard* (exhibition catalogue, Fogg Art Museum, Harvard University, Cambridge, Mass., 1972), no. 1; also the discussion in *XVIIth Century Painting in New England* (exhibition catalogue, Worcester Art Museum, Worcester, Mass., 1934), 51–3. Under the guidance of Louisa Dresser, this is the pioneering research effort in modern scholarship on the subject.

28. Louisa Dresser, 'Studies in the Portraiture of p. 17 New England, Mrs Freake and Baby Mary to Mrs Perez Morton', *Apollo*, XCIV:118 (December, 1971), 473; see also *XVIIth Century Painting, op. cit.*, 81–3.

29. See Louisa Dresser, *op. cit.*, 474; and also p. 18 Mooz, *op. cit.*, 30.

30. Quoted in Perry Miller, ed., *The American Puritans, Their Prose and Poetry* (Doubleday Anchor ed., Garden City, N.Y., 1956), 271.

31. See Perry Miller, *Errand into the Wilderness* (Harper Torchback ed., New York, 1964), 9–10.

p. 19 32. *XVIIth Century Painting, op. cit.,* 103.

33. Mooz, *op. cit.,* 30.

34. Quoted in *XVIIth Century Painting, op. cit.,* 135; and in *American Art at Harvard, op. cit.,* introduction.

p. 20 35. See Louisa Dresser, *op. cit.,* 474; and *XVIIth Century Painting, op. cit.,* 135.

36. See *XVIIth Century Painting,* 141; and *American Art at Harvard, op. cit.,* no. 2.

CHAPTER 3

p. 21 1. See Abbott Lowell Cummings, 'Decorative Painting', in Ian M. G. Quimby, ed., *American Painting to 1776, A Reappraisal* (Winterthur Conference Report, 1971, Charlottesville, Va., 1971), 102–3; and John McCoubrey, 'Painting', in *The Arts in America: The Colonial Period* (New York, 1966), 160–2.

2. Waldron Phoenix Belknap, Jr, *American Colonial Painting, Materials for a History* (Cambridge, Mass., 1959), 63–4, 67 (for Evert Duyckinck); 107–11 (for Gerrit); 118–19 (for Gerardus I); and 119–23 (for Gerardus II). See also Daniel M. Mendelowitz, *A History of American Art* (2nd ed., New York, 1970), 110; and Wayne Craven, 'Painting in New York City', in Quimby, ed., *American Painting, op. cit.,* 254–5.

3. See R. Peter Mooz, 'Colonial Art', in John Wilmerding, ed., *The Genius of American Painting* (London and New York, 1973), 37–8; and Jules D. Prown, *American Painting, From its Beginnings to the Armory Show* (Cleveland, Ohio, 1970), 21.

p. 22 4. Other related prints by Smith after Kneller are *William, Duke of Gloucester,* 1691; *Lord Bury, c.* 1704; and *James, Earl of Salisbury,* 1696. See Belknap, *op. cit.,* plates XXXVII, XXXIX, and XLI.

5. Mary C. Black presents the most cogent case for the all-inclusive attribution in her 'Pieter Vanderlyn and Other Limners of the Upper Hudson', in Quimby, ed., *American Painting, op. cit.,* 217–49. With some modifications R. Peter Mooz shares this view in his 'Colonial Art', *op. cit.,* 41–2. Miss Black cites James Thomas Flexner as also in accord, but S. Lane Faison, John Davis Hatch, Agnes Halsey Jones, Eleanor S. Quandt, and the late Russell J. Quandt as holding the viewpoint that several individuals working in related styles were

responsible for the group; see Black, *op. cit.,* 247. In part, the Quandts based their judgements on technical more than stylistic evidence, an area of information which promises to amplify research on this subject.

6. A later date of 1723 has also been proposed for this, for it was in that year that the sitter married David Ver Planck, and the rose she holds could have symbolized that occasion. See Katherine Kuh, *Art in New York State, The River: Places and People* (exhibition catalogue, New York World's Fair, 1964, The Buffalo Fine Arts Academy, Buffalo, N.Y., 1964), no. 1. However, Mary Black argues that this is an early work, if by the *Aetatis Suae* Limner, done before his departure for Newport and Virginia. The artist was not back in Albany again until 1724. See her 'Limners of the Upper Hudson', *op. cit.,* 223–6.

7. *Ibid.,* 226.

8. *Ibid.,* 234–41. p. 23

9. John Wesley Jarvis' portrait of the same Pierre Van Cortlandt in 1810 (when the sitter was close to ninety-three years old) is in the Sleep Hollow Restorations, Tarrytown, N.Y., and makes an interesting contrast in both age of subject and style of painting.

10. Dr Alexander Hamilton, *Gentleman's Progress* p. 25 (Carl Bridenbaugh, ed., Chapel Hill, N.C., 1948), 72. See also Mooz, *op. cit.,* 43–4.

11. See Christian Brinton, *Gustavus Hesselius* (Philadelphia, 1938), 10; Mooz, *op. cit.,* 39; and Roland E. Fleischer, 'Gustavus Hesselius', in Quimby, ed., *American Painting, op. cit.,* 127.

12. Penn Accounts, Liber 1, fol. 57, The Historical Society of Pennsylvania, Philadelphia. See also R. E. Fleischer's observant stylistic analysis in his 'Gustavus Hesselius', *op. cit.,* 127–33.

13. See *American Printmaking, The First 150 Years* p. 27 (exhibition catalogue, Museum of Graphic Art, New York and Washington, D.C., 1969), 20–1; Mooz, *op. cit.,* 44–5; and Jules D. Prown, *John Singleton Copley* (2 vols., Cambridge, Mass., 1966), I, 9–10.

CHAPTER 4

1. *The Notebook of John Smibert* (Boston, Mass., p. 28 1969), 76. For biographical information see also *ibid.,* 2–3, 73–5; and Stephen T. Riley, 'John Smibert', in Ian M. G. Quimby, ed., *American Painting*

to 1776, *A Reappraisal* (Winterthur Conference Report, 1971, Charlottesville, Va., 1971), 160–1.

p. 28 2. *Ibid.*, 78–86.

3. George Vertue, *Vertue Note Books* (6 vols., Walpole Society, London, 1930–47), III, 30.

4. *Ibid.*, III, 161; and John Kerslake, 'The Significance of the Notebook', in *The Notebook of Smibert, op. cit.*, 15.

5. Sir David Evans, 'The Provenance of the Notebook', in *The Notebook of Smibert, op. cit.*, 3.

6. Quoted in John McCoubrey, 'Painting', in *The Arts in America, The Colonial Period* (New York, 1966), 168.

p. 29 7. *Notebook of Smibert, op. cit.*, 85. See S. T. Riley, 'John Smibert', *op. cit.*, 164, who argues that the painting was begun in 1728 and finished in Boston in 1730. R. Peter Mooz, in 'Colonial Art', in John Wilmerding, ed., *The Genius of American Painting* (London and New York, 1973), 49, gives more complex, but not conclusive, reasons for suggesting that it was not completed until 1739. See also the commentary of Andrew Oliver, 'Notes relating to Smibert's American Portraits', in *The Notebook of Smibert, op. cit.*, 107–8.

8. *Notebook of Smibert*, 89.

9. Oliver reads the date as 1729 and Mooz as 1739.

10. This figure has also been identified as Dr Thomas Moffat, Smibert's nephew, who stayed on in Newport to practise medicine after the artist had gone on to Boston.

11. Quoted in McCoubrey, *op. cit.*, 169.

p. 30 12. Quoted in John McCoubrey, *American Art, 1700–1960, Sources and Documents* (Englewood Cliffs, N.J., 1965), 7.

13. *Ibid.*

14. Quoted in Riley, *op. cit.*, 175.

p. 31 15. *Ibid.*

16. *Ibid.*, 177.

17. See Henry Wilder Foote, *Robert Feke* (Cambridge, Mass., 1930); Waldron Phoenix Belknap, Jr, *American Colonial Painting, Materials for a History* (Cambridge, Mass., 1959), part I; R. Peter Mooz, 'Robert Feke: The Philadelphia Story', in Quimby, ed., *American Painting, op. cit.*, 181–216; and Mooz, 'Colonial Art', *op. cit.*, 51–60. Mooz gives the most interesting and convincing argument for pinning down Feke's dates this precisely.

18. Belknap, 'The Identity of Robert Feke', in *op. cit.*, 10–13.

19. See R. Peter Mooz's discussion of the specific p. 32 mezzotint prototypes in his 'Colonial Art', *op. cit.*, 57, and his 'Robert Feke', *op. cit.*, 195–6.

20. Margaret Simons Middleton, *Jeremiah Theus,* p. 33 *Colonial Artist of Charles Town* (Columbia, S.C., 1953), 33.

21. Biographical details are given in Wayne p. 34 Craven, 'Painting in New York City', in Quimby, ed., *American Painting, op. cit.*, 256–65; and Mooz, 'Colonial Art', *op. cit.*, 63.

22. See Lawrence Park, *Joseph Badger (1708–1765), and a Descriptive List of Some of His Works* (Proceedings of the Massachusetts Historical Society, LI, December 1917), 158–201.

23. See Hermann Warner Williams, Jr, *Mirror* p. 35 *to the American Past, A Survey of American Genre Painting: 1750–1900* (New York, 1973), 24; Alan Burroughs, *John Greenwood in America, 1745–1752* (Andover, Mass., 1943), 47; and Alfred Frankenstein and the Editors of Time-Life Books, *The World of Copley, 1738–1815* (New York, 1970), 19.

24. Jules D. Prown documents this most thoroughly in his monograph, *John Singleton Copley* (2 vols., Cambridge, Mass., 1966), I, 22–7.

CHAPTER 5

1. See Jules D. Prown, *John Singleton Copley* p. 36 (2 vols., Cambridge, Mass., 1966), I, 9–27.

2. Guernsey Jones, ed., *Letters and Papers of John* p. 38 *Singleton Copley and Henry Pelham* (Massachusetts Historical Society Collections, LXXXI) (Boston, 1914), 41–2.

3. *Ibid.*

4. *Ibid.*, 44.

5. *Ibid.*, 42.

6. See John McCoubrey, *American Tradition in Painting* (New York, 1963); and Barbara Novak, *American Painting of the Nineteenth Century* (New York, 1969), chapter 1.

7. See William H. Pierson, Jr, *American Build-* p. 39 *ings and Their Architects, The Colonial and Neoclassical Styles* (New York, 1970), 125–30.

8. *Letters of Copley and Pelham, op. cit.*, 81–2. See also discussion in Prown, *op. cit.*, 77–8.

9. There are three versions: the first in the p. 40 National Gallery of Art, Washington, D.C., commissioned by Watson; the second a copy Copley kept for himself, now in the Museum of Fine Arts, Boston; and the third a smaller vertical version

made in 1782, now in the Detroit Institute of Arts. See Prown's discussion in *op. cit.*, II, 268–74.

10. For the figure of Watson he also made use of *The Gladiator*, a classical sculpture in the Villa Borghese, Rome. See Prown, II, 273.

p. 41 11. Biographical details in Clarence S. Brigham, *Paul Revere's Engravings* (2nd rev. ed., New York, 1965), 4–5.

12. See *ibid.*, 52–78, for details of the whole ironic controversy.

13. Quoted in David H. Dickason, *William Williams, Novelist and Painter of Colonial America* (Bloomington, Ind., and London, 1970), 27. For biographical details see Richard Hirsch, *The World of Benjamin West* (exhibition catalogue, Allentown Art Museum, Allentown, Pa., 1962), 9–47; Grose Evans, *Benjamin West and the Taste of his Times* (Carbondale, Ill., 1959); and Prown, *op. cit.*, II,

268–70. The earliest biography, embellished and somewhat unreliable, is John Galt, *The Life and Studies of Benjamin West, Esq.* (2 vols., Philadelphia, 1816).

14. See Prown, *op. cit.*, 269–70. For West's views p. 42 on art see Galt, *op. cit.*, II, 83–176.

15. Letter to Charles Willson Peale, 1809, quoted in William Dunlap, *History of the Rise and Progress of the Arts of Design in the United States* (2 vols., New York, 1834), I, 84–5.

16. *Ibid.*, 63. p. 43

17. For a summary of West's use of the Sublime and the iconography of *Death on the Pale Horse*, see Evans, *op. cit.*, 60–4. For a contemporary analysis of the picture see William Carey, *Critical Description and Analytic Review of Death Upon the Pale Horse, Painted by Benjamin West, P.R.A.* (8 vols., London, 1817; 2nd ed., Philadelphia, 1836).

NOTES TO PART TWO

CHAPTER 6

p. 47　1. See Richard Hirsch, *The World of Benjamin West* (exhibition catalogue, Allentown Art Museum, Allentown, Pa., 1962), 34, 37–8; and Jules D. Prown, *American Painting from its Beginnings to the Armory Show* (Cleveland, Ohio, 1970), 38.

2. Prown suggests this figure may be Pratt, although the age difference between Pratt and West more convincingly points to the alternative identification. In addition, the figure on the left in *The American School* bears a striking resemblance to another portrait Pratt did at this time of West, now in the Pennsylvania Academy of the Fine Arts.

3. William Dunlap, *History of the Rise and Progress of the Arts of Design in the United States* (2 vols., New York, 1834), I, 351.

p. 48　4. *Ibid.*, 357–8.

5. See Theodore Sizer, *The Works of Colonel John Trumbull, Artist of the American Revolution* (rev. ed., New Haven, Conn., and London, 1967), 7–8, and figure 145.

p. 49　6. Quoted in Dunlap, *op. cit.*, I, 384–7.

7. The most complete biography of Stuart is Charles Merrill Mount's *Gilbert Stuart, A Biography* (New York, 1964); summary details also in E. P. Richardson, *Gilbert Stuart, Portraitist of the Young Republic* (exhibition catalogue, Museum of Art, Rhode Island School of Design, Providence, 1967).

8. Dunlap, *op. cit.*, I, 167.

9. Quoted in Richardson, *op. cit.*, 14.

p. 50　10. Dunlap, *op. cit.*, I, 162.

11. C. M. Mount believes the original done from life is the one now in the National Gallery of Art, Washington, D.C., Mellon Collection; he lists over a dozen more replicas in other public and private collections in his *Gilbert Stuart, op. cit.*, 378.

p. 51　12. See Dunlap, *op. cit.*, I, 162.

13. *Ibid.*, 185.

14. *Ibid.*, 217.

15. For discussion of the portrait and its background see Mount, *op. cit.*, 242 ff. and 275 ff.

p. 52　16. *Ibid.*, 247.

17. See Laurence B. Goodrich, *Ralph Earl, Recorder for an Era* (Yellow Springs, Ohio, 1967), 2–3.

18. *Ibid.*, 78.

19. See Mary Black and Jean Lipman, *American Folk Painting* (New York, 1966), 19–23.　p. 53

20. *Ibid.*, 19.

21. See Elsa Honig Fine, *The Afro-American Artist, A Search for Identity* (New York, 1973), 26–9.

CHAPTER 7

1. For a more detailed discussion of this see Wayne Craven, *Sculpture in America* (New York, 1968), 12–14.　p. 54

2. *Ibid.*, 22.

3. See Harold Kirker, *The Architecture of Charles Bulfinch* (Cambridge, Mass., 1969), 78–85.　p. 55

4. John K. Howat, *et al.*, *19th-Century America, Paintings and Sculpture* (New York, 1970), nos. 26 and 27.

5. Quoted in Charles Coleman Sellers, *Charles Willson Peale* (New York, 1969), 122.

6. *Ibid.*, 29.

7. *Ibid.*, 212. See also pp. 191, 204, 236, and 256.　p. 56

8. Quoted in Howat, *et al.*, *op. cit.*, no. 11.　p. 57

9. See Sellers, *op. cit.*, 388, plate XI; and Charles H. Elam, *The Peale Family, Three Generations of American Artists* (exhibition catalogue, Detroit Institute of Arts, Detroit, 1967), 70.

10. Quoted in Sellers, *op. cit.*, 402.

11. See Elam, *op. cit.*, 132–3; and Sellers, *op. cit.*, 334 and 340.　p. 58

12. Quoted in Sellers, *op. cit.*, 403. See also plate XII.

13. See Elam, *op. cit.*, 43, 125, 129.

14. See William H. Gerdts and Russell Burke, *American Still-Life Painting* (New York, 1971), 30–1. One final twist on this point is the fact that Peale painted his picture over a replica of C. W. Peale's *Portrait of Raphaelle* of 1817, thus compounding further the identity and reality of images (*ibid.*, 238).　p. 59

15. *Ibid.*, 31.

16. See Gerdts and Burke, *op. cit.*, 52.　p. 60

CHAPTER 8

p. 61 1. A somewhat parallel situation exists with Ingres, Géricault, and Delacroix, who grew up in post-Revolutionary France. Their art accordingly became increasingly romantic and historicist, as memory and feeling emerged as dominant artistic expressions.

2. See Kenneth C. Lindsay, *The Works of John Vanderlyn, From Tammany to the Capitol* (exhibition catalogue, University Art Gallery, State University of New York, Binghamton, 1970), 8–11. This is the most thorough compendium of Vanderlyn material available.

p. 62 3. The most complete and perceptive analysis of this work is by Samuel Y. Edgerton, Jr, 'The Murder of Jane McCrea: The Tragedy of an American "Tableau d'histoire"', *Art Bulletin*, XLVII, 5 (December 1965), 481–92.

4. From Joel Barlow, *The Columbiad*; quoted in Lindsay, *op. cit.*, 73.

p. 63 5. Quoted in Lindsay, *op. cit.*, 71.

6. *Ibid.*

7. See *ibid.*, 72. The subject was also a popular and familiar one in late-eighteenth-century English and French art and literature.

8. See William Dunlap, *History of the Rise and Progress of the Arts of Design in the United States* (2 vols., New York, 1834), II, 36.

9. See Lindsay, *op. cit.*, 138.

10. *Ibid.*, 71, 73.

p. 64 11. Quoted in John McCoubrey, ed., *American Art, 1700–1960, Sources and Documents* (Englewood Cliffs, N.J., 1965), 44.

12. Quoted in Lindsay, *op. cit.*, 4.

p. 65 13. Quoted in E. P. Richardson, Jr, *Washington Allston* (Apollo ed., New York, 1967), 71.

p. 66 14. See *American Paintings in the Museum of Fine Arts, Boston* (2 vols., Boston, 1969), I, 14. Further, the picture is noteworthy as being the first accession in the Boston Museum's collection.

15. McCoubrey, ed., *American Art, op. cit.*, 58.

16. *Ibid.*, 69.

17. See Richardson, *op. cit.*, 122–8. A definitive and exhaustive study of this work is William Gerdts' two-piece article, 'Allston's "Belshazzar's Feast"', *Art in America*, LXI, 2 (March–April 1973), 59–66; and 'Belshazzar's Feast II: "That is his shroud"', *Art in America*, LXI, 3 (May–June 1973), 58–65.

18. See Dunlap, *op. cit.*, I, 134–5; and Harry B. p. 67 Wehle, *Samuel F. B. Morse, American Painter* (exhibition catalogue, Metropolitan Museum of Art, New York, 1932), 15–16.

19. Quoted in Wehle, *op. cit.*, 16.

20. *Ibid.*

21. 'Lay it on here, Samuel – more yellow ... damn it if I had been a painter what a picture I should have painted. ... Crowds get around the picture, for Samuel has quite made a hit in the Louvre.' Quoted in John K. Howat, *et al.*, *19th-Century America, Paintings and Sculpture* (exhibition catalogue, Metropolitan Museum of Art, New York, 1970), no. 30.

CHAPTER 9

1. Now in the Historical Society of Pennsylvania, p. 69 Philadelphia. See Charles Hart, ed., *A Register of Portraits Painted by Thomas Sully, 1801–1871* (Philadelphia, 1908); and Edward Biddle and Mantle Fielding, *The Life and Works of Thomas Sully* (Philadelphia, 1921).

2. Thomas Sully, *Hints to Young Painters* (reprinted ed., New York, 1965), 34.

3. *Ibid.*, 31.

4. Another version is in the Museum of Fine p. 70 Arts, Boston.

5. Quoted in John K. Howat, *et al.*, *19th-Century* p. 71 *America, Paintings and Sculpture* (exhibition catalogue, Metropolitan Museum of Art, New York, 1970), no. 108.

6. Details of the process and the history of its introduction into the United States can be found in a number of books, including Robert Taft, *Photography and the American Scene* (Dover ed., New York, 1964); Floyd and Marion Rinhart, *American Daguerreian Art* (New York, 1967); and Beaumont Newhall, *The Daguerreotype in America* (rev. ed., New York, 1968).

7. Quoted in Richard Rudisill, *Mirror Image, The Influence of the Daguerreotype in American Society* (Albuquerque, New Mexico, 1971), 57.

8. See Taft, *op. cit.*, 76, 93.

9. Rudisill, *op. cit.*, 198. This is the most thought- p. 72 ful study of this subject, analysing in depth the role of daguerreotype in American life.

p. 72 10. Details in *ibid.*, chapter 7; and Rachael Johnston Homer, *The Legacy of Josiah Johnson Hawes, 19th Century Photographs of Boston* (Barre, Mass., 1972), 10–11.

11. See Andrew Oliver, *The Adams Papers, Portraits of John Quincy Adams and His Wife* (Cambridge, Mass., 1970), 285–7.

12. Quoted in Newhall, *op. cit.*, 44.

13. Quoted in Rudisill, *op. cit.*, 176–7.

p. 73 14. Quoted in Andrew Oliver, *The Adams Papers, Portraits of John and Abigail Adams* (Cambridge, Mass., 1967), 202.

15. Browere made the mask from life in 1825, then did a second plaster based on it, adding a bust in the Roman manner. In 1938 this latter mould was used to make a bronze cast. All three pieces are at Cooperstown. See Oliver's summary in *Portraits of John Adams, op. cit.*, 202–8. Appropriately, Oliver has established himself as the senior scholar on this material.

16. See Wayne Craven, *Sculpture in America* (New York, 1968), 85.

17. *Ibid.*, 92–3.

p. 74 18. On the Robertsons see *American Drawings, Pastels and Watercolors, Part One: Works of the Eighteenth and Early Nineteenth Centuries* (exhibition catalogue, Kennedy Galleries, Inc., New York, 1967), 13–24; on Groombridge see William Dunlap, *History of the Rise and Progress of the Arts of Design in the United States* (2 vols., New York, 1834), II, 47; and on Cornè see John Wilmerding, *A History of American Marine Painting* (Boston and Salem, 1968), chapter VI; and Nina Fletcher Little, *Michele Felice Cornè* (exhibition catalogue, Peabody Museum of Salem, Mass., 1972).

19. See Marshall B. Davidson and the Editors of *American Heritage, The Artist's America* (New York, 1973), 68.

20. Quoted in Howat, *et al.*, *op. cit.*, no. 25.

21. See Wilmerding, *op. cit.*, chapter VII; William H. Gerdts, *Thomas Birch, 1779–1851, Paintings and Drawings* (exhibition catalogue, Philadelphia Maritime Museum, Philadelphia, 1966); and *M. and M. Karolik Collection of American Paintings, 1815 to 1865* (Cambridge, Mass., 1949), 114.

p. 75 22. A complete examination of Salmon's career may be found in John Wilmerding, *Robert Salmon, Painter of Ship and Shore* (Boston and Salem, 1971).

23. John Hill, *Picturesque Views of American Scenery* (Philadelphia, 1820), introduction.

CHAPTER 10

1. William Dunlap, *History of the Rise and Progress of the Arts of Design in the United States* (2 vols., New York, 1834), I, 243. p. 76

2. *Ibid.*, II, 197.

3. *Ibid.*, II, 380. p. 77

4. See Frank H. Goodyear, Jr, *Thomas Doughty, 1793–1856, An American Pioneer in Landscape Painting* (exhibition catalogue, Pennsylvania Academy of the Fine Arts, Philadelphia, 1973), 15.

5. See Albert TenEyck Gardner and Stuart P. Feld, *American Paintings, A Catalogue of the Collection of the Metropolitan Museum of Art*, I (New York, 1965), 196.

6. Dunlap, *op. cit.*, II, 381.

7. Possibly he became interested in marine subjects through his family. Though not artists, his father had been a ship carpenter, his oldest brother William was a naval draughtsman, and another brother Samuel was a sometime mariner. See Goodyear, *op. cit.*, 11.

8. For clarification on this (through many a p. 78 glass darkly) my thanks to James Byrne, Samuel Eliot Morison, and Ray and Elise Hawtin.

9. Dunlap, *op. cit.*, II, 359–60; see also Louis Legrand Noble, *The Life and Works of Thomas Cole* (Elliot S. Vessell, ed., John Harvard Library, Cambridge, Mass., 1964), 35.

10. See the full discussion of James T. Callow, *Kindred Spirits, Knickerbocker Writers and American Artists, 1807–1855* (Chapel Hill, N.C., 1967).

11. Thomas Cole, *Essay on American Scenery*, p. 79 quoted in John W. McCoubrey, ed., *American Art, 1700–1960, Sources and Documents* (Englewood Cliffs, N.J., 1965), 102.

12. *Ibid.*

13. *Ibid.*, 105.

14. *Ibid.*, 107.

15. *Ibid.*, 99.

16. *Ibid.*, 100.

17. Quoted in Noble, *op. cit.*, 100.

18. *Ibid.*, 111.

19. *Ibid.*, 130. p. 80

20. *Ibid.*

21. See *ibid.*, 130 and 174.

22. Quoted in McCoubrey, ed., *American Art, op. cit.*, 109.

23. *Ibid.*, 104.

p. 81 24. *The Complete Essays and Other Writings of Ralph Waldo Emerson* (Modern Library ed., New York, 1950), 6.

25. Quoted in McCoubrey, ed., *American Art, op. cit.*, 106.

26. *Ibid.*, 110.

p. 82 27. Henry David Thoreau, *The Maine Woods* (Apollo ed., New York, 1961), 138. Further parallels might be drawn between the novels of Cooper on the one hand and of Richard Henry Dana on the other. Cooper, in fact, was inspired to write his novel *The Crater* after seeing *The Course of Empire*, and he actually mentions Cole's series in the final pages of his story. Barbara Novak gives a definitive analysis of the differences between Cole and Durand in her *American Painting of the Nineteenth Century* (New York, 1969), chapters 3 and 4.

NOTES TO PART THREE

CHAPTER 11

p. 85 1. *The Literary World* (15 May 1847), xv, 347–8. See also Perry Miller, *Nature's Nation* (Cambridge, Mass., 1967), 197 ff.

2. See William S. Talbot, *Jasper F. Cropsey, 1823–1900* (exhibition catalogue, National Collection of Fine Arts, Washington, D.C., 1970), 16.

3. *Ibid.*, 19–22.

p. 86 4. *Ibid.*, 90.

5. Alvan Fisher was a generation older; born near Boston and working largely along the New England coast, he was more nearly a contemporary of Durand and Doughty.

p. 87 6. Guy McElroy, *Robert S. Duncanson, A Centennial Exhibition* (exhibition catalogue, Cincinnati Art Museum, Cincinnati, Ohio, 1972), 5–15. Other interesting figures are George Tirrell of Massachusetts, who spent much of his life in California, and who is best known for his glowing panorama of Sacramento (Museum of Fine Arts, Boston) painted about 1860; and William Aiken Walker (c. 1838–1921), a native of Charleston and painter of extensive genre and landscape scenes in South Carolina, Louisiana, and Florida.

7. Henry T. Tuckerman, *Book of the Artists, American Artist Life* (reprinted ed., New York, 1966), 510. See also John K. Howat, *John Frederick Kensett, 1816–1872* (exhibition catalogue, The American Federation of Arts, New York, 1968); and Joan C. Siegfried, *John Frederick Kensett, A Retrospective Exhibition* (exhibition catalogue, Hathorn Gallery, Skidmore College, Saratoga Springs, N.Y., 1967).

p. 88 8. Tuckerman, *op. cit.*, 514.

9. *Ibid.*

10. John I. H. Baur, ed., *The Autobiography of Worthington Whittredge* (reprinted ed., New York, 1969), 7.

p. 89 11. See Donelson F. Hoopes, *The Düsseldorf Academy and the Americans* (exhibition catalogue, The High Museum of Art, Atlanta, Ga., 1972). See also Fritz Novotny, *Painting and Sculpture in Europe, 1780–1880* (The Pelican History of Art), 2nd ed. (Harmondsworth, 1970), 133 f., 168.

12. *Autobiography of Whittredge, op. cit.*, 24.

13. See *ibid.*, 34, 36, 38; and Edward H. Dwight, *Worthington Whittredge (1820–1910), A Retrospective Exhibition of an American Artist* (exhibition catalogue, Munson-Williams-Proctor Institute, Utica, N.Y., 1969). George Loring Brown also passed a good deal of time in Rome, pursuing a career parallel to, if more uneven than, those of his contemporaries. See Thomas W. Leavitt, *George Loring Brown, Landscapes of Europe and America, 1834–1880* (exhibition catalogue, The Robert Hull Fleming Museum, Burlington, Vermont, 1973).

14. *Autobiography of Whittredge, op. cit.*, 31.

15. *Ibid.*, 46. See also Nancy Dustin Wall Moure, 'Five Eastern Artists Out West', *American Art Journal*, v, 2 (November 1973), 15–31.

16. See John K. Howat, *The Hudson River and Its p. 90 Painters* (New York, 1972), 161.

17. For further information on Haseltine see Helen Haseltine Plowden, *William Stanley Haseltine, Sea and Landscape Painter (1835–1900)* (London, 1947); and on Richards see Linda S. Ferber, *William Trost Richards, American Landscape and Marine Painter, 1833–1905* (exhibition catalogue, The Brooklyn Museum, Brooklyn, N.Y., 1973).

18. See Jeffrey R. Brown, *Alfred Thompson Bricher, 1837–1908* (exhibition catalogue, Indianapolis Museum of Art, Indianapolis, Ind., 1973), 63.

19. Elisha Kent Kane, *Arctic Explorations in the p. 91 Years 1853, '54, '55* (2 vols., Philadelphia, 1856). See also Arlene Jacobowitz, *James Hamilton, 1819–1878, American Marine Painter* (exhibition catalogue, The Brooklyn Museum, Brooklyn, N. Y., 1966).

20. See John Wilmerding, *William Bradford, 1823–1892, Artist of the Arctic, An Exhibition of his Paintings and Photographs* (exhibition catalogue, DeCordova Museum, Lincoln, Mass., 1969); and *idem, Fitz Hugh Lane* (New York, 1971), 28–9, 35.

21. Besides Kent's book, which appeared in 1856, the Rev. Louis L. Noble, biographer of Thomas Cole, published his account of an 1859 trip with Church, *After Icebergs with A Painter, A Summer Voyage to Labrador and Around Newfoundland* (New York, 1861).

22. William Bradford, *The Arctic Regions, Illustrated with Photographs taken on an Art Expedition to Greenland, with Descriptive Narrative by the Artist* (London, 1873).

23. Noble, *op. cit.*, 223.

24. Bradford, *op. cit.*, 12.

p. 92 25. *Ibid.*, 74. See also Frank Horch, 'Photographs and Paintings by William Bradford', *The American Art Journal*, v, 2 (November 1973), 61–70.

CHAPTER 12

p. 93 1. The best discussion of Ruskin's impact on American culture is Roger B. Stein's *John Ruskin and Aesthetic Thought in America, 1840–1900* (Cambridge, Mass., 1967).

2. See John Wilmerding, *Fitz Hugh Lane* (New York, 1971), 50–1; and David C. Huntington, *The Landscapes of Frederic Edwin Church* (New York, 1966), 44–5.

3. A. J. Downing, *The Architecture of Country Houses* (New York, 1850; Dover ed., New York, 1969), xix.

4. See James Jackson Jarves, *The Art-Idea* (John Harvard Library ed., Cambridge, Mass., 1960), especially the introduction by Benjamin Rowland, Jr, xi–xxviii.

5. *Ibid.*, 189.

6. *Ibid.*, 191–3.

p. 94 7. Henry T. Tuckerman, *Book of the Artist, American Artist Life* (New York, 1867; reprinted ed., New York, 1966), 543.

8. *The Complete Essays and Other Writings of Ralph Waldo Emerson* (Modern Library ed., New York, 1950), 6.

9. John I. H. Baur is credited with first defining the concept of luminism in his articles, 'Early Studies in Light and Air by American Landscape Painters', *The Brooklyn Museum Bulletin*, IX, 2 (Winter 1948), 1–9; and 'American Luminism', *Perspectives USA*, IX (Autumn 1954), 90–8. A more recent study is Theodore E. Stebbins, Jr, *et al.*, *Luminous Landscape: The American Study of Light, 1860–1875* (exhibition catalogue, Fogg Art Museum, Cambridge, Mass., 1966). More comprehensive and provocative is Barbara Novak's analysis in her *American Painting of the Nineteenth Century* (New York, 1969), chapters 5–7.

10. See Barbara Novak's articles on this duality: 'Grand Opera and the Small Still Voice', *Art in America*, LIX, 2 (March–April 1971), 64–73; and 'American Landscape: The Nationalist Garden and the Holy Book', *Art in America*, LX, 1 (January–February 1972), 46–57.

11. See Wilmerding, *op. cit.*, 49–50; also E. P. Richardson, *Painting in America* (New York, 1956), 219; and Theodore E. Stebbins, Jr, *Martin Johnson Heade* (exhibition catalogue, Whitney Museum, New York, 1969).

12. Jarves, *op. cit.*, 190.

13. See Wilmerding, *op. cit.*, 187–90, and chap- p. 95 ters 1 and 2. This monograph is a complete account of Lane's career. See also chapter 6 in B. Novak's *American Painting, op. cit.*

14. T. E. Stebbins poses a different argument in p. 96 his *Heade, op. cit.* However, comparison of Heade's *Woodland Scene* of c. 1850–5 (Hirschl & Adler Galleries, New York) with Whittredge's *View of Cincinnati* of c. 1845 (Worcester Art Museum) and *Old Hunting Grounds* of c. 1859 (Reynolda House, Winston-Salem, N.C.), or Kensett's *Cascade in the Forest* of 1852 (Detroit Institute) and *Bish-Bash Falls* of 1855 (Museum of Fine Arts, Boston), suggests a contrast in technical ability rather than in attitude or interpretation.

15. This argument is thoroughly presented in John Wilmerding, *A History of American Marine Painting* (Boston and Salem, 1968), chapter XI; and *idem, Fitz Hugh Lane, op. cit.*, chapter 9.

16. Stebbins, *Heade, op. cit.*, has shown that the p. 97 location is probably Point Judith, R.I. Heade himself painted *Storm Clouds on the Coast* in 1859 (Farnsworth Museum, Rockland, Maine), and Lane the next year completed the equally unusual oil *Schooners before Approaching Storm (Off Owl's Head)* (private collection). Heade's other major canvas of terrifying power is *Thunderstorm over Narragansett Bay*, 1868 (Collection Ernest Rosenfeld, New York).

17. I am indebted to David C. Huntington for his analysis of the meaning of Church's art in his *Landscapes of Frederic Edwin Church, op. cit.*

18. Thomas Cole, *Essay on American Scenery*, 1835; quoted in John W. McCoubrey, ed., *American Art, 1700–1960, Sources and Documents* (Englewood Cliffs, N.J., 1965), 105.

19. See Huntington's discussion in *op. cit.*, 1–4, p. 98 65–71.

p. 98 20. See Wilmerding, *F. H. Lane, op. cit.*, chapter 5; and Stebbins, *Luminous Landscape, op. cit.*, 9–10.

21. See Wilmerding, *F. H. Lane, op. cit.*, 49, 82–3; and Huntington, *op. cit.*, 29, 43.

22. To be seen, let alone understood, properly, this can only be reproduced in colour, an impossibility here. Its predecessors include *Bar Harbor*, 1855, an oil sketch (Olana, Hudson, New York), and *Sunset*, 1856 (Munson-Williams-Proctor Institute, Utica, N.Y.).

23. Quoted in Samuel Eliot Morison, *The Oxford History of the American People* (New York, 1965), 413.

24. The fullest account is given in Douglas Botting, *Humboldt and the Cosmos* (New York and London, 1973).

25. Known in versions from pencil and oil studies through several finished oils, dating from the mid fifties to 1863; the final canvas, in the collection of John Astor, New York, measures seven by twelve feet.

26. Alexander von Humboldt, *Splendid Scenery from Travels and Researches* (New York, 1833), 239.

27. Quoted in John Howat, *et al.*, *19th-Century America, Paintings and Sculpture* (exhibition catalogue, Metropolitan Museum, New York, 1970), no. 107. See also Huntington, *op. cit.*, 12–13.

p. 99 28. Details from Nicolai Cikovsky, Jr, *Sanford Robinson Gifford* (exhibition catalogue, University of Texas Art Museum, Austin, Tex., 1970).

29. *Ibid.*, 25.

30. See Roland Van Zandt, *The Catskill Mountain House* (New Brunswick, N.J., 1966).

31. H. D. Thoreau, *The Maine Woods* (Apollo ed., New York, 1966), 93.

32. Cikovsky, *op. cit.*, 16.

CHAPTER 13

p. 100 1. For details about Francis and Roesen in the development of American still-life painting, see William H. Gerdts and Russell Burke, *American Still-Life Painting* (New York, 1971), 60–6.

p. 101 2. Periodic surveys of this field are undertaken. Among the more useful are Jean Lipman, *American Primitive Painting* (London and New York, 1942); Nina Fletcher Little, *American Decorative Wall Painting, 1700–1850* (Sturbridge, Mass., 1952); Mary Black and Jean Lipman, *American Folk Painting* (New York, 1966); Jean Lipman and Alice Winchester, *The Flowering of American Folk Art, 1776–1876* (New York, 1974). These authors together have been the four evangelists of American folk art in the twentieth century.

3. On this point see Barbara Novak, *American Painting of the Nineteenth Century* (New York, 1969), 97–103, 110–11; and John Wilmerding, *Fitz Hugh Lane* (New York, 1971), 18–19.

4. Nina Fletcher Little, *The Abby Aldrich Rockefeller Folk Art Collection* (Boston, 1957), 98.

5. *Ibid.*, 48.

6. A full study of Phillips's career and the history of attributing the various parts of his oeuvre may be found in Mary Black, *et al.*, *Ammi Phillips: Portrait Painter, 1788–1865* (New York, 1969).

p. 102 7. See Little, *Rockefeller Folk Art Collection, op. cit.*, 98, 3.

8. See Jean Lipman, *Rufus Porter, Yankee Pioneer* (New York, 1968); and Alice Winchester, *Versatile Yankee, The Art of Jonathan Fisher, 1768–1847* (New York, 1973).

p. 103 9. Estimates range from fifty to one hundred versions known. For discussion of them and biographical details see Alice Ford, *Edward Hicks: Painter of the Peaceable Kingdom* (Philadelphia, 1952); and Eleanore Price Mather, *Edward Hicks, A Peaceable Season* (Princeton, N. J., 1973).

10. See the discussion in John Wilmerding, *A History of American Marine Painting* (Boston and Salem, 1968), 38–9, and bibliographical references, 260.

11. See Little, *Rockefeller Folk Art Collection, op. cit.*, 48; and Jean Lipman and Alice Winchester, *Primitive Painters in America, 1750–1850, An Anthology* (New York, 1950), *passim*.

p. 104 12. See Black and Lipman, *Folk Painting, op. cit.*, 216–17.

p. 105 13. From a speech by Young Chief of the Cayuses in 1855; quoted in T. C. McLuhan, *Touch the Earth, A Self Portrait of Indian Existence* (New York, 1971), 8.

14. See Norman Feder, *Two Hundred Years of North American Indian Art* (exhibition catalogue, Whitney Museum, New York, 1971), 14–15; and *ibid.*, *American Indian Art* (New York, 1971), 158.

15. Feder, *American Indian Art*, 254.

16. McLuhan, *op. cit.*, 7.

CHAPTER 14

p. 106 1. For further discussion of these ideas see Margaret Farrand Thorp, *The Literary Sculptors* (Durham, N.C., 1965); William H. Gerdts, *American Neo-Classical Sculpture, The Marble Resurrection* (New York, 1973); and William H. Pierson, Jr, *American Buildings and Their Architects, The Colonial and Neo-Classical Styles* (New York, 1970), part II.

p. 107 2. See Thorp, *op. cit.*, 51–63.

3. Sylvia E. Crane, *White Silence, Greenough, Powers, and Crawford, American Sculptors in Nineteenth-Century Italy* (Coral Gables, Fla., 1972), 71.

4. See Gerdts, *op. cit.*, 24.

5. Quoted in Crane, *op. cit.*, 69.

6. *Ibid.*, 83; see also 75.

7. *Ibid.*, 75.

8. See *ibid.*, 75–6; and Gerdts, *op. cit.*, 98.

9. For other useful surveys of Greenough's career see Albert TenEyck Gardner, *Yankee Stonecutters, The First American School of Sculpture, 1800–1850* (New York, 1945); Nathalia Wright, *Horatio Greenough, The First American Sculptor* (Philadelphia, 1963); and Wayne Craven, *Sculpture in America, From the Colonial Period to the Present* (New York, 1968), chapter 4.

10. Horatio Greenough, ed. Harold A. Small, *Form and Function, Remarks on Art, Design, and Architecture* (Berkeley and Los Angeles, 1962), 71.

11. *Ibid.*, 22.

p. 108 12. Crane, *op. cit.*, 151.

13. *Ibid.*, 174.

14. *Ibid.*, 184–5.

15. For technical details of the pointing system used by the neo-classical sculptors see Craven, *op. cit.*, 106.

16. Crane, *op. cit.*, 203.

17. *Ibid.*, 204.

18. *Ibid.*, 222.

19. See *ibid.*, chapter 13; and Gerdts, *op. cit.*, 52–5.

p. 109 20. Further biographical details in Crane, *op. cit.*, chapters 15–18; and in Robert Gale, *Thomas Crawford, American Sculptor* (Pittsburgh, Pa., 1964).

21. Other notable examples were Margaret Foley, Anne Whitney, and Emma Stebbins.

22. See Thorp, *op. cit.*, 93–5; Gerdts, *op. cit.*, 132–3; and Elsa Honig Fine, *The Afro-American Artist* (New York, 1973), 63–6.

23. Quoted in Gardner, *op. cit.*, 36. p. 110

24. *Ibid.*

25. Biographical information and an illustrated checklist of Rogers' work may be found in David H. Wallace, *John Rogers, The People's Sculptor, His Life and his Work* (Middletown, Conn., 1967).

26. *Ibid.*, 112.

27. *Ibid.*, 239. Only *Coming to the Parson* of p. 111 1870 over the years sold more – eight thousand copies.

28. See *ibid.*, 62–3. Bingham also borrowed from Wilkie's figural arrangements. The works of Bingham most obviously relevant to Rogers include *Raftsmen Playing Cards*, 1847; *The Checker Players*, 1850; and *In a Quandary*, 1851. See also E. Maurice Bloch, *George Caleb Bingham, The Evolution of an Artist* (2 vols., Berkeley and Los Angeles, 1967), I, 91–2.

29. See Francis S. Grubar, *Richard Caton Woodville, an Early American Genre Painter* (exhibition catalogue, Corcoran Gallery of Art, Washington, D.C., 1967); and Hermann Warner Williams, Jr, *Mirror to the American Past, A Survey of American Genre Painting: 1750–1900* (Greenwich, Conn., 1973), 78–81.

30. See Williams, *op. cit.*, 199–201. p. 112

31. This is more fully argued in John Wilmerding, *Winslow Homer* (New York, 1972), 87.

CHAPTER 15

1. John I. H. Baur, *John Quidor* (exhibition catalogue, Whitney Museum, New York, 1965), 11. p. 113 There are a few doctoral dissertations on Quidor, but this is the major published source of information on his enigmatic and incompletely known career.

2. Much of the myth of Quidor's lonely separa- p. 114 tion from the course of American painting appears to be the result of few biographical facts being available. Even the assertion that he is the 'only non-derivative romanticist of a period dominated by the realists' (Baur, *op. cit.*, 6) has to be qualified by citing such visionary contemporaries as Allston and William Page.

3. See James T. Callow, *Kindred Spirits, Knickerbocker Writers and American Artists, 1807–1855* (Chapel Hill, N.C., 1967), 185.

4. Washington Irving, *The Sketch Book*; quoted in Baur, *op. cit.*, 24.

p. 114 5. On these points see Denis R. O'Neill, 'Dutch Influences in American Painting', *Antiques*, CIV, 6 (December 1973), 1076–9; Bartlett Cowdrey and Hermann Warner Williams, Jr, *William Sidney Mount, 1807–1868, An American Painter* (New York, 1944), 4; and E. Maurice Bloch, *George Caleb Bingham, The Evolution of an Artist* (2 vols., Berkeley and Los Angeles, 1967), I, 91–2, 129.

p. 115 6. Quoted in Baur, *op. cit.*, 30.

7. *Ibid.*, 14.

p. 116 8. Cowdrey and Williams, *op. cit.*, 4, 8. Compare, for example, Mount's *Rustic Dance after a Sleigh Ride* of 1830 (Museum of Fine Arts, Boston) with Jan Steen's *Dancing Couple* of *c.* 1660–70 (National Gallery of Art, Washington, D.C.).

9. Quoted in Alfred Frankenstein, *Painter of Rural America, William Sidney Mount, 1807–1868* (exhibition catalogue, National Gallery of Art, Washington, D.C., 1969), 21.

10. That this is a compositional device is clear from the fact that no hills of such prominence exist in the flat farmlands of eastern Long Island.

p. 117 11. Quoted in Stuart P. Feld, 'In the Midst of "High Vintage"', *The Metropolitan Museum of Art Bulletin* (April 1967), 302, the primary source of information on this painting. I am also grateful for information to Joseph Hudson of Yale University. For details of the historical background see Samuel Eliot Morison, *The Oxford History of the American People* (New York, 1965), 454–61.

12. Frankenstein, *op. cit.*, 37.

13. *Ibid.*

14. See Barbara Novak's discussion of these points in Mount's work in her *American Painting of the Nineteenth Century* (New York, 1969), chapter 8.

15. Walt Whitman, 'Paumanok', from *Leaves of Grass* (Mentor ed., New York, 1954), 385.

16. *Ibid.*, 45.

17. Complete biographical information may be p. 118 found in the definitive monograph by Bloch, *G. C. Bingham*, *op. cit.*, chapters I–V for the early periods.

18. The one Bloch and others most commonly cite as Mount precedents are his *Rustic Dance*, 1830, and *Dance of the Haymakers*, 1845, compared with Bingham's *Jolly Flatboatmen*, 1846; or Mount's *Long Story*, 1837, with Bingham's *Country Politician*, 1849, and *Canvassing for a Vote*, 1851. See E. Maurice Bloch, 'A Bingham Discovery', *American Art Review*, I: 1 (September–October 1973), 22–7. To this should also be added the comparisons of Mount's *Girl Asleep*, 1843, with Bingham's *Dull Story*, 1843–4. Also, Mount's *Country Lad on a Fence*, 1831, *The Studious Boy*, 1834, and *Leisure Hours*, 1834, would all seem to have influenced (as much as Sully's *Torn Hat*, 1820) Bingham's *Mill Boy*, 1844. Finally, Mount's *Card Players*, 1845–50, joined versions by Wilkie, Woodville, and others as precedents for *Raftsmen Playing Cards*, 1847, *The Checker Players*, 1850, and *In a Quandary*, 1851, by Bingham.

19. Bloch, *G. C. Bingham*, *op. cit.*, 82.

20. Bloch points out another likely source in Marcantonio Raimondi's well known engraving after Raphael's *Judgement of Paris; ibid.*, 81.

21. See *ibid.* for a full analysis of Bingham's p. 119 compositional adaptations for his genre subjects, chapter VI.

22. See David C. Huntington, *Art and the Excited Spirit: America in the Romantic Period* (exhibition catalogue, The University of Michigan Museum of Art, Ann Arbor, Mich., 1972).

23. John I. H. Baur, ed., *The Autobiography of* p. 120 *Worthington Whittredge* (reprinted ed., New York, 1969), 22. See also John Howat *et al.*, *19th-Century America, Paintings and Sculpture* (exhibition catalogue, Metropolitan Museum, New York, 1970), no. 87.

NOTES TO PART FOUR

CHAPTER 16

p. 123 1. See Howard Mumford Jones, *O Strange New World, American Culture: The Formative Years* (New York, 1964), chapter x; and Robert V. Hine, *The American West, An Interpretive History* (Boston, 1973).

2. In 1834 Washington Irving also published *A Tour on the Prairies* (Pantheon ed., New York, 1967). In it he described the Indians as, variously, 'so many noble bronze figures', and 'an Adonis of the frontier' (12, 16). The landscape was 'a region of adventure . . . a glorious country spreading out far and wide in the golden sunshine' (81).

p. 124 3. See Marshall B. Davidson, *The Original Water-Color Paintings by John James Audubon for the Birds of America* (New York, 1966), xxi. This contains a good summary biography and discussion of Audubon's art. See also Alexander B. Adams, *John James Audubon, A Biography* (New York, 1966).

4. *Audubon, By Himself, A Profile of John James Audubon, From Writings Selected, Arranged and Edited* (ed. by Alice Ford, Garden City, N.Y., 1969), 68–9.

5. *Ibid.*, 158.

p. 125 6. *Ibid.*, 223–4.

7. Quoted in Marjorie Halpin, *Catlin's Indian Gallery* (Washington, D.C., 1965), 5.

8. *Ibid.*, 3, 7. For biographical details see also Harold McCracken, *George Catlin and the Old Frontier* (New York, 1969).

9. George Catlin, *Letters and Notes on the Manners, Customs, and Conditions of the North American Indians, Written during Eight Years' Travel (1832–1839) amongst the Wildest Tribes of Indians in North America* (2 vols., London, 1844; Dover ed., New York, 1973), I, 177.

10. *Ibid.*, I, 102.

11. *Ibid.*, II, 195–6.

p. 126 12. For a full monographic study see Richard Shafer Trump, 'Life and Works of Albert Bierstadt' (unpublished doctoral dissertation, Ohio State University; University Microfilms ed., Ann Arbor, Mich., 1965).

13. These are comprehensively documented in Gordon Hendricks, 'The First Three Western Journeys of Albert Bierstadt', *Art Bulletin*, XLVI (September 1964), 333–65.

14. Fitz Hugh Ludlow, *The Heart of the Continent: A Record of Travel Across the Plains and in Oregon, with an Examination of the American Principle* (New York, 1870).

15. *Ibid.*, 76.

16. *Ibid.*, 76, 426. See also Jones, *op. cit.*, chapter p. 127 x.

17. See Trump, *op. cit.*, 111; and Robert Taft, *Photography and the American Scene, A Social History, 1839–1889* (Dover ed., New York, 1964), 269–70.

18. Ludlow, *op. cit.*, 412.

19. *Ibid.*, 431–2.

20. See Thurman Wilkins, *Thomas Moran, Artist* p. 128 *of the Mountains* (Norman, Okla., 1965); and William H. Truettner, *National Parks and the American Landscape* (exhibition catalogue, National Collection of Fine Arts, Washington, D.C., 1972). Another artist of great interest in this generation is the Californian William Keith.

21. For information see James D. Horan, *Timothy O'Sullivan, America's Forgotten Photographer* (New York, 1966); Peter Pollack, *The Picture History of Photography, From the Earliest Beginnings to the Present Day* (rev. ed., New York, 1969), chapters 16 and 17; and Taft, *op. cit.*, chapters 13, 14, and 15.

22. See Don D. Fowler, *In a Sacred Manner We* p. 129 *Live, Photographs of the North American Indian by Edward S. Curtis* (Barre, Mass., 1972).

23. T. C. McLuhan, *Touch the Earth, A Self-Portrait of Indian Existence* (New York, 1971), 156.

24. *Ibid.*, 120, 136.

CHAPTER 17

1. See Howard Mumford Jones, *The Age of* p. 130 *Energy, Varieties of American Experience, 1865–1915* (New York, 1971), especially chapters I–IV.

2. See Patricia Hills, *Eastman Johnson* (exhibition catalogue, Whitney Museum, New York, 1972), 14. This, and John I. H. Baur, *Eastman Johnson,*

1824–1906, An American Genre Painter (exhibition catalogue, Brooklyn Museum, N.Y., 1940; reprinted ed., New York, 1969), are the two principal sources of information.

p. 131 3. An almost identical waving figure culminates the composition of Leutze's *Westward the Course of Empire Takes Its Way*, 1861 (National Collection of Fine Arts, Washington, D.C.).

p. 132 4. See John K. Howat, *et al.*, *19th-Century America, Paintings and Sculpture* (exhibition catalogue, Metropolitan Museum, New York, 1970), nos. 143 and 144.

p. 133 5. See the text of Gardner's own description accompanying the plate in his *Photographic Sketch Book of the Civil War* (Washington, D.C., 1866; Dover ed., New York, 1959), plate 41.

6. For examination of Homer's graphic work see David Tatham, 'Some Apprentice Lithographs of Winslow Homer', *Old Time New England*, LIX, 4 (April–June 1969), 86–104; and Lloyd Goodrich, *The Graphic Art of Winslow Homer* (exhibition catalogue, Whitney Museum, New York, 1968).

7. The case for Homer's familiarity with photography is extensively argued in John Wilmerding, *Winslow Homer* (New York, 1972), chapter 2.

8. Gardner, *op. cit.*, introduction.

9. Walt Whitman, *Leaves of Grass* (Mentor ed., New York, 1954), 233.

10. Walt Whitman, *Specimen Days* (Philadelphia, 1882; reprinted ed., Boston, 1971).

11. This period in Homer's career receives extensive discussion in Albert Ten Eyck Gardner, *Winslow Homer, American Artist: His World and His Work* (New York, 1961); and Wilmerding, *op. cit.*

p. 134 12. Most notably, *High Tide: The Bathers*, 1870 (Metropolitan Museum); *Waiting for Dad*, 1873 (Collection Paul Mellon); and *New England Country School*, 1872 (Addison Gallery, Andover, Mass.).

p. 135 13. This argument is elaborated in Wilmerding, *op. cit.*, chapter 4.

14. For much of this information I am grateful to Raymond Fieldhouse of Scarborough, Yorkshire, who first called these comparisons to my attention, cited numerous specific examples from the period Homer was in Tynemouth, and described the factual background of the English magazines, their circulation and popularity.

15. The fullest treatment of this period of Homer's career is Philip Beam's *Winslow Homer at Prout's Neck* (Boston, 1968).

CHAPTER 18

1. Sylvan Schendler, *Eakins* (Boston, 1967), 229. p. 137 I am deeply indebted to Schendler for his eloquent and perceptive analysis of Eakins' art.

2. Lloyd Goodrich, *Winslow Homer* (New York, 1945), 1.

3. Schendler, *op. cit.*, 1

4. *Ibid.*, 18.

5. *Ibid.*, 50–5, 285. See also Gordon Hendricks, p. 138 'Thomas Eakins's "Gross Clinic"', *Art Bulletin*, LI, 1 (March 1969), 57–64. The picture's relationship to other nineteenth-century French works, such as François Nicholas Augustin Feyen-Perrin's *La Leçon d'anatomie du docteur Velpeau*, 1864, and Daumier's 1869 lithograph of *La Leçon d'anatomie* in *Le Charivari*, is discussed in Ellwood C. Parry, III, 'The Gross Clinic as Anatomy Lesson and Memorial Portrait', *Art Quarterly*, XXXII, 4 (Winter 1969), 373–91. Neil Hyman makes a cogent case for suggesting another source in the woodcut title page of *De Humani Corporis Fabrica* by Andreas Vesalius, first edition published in 1543 and known in many subsequent editions; see his 'Eakins' *Gross Clinic* Again', *Art Quarterly*, XXXV, 2 (Summer 1972), 158–64. Of additional interest is the fact that Édouard Manet made his own copy of Rembrandt's *Anatomy Lesson of Dr Tulp* (private collection, Paris) in 1866, the year that Eakins arrived in Paris. For further information on the circumstances surrounding Eakins' work on *The Gross Clinic* see Gordon Hendricks, *The Life and Work of Thomas Eakins* (New York, 1974), especially chapter 6, 'Portrait of Professor Gross, 1875–1876'.

6. Walt Whitman, *Leaves of Grass* (Mentor ed., p. 139 New York, 1954), 31.

7. See Moussa M. Domit, *The Sculpture of Thomas Eakins* (exhibition catalogue, Corcoran Gallery of Art, Washington, D.C., 1969); and Gordon Hendricks, *The Photographs of Thomas Eakins* (New York, 1972).

8. See Kevin MacDonnell, *Eadweard Muybridge,* p. 140 *The man who invented the moving picture* (Boston, 1972), 27; and Anita Ventura Mozley, *et al.*, *Eadweard Muybridge: The Stanford Years, 1872–1882* (exhibition catalogue, Stanford University Museum of Art, Stanford, Cal., 1972). Eakins' picture makes an interesting comparison with a work by his most accomplished pupil and successor at the Pennsylvania Academy, Thomas Anshutz's *Ironworkers Noontime*, 1882–3 (private collection).

This is also an ode to American energies, but now set in an industrial landscape. Although painted with the master's strong brushwork and lighting, it has a posturing and contrived air, ultimately without Eakins' depth of feeling.

p. 141 9. The most comprehensive source of information on Peto, Harnett, and their contemporaries is Alfred Frankenstein's exhaustive researches, especially his *After the Hunt, William Harnett and other American Still Life Painters, 1870–1900* (rev. ed., Berkeley and Los Angeles, 1969); and his *Reality of Appearance, The Trompe l'œil Tradition in American Painting* (exhibition catalogue, University Art Museum, Berkeley, Cal., 1970).

p. 142 10. See Frankenstein, *Reality of Appearance*, 80–3.

p. 143 11. Idem, *After the Hunt*, 103.

CHAPTER 19

p. 144 1. *Indianapolis Star* (14 January 1899), 9; quoted in Wilbur D. Peat, *Chase Centennial Exhibition* (exhibition catalogue, John Herron Art Museum, Indianapolis, Ind., 1949).

2. Useful biographical and stylistic information summarized respectively in Francis W. Bilodeau, *Frank Duveneck* (exhibition catalogue, Chapellier Gallery, New York, 1972); and Ala Story, *William Merritt Chase (1849–1916)* (exhibition catalogue, Art Gallery, University of California, Santa Barbara, 1964). An important discussion of the Munich School is in Axel von Soldern's *Triumph of Realism* (exhibition catalogue, Brooklyn Museum, N.Y., 1966).

3. Henry James, 'On Some Pictures Lately Exhibited', *The Galaxy*, xx (July 1875), 89–97; quoted in John W. McCoubrey, ed., *American Art, 1700–1960, Sources and Documents* (Englewood Cliffs, N.J., 1965), 166–7.

p. 145 4. *Ibid.*, 167.

5. See Donelson F. Hoopes, *The American Impressionists* (New York, 1972), 42.

6. Chase's students included figures as different as Demuth, Hartley, Hopper, Kent, O'Keeffe, and Sheeler. See Story, *op. cit.*

p. 146 7. Helen M. Knowlton, *The Art Life of William Morris Hunt* (Boston, 1900), 109.

8. *Ibid.*, 119.

p. 147 9. Whistler admired the work of Velázquez, Terborch, and Hals. He owned a photograph of Vermeer's *Little Street*, and could have become further acquainted with his art through the theories of the French critic Thoré-Burger. See Denys Sutton, *James McNeill Whistler, Paintings, Etchings, Pastels, & Watercolours* (London, 1966), 14, 44.

10. Quoted in Tom Prideaux *et al.*, *The World of Whistler, 1834–1903* (New York, 1970), 80.

11. *Ibid.*, 111.

12. McCoubrey, *op. cit.*, 183. p. 148

13. Quoted in Richard Ormond, *John Singer* p. 149 *Sargent, Paintings, drawings, watercolors* (New York, 1970), 29.

14. *Ibid.*, 31.

15. See the comparison drawn between the painter and writer by Leon Edel, *Henry James, The Middle Years, 1882–1895* (Philadelphia and New York, 1962), 109.

16. Henry James, 'John Singer Sargent', in *Picture and Text* (New York, 1893), 97, 107.

17. See Frederick D. Hill, 'Cecilia Beaux, the Grande Dame of American Portraiture', *The Magazine Antiques*, cv, 1 (January, 1974), 160 ff.

18. For a definitive survey of Saint-Gaudens' p. 150 portrait reliefs, see John Dryfhout, *Augustus Saint-Gaudens, The Portrait Reliefs* (exhibition catalogue, National Portrait Gallery, Washington, D.C., 1969).

19. One of Lowell's most moving poems is 'For the Union Dead', from his volume of the same title (New York, 1964), 70–2. Another stanza concludes:

When he leads his black soldiers to death,
he cannot bend his back.

CHAPTER 20

1. Three surveys with different viewpoints of p. 152 American Impressionism are Donelson F. Hoopes, *The American Impressionists* (New York, 1972); Moussa M. Domit, *American Impressionist Painting* (exhibition catalogue, National Gallery of Art, Washington, D.C., 1973); and Richard J. Boyle, *American Impressionism* (New York, 1974). The most thoughtful analysis of Impressionism's more contemplative side, variously called tonalism, quietism, intimism, is Wanda M. Corn's *The Color of Mood: American Tonalism, 1880–1910* (exhibition catalogue, M. H. de Young Memorial Museum, San Francisco, 1972).

2. Nicolai Cikovsky, Jr, *George Inness* (New York, 1971), 53.

p. 152 3. See Alfred Werner, *Inness Landscapes* (New York, 1973), 24.

p. 153 4. For a relevant examination of Barbizon attitudes, see Robert H. Herbert, *Barbizon Revisited* (exhibition catalogue, Museum of Fine Arts, Boston, 1962).

5. Cikovsky, *op. cit.*, 55.

p. 154 6. Werner, *op. cit.*, 16.

7. Henry A. La Farge, *John La Farge, Oils and Watercolors* (exhibition catalogue, Kennedy Galleries, New York, 1968), introduction.

8. John La Farge, *Reminiscences of the South Seas* (Garden City, N.Y., 1916), 480.

9. Henry La Farge, *op. cit.*

10. John La Farge, *op. cit.*, 277.

11. *Ibid.*, 286–7.

p. 155 12. *Ibid.*, 93.

13. E. John Bullard, *Mary Cassatt, Oils and Pastels* (New York, 1972), 13.

14. See Adelyn Dohme Breeskin, *Mary Cassatt, A Catalogue Raisonné of the Oils, Pastels, Watercolors, and Drawings* (Washington, D.C., 1970), 81–2; and Frederick A. Sweet, *Miss Mary Cassatt, Impressionist from Pennsylvania* (Norman, Okla., 1966), 85–6.

p. 156 15. For a detailed explanation of Mary Cassatt's use of these respective etching techniques, see Adelyn D. Breeskin, *The Graphic Work of Mary Cassatt, A Catalogue Raisonné* (New York, 1948), 25–8, 47–9.

16. Completing The Ten were Robert Reid and E. E. Simmons. Chase joined after Twachtman's death in 1902. Dewing is discussed at greater length in Chapter 21.

17. See James F. O'Gorman and John Wilmerding, *Portrait of A Place, Some American Landscape Painters in Gloucester* (exhibition catalogue, Gloucester 350th Anniversary Celebration Inc., Gloucester, Mass., 1973). p. 15

18. The prevailing attitude, which sees the later Impressionist achievements as the ones to be acclaimed, is typically argued in Hermann Warner Williams, Jr, *Childe Hassam, a retrospective exhibition* (exhibition catalogue, Corcoran Gallery of Art, Washington, D.C., 1965), 17; and Eliot Clark, *John Twachtman* (New York, 1924), 41 ff.

19. Quoted in Helmut and Alison Gernsheim, *The History of Photography, from the camera obscura to the beginning of the modern era* (New York, 1969), 468. See also Peter Pollack, *The Picture History of Photography, From the Earliest Beginnings to the Present Day* (rev. ed., New York, 1969), 244–6; and Corn, *op. cit.*, 13–19. p. 15

CHAPTER 21

p. 161 1. The standard monograph on Page is Joshua C. Taylor's *William Page, The American Titian* (Chicago, 1957); chapter IX is devoted to 'Page's Theories of Art'.

2. *Ibid.*, 111.

p. 162 3. *Ibid.*, 170.

4. Quoted in Lincoln Kirstein, *William Rimmer, 1816–1879* (exhibition catalogue, Whitney Museum of American Art, New York, 1946), introduction. This is the most understanding summary of Rimmer's life and art.

p. 163 5. This symbolism is fully worked out by Charles A. Sarnoff, 'The Meaning of William Rimmer's Flight and Pursuit', *The American Art Journal*, v, 1 (May 1973), 18–19.

6. Quoted in Thomas H. Bartlett, *The Art Life of William Rimmer, Sculptor, Painter, and Physician* (Boston and New York, 1890; reprinted ed., New York, 1970), 104.

7. Elihu Vedder, *The Digressions of V.* (Boston and New York, 1910), 134.

8. *Ibid.*, 136.

9. *Ibid.*, 194.

10. *Ibid.*, 264.

11. *Ibid.*, 259. The most comprehensive biography of the artist is Regina Soria, *Elihu Vedder, American Visionary Artist in Rome (1836–1923)* (Rutherford, N.J., 1970). See also her summary essay in *Paintings and Drawings by Elihu Vedder* (exhibition catalogue, Smithsonian Institution, Washington, D.C., 1966).

. 164 12. Quoted in Elsa Honig Fine, *The Afro-American Artist, A Search for Identity* (New York, 1973), 53.

13. Details from *ibid.*

14. The most thoughtful reappraisal of Blakelock's painting, if unnecessarily defensive and argumentative, is to be found in David Gebhard and Phyllis Stuurman, *The Enigma of Ralph A. Blakelock, 1847–1919* (exhibition catalogue, The Art Galleries, University of California, Santa Barbara, 1969).

15. *Ibid.*, 19.

16. See *ibid.*, 18; and Elliott Daingerfield, *Ralph Albert Blakelock* (New York, 1914), 19. p. 165

17. Useful biographical information in Fine, *op. cit.*, 67–75; Marcia M. Matthews, *Henry Ossawa Tanner* (Chicago, 1969); and Carroll Greene, Jr, *The Art of Henry Tanner* (exhibition catalogue, Smithsonian Institution, Washington, D.C., 1969). See also Ellwood Parry, *The Image of the Indian and the Black Man in American Art, 1590–1900* (New York, 1974), especially 163–8.

18. See Richard J. Boyle, 'The Second Half of the Nineteenth Century', in J. Wilmerding, ed., *The Genius of American Painting* (London and New York, 1973), 186–8; Donelson F. Hoopes, *The American Impressionists* (New York, 1972), 78–81; and Wanda M. Corn, *The Color of Mood: American Tonalism, 1880–1910* (exhibition catalogue, M. H. de Young Memorial Museum, San Francisco, 1972).

19. The primary source for information on p. 166 Ryder is Lloyd Goodrich's research. See his *Albert P. Ryder* (New York, 1959); and his *Albert Pinkham Ryder* (exhibition catalogue, Corcoran Gallery of Art, Washington, D.C., 1961).

20. *Idem, Ryder* (catalogue), 11.

21. A. P. Ryder, 'Paragraphs from the Studio of a Recluse', *Broadway Magazine*, XIV (September 1905), 10–11; quoted in John W. McCoubrey, *American Art, 1700–1960, Sources and Documents* (Englewood Cliffs, N.J., 1965), 187–8.

22. Goodrich, *Ryder* (catalogue), *op. cit.*, 12. p. 167

CHAPTER 22

1. Walter Pach, 'A Recollection of Arthur B. p. 168 Davies', in *Arthur B. Davies [1862–1928] A Centennial Exhibition* (exhibition catalogue, Munson–Williams–Proctor Institute, Utica, N.Y., 1962), 7.

2. Guy Pène du Bois, quoted in Milton W. Brown, *The Story of the Armory Show* (New York, 1963), 40.

3. *Ibid.*

4. See biographical and artistic summaries in Harris K. Prior, *Arthur B. Davies* (exhibition catalogue), *op. cit.*; and Mahonri Sharp Young, *The*

Eight, The Realist Revolt in American Painting (New York, 1973), 62–77. Also Duncan Phillips has a sympathetic appreciation in 'Arthur B. Davies, 1862–1928', *A Bulletin of the Phillips Collection* (Washington, D.C., 1929), 8–29.

p. 168 5. See the discussion of these influences in Hedley Howell Rhys, *Maurice Prendergast, 1859–1924* (exhibition catalogue, Museum of Fine Arts, Boston, 1960).

p. 169 6. See *ibid.*, 19. I am also indebted to Helen Singer of Chicago, who has extensively researched Prendergast's possible and actual uses of art illustrations in his work.

7. Quoted in William Inness Homer, *Robert Henri and His Circle* (Ithaca and London, 1969), 13. This gives a full account and analysis of Henri's life and art.

8. *Ibid.*, 28.

9. *Ibid.*, 32.

p. 170 10. Robert Henri, *The Art Spirit* (Philadelphia and London, 1923), 15, 17.

11. *Ibid.*, 242.

p. 171 12. Possibly as influential as West over a century earlier, and Hans Hofmann later in the twentieth century, Henri taught future artists as diverse and prominent as Stuart Davis, Guy Pène du Bois, and Rockwell Kent.

13. Luks' debt is evident in paintings such as his *Wrestlers* of 1905 (Museum of Fine Arts, Boston), which is reminiscent of Eakins' *Wrestlers* of 1899 (formerly National Academy of Design) and Anshutz's *Ironworkers Noontime* of c. 1883 (private collection). For a well illustrated survey and summary discussion see Joseph S. Trovato, *George Luks, 1866–1933* (exhibition catalogue, Munson–Williams–Proctor Institute, Utica, N.Y., 1973).

p. 172 14. John Sloan, *The Gist of Art* (New York, 1939), 44. Along with the ideas, later published, of Sloan and Henri, the early years of the century also saw major histories of American art undertaken by, most notably, Charles Henry Caffin, *The Story of American Painting* (New York, 1907); Sadakichi Hartman, *A History of American Art* (2 vols., Boston, 1902); Samuel Isham, *The History of American Painting* (New York, 1905); and Loredo Taft, *The History of American Sculpture* (New York, 1903). These might be viewed as related forms of celebration of American cultural progress and modernism. In another parallel the city also became

at this time an important setting for the novels of Theodore Dreiser and Frank Norris.

15. Sloan, *op. cit.*, 146.

16. *Ibid.*, 43.

17. Quoted in Charles H. Morgan, *George Bellows, Painter of America* (New York, 1965), 37.

18. See *ibid.*, 243, 270.

19. *Ibid.*, 263. p. 173

20. Quoted in Dorothy Norman, *Alfred Stieglitz, An American Seer* (New York, 1973), 45. This is a comprehensive source of first-hand and documentary information.

21. *Ibid.*, 77.

22. That year he held the first American showings of drawings by Rodin and Matisse, and in succeeding years works by Cézanne, Toulouse-Lautrec, Picasso, and Braque. Also shown were the Americans John Marin, Alfred Maurer, Arthur Dove, Max Weber, and Marsden Hartley, as well as children's art and African sculpture. Full listings in *ibid.*, 232–8.

23. *Ibid.*, 76. p. 174

CHAPTER 23

1. Milton W. Brown gives a full survey of the p. 175 occasion in his *Story of the Armory Show* (New York, 1963). See also his book covering the artistic developments of this period, *American Painting from the Armory Show to the Depression* (Princeton, N.J., 1970).

2. I am indebted here to the cogent and thoughtful essay of Meyer Schapiro, 'Rebellion in Art', in Daniel Aaron, ed., *America in Crisis* (New York, 1952), 203–42.

3. See Anne d'Harnoncourt and Kynaston Mc- p. 176 Shine, *Marcel Duchamp* (exhibition catalogue, Museum of Modern Art, New York, 1973), especially sections on 'Marcel Duchamp and the French Intellectual Tradition', and 'The Influence of Marcel Duchamp'. Also, George Heard Hamilton covers Duchamp's artistic achievements in his volume in the Pelican History of Art series, *Painting and Sculpture in Europe, 1880–1940* (Harmondsworth and Baltimore, 1967), 167–8, 242–7.

4. Quoted in *The Art of Stanton Macdonald-* p. 17 *Wright* (exhibition catalogue, National Collection of Fine Arts, Washington, D.C., 1967), 12.

5. *Ibid.*, 16.

6. Quoted in Sheldon Reich, *John Marin, A Stylistic Analysis and Catalogue Raisonné* (2 vols., Tucson, Ariz., 1970), I, 55.

p. 178 7. Quoted in Sheldon Reich, *Alfred H. Maurer, 1868–1932* (exhibition catalogue, National Collection of Fine Arts, Washington, D.C., 1973), 45.

p. 179 8. Quoted in Lloyd Goodrich, *Max Weber* (New York, 1949), 21.

9. *Ibid.*, 30–1.

10. Quoted in James Johnson Sweeney, *Stuart Davis* (New York, 1945), 9.

11. *Ibid.*, 10; see also E. C. Goosen, *Stuart Davis* (New York, 1959), 15–16.

p. 180 12. Quoted in John I. H. Baur, *Joseph Stella* (New York, 1971), 34.

13. *Ibid.*, 36.

14. *Ibid.*

15. *Ibid.*, 34. Baur's book is a balanced survey of Stella's life and art. The most comprehensive and thorough monograph is Irma Jaffe's *Joseph Stella* (Cambridge, Mass., 1970); see especially chapter VII.

16. *The Complete Poems of Hart Crane* (Anchor ed., Garden City, N.Y., 1958), 4. See also I. Jaffe's discussion of the relationship between Crane's and Stella's works in her *Stella, op. cit.*, 245–8.

p. 181 17. Others were of Marin, Hartley, Arthur Dove, and Gertrude Stein. See comment on the Williams painting in John W. McCoubrey, *Robert Indiana* (exhibition catalogue, Institute of Contemporary Art of the University of Pennsylvania, Philadelphia, 1968), 27.

18. Quoted in *ibid.*

19. Similar devices of fragmentation, repetition, and personal imagery characterize other poetry of this period, for example, that of Wallace Stevens, Marianne Moore, and e. e. cummings.

20. Sheeler once remarked that 'Photography is nature seen from the eyes outward, painting from the eyes inward'. Quoted in Martin Friedman, *et al.*, *Charles Sheeler* (exhibition catalogue, National Collection of Fine Arts, Washington, D.C., 1968), 40.

21. See Barbara Novak's discussion of Sheeler and precisionism in relationship to luminism in her *American Painting of the Nineteenth Century* (New York, 1969), chapter 15, especially 274–5. *Rolling Power* also belongs to the romantic tradition of Cropsey's *Starrucca Viaduct* and Inness's *Lackawanna Valley* (Plates 97 and 185).

CHAPTER 24

1. Working under various programmes of the p. 182
government were artists as diverse as Rockwell Kent, associated with Ash Can realism; Stuart Davis, Stanton Macdonald-Wright, and Joseph Stella, associated with various forms of abstraction and cubism; social realists like Ben Shahn, Moses Sawyer, and Reginald Marsh; more imaginative realists and surrealists like Jack Levine, Peter Blume, Paul Cadmus, and Morris Graves; and forerunners or exponents of abstract expressionism like Arshile Gorky, Jack Tworkov, Willem de Kooning, Philip Guston, and David Smith. Two important studies of the period are Richard D. McKenzie, *The New Deal for Artists* (Princeton, N. J., 1973); and William Stott, *Documentary Expression and Thirties America* (New York, 1973).

2. Thomas Hart Benton, *An American in Art, A Professional and Technical Autobiography* (Kansas City, Mo., 1951), 186.

3. *Ibid.*, 39.

4. See T. H. Benton, *The Arts of Life in America* (exhibition catalogue, Whitney Museum of American Art, New York, 1932).

5. See Darrell Garwood, *Artist in Iowa, A Life of* p. 183
Grant Wood (New York, 1944), 114–17; and Edward A. Maser, *Grant Wood, 1891–1942* (exhibition catalogue, University of Kansas Museum of Art, Lawrence, Kansas, 1959).

6. Quoted in Garwood, *op. cit.*, 180.

7. Closely parallel were currents in contemporary Regionalist literature, such as the novels of John Dos Passos, John Steinbeck, Sinclair Lewis, and Sherwood Anderson.

8. Benton, *An American in Art, op. cit.*, 147.

9. Quoted in James Thrall Soby, *Ben Shahn* p. 184
Paintings (New York, 1963), 14. See also this essay for a useful summary of Shahn's biography and career. In addition, publication in 1957 of Shahn's lectures at Harvard in *The Shape of Content* (Cambridge, Mass., 1957) confirmed him as an articulate and eloquent spokesman for the role and nature of the artist in modern life.

10. See Frank Getlein, *Jack Levine* (New York, 1966), 20.

11. At one point Burchfield kept a notebook of drawings called 'Conventions for Abstract Thought', in which he associated certain figural details with types of feeling (such as staring eyes

and imbecility, ragged teeth and dangerous brood-ing, etc.). See John I. H. Baur, *Charles Burchfield* (New York, 1956), 28 ff.

p. 185 12. *Ibid.*, 47. Baur also quotes at length Burch-field's description of finding and painting in 1929 an old farmhouse on a September afternoon. The clouds alone were 'a galaxy of shapes and colors so marvelous as to put despair into my heart' (*ibid.*, 48). On this and related pictures in the Fogg see Benjamin Rowland, Jr, 'Burchfield's Seasons', *The Bulletin of the Fogg Museum of Art*, x (November 1946), 155–61.

 13. See Frederick S. Wight, *Morris Graves* (Berkeley and Los Angeles, 1956), 16–20. Other useful references are *Morris Graves, A Retrospective* (exhibition catalogue, University of Oregon Museum of Art, Eugene, 1966); and John Cage, *et al., The Drawings of Morris Graves* (New York, 1975).

p. 186 14. Quoted in Frederick A. Sweet, *Ivan Albright* (exhibition catalogue, Art Institute of Chicago, Chicago, 1964), 16.

 15. *Ibid.*

 16. Quoted in Nancy Newhall, ed., *Edward Weston, The Flame of Recognition* (New York, 1971), 33–4.

 17. With thoughtful humour Weston could write: 'It has been suggested that I am a cannibal to eat my models after a masterpiece. But I rather like the idea that they become a part of me, enrich my blood as well as my vision' (*ibid.*, 33).

p. 187 18. A probing examination of this subject is in Stott, *op. cit.*, part four. See also John Szarkowski, *Walker Evans* (New York, 1971), introduction.

 19. James Agee and Walker Evans, *Let Us Now Praise Famous Men, Three Tenant Families* (reprinted ed., Boston, 1969), 143.

p. 188 20. Quoted in Lloyd Goodrich, *Edward Hopper* (New York, 1971), 31. This is the most compre-hensive and fully illustrated monograph on Hopper. See also the thoughtful essay on Hopper by William C. Seitz in *Sao Paulo 9, United States of America* (exhibition catalogue, National Collection of Fine Arts, Washington, D.C., 1967), 17–28.

p. 189 21. Moreover, there is an expressive energy in many of Wyeth's drawings and preparatory water-colours, which are unexpectedly close to the abstract expressionist work of painters like Franz Kline. Of all the literature accumulating on Wyeth, an artist of almost unique popularity in his lifetime, perhaps the most interesting and persuasive study is Wanda M. Corn's *The Art of Andrew Wyeth* (exhibition catalogue, Fine Arts Museums of San Francisco, San Francisco, 1973).

CHAPTER 25

 1. I am indebted for biographical and artistic p. 190 information on Nadelman to Lincoln Kirstein's exemplary monograph, *Elie Nadelman* (New York, 1973), eloquent equally in its interpretation and production.

 2. *Ibid.*, 170. A specific precedent Nadelman may have had in mind was Matisse's *Serpentine* of 1909.

 3. Upon seeing Lachaise's first exhibition in p. 191 1918, Daniel Chester French, the venerable arbiter of American academic classicism, proclaimed, 'his vision is monstrous'. One can understand why by comparing their work (see Plates 184 and 240). Quotation from Gerald Nordland, *Gaston Lachaise, 1882–1935, Sculpture and Drawings* (exhibition catalogue, Los Angeles County Museum of Art, Los Angeles, 1963). For further information see also Hilton Kramer, *et al., The Sculpture of Gaston Lachaise* (New York, 1967).

 4. Nordland, *op. cit.*

 5. For a more detailed comparison of Lachaise and Nadelman see *ibid.*, and Kirstein, *op. cit.*, 27–8.

 6. *Letters of John Flannagan* (New York, 1942), 20, 83. Many of the same qualities are evident in the work of Flannagan's contemporary, William Zorach (1887–1966), also a sculptor engaged in defining the transition from classicism to modern-ism. Another stone carver of great interest is the Black sculptor William Edmondson (c. 1883–1951) of Tennessee, whose figural tombstones share a similar quality of modern abstraction com-bined with the vernacular strength of folk art craftsmanship. See Edmund L. Fuller, *Visions in Stone, The Sculpture of William Edmondson* (Pitts-burgh, Pa., 1973).

 7. Isamu Noguchi, *A Sculptor's World* (London p. 19 and New York, 1967), 15. Borglum was of course to be known later for his monumental carvings of American presidents on the face of Mount Rush-more in South Dakota.

 8. *Ibid.*, 16.

 9. *Ibid.*, 17.

 10. *Ibid.*, 165.

 11. *Ibid.*, 28, 39.

p. 193 12. Quoted in Frederick S. Wight, *Arthur G. Dove* (Berkeley and Los Angeles, 1958), 30.

13. *Ibid.*, 37.

p. 194 14. Quoted in Lloyd Goodrich and Doris Bry, *Georgia O'Keeffe* (exhibition catalogue, Whitney Museum of American Art, New York, 1970), 9.

15. For helpful summary information see Elsa Honig Fine, *The Afro-American Artist, A Search for Identity* (New York, 1973), 112–20.

p. 195 16. The intense competition to acquire the pictures culminated with the Museum of Modern Art and the Phillips Collection agreeing to divide the series between them.

17. For a fuller analysis of Hofmann's background and development see Sam Hunter, *Hans Hofmann* (New York, 1963).

18. *Ibid.*, 12. Hofmann as a teacher was as influential in his time as Benjamin West and Robert Henri had been earlier. Hofmann's students included artists as eminent and varied as Helen Frankenthaler, Allan Kaprow, Conrad Marca-Relli, Marisol, Louise Nevelson, George Ortman, Larry Rivers, and Richard Stankiewicz (see Plates 260, 278, 267, and 272).

19. *Ibid.*, 41, 14. p. 196

20. *Ibid.*, 40.

21. Quoted in Julien Levy, *Arshile Gorky* (New York, 1966), 15.

22. See *ibid.*, 24. See also the more interpretative study by Harold Rosenberg: *Arshile Gorky, The Man, The Time, The Idea* (New York, 1962).

23. Levy, *op. cit.*, 30. See also William C. Seitz, *Arshile Gorky, Paintings, Drawings, Studies* (exhibition catalogue, Museum of Modern Art, New York, 1962), especially 40–1.

CHAPTER 26

p. 201 1. The term 'abstract expressionism' is often associated with Alfred Barr, who had earlier used it in discussing Kandinsky's work. He also referred to the movement as The New American Painting, the title of his summary exhibition catalogue (Museum of Modern Art, New York, 1959). Harold Rosenberg, another major critic of this period, is credited with the term 'action painting', one useful enough for many of the major figures, but which tends to exclude or slight the colour-field painters and the more contemplative side of the movement. See Irving Sandler, *The Triumph of American Painting, A History of Abstract Expressionism* (New York, 1970), 270.

Others have used the title 'New York School', reflecting the primary development of this group in New York, yet this also is too narrow, excluding such figures as Mark Tobey. See Dore Ashton, *The New York School, A Cultural Reckoning* (New York, 1973), a study emphasizing the intellectual and social background of the school's development.

2. Most notable of these immigrants were André Breton, Marc Chagall, Salvador Dali, Max Ernst, Fernand Léger, Jacques Lipchitz, André Masson, Matta Echaurren, Piet Mondrian, Amédée Ozenfant, and Yves Tanguy.

3. Quoted in Bryan Robertson, *Jackson Pollock* (New York, 1960), 193. This is a comprehensive examination of Pollock's artistic development. For a more interpretative biography, emphasizing the personal background and documentary material, see B. H. Friedman, *Jackson Pollock, Energy Made Visible* (New York, 1972).

p. 202 4. See the discussion of this in the important catalogue essay by Michael Fried, *Three American Painters, Kenneth Noland, Jules Olitski, Frank Stella* (exhibition catalogue, Fogg Art Museum, Harvard University, Cambridge, Mass., 1965), part II.

5. Written in 1948, quoted in Robertson, *op. cit.*, 193.

6. The phrase 'Crisis of the Easel Picture' is Clement Greenberg's, and the title of his short but penetrating essay of 1948, reprinted in his *Art and Culture, Critical Essays* (Boston, 1961), 154–7. Also described in that article is the concept of 'all-over' painting, another phrase since joined to the language of abstract expressionism.

7. See, for example, Ferlinghetti's book of poems, p. 203 *Starting From San Francisco* (New Directions ed., New York, 1967), whose title consciously recalls Whitman's lines of a century earlier: 'Starting from Paumanok . . . I strike up for a New World.'

The paintings of Kline and Pierre Soulages also make a revealing comparison. The latter's work retains a classical spirit of order, restraint, and self-containment characteristic of the French tradition from Poussin through Ingres and Degas to Cézanne and Braque. In spite of the broad energetic brushstrokes, Soulages' paintings remain essentially figurative, and bounded within the framing edges.

8. Quoted in William C. Seitz, *Mark Tobey* (exhibition catalogue, Museum of Modern Art, New York, 1962), 38.

9. Quoted in Sandler, *op. cit.*, 256. See also John Gordon, *Franz Kline, 1910–1962* (exhibition catalogue, Whitney Museum of American Art, New York, 1968).

10. Quoted in Sandler, 122. For further informa- p. 20 tion on de Kooning see Thomas B. Hess, *Willem de Kooning* (exhibition catalogue, Museum of Modern Art, New York, 1968). After painting a group of abstract landscapes, de Kooning returned to new versions of the *Woman* theme in the 1960s, and in the mid seventies he turned to producing expressionist bronze sculptures. See Peter Schjeldahl, 'De Kooning's Sculptures: Amplified Touch', *Art in America*, LXII, 2 (March–April 1974), 59–63.

11. See Marjorie Phillips, *Duncan Phillips and his* p. 20 *Collection* (Boston, 1970), 288. Rothko talked of one section of another work in the Phillips Collection as analogous to happiness, another to worry. In this regard a deepening gloom seemed to infuse his later life and art, terminated by suicide in 1970.

12. Quoted in Sandler, *op. cit.*, 189–90.

13. Thomas B. Hess gives the most persuasive and probing interpretation of the religious content of Newman's painting in his *Barnett Newman* (New York, 1971), to which I am much indebted for my discussion here.

14. See *ibid.*, 65 ff. Hess notes that Newman had in mind Pollock's recent large canvases measuring exactly nine by eighteen feet, an all too static and traditional proportion, Newman felt. In addition, the number eighteen had multiple symbolic associations for the artist, relating to Jewish ritual and history, etc.

15. The comparison with West is not idle, for it turns out that the final form of the title occurred to Newman after he had heard the news on 11 April 1951 that President Truman was relieving General Douglas McArthur of his Korean War command. Here were raised again the great questions of human conduct, of Man, Heroic and Sublime. See *ibid.*, 81 ff.

Newman called his marking lines 'zips', for they move equally up and down, dividing as well as joining adjacent panels.

p. 206
16. Sandler comments on the arguments for this interpretation in *ibid.*, 162, 174.

17. Quoted in *ibid.*, 170. Compare these words with Worthington Whittredge's, quoted in Chapter 11, page 89.

18. Quoted in John W. McCoubrey, ed., *American Art, 1700–1960, Sources and Documents* (Englewood Cliffs, N. J., 1965), 211.

19. Among the major figures on this central ground would be James Brooks, Bradley Walker Tomlin, William Baziotes, Jack Tworkov, and Philip Guston. Generally speaking, they all belonged to the first generation of abstract expressionists, born in or close to the first decade of the twentieth century.

20. See Sandler, *op. cit.*, 193. For further information see also Robert Doty and Diane Waldman, *Adolph Gottlieb* (exhibition catalogue, Whitney Museum of American Art and Guggenheim Museum, New York, 1968), part 1; and Martin Friedman, *Adolph Gottlieb* (exhibition catalogue, Walker Art Center, Minneapolis, Minn., 1963).

p. 207
21. Quoted in Sandler, 207.

22. Quoted in Frank O'Hara, *Robert Motherwell* (exhibition catalogue, Museum of Modern Art, New York, 1965), 43. Furthermore, the title came from a line by Baudelaire, 'To the depths of the unknown to find the new'. See Sandler, 203.

23. Others born in the decade of the twenties include Sam Francis, Joan Mitchell, Theodoros Stamos, and Grace Hartigan.

24. Quoted in Barbara Rose, *Frankenthaler* (New York, 1970), 29.

CHAPTER 27

1. Quoted in Frederick S. Wight, *Arthur G. Dove* (Berkeley and Los Angeles, 1958), 62. p. 208

2. The fullest survey of this movement is William C. Seitz's *The Art of Assemblage* (exhibition catalogue, Museum of Modern Art, New York, 1961). See also George Rickey, *Constructivism: Origins and Evolution* (New York, 1967).

3. For fuller biographical information and exten- p. 209 sive pictorial surveys of Calder's work see H. H. Arnason, *Calder* (New York, 1966); Alexander Calder, *Calder, an Autobiography with Pictures* (New York, 1966); and H. Harvard Arnason, *et al.*, *Calder* (New York, 1971).

4. Quoted in Seitz, *op. cit.*, 77. I am indebted to Jack O'Neil for assistance in studying the Towers, and for insights into contemporary California culture.

5. Among the most notable being Theodore Roszak, Seymour Lipton, Ibram Lassaw, David Hare, Reuben Nakian, and Herbert Ferber. Most were born during the first decade of the century, and worked under the combined influences of surrealism and constructivism. They experimented with different techniques of welding, hammering, brazing, etc. on a wide variety of metals, including bronze, nickel, steel, and iron. For a well-illustrated survey see Dore Ashton, *Modern American Sculpture* (New York, 1968).

6. See Jane Harrison Cone, *David Smith, 1906–* p. 210 *1965* (exhibition catalogue, Fogg Art Museum, Harvard University, Cambridge, Mass., 1966), 6. This provides a thoughtful analysis and summary of Smith's career.

7. Quoted in Rosalind E. Krauss, *Terminal Iron Works, The Sculpture of David Smith* (Cambridge, Mass., and London, 1971), 10.

8. This argument is at the heart of Krauss' provocative and probing study. If at times unnecessarily polemical, she nonetheless examines Smith's achievement with an intelligence and originality equal to the subject.

9. See *ibid.*, 56 ff.

10. *Ibid.*, 62. p. 211

11. Quoted in *ibid.*, 51.

12. Quoted in *ibid.*, 178. This is quite distinct from the interpretation of these late works as dematerializing as in a form of Impressionism, in the surrounding light and atmosphere. See Krauss' commentary on this argument, 114–16.

p. 211 13. Others being Richard Stankiewicz, Lee Bontecou, Edward Higgins, and Bruce Connor, all born during the twenties or early thirties. Chamberlain turned to painting for a few years in the mid sixties, and in the early seventies worked with crushed sculptures in other media, such as plexiglass, paper, and urethane foam. These often possess a sexual character, an association with violence to his materials that also recalls Smith's art.

p. 212 14. Quoted in Daniel Mendelowitz, *A History of American Art* (2nd ed., New York, 1971), 495.

15. Also Jasper Johns, Louise Bourgeois, and Gabriel Kohn.

p. 213 16. Quoted in Arnold B. Glimcher, *Louise Nevelson* (New York, 1972), 22.

17. *Ibid.*, 22–3. In the sixties Nevelson painted some groups all white or gold, in allusion to conditions of day or night, royalty and majesty, or the otherworldliness of some spiritual realm. Returning to compositions in black at the end of the decade and during the seventies, she undertook monumental pieces in metals and fibreglass, occasionally introducing mirrors, but always evoking a combination of grace and strength, along with concreteness and mystery.

p. 214 18. For a more extensive description of his working procedures see Elsa Honig Fine, *The Afro-American Artist, A Search for Identity* (New York, 1973), 224. Gilliam's conception of the objecthood of his canvas is carried a step further by Christo in his *Valley Curtain* of 1972 (Plate 299).

19. Quoted in *ibid.*, 225–6.

CHAPTER 28

p. 215 1. Robert Rauschenberg, 'Autobiography', in Andrew Forge, *Rauschenberg* (New York, n. d. [1970?]), 226, a full-length monograph printed to be almost illegible. See also the condensed version (Meridian ed., New York, 1973), 80. For fuller comparisons of the similarities and differences between the two artists see Max Kozloff, *Jasper Johns* (New York, 1969), 36–7; and Lawrence Alloway, *American Pop Art* (exhibition catalogue, Whitney Museum of American Art, New York, 1974), 52–5. Despite their inclusion by Alloway in the Pop movement per se, both Rauschenberg and Johns are more convincingly viewed as major precursors or progenitors of Pop art.

2. Rauschenberg, 'Autobiography' (Meridian ed.), *op. cit.*, 79.

3. See Alan R. Solomon's useful discussion in his *Robert Rauschenberg* (exhibition catalogue, The Jewish Museum, New York, 1963).

4. *Ibid.*

5. Quoted in Alloway, *op. cit.*, 63. p. 216

6. *Ibid.*, 65.

7. Quoted in Solomon, *op. cit.*

8. In related works of this period he tested further the property and capacity of his objects in different contexts; for example, he perceived other aspects of the tyre through its reappearance in *First Landing Jump* of 1961 (Philip Johnson Collection, New Canaan, Conn.) and *Tadpole* of 1963 (Collection Bruno Rischofberger, Zürich, Switzerland). See Alloway, *op. cit.*, 63–5.

9. See also the precedents of Rothko and Newman in relationship to his and Johns' work, such as his *White Painting (Seven Panels)* of 1951 (collection of the artist) and Johns' flag, alphabet, and number paintings a few years later.

10. Quoted in Kozlov, *op. cit.*, 18. See also his p. 217 shorter essay on the artist published subsequently, *Jasper Johns* (Meridian ed., New York, 1973). Also compare these paintings with Indiana's hard-edged number series and Stella's schematized colour structures of a decade later (see Plates 279 and 293).

11. Quoted in Kozlov, *Johns*, 40. A variant, 'Take a canvas. Put a mark on it. Put another mark on it. Ditto', is quoted in his Meridian ed., 16. Note, too, that Johns has read the writings of Marshall McLuhan and Ludwig Wittgenstein on the nature of language and visual and verbal meanings.

12. For example, *The Studio* (1956, Minneapolis p. 21 Institute of Arts, Minneapolis, Minn.), a canvas of over six by sixteen feet, alluding not only to Courbet's *Atelier*, but also to a figure in Delacroix's *Liberty at the Barricade*, the composition of Gauguin's *Whence Come We?*, along with quotations from Rivers' own earlier works (his *Double Portrait of Berdie* of the preceding year) and additional portraits of his family and friends. Further, it combines portraiture with interior genre, exterior landscape, and informal history painting. For a comprehensive and well-illustrated discussion of Rivers see Sam Hunter, *Larry Rivers* (New York, 1969); and the condensed version (Meridian ed., New York, 1973).

13. Fuller biographical information in Adelyn D. Breeskin and Rudy H. Turk, *Scholder/Indians* (Flagstaff, Ariz., 1972).

14. *Ibid.*, 32. See also 2.

p. 219 15. What Norman Mailer has called 'The Faith of Graffiti'; see his rather puffy book by that title (New York, 1974). For further information on Saunders and excerpts from his statements see Elsa Honig Fine, *The Afro-American Artist, A Search for Identity* (New York, 1973), 262–3.

16. These themes are comprehensively and convincingly analysed in Dore Ashton's *Richard Lindner* (New York, 1969).

p. 220 17. Quoted in M. Bunch Washington, *The Art of Romare Bearden, The Prevalence of Ritual* (New York, 1973), 22.

p. 221 18. See biographical details and technical information in Maurice Tuchman, *Edward Kienholz* (exhibition catalogue, Los Angeles County Museum of Art, Los Angeles, Cal., 1966). In addition to its other objects, real and invented, *The Beanery* of 1965 also contained elements of sound and smell in a tape recorder and 'odour-producing chemicals'. See *ibid.*, 52 ff.

19. *Ibid.*, 8.

20. *Ibid.*

21. See Leon Shulman, *Marisol* (exhibition catalogue, Worcester Art Museum, Worcester, Mass., 1971).

CHAPTER 29

p. 222 1. From an interview with G. R. Swenson, 1963; quoted in John Russell and Suzi Gablik, *Pop Art Redefined* (New York, 1969), 92. This remains one of the most useful publications on the movement, along with Lucy R. Lippard's *Pop Art* (New York, 1966). See also Mario Amaya, *Pop Art and After* (New York, 1966). The titling of the movement is credited to Lawrence Alloway, an observer of the Pop scene since the fifties and in America thereafter; see his *American Pop Art* (exhibition catalogue, Whitney Museum of American Art, New York, 1974). English Pop tended to be more of a conservative parallel, than an influential precedent, of the American developments.

2. Consider the precedent of balloon-frame construction technology and its making equally available different architectural styles across the country in the years after the Civil War.

3. On this subject see Daniel Boorstin's important and provocative book, *The Image, A Guide to Pseudo-Events in America* (Harper Colophon ed., New York, 1961).

4. Quoted in John W. McCoubrey, *Robert Indiana* (exhibition catalogue, Institute of Contemporary Art of the University of Pennsylvania, Philadelphia, 1968), 9. This is the best and most comprehensive publication of documentary and interpretative material on Indiana. p. 223

5. Indiana called Demuth's work 'my favorite American painting in New York City's Metropolitan Museum'. For further associations attached by Indiana to his picture see *ibid.*, 27. His dream of numbers should also be thought of in relation to such realities as computerization and cybernetics in modern life.

6. Other pictures, such as *Silo* (1963–4, Tate Gallery, London) and *Director* (1964, private collection) specifically suggest sources in de Kooning's *Women* series. p. 224

7. Marcia Tucker effectively analyses this as 'a pictorial metaphor for how we see and experience things in the world', in her *James Rosenquist* (exhibition catalogue, Whitney Museum of American Art, New York, 1972), 14. Lawrence Alloway takes issue with her argument in his *American Pop Art, op. cit.*, 88.

8. From an interview with G. R. Swenson, 1964; quoted in Russell and Gablik, *op. cit.*, 112.

9. *Ibid.*, 104, 106, 111, 112. Rosenquist also talked of working with 'pink, yellow, and blue, which are the three basic colors of the spectrum' (107). At the same time he frequently shifted these hues slightly to variations of red, white, and blue, the national colours, thus combining conceptually basic formal and symbolic issues. See also Alloway, *op. cit.*, 88.

10. Russell and Gablik, *op. cit.*, 112. Compare the muscular bigness Rosenquist suggests of America with the abstract expressionist parallels by his fellow North Dakotan, Clyfford Still (Plate 257).

After President Kennedy's assassination in 1963, with violence flaring in city ghettos, and America's arms commitments accelerating in Southeast Asia, Rosenquist turned to more apocalyptic and topical themes, such as his celebrated eighty-six-foot canvas, *F-111* (Collection Mr and Mrs Robert Scull).

11. For further information on his procedures, and extensive illustrations in colour, see Diane Waldman, *Roy Lichtenstein* (New York, 1971).

12. See Albert Boime, 'Roy Lichtenstein and the Comic Strip', *Art Journal*, II (1968–9), 155–60. p. 225

13. For further relationships between Pop and other parallel styles see Robert Rosenblum, 'Pop

Art and Non-Pop Art', in Russell and Gablik, *op. cit.*, 53–6.

p. 225 14. Note that Indiana also made a painting of the word ART; Rosenquist titled one picture *Binoculars* and another *Sightseeing*. Closely related are the numerous works by Jim Dine and others that are emblematic of the artist's studio; for example, Dine's *Paint Boxes Color Chart, Studio Wall, Studio Landscape,* and *Palette (Self Portrait)*. In sculpture George Segal modelled a plaster of *John Chamberlain Working*.

Pop art and life were served with the loan of the *Mona Lisa* to New York's Metropolitan Museum in this decade, while the Pope sent Michelangelo's *Pietà* to the New York World's Fair in 1964, where it was placed in a setting contrived by the Broadway show set designer Jo Mielziner.

15. Quoted in *Andy Warhol* (exhibition catalogue, Moderna Museet, Stockholm, 1968).

16. *Ibid.* For further details on his methods of work see Rainer Crone, *Andy Warhol* (New York, 1970), 10–11, 23–4; and John Coplans, *Andy Warhol* (New York, 1970), 50–1.

p. 226 17. *Warhol* (Moderna Museet catalogue), *op. cit.* There are other connections between Pop and minimal art, such as Richard Artschwager's bureau drawers, *Portrait II* (collection of the artist), or Joe Goode's *Staircase* (Collection Ron Cooper, Venice, Cal.), and Don Judd's stainless steel boxes.

18. Quoted in Russell and Gablik, *op. cit.*, 118.

19. One of his last series was *Silver Clouds*, 'a painting that floats . . . the idea is to fill them with helium and let them out of your window and they'll float away and that's one less object . . . to move around. And, it's the, . . . well, it's the way of finishing up painting and . . .' Quoted in Crone, *op. cit.*, 30. This directly forecasts the emergence of conceptual and process art in the later sixties and early seventies. On Warhol's films see Stephen Koch, *Stargazer, Andy Warhol's World and His Films* (New York, 1973).

20. One might also note the constructed and painted figures of Red Grooms, who evolves more out of the junk assemblage tradition; and Duane Hanson, whose polyester and fibreglass casts of live models carry Pop over into the concurrent development of super-realism in both painting and sculpture during the sixties and seventies.

21. Claes Oldenburg, *Store Days* (New York, 1967), 39, 41. The most thoroughgoing analysis of

Oldenburg's work is Barbara Rose's *Claes Oldenburg* (New York, 1970).

22. 'What interests me is a series of shocks and p. 22 encounters that a person can have moving through space around objects placed in careful relationship.' Quoted in Jeanne C. Wasserman, *Recent Figure Sculpture* (exhibition catalogue, Fogg Art Museum, Harvard University, Cambridge, Mass., 1972), 40.

23. Furthering the comparison is the fact that the details of Olympia's nipples are not shown (obscured under the harsh flattening light), while often Matisse's figures (e.g., *The Pink Nude*, 1935) are without facial features (to emphasize purely formal or decorative values).

During the later sixties Wesselmann isolated each of these erogenous features in its own gigantic landscape, as a fetish still life (or more accurately in the French, *nature morte*) exemplary of American attitudes towards sex, sexism, and pornography.

24. See the trenchant discussion of Pearlstein by p. 22 Linda Nochlin in her *Philip Pearlstein* (exhibition catalogue, Georgia Museum of Art, Athens, Ga., 1970), from which this quotation is taken.

This movement has been variously termed sharp-focus, hyper, or super realism. Others working in this manner are Alfred Leslie, Richard McLean, and Robert Bectle.

One of the important developments related to the re-emergence of realist painting in the 1960s, both within and outside the Pop movement, was the renewed attention to and major re-investigation of nineteenth-century American realism, initiated in the same period. See, for example, the exemplary studies by David C. Huntington, *The Landscapes of Frederic Edwin Church* (New York, 1966); Sylvan Schendler, *Eakins* (Boston, 1967); and Barbara Novak, *American Painting of the Nineteenth Century* (New York, 1969).

25. About two tablespoons of black acrylic paint for one portrait. For details see Cindy Nemser, 'Presenting Charles Close', *Art in America*, 1 (January–February 1970), 98–101.

26. *Diane Arbus* (Milletron, New York, 1972), 9.

27. *Ibid.*, 3.

28. *Ibid.*, 12.

29. *Ibid.*, 5. On another occasion she remarked: 'It's what I've never seen before that I recognize . . . I'm trying to get back to some kind of obscurity.' See *ibid.*, title page and 9.

CHAPTER 30

p. 230 1. See Dore Ashton's balanced and cogent summary of this period, 'From the 1960's to the Present Day', in John Wilmerding, ed., *The Genius of American Painting* (New York and London, 1973). Also Sam Hunter, *American Art of the 20th Century* (New York, 1972), chapters 11, 12, 13; an especially intelligent, comprehensive, and extensively illustrated survey (2nd ed., 1974, with chapters on architecture by John Jacobus).

2. Similarly, one could argue that the severe abstraction of controlled geometry and symmetry in Mondrian, Kandinsky, and Malevich are responses to the profound disruptions of World War I. However, it is interesting to compare their respective philosophies of utopianism or idealism with American abstract expressionism after World War II, which combines an unavoidable anguish with its optimism. In turn, abstraction in American painting of the late sixties seems drained even of that exuberance; its order is more methodical and mechanical, its beauty more hermetic and self-referring.

3. The three other variant systems are for three colours, and respectively read (across by up and down): 2, 1, 4, 1, 2×1, $\frac{1}{2}$, 4, $1\frac{1}{2}$, 3; 1, 2, 4, 2, $1 \times \frac{1}{2}$, 1, 4, 3, $1\frac{1}{2}$; and 1, 1, 6, 1, $1 \times \frac{1}{2}$, $\frac{1}{2}$, 6, $1\frac{1}{2}$, $1\frac{1}{2}$. See diagrams and related discussion in Werner Spies, *Albers* (New York, 1970), 49; and Euge˙ Gomringer, *Josef Albers* (New York, 1968), 139.

4. Quoted in Gomringer, 137.

p. 231 5. *Ibid.*, 104. See also Albers' most influential publication, *Interaction of Color* (New Haven, Conn., and London, 1963). Relatively uncommon in his *Homage* series is the device in *Apparition* of the diagonal lines at the corners, adding further to the illusory quality of a receding/advancing frame.

As a final felicity, we may note the appropriateness of Albers' choosing to live during his later years in a town with the name of a colour: Orange, Connecticut.

6. Other notable examples would be the painters Kenneth Noland, Gene Davis, Larry Zox, Hannes Beckmann; and sculptors Larry Bell and Don Judd. See William C. Seitz, *The Responsive Eye* (exhibition catalogue, Museum of Modern Art, New York, 1965); and John Coplans, *Serial Imagery* (exhibition catalogue, Pasadena Art Museum, Pasadena, Cal., 1968).

7. For example, Dan Flavin and James Seawright. See especially Jack Burnham's provocative book *Beyond Modern Sculpture, The Effects of Science and Technology on the Sculpture of this Century* (New York, 1968); and Douglas Davis, *Art and the Future, A History/Prophecy of the Collaboration Between Science, Technology and Art* (New York, 1973).

8. In the latter, words, syllables, or letters are p. 232 arranged across a page so that the eye and ear are made aware of the visual or aural properties of language, concrete in themselves, and not necessarily as vehicles of narration or information beyond themselves.

9. Information from E. C. Goosen's exemplary study of the artist, *Ellsworth Kelly* (exhibition catalogue, Museum of Modern Art, New York, 1973). See also Phyllis Tuchman, 'Ellsworth Kelly's Photographs', *Art in America*, 1 (January–February 1974), 55–61.

10. Quoted in William Rubin, *Frank Stella* (exhibition catalogue, Museum of Modern Art, New York, 1970), 10.

11. Indicative of Stella's matter-of-factness, p. 233 these swaths of paint were intended less as autobiographical gestures than, according to his friend and fellow artist Carl André, as 'the paths of brush on canvas'. Quoted in Dorothy Miller, ed., *Sixteen Americans* (exhibition catalogue, Museum of Modern Art, New York, 1959), 76. For further interpretation and stylistic chronology see Rubin, *op. cit.*; and Robert Rosenblum, *Penguin New Art*, 1, *Frank Stella* (Harmondsworth and Baltimore, 1971).

To some these were visual tautologies, borne out by such statements from Stella as, 'When I'm painting the picture, I'm painting a picture'; or 'What you see is what you see.' Quoted in Rubin, 37, 42. Depending on one's critical viewpoint, they were single-minded or narrow-minded explorations of a discrete formal and perceptual problem.

With regard to the reciprocal relationship between surface pattern and shaping edges, two of Stella's principal proponents, William Rubin and Michael Fried, have argued over which element is the determining formal force. See Michael Fried, *Three American Painters, Kenneth Noland, Jules Olitski, Frank Stella* (exhibition catalogue, Fogg Art Museum, Harvard University, Cambridge, Mass., 1965), part v; also his 'Shape as Form: Frank Stella's New Paintings', *Artforum* (November 1966), 18–27; and Rubin, *op. cit.*, 54–60.

p. 233 12. The series totalled ninety-three in all; there were thirty-one related formats, each in three variations called respectively 'interlaces', 'rainbows', and 'fans'. See diagrams in Rubin, 136–7, and discussion 127 ff.

13. See Smith's remark: 'In the studio they remind me of Stonehenge . . . if the light is subdued a little, it has more of the archaic and prehistoric look that I prefer.' Quoted in Lucy R. Lippard, *Tony Smith* (New York, 1972), 19. Smith also recalled from childhood his strong impressions of the pueblo dwellings in Mesa Verde, New Mexico, both as primitive and as organic forms. See *ibid.*, 8, 19.

p. 234 14. Also included within the group of the so-called 'Washington colour painters' were Gene Davis, Thomas Downing, Howard Mehring, and Paul Reed. See Gerald Nordland, *The Washington Color Painters* (exhibition catalogue, Washington Gallery of Modern Art, Washington, D.C., 1965). On Noland see Fried, *op. cit.*, part III; and on Louis see *idem, Morris Louis* (New York, 1972).

Other contemporaries of Louis have worked extensively in colour-stained fields, notably Sam Francis and Paul Jenkins, but seldom achieving the same economy yet force of expression.

15. For biographical details and an ardent partisan exposition of Olitski's career see Kenworth Moffett, *Jules Olitski* (exhibition catalogue, Museum of Fine Arts, Boston, 1973).

Olitski's art especially has been subject to opposing extremes of critical viewpoints; on the one hand: 'There is a unique and highly cultivated thrill in watching initial simplicity, even blankness, yield ultimate richness and fullness of experience' (*ibid.*, 17). And on the other: 'Formalist critics always bypass the conceptual element in works of art . . . "They're visual *Muzak*"' (Joseph Kosuth and Lucy Lippard, quoted in Ursula Meyer, *Conceptual Art* (New York, 1972), 161).

p. 235 16. Details from Robert Pincus-Witten and Linda Shearer, *Eva Hesse: A Memorial Exhibition* (exhibition catalogue, Guggenheim Museum, New York, 1972). From Hesse's notebooks: '1. Mother force: unstable, creative, sexual, threatening my stability, sadistic – aggressive. 2. Father, Stepmother force: good little girl, obedient, neat, clean, organized–masochistic.' Quoted in *ibid*.

17. *Ibid.*

18. *Ibid.*

19. Quoted in Meyer, *op. cit.*, 137. Some of this thinking relates to fields such as perceptual psychology and information theory. But it also relates to Rauschenberg's telegram to Iris Clert's request for a portrait: 'This is a portrait of Iris Clert if I say so.' Quoted in Lucy R. Lippard, *Pop Art* (New York, 1966), 23.

Similar ideas recur in statements made by many of Huebler's colleagues: 'I do not mind objects, but I do not care to make them' (Lawrence Weiner). 'All ideas are art if they are concerned with art and fall within the conventions of art' (Sol Lewitt). *Ibid.*, 217, 175. The most comprehensive documentary survey is Lucy R. Lippard's *Six Years: The dematerialization of the art object from 1966 to 1972* (New York, 1973).

20. Others were moulds and casts of parts of his p. 236 body, films and videotapes of his face or movements, the spelling of his name in neon, and created spaces which defined different relationships of his (and the spectator's) physical presence to his surroundings.

Typical of Acconci was his film *Hand in Mouth* (1970): 'Pushing my hand into my mouth until I begin choking and am forced to release it. Repeating the activity for the duration of the film.' See Meyer, *op. cit.*, 4–5. Also see the issue of *Avalanche* magazine (Fall 1972) devoted to Acconci.

21. The former project was at the invitation of the then director Jan van der Marck, who defended it in his article, 'Why Pack a Museum', *Arts Canada* (Toronto, October 1969). For discussion and extensive photographic coverage see David Bourdon, *Christo* (New York, 1970).

22. Characteristic of concept art, this project, too, now exists only in documentary form. See Christo, *Valley Curtain* (New York, 1973), consisting entirely of all the records and correspondence pertaining to the work, plus full photographic coverage in black and white and colour.

23. Quotations from Lippard, *Six Years, op. cit.*, p. 237 56, 87, 89. See also Susan Ginsburg and Joseph Masheck, *Robert Smithson: Drawings* (exhibition catalogue, The New York Cultural Center, New York, 1974).

24. Another conceptual artist, Iain Baxter, drew a conscious link, partly facetious, unexpectedly accurate: 'I feel I am the new Hudson River School traditionalist, using water, air, sky, land, clouds, and boats.' Quoted in Meyer, *op. cit.*, 192.

BIBLIOGRAPHY

The Bibliography is arranged in two major sections, *General*, with further subdivisions according to genre and period, and *Individual Artists*, as follows:

I. GENERAL

II. INDIVIDUAL ARTISTS

For futher references the reader should consult additional listings in appropriate footnotes.

1. GENERAL

1. Reference Works

The Britannica Encyclopedia of American Art. New York, 1973.

GROCE, G. C., and WALLACE, D. H. The New-York Historical Society's Dictionary of Artists in America, 1564–1860. New Haven, 1957.

HAMER, P. M., ed. A Guide to Archives and Manuscripts in the United States. New Haven, 1961.

Index of Twentieth Century Artists. New York, 1933–7.

McCOUBREY, J. American Art, 1700–1960, Sources and Documents. Englewood Cliffs, N.J., 1965.

PIERSON, W. H., JR, and DAVIDSON, M., eds. Arts of the United States: a Pictorial Survey. New York, 1960.

ROSE, B. Readings in American Art Since 1900: A Documentary Survey. New York, 1968.

SMITH, R. C. Biographical Index of American Artists. Baltimore, 1930.

YOUNG, W., ed. A Dictionary of American Artists, Sculptors, and Engravers. From the beginnings to the turn of the Twentieth Century. Cambridge, Mass., 1968.

2. Museum Collections

American Art at Harvard. Exhibition catalogue, Fogg Art Museum, Harvard University. Cambridge, Mass., 1972.

American Paintings in the Museum of Fine Arts, Boston. 2 vols. Boston, 1969.

American Paintings and Sculpture: an Illustrated Catalogue. Catalogue of the collection, National Gallery of Art. Washington, D.C., 1970.

The Amherst Sesquicentennial Exhibition, From the Collections of Amherst College. Exhibition catalogue, Hirschl & Adler Galleries. New York, 1972.

BOYLE, R. J. American Paintings from Newport, From the Redwood Library and Other Collections. Exhibition catalogue, Wichita Art Museum. Wichita, Kans., 1969.

BOYLE, R. J. Masterpieces of American Painting, from the Pennsylvania Academy of the Fine Arts. Exhibition catalogue, Cincinnati Art Museum. Cincinnati, Ohio, 1974.

CARLISLE, L. B., ed. Eighteenth and Nineteenth Century American Art at Shelburne Museum. Catalogue of the collection. Shelburne, Vermont, 1960.

A Catalogue of the Collection of American Paintings in the Corcoran Gallery of Art. 2 vols. Washington, D.C., 1966.

Catalogue of American Portraits in the New-York Historical Society. New Haven and London, 1974.

A Collection in the Making. Catalogue of the collection, Phillips Collection. Washington, D.C., 1926.

Collection of the Société Anonyme. Yale University Art Gallery. New Haven, Conn., 1950.

GARDNER, A. T. E. American Sculpture, A Catalogue of the Metropolitan Museum of Art. New York, 1965.

GARDNER, A. T. E. A Concise Catalogue of the American Paintings in the Metropolitan Museum of Art. New York, 1957.

GARDNER, A. T. E., and FELD, S. P. American Paintings, A Catalogue of the Collection of the Metropolitan Museum of Art, 1. New York, 1965.

GOODRICH, L., and BAUR, J. I. H. American Art of our Century. Catalogue of the collection, Whitney Museum of American Art. New York, 1961.

GOODYEAR, F., JR. American Paintings in The Rhode Island Historical Society. Catalogue of the collection. Providence, R.I., 1974.

GRAHAM, F. L. Three Centuries of American Painting. Catalogue of the collection, M. H. de Young Memorial Museum and the California Palace of the Legion of Honor. San Francisco, 1971.

Handbook of the Colby College Art Museum. Catalogue of the collection. Waterville, Maine, 1973.

Highlights of the National Collection of Fine Arts. Washington, D.C., 1968.

LASSITER, B. Reynolda House American Paintings. Exhibition catalogue, Hirschl & Adler Galleries. New York, 1971.

LERNER, A., et al. The Hirshhorn Museum and Sculpture Garden. New York, 1974.

M. and M. Karolik Collection of American Paintings, 1815 to 1865. Cambridge, Mass., 1949.

M. and M. Karolik Collection of American Water Colors and Drawings, 1800–1875. 2 vols. Boston, 1962.

MAYTHAM, T. N. *Great American Paintings from the Boston and Metropolitan Museums.* Exhibition catalogue, Seattle Art Museum. Seattle, Washington, 1970.

The Phillips Collection, a Museum of Modern Art and Its Sources: Catalogue. Washington, D.C., 1952.

PHILLIPS, M. *Duncan Phillips and his Collection.* Boston, 1970.

3. Surveys of American Art

BENJAMIN, S. G. W. *Art in America: A Critical and Historical Sketch.* New York, 1880.

BENJAMIN, S. G. W. *Our American Artists.* Boston, 1879.

CAHILL, H., and BARR, A. H., JR. *Art in America: A Complete Survey.* New York, 1935.

DAVIDSON, M. B. *Life in America.* Boston, 1951.

DAVIDSON M. B., and the Editors of *American Heritage. The Artist's America.* New York, 1973.

Editors of *Art in America. The Artist in America.* New York, 1967.

GOODRICH, L. *Art of the United States.* Exhibition catalogue, Whitney Museum of American Art. New York, 1966.

GOODRICH, L. *Three Centuries of American Art.* New York, 1966.

GREEN, S. M. *American Art: A Historical Survey.* New York, 1966.

HARRIS, N. *The Artist in American Society.* New York, 1966.

HARTMANN, S. *A History of American Art.* 2 vols. Boston, 1902.

KEPPEL, F. P., and DUFFUS, R. L. *The Arts in American Life.* New York and London, 1933.

LA FOLLETTE, S. *Art in America.* New York, 1929.

LARKIN, O. W. *Art and Life in America.* 2nd ed. New York, 1960.

LESTER, C. E. *The Artists of America.* New York, 1846.

Life in America. Exhibition catalogue, Metropolitan Museum. New York, 1939.

MCLANATHAN, R. B. *The American Tradition in the Arts.* New York, 1968.

MCLANATHAN, R. B. *Art in America, A Brief History.* New York, 1973.

MENDELOWITZ, D. M. *A History of American Art.* 2nd ed. New York, 1970.

NEUHAUS, E. *The History and Ideals of American Art.* Stanford, Cal., 1931.

PROWN, J. D. *American Art from Alumni Collections.* Exhibition catalogue, Yale University Art Gallery. New Haven, Conn., 1968.

SAINT-GAUDENS, H. *The American Artist and His Times.* New York, 1941.

SHELDON, G. W. *Recent Ideals of American Art.* 8 vols. New York and London, 1888.

TUCKERMAN, H. T. *Book of the Artists, American Artist Life.* Reprinted ed., New York, 1966.

ZIGROSSER, C. *The Artist in America.* New York, 1942.

4. Surveys of Painting and of Sculpture

BAIGELL, M. *A History of American Painting.* New York, 1971.

BARKER, V. *American Painting: History and Interpretation.* New York, 1950.

BARKER, V. *A Critical Introduction to American Painting.* New York, 1931.

BRODER, P. *Bronzes of the American West.* New York, 1974.

BURROUGHS, A. *Limners and Likenesses: Three Centuries of American Painting.* Cambridge, Mass., 1936.

CAFFIN, C. H. *American Masters of Painting.* New York, 1902.

CAFFIN, C. H. *The Story of American Painting.* New York, 1907.

CORISSOZ, R. *American Artists.* New York and London, 1923.

CRAVEN, W. *Sculpture in America, From the Colonial Period to the Present.* New York, 1968.

DAVIDSON, A. A. *The Story of American Painting.* New York, 1974.

ELIOT, A. *Three Hundred Years of American Painting.* New York, 1957.

FLEXNER, J. T. *The Pocket History of American Painting.* New York, 1962.

ISHAM, S. *The History of American Painting.* New York, 1905.

McCoubrey, J. *American Tradition in Painting.* New York, 1963.

McSpadden, J. W. *Famous Painters of America.* New York, 1923.

McSpadden, J. W. *Famous Sculptors of America.* New York, 1924.

Prown, J. D. *American Painting, From its Beginnings to the Armory Show.* Cleveland, Ohio, 1970.

Richardson, E. P. *Painting in America.* New York, 1956.

Richardson, E. P. *A Short History of Painting in America.* Crowell, ed. New York, 1963.

Sheldon, G. W. *American Painters.* New York, 1879.

Taft, L. *History of American Sculpture.* New York, 1930.

Tuckerman, H. T. *Artist-Life: or Sketches of American Painters.* New York and Philadelphia, 1847.

Walker, J., and James, M. *Great American Paintings from Smibert to Bellows, 1729–1924.* New York, 1943.

Wilmerding, J., ed. *The Genius of American Painting.* London and New York, 1973.

5. Surveys of Types of Painting

Boas, G., ed. *Romanticism in America.* Baltimore, 1940.

Born, W. *American Landscape Painting: An Interpretation.* New Haven, Conn., 1948.

Born, W. *Still-Life Painting in America.* New York, 1947.

Blashfield, E. B. *Mural Painting in America.* New York, 1913.

Dillenberger, J., and Taylor, J. C. *The Hand and The Spirit: Religious Art in America, 1700–1900.* Exhibition catalogue, National Collection of Fine Arts. Washington, D.C., 1972.

Frankenstein, A. *The Reality of Appearance, The Trompe L'Œil Tradition in American Painting.* Exhibition catalogue, University Art Museum. Berkeley, Cal., 1970.

Frankenstein, A., and Van Deventer, A. *American Self-Portraits, 1670–1973.* Exhibition catalogue, National Portrait Gallery. Washington, D.C., 1974.

Gallatin, A. E. *American Water-Colourists.* New York, 1922.

Gardner, A. T. E. *History of Water Color Painting in America.* New York, 1966.

Gerdts, W. H. *The Great American Nude, A History in Art.* New York, 1974.

Gerdts, W. H., and Burke, R. *American Still-Life Painting.* New York, 1971.

Goodrich, L. *American Genre.* Exhibition catalogue, Whitney Museum of American Art. New York, 1935.

Hills, P. *The Painter's America, Rural and Urban Life, 1810–1910.* New York, 1974.

Hoopes, D. F. *American Narrative Painting.* New York, 1974.

Luck, R. H. *Twice as Natural: 19th Century American Genre Painting.* Exhibition catalogue, Finch College Museum of Art. New York, 1973.

Protter, E., ed. *Painters on Paintings.* New York, 1963.

Richardson, E. P. *American Romantic Painting.* New York, 1944.

Sheldon, G. W. *American Painters.* New York, 1879.

Soby, J. T., and Miller, D. C. *Romantic Painting in America.* New York, 1943.

Williams, H. W., Jr. *Mirror to the American Past, A Survey of American Genre Painting: 1750–1900.* New York, 1973.

Wilmderding, J. *A History of American Marine Painting.* Boston and Salem, Mass., 1968.

6. Surveys of Black and Indian Art

Bearden, R., and Henderson, H. *6 Black Masters of American Art.* Zenith ed., Garden City, N.Y., 1972.

Covarrubias, M. *The Eagle, the Jaguar, and the Serpent.* New York, 1954.

Davis, R. T. *Native Arts of the Pacific Northwest.* Stanford, Cal., 1949.

Dockstader, F. J. *Indian Art in America.* Greenwich, Conn., 1961.

Douglas, F. H., and d'Harnoncourt, R. *Indian Arts of the United States.* New York, 1941.

Farb, P. *Man's Rise to Civilization as Shown by the Indians of North America from Primeval Times to the Coming of the Industrial State.* New York, 1968.

Feder, N. *American Indian Art.* New York, 1971.

FEDER, N. *Two Hundred Years of North American Indian Art*. New York, 1971.

FINE, E. H. *The Afro-American Artist, A Search for Identity*. New York, 1973.

FOWLER, D. D. *In a Sacred Manner We Live, Photographs of the North American Indian by Edward S. Curtis*. Barre, Mass., 1972.

HABERLAND, W. *The Art of North America*. New York, 1968.

INVERARITY, R. B. *Art of the Northwest Coast Indians*. Berkeley, Cal., 1950.

LaFARGE, O. *A Pictorial History of the American Indian*. New York, 1956.

McLUHAN, T. C. *Touch the Earth, A Self Portrait of Indian Existence*. New York, 1971.

PARRY, E. *The Image of the Indian and the Black Man in American Art, 1590–1900*. New York, 1974.

PORTER, J. A. *Modern Negro Art*. New York, 1943.

VALLIANT, G. *Indian Arts of North America*. New York, 1939.

LIPMAN, J. *American Primitive Painting*. London and New York, 1942.

LIPMAN, J., and WINCHESTER, A. *The Flowering of American Folk Art, 1776–1876*. New York, 1974.

LIPMAN, J., and WINCHESTER, A. *Primitive Painters in America, 1750–1850, An Anthology*. New York, 1950.

LITTLE, N. F. *The Abby Aldrich Rockefeller Folk Art Collection*. Boston, 1957.

LITTLE, N. F. *American Decorative Wall Painting, 1700–1850*. Sturbridge, Mass., 1952.

McGRATH, R. L. *Early Vermont Wall Paintings, 1790–1850*. Hanover, N.H., 1972.

POLLEY, R., ed. *America's Folk Art*. New York, 1968.

SEARS, C. E. *Some American Primitives*. Boston, 1941.

7. Folk Art

American Folk Art. Exhibition catalogue, Mead Art Building, Amherst College. Amherst, Mass., 1974.

BISHOP, R. *American Folk Sculpture*. New York, 1974.

BLACK, M., and LIPMAN, J. *American Folk Painting*. New York, 1966.

CAHILL, H. *American Folk Art, the Art of the Common Man in America, 1750–1900*. New York, 1932.

CHRISTENSEN, E. O. *The Index of American Design*. New York, 1950.

FORD, A. *Pictorial Folk Art, New England to California*. New York, 1949.

GARDNER, A. T. E. *101 Masterpieces of American Primitive Painting from the Collection of Edgar William and Bernice Chrysler Garbisch*. New York, 1962.

HEMPHILL, H. W., Jr, and WEISSMAN, J. *Twentieth-Century American Folk Art and Artists*. New York, 1974.

HORNUNG, C. P. *Treasury of American Design*. 2 vols. New York, 1973.

LIPMAN, J. *American Folk Art in Wood, Metal, Stone*. New York, 1948.

8. Graphic and Decorative Arts

American Printmaking, The First 150 Years. Exhibition catalogue, The Museum of Graphic Art. New York and Washington, D.C., 1969.

CAFFIN, C. H. *Photography as a Fine Art*. New York, 1972.

COKE, V. D. *The Painter and the Photograph*. Albuquerque, N.M., 1964.

COMSTOCK, H. *American Furniture*. New York, 1962.

DOTY, R., ed. *Photography in America*. New York, 1974.

DROPPARD, C. W. *Early American Prints*. New York, 1930.

Fourteen American Women Printmakers of the '30s and '40s. Exhibition catalogue, Mount Holyoke College Art Museum. South Hadley, Mass., 1973.

GERNSHEIM, H. and A. *The History of Photography, from the camera obscura to the beginning of the modern era*. New York, 1969.

HAMILTON, S. *Early American Book Illustrators and Wood Engravers, 1670–1870*. Princeton, N.J., 1950.

HOOD, G. *American Silver, A History of Style, 1650–1900*. New York, 1971.

MAYOR, H. *Popular Prints of the Americas*. New York, 1973.

MORSE, J. D., ed. *Prints in and of America to 1850*. Winterthur Conference Report, 1970. Charlottesville, Va., 1970.

NEWHALL, B. *The Daguerreotype in America.* Revised ed. New York, 1968.

NEWHALL, B. *The History of Photography.* New York, 1964.

PETERS, H. T. *America on Stone.* New York, 1931.

PHILLIPS, J. M. *American Silver.* New York, 1949.

POLLACK, P. *The Picture History of Photography, From the Earliest Beginnings to the Present Day.* Revised ed. New York, 1969.

Private Realities: Recent American Photography. New York, 1974.

RINHART, F. and M. *American Daguerreian Art.* New York, 1967.

RUDISILL, R. *Mirror Image, The Influence of the Daguerreotype in American Society.* Albuquerque, N.M., 1971.

SCHARF, A. *Art and Photography.* London, 1968.

STAUFFER, D. *American Engravers Upon Copper and Steel.* New York, 1907.

SZARKOWSKI, J., ed. *The Photographer and the American Landscape.* New York, 1963.

TAFT, R. *Photography and the American Scene.* Dover ed., New York, 1964.

TUCKER, A. *The Woman's Eye.* New York, 1975.

WEITENKAMP, F. *American Graphic Art.* New York, 1924.

9. Regional Arts and Schools

CARPENTER, J. M. *Landscape in Maine, 1820–1970.* Exhibition catalogue, Colby College Art Museum. Waterville, Me., 1970.

COKE, V. D. *Taos and Santa Fe: The Artist's Environment, 1882–1942.* Albuquerque, N.M., 1963.

CURRY, L. *The American West, Painters from Catlin to Russell.* Exhibition catalogue, Los Angeles County Museum of Art. Los Angeles, Cal., 1972.

FAIRBANKS, J. L., et al. *Frontier America: The Far West.* Exhibition catalogue, Museum of Fine Arts. Boston, 1975.

FAIRMAN, C. E. *Art and Artists of the Capitol of the United States of America.* Washington, D.C., 1927.

FRENCH, H. *Art and Artists in Connecticut.* Boston, 1879.

GOTTESMAN, R. *The Arts and Crafts in New York, 1726–1776.* New York, 1937.

GOTTESMAN, R. *The Arts and Crafts in New York, 1777–1799.* New York, 1954.

HILLS, P. *The American Frontier, Images and Myths.* Exhibition catalogue, Whitney Museum of American Art. New York, 1973.

HOWAT, J. K. *The Hudson River and Its Painters.* New York, 1972.

The Hudson River School: American Landscape Paintings from 1821 to 1907. Exhibition catalogue, R. W. Norton Art Gallery. Shreveport, La., 1973.

KUH, K. *Art in New York State, The River: Places and People.* Exhibition catalogue, New York World's Fair, 1964. The Buffalo Fine Arts Academy, Buffalo, N.Y., 1964.

McCRACKEN, H. *Portrait of the Old West.* New York, 1952.

MELLON, G. A., and WILDER, E. A., eds. *Maine and Its Role in American Art.* New York, 1963.

MILLER, J. *Drawings of the Hudson River School, 1825–1875.* Exhibition catalogue, Brooklyn Museum. Brooklyn, N.Y., 1970.

NAEF, W. J. *Era of Exploration: The Rise of Landscape Photography in the American West, 1860–1885.* Exhibition catalogue, Metropolitan Museum of Art. New York, 1975.

O'GORMAN, J., and WILMERDING, J. *Portrait of A Place, Some American Landscape Painters in Gloucester.* Exhibition catalogue, Cape Ann Historical Association. Gloucester, Mass., 1973.

RATHBONE, P. *Westward the Way.* Exhibition catalogue, City Art Museum. St Louis, Mo., 1954.

SEARS, C. E. *Highlights Among the Hudson River Artists.* Boston, 1947.

SHEPARD, L. A. *American Painters of the Arctic.* Exhibition catalogue, Mead Art Building, Amherst College. Amherst, Mass., 1975.

SWEET, F. A. *The Hudson River School and the Early American Landscape Tradition.* Chicago, 1945.

TAFT, R. *Artists and Illustrators of the Old West: 1850–1900.* New York, 1953.

10. American Culture

AARON, D., ed. *America in Crisis.* New York, 1952.

BOORSTIN, D. *The Image, A Guide to Pseudo-Events in America.* Colophon ed., New York, 1961.

HINE, R. V. *The American West, An Interpretative History.* Boston, 1973.

HUTH, H. *Nature and the American.* Berkeley and Los Angeles, 1957.

JEWELL, E. A. *Have We an American Art?* New York, 1939.

JONES, H. M. *The Age of Energy, Varieties of American Experience, 1865–1915.* New York, 1971.

JONES, H. M. *O Strange New World, American Culture: The Formative Years.* New York, 1964.

KOUWENHOVEN, J. A. *Made in America.* Anchor ed., Garden City, N.Y., 1962.

LIPMAN, J. *What is American in American Art.* New York, 1963.

MARX, L. *The Machine in the Garden: Technology and the Pastoral Ideal in America.* New York, 1964.

MATHER, F. J., JR, MOREY, C. F., and HENDERSON, W. J. *The American Spirit in Art.* New Haven, Conn., 1927.

MELLQUIST, J. *The Emergence of an American Art.* New York, 1942.

MILLER, P. *Nature's Nation.* Cambridge, Mass., 1967.

NASH, R. *Wilderness and the American Mind.* New Haven and London, 1967.

TOCQUEVILLE, A. DE. *Democracy in America.* London, 1835; 2 vol. ed., New York, 1942.

11. *Arts of the Colonial and Federal Periods*

BRIDENBAUGH, C. *The Colonial Craftsman.* Chicago, 1966.

DICKSON, H. E. *Arts of the Young Republic.* Chapel Hill, N.C., 1969.

DREPPARD, C. W. *American Pioneer Arts and Artists.* Springfield, Mass., 1942.

DUNLAP, W. *History of the Rise and Progress of the Arts of Design in the United States.* 2 vols. New York, 1834.

FAIRBANKS, J. *Paul Revere's Boston: 1735–1818.* Exhibition catalogue, Museum of Fine Arts. Boston, 1975.

FORBES, H. *Gravestones of Early New England.* Da Capo ed., New York, 1967.

GARRETT, W. D. and J. N. 'A Bibliography of the Arts in Early American History', *The Arts in American History.* Chapel Hill, N.C., 1965.

LUDWIG, A. I. *Graven Images, New England Stonecarving and its Symbols, 1650–1815.* Middletown, Conn., 1966.

McCOUBREY, J. W., et al. *The Arts in America: The Colonial Period.* New York, 1966.

MILLER, L. B. *In the Minds and Hearts of the People: Prologue to the American Revolution, 1760–1774.* Exhibition catalogue, National Portrait Gallery. Washington, D.C., 1974.

MILLER, L. B. *The Die is Now Cast: The Road to American Independence, 1774–1776.* Exhibition catalogue, National Portrait Gallery. Washington, 1975.

MILLER, P. *Errand into the Wilderness.* Torchbooks ed., New York, 1964.

SIRKIS, N., and PARRY, E. *Reflections of 1776: The Colonies Revisited.* New York, 1974.

TASHJIAN, D. and A. *Memorials for Children of Change, The Art of Early New England Stonecarving.* Middletown, Conn., 1974.

12. *Colonial and Federal Painting*

BAYLEY, F. *Five Colonial Artists of New England.* Boston, 1929.

BELKNAP, W. P., JR. *American Colonial Painting, Materials for a History.* Cambridge, Mass., 1959.

BOLTON, C. *Portraits of the Founders.* Boston, 1919.

BOLTON, T. *Early American Portrait Draughtsmen in Crayons.* New York, 1923.

BOLTON, T. *Early American Portrait Painters in Miniature.* New York, 1921.

DRESSER, L., et al. *XVIIth Century Painting in New England.* Exhibition catalogue, Worcester Art Museum. Worcester, Mass., 1934.

FLEXNER, J. T. *America's Old Masters: First Artists of the New World.* New York, 1967.

FLEXNER, J. T. *First Flowers of Our Wilderness: American Painting.* Boston, 1947.

FLEXNER, J. T. *The Light of Distant Skies, 1760–1835.* New York, 1954.

HAGEN, O. *The Birth of the American Tradition in Art.* New York and London, 1940.

HARIOT, T. *A Briefe and True Report of the New Found Land of Virginia.* Dover ed., New York, 1972.

KELBY, W. *Notes on American Artists, 1754–1820.* New York, 1922.

LEE, C. *Early American Portrait Painters.* New Haven, Conn., 1929.

LORANT, S., ed. *The New World, The First Pictures of America.* Revised ed., New York, 1965.

MOOZ, R. P. *The Winslows, Pilgrims, Patrons and Portraits.* Exhibition catalogue, Bowdoin College Museum of Art. Brunswick, Me., 1974.

OLIVER, A. *The Adams Papers, Portraits of John and Abigail Adams.* Cambridge, Mass., 1967.

OLIVER, A. *The Adams Papers, Portraits of John Quincy Adams and His Wife.* Cambridge, Mass., 1970.

PARKER, B. N., ed. *New England Miniatures, 1750–1850.* Boston, 1957.

QUIMBY, I. M. G., ed. *American Painting to 1776, A Reappraisal.* Winterthur Conference Report, 1971. Charlottesville, Va., 1971.

SADIK, M. *Colonial and Federal Portraits at Bowdoin College.* Catalogue of the collection. Brunswick, Me., 1966.

SWEET, F., and HUTH, H. *From Colony to Nation.* Exhibition catalogue, Art Institute of Chicago. Chicago, 1949.

WEHLE, H. B., and BOLTON, T. *American Miniatures, 1738–1850.* New York, 1927.

WHEELER, R., and MACFARLANE, J. *Hudson Valley Paintings, 1700–1750, in the Albany Institute of History and Art.* Catalogue of the collection. Albany, N.Y., 1959.

13. Art Institutions

CLARK, E. *History of the National Academy of Design, 1825–1953.* New York, 1954.

COWDREY, M. B., ed. *American Academy of Fine Arts and American Art-Union, 1816–1852.* New York, 1953.

CUMMINGS, T. S. *Historic Annals of the National Academy of Design.* Philadelphia, 1865.

HENDERSON, E. W. *The Pennsylvania Academy of the Fine Arts and Other Collections of Philadelphia.* Boston, 1911.

LANDGREN, M. E. *Years of Art: the Story of the Art Students' League of New York.* New York, 1940.

MILLER, L. B. *Patrons and Patriotism: the Encouragement of the Fine Arts in the United States, 1790–1860.* Chicago and London, 1966.

NAYLOR, M., ed. *The National Academy of Design Exhibition Record: 1861–1900.* 2 vols. New York, 1973.

PACH, W. *The Art Museum in America.* New York, 1948.

RUTLEDGE, A. W., ed. *The Pennsylvania Academy of the Fine Arts, 1807–1870; The Society of Artists, 1800–1814; The Artists' Fund Society, 1835–1845.* Philadelphia, 1955.

SWAN, M. M. *The Athenaeum Gallery, 1827–1873.* Boston, 1940.

THOMPSON, J. *A Critical Guide to the Exhibition at the National Academy of Design.* New York, 1859.

14. Nineteenth-Century Art: General

BAUR, J. I. H. *American Painting in the Nineteenth Century.* New York, 1953.

CHAMPNEY, B. *Sixty Years' Memories of Art and Artists.* Woburn, Mass., 1900.

CLEMENT, C., and HUTTON, L. *Artists of the Nineteenth Century and Their Work.* Boston, 1879.

The Crayon: A Journal Devoted to the Graphic Arts and the Literature Related to Them. New York, 1855–61 (monthly).

FLEXNER, J. T. *Nineteenth Century American Painting.* New York, 1970.

FLEXNER, J. T. *That Wilder Image.* Boston, 1962.

GARRETT, W., et al. *The Arts in America, The Nineteenth Century.* New York, 1969.

GERDTS, W. H. *Revealed Masters; 19th Century American Art.* Exhibition catalogue, The American Federation of Arts. New York, 1974.

HOOPES, D. F. *The Düsseldorf Academy and the Americans.* Exhibition catalogue, The High Museum of Art. Atlanta, Ga., 1972.

HOWAT, J. E., et al. *19th-Century America, Paintings and Sculpture.* Exhibition catalogue, Metropolitan Museum of Art. New York, 1970.

HUNTINGTON, D. C. *Art and the Excited Spirit: America in the Romantic Period.* Exhibition catalogue, The University of Michigan Museum of Art. Ann Arbor, Mich., 1972.

LANMAN, C. *Haphazard Personalities, Chiefly of Noted Americans.* Boston, 1886.

LYNES, R. *The Art-Makers of Nineteenth Century America.* New York, 1970.

NOVAK, B. *American Painting of the Nineteenth Century, Realism, Idealism, and the American Experience.* New York, 1969.

PETERSON, H. L. *Americans at Home, From the Colonists to the Late Victorians.* New York, 1971.

RICHARDSON, E. P., and WITTMANN, O., JR. *Travelers in Arcadia, American Artists in Italy, 1830–1875.* Exhibition catalogue, Detroit Institute of Arts. Detroit, Mich., 1951.

SARTAIN, J. *The Reminiscences of a Very Old Man, 1808–1897.* New York, 1899.

The Shaping of Art & Architecture in Nineteenth-Century America. New York, 1972.

TATHAM, D. *The Lure of the Striped Pig, The Illustration of Popular Music in America, 1820–1870.* Barre, Mass., 1973.

TRUETTNER, W. H. *National Parks and the American Landscape.* Exhibition catalogue, National Collection of Fine Arts. Washington, D.C., 1972.

WILMERDING, J. *Audubon, Homer, Whistler and 19th Century America.* New York, 1972.

15. Nineteenth-Century Art: Pre-Civil War

BAKER, P. R. *The Fortunate Pilgrims, Americans in Italy, 1800–1860.* Cambridge, Mass., 1964.

CALLOW, J. T. *Kindred Spirits, Knickerbocker Writers and American Artists, 1807–1855.* Chapel Hill, N.C., 1967.

CRANE, S. E. *White Silence, Greenough, Powers, and Crawford, American Sculptors in Nineteenth-Century Italy.* Coral Gables, Fla., 1972.

GARDNER, A. T. E. *Yankee Stonecutters, The First American School of Sculpture, 1800–1850.* New York, 1945.

GERDTS, W. H. *American Neo-Classical Sculpture, The Marble Resurrection.* New York, 1973.

LANMAN, C. *Letters from a Landscape Painter.* Boston, 1845.

MILLER, P. *The Life of the Mind in America, From the Revolution to the Civil War.* New York, 1965.

SVIN'IN, P. P. *Picturesque United States of America, 1811–1813.* New York, 1930.

THORP, M. F. *The Literary Sculptors.* Durham, N.C., 1965.

VAN ZANDT, R. *The Catskill Mountain House.* New Brunswick, N.J., 1966.

16. Nineteenth-Century Art: Post-Civil War

BAUR, J. *Leaders of American Impressionism.* Exhibition catalogue, Brooklyn Museum. Brooklyn, N.Y., 1937.

BOYLE, R. J. *American Impressionism.* New York, 1974.

CORN, W. M. *The Color of Mood: American Tonalism, 1880–1910.* Exhibition catalogue, M. H. de Young Memorial Museum. San Francisco, Cal., 1972.

DOMIT, M. M. *American Impressionist Painting.* Exhibition catalogue, National Gallery of Art. Washington, D.C., 1973.

FRANKENSTEIN, A. *The Reminiscent Object, Paintings by William Michael Harnett, John Frederick Peto and John Haberle.* Exhibition catalogue, La Jolla Museum of Art. La Jolla, Cal., 1965.

HOOPES, D. F. *The American Impressionists.* New York, 1972.

JAMES, H. *Picture and Text.* New York, 1893.

MORGAN, H. W. *Victorian Culture in America, 1865–1914.* Itasca, Ill., 1973.

MUMFORD, L. *The Brown Decades.* Dover ed., New York, 1955.

PILGRIM, D. H. *American Impressionist and Realist Paintings & Drawings, from the Collection of Mr & Mrs Raymond J. Horowitz.* Exhibition catalogue, Metropolitan Museum. New York, 1973.

SCHEYER, E. *The Circle of Henry Adams: Art and Artist.* Detroit, 1970.

STEBBINS, T. E., JR, et al. *Luminous Landscape: The American Study of Light, 1860–1875.* Exhibition catalogue, Fogg Art Museum, Harvard University. Cambridge, Mass., 1966.

SWEET, F. A. *Sargent, Whistler and Mary Cassatt.* Chicago, 1954.

VON SOLDERN, A. *Triumph of Realism.* Exhibition catalogue, Brooklyn Museum. Brooklyn, N.Y., 1966.

WILLIAMS, H. W., JR. *The Civil War: The Artists' Record.* Exhibition catalogue, Corcoran Gallery of Art. Washington, D.C., 1961.

17. Art Criticism

ASHTON, D. *The Unknown Shore: A View of Contemporary Art.* Boston, 1962.

BATTCOCK, G., ed. *Minimal Art: A Critical Anthology.* New York, 1968.

BATTCOCK, G., ed. *The New Art: A Critical Anthology.* New York, 1966.

CALAS, N. *Art in the Age of Risk and Other Essays.* New York, 1968.

CALAS, N. and E. *Icons and Images of the Sixties.* New York, 1971.

COX, K. *The Classic Point of View.* New York, 1911.

COX, K. *Concerning Painting.* New York, 1917.

DICKSON, H., ed. *Observations on American Art: Selections from the Writings of John Neal (1793–1876).* State College, Pa., 1943.

FRY, E. F., ed. *On the Future of Art.* New York, 1970.

GALLATIN, A. E. *Certain Contemporaries: A Set of Notes in Art Criticism.* New York, 1916.

GREENBERG, C. *Art and Culture.* Boston, 1961.

JARVES, J. J. *Art Hints, Architecture, Sculpture and Painting.* New York, 1855.

JARVES, J. J. *The Art-Idea.* John Harvard Library ed., Cambridge, Mass., 1960.

JARVES, J. J. *Art Thoughts.* New York, 1869.

KOZLOFF, M. *Renderings: Critical Essays on a Century of Modern Art.* New York, 1969.

KRAMER, H. *The Age of the Avant-Garde, An Art Chronicle of 1956–1972.* New York, 1973.

KUH, K. *Break-Up: The Core of Modern Art.* Greenwich, Conn., 1965.

LIPPARD, L. R. *Changing: Essays in Art Criticism.* New York, 1971.

ROSENBERG, H. *The Anxious Object.* New York, 1964.

ROSENBERG, H. *Artworks and Packages.* New York, 1969.

ROSENBERG, H. *The de-definition of art; action art to pop to earthworks.* New York, 1972.

ROSENBERG, H. *Discovering the Present.* Chicago, 1974.

ROSENBERG, H. *Tradition of the New.* New York, 1959.

STEEGMULLER, F. *The Two Lives of James Jackson Jarves.* New Haven, Conn., 1951.

STEIN, R. B. *John Ruskin and Aesthetic Thought in America, 1840–1900.* Cambridge, Mass., 1967.

18. Twentieth-Century Art: General

ARNASON, H. H. *History of Modern Art: Painting, Sculpture, Architecture.* New York, 1968.

BAUR, J. I. H. *Revolution and Tradition in Modern American Art.* Cambridge, Mass., 1951.

BREESKIN, A. *Roots of Abstract Art in America, 1910–1950.* Exhibition catalogue, National Collection of Fine Arts. Washington, D.C., 1965.

CAHILL, H., and BARR, A. H., JR. *Art in America in Modern Times.* New York, 1934.

CHENEY, M. C. *Modern Art in America.* New York, 1939.

CHENEY, S. *A Primer of Modern Art.* New York, 1924.

CHENEY, S. *The Story of Modern Art.* New York, 1941.

CRAVEN, T. *Men of Art.* New York, 1931.

CRAVEN, T. *Modern Art – the Men, the Movements, the Meaning.* New York, 1934.

DREIER, K. S. *Western Art and the New Era.* New York, 1923.

GELDZAHLER, H. *New York Painting and Sculpture: 1940–1970.* Exhibition catalogue, Metropolitan Museum of Art. New York, 1969.

GOODRICH, L., and MORE, H. *Juliana Force and American Art: A Memorial Exhibition.* Exhibition catalogue, Whitney Museum of American Art. New York, 1949.

GUGGENHEIM, P. *Confessions of an Art Addict.* New York, 1960.

GUGGENHEIM, P. *Art of This Century.* New York, 1946.

HUNTER, S. *Modern American Painting and Sculpture.* Dell ed., New York, 1959.

HUNTER, S., and JACOBUS, J. *American Art and Architecture of the 20th Century.* New York, 1974.

KEPES, G., ed. *Vision and Value.* 6 vols. New York, 1965–6.

O'DOHERTY, B. *American Masters: The Voice and the Myth.* New York, 1973.

O'HARA, F. *The Peggy Guggenheim Collection.* Exhibition catalogue, Tate Gallery. London, 1965.

PACH, W. *Modern Art in America.* New York, 1928.

SAYLER, O. M. *Revolt in the Arts: a survey of the creation, distribution, and appreciation of art in America.* New York, 1930.

WHEELER, M. *Painters and Sculptors of Modern America.* New York, 1942.

WRIGHT, W. H. *American Painting and Sculpture.* New York, 1932.

BIBLIOGRAPHY

19. Twentieth-Century Art: Painting and Sculpture

ASHTON, D. *Modern American Sculpture*. New York, 1968.

BARNES, A. C. *The Art in Painting*. New York, 1925.

BAUR, J. I. H., ed. *New Art in America: 50 American Painters in the 20th Century*. New York, 1957.

BRUMMÉ, C. L. *Contemporary American Sculpture*. New York, 1948.

GOOSEN, E. C., et al. *Three American Sculptors: Ferber, Hare, Lassaw*. New York, 1959.

ELY, C. B. *The Modern Tendency in Painting*. New York, 1925.

GELDZAHLER, H. *American Painting in the Twentieth Century*. Catalogue of the collection, Metropolitan Museum of Art. New York, 1965.

GIEDION-WELCKER, C. *Contemporary Sculpture: An Evolution in Volume and Space*. New York, 1955.

GOLDWATER, R. *Primitivism in Modern Painting*. New York, 1938.

HALE, R. B. *100 American Painters of the 20th Century*. Exhibition catalogue, Metropolitan Museum. New York, 1950.

JANIS, S. *They Taught Themselves; American Primitive Painters of the Twentieth Century*. New York, 1942.

KOOTZ, S. *Modern American Painters*. New York, 1930.

MATHER, F. J. *Modern Painting, a Study of Tendencies*. New York, 1927.

McCOUBREY, J., and the Editors of *Time-Life Books*. *American Painting, 1900–1970*. New York, 1970.

PACH, W. *Queer Thing, Painting*. New York, 1938.

RITCHIE, A. C. *Sculpture of the Twentieth Century*. New York, 1952.

ROSE, B. *American Painting Since 1900: A Critical History*. New York, 1967; 2nd ed., 1974.

ROSE, B. *American Painting, The Twentieth Century*. Cleveland, Ohio, 1970.

SCHNIER, J. *Sculpture in Modern America*. Berkeley and Los Angeles, 1948.

SEITZ, W. C. *The Art of Assemblage*. New York, 1964.

SEYMOUR, C., JR. *Tradition and Experiment in Modern Sculpture*. Washington, D.C., 1949.

20. Twentieth-Century Art: First Three Decades

AGEE, W. C. *Synchromism and Color Principles in American Painting*. New York, 1965.

Armory Show Fiftieth Anniversary Exhibition. Exhibition catalogue, Munson-Williams-Proctor Institute. Utica, N.Y., 1963.

BAUR, J. I. H. *The Eight*. Exhibition catalogue, The Brooklyn Museum. Brooklyn, N.Y., 1944.

BRINTON, C. *Modern Art in the Sesqui-Centennial Exhibition*. New York, 1926.

BROWN, M. *American Painting from the Armory Show to the Depression*. Princeton, N.J., 1955.

BROWN, M. *The Story of the Armory Show*. New York, 1963.

de ZAYAS, M., and HAVILAND, P. *A Study of the Modern Evolution of Plastic Expression*. New York, 1913.

EDDY, A. J. *Cubists and Post-Impressionists*. Chicago, 1914.

FRIEDMAN, M. *The Precisionist View in American Art*. Exhibition catalogue, Walker Art Center. Minneapolis, Minn., 1960.

GOODRICH, L. *Pioneers of Modern Art in America*. New York, 1946.

GOODRICH, L. *Pioneers of Modern Art in America: The Decade of the Armory Show, 1910–1920*. New York, 1963.

HOMER, W. I., et al. *The Rise of the American Avant-Garde: 1910–1925*. Exhibition catalogue, Delaware Art Museum. Wilmington, 1975.

KUHN, W. *The Story of the Armory Show*. New York, 1938.

ROSENFELD, P. *Port of New York: Essays on Fourteen American Moderns*. New York, 1924.

TASHJIHAN, D. *Skyscraper Primitives, Dada and the American Avant-Garde, 1910–1925*. Middletown, Conn., 1975.

YOUNG, M. S. *Early American Moderns, Painters of the Stieglitz Group*. New York, 1974.

YOUNG, M. S. *The Eight, The Realist Revolt in American Painting*. New York, 1973.

21. Twentieth-Century Art: Thirties and Forties

BAIGELL, M. *The American Scene, American Painting of the 1930s*. New York, 1974.

BAUR, J. I. H. *Nature in Abstraction*. New York, 1958.

BIBLIOGRAPHY

CAHILL, H. *Art as a Function of Government.* Washington, D.C., 1937.

CAHILL, H. *New Horizons in American Art.* New York, 1936.

HILLIER, B. *Art Deco.* London, 1968. Exhibition catalogue, Minneapolis Institute of Arts. Minneapolis, Minn., 1971.

KIRSTEIN, L., and LEVY, J. *Murals by American Painters and Photographers.* New York, 1932.

LANGE, D., and TAYLOR, P. S. *An American Exodus, A Record of Human Erosion in the Thirties.* New Haven and London, 1969.

McKENZIE, R. D. *The New Deal for Artists.* Princeton, N.J., 1973.

MILLER, D., and BARR, A. H., JR, eds. *American Realists and Magic Realists.* New York, 1943.

MORRIS, G. L. K. *American Abstract Art.* Exhibition catalogue, St Etienne Galerie. New York, 1940.

O'CONNOR, F. V. *Federal Art Patronage, 1933–1943.* College Park, Md., 1966.

SHAPIRO, D., ed. *Social Realism, Art as a Weapon.* New York, 1973.

STELLA, J. *The 30's: Painting in New York.* Exhibition catalogue, Poindexter Gallery. New York, 1957.

STOTT, W. *Documentary Expression and Thirties America.* New York, 1973.

SWEENEY, J. J. *Plastic Redirections in Twentieth Century Painting.* Chicago, 1934.

22. Abstract Expressionism

ARNASON, H. H. *Abstract Expressionists and Imagists.* Exhibition catalogue, Guggenheim Museum. New York, 1961.

ASHTON, D. *The New York School, A Cultural Reckoning.* New York, 1973.

BLESCH, R. *Modern Art USA.* New York, 1956.

FRIEDMAN, B. H., ed. *School of New York: Some Younger Artists.* New York, 1959.

GOODALL, D. B., and KASANIN, M. C. *Partial Bibliography of American Abstract-Expressive Painting, 1943–1956.* Los Angeles, 1956.

HESS, T. B. *Abstract Painting: Background and American Phase.* New York, 1951.

HUNTER, S. 'USA', *Art Since 1945.* New York, 1958.

JANIS, S. *Abstract and Surrealist Art in America.* New York, 1944.

MILLER, D., ed. *15 Americans.* Exhibition catalogue, Museum of Modern Art. New York, 1952.

MILLER, D., ed. *Fourteen Americans.* Exhibition catalogue, Museum of Modern Art. New York, 1946.

MOTHERWELL, R., and REINHARDT, A., eds. *Modern Artists in America.* First series. New York, 1952.

RICHMAN, R., ed. *The Arts at Mid-Century.* New York, 1954.

RITCHIE, A. C. *Abstract Painting and Sculpture in America.* New York, 1951.

SANDLER, I. *The Triumph of American Painting: A History of Abstract Expressionism.* New York, 1970.

SEITZ, W. C. *Abstract Expressionist Painting in America.* Unpublished doctoral dissertation, Princeton University. Princeton, N.J., 1955.

SWEENEY, J. J. *American Painting 1950.* Exhibition catalogue, Virginia Museum of Fine Arts. Richmond, Va., 1950.

TUCHMAN, M. *The New York School: Abstract Expressionism in the 40's and 50's.* London, 1969.

23. Twentieth-Century Art: Fifties and Sixties

GOODRICH, L. *Young America, 1965: Thirty American Artists Under Thirty-Five.* New York, 1965.

HUNTER, S. *Art Since 1950.* Exhibition catalogue, Seattle World's Fair. Seattle, Washington, 1962.

KAUFMANN, R., and McCOUBREY, J. *The Disappearance and Reappearance of the Image: American Painting since 1945.* Exhibition catalogue, National Collection of Fine Arts. Washington, D.C., 1969.

KUH, K. *The Artist's Voice: Talks with Seventeen Artists.* New York, 1960.

KULTERMAN, U. *The New Painting.* New York, 1969.

LUCIE-SMITH, E. *Late Modern: The Visual Arts Since 1945.* New York, 1969.

MILLER, D. C. *Sixteen Americans.* Exhibition catalogue, Museum of Modern Art. New York, 1959.

MILLER, D. C., ed. *12 Americans*. Exhibition catalogue, Museum of Modern Art. New York, 1956.

NORDNESS, L., and WELLER, A. S. *Art U.S.A. Now*. 2 vols. New York, 1963.

PLAGENS, P. *Sunshine Muse, Contemporary Art on the West Coast*. New York, 1974.

SHARPLESS, T.-G. *60 American Painters*. Exhibition catalogue, Walker Art Center. Minneapolis, Minn., 1960.

SOLOMON, A. *New York: The Art Scene*. New York, 1968.

SWEENEY, J. J. *Younger American Painters: a Selection*. Exhibition catalogue, Guggenheim Museum. New York, 1954.

TUCHMAN, M., ed. *American Sculpture of the Sixties*. Exhibition catalogue, Los Angeles County Museum of Art. Los Angeles, 1967.

VAN DER MARCK, J. *American Art third quarter century*. Exhibition catalogue, Seattle Art Museum. Seattle, Washington, 1973.

NORDLAND, G. *The Washington Color Painters*. Exhibition catalogue, Washington Gallery of Modern Art. Washington, D.C., 1965.

POPPER, F. *Kinetic Art*. Greenwich, Conn., and London, 1968.

SEITZ, W. C. *The Responsive Eye*. Exhibition catalogue, Museum of Modern Art. New York, 1964.

SELZ, P., and RICKEY, G. *Directions in Kinetic Sculpture*. Exhibition catalogue, University Art Museum, University of California. Berkeley, 1966.

WESCHER, H. *Collage*. New York, 1968.

24. Formalist Art

ALLOWAY, L. *The Shaped Canvas*. New York, 1964.

ALLOWAY, L. *Six Painters and the Object*. Exhibition catalogue, Guggenheim Museum. New York, 1964.

ALLOWAY, L. *Systemic Painting*. Exhibition catalogue, Guggenheim Museum. New York, 1966.

BARRETT, C. *Optical Art*. New York, 1970.

COPLANS, J. *Serial Imagery*. Exhibition catalogue, Pasadena Art Museum. Pasadena, Cal., 1968.

FRIED, M. *Three American Painters, Kenneth Noland, Jules Olitski, Frank Stella*. Exhibition catalogue, Fogg Art Museum, Harvard University. Cambridge, Mass., 1965.

GORDON, J. *Geometric Abstraction in America*. New York, 1962.

The Great Decade of American Abstraction Modernist Art, 1960–1970. Exhibition catalogue, Museum of Fine Arts. Houston, Tex., 1974.

GREENBERG, C. *Post-Painterly Abstraction*. Exhibition catalogue, Los Angeles County Museum of Art. Los Angeles, 1964.

MCSHINE, K. *Primary Structures: Younger American and British Sculptors*. Exhibition catalogue, The Jewish Museum. New York, 1966.

25. New Realism

ALLOWAY, L. *American Pop Art*. Exhibition catalogue, Whitney Museum of American Art. New York, 1974.

BARKER, V. *From Realism to Reality in Recent American Painting*. Lincoln, Nebr., 1959.

BARR, A. H., JR. *Recent Painting U.S.A.: The Figure*. Exhibition catalogue, Museum of Modern Art. New York, 1962.

FINCH, C. *Pop Art: Object and Image*. New York, 1968.

GOOSEN, E. C. *The Art of the Real: U.S.A., 1948–1968*. Exhibition catalogue, Museum of Modern Art. New York, 1968.

KULTERMAN, U. *New Realism*. Greenwich, Conn., 1972.

LIPPARD, L. R. *Pop Art*. New York, 1966.

RUBLOWSKY, J. *Pop Art*. New York, 1965.

RUSSELL, J., and GABLIK, S. *Pop Art Redefined*. London, 1969.

Seven Realists. Exhibition catalogue, Yale University Art Gallery. New Haven, Conn., 1974.

WASSERMAN, J. C. *Recent Figure Sculpture*. Exhibition catalogue, Fogg Art Museum, Harvard University. Cambridge, Mass., 1972.

26. Conceptual Art

BURNHAM, J. *Beyond Modern Sculpture: The Effects of Science and Technology on the Sculpture of This Century*. New York, 1968.

BURNHAM, J. *Great Western Salt Works: Essays on the Meaning of Post-Formalist Art*. New York, 1974.

BIBLIOGRAPHY

BURNHAM, J. *The Structure of Art.* New York, 1971.

DAVIS, D. *Art and the Future, A History/Prophecy of the Collaboration Between Science, Technology and Art.* New York, 1973.

CAGE, J. *Silence.* Middletown, Conn., 1961.

CELANT, G. *Arte Povera.* New York, 1969.

DOTY, R. *Light: Object and Image.* Exhibition catalogue, Whitney Museum of American Art. New York, 1968.

HANSEN, A. *A Primer of Happenings and Time/Space Art.* New York, 1965.

HENRI, A. *Total Art: Environments, Happenings, and Performance.* New York, 1974.

KAPROW, A. *Assemblage, Environments and Happenings.* New York, 1966.

KARSHAN, D. *Conceptual Art and Conceptual Aspects.* Exhibition catalogue, New York Cultural Center. New York, 1970.

KIRBY, M. *The Art of Time: Essays on the Avant-Garde.* New York, 1969.

KIRBY, M. *Happenings.* New York, 1965.

KULTERMAN, U. *The New Sculpture, Environments and Assemblages.* New York, 1968.

LIPPARD, L. R. *Six Years: The dematerialization of the art object from 1966 to 1972.* New York, 1973.

McSHINE, K. *Information.* Exhibition catalogue, Museum of Modern Art. New York, 1970.

MEYER, U. *Conceptual Art.* New York, 1972.

PINCUS-WITTEN, R. *Against Order/Chance and Art.* Exhibition catalogue, Institute of Contemporary Art, University of Pennsylvania. Philadelphia, 1970.

REICHART, J. *Cybernetics, Art, and Ideas.* Greenwich, Conn., 1971.

SHARP, W. *Air Art.* Exhibition catalogue, Arts Council, YM/YWHA. Philadelphia, 1968.

SHARP, W. *Light, Motion, Space.* Exhibition catalogue, Walker Art Center. Minneapolis, Minn., 1967.

VAN DER MARCK, J. *Art by Telephone.* Exhibition catalogue, Museum of Contemporary Art. Chicago, 1969.

II. INDIVIDUAL ARTISTS

ABBEY, EDWIN AUSTIN (1852–1911)
Foster, K. A., and Quick, M. *Edwin Austin Abbey.* Exhibition catalogue, Yale University Art Gallery. New Haven, Conn., 1974.
Lucas, E. V. *Edwin Austin Abbey, Royal Academician, The Record of His Life and Work.* 2 vols. London and New York, 1921.

ABBOTT, BERENICE (b. 1898)
Abbott, Berenice. *Photographs.* 1970.
Abbott, Berenice, and Lanier, H. W. *Greenwich Village Today and Yesterday.* New York, 1949.

ADAMS, ANSEL (b. 1902)
Ansel Adams: Images 1923–1974. New York, 1974.
Newhall, N. *Ansel Adams: The Eloquent Light.* San Francisco, 1963.

ALBERS, JOSEF (b. 1888)
Albers, Josef. *Interaction of Color.* 2 vols. New Haven and London, 1963.
Gomringer, E. *Josef Albers.* New York, 1968.
Hamilton, G. H. *Josef Albers: Paintings, Prints, Projects.* New Haven, 1956.
McShine, K. *Josef Albers.* Exhibition catalogue, Museum of Modern Art. New York, 1964.
Spies, W. *Josef Albers.* New York, 1970.

ALBRIGHT, IVAN (b. 1897)
Sweet, F. A. *Ivan Albright.* Exhibition catalogue, Art Institute of Chicago. Chicago, 1964.

ALEXANDER, JOHN WHITE (1856–1915)
Catalogue of Paintings, John White Alexander Memorial Exhibition. Exhibition catalogue, Carnegie Institute. Pittsburgh, Pa., 1916.

ALLSTON, WASHINGTON (1779–1843)
Allston, Washington. *Lectures on Art and Poems.* New York, 1850.
Flagg, J. B. *The Life and Letters of Washington Allston.* New York, 1892.
Richardson, E. P. *Washington Allston.* Apollo ed., New York, 1967.

AMES, EZRA (1768–1836)
Bolton, T., and Cortelyou, I. *Ezra Ames of Albany.* New York, 1955.

ANDRÉ, CARL (b. 1935)
Waldman, D. *Carl André.* Exhibition catalogue, Guggenheim Museum. New York, 1970.

ANSHUTZ, THOMAS (1851–1912)
Thomas Anshutz, 1851–1912. Exhibition catalogue, Graham Gallery. New York, 1963.

ARBUS, DIANE (1923–1971)

Szarkowski, J. *Photographs by Diane Arbus.* Exhibition catalogue, Museum of Modern Art. New York, 1972.

AUDUBON, JOHN JAMES (1785–1851)

Adams, A. B. *John James Audubon. A Biography.* New York, 1966.

Davidson, M. B. *The Original Water-Color Paintings by John James Audubon for the Birds of America.* New York, 1966.

Ford, A., ed. *Audubon, By Himself, A Profile of John James Audubon, From Writings Selected, Arranged and Edited by Alice Ford.* Garden City, N.Y., 1969.

Herrick, F. *Audubon the Naturalist, A History of his Life and Time.* New York, 1917.

AVERY, MILTON (1893–1965)

Breeskin, A. *Milton Avery.* Exhibition catalogue, American Federation of Arts. New York, 1960.

Kramer, H. *Milton Avery: Paintings, 1930–1960.* New York, 1962.

Wight, F. S. *Milton Avery.* Exhibition catalogue, Baltimore Museum of Art. Baltimore, Md., 1952.

BADGER, JOSEPH (1708–1765)

Park, L. ' Joseph Badger (1708–1765), and a Descriptive List of Some of His Works', *Proceedings of the Massachusetts Historical Society,* LI (December 1917), 158–201.

BALL, THOMAS (1819–1911)

Ball, Thomas. *My Threescore Years and Ten.* Boston, 1891.

BASKIN, LEONARD (b. 1922)

Roylance, D. *Leonard Baskin: The Graphic Work, 1950–1970.* New York, 1970.

BAZIOTES, WILLIAM (1912–1963)

Alloway, L. *Baziotes.* Exhibition catalogue, Guggenheim Museum. New York, 1965.

BEARDEN, ROMARE (b. 1914)

Bearden, Romare, and Holty, C. *The Painter's Mind.* New York, 1969.

Greene, C. *Romare Bearden: The Prevalence of Ritual.* Exhibition catalogue, Museum of Modern Art. New York, 1970.

Washington, M. B. *The Art of Romare Bearden, The Prevalence of Ritual.* New York, 1973.

BEAUX, CECILIA (1863–1942)

Beaux, Cecilia. *Background with Figures.* Boston, 1930.

Goodyear, F. H., Jr. *Cecilia Beaux, Portrait of an Artist.* Exhibition catalogue, Pennsylvania Academy of the Fine Arts. Philadelphia, 1974.

BELLOWS, GEORGE (1882–1925)

Boswell, P. *George Bellows.* New York, 1942.

Braider, D. *George Bellows and the Ashcan School of Painting.* New York, 1971.

George Bellows: Paintings, Drawings and Prints. Exhibition catalogue, Art Institute of Chicago. Chicago, 1964.

Morgan, C. H. *George Bellows, Painter of America.* New York, 1965.

Young, M. S. *The Paintings of George Bellows.* New York, 1973.

BENTON, THOMAS HART (1889–1975)

The Arts of Life in America: A Series of Murals by Thomas Benton. Exhibition catalogue, Whitney Museum of American Art. New York, 1932.

Baigell, M. *Thomas Hart Benton.* New York, 1974.

Benton, Thomas Hart. *An American in Art: A Professional and Technical Autobiography.* Lawrence, Kans., 1969.

Benton, Thomas Hart. *An Artist in America.* Revised ed., Kansas City, Mo., 1951.

Craven, T. *Thomas Hart Benton.* New York, 1939.

Fath, C., ed. *The Lithographs of Thomas Hart Benton.* Austin, Tex., 1969.

BIERSTADT, ALBERT (1830–1902)

Hendricks, G. *Albert Bierstadt.* Exhibition catalogue, Whitney Museum of American Art. New York, 1972.

Hendricks, G. *Albert Bierstadt, Painter of the American West.* New York, 1974.

Ludlow, F. H. *The Heart of the Continent: A Record of Travel Across the Plains and in Oregon, with an Examination of the American Principle.* New York, 1870.

Trump, R. S. *Life and Works of Albert Bierstadt.* Unpublished doctoral dissertation, Ohio State University. University Microfilms ed., Ann Arbor, Mich., 1965.

BINGHAM, GEORGE CALEB (1811–1879)

Bloch, E. M. *George Caleb Bingham.* Exhibition catalogue, National Collection of Fine Arts. Washington, D.C., 1967.

Bloch, E. *George Caleb Bingham, The Evolution of an Artist and A Catalogue Raisonné.* 2 vols. Berkeley and Los Angeles, 1967.

Christ-Janer, A. *George Caleb Bingham: Frontier Painter of Missouri.* New York, 1975.

Christ-Janer, A. *George Caleb Bingham of Missouri.* New York, 1940.

McDermott, J. F. *George Caleb Bingham.* Norman, Okla., 1959.

BIRCH, THOMAS (1779–1851)
Gerdts, W. H. *Thomas Birch, 1779–1851, Paintings and Drawings.* Exhibition catalogue, Philadelphia Maritime Museum. Philadelphia, 1966.

BLACKBURN, JOSEPH (fl. 1753–1763)
Morgan, J. H., and Foote, H. W. *An Extension of Lawrence Park's List of the Work of Joseph Blackburn.* Worcester, Mass., 1937.

Park, L. *Joseph Blackburn, Colonial Portrait Painter, with a Descriptive List of His Works.* Worcester, Mass., 1923.

BLAKELOCK, RALPH A. (1897–1919)
Gebhard, D., and Stuurman, P. *The Enigma of Ralph A. Blakelock, 1847–1919.* Exhibition catalogue, The Art Galleries, University of California. Santa Barbara, Cal., 1969.

Ralph Albert Blakelock Centenary Exhibition. Exhibition catalogue, Whitney Museum of American Art. New York, 1947.

Young, J. W. *Catalogue of the Works of R. A. Blakelock, N.A., and of his Daughter Marian Blakelock.* Exhibition catalogue, Young's Art Galleries. Chicago, 1916.

BLOOM, HYMAN (b. 1913)
Wight, F. *Hyman Bloom.* Exhibition catalogue, Institute of Contemporary Art. Boston, 1954.

BLUME, PETER (b. 1906)
Buckley, C. *Peter Blume, Paintings and Drawings in Retrospect: 1925–1964.* Exhibition catalogue, Currier Gallery of Art. Manchester, N.H., 1964.

Getlein, F. *Peter Blume.* Exhibition catalogue, Kennedy Galleries. New York, 1968.

BLYTHE, DAVID GILMORE (1815–1865)
Miller, D. *The Life and Work of David G. Blythe.* Pittsburgh, Pa., 1950.

BODMER, KARL (1809–1893)
Karl Bodmer Paints the Indian Frontier, A Traveling Exhibition. Exhibition catalogue, Smithsonian Institution. Washington, D.C., 1954.

BRADFORD, WILLIAM (1823–1892)
Bradford, William. *The Arctic Regions. Illustrated with Photographs taken on an Art Expedition to Greenland, with Descriptive Narrative by the Artist.* London, 1873.

Wilmerding, J. *William Bradford, 1823–1892, Artist of the Arctic, An Exhibition of his Paintings and Photographs.* Exhibition catalogue, DeCordova Museum. Lincoln, Mass., 1969.

BRADY, MATHEW (c. 1823–1896)
Horan, J. *Mathew Brady, Historian with a Camera.* New York, 1955.

Meredith, R. *Mr Lincoln's Contemporaries, An Album of Portraits by Mathew B. Brady.* New York, 1951.

BRICHER, ALFRED THOMPSON (1837–1908)
Brown, J. R. *Alfred Thompson Bricher, 1837–1908.* Exhibition catalogue, Indianapolis Museum of Art. Indianapolis, Ind., 1973.

BROOKS, JAMES (b. 1906)
Hunter, S. *James Brooks.* Exhibition catalogue, Whitney Museum of American Art. New York, 1963.

BROWERE, JOHN H. I. (1792–1834)
Bennet, J. *The Mask of Fame.* Highland Park, Ill., 1938.

Hart, C. *Browere's Life Masks of Great Americans.* New York, 1899.

BROWN, GEORGE LORING (1814–1889)
Leavitt, T. W. *George Loring Brown, Landscapes of Europe and America, 1834–1880.* Exhibition catalogue, The Robert Hull Fleming Museum. Burlington, Vt., 1973.

BRUSH, GEORGE DE FOREST (1855–1941)
A Catalogue of an Exhibition of Paintings and Drawings by George de Forest Brush. American Academy of Arts and Letters. New York, 1933.

BURCHFIELD, CHARLES (1893–1967)
Baur, J. I. H. *Charles Burchfield.* New York, 1956.

Baur, J. I. H. *Charles Burchfield.* Exhibition catalogue, Whitney Museum of American Art. New York, 1956.

Jones. E. H., ed. *The Drawings of Charles Burchfield.* New York, 1968.

CADMUS, PAUL (b. 1904)
Johnson, U. *Paul Cadmus: Prints and Drawings, 1922–1967.* Brooklyn, N.Y., 1968.

CALDER, ALEXANDER (b. 1898)
Arnason, H. H. *Alexander Calder.* Princeton, N.J., 1966.

Messer, T. *Alexander Calder: A Retrospective Exhibition.* Exhibition catalogue, Guggenheim Museum. New York, 1964.

Sweeney, J. J. *Alexander Calder.* Exhibition catalogue, Museum of Modern Art. New York, 1951.

CASSATT, MARY (1845–1926)

Breeskin. A. D. *The Graphic Work of Mary Cassatt, A Catalogue Raisonné.* New York, 1948.

Breeskin, A. D. *Mary Cassatt, A Catalogue Raisonné of the Oils, Pastels, Watercolors, and Drawings.* Washington, D.C., 1970.

Bullard, J. *Mary Cassatt, Oils and Pastels.* New York, 1972.

Carson, J. M. *Mary Cassatt.* New York, 1966.

Sweet, F. A. *Miss Mary Cassatt, Impressionist from Pennsylvania.* Norman, Okla., 1966.

CATLIN, GEORGE (1796–1872)

Catlin, George. *Letters and Notes on the Manners, Customs, and Conditions of the North American Indians, Written during Eight Years' Travel (1832–1839) amongst the Wildest Tribes of Indians in North America.* 2 vols. London, 1844; Dover ed., New York, 1973.

Haberly, L. *Pursuit of the Horizon: The Life of George Catlin.* New York, 1948.

Halpin, M. *Catlin's Indian Gallery.* Washington, D.C., 1965.

McCracken, H. *George Catlin and the Old Frontier.* New York, 1969.

CHAMBERLAIN, JOHN (b. 1927)

Waldman, D. *John Chamberlain.* Exhibition catalogue, Guggenheim Museum. New York, 1971.

CHAPMAN, JOHN GADSBY (1808–1889)

Chamberlain, G. *Studies on John Gadsby Chapman, American Artist.* Annandale, Va., 1963.

CHASE, WILLIAM MERRITT (1849–1916)

Pasano, R. G. *The Students of William Merritt Chase.* Exhibition catalogue, Heckscher Museum. Huntington, N.Y., 1973.

Peat, W. D. *Chase Centennial Exhibition.* Exhibition catalogue, John Herron Art Museum. Indianapolis, Ind., 1949.

Roof, K. *The Life and Art of William Merritt Chase.* New York, 1917.

Story, A. *William Merritt Chase (1849–1916).* Exhibition catalogue, Art Gallery, University of California. Santa Barbara, Cal., 1964.

CHRISTO (b. 1935)

Bourdon, D. *Christo.* New York, 1970.

Christo. *Valley Curtain.* New York, 1973.

CHRYSSA (b. 1933)

Hunter, S. *Chryssa.* New York, 1974.

CHURCH, FREDERIC EDWIN (1826–1900)

Hanson, B. *Frederic Edwin Church: The Artist at Work.* Exhibition catalogue, Joseloff Gallery, University of Hartford, Conn., 1974.

Huntington, D. C. *Frederic Edwin Church.* Exhibition catalogue, National Collection of Fine Arts. Washington, D.C., 1966.

Huntington, D. C. *The Landscapes of Frederic Edwin Church, Vision of an American Era.* New York, 1966.

Noble, L. L. *After Icebergs with A Painter, A Summer Voyage to Labrador and Around Newfoundland.* New York, 1861.

COLE, THOMAS (1801–1848)

Merritt, H. S. *Thomas Cole.* Exhibition catalogue, Memorial Art Gallery of the University of Rochester. Rochester, N.Y., 1969.

Noble, L. L. *The Life and Works of Thomas Cole.* John Harvard Library ed., Cambridge, Mass., 1964.

Noble, L. L. *The Course of Empire, Voyage of Life and Other Pictures of Thomas Cole, N.A.* New York, 1853.

Seaver, E. I. *Thomas Cole, 1801–1848, One Hundred Years Later.* Exhibition catalogue, Wadsworth Atheneum. Hartford, Conn., 1948.

COPLEY, JOHN SINGLETON (1738–1815)

Amory, M. B. *Domestic and Artistic Life of John Singleton Copley, R.A.* Boston, 1882.

Bayley, F. W. *The Life and Works of John Singleton Copley.* Boston, 1915.

Flexner, J. T. *John Singleton Copley.* Boston, 1948.

Frankenstein, A., and the Editors of *Time-Life* Books. *The World of Copley, 1738–1815.* New York, 1970.

Jones, G., ed. *Letters and Papers of John Singleton Copley and Henry Pelham. Massachusetts Historical Society Collections,* LXXXI (Boston, 1914), 41–2.

Parker, B. N., and Wheeler, A. B. *John Singleton Copley.* Boston, 1938.

Perkins, A. T. *A Sketch of the Life and a List of Some of the Works of John Singleton Copley.* Boston, 1873.

Prown, J. D. *John Singleton Copley.* 2 vols. Cambridge, Mass., 1966.

Prown, J. D. *John Singleton Copley.* Exhibition catalogue, National Gallery of Art. Washington, D.C., 1965.

CORNELL, JOSEPH (1903–1973)

Ashton, D. *A Joseph Cornell Album*. New York, 1974.

Waldman, D. *Joseph Cornell*. Exhibition catalogue, Guggenheim Museum. New York, 1967.

CRAWFORD, RALSTON (b. 1906)

Dwight, E. *Ralston Crawford*. Exhibition catalogue, Milwaukee Art Center. Milwaukee, Wis., 1958.

Sweeney, J. J. *Ralston Crawford*. Exhibition catalogue, Louisiana State University Art Gallery. Baton Rouge, La., 1950.

CRAWFORD, THOMAS (c. 1813–1857)

Gale, R. *Thomas Crawford, American Sculptor*. Pittsburgh, Pa., 1964.

CROPSEY, JASPER F. (1823–1900)

Bermingham, P. *Jasper F. Cropsey, 1823–1900, Retrospective View of America's Painter of Autumn*. Exhibition catalogue, University of Maryland Art Gallery. University Park, Md., 1968.

Talbot, W. S. *Jasper F. Cropsey, 1823–1900*. Exhibition catalogue, National Collection of Fine Arts. Washington, D.C., 1970.

CURRY, JOHN STEUART (1897–1946)

Retrospective Exhibition of Works by John Steuart Curry. Exhibition catalogue, Syracuse University. Syracuse, N.Y., 1956.

Schmeckebier, L. *John Steuart Curry's Pageant of America*. New York, 1943.

DAVIES, ARTHUR B. (1862–1928)

Arthur B. Davies, Essays on His Art. New York, 1974.

Arthur Bowen Davies, 1862–1928: A Centennial Exhibition. Exhibition catalogue, Munson-Williams-Proctor Institute. Utica, N.Y., 1962.

Catalogue of a Memorial Exhibition of the Works of Arthur B. Davies. Metropolitan Museum. New York, 1930.

Cortissoz, R. *Arthur B. Davies*. New York, 1931.

DAVIS, GENE (b. 1920)

Gene Davis. Exhibition catalogue, Gallery of Modern Art. Washington, D.C., 1968.

DAVIS, STUART (1894–1964)

Arnason, H. H. *Stuart Davis*. Washington, D.C., 1965.

Goosen, E. C. *Stuart Davis*. New York, 1959.

Kelder, D., ed. *Stuart Davis*. New York, 1971.

Stuart Davis. Exhibition catalogue, Walker Art Center. Minneapolis, Minn., 1957.

Stuart Davis Memorial Exhibition. Exhibition catalogue, National Collection of Fine Arts. Washington, D.C., 1965.

DE KOONING, WILLEM (b. 1904)

Hess, T. B. *Willem de Kooning*. New York, 1959.

Hess, T. B. *Willem de Kooning*. Exhibition catalogue, Museum of Modern Art. New York, 1968.

Larson, P., and Schjeldahl, P. *De Kooning: Drawings/Sculptures*. New York, 1974.

Rosenberg, H. *Willem de Kooning*. New York, 1974.

DEMUTH, CHARLES (1883–1935)

Farnham, E. *Behind a Laughing Mask*. Norman, Okla., 1971.

Ritchie, A. C. *Charles Demuth*. New York, 1950.

Ritchie, A. C. *Charles Demuth*. Exhibition catalogue, Museum of Modern Art. New York, 1950.

DICKINSON, EDWIN (b. 1891)

Goodrich, L. *The Drawings of Edwin Dickinson*. New Haven, Conn., 1963.

Goodrich, L. *Edwin Dickinson*. Exhibition catalogue, Whitney Museum of American Art. New York, 1965.

DILLER, BURGOYNE (1906–1965)

Burgoyne Diller: 1906–1965. Exhibition catalogue, New Jersey State Museum. Trenton, N.J., 1966.

Larson, P. *Burgoyne Diller*. Exhibition catalogue, Walker Art Center. Minneapolis, Minn., 1972.

DINE, JIM (b. 1935)

Dine, Jim. *Welcome Home Lovebirds: Poems and Drawings*. London, 1969.

Gordon, J. *Jim Dine*. Exhibition catalogue. Whitney Museum of American Art. New York, 1970.

Jim Dine: Complete Graphics. Exhibition catalogue, Galerie Mirko. Berlin, 1970.

DOUGHTY, THOMAS (1793–1856)

Doughty, H. N. *Life and Works of Thomas Doughty*. Unpublished manuscript, New-York Historical Society. New York, n.d.

Goodyear, F. H., Jr. *Thomas Doughty, 1793–1856, An American Pioneer in Landscape Painting*. Exhibition catalogue, Pennsylvania Academy of the Fine Arts. Philadelphia, 1973.

DOVE, ARTHUR G. (1880–1946)

Johnson, D. R. *Arthur Dove: The Years of Collage.*
Exhibition catalogue, J. Millard Tawes Fine
Arts Center, University of Maryland. College
Park, Md., 1967.

Solomon, A. *Arthur G. Dove, 1880–1946. A
Retrospective Exhibition.* Exhibition catalogue,
Andrew Dickson White Museum of Art,
Cornell University. Ithaca, N.Y., 1954.

Wight, F. S. *Arthur G. Dove.* Berkeley, Cal.,
1958.

DU BOIS, GUY PÈNE (1884–1958)

Cortissoz, R. *Guy Pène du Bois.* New York, 1931.

du Bois, Guy Pène. *Artists Say the Silliest Things.*
New York, 1940.

Medford, R. C. *Guy Pène du Bois.* Exhibition
catalogue, Washington County Museum of
Fine Arts. Maryland, 1940.

DUNCANSON, ROBERT S. (1817–1872)

McElroy, G. *Robert S. Duncanson, A Centennial
Exhibition.* Exhibition catalogue, Cincinnati
Art Museum. Cincinnati, Ohio, 1972.

DUNLAP, WILLIAM (1766–1839)

Barck, D. C., ed. *Diary of William Dunlap (1766–
1839).* New York, 1930.

Coad, O. S. *William Dunlap, a Study of His Life
and Works and of His Place in Contemporary
Culture.* New York, 1917.

DURAND, ASHER B. (1796–1886)

Durand, J. *The Life and Times of Asher B. Durand.*
New York, 1894.

Lawall, D. B. *A. B. Durand, 1796–1886.* Exhibi-
tion catalogue, Montclair Art Museum. Mont-
clair, N.J., 1971.

DURRIE, GEORGE HENRY (1820–1863)

Cowdrey, M. B. *George Henry Durrie, 1820–
1863, Connecticut Painter of American Life.*
Exhibition catalogue, Wadsworth Atheneum.
Hartford, Conn., 1947.

DUVENECK, FRANK (1848–1919)

Bilodeau, F. W. *Frank Duveneck.* Exhibition
catalogue, Chapellier Gallery. New York,
1972.

Exhibition of the Work of Frank Duveneck. Exhibi-
tion catalogue, Cincinnati Art Museum. Cin-
cinnati, Ohio, 1936.

Heerman, N. *Frank Duveneck.* Boston, 1918.

EAKINS, THOMAS (1844–1916)

Casteras, S. *Susan Macdowell Eakins, 1851–
1938.* Exhibition catalogue, Pennsylvania
Academy of the Fine Arts. Philadelphia,
1973.

Domit, M. M. *The Sculpture of Thomas Eakins.*
Exhibition catalogue, Corcoran Gallery of Art.
Washington, D.C., 1969.

Goodrich, L. *Thomas Eakins.* New York, 1933.

Goodrich, L. *Thomas Eakins.* Exhibition cata-
logue, Whitney Museum of American Art.
New York, 1970.

Goodrich, L. *Thomas Eakins, A Retrospective
Exhibition.* Exhibition catalogue, National
Gallery of Art. Washington, D.C., 1961.

Hendricks, G. *The Life and Work of Thomas
Eakins.* New York, 1974.

Hendricks, G. *The Photographs of Thomas Eakins.*
New York, 1972.

Hendricks, G. *Thomas Eakins: His Photographic
Works.* Exhibition catalogue, Pennsylvania
Academy of the Fine Arts. Philadelphia, 1969.

Hoopes, D. F. *Eakins Watercolors.* New York,
1971.

McHenry, M. *Thomas Eakins Who Painted.* New
York, 1946.

Porter, F. *Thomas Eakins.* New York, 1959.

Schendler, S. *Eakins.* Boston, 1967.

EARL, RALPH (1751–1801)

Goodrich, L. B. *Ralph Earl, Recorder for an Era.*
Yellow Springs, Ohio, 1967.

Sawitsky, W. *Ralph Earl, 1751–1801.* Exhibition
catalogue, Whitney Museum of American Art.
New York, 1945.

Sawitsky, W. *Connecticut Portraits by Ralph Earl,
1751–1801.* Exhibition catalogue, Yale Univer-
sity Art Gallery. New Haven, Conn., 1935.

EASTMAN, SETH (1808–1875)

Burkhalter, L. *A Seth Eastman Sketchbook, 1848–
1849.* Austin, Texas, 1961.

McDermott, J. F. *Seth Eastman, Pictorial History
of the Indian.* Norman, Okla., 1961.

EILSHEMIUS, LOUIS M. (1864–1941)

Schack, W. *And He Sat Among the Ashes.* New
York, 1939.

EVANS, WALKER (1903–1975)

Evans, Walker, and Agee, J. *Let Us Now Praise
Famous Men.* New York, 1941.

Kirstein, L. *Walker Evans, American Photographs.*
Exhibition catalogue, Museum of Modern
Art. New York, 1962.

Szarkowski, J. *Walker Evans, Photographs.* Green-
wich, Conn., 1972.

EVERGOOD, PHILIP (1901–1973)

Baur, J. I. H. *Philip Evergood.* Exhibition cata-
logue, Whitney Museum of American Art.
New York, 1960.

Larkin, O. *Twenty Years of Painting by Philip Evergood*. Exhibition catalogue, Whitney Museum of American Art. New York, 1946.

Lippard, L. R. *The Graphic Work of Philip Evergood: Selected Drawings and Complete Prints*. New York, 1966.

FEELEY, PAUL (1910–1966)

Baro, G. *Paul Feeley, Memorial Exhibition*. Exhibition catalogue, Guggenheim Museum. New York, 1968.

FEININGER, LYONEL (1871–1956)

Lyonel Feininger. Exhibition catalogue, Pasadena Art Museum. Pasadena, Cal., 1966.

FEKE, ROBERT (c. 1705–c. 1750)

Foote, H. W. *Robert Feke*. Cambridge, Mass., 1930.

Goodrich, L. *Robert Feke*. Exhibition catalogue, Whitney Museum of American Art. New York, 1946.

FERBER, HERBERT (b. 1906)

Anderson, W. V. *The Sculpture of Herbert Ferber*. Exhibition catalogue, Walker Art Center. Minneapolis, Minn., 1962.

FISHER, JONATHAN (1768–1847)

Chase, M. *Jonathan Fisher, Maine Parson, 1768–1847*. New York, 1948.

Winchester, A. *Versatile Yankee, The Art of Jonathan Fisher, 1768–1847*. New York, 1973.

FLANNAGAN, JOHN B. (1895–1942)

Forsyth, R. J. *John B. Flannagan*. South Bend, Ind., 1963.

John B. Flannagan: Sculpture/Drawings, 1924–1938. Exhibition catalogue, Weyhe Gallery. New York, 1973.

Letters of John Flannagan. New York, 1942.

The Sculpture of John B. Flannagan. Exhibition catalogue, Museum of Modern Art. New York, 1942.

FLAVIN, DAN (b. 1933)

Bochner, M., and Judd, D. *Fluorescent Light, etc. from Dan Flavin*. Exhibition catalogue, National Gallery of Canada. Ottawa, 1969.

FOSTER, JOHN (1648–1681)

Green, S. A. *John Foster, the Earliest American Engraver and the First Boston Printer*. Boston, 1909.

FRANCIS, SAM (b. 1923)

de Wilde, E., and Schmied, W. *Sam Francis*. Exhibition catalogue, Stedelijk Museum. Amsterdam, 1968.

Sam Francis. Exhibition catalogue, Albright-Knox Art Gallery. Buffalo, N.Y., 1972.

Sweeney, J. J. *Sam Francis*. Exhibition catalogue, Museum of Fine Arts. Houston, Tex., 1967.

FRANKENTHALER, HELEN (b. 1928)

Goosen, E. C. *Helen Frankenthaler*. Exhibition catalogue, Whitney Museum of American Art. New York, 1969.

O'Hara, F. *Helen Frankenthaler*. Exhibition catalogue, The Jewish Museum. New York, 1960.

Rose, B. *Helen Frankenthaler*. New York, 1971.

FRENCH, DANIEL CHESTER (1850–1931)

Adams, A. *Daniel Chester French: Sculptor*. Boston, 1932.

Cresson, M. *Journey into Fame, The Life of Daniel Chester French*. Cambridge, Mass., 1947.

GARDNER, ALEXANDER (1821–1882)

Gardner, Alexander. *Photographic Sketch Book of the Civil War*. Washington, D.C., 1866; Dover ed., New York, 1959.

GIFFORD, SANFORD R. (1823–1880)

Cikovsky, N., Jr. *Sanford Robinson Gifford*. Exhibition catalogue, University of Texas Art Museum. Austin, Tex., 1970.

Gifford Memorial Meeting of the Century. The Century Club, New York, 1880.

Weiss, I. *Sanford Robinson Gifford*. Unpublished doctoral dissertation, Columbia University. New York, 1968.

GLACKENS, WILLIAM (1870–1938)

du Bois, G. P. *William Glackens*. New York, 1931.

Glackens, I. *William Glackens and the Ashcan Group*. New York, 1957.

Katz, L. *William Glackens in Retrospect*. Exhibition catalogue, City Art Museum. St Louis, Mo., 1966.

GORKY, ARSHILE (1904–1948)

Joyner, B. *The Drawings of Arshile Gorky*. Exhibition catalogue, J. Millard Tawes Fine Arts Center, University of Maryland. College Park, Md., 1969.

Levy, J. *Arshile Gorky*. New York, 1966.

Rosenberg, H. *Arshile Gorky*. New York, 1962.

Schwabacher, E. K. *Arshile Gorky*. New York, 1957.

Schwabacher, E. K. *Arshile Gorky: Memorial Exhibition*. Exhibition catalogue, Whitney Museum of American Art. New York, 1951.

Seitz, W. C. *Arshile Gorky: Paintings, Drawings, Studies.* Exhibition catalogue, Museum of Modern Art. New York, 1962.

GOTTLIEB, ADOLPH (1903–1974)
Doty, R., and Waldman, D. *Adolph Gottlieb.* Exhibition catalogue, Whitney Museum of American Art and Guggenheim Museum. New York, 1968.
Friedman, M. *Adolph Gottlieb.* Exhibition catalogue, Walker Art Center. Minneapolis, Minn., 1963.
Greenberg, C. *Adolph Gottlieb.* Exhibition catalogue, The Jewish Museum. New York, 1957.

GRAVES, MORRIS (b. 1910)
Cage, J., et al. *The Drawings of Morris Graves.* New York, 1975.
Morris Graves, A Retrospective. Exhibition catalogue, Museum of Art, University of Oregon. Eugene, Ore., 1966.
Wight, F. S., et al. *Morris Graves.* Berkeley, Cal., 1956.

GREENOUGH, HORATIO (1805–1852)
Bender, H., ed. *Travels, Observations, and Experiences of a Yankee Stonecutter.* New York, 1852.
Greenough, F. B., ed. *Letters of Horatio Greenough to his Brother Henry Greenough.* Boston, 1887.
Greenough, Horatio. *Form and Function, Remarks on Art, Design, and Architecture.* Berkeley and Los Angeles, 1962.
Tuckerman, H. *A Memorial of Horatio Greenough.* New York, 1853.
Wright, N. *Horatio Greenough, The First American Sculptor.* Philadelphia, 1963.

GREENWOOD, JOHN (1727–1792)
Burroughs, A. *John Greenwood in America, 1745–1752.* Andover, Mass., 1943.

GUSTON, PHILIP (b. 1913)
Arnason, H. H. *Philip Guston.* Exhibition catalogue, Guggenheim Museum. New York, 1962.
Ashton, D. *Philip Guston.* New York, 1959.
Hunter, S., and Rosenberg, H. *Philip Guston: Recent Paintings and Drawings.* Exhibition catalogue, The Jewish Museum. New York, 1966.

HAMILTON, JAMES (1819–1878)
Jacobowitz, A. *James Hamilton, 1819–1878, American Marine Painter.* Exhibition catalogue, The Brooklyn Museum. Brooklyn, N.Y., 1966.

HARDING, CHESTER (1791–1866)
Harding, Chester. *My Egohistography.* Boston, 1866.
White, M. *A Sketch of Chester Harding, Artist, Drawn by his Own Hand.* Boston, 1929.

HARNETT, WILLIAM M. (1848–1892)
Frankenstein, A. *After the Hunt, William Harnett and other American Still Life Painters, 1870–1900.* Revised ed. Berkeley and Los Angeles, 1969.

HARTLEY, MARSDEN (1877–1943)
Hartley, Marsden. *Adventures in the Arts: Informal Chapters on Painters, Vaudeville and Poets.* New York, 1921.
Marsden Hartley. Exhibition catalogue, Stedelijk Museum. Amsterdam, 1960.
McCausland, E. *Marsden Hartley.* Minneapolis, Minn., 1952.
Miller, D. *Lyonel Feininger and Marsden Hartley.* New York, 1944.

HASELTINE, WILLIAM STANLEY (1835–1900)
Plowden, H. H. *William Stanley Haseltine, Sea and Landscape Painter (1835–1900).* London, 1947.

HASSAM, CHILDE (1839–1935)
Adams, A. *Childe Hassam.* New York, 1938.
Williams, H. W., Jr. *Childe Hassam, a retrospective exhibition.* Exhibition catalogue, Corcoran Gallery of Art. Washington, D.C., 1965.

HEADE, MARTIN JOHNSON (1819–1904)
McIntyre, R. G. *Martin Johnson Heade.* New York, 1948.
Stebbins, T. E., Jr. *Martin Johnson Heade.* Exhibition catalogue, Whitney Museum of American Art. New York, 1969.

HEALY, GEORGE P. A. (1813–1894)
Bigot, M. C. *Life of George P. A. Healy.* Chicago, 1913.
de Mare, M. *G. P. A. Healy, American Artist.* New York, 1954.
Healy, George P. A. *Reminiscences of a Portrait Painter.* Chicago, 1894.

HELD, AL (b. 1928)
Green, E. *Al Held.* Exhibition catalogue, San Francisco Museum of Art. San Francisco, 1968.

HENRI, ROBERT (1865–1929)
Henri, Robert. *The Art Spirit.* New York, 1923; new ed., New York, 1960.
Homer, W. I. *Robert Henri and His Circle.* Ithaca, N.Y., and London, 1969.
Read, H. A. *Robert Henri.* New York, 1931.

Read, H. A. *Robert Henri and His Pupils.* Exhibition catalogue, Century Association. New York, 1946.

HENRY, EDWARD LAMSON (1841–1919)
McCausland, E. *The Life and Work of Edward Lamson Henry, N.A., 1841–1919.* New York, 1945.

HESSE, EVA (1936–1970)
Pincus-Witten, R., and Shearer, L. *Eva Hesse: A Memorial Exhibition.* Exhibition catalogue, Guggenheim Museum. New York, 1972.

HESSELIUS, GUSTAVUS (1682–1755)
Brinton, C. *Gustavus Hesselius.* Philadelphia, 1938.

HICKS, EDWARD (1780–1849)
Ford, A. *Edward Hicks: Painter of the Peaceable Kingdom.* Philadelphia, 1952.
Mather, E. P. *Edward Hicks, A Peaceable Season.* Princeton, N.J., 1973.

HILL, JOHN WILLIAM (1812–1879)
Hill, J. H. *John William Hill, An Artist's Memorial.* New York, 1888.

HOFMANN, HANS (1880–1966)
Greenberg, C. *Hans Hofmann.* Paris, 1961.
Hofmann, Hans. *Search for the Real and Other Essays.* Revised ed. Cambridge, Mass., 1967.
Hunter, S. *Hans Hofmann.* New York, 1963.
Seitz, W. C. *Hans Hofmann.* New York, 1963.
Seitz, W. C. *Hans Hofmann.* Exhibition catalogue, Museum of Modern Art. New York, 1963.

HOMER, WINSLOW (1836–1910)
Beam, P. *Winslow Homer at Prout's Neck.* Boston, 1968.
Downes, W. H. *The Life and Works of Winslow Homer.* Boston and New York, 1911.
Flexner, J. T., and the Editors of *Time-Life Books. The World of Winslow Homer, 1836–1910.* New York, 1966.
Gardner, A. T. *Winslow Homer, American Artist: His World and His Work.* New York, 1961.
Goodrich, L. *The Graphic Art of Winslow Homer.* Exhibition catalogue, Whitney Museum of American Art. New York, 1968.
Goodrich, L. *Winslow Homer.* New York, 1945.
Goodrich, L. *Winslow Homer.* New York, 1959.
Goodrich, L. *Winslow Homer.* Exhibition catalogue, Whitney Museum of American Art. New York, 1973.
Goodrich, L. *Winslow Homer's America.* New York, 1969.

Grossman, J. *The Echo of a Distant Drum: Winslow Homer and the Civil War.* New York, 1974.
Hannaway, P. *Winslow Homer in the Tropics.* Richmond, Va., 1973.
Hoopes, D. F. *Winslow Homer Watercolors.* New York, 1969.
Wilmerding, J. *Winslow Homer.* New York, 1972.

HOPPER, EDWARD (1882–1967)
Barr, A. H., Jr., and Burchfield, C. *Edward Hopper Retrospective.* Exhibition catalogue, Museum of Modern Art. New York, 1933.
Goodrich, L. *Edward Hopper.* New York, 1971.
Goodrich, L. *Edward Hopper.* Exhibition catalogue, Whitney Museum of American Art. New York, 1964.

HOSMER, HARRIET (1830–1908)
Carr, C., ed. *Harriet Hosmer, Letters and Memories.* New York, 1912.

HOVENDEN, THOMAS (1840–1895)
Last Moments of John Brown, Painted by Thomas Hovenden. Philadelphia, 1885.

HUNT, WILLIAM MORRIS (1824–1879)
Angell, H. C. *Records of William M. Hunt.* Boston, 1881.
Hunt, William Morris. *Talks on Art.* 1st series, Boston, 1875; 2nd series, Boston, 1884.
Knowlton, H. M. *The Art Life of William Morris Hunt.* Boston, 1900.
Shannon, M. A. S. *Boston Days of William Morris Hunt.* Boston, 1923.

HUNTINGTON, DANIEL (1816–1906)
Catalogue of Paintings by Daniel Huntington, N. A., Exhibiting at the Art Union Building. New York, 1950.

INDIANA, ROBERT (b. 1928)
Alasko, R.-R. *Robert Indiana Graphics.* Exhibition catalogue, St Mary's College, Notre Dame University. South Bend, Ind., 1969.
Indiana, Robert, and Creeley, R. *Numbers.* Stuttgart, 1968.
McCoubrey, J. *Robert Indiana.* Exhibition catalogue, Institute of Contemporary Art, University of Pennsylvania. Philadelphia, 1968.
Robert Stankiewicz, Robert Indiana. Exhibition catalogue, Walker Art Center. Minneapolis, Minn., 1963.

INNESS, GEORGE (1825–1894)
Cikovsky, N., Jr. *George Inness.* New York, 1971.
Cikovsky, N., Jr. *The Paintings of George Inness.* Exhibition catalogue, University of Texas. Austin, Tex., 1965.

Daingerfield, E. *George Inness: the Man and His Art.* New York, 1911.

Inness, George, Jr. *The Life, Art and Letters of George Inness.* New York, 1917.

Ireland, L. R. *The Works of George Inness, An Illustrated Catalogue Raisonné.* Austin, Tex., and London, 1965.

Werner, A. *Inness Landscapes.* New York, 1973.

JACKSON, WILLIAM HENRY (1843–1942)

Hafen, L. R., ed. *The Diaries of William Henry Jackson.* Glendale, Cal., 1959.

Jackson, C. *Picture Maker of the Old West, William Henry Jackson.* New York, 1947.

Newhall, B., and Edkins, D. E. *William H. Jackson.* Fort Worth, Tex., 1974.

JARVIS, JOHN WESLEY (1780–1840)

Dickson, H. E. *John Wesley Jarvis, American Painter, 1780–1840.* New York, 1949.

JENKINS, PAUL (b. 1923)

Cassou, J. *Jenkins.* New York, 1963.

Elsen, A. *Paul Jenkins.* New York, n.d. [1973?].

Nordland, G. *Paul Jenkins.* Exhibition catalogue, Museum of Fine Arts. Houston, Tex., 1971.

JOHNS, JASPER (b. 1930)

Field, R. S. *Jasper Johns Prints, 1960–1970.* New York, 1970.

Kozloff, M. *Jasper Johns.* New York, 1967.

Solomon, A., and Cage, J. *Jasper Johns.* Exhibition catalogue, The Jewish Museum. New York, 1964.

Steinberg, L. *Jasper Johns.* New York, 1963.

JOHNSON, EASTMAN (1824–1906)

Baur, J. I. H. *Eastman Johnson, 1824–1906. An American Genre Painter.* Exhibition catalogue, Brooklyn Museum, New York, 1940; reprinted ed., New York, 1969.

Hills, P. *Eastman Johnson.* Exhibition catalogue, Whitney Museum of American Art. New York, 1972.

JOHNSTON, DAVID CLAYPOOLE (1797–1865)

Johnson, M. *David Claypoole Johnston.* Exhibition catalogue, American Antiquarian Society. Worcester, Mass., 1970.

JOHNSTON, HENRIETTA (fl. 1705–1729)

Middleton, M. S. *Henrietta Johnston of Charles Town, South Carolina, America's First Pastellist.* Columbia, S.C., 1966.

JOHNSTON, JOSHUA (fl. 1796–1824)

Pleasants, J. H. *Joshua Johnston, The First American Negro Portrait Painter.* Baltimore, Md., 1942.

JOUETT, MATTHEW HARRIS (1787–1827)

Jonas, E. A. *Matthew Harris Jouett, Kentucky Portrait Painter, 1787–1827.* Louisville, Ky., 1938.

JUDD, DON (b. 1928)

Agee, W. C. *Don Judd.* Exhibition catalogue, Whitney Museum of American Art. New York, 1968.

Coplans, J. *Don Judd.* Exhibition catalogue, Pasadena Art Museum. Pasadena, Cal., 1971.

Leering, J. *Don Judd.* Exhibition catalogue, Stedelijk van Abbemuseum. Eindhoven, 1970.

KÄSEBIER, GERTRUDE (1852–1934)

Gertrude Käsebier. Exhibition catalogue, Brooklyn Institute of Arts and Sciences. Brooklyn, N.Y., 1926.

KELLY, ELLSWORTH (b. 1923)

Coplans, J. *Ellsworth Kelly.* New York, 1972.

Goosen, E. C. *Ellsworth Kelly.* Exhibition catalogue, Museum of Modern Art. New York, 1973.

Waldman, D. *Ellsworth Kelly: Drawings, Collages and Prints.* Greenwich, Conn., 1971.

KENSETT, JOHN F. (1816–1872)

Howat, J. K. *John Frederick Kensett, 1816–1872.* Exhibition catalogue, American Federation of Arts. New York, 1968.

Siegfried, J. C. *John Frederick Kensett, A Retrospective Exhibition.* Exhibition catalogue, Hathorn Gallery, Skidmore College. Saratoga Springs, N.Y., 1967.

KENT, MARY CORITA (b. 1918)

[Kent], Sister Corita. *Footnotes and Headlines, A Play-Pray Book.* New York, 1967.

KENT, ROCKWELL (1882–1971)

Armitage, M. *Rockwell Kent.* New York, 1932.

Rockwell Kent. New York, 1945.

KIENHOLZ, EDWARD (b. 1927)

Hopps, W. *Edward Kienholz: Work from the 1960's.* Exhibition catalogue, Washington Gallery of Modern Art. Washington, D.C., 1968.

Hultén, K. G. P. *Edward Kienholz: 11 + 11 Tableaux.* Exhibition catalogue, Moderna Museet. Stockholm, 1970.

Kienholz, Ed, and Hultén, K. G. P. *Kienholz.* New York, 1975.

Tuchman, M. *Edward Kienholz.* Exhibition catalogue, Los Angeles County Museum of Art. Los Angeles, 1966.

KLINE, FRANZ (1910–1962)

Dawson, F. *An Emotional Memoir of Franz Kline.* New York, 1967.

de Kooning, E. *Franz Kline.* Exhibition catalogue, Washington Gallery of Fine Art. Washington, D.C., 1962.

Gordon, J. *Franz Kline: 1910–1962.* Exhibition catalogue, Whitney Museum of American Art. New York, 1968.

O'Hara, F. *Franz Kline.* Exhibition catalogue, Whitechapel Art Gallery. London, 1964.

KUHN, WALT (1880–1949)

Bird, P. *Fifty Paintings by Walt Kuhn.* New York, 1940.

Painter of Vision: Walt Kuhn. Exhibition catalogue, University of Arizona Art Gallery. Tucson, Ariz., 1966.

LACHAISE, GASTON (1882–1935)

Gallatin, A. E. *Gaston Lachaise.* New York, 1924.

Kramer, H. *The Sculpture of Gaston Lachaise.* New York, 1967.

Nordland, G. *Gaston Lachaise, 1882–1935.* Exhibition catalogue, Los Angeles County Museum of Art. Los Angeles, 1963.

LA FARGE, JOHN (1835–1910)

Cortissoz, R. *John La Farge: A Memoir and a Study.* Boston and New York, 1911.

John La Farge. Exhibition catalogue, Graham Gallery. New York, 1966.

La Farge, H. A. *John La Farge, Oils and Watercolors.* Exhibition catalogue, Kennedy Galleries. New York, 1968.

La Farge, John. *Reminiscences of the South Seas.* Garden City, N.Y., 1916.

LANE, FITZ HUGH (1804–1865)

Paintings and drawings by Fitz Hugh Lane at the Cape Ann Historical Association. Catalogue of the collection. Gloucester, Mass., 1974.

Wilmerding, J. *Fitz Hugh Lane.* New York, 1971.

Wilmerding, J. *Fitz Hugh Lane, 1804–1865, American Marine Painter.* Salem, Mass., 1964.

Wilmerding, J. *Fitz Hugh Lane, the First Major Exhibition.* Exhibition catalogue, De Cordova Museum. Lincoln, Mass., 1966.

Wilmerding, J. *Paintings by Fitz Hugh Lane.* Exhibition catalogue, Farnsworth Art Museum. Rockland, Me., 1974.

LAWRENCE, JACOB (b. 1917)

Brown, M. W. *Jacob Lawrence.* Exhibition catalogue, Whitney Museum of American Art. New York, 1974.

LEVINE, JACK (b. 1915)

Getlein, F. *Jack Levine.* New York, 1966.

Wight, F. S. *Jack Levine.* Exhibition catalogue, Institute of Contemporary Art. Boston, 1952.

LEWITT, SOL (b. 1928)

Develing, E. *Sol Lewitt.* Exhibition catalogue, Gemeentemuseum. The Hague, 1970.

LIBERMAN, ALEXANDER (b. 1912)

Pilgrim, J., et al. *Alexander Liberman.* Exhibition catalogue, Corcoran Gallery of Art. Washington, D.C., 1970.

LICHTENSTEIN, ROY (b. 1923)

Coplans, J., ed. *Roy Lichtenstein.* New York, 1972.

Coplans, J. *Roy Lichtenstein.* Exhibition catalogue, Pasadena Art Museum. Pasadena, Cal., 1967.

Waldman, D. *Roy Lichtenstein: Drawings and Prints.* New York, 1969.

Waldman, D. *Roy Lichtenstein.* Exhibition catalogue, Guggenheim Museum. New York, 1969.

LINDNER, RICHARD (b. 1901)

Ashton, D. *Richard Lindner.* New York, 1969.

Dienst, R.-G. *Lindner.* New York, 1970.

Tillim, S. *Lindner.* Chicago, 1960.

LIPCHITZ, JACQUES (1891–1973)

Hope, H. *The Sculpture of Jacques Lipchitz.* New York, 1954.

LIPTON, SEYMOUR (b. 1903)

Seymour Lipton: Recent Works. Exhibition catalogue, Marlborough-Gerson Gallery. New York, 1971.

LOUIS, MORRIS (1912–1962)

Alloway, L. *Morris Louis: 1912–1962.* Exhibition catalogue, Guggenheim Museum. New York, 1963.

Fried, M. *Morris Louis.* New York, 1970.

Fried, M. *Morris Louis, 1912–1962.* Exhibition catalogue, Museum of Fine Arts. Boston, 1967.

LUKS, GEORGE (1867–1933)

Cary, E. L. *George Luks.* New York, 1931.

George Luks, 1867–1933. Exhibition catalogue, Heritage Gallery. New York, 1967.

The Work of George Benjamin Luks. Exhibition catalogue, Newark Museum. Newark, N.J., 1934.

MACDONALD-WRIGHT, STANTON (b. 1890)
Brown, R. F. *A Retrospective Showing of the Work of Stanton MacDonald-Wright*. Exhibition catalogue, Los Angeles County Museum of Art. Los Angeles, 1956.
Scott, D. W. *The Art of Stanton MacDonald-Wright*. Exhibition catalogue, National Collection of Fine Arts. Washington, D.C., 1967.
Wight, F. S. *Stanton MacDonald-Wright: A Retrospective Exhibition, 1911–1970*. Exhibition catalogue, Art Galleries, University of California. Los Angeles, 1970.

MALBONE, EDWARD GREENE (1777–1807)
Tolman, R. P. *The Life and Works of Edward Greene Malbone, 1777–1807*. New York, 1958.

MANSHIP, PAUL (1885–1966)
Murtha, E. *Paul Manship*. New York, 1947.

MARCA-RELLI, CONRAD (b. 1913)
Agee, W. C. *Marca-Relli*. Exhibition catalogue, Whitney Museum of American Art. New York, 1968.
Arnason, H. H. *Marca-Relli*. New York, 1963.

MARIN, JOHN (1870–1953)
Benson, E. M. *John Marin, The Man and His Work*. New York, 1935.
Helm, MacK. *John Marin*. New York, 1948.
Norman, D., ed. *The Selected Writings of John Marin*. New York, 1949.
Reich, S. *John Marin: Drawings, 1886–1951*. Salt Lake City, Utah, 1969.
Reich, S. *John Marin: A Stylistic Analysis and Catalogue Raisonné*. 2 vols. Tucson, Ariz., 1970.
Seligmann, H. J., ed. *Letters of John Marin*. New York, 1931.

MARSH, REGINALD (1898–1954)
Goodrich, L. *Reginald Marsh*. New York, 1972.
Goodrich, L. *Reginald Marsh*. Exhibition catalogue, Whitney Museum of American Art. New York, 1955.
Laning, E. *East Side, West Side, All Around the Town: A Retrospective Exhibition of Paintings, Watercolors and Drawings by Reginald Marsh*. Exhibition catalogue, University of Arizona Art Gallery. Tucson, Ariz., 1969.
Laning, E. *The Sketchbooks of Reginald Marsh*. New York, 1973.
Sasowsky, N. *Reginald Marsh: Etchings, Engravings, Lithographs*. New York, 1956.

MARTIN, HOMER DODGE (1836–1897)
Martin, E. *Homer Dodge Martin, a Reminiscence*. New York, 1904.
Mather, F. J. *Homer Martin, Poet in a Landscape*. New York, 1912.

MAURER, ALFRED H. (1868–1932)
McCausland, E. *A. H. Maurer*. New York, 1951.
McCausland, E. *A. H. Maurer, 1868–1932*. Exhibition catalogue, Walker Art Center. Minneapolis, Minn., 1949.
Reich, S. *Alfred H. Maurer, 1868–1932*. Exhibition catalogue, National Collection of Fine Arts. Washington, D.C., 1973.

MILLER, ALFRED JACOB (1810–1874)
Bell, M. *Braves and Buffalo, Plains Indian Life in 1837, Watercolours of Alfred Jacob Miller*. Toronto, 1973.

MILLER, KENNETH HAYES (1876–1952)
Burroughs, A. *Kenneth Hayes Miller*. New York, 1931.

MITCHELL, JOAN (b. 1926)
Joan Mitchell. Exhibition catalogue, Whitney Museum of American Art. New York, 1974.

MORAN, THOMAS (1837–1926)
Wilkins, T. *Thomas Moran, Artist of the Mountains*. Norman, Okla., 1965.

MORRIS, ROBERT (b. 1931)
Compton, M., and Sylvester, D. *Robert Morris*. Exhibition catalogue, Tate Gallery. London, 1971.
Michelson, A. *Robert Morris*. Exhibition catalogue, Corcoran Gallery of Art. Washington, D.C., 1969.
Tucker, M. *Robert Morris*. Exhibition catalogue, Whitney Museum of American Art. New York, 1970.

MORSE, SAMUEL F. B. (1791–1872)
Larkin, O. W. *Samuel F. B. Morse and American Democratic Art*. Boston and Toronto, 1954.
Mabee, C. *The American Leonardo: A Life of Samuel F. B. Morse*. New York, 1943.
Morse, E. L., ed. *Samuel F. B. Morse, His Letters and Journals*. 2 vols. Boston and New York, 1914.
Prime, S. I. *The Life of Samuel F. B. Morse, L.L.D., Inventor of the Electro-Magnetic Recording Telegraph*. New York, 1875.
Wehle, H. B. *Samuel F. B. Morse, American Painter*. Exhibition catalogue, Metropolitan Museum of Art. New York, 1932.

MOTHERWELL, ROBERT (b. 1915)
Hunter, S. *Robert Motherwell Collages*. Paris, 1960.
O'Hara, F. *Robert Motherwell*. Exhibition catalogue, Museum of Modern Art. New York, 1965.

MOUNT, WILLIAM SIDNEY (1807–1868)
Cowdrey, B., and Williams, H. W., Jr. *William Sidney Mount, 1807–1868, An American Painter*. New York, 1944.
Frankenstein, A. *Painter of Rural America. William Sidney Mount, 1807–1868*. Exhibition catalogue, National Gallery of Art. Washington, D.C., 1969.
Frankenstein, A. *William Sidney Mount*. New York, 1975.

MUYBRIDGE, EADWEARD (1830–1904)
Brown, L., ed. *Animals in Motion*. New York, 1957.
Hendricks, G. *Eadweard Muybridge, The Father of the Motion Picture*. New York, 1975.
MacDonnell, K. *Eadweard Muybridge, The man who invented the moving picture*. Boston, 1972.
Mozley, A. V., et al. *Eadweard Muybridge: The Stanford Years, 1872–1882*. Exhibition catalogue, Stanford University Museum of Art. Stanford, Cal., 1972.
Muybridge, Eadweard. *Animal Locomotion*. Philadelphia, 1887.

MYERS, JEROME (1867–1940)
Jerome Myers Memorial Exhibition. Exhibition catalogue, Whitney Museum of American Art. New York, 1941.
Myers, Jerome. *An Artist in Manhattan*. New York, 1940.

NADELMAN, ELIE (1882–1946)
Kirstein, L. *Elie Nadelman*. New York, 1973.
Kirstein, L. *Elie Nadelman Drawings*. New York, 1949.
Kirstein, L. *The Sculpture of Elie Nadelman*. Exhibition catalogue, Museum of Modern Art. New York, 1948.

NAKIAN, REUBEN (b. 1897)
O'Hara, F. *Nakian*. New York, 1966.

NEAGLE, JOHN (1796–1865)
Lynch, M. 'John Neagle's Diary', *Art in America*, XXXVII (April 1949), 77–99.

NEVELSON, LOUISE (b. 1900)
Glimcher, A. *Louise Nevelson*. New York, 1972.
Gordon, J. *Louise Nevelson*. Exhibition catalogue, Whitney Museum of American Art. New York, 1967.

Johnson, U. E., and Miller, J. *Louise Nevelson: Prints and Drawings, 1953–1966*. Exhibition catalogue, Brooklyn Museum. Brooklyn, N.Y., 1967.

NEWMAN, BARNETT (1905–1970)
Alloway, L. *Barnett Newman: The Stations of the Cross*. Exhibition catalogue, Guggenheim Museum. New York, 1966.
Hess, T. B. *Barnett Newman*. New York, 1969.
Hess, T. B. *Barnett Newman*. New York, 1971.

NOGUCHI, ISAMU (b. 1904)
Gordon, J. *Isamu Noguchi*. Exhibition catalogue, Whitney Museum of American Art. New York, 1966.
Noguchi, Isamu. *A Sculptor's World*. New York, 1968.

NOLAND, KENNETH (b. 1924)
Fried, M. *Kenneth Noland*. Exhibition catalogue, The Jewish Museum. New York, 1965.

O'KEEFFE, GEORGIA (b. 1887)
Goodrich, L., and Bry, D. *Georgia O'Keeffe*. Exhibition catalogue, Whitney Museum of American Art. New York, 1970.
Rich, D. C. *Georgia O'Keeffe*. Exhibition catalogue, Art Institute of Chicago. Chicago, 1943.
Rich, D. C. *Georgia O'Keeffe*. Exhibition catalogue, Worcester Art Museum. Worcester, Mass., 1960.
Wilder, M. *Georgia O'Keeffe: An Exhibition of the Work of the Artist from 1915 to 1966*. Exhibition catalogue, Amon Carter Museum of Western Art. Fort Worth, Tex., 1966.

OLDENBURG, CLAES (b. 1929)
Baro, G. *Claes Oldenburg: Drawings and Prints*. New York, 1969.
Oldenburg, Claes. *Notes in Hand, Miniatures of my Notebook Pages*. New York, 1971.
Oldenburg, Claes. *Proposals for Monuments and Buildings, 1965–1969*. Chicago, 1969.
Oldenburg, Claes. *Raw Notes*. New York, 1974.
Oldenburg, Claes. *Store Days*. New York, 1967.
Rose, B. *Claes Oldenburg*. New York, 1969.

OLITSKI, JULES (b. 1922)
Krauss, R. *Jules Olitski: Recent Paintings*. Exhibition catalogue, Institute of Contemporary Art, University of Pennsylvania. Philadelphia, 1968.
Moffett, K. *Jules Olitski*. Exhibition catalogue, Museum of Fine Arts. Boston, 1973.

O'SULLIVAN, TIMOTHY (1840–1882)
Horan, J. D. *Timothy O'Sullivan, America's Forgotten Photographer.* New York, 1966.
Newhall, B. and N. *Timothy H. O'Sullivan, Photographer.* New York, 1966.

PAGE, WILLIAM (1811–1885)
Taylor, J. C. *William Page, the American Titian.* Chicago, 1957.

PEALE FAMILY
Checklist Portraits and Miniatures by Charles Willson Peale. American Philosophical Society Transactions, XLII (1952), part 1.
Elam, C. H. *The Peale Family, Three Generations of American Artists.* Exhibition catalogue, Detroit Institute of Arts. Detroit, 1967.
Hunter, W. *The Story of America's Oldest Museum Building.* Baltimore, Md., 1964.
Sellers, C. C. *Charles Willson Peale.* 2 vols. Philadelphia, 1947.
Sellers, C. C. *Charles Willson Peale.* New York, 1969.

PEARLSTEIN, PHILIP (b. 1924)
Nochlin, L. *Philip Pearlstein.* Exhibition catalogue, Museum of Art, University of Georgia. Athens, Ga., 1970.

PETO, JOHN F. (1854–1907)
Frankenstein, A. *John Frederick Peto.* Exhibition catalogue, Smith College Museum of Art. Northampton, Mass., 1950.

PHILLIPS, AMMI (1788–1865)
Black, M., et al. *Ammi Phillips: Portrait Painter, 1788–1865.* New York, 1969.

POLLOCK, JACKSON (1912–1956)
Friedman, B. H. *Jackson Pollock, Energy Made Visible.* New York, 1972.
Hunter, S. *Jackson Pollock.* Exhibition catalogue, Marlborough-Gerson Gallery. New York, 1964.
O'Connor, Francis K. *The Genesis of Jackson Pollock: 1912 to 1943.* Unpublished doctoral dissertation, Johns Hopkins University. Baltimore, Md., 1965.
Robertson B. *Jackson Pollock.* New York, 1960.
Rose, B. *Jackson Pollock: The Works on Paper.* New York, 1969.

PORTER, RUFUS (1792–1884)
Lipman, J. *Rufus Porter, Yankee Pioneer.* New York, 1968.

POWERS, HIRAM (1805–1873)
Powers' Statue of the Greek Slave. Boston, 1848.
Wunder, R. P. *Hiram Powers: Vermont Sculptor.* Woodstock, Vt., 1974.

PRATT, MATTHEW (1734–1805)
Sawitsky, W. *Matthew Pratt, 1734–1805.* New York, 1942.

PRENDERGAST, MAURICE (1859–1924)
Rhys, H. H. *Maurice Prendergast, 1859–1924.* Cambridge, Mass., 1960.
Sawyer, C. H. *Paintings and Watercolors by Maurice Prendergast.* Exhibition catalogue, M. Knoedler & Co. New York, 1966.

QUIDOR, JOHN (1801–1881)
Baur, J. I. H. *John Quidor.* Exhibition catalogue, Whitney Museum of American Art. New York, 1965.
Sokol, D. M. *John Quidor, Painter of American Legend.* Exhibition catalogue, Wichita Art Museum. Wichita, Kans., 1973.

RANNEY, WILLIAM (1813–1857)
Grubar, F. S. *William Ranney, Painter of the Early West.* Washington, D.C., 1962.

RATTNER, ABRAHAM (b. 1895)
Getlein, F. *Abraham Rattner.* New York, 1960.
Leepa, A. *Rattner.* New York, 1974.
Weller, A. *Abraham Rattner.* Urbana, Ill., 1956.

RAUSCHENBERG, ROBERT (b. 1925)
Forge, A. *Robert Rauschenberg.* New York, 1969.
Rauschenberg, Robert. *Illustrations for Dante's Inferno.* New York, 1964.
Robertson, B., et al. *Robert Rauschenberg: Paintings, Drawings and Combines, 1949–1964.* Exhibition catalogue, Whitechapel Art Gallery. London, 1964.
Solomon, A. *Robert Rauschenberg.* Exhibition catalogue, The Jewish Museum. New York, 1963.

RAY, MAN (b. 1890)
Crane, A. H. *Man Ray, Photo Graphics from the Collection of Arnold Crane.* Exhibition catalogue, Milwaukee Art Center. Milwaukee, Wis., 1973.
Langsner, J. *Man Ray.* Exhibition catalogue, Los Angeles County Museum of Art. Los Angeles, 1966.
Ray, Man. *Alphabet for Adults.* Beverly Hills, Cal., 1948.
Ray, Man. *Self-Portrait.* Boston, 1963.

REINHARDT, AD (1913–1967)
Hunter, S., and Lippard, L. R. *Ad Reinhardt.* Exhibition catalogue, The Jewish Museum. New York, 1966.

BIBLIOGRAPHY

REMINGTON, FREDERIC (1861–1909)

Frederic Remington, A Retrospective Exhibition of Painting and Sculpture. Exhibition catalogue, Paine Art Center. Oshkosh, Wis., 1967.

Hassrick, P. *Frederic Remington*. New York, 1973.

McCracken, H. *Frederic Remington, Artist of the Old West*. Philadelphia, 1947.

McCracken, H. *The Frederic Remington Book*. New York, 1966.

REVERE, PAUL (1735–1818)

Brigham, C. S. *Paul Revere's Engravings*. 2nd rev. ed. New York, 1965.

Forbes, E. *Paul Revere and the World He Lived In*. Boston, 1942.

RICHARDS, WILLIAM TROST (1833–1905)

Ferber, L. S. *William Trost Richards, American Landscape and Marine Painter, 1833–1905*. Exhibition catalogue, The Brooklyn Museum. Brooklyn, N.Y., 1973.

RICKEY, GEORGE (b. 1907)

George Rickey: Kinetic Sculptures. Exhibition catalogue, Institute of Contemporary Art. Boston, 1964.

Selz, P. *George Rickey: Sixteen Years of Kinetic Sculpture*. Exhibition catalogue, Corcoran Gallery of Art. Washington, D.C., 1966.

RIMMER, WILLIAM (1816–1879)

Bartlett, T. H. *The Art Life of William Rimmer, Sculptor, Painter and Physician*. Boston, 1882.

Kirstein, L. *William Rimmer*. Exhibition catalogue, Whitney Museum of American Art. New York, 1946.

RIVERS, LARRY (b. 1923)

Hunter, S. *Larry Rivers*. New York, 1970.

Hunter, S. *Larry Rivers*. Exhibition catalogue, The Jewish Museum. New York, 1966.

Selle, C. *Larry Rivers: Drawings, 1949–1969*. Exhibition catalogue, Art Institute of Chicago. Chicago, 1970.

ROBINSON, THEODORE (1852–1896)

Baur, J. I. H. *Theodore Robinson, 1852–1896*. Brooklyn, N.Y., 1946.

Johnston, S. *Theodore Robinson, 1852–1896*. Exhibition catalogue, Baltimore Museum of Art. Baltimore, Md., 1973.

ROGERS, JOHN (1829–1904)

Wallace, D. H. *John Rogers, The People's Sculptor, His Life and his Work*. Middletown, Conn., 1967.

ROSENQUIST, JAMES (b. 1933)

Karp, I. C. *James Rosenquist*. Exhibition catalogue, National Gallery of Canada. Ottawa, 1968.

Tucker, M. *James Rosenquist*. Exhibition catalogue, Whitney Museum of American Art. New York, 1972.

ROSZAK, THEODORE (b. 1907)

Arnason, H. H. *Theodore Roszak*. Exhibition catalogue, Whitney Museum of American Art. New York, 1956.

ROTHKO, MARK (1903–1970)

Robertson, B. *Mark Rothko*. Exhibition catalogue, Whitechapel Art Gallery. London, 1961.

Selz, P. *Mark Rothko*. Exhibition catalogue, Museum of Modern Art. New York, 1961.

RUSH, WILLIAM (1756–1833)

Marceau, H. *William Rush, 1756–1833, The First Native American Sculptor*. Exhibition catalogue, Pennsylvania Museum of Art. Philadelphia, 1937.

RUSSELL, CHARLES M. (1864–1926)

McCracken, H. *The Charles M. Russell Book*. Garden City, N.Y., 1957.

Renner, F. *Charles M. Russell, Paintings, Drawings, and Sculpture in the Amon G. Carter Collection*. Austin, Tex., 1966.

RYDER, ALBERT P. (1847–1917)

Goodrich, L. *Albert P. Ryder*. New York, 1959.

Goodrich, L. *Albert Pinkham Ryder*. Exhibition catalogue, Whitney Museum of American Art. New York, 1947.

SAINT-GAUDENS, AUGUSTUS (1848–1907)

Dryfhout, J. *Augustus Saint-Gaudens, The Portrait Reliefs*. Exhibition catalogue, National Portrait Gallery. Washington, D.C., 1969.

Kirstein, L. *Lay this Laurel*. New York, 1974.

Tharp, L. H. *Saint-Gaudens and the Gilded Era*. Boston, 1969.

SAINT-MEMIN, CHARLES F. (1770–1852)

Norfleet, F. *The St-Memin Collection of Portraits: Consisting of Seven Hundred and Sixty Medallion Portraits, Principally of Distinguished Americans*. New York, 1862.

Norfleet, F. *Saint-Memin in Virginia: Portraits and Biographies*. Richmond, Va., 1942.

SALMON, ROBERT (1775–c. 1845)

Wilmerding, J. *Robert Salmon, The First Major Exhibition*. Exhibition catalogue, De Cordova Museum. Lincoln, Mass., 1967.

Wilmerding, J. *Robert Salmon, Painter of Ship and Shore.* Boston and Salem, Mass., 1971.

SAMARAS, LUCAS (b. 1936)

Alloway, L. *Samaras: Selected Works, 1960–1966.* Exhibition catalogue, Pace Gallery. New York, 1966.

Samaras, Lucas. *Samaras Album: Autointerview, Autobiography, Autopolaroid.* New York, 1971.

SARGENT, JOHN SINGER (1856–1925)

Charteris, E. *John Singer Sargent.* New York, 1927.

Downes, W. H. *John S. Sargent: His Life and Work.* London, 1926.

Hoopes, D. F. *The Private World of John Singer Sargent.* Exhibition catalogue, Corcoran Gallery of Art. Washington, D.C., 1964.

Hoopes, D. F. *Sargent Watercolors.* New York, 1970.

McKibbin, D. *Sargent's Boston.* Boston, 1956.

Mount, C. M. *John Singer Sargent, a Biography.* New York, 1955.

Ormond, R. *John Singer Sargent, Paintings, drawings, watercolors.* New York, 1970.

SCHAMBERG, MORTON (1882–1918)

Wolk, B. *Morton Livingston Schamberg.* Philadelphia, 1963.

SCHOLDER, FRITZ (b. 1937)

Breeskin, A. D., and Turk, R. H. *Scholder/Indians.* Flagstaff, Ariz., 1972.

SHAHN, BEN (1898–1969)

Shahn, Ben. *The Autobiography of a Painting.* New York, 1966.

Shahn, Ben. *The Shape of Content.* Cambridge, Mass., 1957.

Shahn, B. B. *Ben Shahn.* New York, 1972.

Soby, J. T. *Ben Shahn.* New York, 1947.

Soby, J. T. *Ben Shahn, His Graphic Art.* New York, 1957.

Soby, J. T. *Ben Shahn Paintings.* New York, 1963.

SHARPLES FAMILY

Knox, K. McC. *The Sharples: Their Portraits of George Washington and His Contemporaries.* New Haven, Conn., 1930.

SHAW, JOSHUA (c. 1777–1860)

Shaw, Joshua. *A New and Original Drawing Book.* Philadelphia, 1816.

Shaw, Joshua. *Picturesque Views of American Scenery.* Philadelphia, 1820–1.

SHEELER, CHARLES (1883–1965)

Dochterman, L. *The Quest of Charles Sheeler.* Iowa City, Iowa, 1963.

Friedman, M., et al. *Charles Sheeler.* Exhibition catalogue, National Collection of Fine Arts. Washington, D.C., 1968.

Rourke, C. *Charles Sheeler: Artist in the American Tradition.* New York, 1938.

Williams, W. C. *Charles Sheeler: Paintings, Drawings, Photographs.* New York, 1939.

SHINN, EVERETT (1873–1953)

Everett Shinn, 1873–1953. Exhibition catalogue, New Jersey State Museum. Trenton, N.J. 1973.

SLOAN, JOHN (1871–1951)

Brooks, V. W. *John Sloan, A Painter's Life.* New York, 1955.

Goodrich, L. *John Sloan.* New York, 1952.

Morse, P. *John Sloan's Prints.* New Haven, Conn., 1969.

St John, B. *John Sloan.* New York, 1971.

St John, B., ed. *John Sloan's New York Scene.* New York, 1965.

Scott, D., and Bullard, J. *John Sloan.* Washington, D.C., 1971.

Sloan, John. *Gist of Art.* New York, 1939.

SMIBERT, JOHN (1688–1751)

Foote, H. W. *John Smibert.* Cambridge, Mass., 1950.

The Notebook of John Smibert. Boston, Mass., 1969.

SMITH, DAVID (1906–1965)

Cone, J. H. *David Smith: A Retrospective Exhibition.* Exhibition catalogue, Fogg Art Museum, Harvard University. Cambridge, Mass., 1966.

Fry, E. F. *David Smith.* Exhibition catalogue, Guggenheim Museum. New York, 1969.

Gray, C., ed. *David Smith by David Smith.* New York, 1968.

Kramer, H. *David Smith, A Memorial Exhibition.* Exhibition catalogue, Los Angeles County Museum of Art. Los Angeles, 1965.

Krauss, R. E. *Terminal Iron Works, The Sculpture of David Smith.* Cambridge, Mass., and London, 1971.

SMITH, TONY (b. 1912)

Lippard, L. R. *Tony Smith.* New York, 1972.

Lippard, L. R. *Tony Smith: Recent Sculpture.* Exhibition catalogue, M. Knoedler & Co. New York, 1971.

SMITH, W. EUGENE (b. 1919)
Kirstein, L. *W. Eugene Smith.* New York, 1969.

SMITHSON, ROBERT (1938–1973)
Ginsburg, S., and Masheck, J. *Robert Smithson: Drawings.* Exhibition catalogue, New York Cultural Center. New York, 1974.

SOUTHWORTH AND HAWES
Homer, R. J. *The Legacy of Josiah Johnson Hawes, 19th Century Photographs of Boston.* Barre, Mass., 1972.
Stokes, I. N. P. *The Hawes-Stokes Collection of American Daguerreotypes by Albert Sands Southworth and Josiah Johnson Hawes: A Catalogue.* New York, 1939.

SOYER, MOSES (b. 1899)
Smith, B. *Moses Soyer.* New York, 1944.

SOYER, RAPHAEL (b. 1899)
Cole, S., Jr. *Raphael Soyer: 50 Years of Printmaking, 1917–1967.* New York, 1967.
Goodrich, L. *Raphael Soyer.* New York, 1972.
Goodrich, L. *Raphael Soyer.* Exhibition catalogue, Whitney Museum of American Art. New York, 1967.
Gutman, W. K. *Raphael Soyer: Paintings and Drawings.* New York, 1960.

SPEICHER, EUGENE (b. 1883)
Eugene Speicher: A Retrospective Exhibition of Oils and Drawings. Exhibition catalogue, Buffalo Fine Arts Academy. Buffalo, N.Y., 1950.
Mather, F. J. *Eugene Speicher.* New York, 1931.

SPENCER, NILES (1893–1952)
Freeman, R. B. *Niles Spencer.* Exhibition catalogue, University of Kentucky Art Gallery. Lexington, Ky., 1965.

STAMOS, THEODOROS (b. 1922)
Pomeroy, R. *Stamos.* New York, 1974.

STANLEY, JOHN MIX (1814–1872)
Kinietz, W. *John Mix Stanley and His Indian Paintings.* Ann Arbor, Mich., 1942.

STEICHEN, EDWARD (1879–1973)
Sandburg, C. *Steichen the Photographer.* New York, 1929.
Steichen, Edward, ed. *The Bitter Years: 1935–1941.* New York, 1962.
Steichen, Edward. *The Family of Man.* New York, 1955.
Steichen, Edward. *A Life in Photography.* Garden City, N.Y., 1963.

STELLA, FRANK (b. 1936)
Fried, M. *Frank Stella: An Exhibition of Recent Paintings.* Exhibition catalogue, Pasadena Art Museum. Pasadena, Cal., 1966.
Rosenblum, R. *Penguin New Art I, Frank Stella.* Harmondsworth and Baltimore, 1970.
Rubin, W. S. *Frank Stella.* New York, 1970.

STELLA, JOSEPH (1877–1946)
Baur, J. I. H. *Joseph Stella.* New York, 1963.
Baur, J. I. H. *Joseph Stella.* New York, 1971.
Jaffe, I. B. *Joseph Stella.* Cambridge, Mass., 1970.

STIEGLITZ, ALFRED (1864–1946)
Bry, D. *Exhibition of Photographs by Alfred Stieglitz.* Exhibition catalogue, National Gallery of Art. Washington, D.C., 1958.
Doty, R. *Photo-Secession: Photography as a Fine Art.* Rochester, N.Y., 1934.
Frank, W., et al., eds. *America and Alfred Stieglitz.* New York, 1934.
Green, J., ed. *Camera Work: A Critical Anthology.* Millerton, N.Y., 1973.
Norman, D. *Alfred Stieglitz, An American Seer.* New York, 1973.

STILL, CLYFFORD (b. 1904)
Clyfford Still: Paintings in the Albright-Knox Art Gallery. Buffalo, N.Y., 1966.
Sharpless, T.-G. *Clyfford Still.* Philadelphia, 1963.

STORY, WILLIAM WETMORE (1819–1895)
James, Henry. *William Wetmore Story and His Friends.* Boston, 1903.
Phillips, M. *Reminiscences of William Wetmore Story.* Chicago, 1897.

STUART, GILBERT (1755–1828)
Flexner, J. T. *Gilbert Stuart.* New York, 1955.
Morgan, J. H. *Gilbert Stuart and His Pupils.* New York, 1939.
Mount, C. M. *Gilbert Stuart, A Biography.* New York, 1964.
Park, L. *Gilbert Stuart, An Illustrated Descriptive List of His Works.* 4 vols. New York, 1926.
Richardson, E. P. *Gilbert Stuart, Portraitist of the Young Republic.* Exhibition catalogue, Museum of Art, Rhode Island School of Design. Providence, R.I., 1967.
Whitley, W. T. *Gilbert Stuart.* Cambridge, Mass., 1932.

SULLY, THOMAS (1783–1872)
Fielding, M. *The Life and Works of Thomas Sully.* Philadelphia, 1921.
Hart, C., ed. *A Register of Portraits Painted by Thomas Sully, 1801–1871.* Philadelphia, 1908.

Sully, Thomas. *Hints to Young Painters.* Reprinted ed., New York, 1965.

TANNER, HENRY O. (1859–1937)
The Art of Henry O. Tanner. Exhibition catalogue, Frederick Douglas Institute. Washington, D.C., 1969.
Matthews, M. *Henry Ossawa Tanner.* Chicago, 1969.

TARBELL, EDMUND C. (1862–1938)
Price, L., and Coburn, F. *Frank W. Benson; Edmund C. Tarbell.* Exhibition catalogue, Museum of Fine Arts. Boston, 1938.

THAYER, ABBOTT H. (1849–1921)
Abbott H. Thayer. New York, 1923.
Barker, V. *Abbott H. Thayer Memorial Exhibition.* Exhibition catalogue, Corcoran Gallery of Art. Washington, D.C., 1922.
White, N. C. *Abbott H. Thayer: Painter and Naturalist.* Hartford, Conn., 1951.

THEUS, JEREMIAH (c. 1719–1774)
Middleton, M. S. *Jeremiah Theus, Colonial Artist of Charles Town.* Columbia, S.C., 1953.

TOBEY, MARK (b. 1890)
Bowen, B. *Tobey's 80, A Retrospective.* Exhibition catalogue, Seattle Art Museum. Seattle, Wash., and London, 1970.
Breeskin, A. D. *Tribute to Mark Tobey.* Exhibition catalogue, National Collection of Fine Arts. Washington, D.C., 1974.
Roberts, C. *Mark Tobey.* New York, 1959.
Seitz, W. C. *Mark Tobey.* Exhibition catalogue, Museum of Modern Art. New York, 1962.

TOMLIN, BRADLEY WALKER (1899–1953)
Baur, J. I. H. *Bradley Walker Tomlin.* Exhibition catalogue, Whitney Museum of American Art. New York, 1957.

TROVA, ERNEST (b. 1927)
Alloway, L. *Trova: Selected Works, 1953–1966.* Exhibition catalogue, Pace Gallery. New York, 1967.

TRUMBULL, JOHN (1756–1843)
Morgan, J. H. *Paintings by John Trumbull at Yale University.* New Haven, Conn., 1926.
Sizer, T., ed. *The Autobiography of Colonel John Trumbull.* New Haven, 1953.
Sizer, T. *The Works of Colonel John Trumbull, Artist of the American Revolution.* Revised ed. New Haven and London, 1967.

Trumbull, John. *Address Before the Directors of the American Academy of Fine Arts.* New York, 1833.

TRYON, DWIGHT W. (1849–1925)
White, H. C. *The Life and Art of Dwight William Tryon.* Boston and New York, 1930.

TWACHTMAN, JOHN (1853–1902)
Clark, E. *John Twachtman.* New York, 1924.
John Henry Twachtman. Exhibition catalogue, Cincinnati Art Museum. Cincinnati, Ohio, 1966.

TWORKOV, JACK (b. 1900)
Bryant, E. *Jack Tworkov.* Exhibition catalogue, Whitney Museum of American Art. New York, 1964.

VANDERLYN, JOHN (1775–1852)
Lindsay, K. C. *The Works of John Vanderlyn, From Tammany to the Capitol.* Exhibition catalogue, University Art Gallery, State University of New York. Binghamton, N.Y., 1970.
Schoonmaker, M. *John Vanderlyn, Artist, 1775–1852.* Kingston, N.Y., 1950.

VEDDER, ELIHU (1836–1923)
Dyke, J. C. Van. *The Works of Elihu Vedder.* Exhibition catalogue, American Academy of Arts and Letters. New York, 1937.
Soria, R. *Elihu Vedder, American Visionary Artist in Rome (1836–1923).* Rutherford, N.J., 1970.
Soria, R. *Paintings and Drawings by Elihu Vedder.* Exhibition catalogue, Smithsonian Institution. Washington, D.C., 1966.
Vedder, Elihu. *The Digressions of 'V'.* Boston and New York, 1910.

WALKOWITZ, ABRAHAM (c. 1880–1965)
McBride, H., et al. *One Hundred Drawings by Abraham Walkowitz.* New York, 1925.
Walkowitz, A. *Art from Life to Life.* Girard, Kans., 1951.

WARHOL, ANDY (b. 1930)
Andy Warhol. Exhibition catalogue, Moderna Museet. 2nd ed. New York, 1969.
Coplans, J., et al. *Andy Warhol.* Greenwich, Conn., 1970.
Crone, R. *Andy Warhol.* New York, 1970.
Green, S. A. *Andy Warhol.* Exhibition catalogue, Institute of Contemporary Art, University of Pennsylvania. Philadelphia, 1965.
Koch, S. *Stargazer, Andy Warhol's World and His Films.* New York, 1973.

WEBER, MAX (1881–1961)
Cahill, H. *Max Weber*. New York, 1930.
Goodrich, L. *Max Weber: Retrospective Exhibition*. Exhibition catalogue, Whitney Museum of American Art. New York, 1959.
Max Weber. Exhibition catalogue, Art Gallery, University of California. Santa Barbara, Cal., 1968.

WEIR, J. ALDEN (1852–1919)
Young, D. W. *The Life and Letters of J. Alden Weir*. New Haven, Conn., 1960.

WEIR, JOHN F. (1841–1926)
Sizer, T., ed. *The Recollections of John Ferguson Weir, 1869–1913*. New York and New Haven, 1957.

WEIR, ROBERT W. (1803–1889)
Weir, I. *Robert W. Weir*. New York, 1947.

WESSELMANN, TOM (b. 1931)
Garver, T. H. *Tom Wesselmann: Early Still Lifes*. Exhibition catalogue, Newport Harbor Art Museum. Balboa, Cal., 1970.

WEST, BENJAMIN (1738–1820)
Carey, W. *Critical Description and Analytic Review of Death Upon the Pale Horse, Painted by Benjamin West, P.R.A.* London, 1817; 2nd ed., Philadelphia, 1936.
Evans, G. *Benjamin West and the Taste of his Times*. Carbondale, Ill., 1959.
Galt, J. *The Life and Studies of Benjamin West, Esq.* 2 vols. Philadelphia, 1816.
Hirsch, R. *The World of Benjamin West*. Exhibition catalogue, Allentown Art Museum. Allentown, Pa., 1962.

WESTON, EDWARD (1886–1958)
Armitage, M. *The Art of Edward Weston*. New York, 1932.
Maddow, B. *Edward Weston: Fifty Years*. New York, 1974.
Newhall, N., ed. *Edward Weston*. New York, 1965.
Weston, Edward. *The Daybooks of Edward Weston*. Rochester, N.Y., 1962.

WHISTLER, JAMES A. MCNEILL (1834–1903)
Pennell, E.R. and J. *The Life of James McNeill Whistler*. 2 vols. London and Philadelphia, 1908.
Prideaux, T., et al. *The World of Whistler, 1834–1903*. New York, 1970.
Sutton, D. *James McNeill Whistler, Paintings, Etchings, Pastels, & Watercolours*. London, 1966.

Sutton, D. *Nocturne: The Art of James McNeill Whistler*. London, 1963.
Weintraub, S. *Whistler, A Biography*. New York, 1974.
Whistler, James McNeill. *The Gentle Art of Making Enemies*. London and New York, 1890; reprinted ed., 1943.
Whistler, James McNeill. *Ten O'Clock*. Portland, Me., 1916.
Young, A. McL. *James McNeill Whistler*. Exhibition catalogue, M. Knoedler & Co. New York, 1960.

WHITE, MINOR (b. 1908)
White, Minor. *Mirrors, Messages, Manifestations*. New York, 1969.

WHITTREDGE, WORTHINGTON (1820–1910)
Baur, J. I. H., ed. *The Autobiography of Worthington Whittredge*. Reprinted ed. New York, 1969.
Dwight, E. H. *Worthington Whittredge (1820–1910), A Retrospective Exhibition of an American Artist.* Exhibition catalogue, Munson-Williams-Proctor Institute. Utica, N.Y., 1969.

WILLIAMS, WILLIAM (1727–1791)
Dickason, D. H. *William Williams, Novelist and Painter of Colonial America*. Bloomington, Ind., and London, 1970.

WIMAR, CARL (1828–1862)
Hodges, W. *Carl Wimar*. Galveston, Tex., 1908.
Rathbone, P. *Charles Wimar, 1828–1862, Painter of the Indian Frontier*. Exhibition catalogue, City Art Museum. St Louis, Mo., 1946.

WOOD, GRANT (1892–1942)
Garwood, D. *Artist in Iowa: A Life of Grant Wood*. New York, 1944.
Maser, E. A. *Grant Wood, 1892–1942*. Exhibition catalogue, University of Kansas Museum of Art. Lawrence, Kans., 1959.

WOOD, THOMAS WATERMAN (1823–1903)
Lipke, W. C. *Thomas Waterman Wood, PNA, 1823–1903*. Exhibition catalogue, Wood Art Gallery. Montpelier, Vt., 1972.

WOODVILLE, RICHARD CATON (1825–1855)
Grubar, F. S. *Richard Caton Woodville, an early American Genre Painter*. Exhibition catalogue, Corcoran Gallery of Art. Washington, D.C., 1967.
Woodville, R. C., Jr. *Random Recollections*. London, 1914.

WYANT, ALEXANDER H. (1836–1892)
Alexander H. Wyant, 1836–1892. Exhibition catalogue, Museum of Fine Arts, University of Utah. Provo, Utah, 1968.

WYETH, ANDREW (b. 1917)
Corn, W. M., et al. *The Art of Andrew Wyeth.* Exhibition catalogue, Fine Arts Museums. San Francisco, 1973.

Fraser, J. T., Jr. *Andrew Wyeth: Temperas, Watercolors, Dry Brush, Drawings, 1938 to 1966.* Exhibition catalogue, Pennsylvania Academy of the Fine Arts. Philadelphia, 1966.

McCord, D., and Sweet, F. A. *Andrew Wyeth.* Exhibition catalogue, Museum of Fine Arts. Boston, 1970.

Mongan, A. *Andrew Wyeth: Dry Brush and Pencil Drawings.* Exhibition catalogue, Fogg Art Museum, Harvard University. Cambridge, Mass., 1963.

Wyeth, Andrew. *Andrew Wyeth.* Boston, 1968.

Wyeth, B. J., ed. *The Wyeths, The Letters of N. C. Wyeth, 1901–1945.* Boston, 1971.

ZORACH, MARGUERITE (1887–1968)
Tarbell, R. K. *Marguerite Zorach: The Early Years, 1908–1920.* Exhibition catalogue, National Collection of Fine Arts. Washington, D.C., 1973.

ZORACH, WILLIAM (1887–1966)
Baur, J. I. H. *William Zorach.* Exhibition catalogue, Whitney Museum of American Art. New York, 1959.

Hoopes, D. F. *William Zorach: Paintings, Watercolors and Drawings, 1911–1922.* Exhibition catalogue, Brooklyn Museum. New York, 1969.

Wingert, P. *The Sculpture of William Zorach.* New York, 1938.

Zorach, William. *Art is My Life.* Cleveland, Ohio, 1967.

THE PLATES

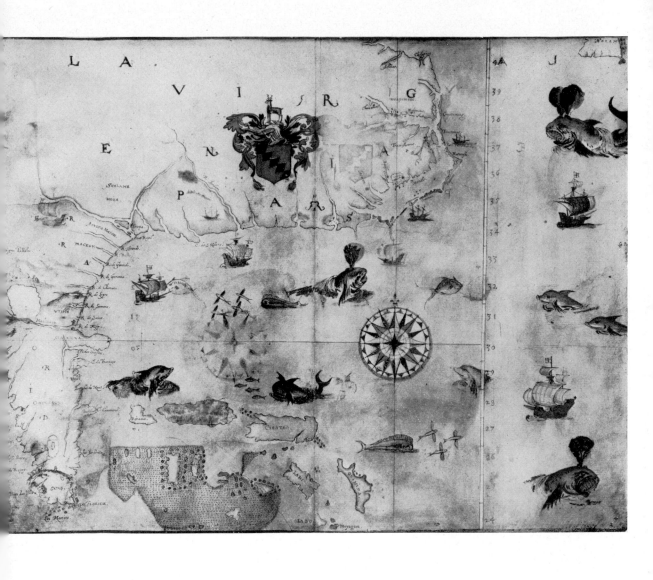

1. John White: Chart of the East Coast from Florida to Chesapeake Bay, 1585. Watercolour.
London, British Museum

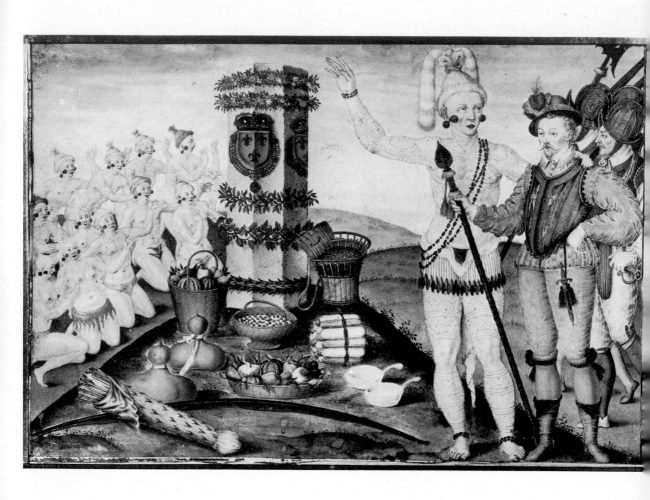

2. Jacques Le Moyne de Morgues: French explorer René de Laudonnière with Chief Athore standing before a decorated column at the mouth of the St Johns River, North Florida, 1564, 1565. Gouache drawing on parchment. *New York Public Library*

3. John White: A Flaminco, 1585. Watercolour. *London, British Museum*

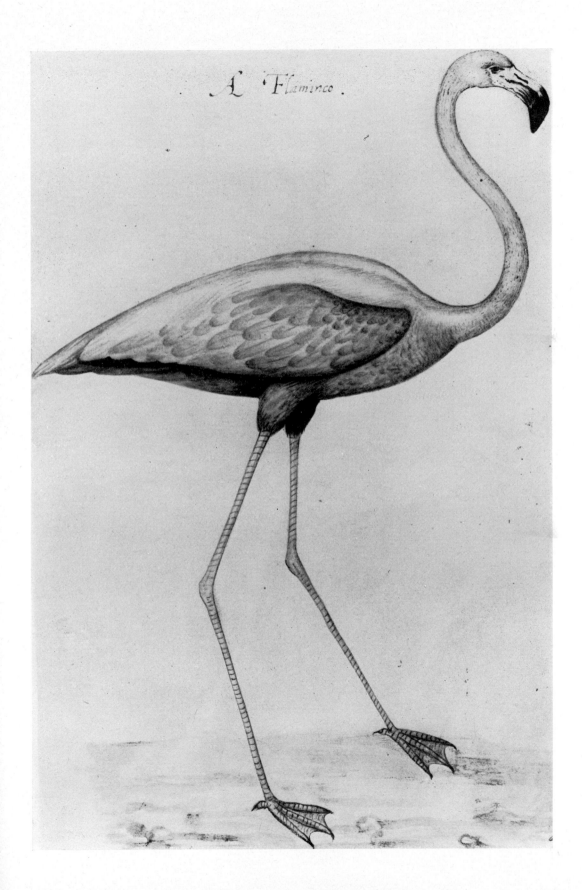

A Flaminco.

4. Effigy pipe, Pittsburg Landing, Tennessee, *c.* 1200–1600. Red bauxite. *Shiloh, Tennessee, Shiloh National Military Park*

5. Gravestone of John Foster, Dorchester, Boston, 1681. Slate

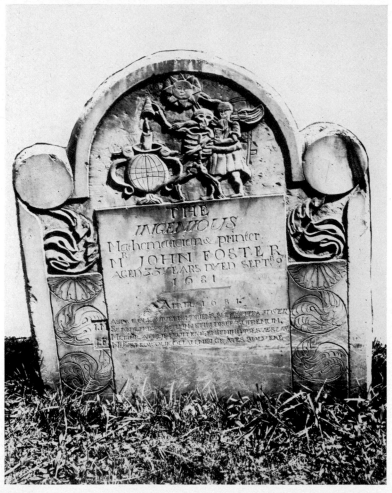

6. John Foster: Richard Mather, *c.* 1670.
Woodcut. *Cambridge, Massachusetts,*
Harvard University, Houghton Library

7. Augustine Clement(?): Dr John Clark,
1664. *Boston Medical Library*

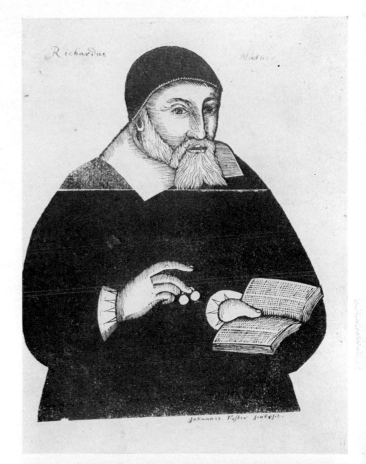

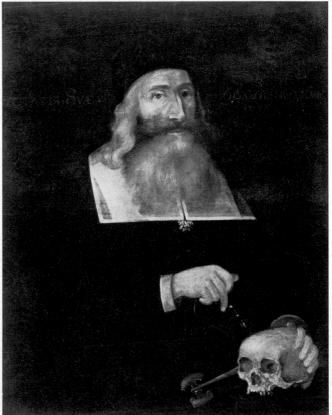

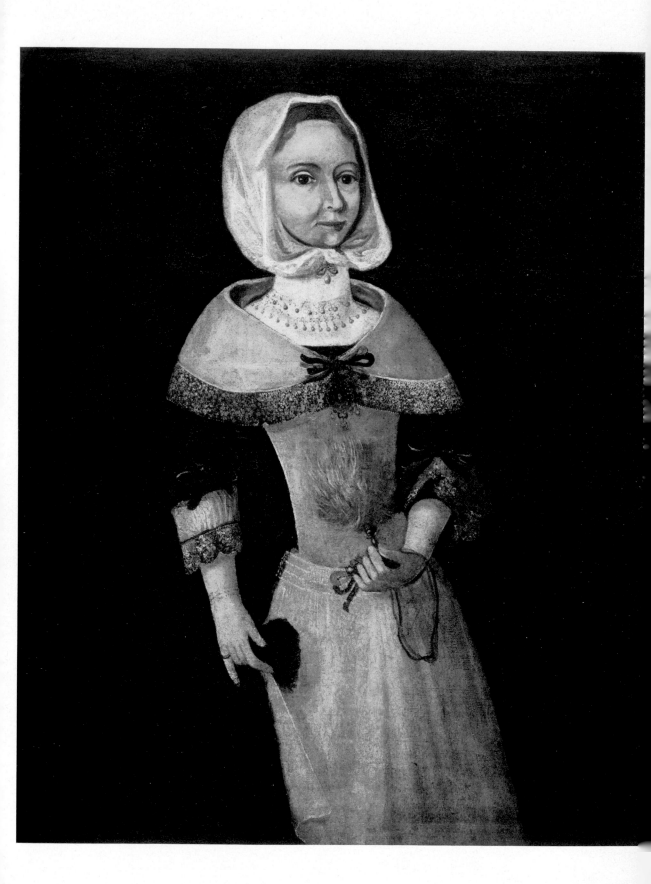

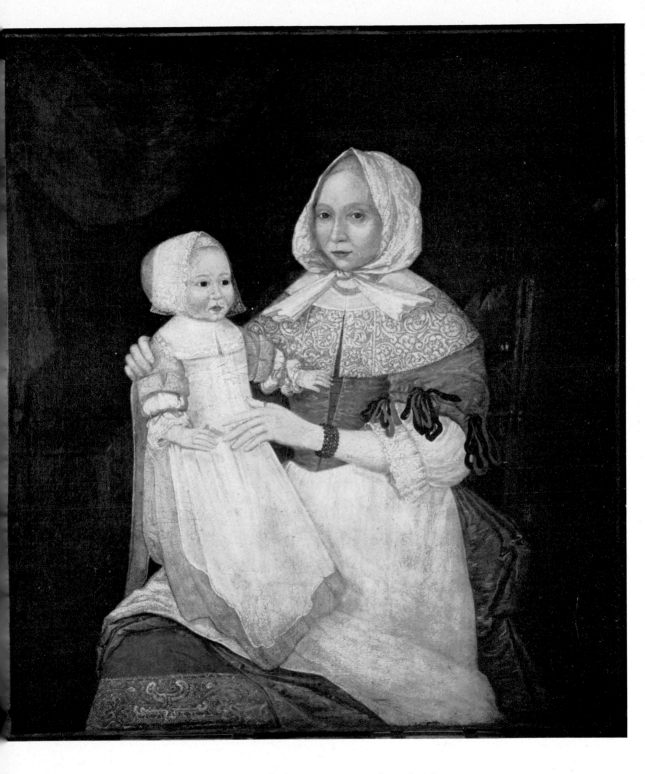

8. Anon.: Elizabeth Eggington, 1664. *Hartford, Connecticut, Wadsworth Atheneum*

9. Anon.: Mrs Elizabeth Freake and Baby Mary, 1674. *Worcester, Massachusetts, Worcester Art Museum*

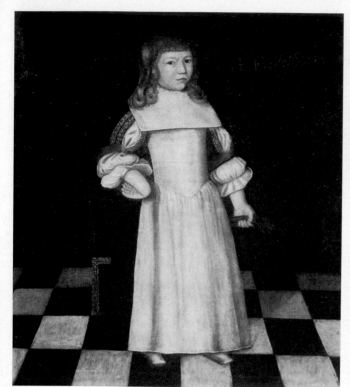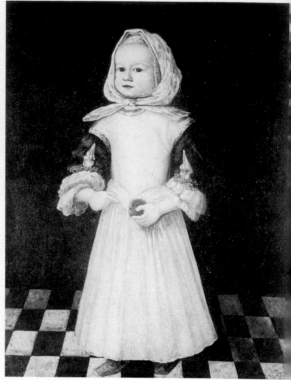

10. Anon.: Robert Gibbs, 1670. *Boston, Museum of Fine Arts*

11. Anon.: Alice Mason, 1670. *Quincy, Massachusetts, United States Department of the Interior, National Park Service, Adams National Historic Site*

12. Anon.: Elizabeth Paddy Wensley, c. 1670–80. *Plymouth, Massachusetts, Pilgrim Hall Museum*

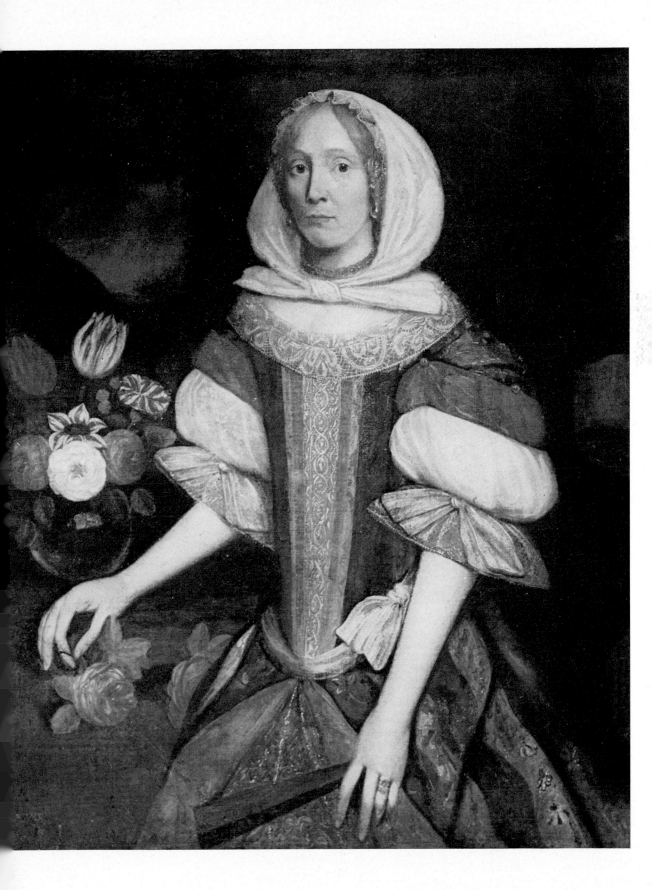

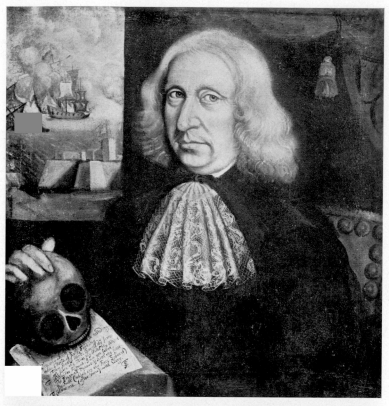

13. Thomas Smith: Self Portrait, c. 1690. *Worcester, Massachusetts, Worcester Art Museum*

14. Anon.: William Stoughton, c. 1700. *Cambridge, Massachusetts, Harvard University Portrait Collection*

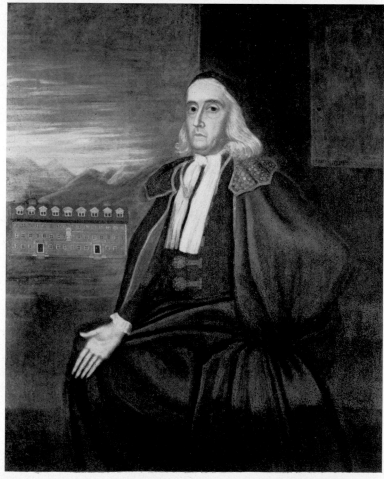

15. Justus Engelhardt Kuhn: Eleanor Darnall, *c. 1710. Baltimore, Maryland Historical Society*

16. *Aetatis Suae* or Schuyler Limner: Mrs David Ver Planck, *c. 1717. Albany Institute of History and Art*

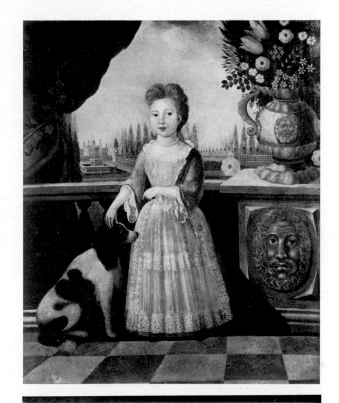

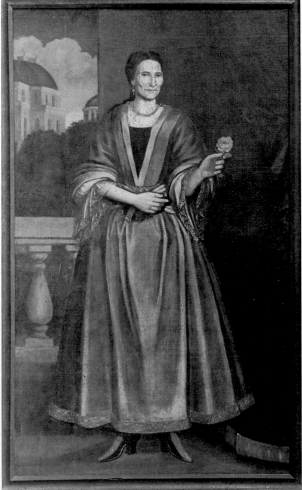

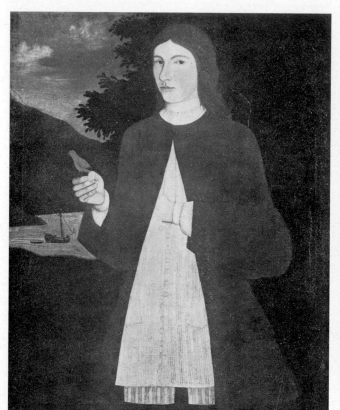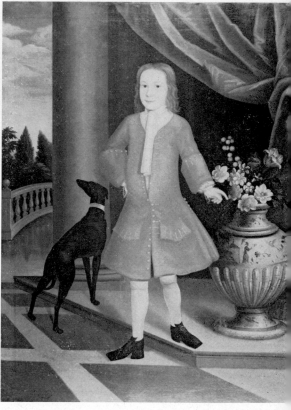

17. Pieter Vanderlyn (the Gansevoort Limner): Pau de Wandelaer, *c.* 1730. *Albany Institute of History and Art*

18. De Peyster Limner(?): Pierre Van Cortlandt, *c.* 1731. *The Brooklyn Museum*

19. Anon.: Anne Pollard, 1721. *Boston, Massachusetts Historical Society*

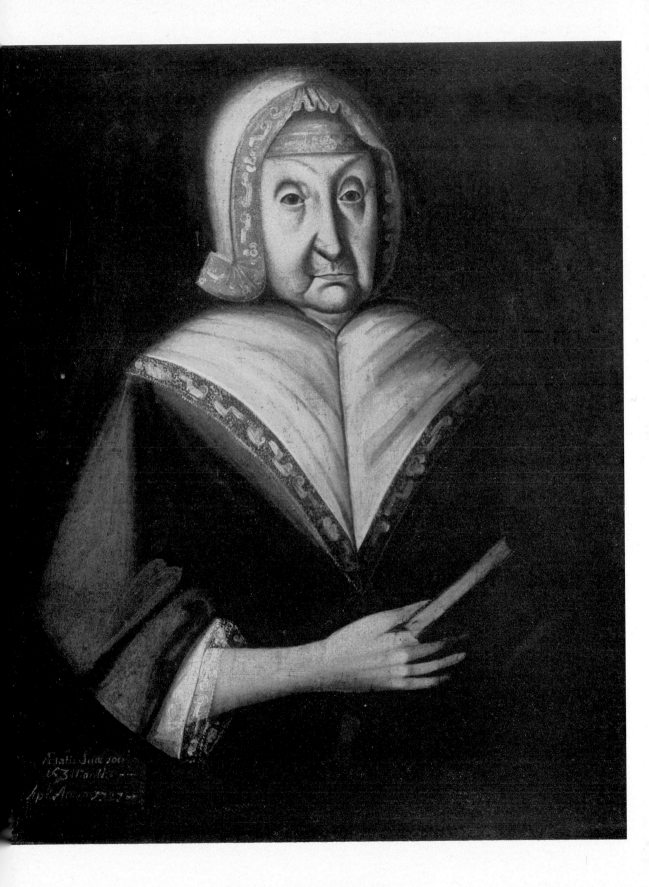

20. Gustavus Hesselius: Bacchus and Ariadne, *c.* 1720. *The Detroit Institute of Arts*

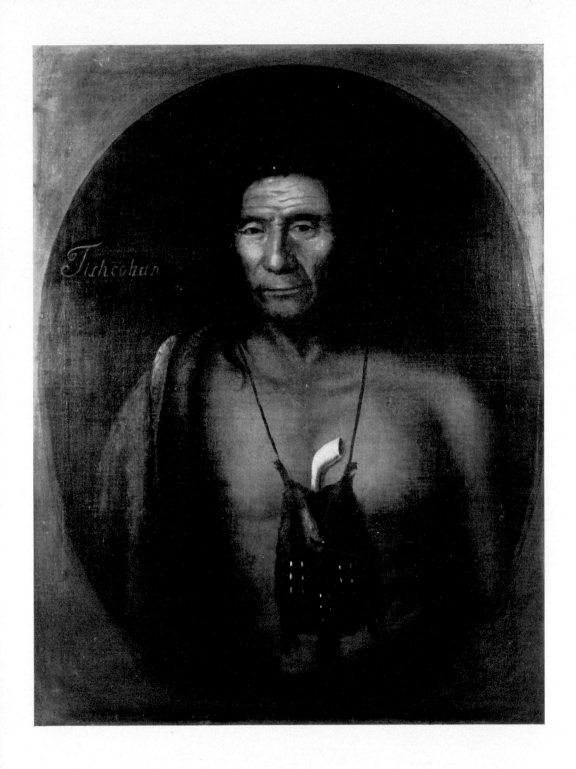

Tishcohan

21. Gustavus Hesselius: Tishcohan, 1735. *Philadelphia, The Historical Society of Pennsylvania*

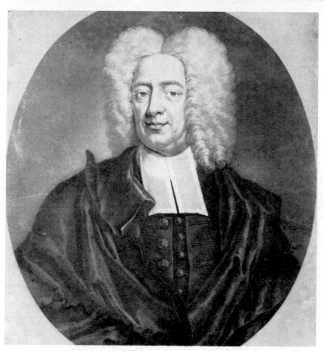

22. William Burgis, engraved by I. Harris: A South East View of ye Great Town of Boston in New England in America, 1743. *Winterthur, Delaware, The Henry Francis du Pont Winterthur Museum*

23. Peter Pelham: Cotton Mather, 1727. Mezzotint. *Worcester, Massachusetts, American Antiquarian Society*

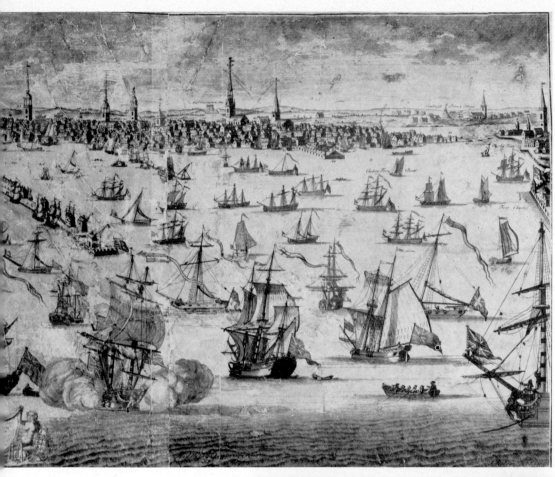

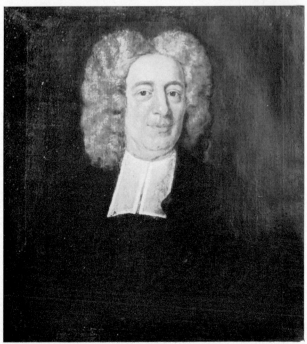

24. Peter Pelham: Cotton Mather,
1727. *Worcester, Massachusetts,
American Antiquarian Society*

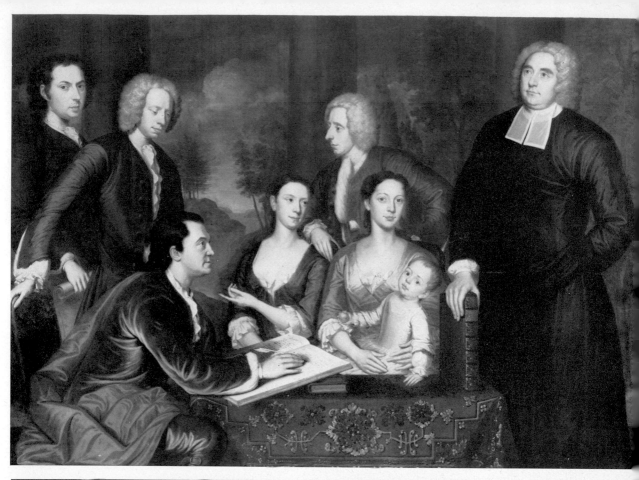

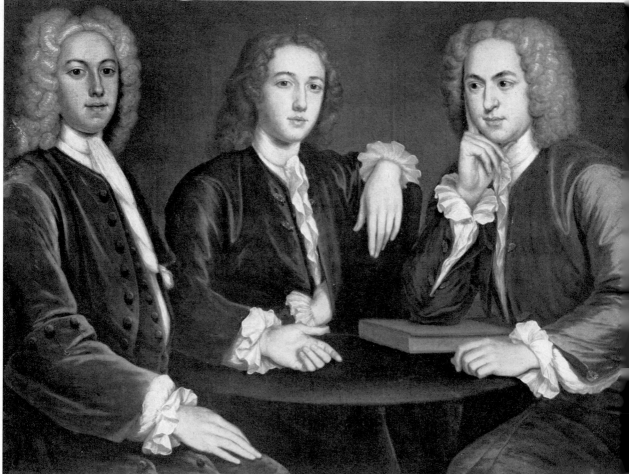

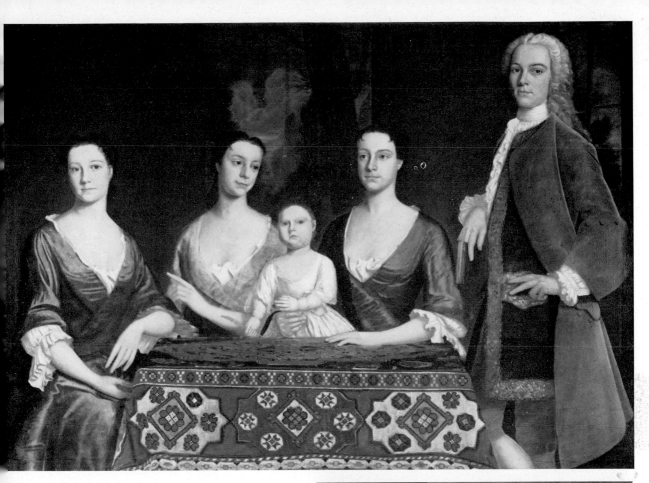

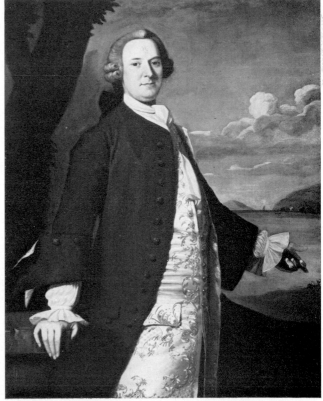

25. John Smibert: Dean George Berkeley and his Family (The Bermuda Group), 1728–9. *New Haven, Connecticut, Yale University Art Gallery*

26. John Smibert: Daniel, Peter, and Andrew Oliver, 1730. *Boston, Museum of Fine Arts*

27. Robert Feke: Isaac Royall and his Family, 1741. *Cambridge, Massachusetts, Harvard University Portrait Collection*

28. Robert Feke: Isaac Winslow, 1748. *Boston, Museum of Fine Arts*

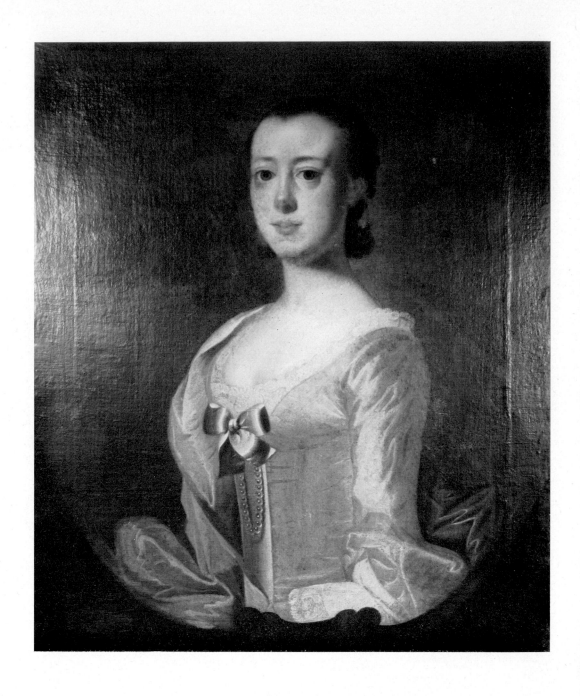

29. Jeremiah Theus: Elizabeth Rothmaler, 1757. *The Brooklyn Museum*

30. John Wollaston: Mrs Fielding Lewis, c. 1756. *Fredericksburg, Virginia, Kenmore*

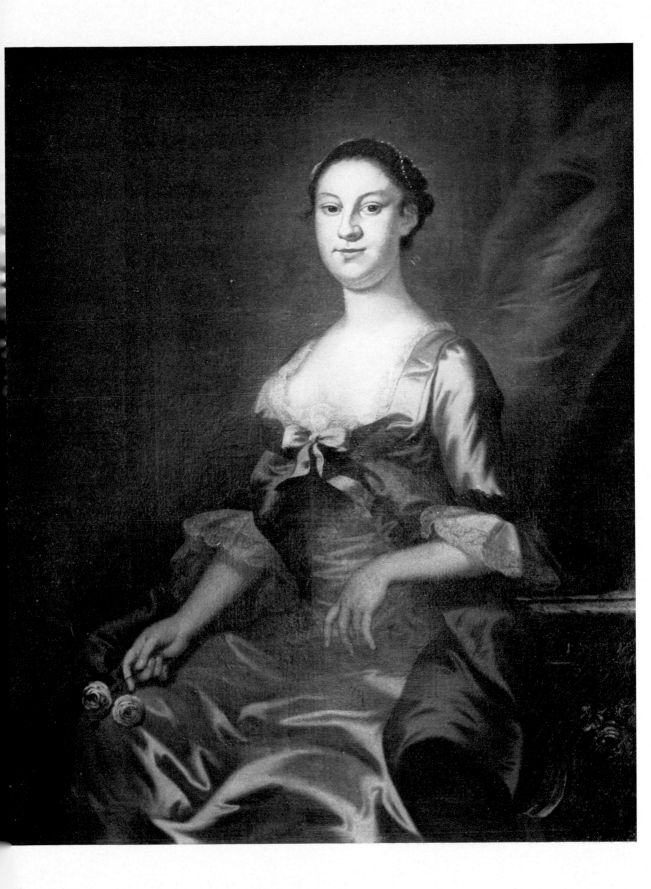

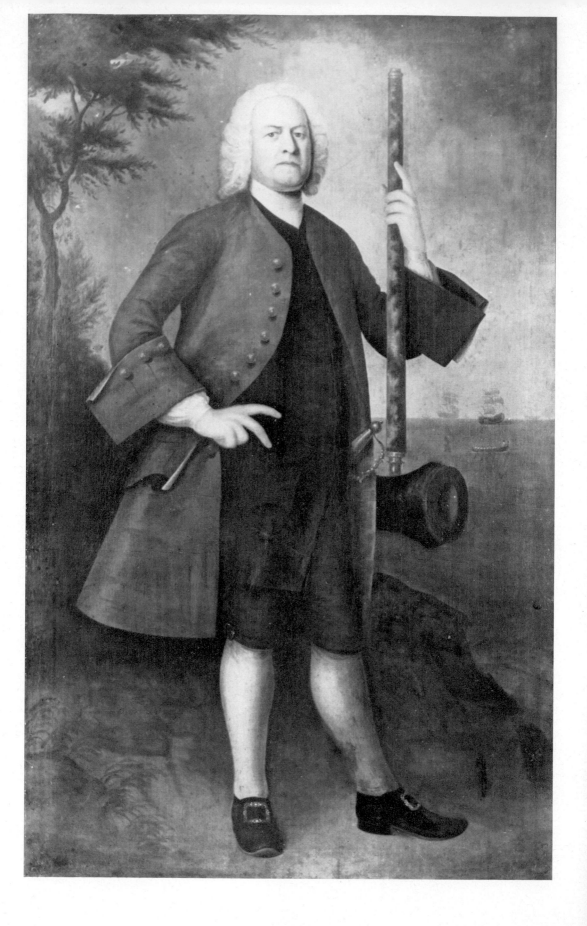

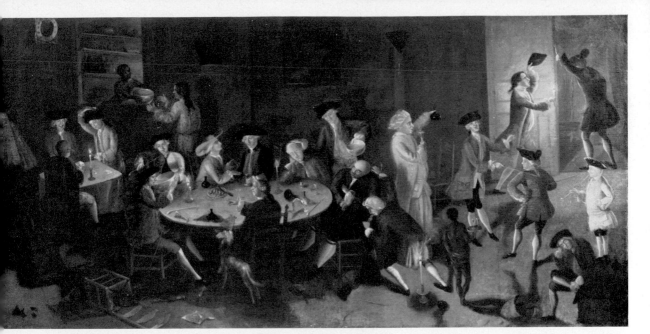

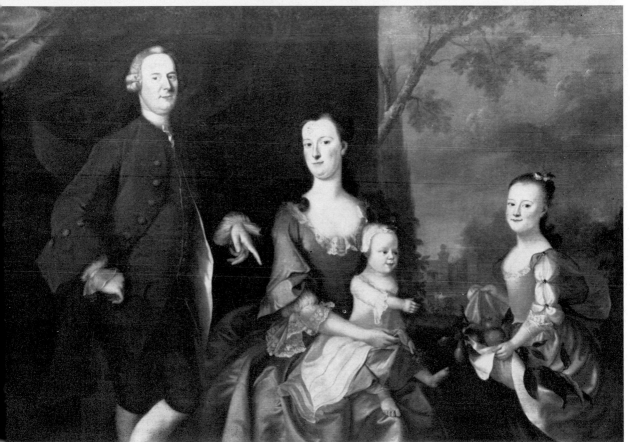

31. Joseph Badger: Captain John Larrabee, *c*. 1760. *Worcester, Massachusetts, Worcester Art Museum*

32. John Greenwood: Sea Captains carousing in Surinam, 1758. Oil on bed ticking. *The St Louis Art Museum*

33. Joseph Blackburn: Isaac Winslow and his Family, 1755. *Boston, Museum of Fine Arts*

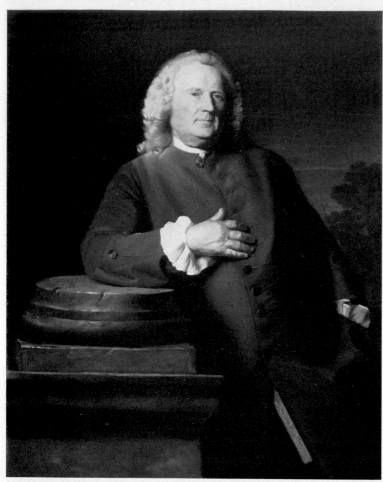

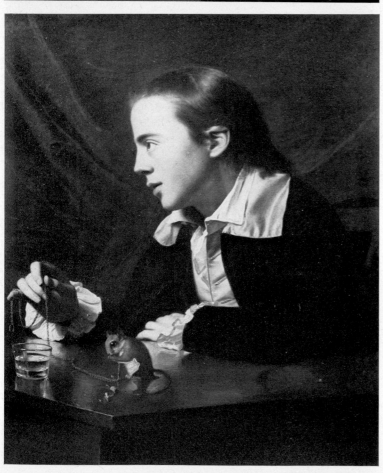

34. John Singleton Copley: Epes Sargent, 1759–61. *Washington, D.C., National Gallery of Art*

35. John Singleton Copley: Henry Pelham (Boy with a Squirrel), 1765. *Boston, Museum of Fine Arts*

36. John Singleton Copley: Jeremiah Lee, 1769. *Hartford, Connecticut, Wadsworth Atheneum*

37. John Singleton Copley: Mrs Humphrey Devereux, 1771. *Wellington, New Zealand, National Art Gallery*

38. John Singleton Copley: Mr and Mrs Isaac Winslow, 1774. *Boston, Museum of Fine Arts*

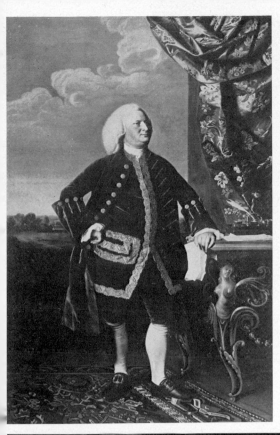
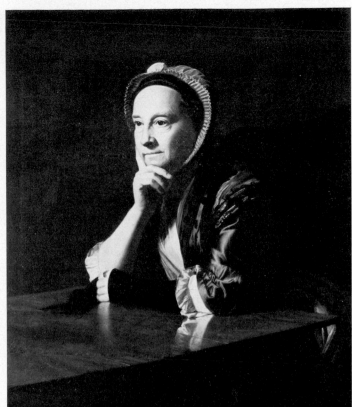
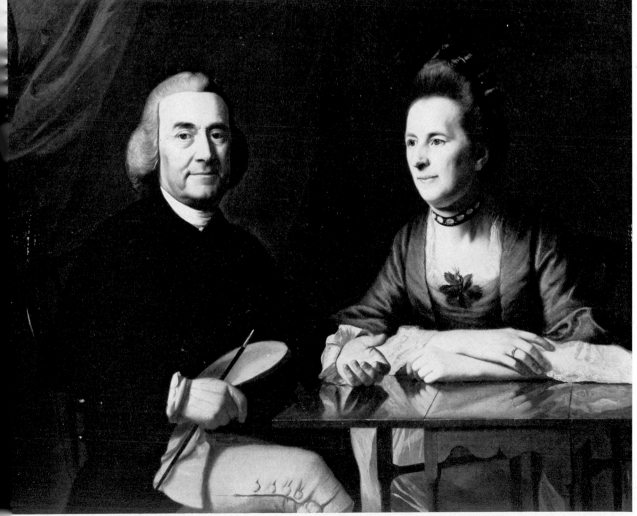

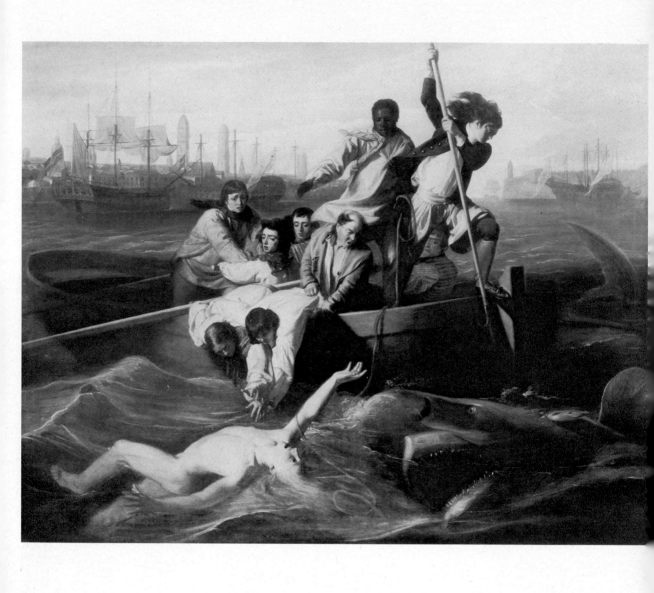

39. John Singleton Copley: Watson and the Shark, 1778. *Washington, D.C., National Gallery of Art*

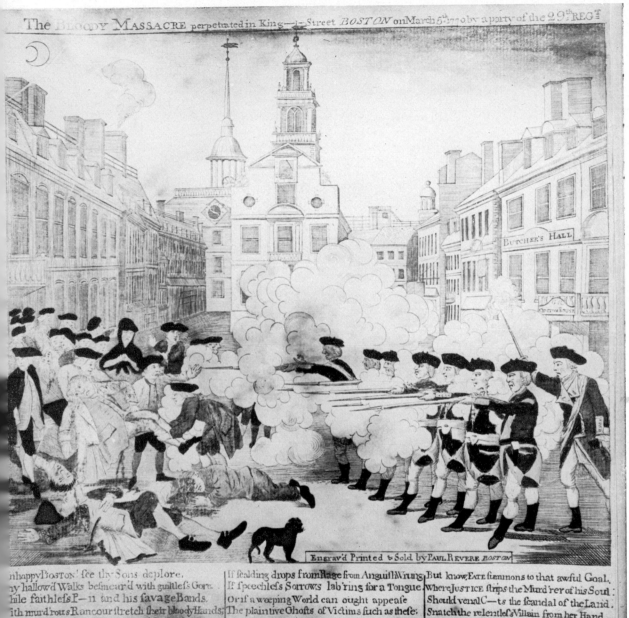

The BLOODY MASSACRE perpetrated in King — — Street BOSTON on March 5th 1770 by a party of the 29th REGT

Engrav'd Printed & Sold by PAUL REVERE BOSTON

Unhappy Boston! see thy Sons deplore,
Thy hallow'd Walks besmear'd with guiltless Gore:
While faithless P——n and his savage Bands,
With murd'rous Rancour stretch their bloody Hands;
Like fierce Barbarians grinning o'er their Prey,
Approve the Carnage, and enjoy the Day.

If scalding drops from Rage from Anguish Wrung,
If speechless Sorrows lab'ring for a Tongue,
Or if a weeping World can ought appease
The plaintive Ghosts of Victims such as these;
The Patriot's copious Tears for each are shed,
A glorious Tribute which embalms the Dead.

But know, Fate summons to that awful Goal,
Where Justice strips the Murd'rer of his Soul:
Should venal C——ts the scandal of the Land,
Snatch the relentless Villain from her Hand,
Keen Execrations on this Plate inscrib'd,
Shall reach a Judge who never can be brib'd.

The unhappy Sufferers were Messrs Saml Gray Saml Maverick, Jams Caldwell, Crispus Attucks & Patk Carr

Killed. Six wounded; two of them (Christr Monk & John Clark) Mortally

40. Paul Revere: The Bloody Massacre perpetrated in King Street, Boston, 1770. Engraving.
Worcester, Massachusetts, American Antiquarian Society

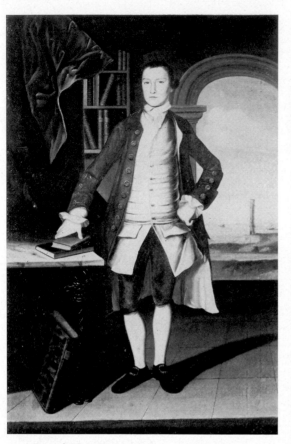

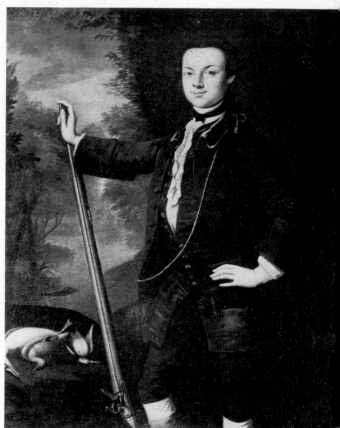

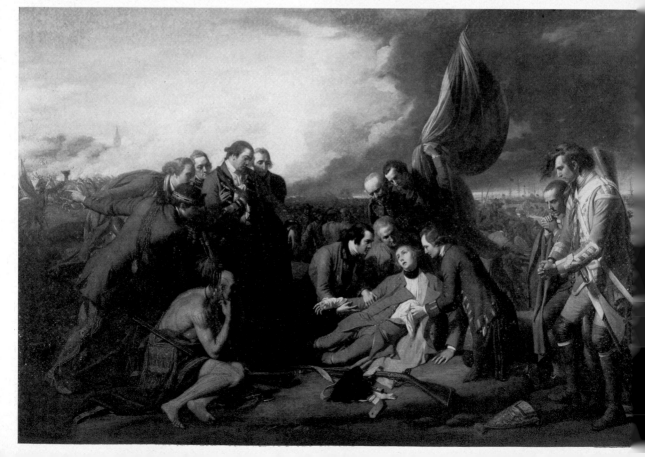

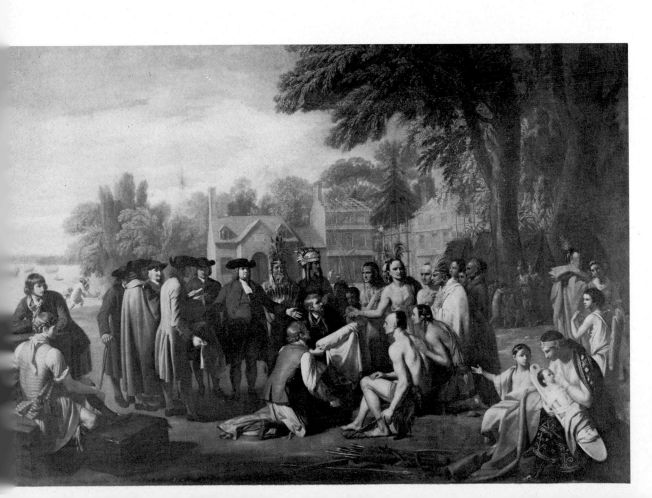

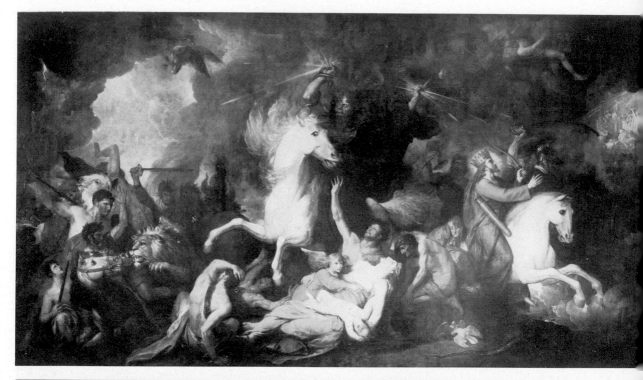

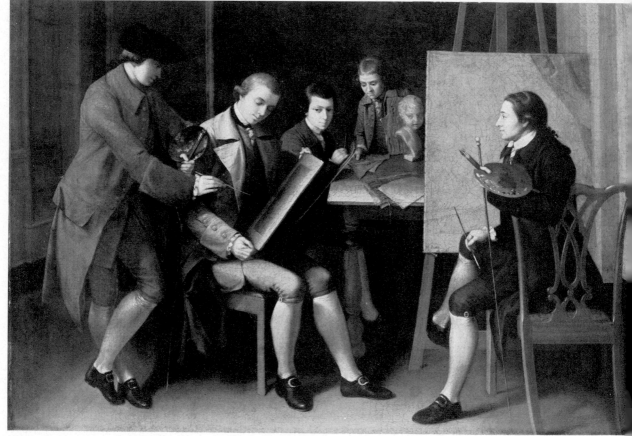

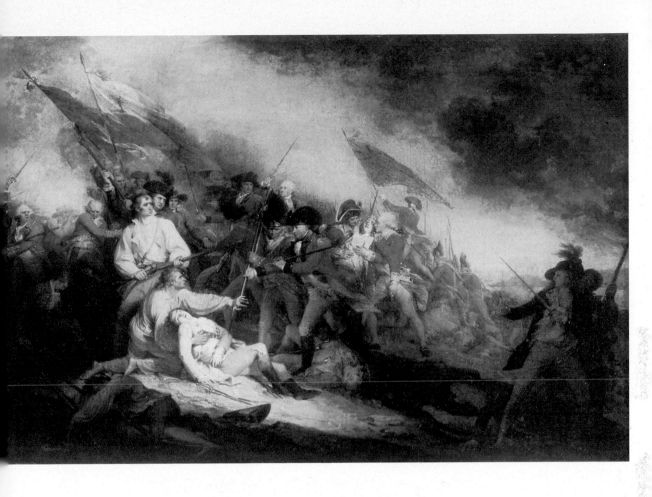

45. Benjamin West: Death on the Pale Horse, 1817. *Philadelphia, The Pennsylvania Academy of the Fine Arts*

46. Matthew Pratt: The American School, 1765. *New York, The Metropolitan Museum of Art*

47. John Trumbull: The Death of General Warren at the Battle of Bunker's Hill, 1786. *New Haven, Connecticut, Yale University Art Gallery*

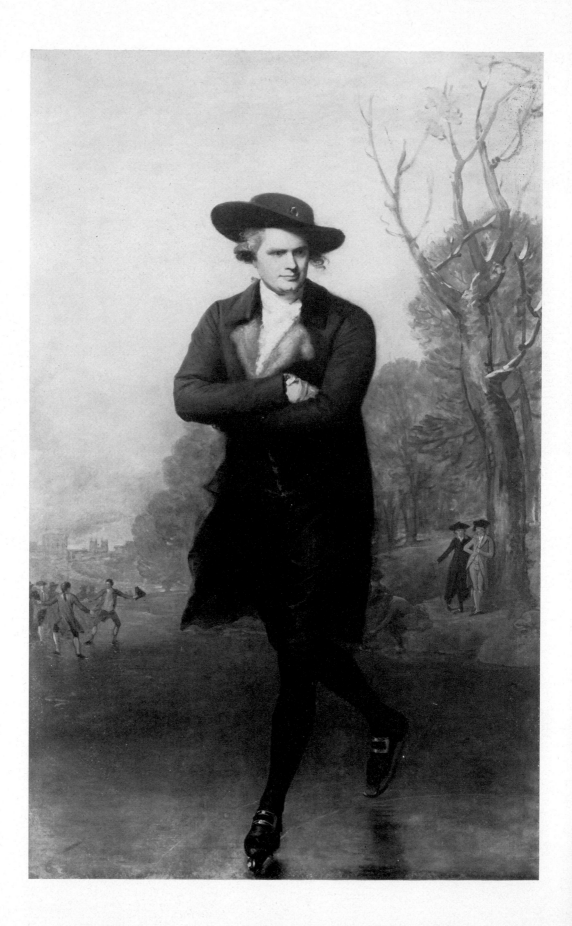

48. Gilbert Stuart: The Skater, 1782. *Washington, D.C., National Gallery of Art*

49. Gilbert Stuart: George Washington (The Athenaeum Portrait), 1796. *Boston, Museum of Fine Arts*

50. Gilbert Stuart: Mrs Perez Morton, 1802. *Worcester, Massachusetts, Worcester Art Museum*

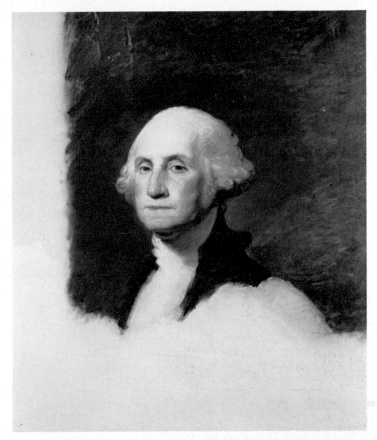

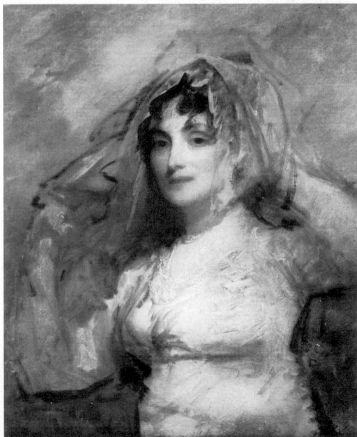

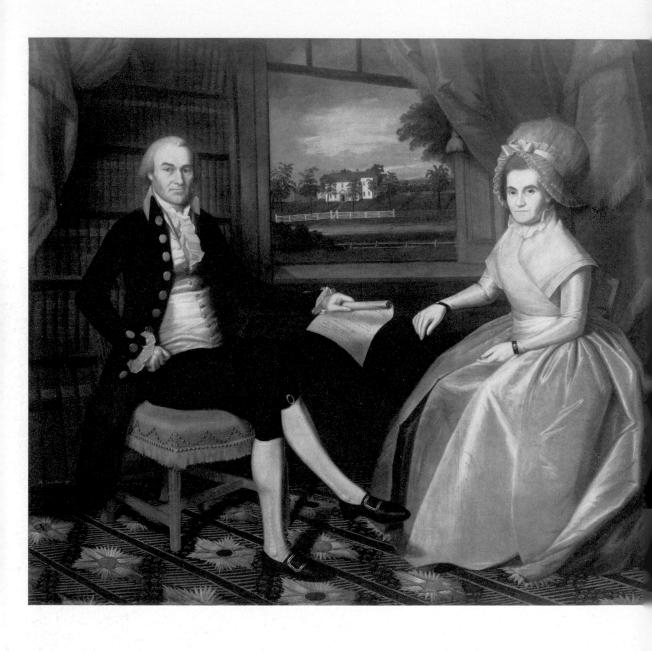

51. Ralph Earl: Chief Justice and Mrs Oliver Ellsworth, 1792. *Hartford, Connecticut, Wadsworth Atheneum*

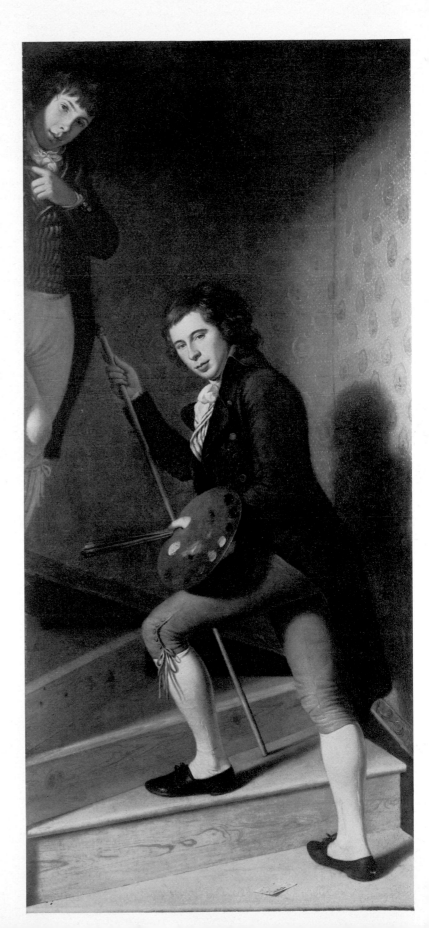

56. Charles Willson Peale: The Staircase Group, 1795. *Philadelphia, The Pennsylvania Museum of Art*

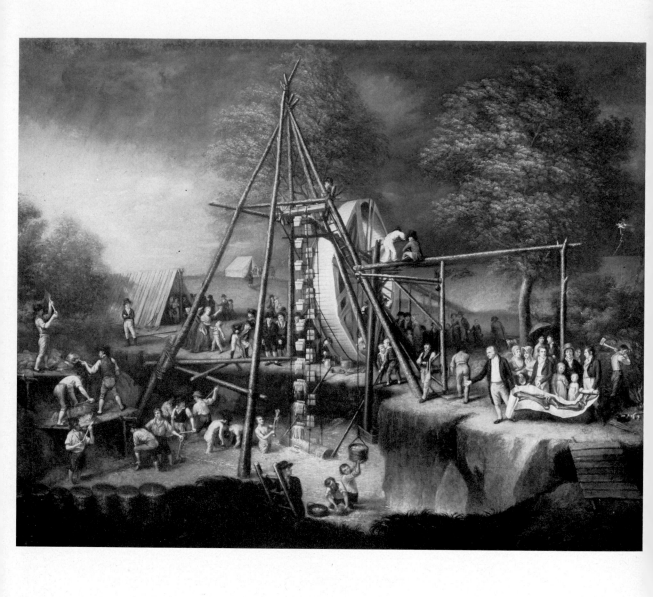

57. Charles Willson Peale: Exhumation of the Mastodon, 1806. *Baltimore, Maryland, The Peale Museum*

58. Charles Willson Peale: Yarrow Mamout, 1819. *Philadelphia, The Historical Society of Pennsylvania*

59. Charles Willson Peale: The Artist in his Museum, 1822. *Philadelphia, The Pennsylvania Academy of the Fine Arts*

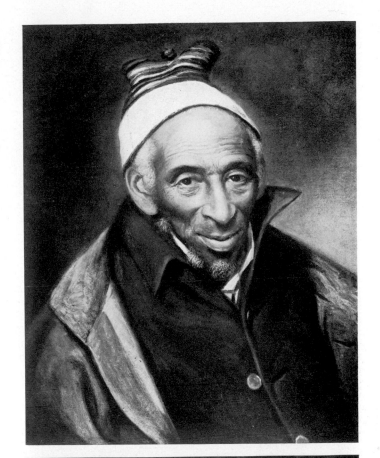

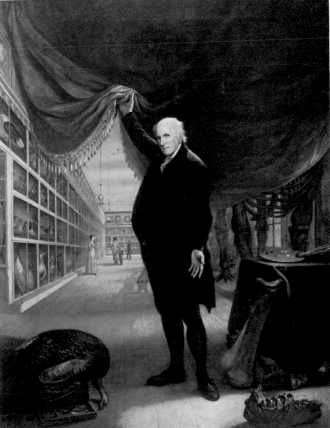

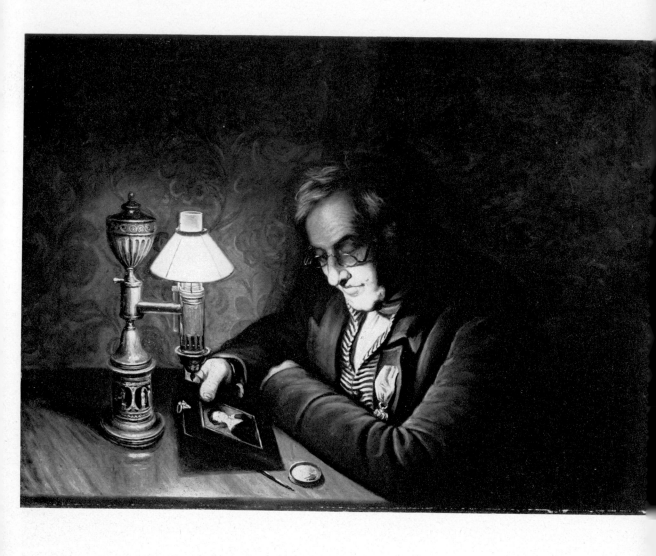

60. Charles Willson Peale: James Peale (The Lamplight Portrait), 1822. *The Detroit Institute of Arts*

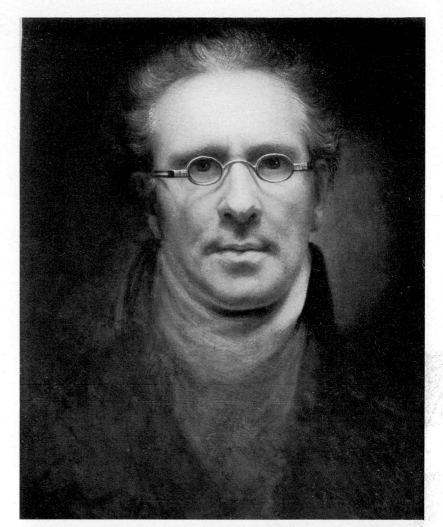

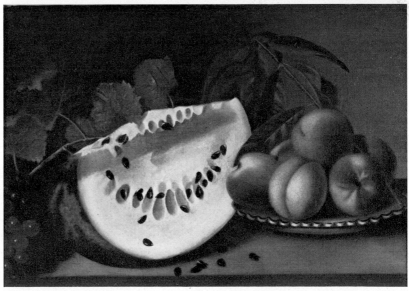

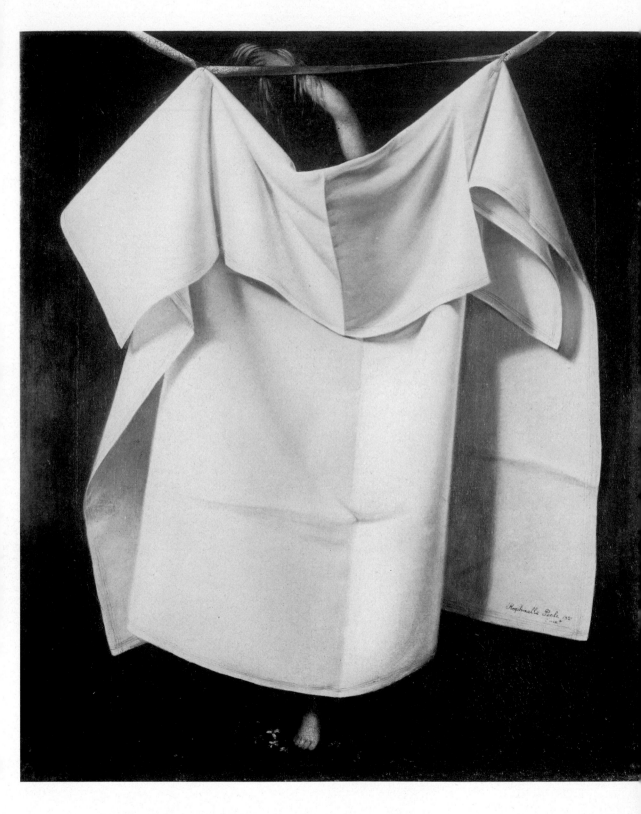

63. Raphaelle Peale: After the Bath, 1823. *Kansas City, Nelson Gallery – Atkins Museum*

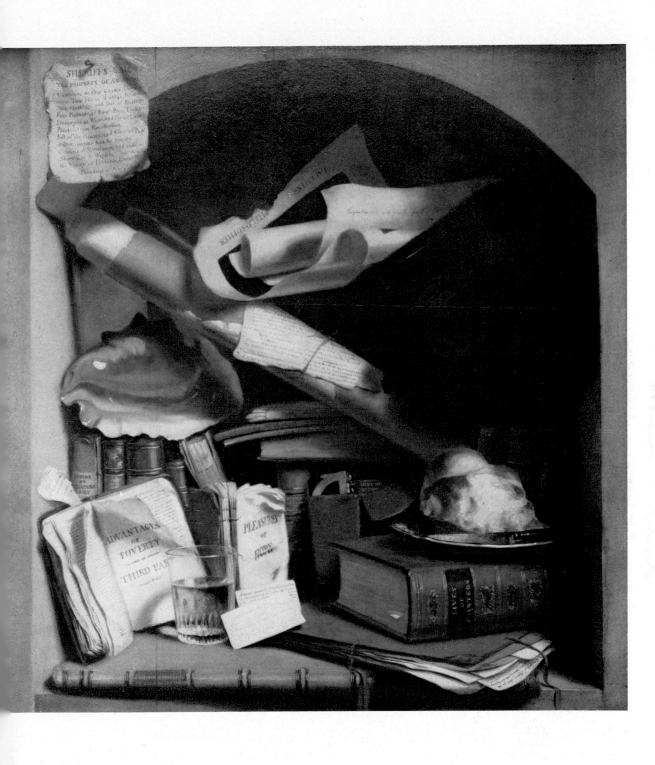

64. Charles Bird King: Poor Artist's Cupboard, *c.* 1815. Oil on wood. *Washington, D.C., The Corcoran Gallery of Art*

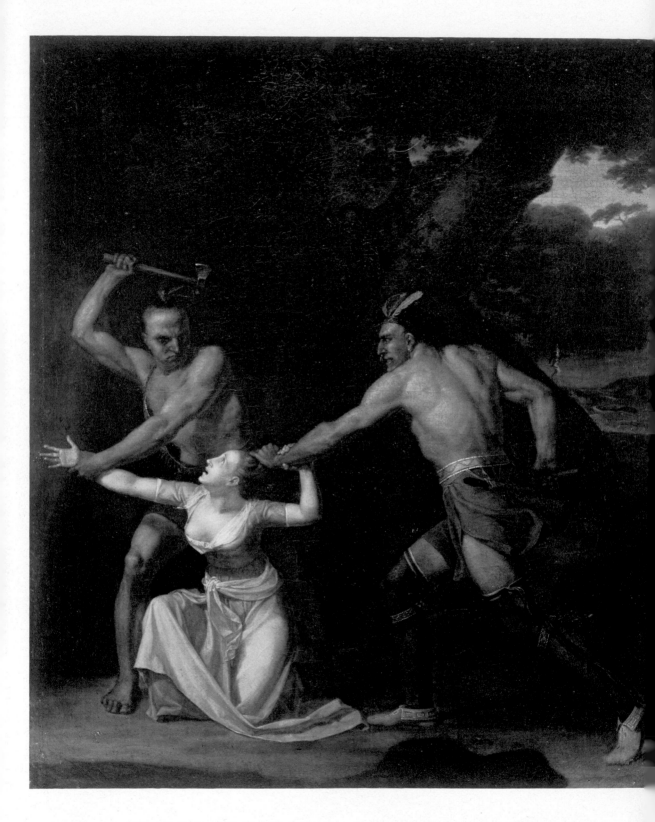

65. John Vanderlyn: Death of Jane McCrea, 1804. *Hartford, Connecticut, Wadsworth Atheneum*

66. John Vanderlyn: Marius amid the Ruins of Carthage, 1807. *The Fine Arts Museums of San Francisco, M. H. de Young Memorial Museum*

67. John Vanderlyn: Ariadne asleep on the Island of Naxos, 1814. *Philadelphia, The Pennsylvania Academy of the Fine Arts*

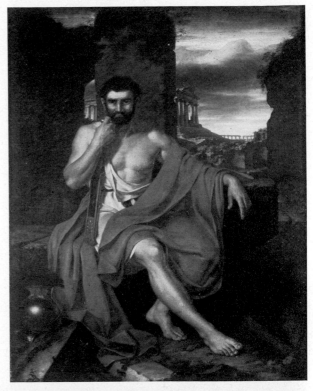

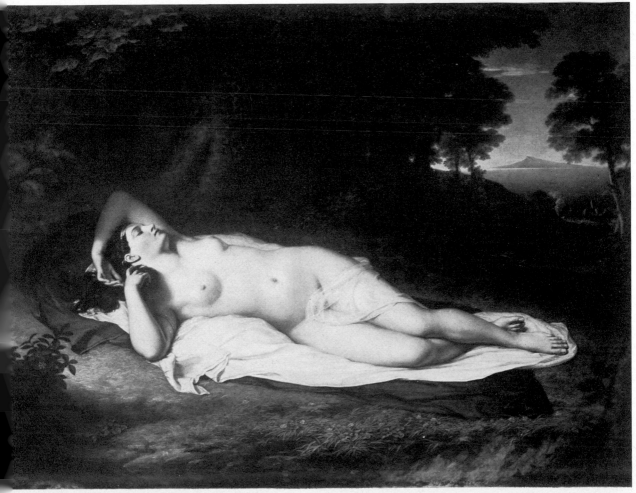

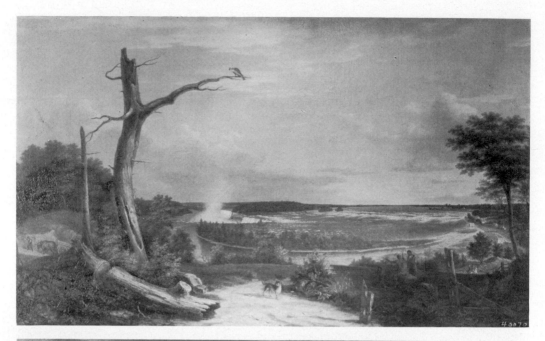

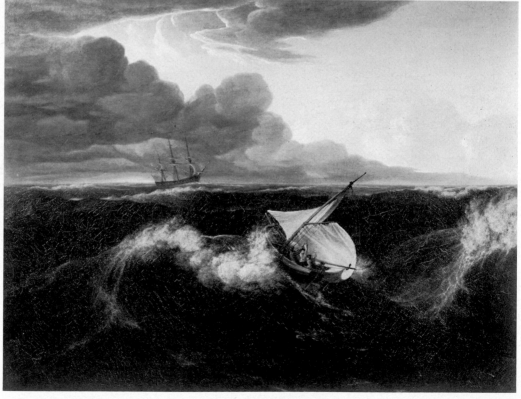

68. John Vanderlyn: Niagara, c. 1842–3. *Kingston, New York, Senate House Museum*

69. Washington Allston: Rising of a Thunderstorm at Sea, 1804. *Boston, Museum of Fine Arts*

70. Washington Allston: Diana in the Chase, 1805. *Cambridge, Massachusetts, Fogg Art Museum, Harvard University*

71. Washington Allston: Elijah in the Desert, 1818. *Boston, Museum of Fine Arts*

72. Washington Allston: Moonlit Landscape, 1819. *Boston, Museum of Fine Arts*

73. Washington Allston: Belshazzar's Feast, 1817–43. Final version. *The Detroit Institute of Arts*

74. Samuel F. B. Morse: The Old House of Representatives, 1822. *Washington, D.C., The Corcoran Gallery of Art*

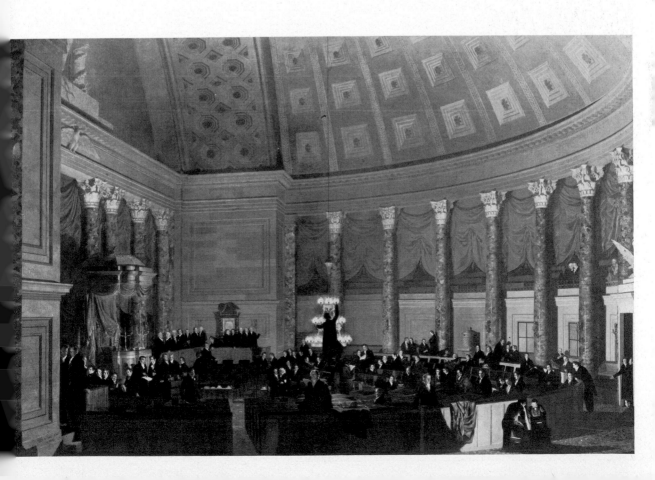

75. Samuel F. B. Morse: The Muse –
Susan Walker Morse, 1835–7. *New York,*
The Metropolitan Museum of Art

76. Thomas Sully: The Torn Hat, 1820.
Oil on panel. *Boston, Museum of Fine Arts*

77. John Neagle: Pat Lyon at the Forge,
1829. *Philadelphia, The Pennsylvania*
Academy of the Fine Arts

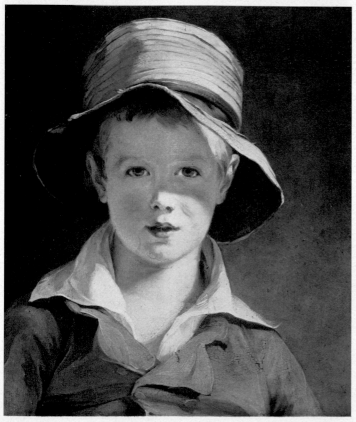

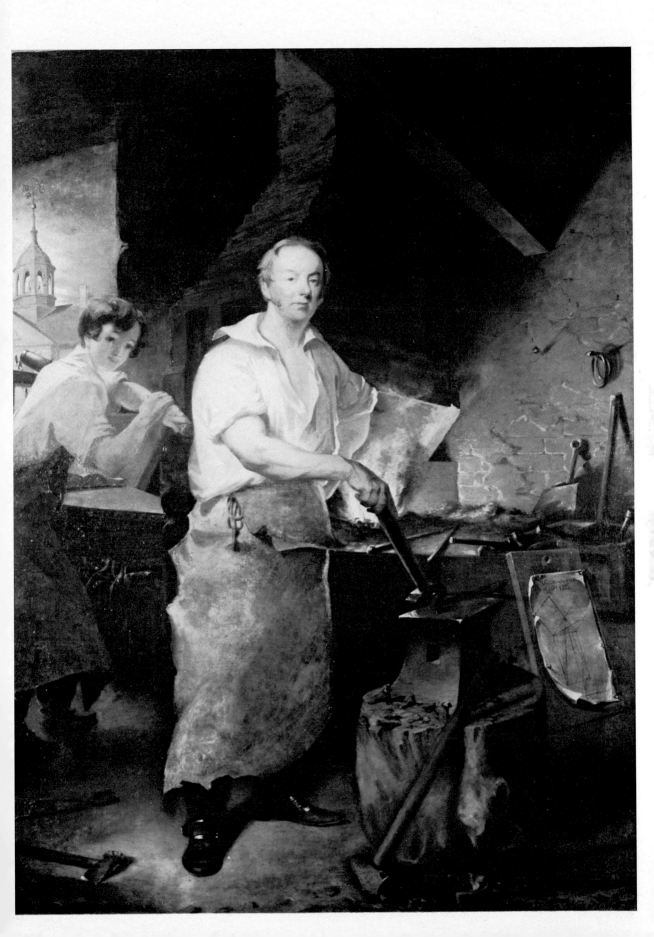

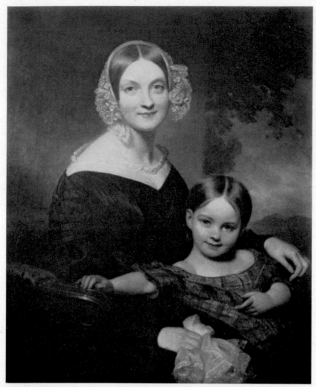

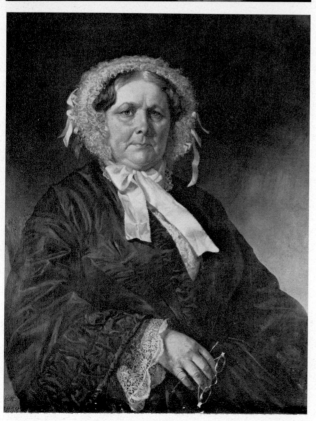

78. Henry Inman: Georgianna Buckham and her Mother, 1839. *Boston, Museum of Fine Arts*

79. Charles Loring Elliott: Mrs Thomas Goulding, 1858. *New York, National Academy of Design*

80. Albert S. Southworth: John Quincy
Adams, *c.* 1843. Daguerreotype. *New York,*
The Metropolitan Museum of Art

81. John H. I. Browere: John Adams, 1825.
Plaster. *Cooperstown, New York State Historical*
Association

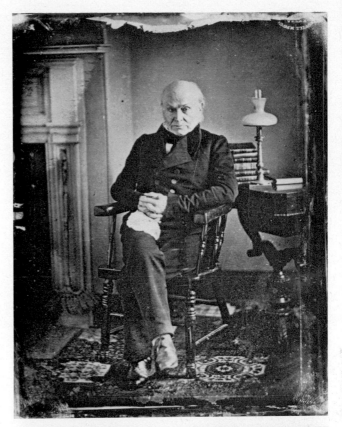

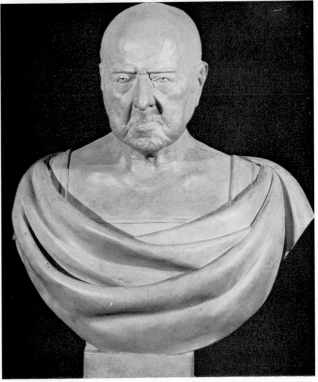

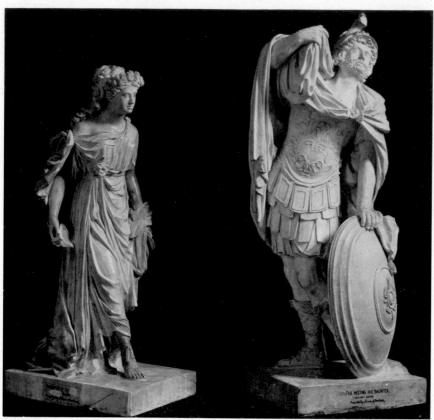

82. Hezekiah Augur:
Jephthah and his
Daughter, *c.* 1828–30.
Marble. *New Haven,
Connecticut, Yale University
Art Gallery*

83. Francis Guy: Winter
Scene in Brooklyn,
1817–20. *Museum of the
City of New York*

84. Thomas Birch: New
York Harbour, *c.* 1830.
*Boston, Museum of Fine
Arts*

85. Robert Salmon:
Boston Harbour from
Mr Greene's House,
Pemberton Hill, 1829.
Tempera on canvas.
*Boston, The Society for the
Preservation of New
England Antiquities*

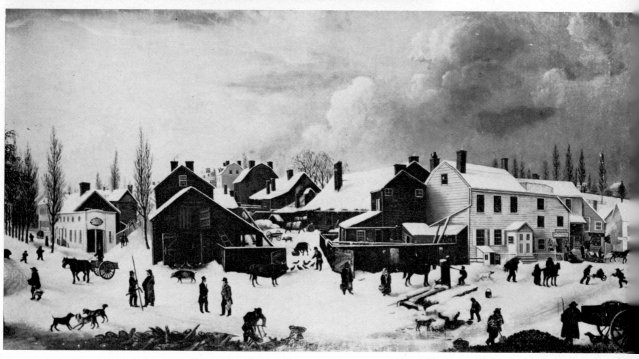

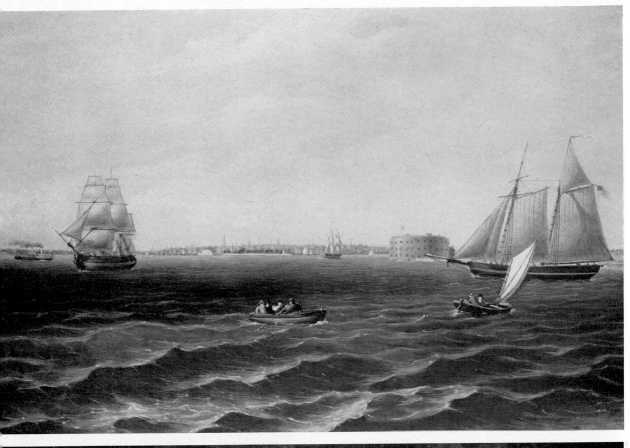

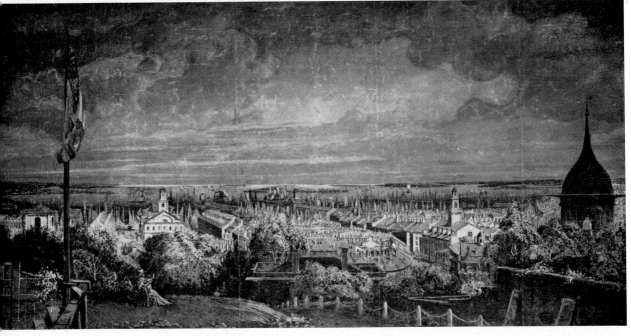

86. Joshua Shaw: On the Susquehanna, 1839. *Boston, Museum of Fine Arts*

87. Thomas Doughty: Mill Pond and Mills, Lowell, Massachusetts, *c.* 1833. *Cambridge, Massachusetts, Harvard Business School*

88. Thomas Doughty: Mount Desert Lighthouse, 1847. *The Newark Museum*

89. Thomas Cole: Scene from 'The Last of the Mohicans', 1827. *Cooperstown, New York State Historical Association*

90. Thomas Cole: Sunny Morning on the Hudson River, *c.* 1827. Oil on panel, *Boston, Museum of Fine Arts*

91. Thomas Cole: The Course of Empire: Consummation, 1836. *The New-York Historical Society*

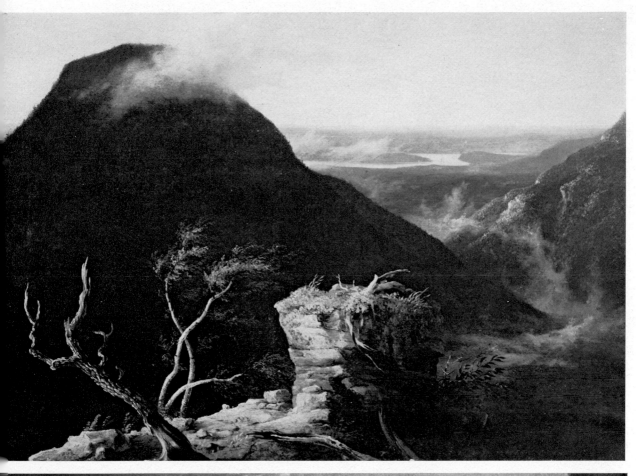

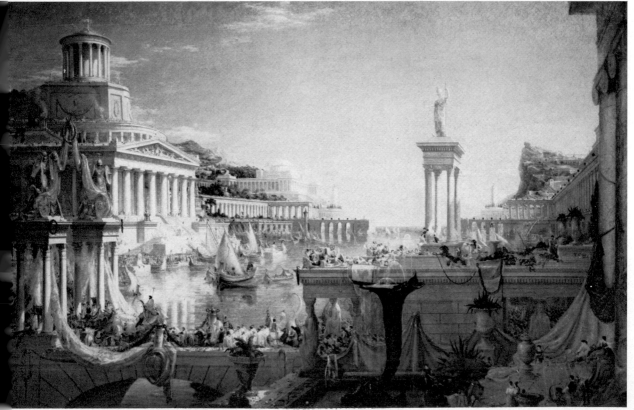

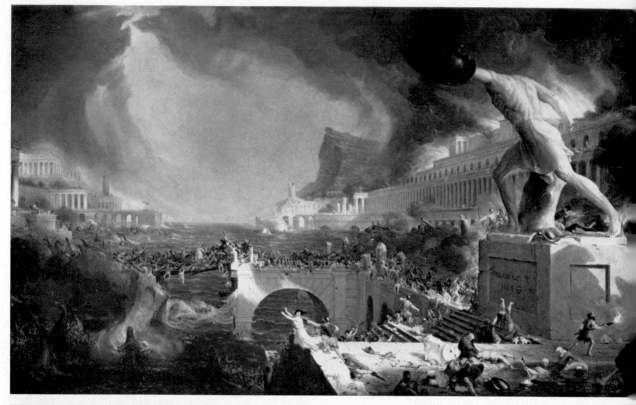
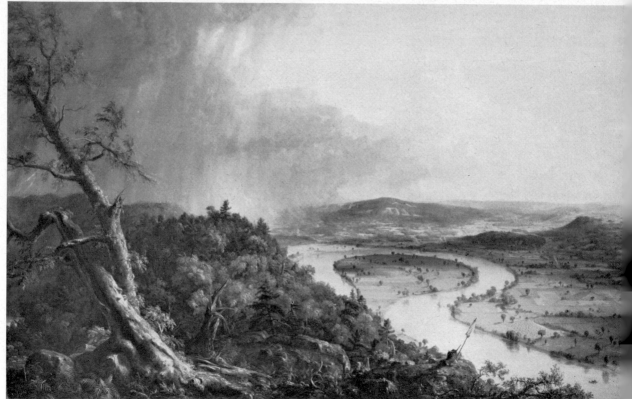

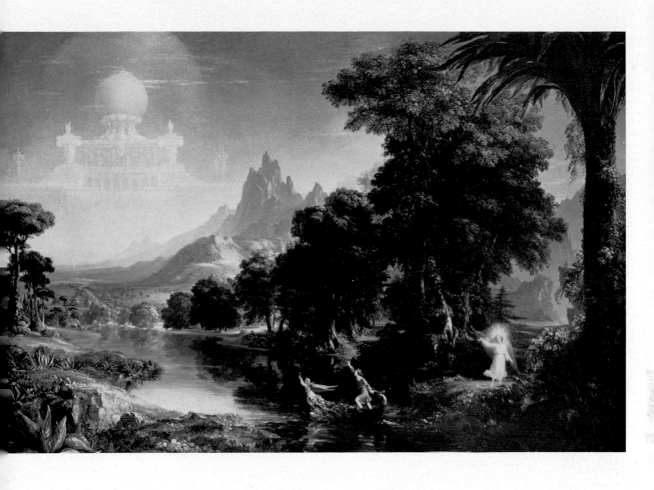

92. Thomas Cole: The Course of Empire: Destruction, 1836. *The New-York Historical Society*

93. Thomas Cole: The Oxbow (The Connecticut River near Northampton), 1836. *New York, The Metropolitan Museum of Art*

94. Thomas Cole: The Voyage of Life: Youth, 1840. *Utica, New York, Munson-Williams-Proctor Institute*

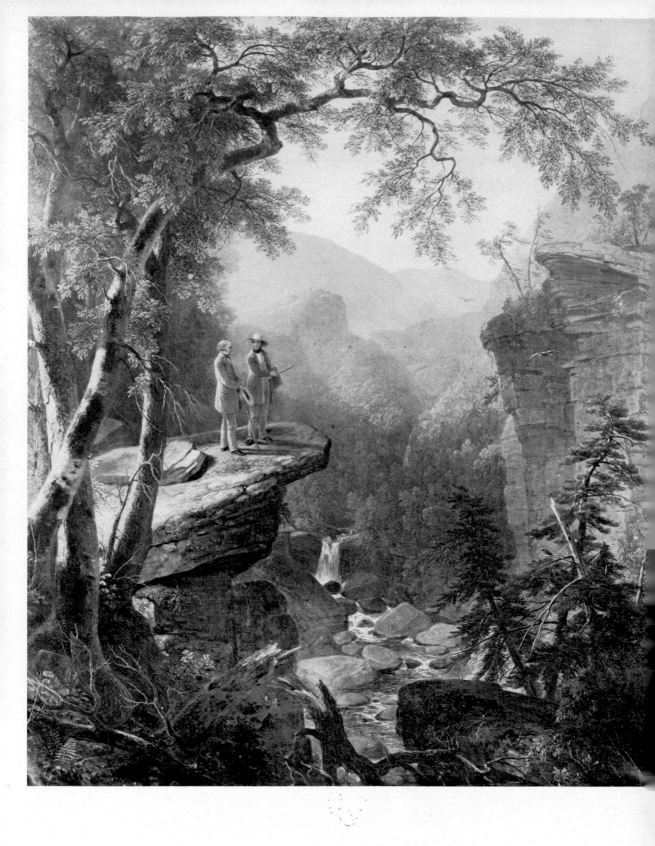

95. Asher B. Durand: Kindred Spirits, 1849. *New York Public Library*

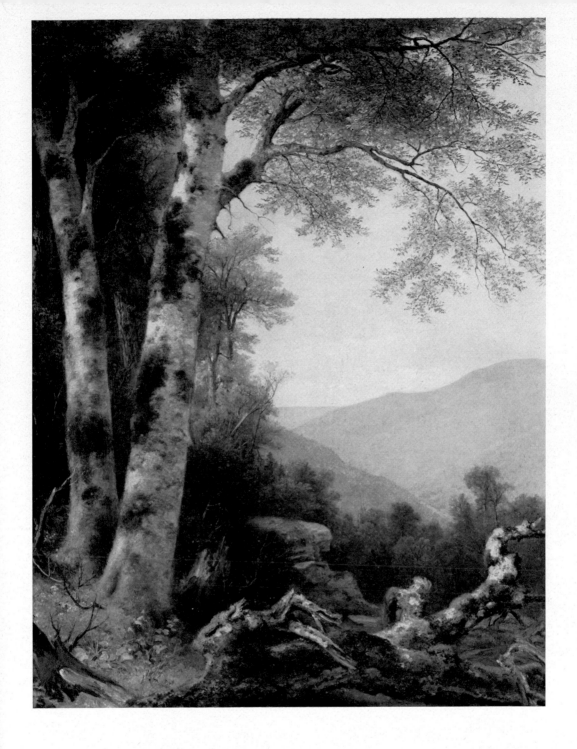

96. Asher B. Durand: Landscape with Birches, 1855. *Boston, Museum of Fine Arts*

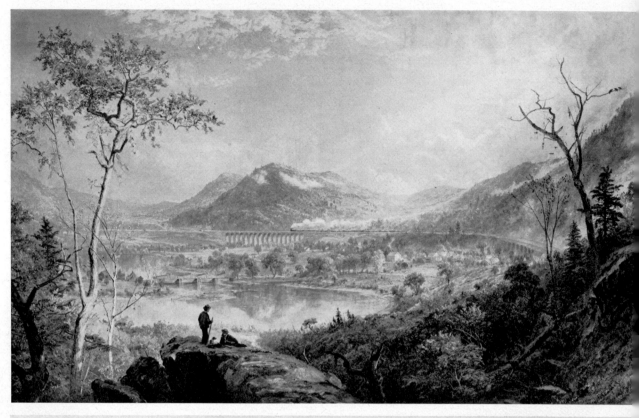

97. Jasper Cropsey: Starrucca Viaduct, 1865. *The Toledo Museum of Art*

98. Robert Duncanson: Blue Hole, Flood Waters, Little Miami River, 1851. *Cincinnati Art Museum*

99. John F. Kensett: Marine off Big Rock, 1869. *Jacksonville, Florida, Cummer Gallery of Art*

100. T. Worthington Whittredge: Home by the Sea, 1872. *Andover, Massachusetts, Addison Gallery of American Art, Phillips Academy*

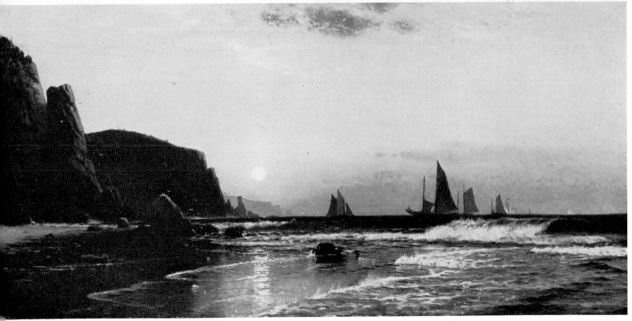

101. Samuel Colman: Storm King on the Hudson, 1866. *Washington, D.C., National Collection of Fine Arts, Smithsonian Institution*

102. Alfred Thompson Bricher: Morning at Grand Manan, 1878. *Indianapolis Museum of Art*

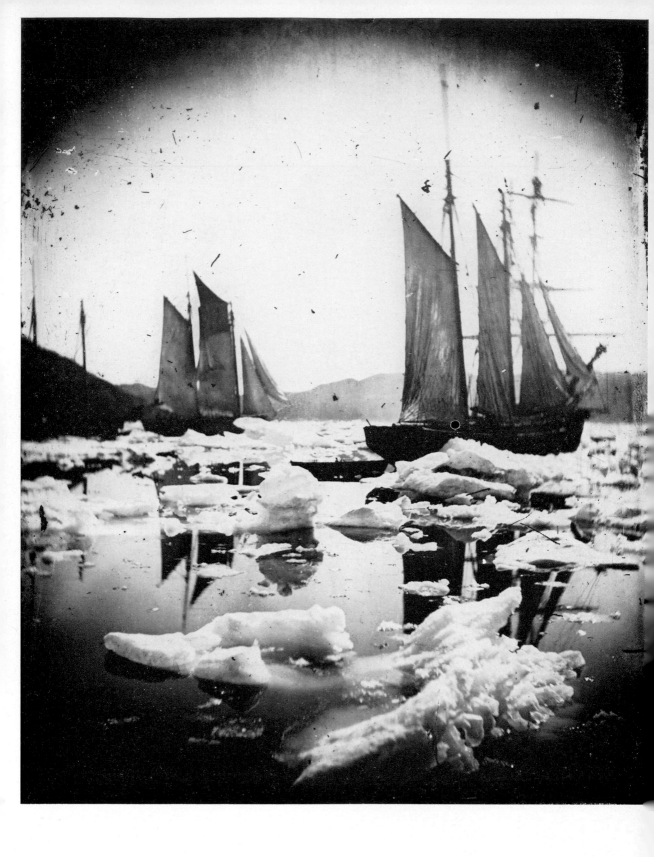

103. William Bradford: Schooners in Arctic Ice, *c.* 1889. Photograph. *New Bedford, Massachusetts, The Whaling Museum*

104. Fitz Hugh Lane: Castine from Hospital Island, 1855. Lithograph. *Newport News, Virginia, The Mariners Museum*

105. Fitz Hugh Lane: The Western Shore with Norman's Woe, 1862. *Gloucester, Massachusetts, Cape Ann Historical Association*

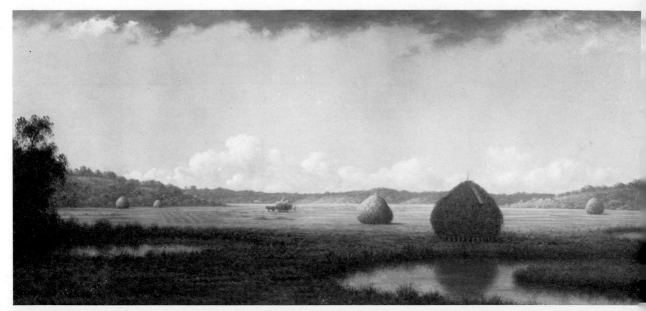

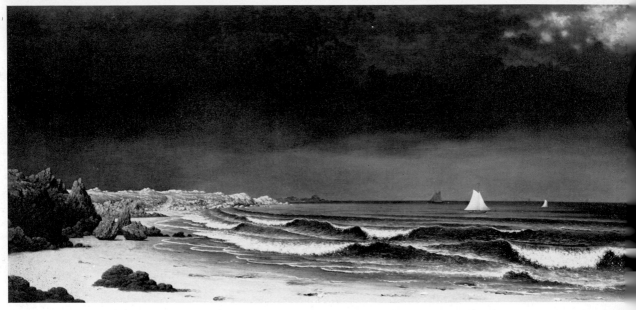

106. Martin Johnson Heade: Summer Showers, c. 1865. *The Brooklyn Museum*

107. Martin Johnson Heade: Approaching Storm; Beach near Newport, c. 1867. *Boston, Museum of Fine Arts*

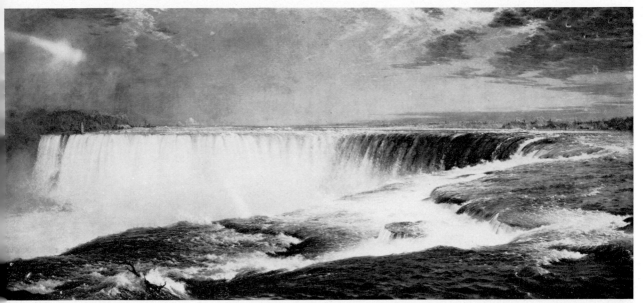

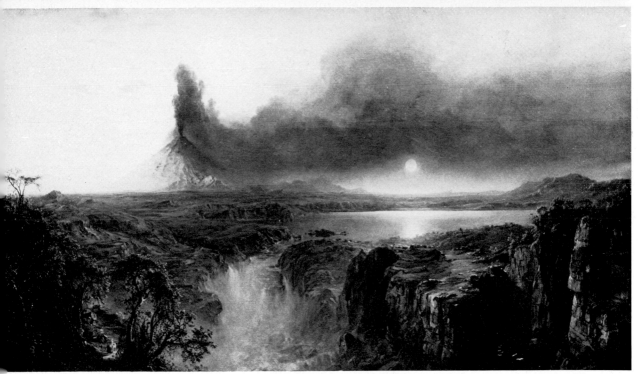

108. Frederic Edwin Church: Niagara, 1857. *Washington, D.C., The Corcoran Gallery of Art*

109. Frederic Edwin Church: Cotopaxi, 1863. *Reading, Pennsylvania, The Reading Public Museum and Art Gallery*

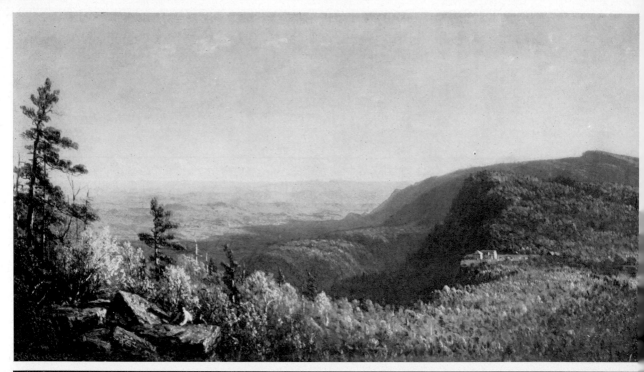
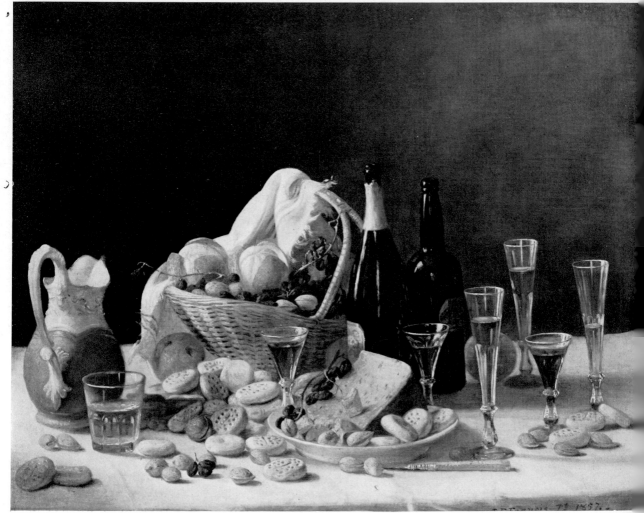

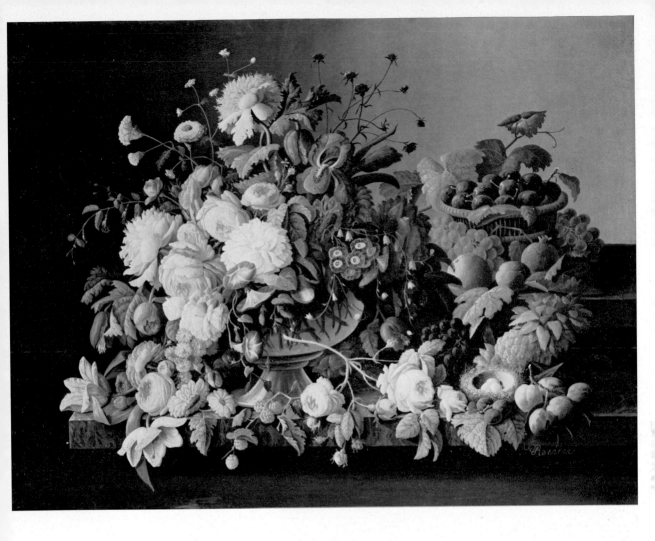

110. Sanford Gifford: Catskill Mountain House, 1862. *Hartford, Connecticut, Austin Arts Center, Trinity College*

111. John F. Francis: Still Life with Wine Bottles and Basket of Fruit, 1857. *Boston, Museum of Fine Arts*

112. Severin Roesen: Still Life: Flowers, *c.* 1858. *New York, The Metropolitan Museum of Art*

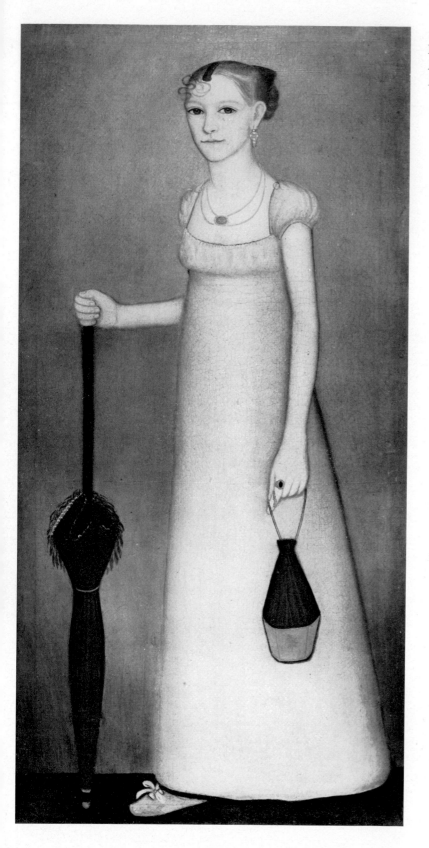

113. Ammi Phillips: Harriet
Leavens, *c.* 1815. *Cambridge,
Massachusetts, Fogg Art Museum,
Harvard University*

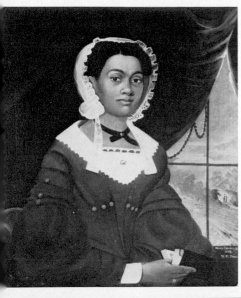

114. William M. Prior: Nancy Lawson, 1843.
Shelburne, Vermont, Shelburne Museum

115. Edward Hicks: The Peaceable Kingdom of the
Branch, 1825–30. Oil on wood. *New Haven,
Connecticut, Yale University Art Gallery*

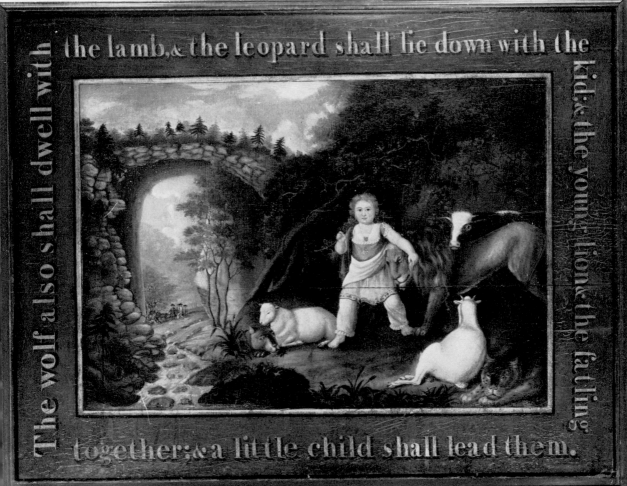

116. Thomas Chambers: Staten Island and the Narrows, *c.* 1835–55. *The Brooklyn Museum*

117. Anon.: Meditation by the Sea, *c.* 1855. *Boston, Museum of Fine Arts*

118. Erastus Salisbury Field: Historical Monument of the American Republic, *c.* 1876. *Springfield, Massachusetts, Museum of Fine Arts*

119. Anon.: Jack Tar. Ship Chandler's Sign, *c.* 1860–70. Wood. *Shelburne, Vermont, Shelburne Museum*

120. Anon.: Carved figure, Wasco tribe, *c.* 1800–50. Wood. *Chicago, Field Museum of Natural History*

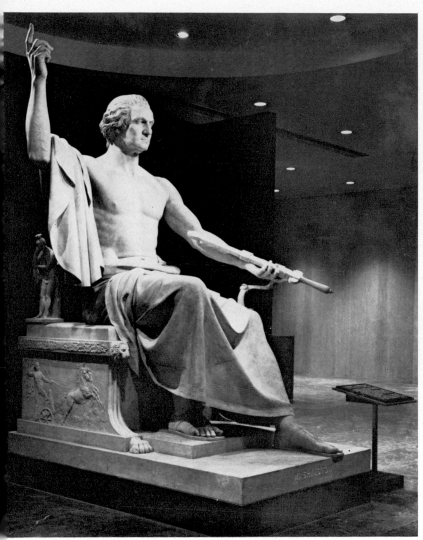

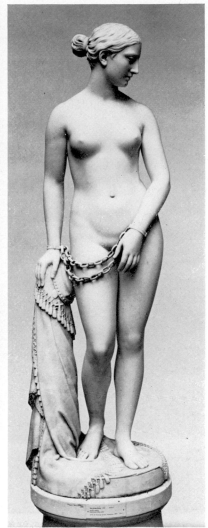

121. Horatio Greenough: George Washington, 1833–41. Marble. *Washington, D.C., The Smithsonian Institution*

122. Hiram Powers: The Greek Slave, 1843. Marble. *Washington, D.C., The Corcoran Gallery of Art*

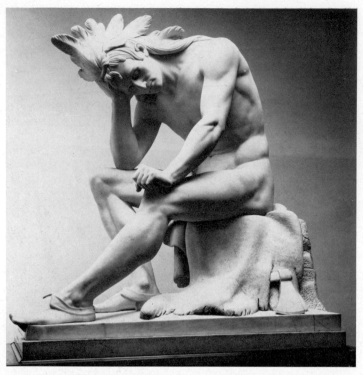

123. Thomas Crawford: The Indian (the Chief contemplating the Progress of Civilization), 1856. Marble. *The New-York Historical Society*

124. Edmonia Lewis: Abraham Lincoln, 1867. Marble. *San Jose, California, San Jose Public Library*

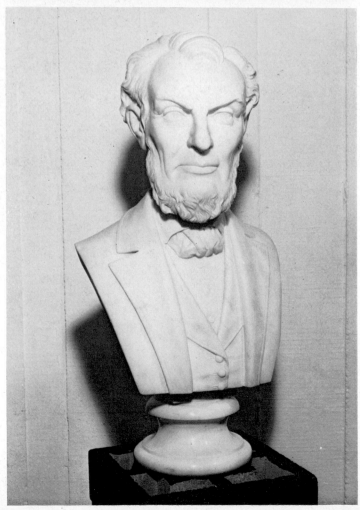

125. William Wetmore Story:
Salome, 1871. Marble. *New York,
The Metropolitan Museum of Art*

126. John Rogers: Checkers up at
the Farm, 1875. Bronze. *The New-
York Historical Society*

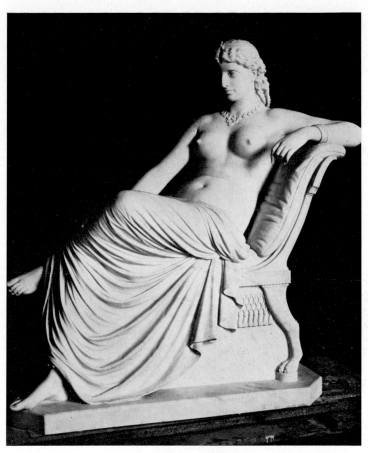

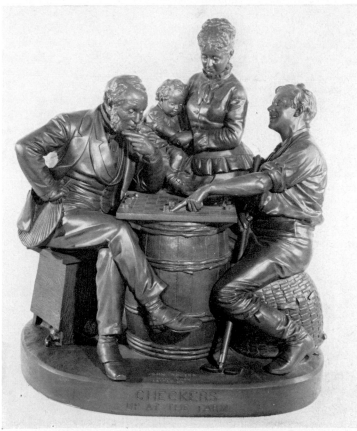

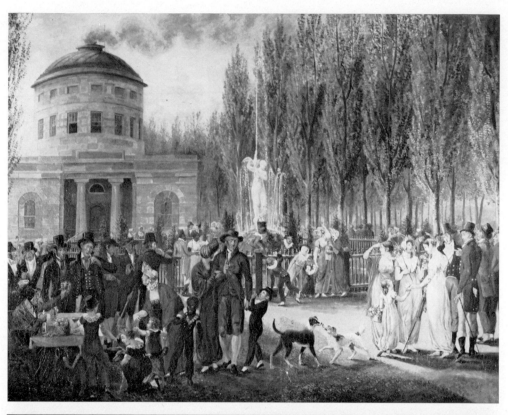

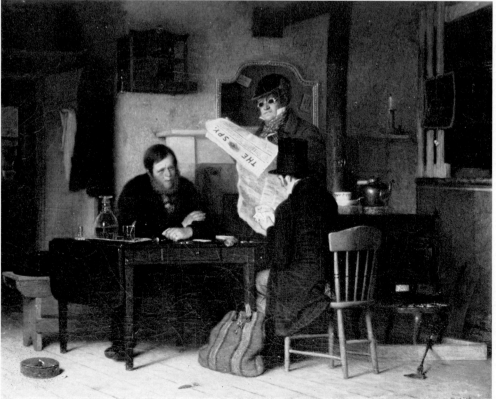

127. John Lewis Krimmel: Fourth of July in Center Square, *c.* 1810–12. *Philadelphia, The Pennsylvania Academy of the Fine Arts*

128. Richard Caton Woodville: Waiting for the Stage, 1851. *Washington, D.C., The Corcoran Gallery of Art*

129. Jerome Thompson: The 'Pick Nick' near Mount Mansfield, *c.* 1858. *The Fine Arts Museums of San Francisco, M. H. de Young Memorial Museum*

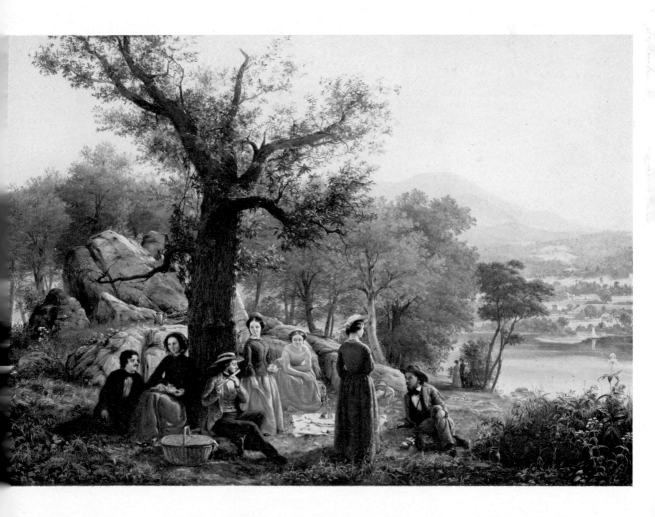

130. Enoch Wood Perry: The Pemigewasset Coach, *c.* 1870. *Shelburne, Vermont, Shelburne Museum*

131. Albertus D. O. Browere: Rip and Wolf chased from Home by Dame Van Winkle, 1880. *Shelburne, Vermont, Shelburne Museum*

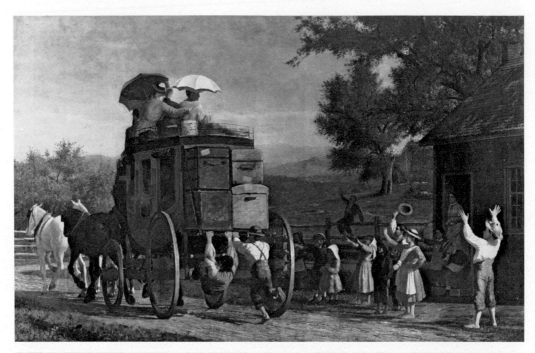

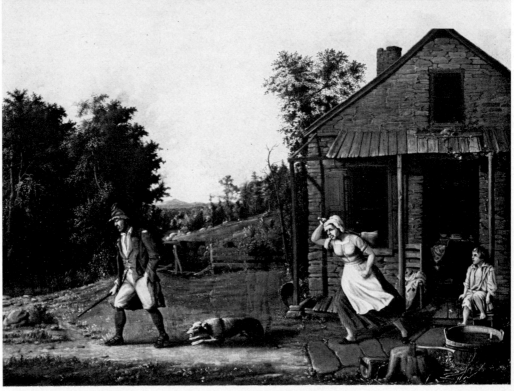

132. John Quidor: The Return of Rip Van Winkle, 1829. *Washington, D.C., National Gallery of Art*

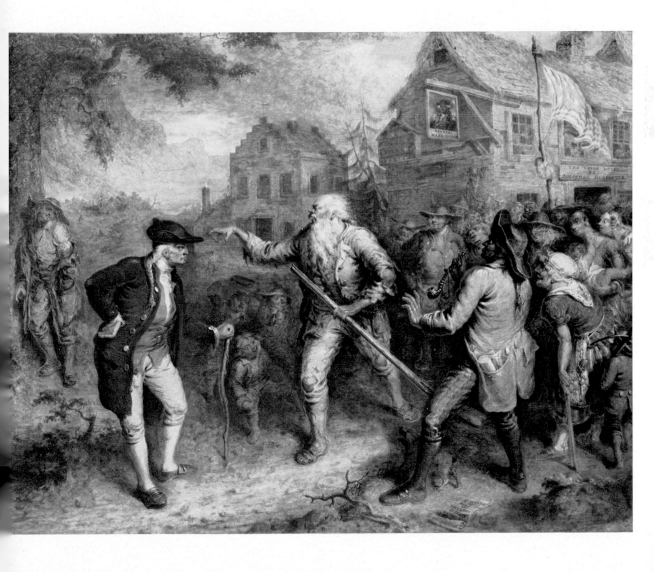

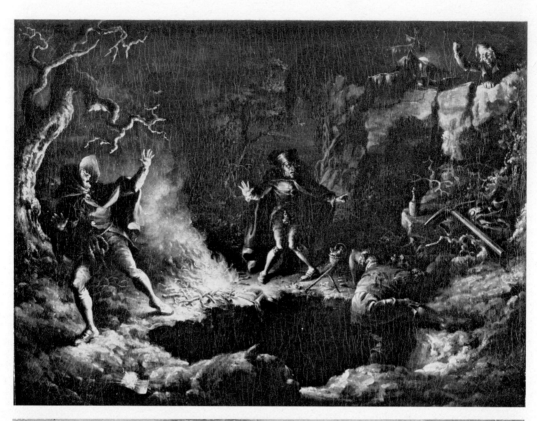

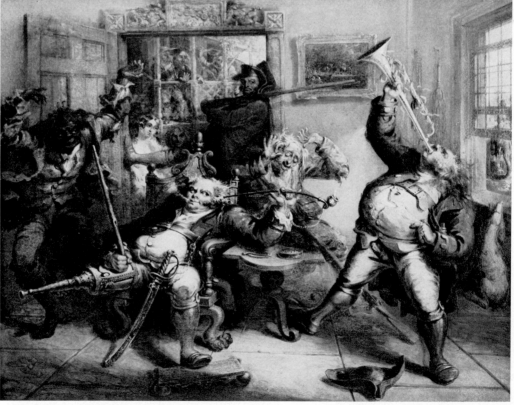

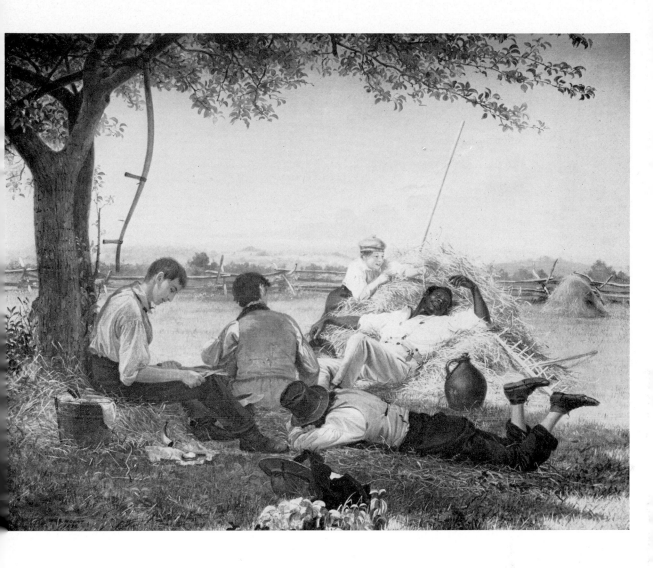

133. John Quidor: The Money Diggers, 1832. *The Brooklyn Museum*

134. John Quidor: Antony van Corlear brought into the Presence of Peter Stuyvesant, 1839. *Utica, New York, Munson–Williams–Proctor Institute*

135. William Sidney Mount: Farmers Nooning, 1836. *Stony Brook, Long Island, Suffolk Museum and Carriage House*

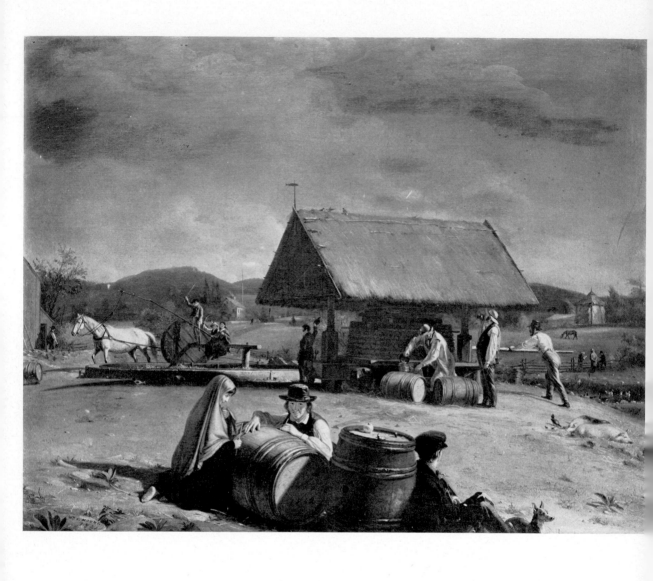

136. William Sidney Mount: Cider Making, 1840–1. *New York, The Metropolitan Museum of Art*

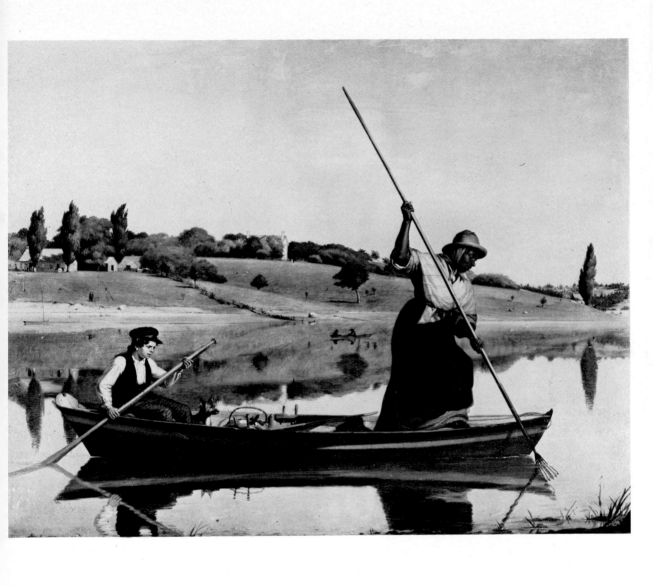

137. William Sidney Mount: Eel Spearing at Setauket, 1845. *Cooperstown, New York State Historical Association*

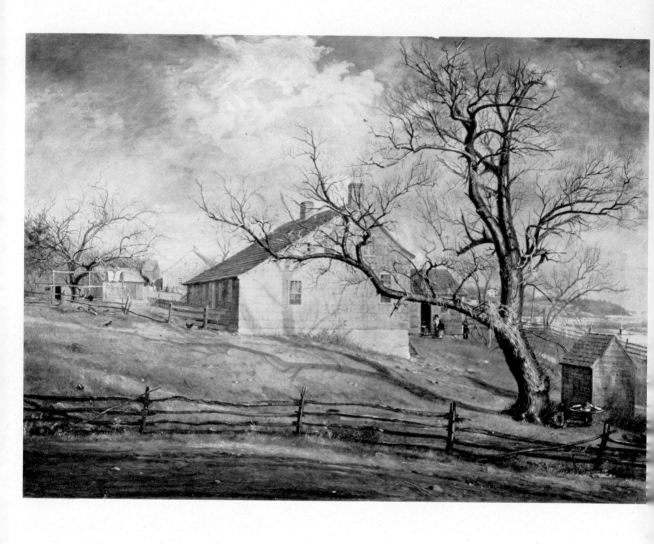

138. William Sidney Mount: Long Island Farmhouses, 1854–9. *New York, The Metropolitan Museum of Art*

139. William Sidney Mount: The Banjo Player, *c.* 1855. *The Detroit Institute of Arts*

140. George Caleb Bingham: Fur Traders descending the Missouri, 1845. *New York, The Metropolitan Museum of Art*

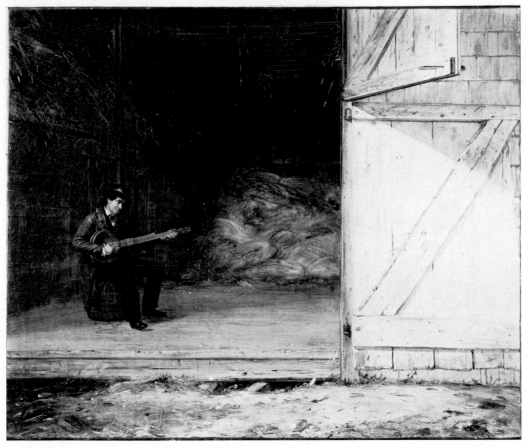

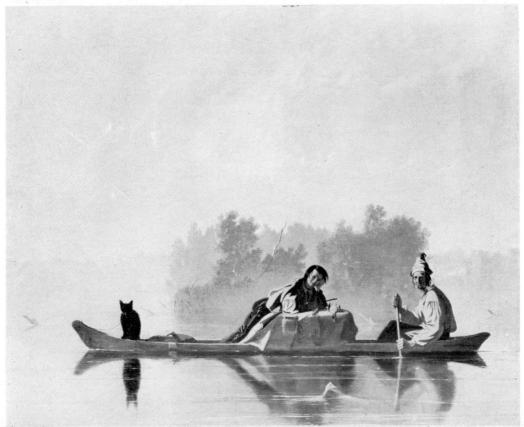

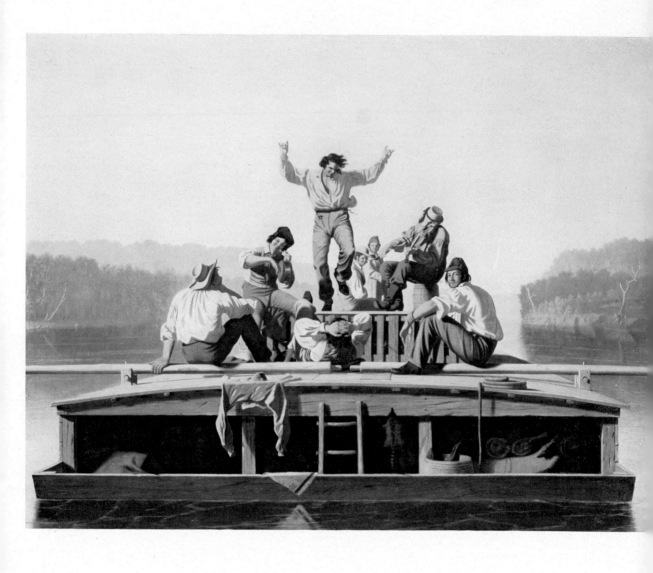

141. George Caleb Bingham: Jolly Flatboatmen, 1846. *Collection Senator Claiborne Pell*

142. George Caleb Bingham: The County Election, 1851–2. *The St Louis Art Museum*

143. Emanuel Gottlieb Leutze: Washington crossing the Delaware, 1851. *New York, The Metropolitan Museum of Art*

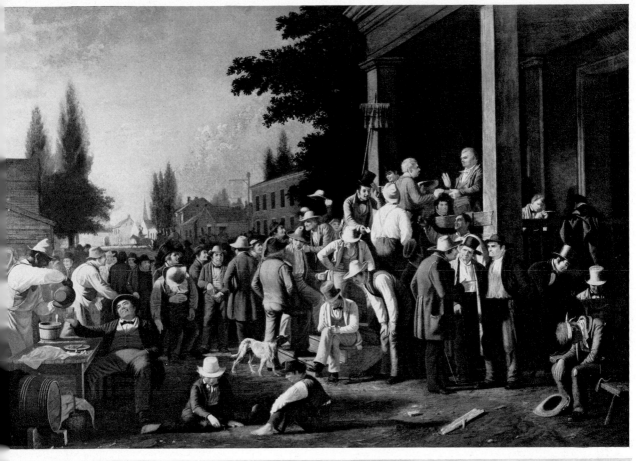

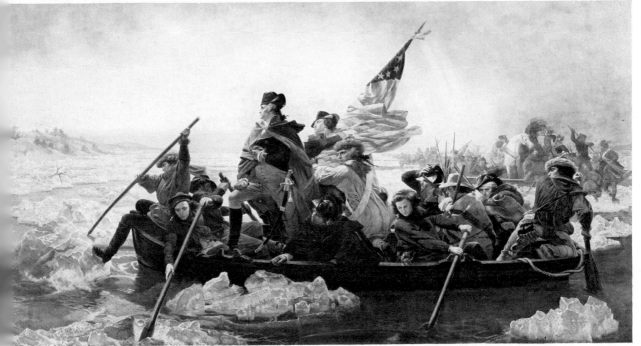

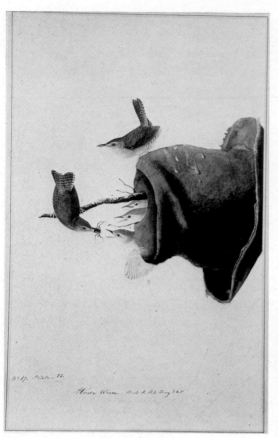 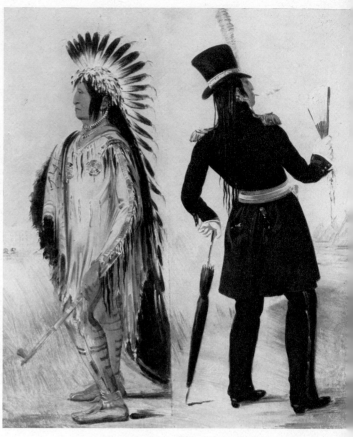

144. John James Audubon: House Wren, *c.* 1834. Watercolour. *The New-York Historical Society*

145. George Catlin: Wi-jun-jon, The Pigeon's Egg Head, Going to and Returning from Washington, 1832. *Washington, D.C., National Collection of Fine Arts, Smithsonian Institution*

146. Charles Deas: The Death
Struggle, 1845. *Shelburne, Vermont,*
Shelburne Museum

147. Albert Bierstadt: The Last of the
Buffalo, 1889. *Washington, D.C.,*
The Corcoran Gallery of Art

148. Albert Bierstadt: Domes of the Yosemite, 1867. *St Johnsbury, Vermont, St Johnsbury Athenaeum*

149. Thomas Moran: Grand Canyon of the Yellowstone, 1872. *Washington, D.C., National Collection of Fine Arts, Smithsonian Institution*

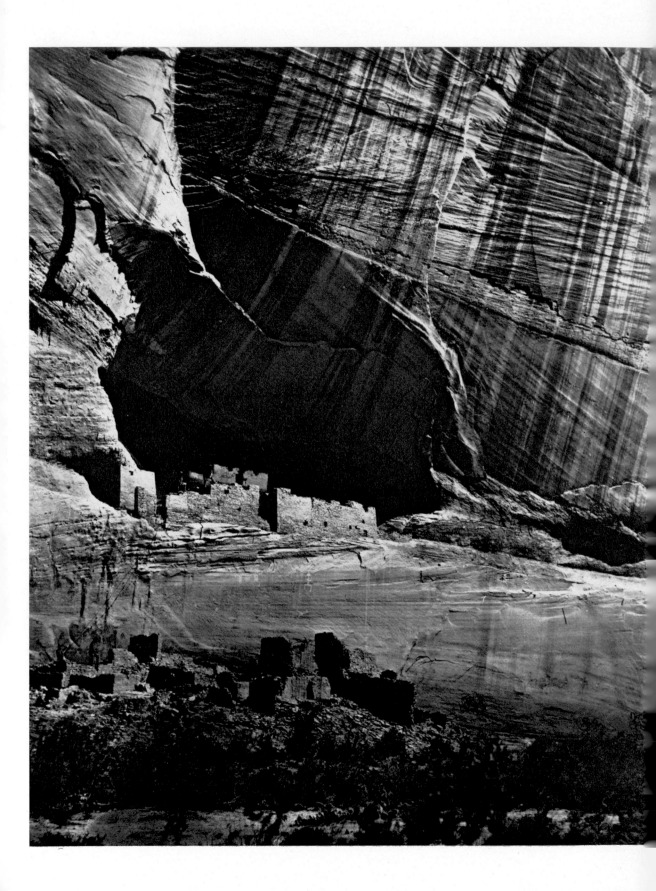

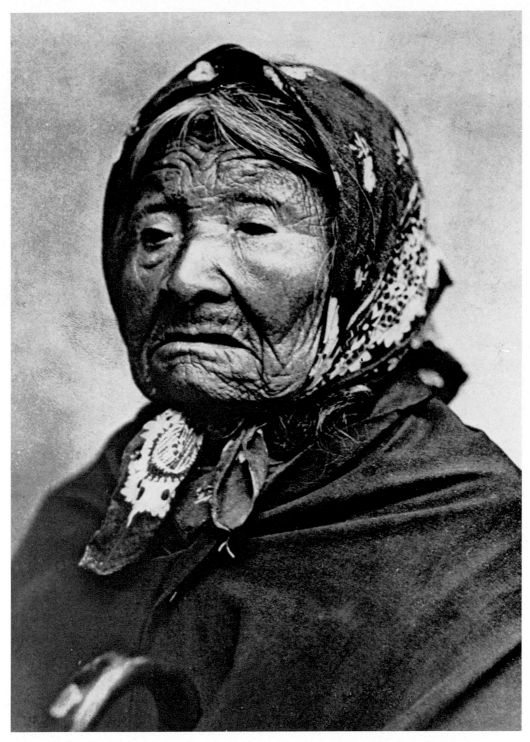

150. Timothy O'Sullivan: Ruins of White House, Canyon de Chelly, Arizona, 1873. Photograph. *Rochester, New York, International Museum of Photography, George Eastman House*

151. Edward Curtis: Princess Angeline, Suguamish Tribe, Daughter of Chief Siahl, 1899, from *North American Indian*

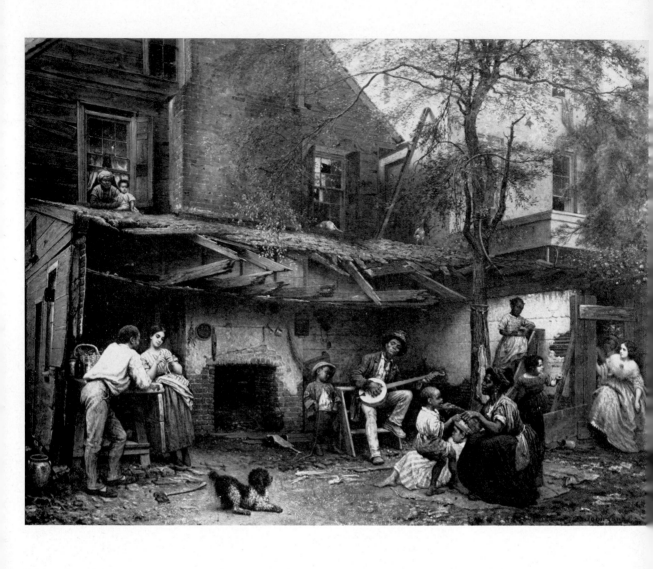

152. Eastman Johnson: Life in the South (Old Kentucky Home), 1859. *The New-York Historical Society*

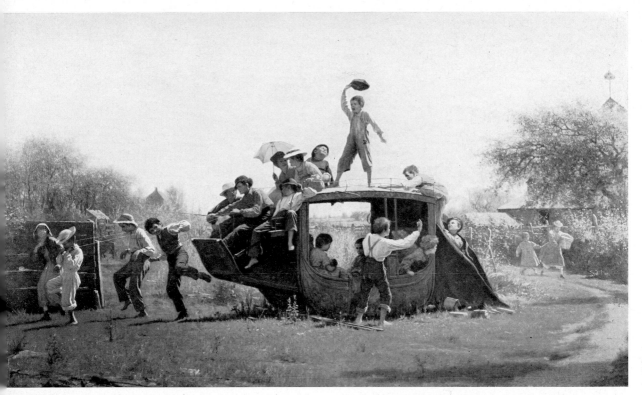

153. Eastman Johnson: The Old Stagecoach, 1871. *Milwaukee Art Center*

154. Eastman Johnson: The Cranberry Harvest, 1880. *San Diego, California, Timken Art Gallery*

155. Eastman Johnson: The Hatch Family, 1871. *New York, The Metropolitan Museum of Art*

156. Eastman Johnson: The Funding Bill, 1881. *New York, The Metropolitan Museum of Art*

157. Alexander Gardner: The Home of a Rebel Sharpshooter, Gettysburg, 1863, from *Photographic Sketchbook of the Civil War. Rochester, New York, International Museum of Photography, George Eastman House*

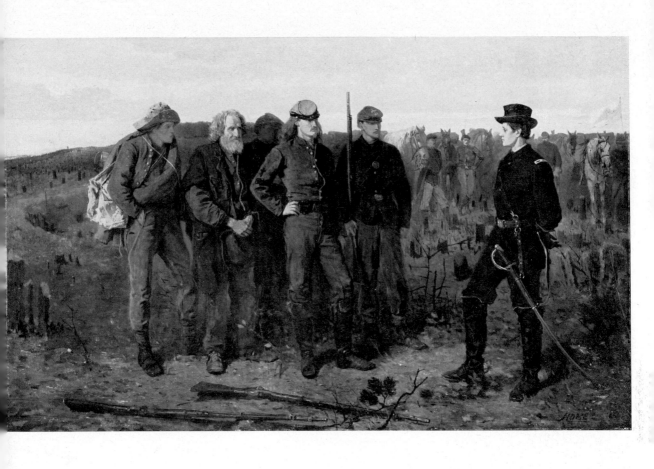

158. Winslow Homer: Prisoners from the Front, 1866. *New York, The Metropolitan Museum of Art*

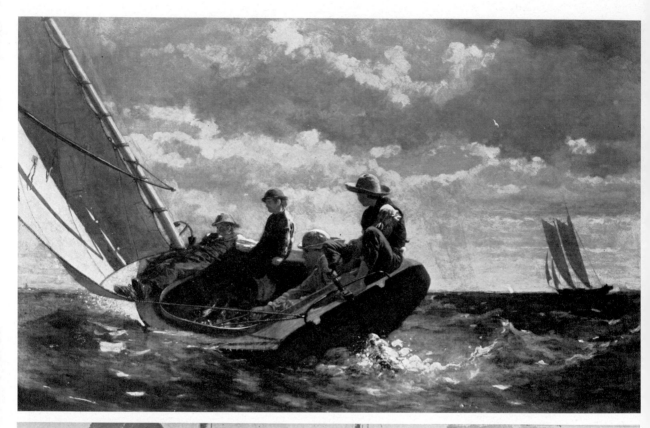

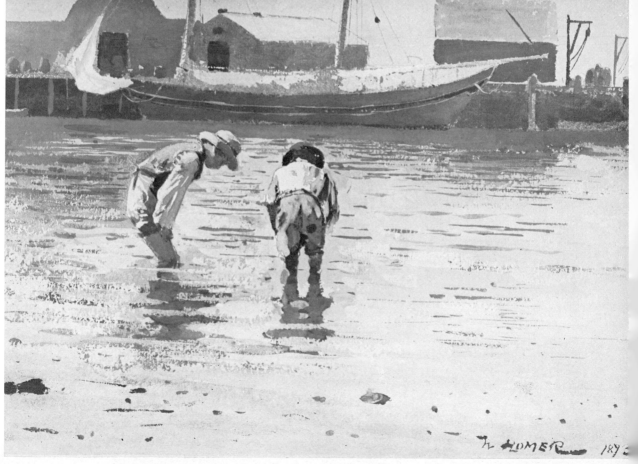

159. Winslow Homer: Breezing Up, 1876. *Washington, D.C., National Gallery of Art*

160. Winslow Homer: Boys Wading, 1873. Watercolour. *Waterville, Maine, Colby College Art Museum*

161. Winslow Homer: Inside the Bar, Tynemouth, 1883. Watercolour. *New York, The Metropolitan Museum of Art*

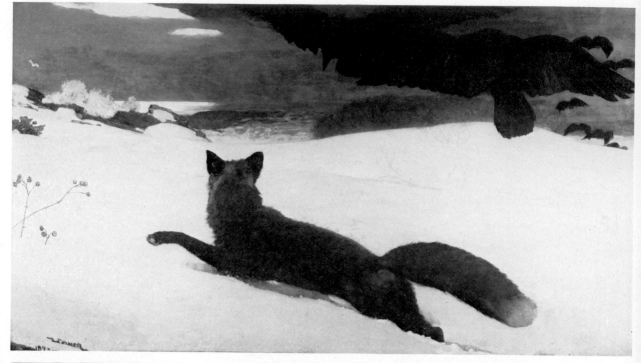

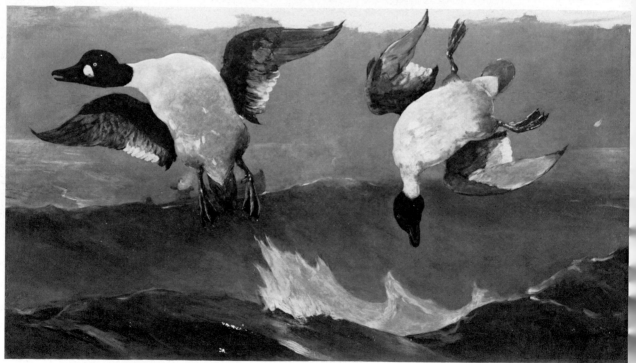

162. Winslow Homer: The Fox Hunt, 1893. *Philadelphia, The Pennsylvania Academy of the Fine Arts*

163. Winslow Homer: Right and Left, 1909. *Washington, D.C., National Gallery of Art*

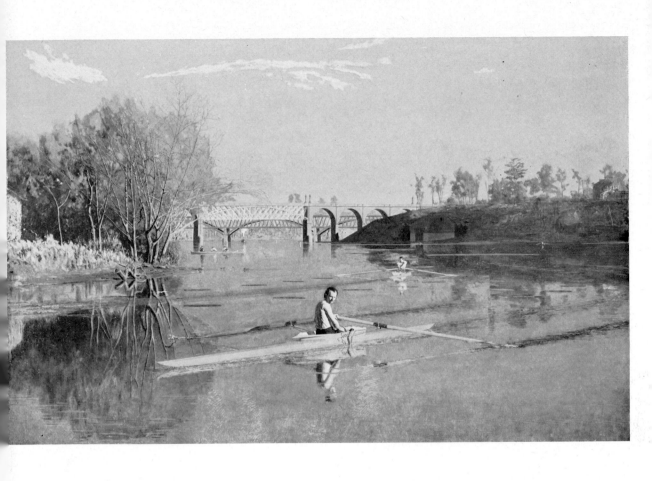

164. Thomas Eakins: Max Schmitt in a Single Scull, 1871. *New York, The Metropolitan Museum of Art*

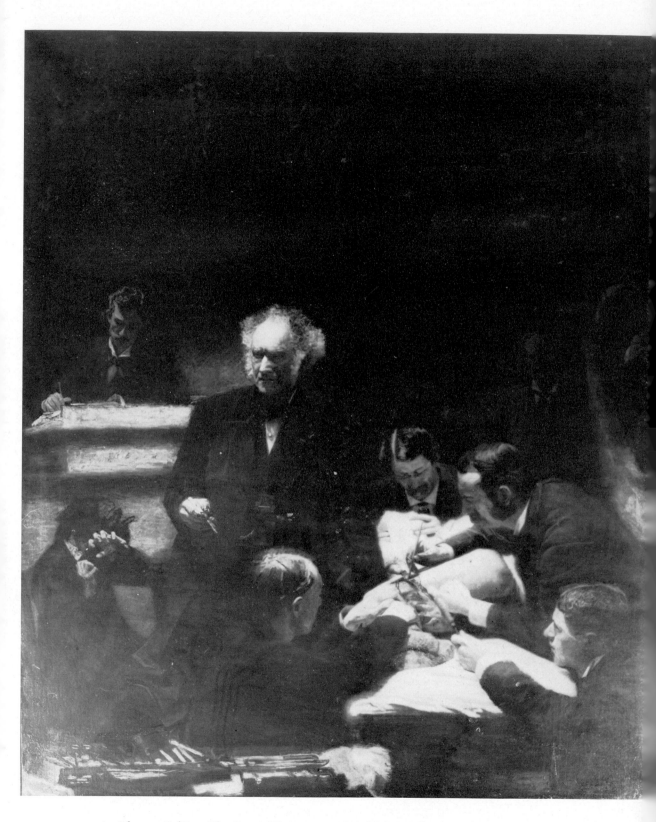

165. Thomas Eakins: The Gross Clinic, 1875. *Philadelphia, Jefferson Medical College*

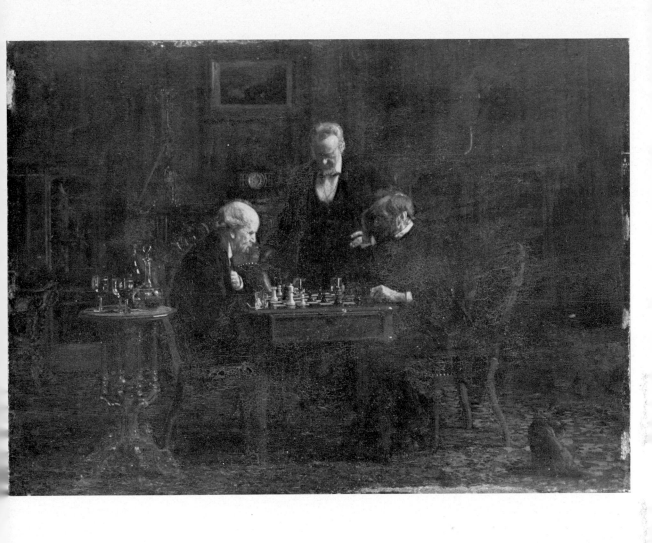

166. Thomas Eakins: The Chess Players, 1876. Oil on wood. *New York, The Metropolitan Museum of Art*

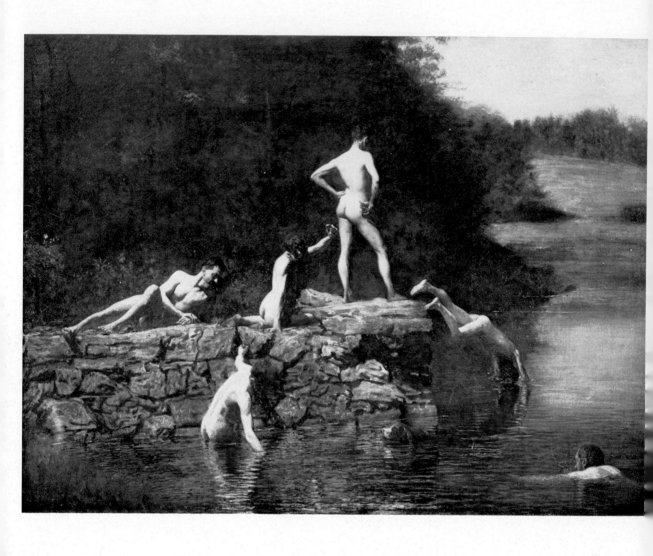

167. Thomas Eakins: The Swimming Hole, 1883. *The Fort Worth Art Museum*

168. Eadweard Muybridge: Galloping Horse (Sallie Gardner running), 1878. Photograph. *Rochester, New York, International Museum of Photography, George Eastman House*

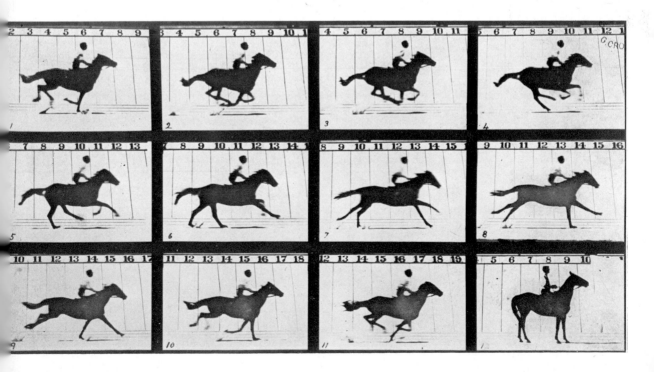

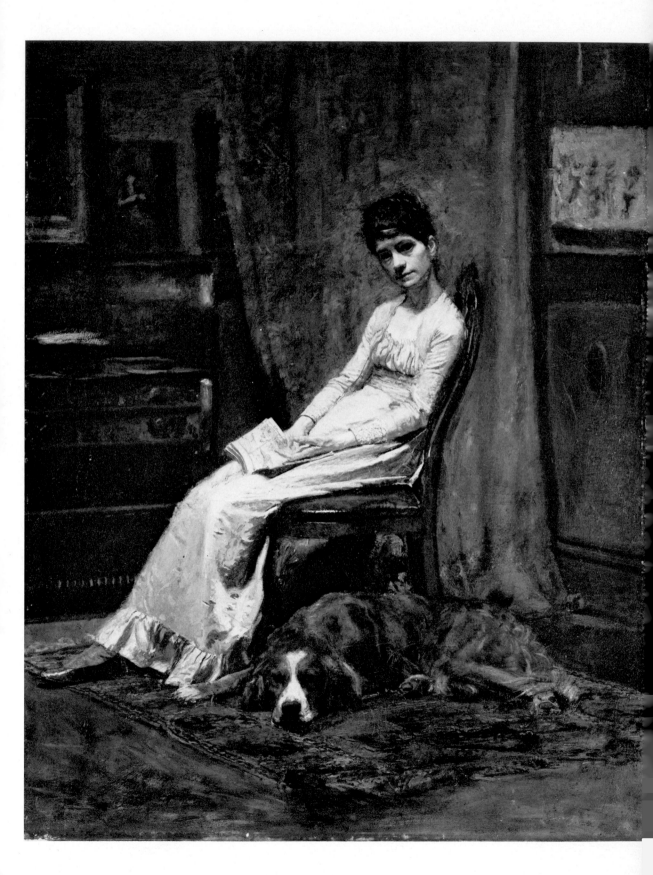

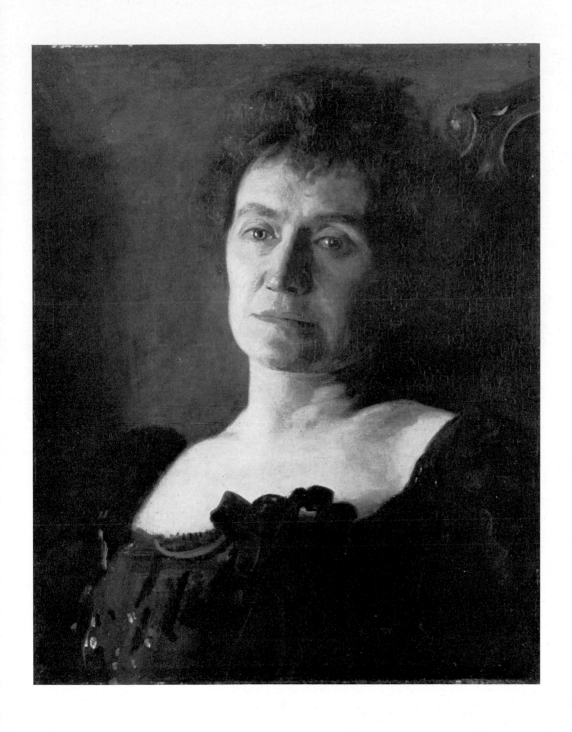

169. Thomas Eakins: Lady with a Setter, 1885. *New York, The Metropolitan Museum of Art*

170. Thomas Eakins: Mrs Edith Mahon, 1904. *Northampton, Massachusetts, Smith College Museum of Art*

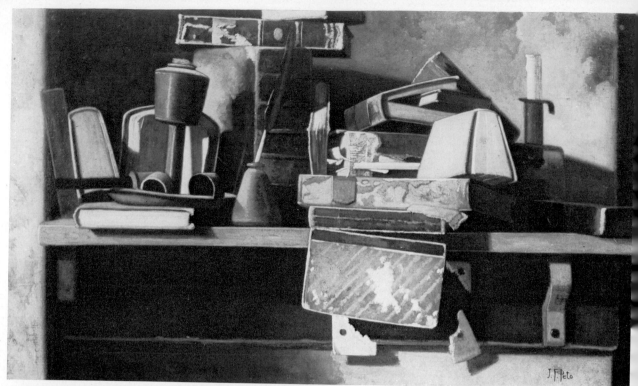

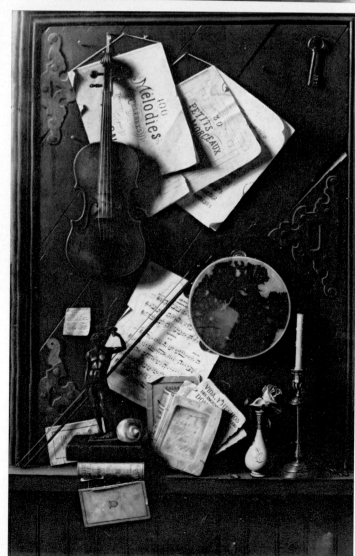

171. John Frederick Peto: Still Life with Lard-Oil Lamp, *c.* 1900. *The Newark Museum*

172. William M. Harnett: Old Cupboard Door, 1889. *Sheffield, Graves Art Gallery*

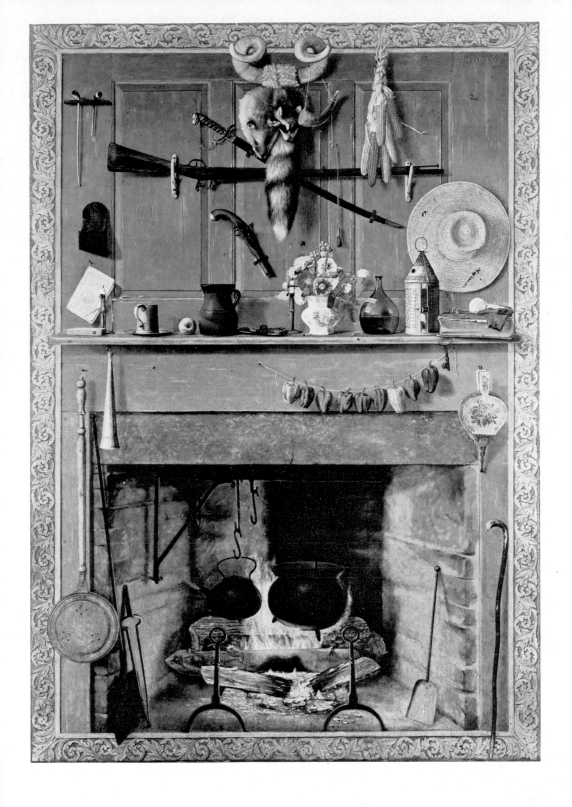

173. John Haberle: Grandma's Hearthstone, 1890. *The Detroit Institute of Arts*

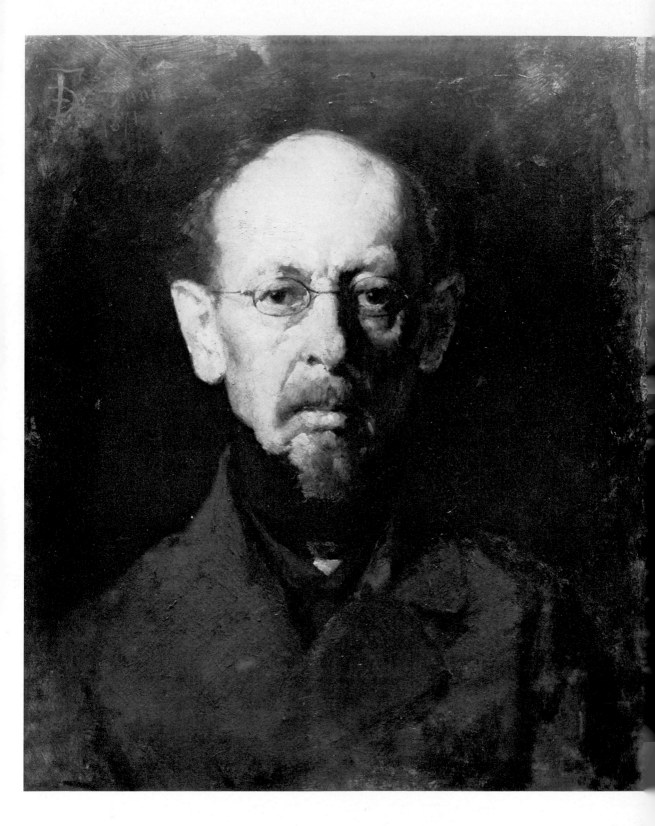

174. Frank Duveneck: The Old Professor, 1871. *Boston, Museum of Fine Arts*

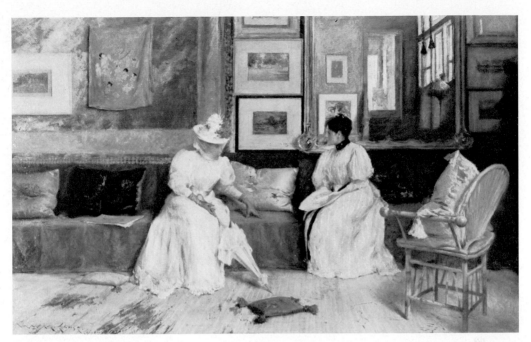

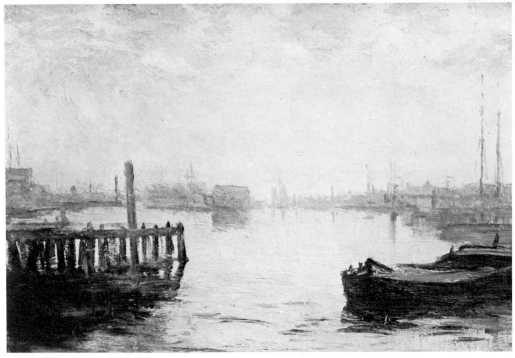

175. William Merritt Chase: A Friendly Call, 1895. *Washington, D.C., National Gallery of Art*

176. William Morris Hunt: Gloucester Harbour, 1877. *Boston, Museum of Fine Arts*

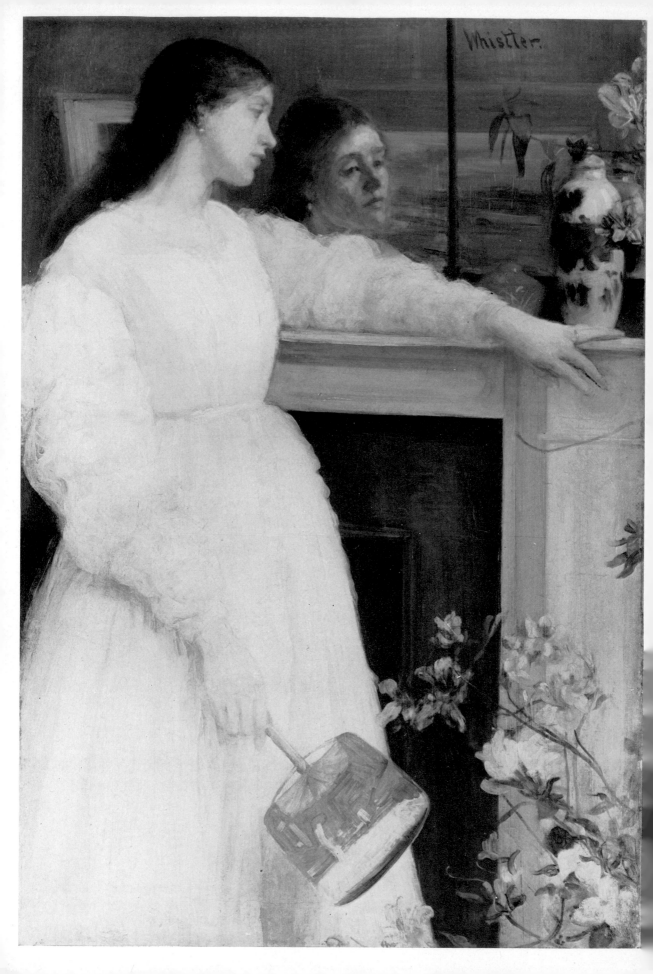

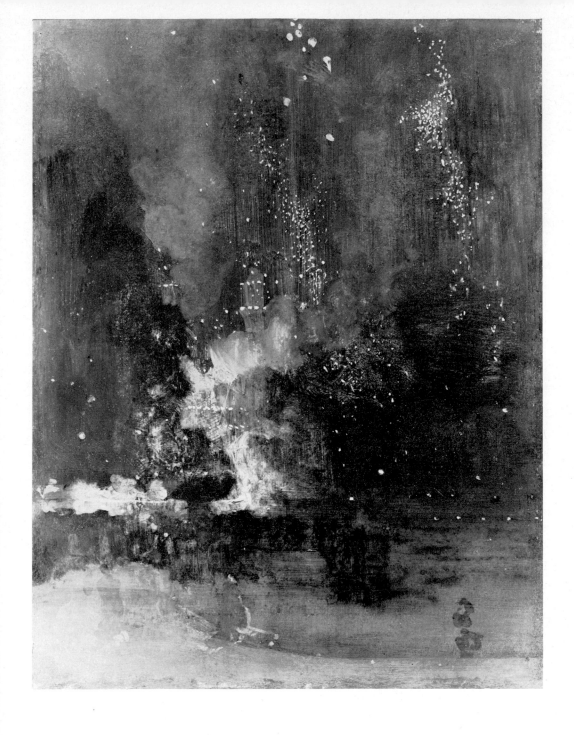

177. James McNeill Whistler: Symphony in White No. 2: The Little White Girl, 1864. *London, Tate Gallery*

178. James McNeill Whistler: Nocturne in Black and Gold: The Falling Rocket, *c.* 1874. Oil on panel. *The Detroit Institute of Arts*

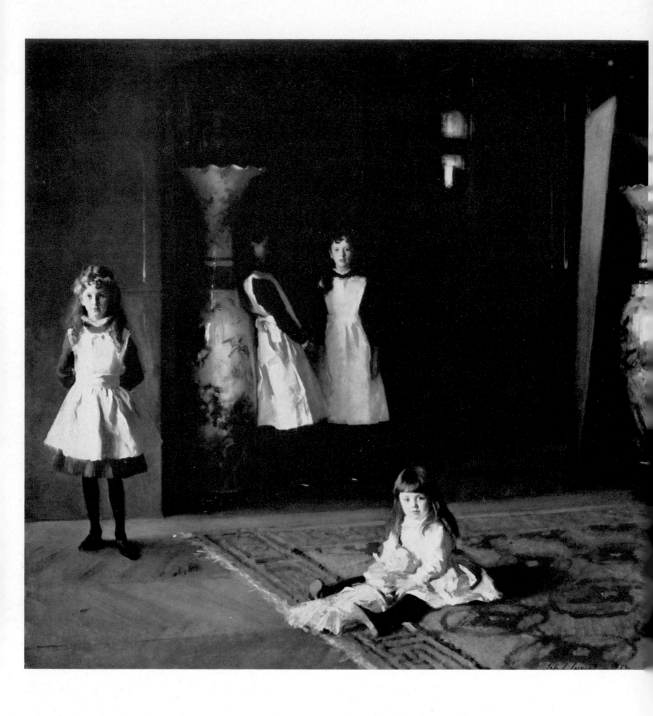

179. John Singer Sargent: The Daughters of Edward Darley Boit, 1882. *Boston, Museum of Fine Arts*

180. John Singer Sargent:
Madame X (Madame
Pierre Gautreau), 1884.
*New York, The Metropolitan
Museum of Art*

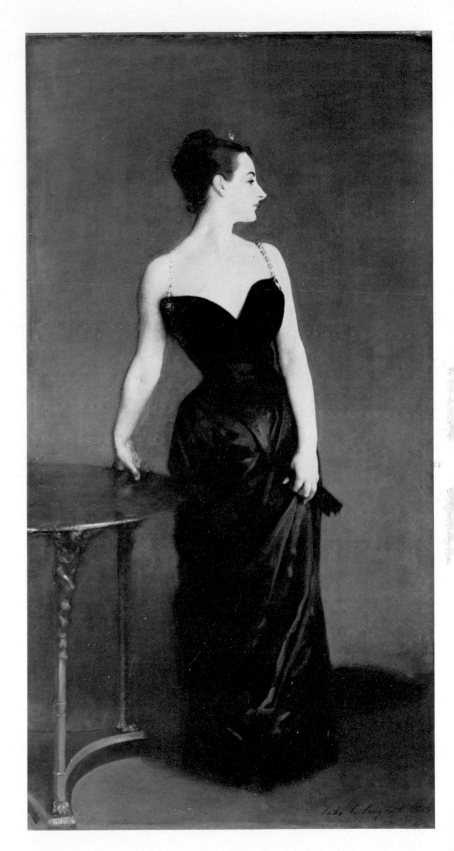

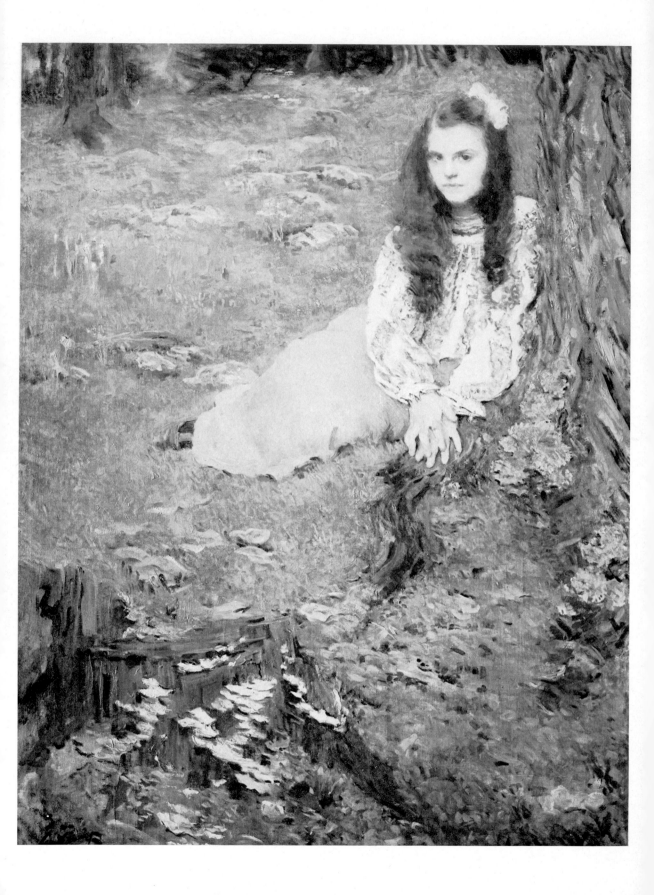

181. Cecilia Beaux: Dorothea in the Woods, 1897. *New York, Whitney Museum of American Art*

182. Augustus Saint-Gaudens: Shaw Memorial, 1884–97. Bronze. *Boston Common*

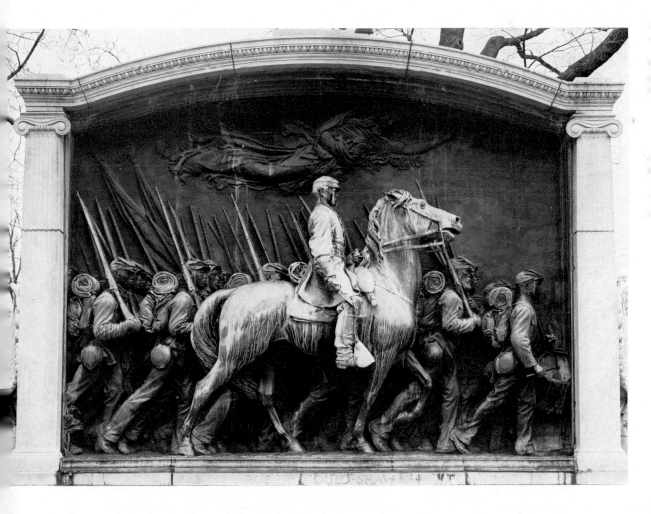

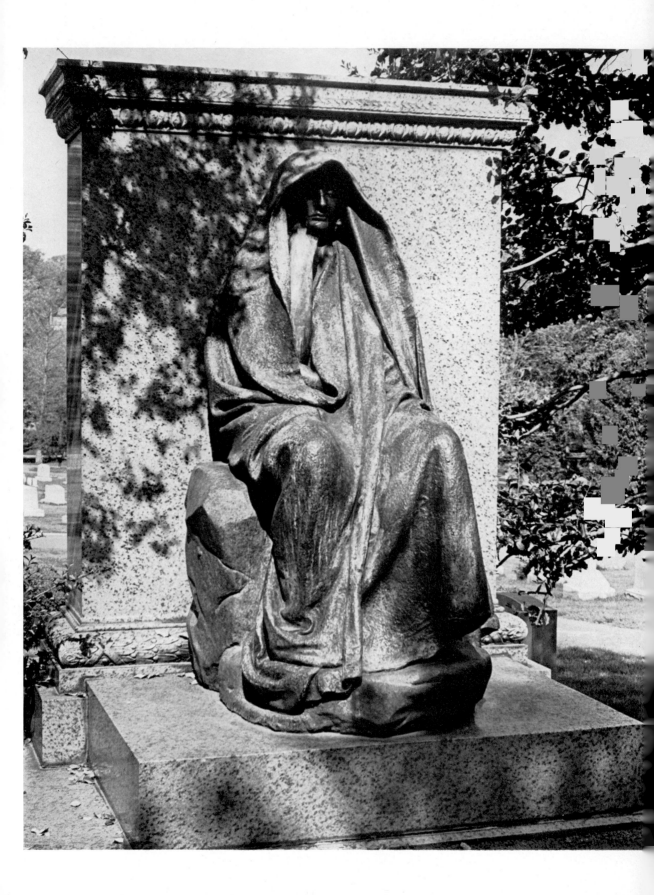

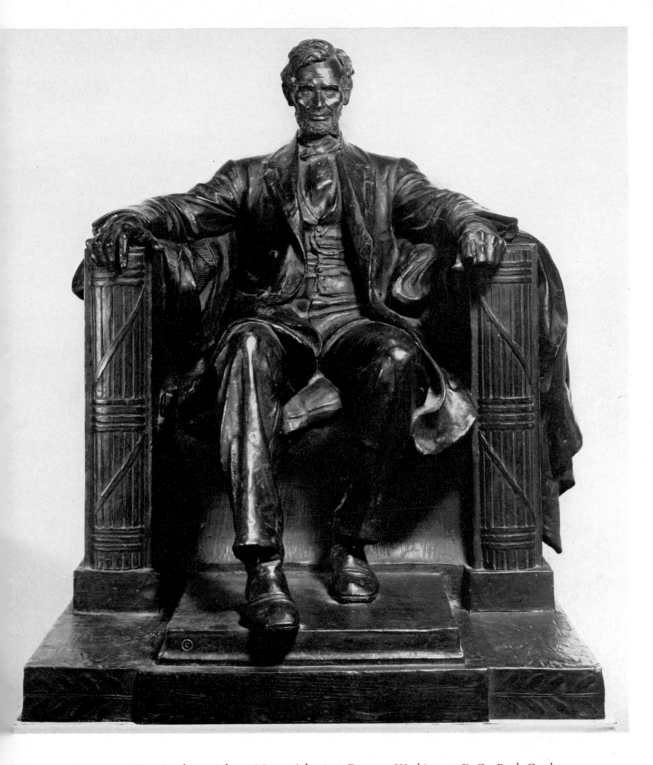

183. Augustus Saint-Gaudens: Adams Memorial, 1891. Bronze. *Washington, D.C., Rock Creek Cemetery*

184. Daniel Chester French: Lincoln, 1916. Bronze. *Cambridge, Massachusetts, Fogg Art Museum, Harvard University*

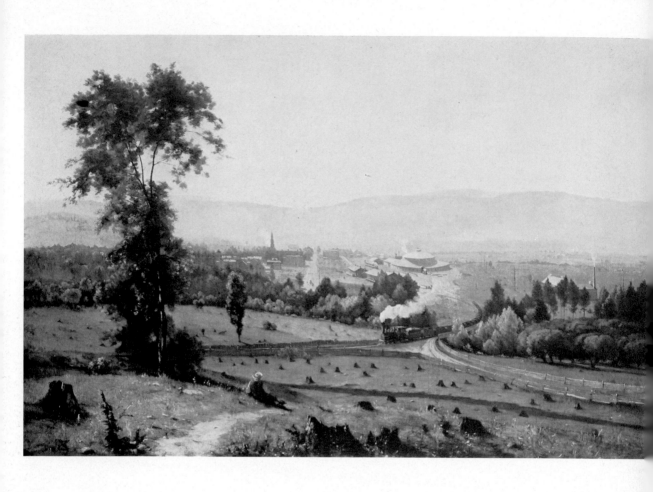

185. George Inness: The Lackawanna Valley, 1855. *Washington, D.C., National Gallery of Art*

186. George Inness: The Coming Storm, 1878. *Buffalo, New York, Albright-Knox Art Gallery*

187. Homer Dodge Martin: Lake Sanford in the Adirondacks, Spring, 1870. *New York, Century Association*

188. John La Farge: Maua – Our Boatman, 1891. *Andover, Massachusetts, Addison Gallery of American Art, Phillips Academy*

189. Mary Cassatt: Lady at the Tea Table, 1885. *New York, The Metropolitan Museum of Art*

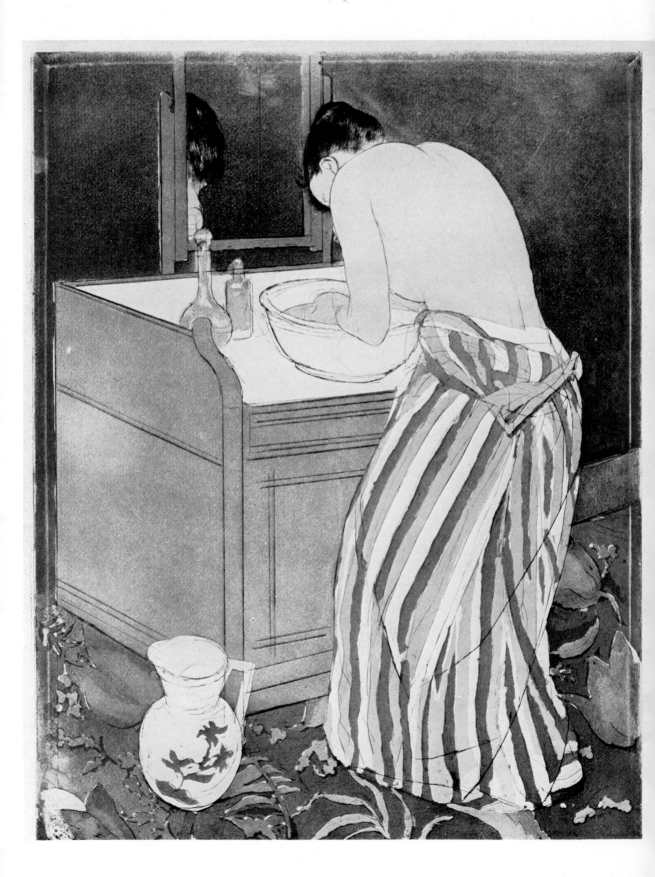

190. Mary Cassatt: Woman
Bathing, *c.* 1891. Drypoint
and aquatint in colour.
*New York, The Metropolitan
Museum of Art*

191. Childe Hassam: The
Flower Garden, 1888.
*Worcester, Massachusetts,
Worcester Art Museum*

192. Childe Hassam: Inner
Harbour, Gloucester, 1918.
Lithograph. *Boston, Museum
of Fine Arts*

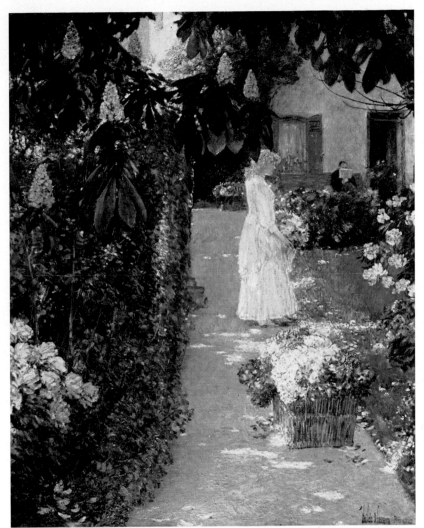

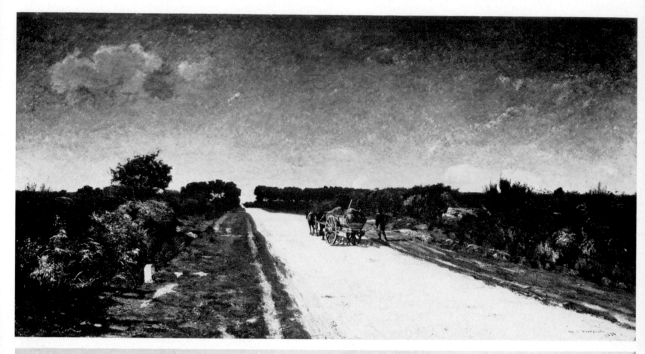

193. William L. Picknell: Road to Concarneau, 1880. *Washington, D.C., The Corcoran Gallery of Art*

194. John H. Twachtman: Arques-la-Bataille, 1885. *New York, The Metropolitan Museum of Art*

195. J. Alden Weir: The Red Bridge, 1895. *New York, The Metropolitan Museum of Art*

196. Edmund C. Tarbell: Josephine and Mercie, 1908. *Washington, D.C., The Corcoran Gallery of Art*

197. John White Alex-
ander: Isabella; or, the Pot
of Basil, 1897. *Boston,
Museum of Fine Arts*

198. Clarence H. White: Spring, 1898. Platinum print photograph. *New York, The Metropolitan Museum of Art*

199. William Page: Mrs William Page, *c.* 1860. *The Detroit Institute of Arts*

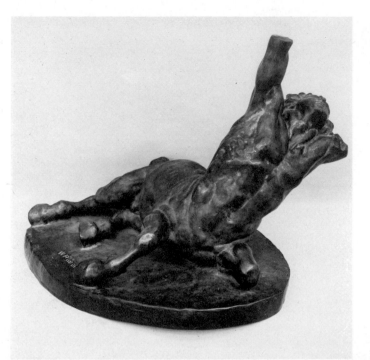

200. William Rimmer: Dying Centaur, 1871. Bronze. *New York, The Metropolitan Museum of Art*

201. William Rimmer: Flight and Pursuit, 1871. *Boston, Museum of Fine Arts*

202. Elihu Vedder: Questioner of the Sphinx, 1863. *Boston, Museum of Fine Arts*

203. Edward Mitchell Bannister:
Approaching Storm, *c.* 1890.
*Washington, D.C., Museum of
African Art*

204. Ralph A. Blakelock: The
Poetry of Moonlight, *c.* 1885–95.
*Huntington, New York, The
Heckscher Museum*

205. Henry Ossawa Tanner: The Artist's Mother, 1897. *Philadelphia, Pennsylvania, Mrs Sadie T. M. Alexander*

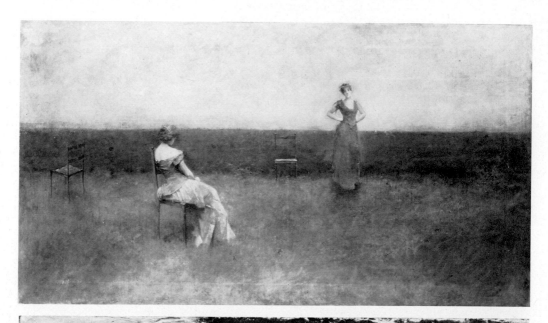

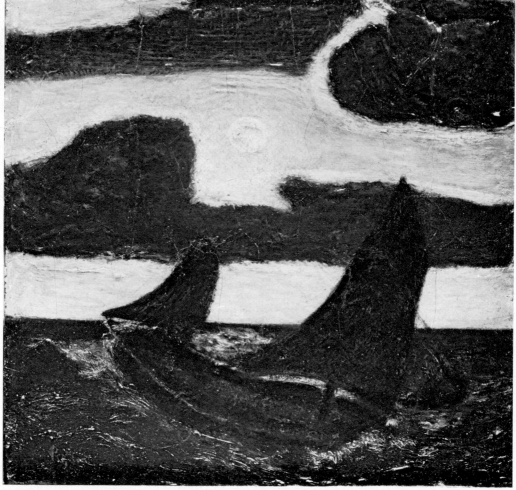

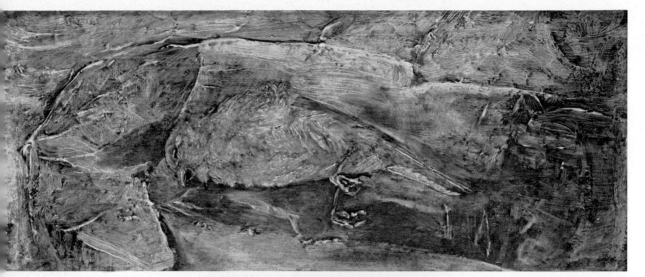

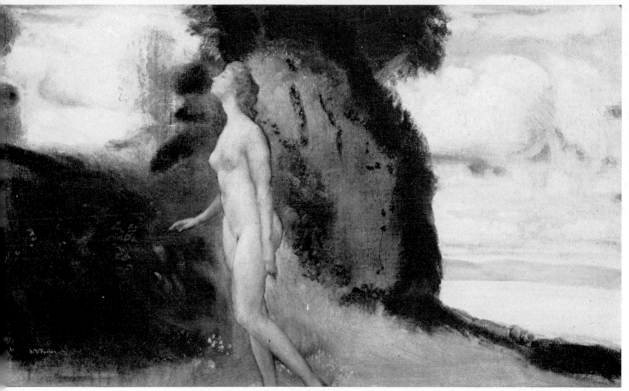

206. Thomas Wilmer Dewing: The Recitation, 1891. *The Detroit Institute of Arts*

207. Albert Pinkham Ryder: Moonlight Marine, *c.* 1890–9. Oil on panel. *New York, The Metropolitan Museum of Art*

208. Albert Pinkham Ryder: The Dead Bird, before 1880. Oil on panel. *Washington, D.C., The Phillips Collection*

209. Arthur B. Davies: Dream, *c.* 1908. *New York, The Metropolitan Museum of Art*

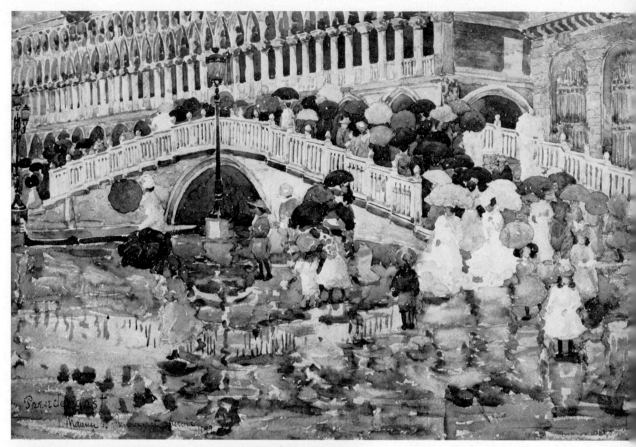

210. Maurice Prendergast: Umbrellas in
the Rain, Venice, 1899. Watercolour.
Boston, Museum of Fine Arts

211. Robert Henri: Eva Green, 1907.
Wichita Art Museum

212. George B. Luks: Woman with Macaws, 1907. *The Detroit Institute of Arts*

213. John Sloan: Gloucester Trolley, 1917. *Canajoharie, New York, Canajoharie Library and Art Museum*

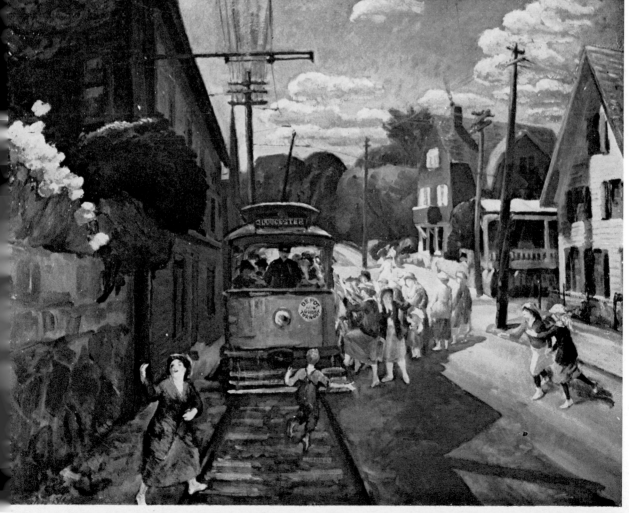

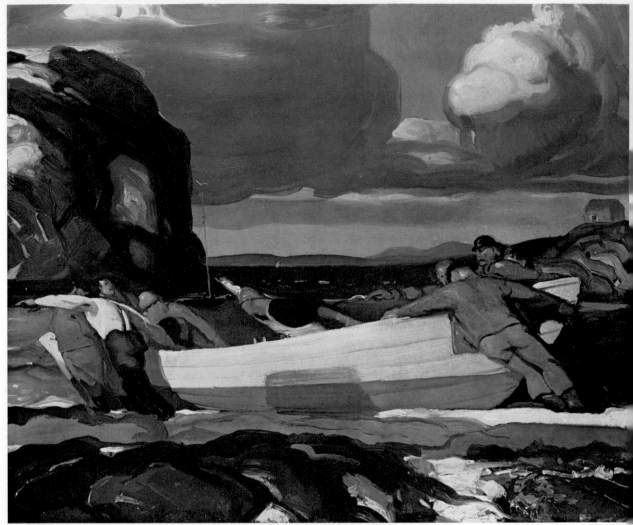

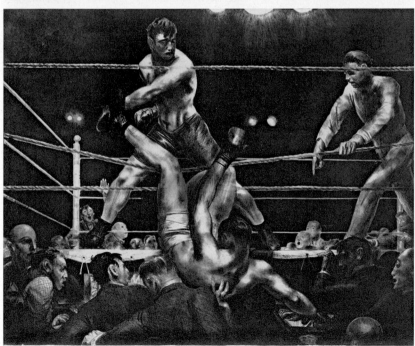

214. George Bellows: The Big Dory, 1913. *The New Britain Museum of American Art*

215. George Bellows: Dempsey and Firpo, 1924. Lithograph. *New York, The Museum of Modern Art*

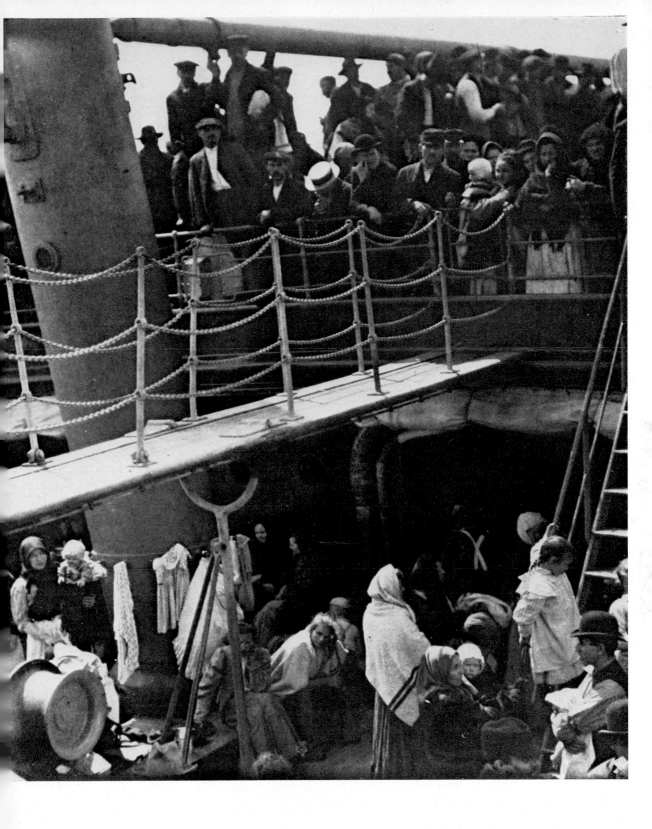

216. Alfred Stieglitz: The Steerage, 1907. Photograph from *Camera Work*, No. 36 (October, 1911)

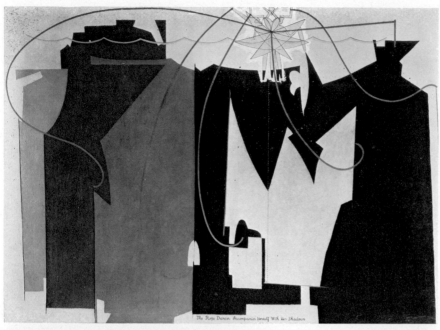

217. Man Ray: The Rope Dancer Accompanies Herself With Her Shadows, 1916. *New York, The Museum of Modern Art*

218. Stanton Macdonald-Wright: Conception Synchromy, 1915. *New York, Whitney Museum of American Art*

219. John Marin:
Maine Islands,
1922. Water-
colour. *Wash-
ington, D.C., The
Phillips Collection*

220. Marsden
Hartley: Fox
Island, Maine,
1937–8. *Andover,
Massachusetts,
Addison Gallery
of American Art,
Phillips Academy*

221. Alfred H. Maurer: Twin Heads, 1930. *New York, Whitney Museum of American Art*

222. Max Weber: Chinese Restaurant, 1915. *New York, Whitney Museum of American Art*

223. Stuart Davis: Salt Shaker, 1931. *New York, The Museum of Modern Art*

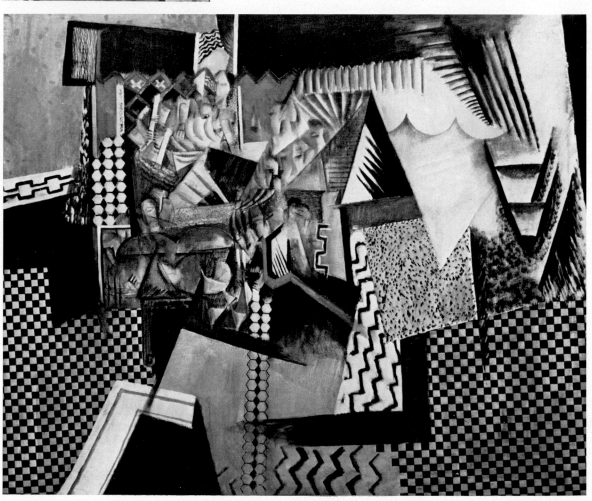

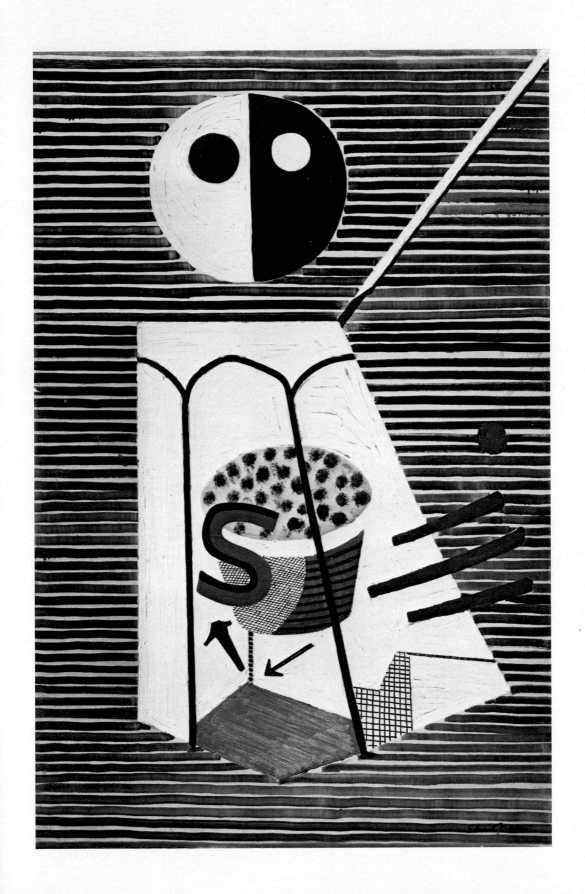

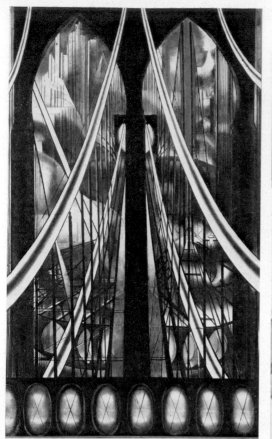

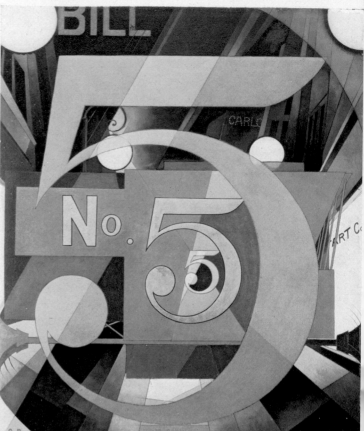

224. Joseph Stella: New York Interpreted: The Bridge, 1922. Gouache. *The Newark Museum*

225. Charles Demuth: 'I Saw the Figure Five in Gold', 1928. Oil on composition board. *New York, The Metropolitan Museum of Art*

226. Charles Sheeler: Rolling Power, 1939. *Northampton, Massachusetts, Smith College Museum of Art*

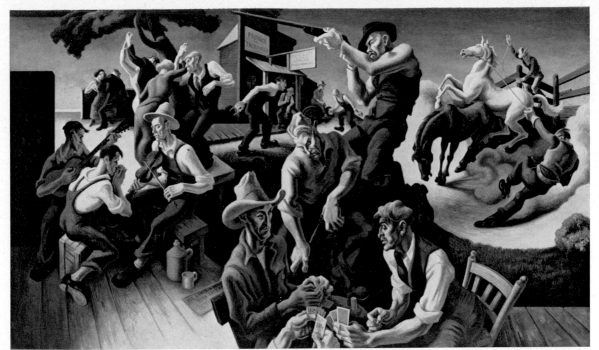

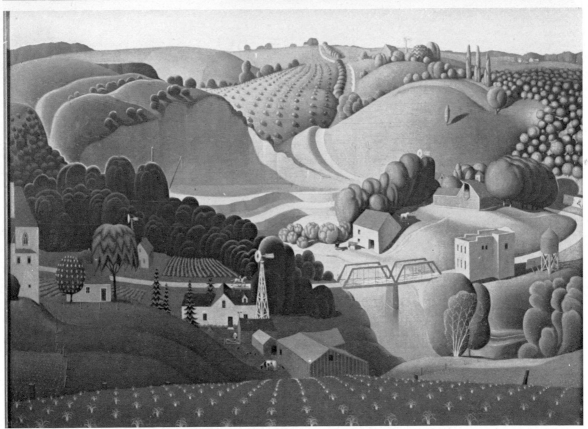

227. Thomas Hart Benton: Arts of the West, 1932. Tempera and oil. *The New Britain Museum of American Art*

228. Grant Wood: Stone City, Iowa, 1930. Oil on wood. *Omaha, Nebraska, Joslyn Art Museum*

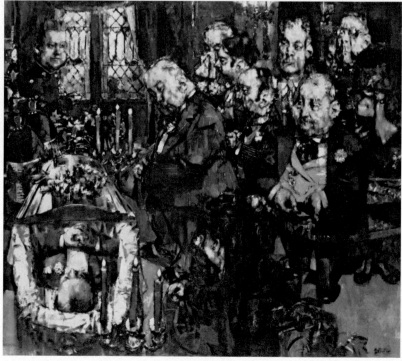

229. Ben Shahn: Willis
Avenue Bridge, 1940.
Tempera on paper over
composition board. *New York,
The Museum of Modern Art*

230. Jack Levine: Gangster
Funeral, 1952–3. *New York,
Whitney Museum of American
Art*

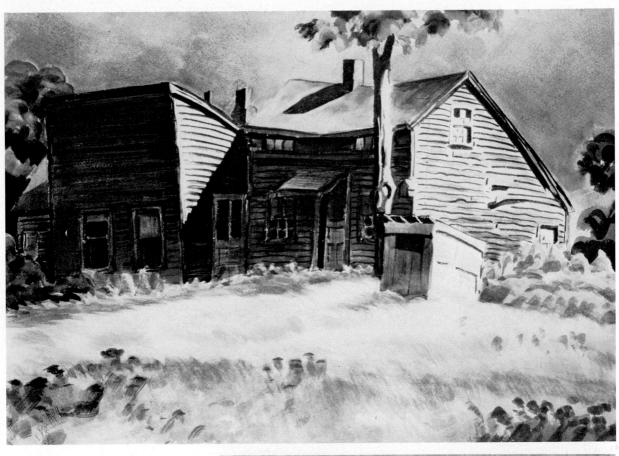

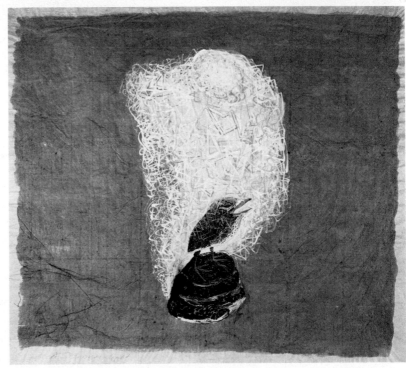

231. Charles Burchfield: Old
Farm House (September
Sunlight), 1932. Watercolour.
Cambridge, Massachusetts,
Fogg Art Museum, Harvard
University

232. Morris Graves: Bird
Singing in the Moonlight,
1938–9. Gouache. *New York,*
The Museum of Modern Art

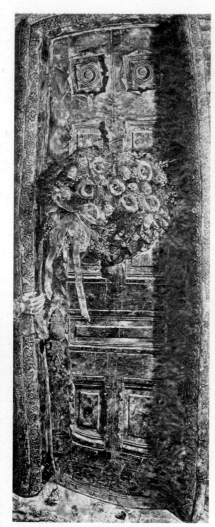
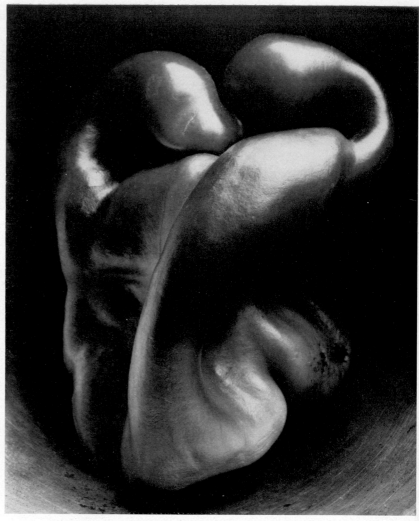

233. Ivan Albright: That Which I Should Have Done I Did Not Do, 1931–41. *The Art Institute of Chicago*

234. Edward Weston: Pepper No. 30, 1930. Photograph. *New York, The Museum of Modern Art*

235. Walker Evans: Bedroom Fireplace, Tenant Farmhouse, Hale County, Alabama, 1936. Photograph. *Washington, D.C., Library of Congress*

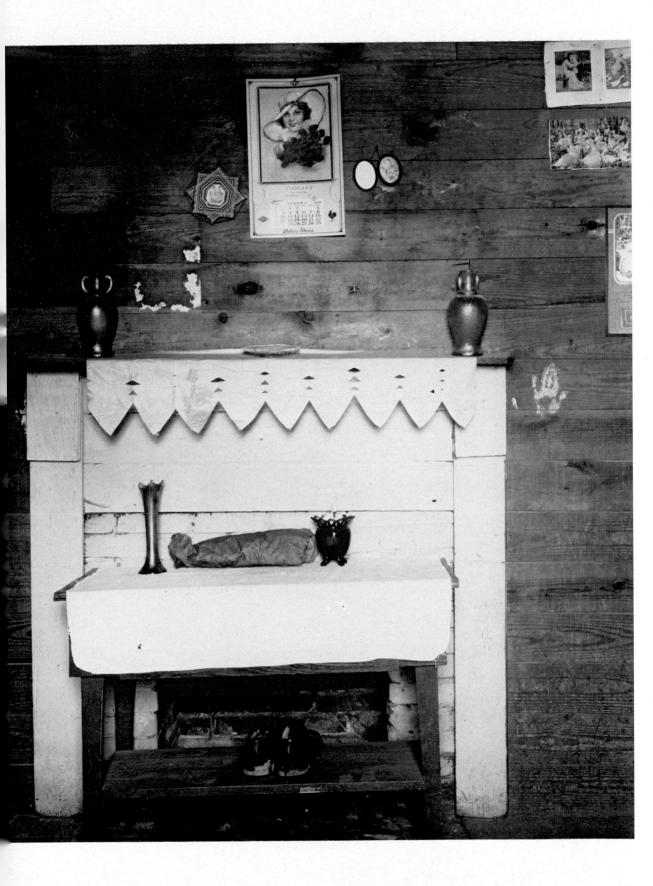

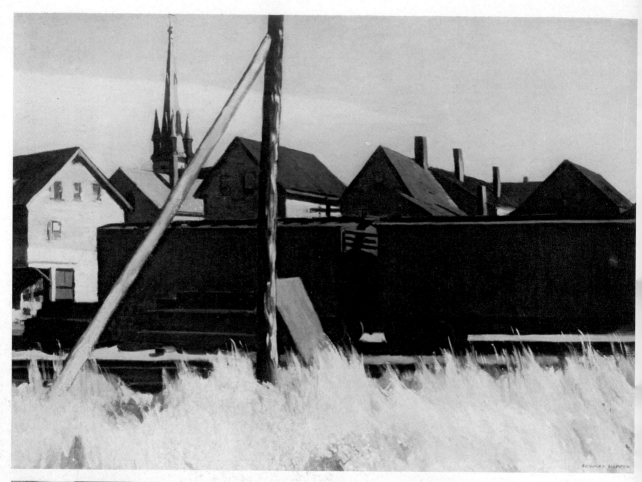

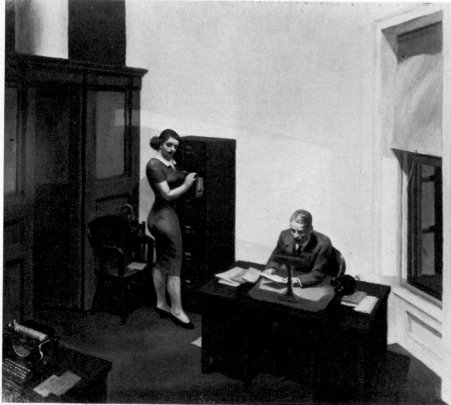

236. Edward
Hopper: Freight
Cars, Gloucester,
1928. *Andover,
Massachusetts,
Addison Gallery of
American Art,
Phillips Academy*

237. Edward
Hopper: Office at
Night, 1940.
*Minneapolis, Minne-
sota, Walker Art
Center*

238. Andrew Wyeth: Grape
Wine, 1966. Tempera on gesso
panel. *New York, The Metropolitan
Museum of Art*

239. Elie Nadelman: Man in the
Open Air, *c.* 1914–15. Bronze.
*New York, The Museum of
Modern Art*

240. Gaston Lachaise: Torso, 1930.
Bronze. *New York, Whitney
Museum of American Art*

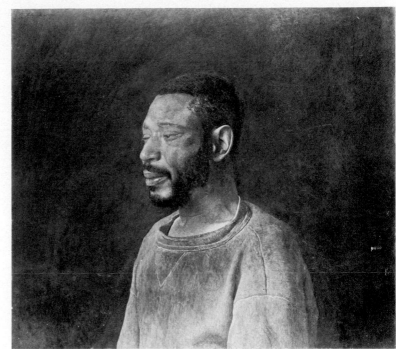

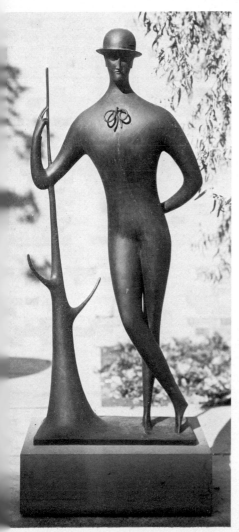

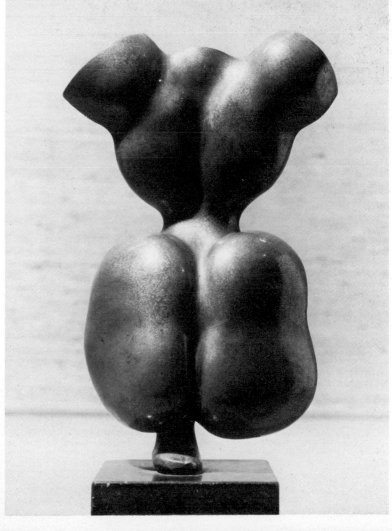

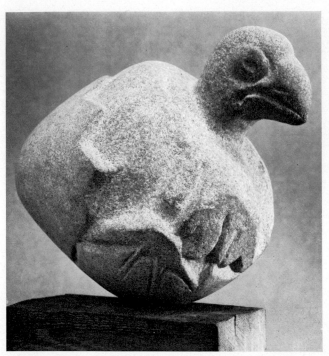

241. John B. Flannagan: Triumph of the Egg, I, 1937. Granite. *New York, The Museum of Modern Art*

242. Isamu Noguchi: The Family, 1956–7. Granite. *Bloomfield, Connecticut, Connecticut General Life Insurance Company*

243. Arthur G. Dove: Fog Horns, 1929. *Colorado Springs Fine Arts Center*

244. Milton Avery: Sea Grasses and Blue Sea, 1958. *New York, The Museum of Modern Art*

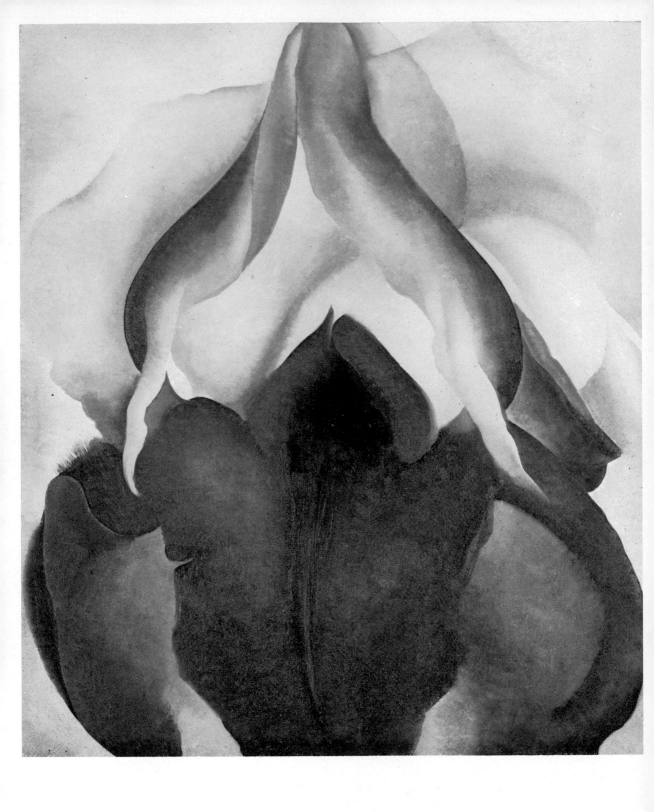

245. Georgia O'Keeffe: Black Iris, 1926. *New York, The Metropolitan Museum of Art*

246. Horace Pippin: Victorian Interior, 1946. *New York, The Metropolitan Museum of Art*

247. Jacob Lawrence: The Migration of the Negro: Panel No. 1: During the World War there was a Great Migration North by Southern Negroes, 1940–1. Tempera on panel. *Washington, D.C., The Phillips Collection*

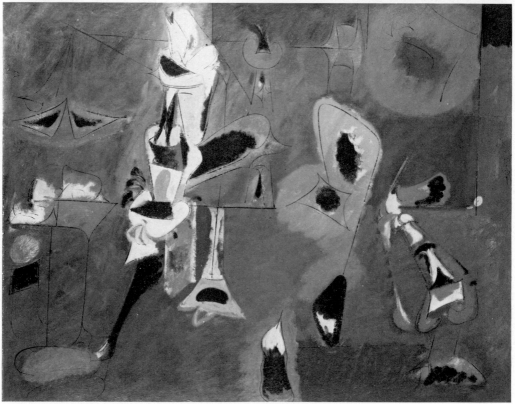

248. Hans Hofmann: Magenta and Blue, 1950. *New York, Whitney Museum of American Art*
249. Arshile Gorky: Agony, 1947. *New York, The Museum of Modern Art*

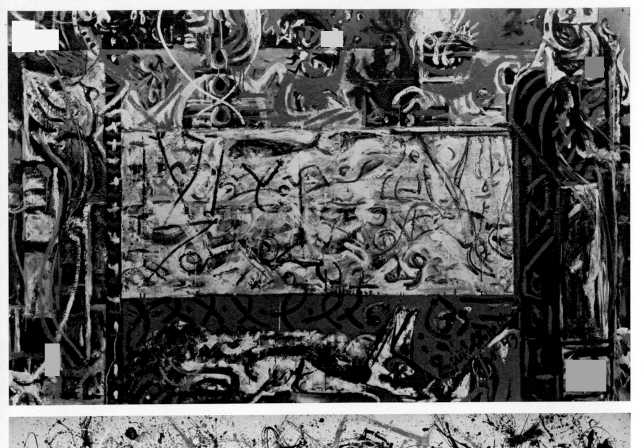

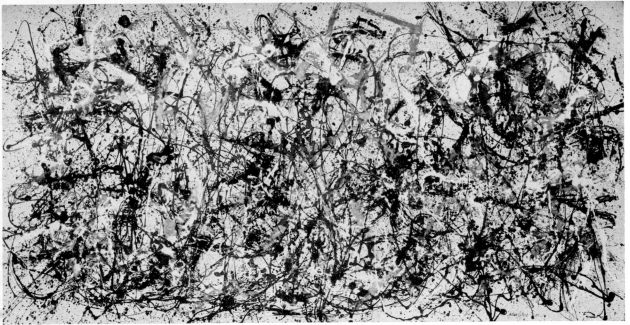

250. Jackson Pollock: Guardians of the Secret, 1943. *San Francisco Museum of Art*

251. Jackson Pollock: Autumn Rhythm, 1950. *New York, The Metropolitan Museum of Art*

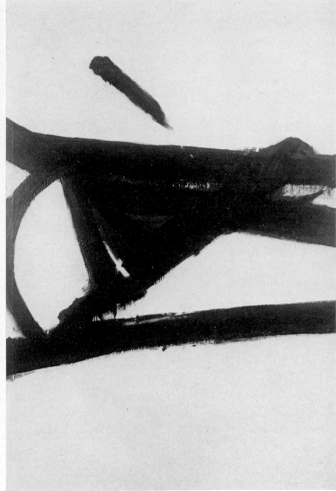

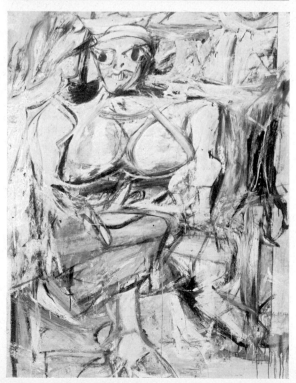

252. Mark Tobey: Edge of August, 1953. Casein on composition board. *New York, The Museum of Modern Art*

253. Franz Kline: Accent Grave, 1955. *The Cleveland Museum of Art*

254. Willem de Kooning: Woman, I, 1950–2. *New York, The Museum of Modern Art*

255. Mark Rothko: Green and Maroon on Blue, 1953. *Washington, D.C., The Phillips Collection*

256. Barnett Newman: Vir Heroicus Sublimis, 1950–1. *New York, The Museum of Modern Art*

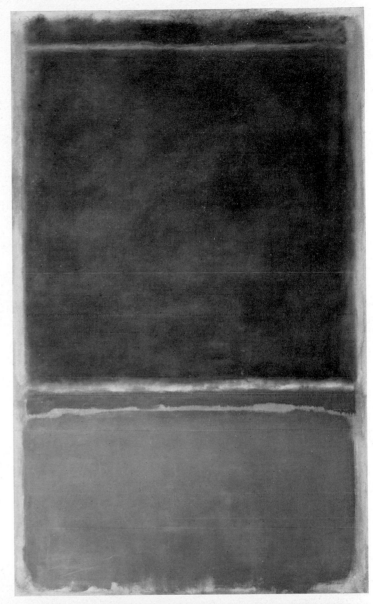

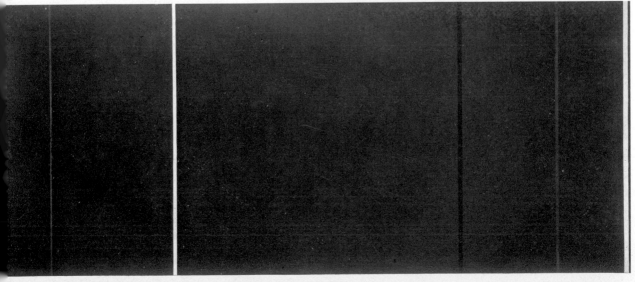

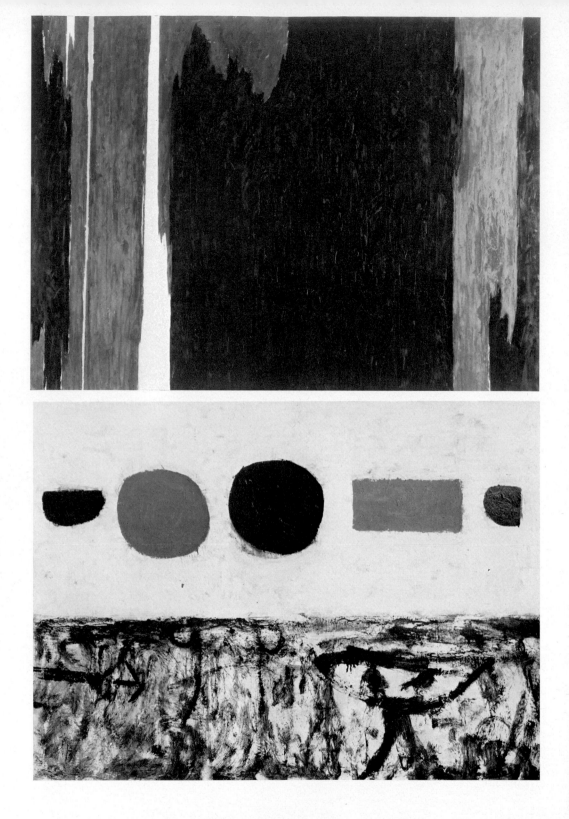

257. Clyfford Still: 1954, 1954. *Buffalo, New York, Albright-Knox Art Gallery*

258. Adolph Gottlieb: The Frozen Sounds, Number I, 1951. *New York, Whitney Museum of American Art*

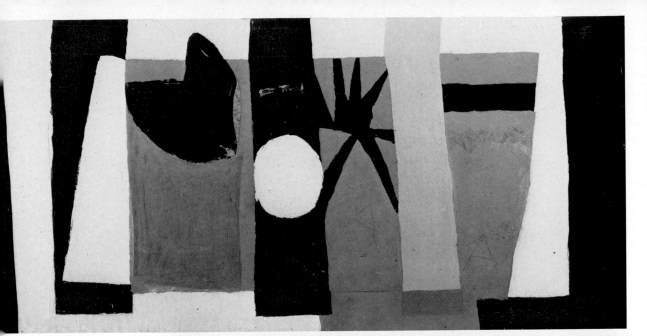

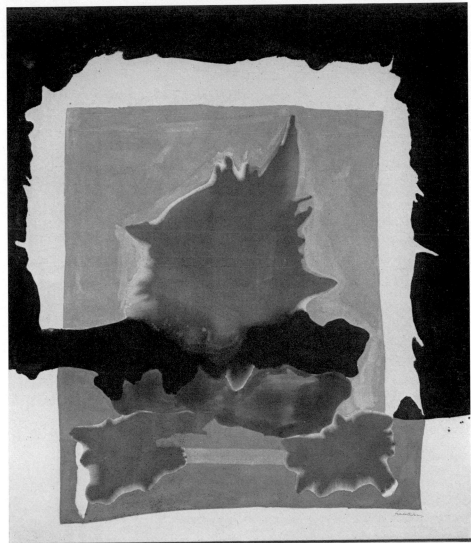

259. Robert
Motherwell: The
Voyage, 1949.
Oil and tempera
on paper mounted
on composition
board. *New York,
The Museum of
Modern Art*

260. Helen
Frankenthaler:
Interior Land-
scape, 1964.
Acrylic on canvas.
*San Francisco
Museum of Art*

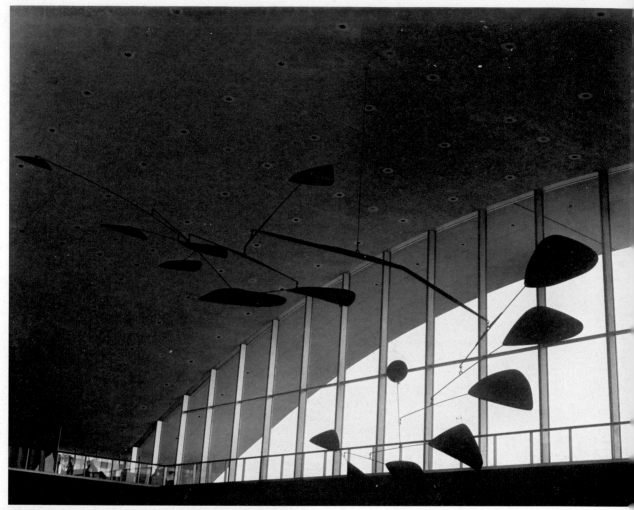

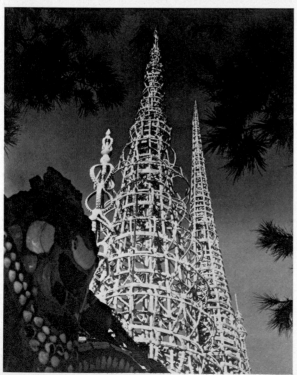

261. Alexander Calder: Mobile, 1957. Steel.
New York, John F. Kennedy International Airport

262. Simon Rodia: The Watts Towers, *c.* 1921–54.
Steel, concrete, and mixed media. *Watts, Los Angeles*

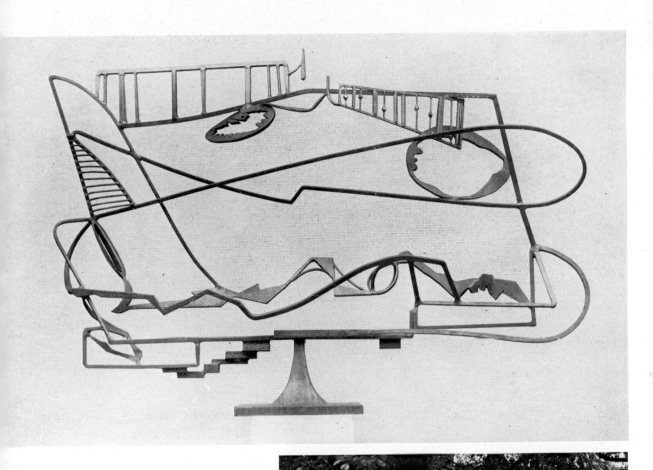

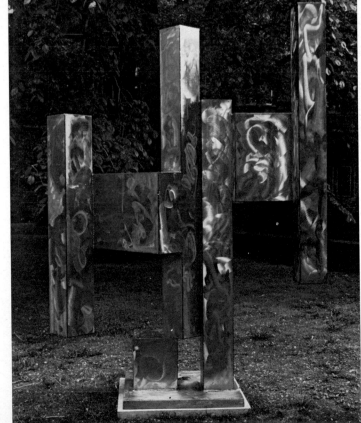

263. David Smith: Hudson River
Landscape, 1951. Welded steel. *New
York, Whitney Museum of American Art*

264. David Smith: Cubi XXII, 1964.
Stainless steel. *New Haven, Connecticut,
Yale University Art Gallery*

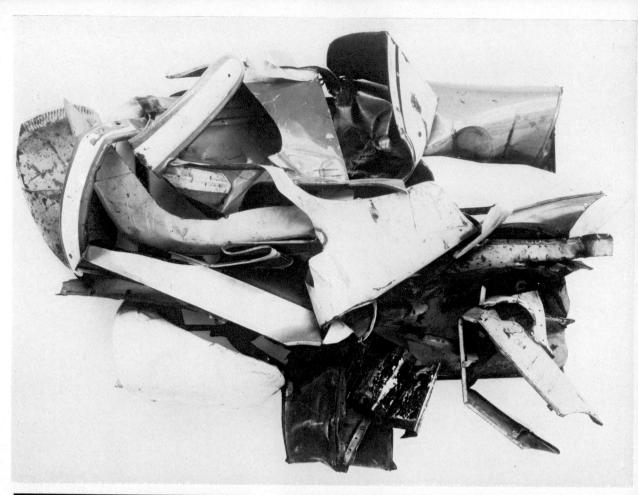

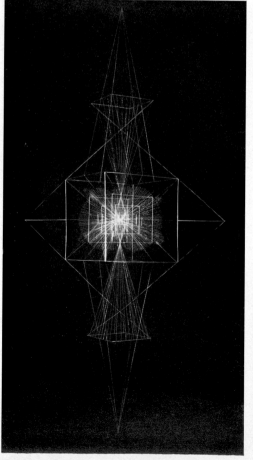

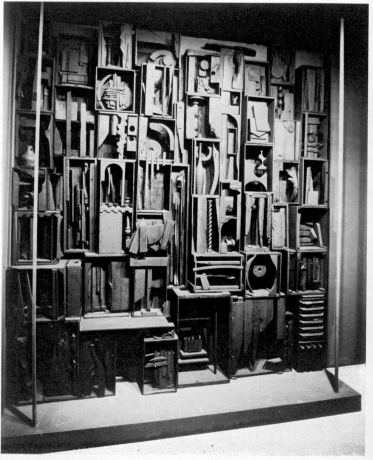

265. John Chamberlain: Dolores James, 1962. Welded and painted steel. *New York, The Solomon R. Guggenheim Museum*

266. Richard Lippold: Variation Number 7: Full Moon, *c.* 1950. Brass rods, nickel-chromium, and stainless steel wire. *New York, The Museum of Modern Art*

267. Louise Nevelson: Sky Cathedral, 1958. Wood painted black. *New York, The Museum of Modern Art*

268. Chryssa: Fragments for the Gates to Times Square, 1966. Neon and plexiglass. *New York, Whitney Museum of American Art*

269. Sam Gilliam: Horizontal Extension, 1969. Acrylic on canvas with powdered aluminum. *Collection of the artist*

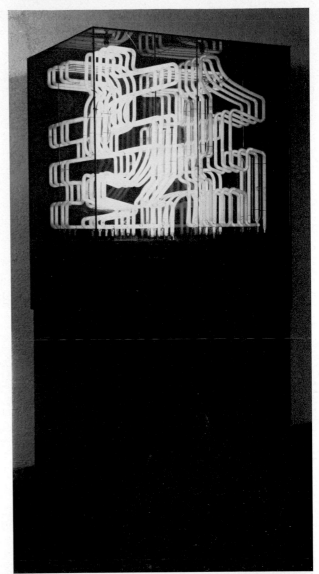

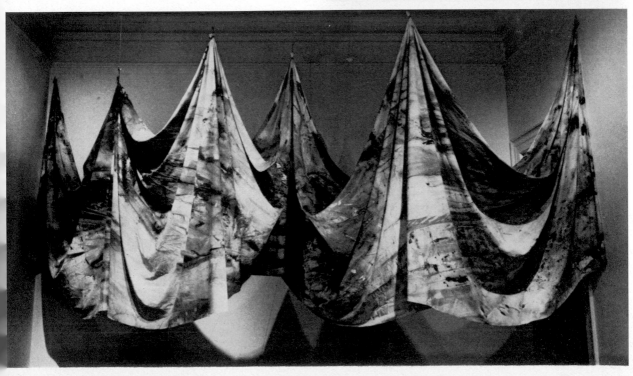

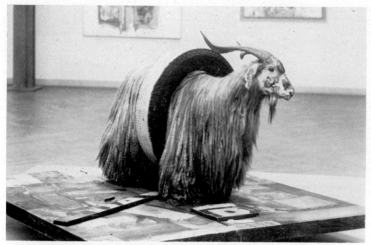

270. Robert Rauschenberg: Monogram, 1959. Construction. *Stockholm Nationalmuseum*

271. Jasper Johns: Field Painting, 1963–4. Oil and mixed media. *Collection of the artist*

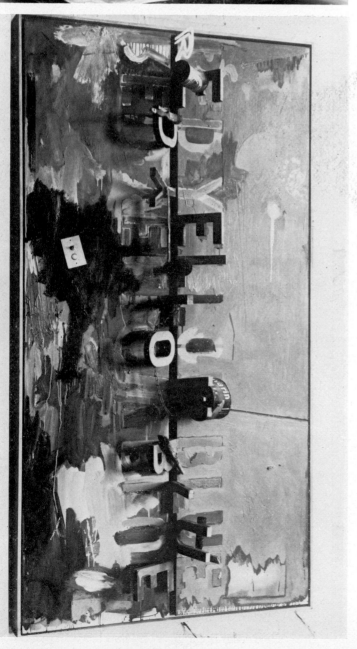

272. Larry Rivers: Parts of the Face: The Vocabulary Lesson, 1961. *London, The Tate Gallery*

273. Fritz Scholder: American Indian, 1970. *Washington, D.C., United States Department of the Interior, Indian Arts and Crafts Board*

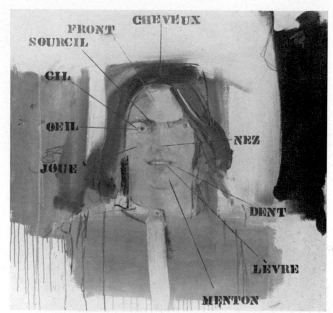

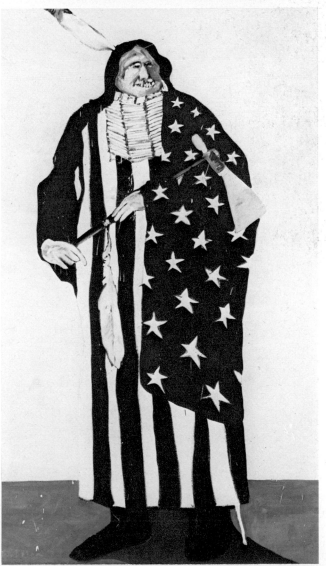

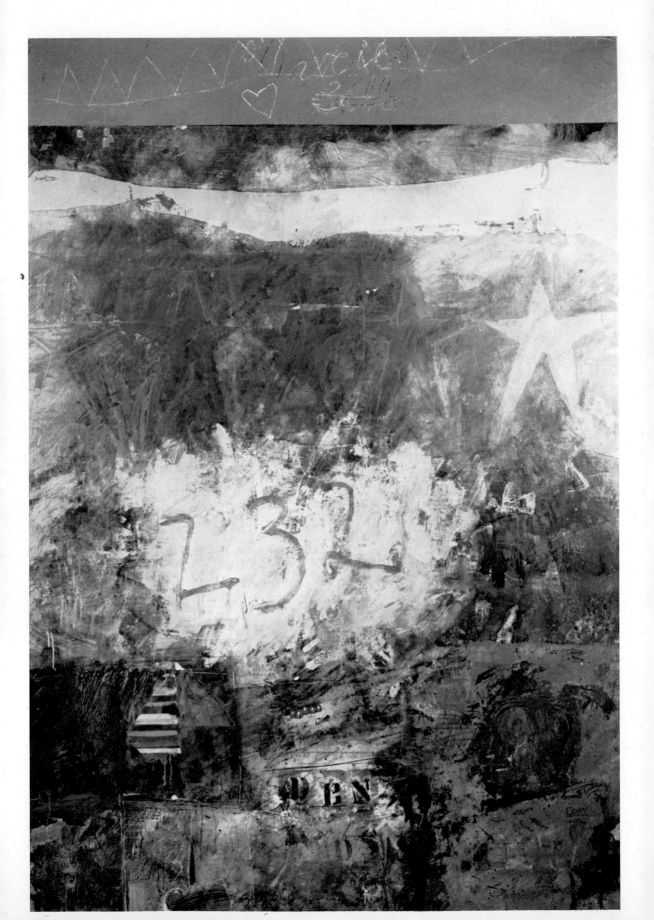

274. Raymond Saunders:
Marie's Bill, 1970. *New
York, Terry Dintenfass Inc.*

275. Richard Lindner:
Rock-Rock, 1966–7.
Dallas Museum of Fine Arts

276. Romare Bearden:
The Street, 1964. Collage.
*New York, Cordier and
Ekstrom*

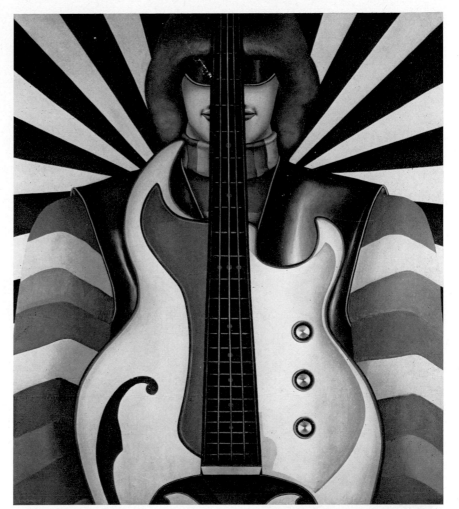

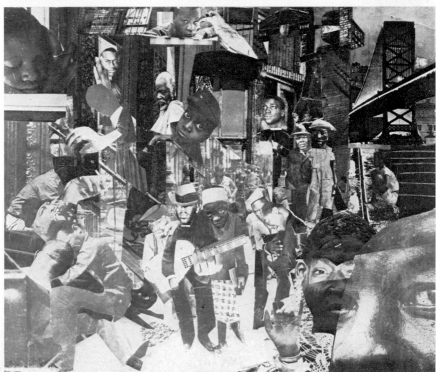

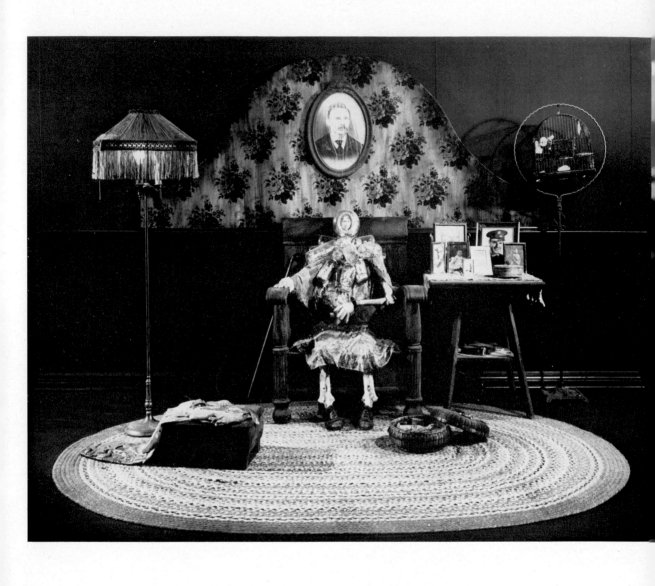

277. Edward Kienholz: The Wait, 1964–5. Assemblage. *New York, Whitney Museum of American Art*

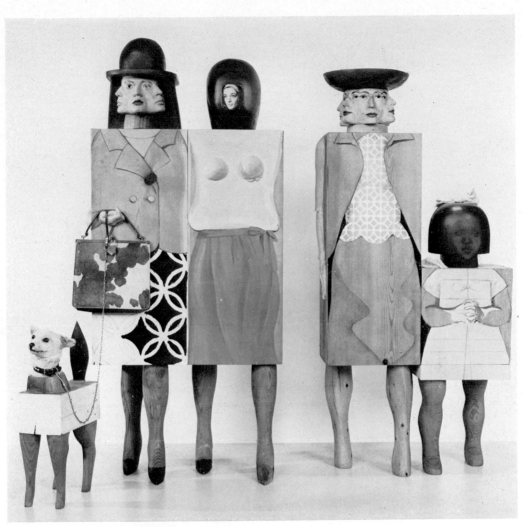

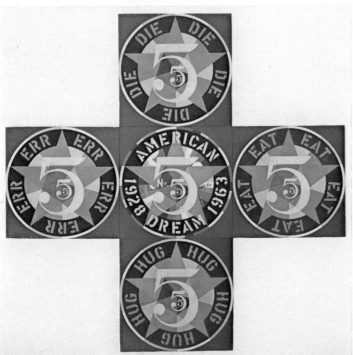

278. Marisol: Women
and Dog, 1964. Mixed
media. *New York, Whitney
Museum of American Art*

279. Robert Indiana: The
Demuth American Dream
No. 5, 1963. *Toronto, Art
Gallery of Ontario*

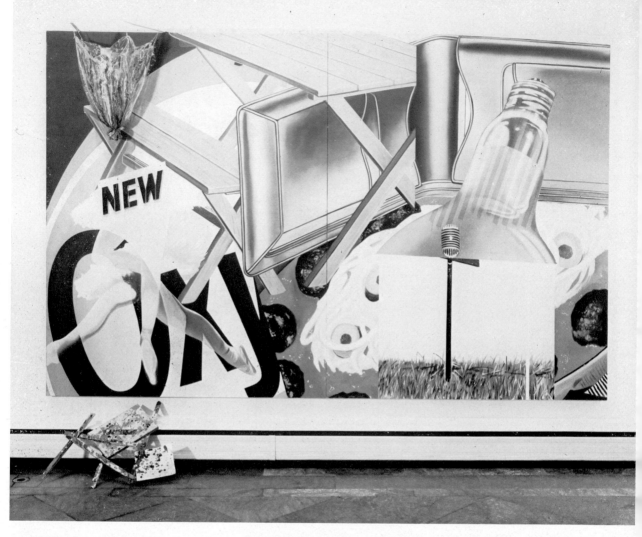

280. James Rosenquist: Nomad, 1963. Oil on canvas, plastic paint, wood. *Buffalo, New York, Albright-Knox Art Gallery*

281. Roy Lichtenstein: As I Opened Fire, 1964. Oil and magna. *Amsterdam, Stedelijk Museum*

282. Andy Warhol: 100 Campbell's Soup Cans, 1962. *Buffalo, New York, Albright-Knox Art Gallery*

283. Andy Warhol: 5 Deaths 11 Times in Orange, 1963. Acrylic and silkscreen. *Turin, Museo Civico*

284. Claes Oldenburg: Giant Hamburger, 1962. Painted sailcloth stuffed with foam. *Toronto, Art Gallery of Ontario*

285. George Segal: The Gas Station, 1963. Plaster and mixed media. *Ottawa, The National Gallery of Canada*

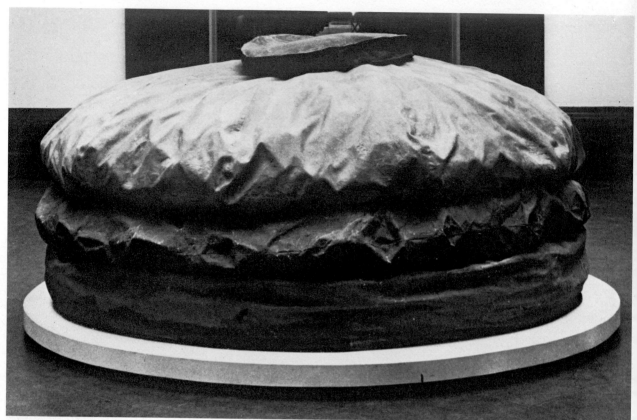

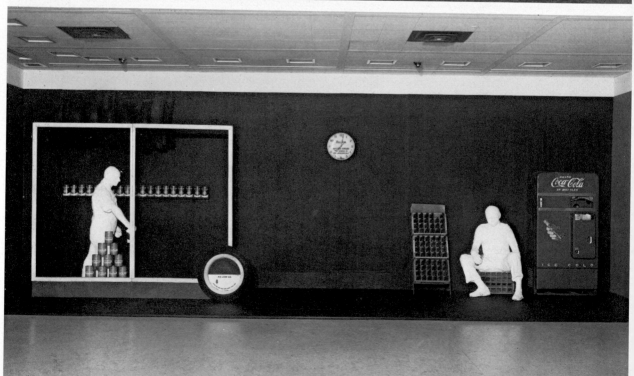

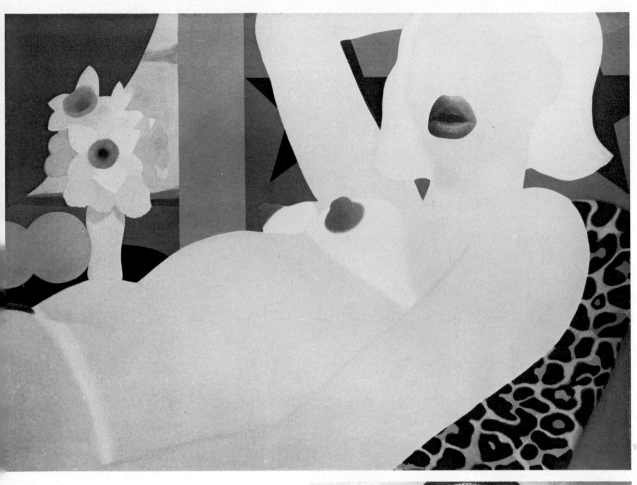

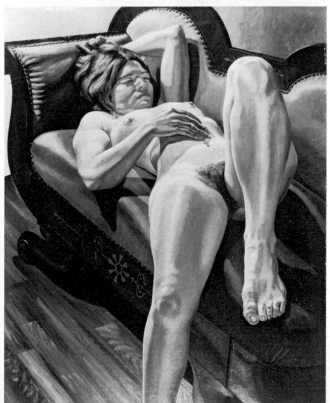

286. Tom Wesselmann: Great American
Nude, No. 57, 1964. Synthetic polymer
paint on composition board. *New York,
Whitney Museum of American Art*

287. Philip Pearlstein: Reclining Nude on
Green Couch, 1971. *Washington, D.C.,
The Corcoran Gallery of Art*

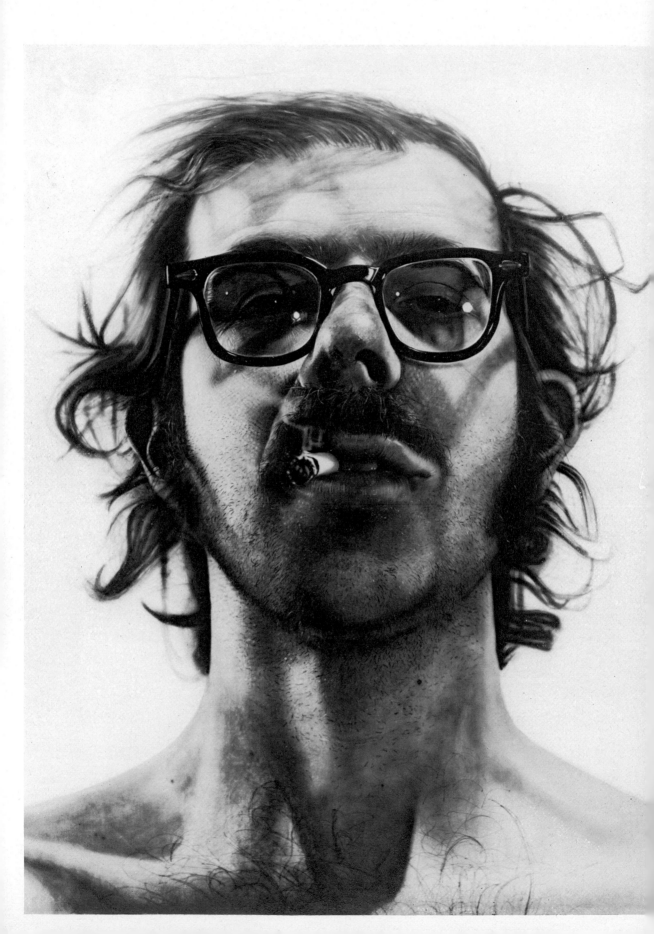

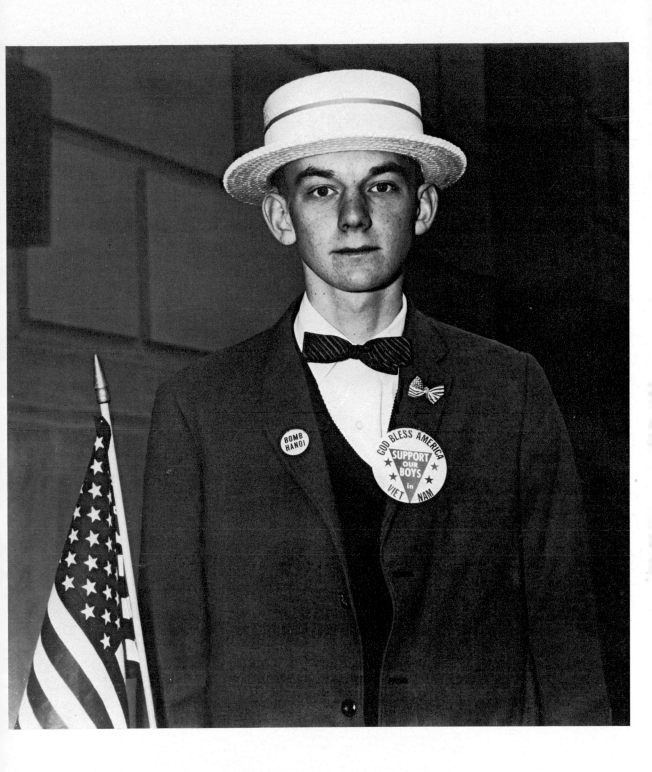

288. Chuck Close: Self Portrait, 1968. Acrylic on canvas. *Minneapolis, Minnesota, Walker Art Center*

289. Diane Arbus: Boy with a straw hat waiting to march in a pro-war parade, 1966. Photograph. *Cambridge, Massachusetts, Fogg Art Museum, Harvard University*

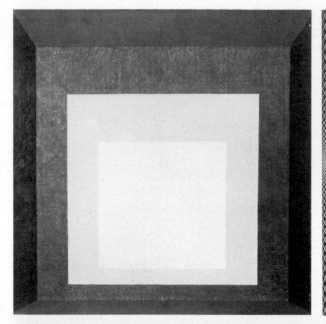

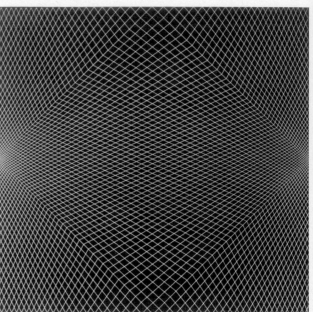

290. Josef Albers: Homage to the Square: Apparition, 1959. Oil on board. *New York, The Solomon R. Guggenheim Museum*

291. Richard Anuskiewicz: Between, 1966. Acrylic. *Hanover, New Hampshire, Dartmouth College Collection*

292. Ellsworth Kelly: Green White, 1961. *Hanover, New Hampshire, Dartmouth College Collection*

293. Frank Stella: Agbatana III, 1968. Fluorescent acrylic on canvas. *Oberlin, Ohio, Allen Memorial Art Museum, Oberlin College*

294. Tony Smith: Grace-hoper, 1961. Sheet steel. *The Detroit Institute of Arts*

295. Morris Louis: Theta, 1960. Acrylic on canvas. *Boston, Museum of Fine Arts*

296. Jules Olitski: High A Yellow, 1967. Acrylic on canvas. *New York, Whitney Museum of American Art*

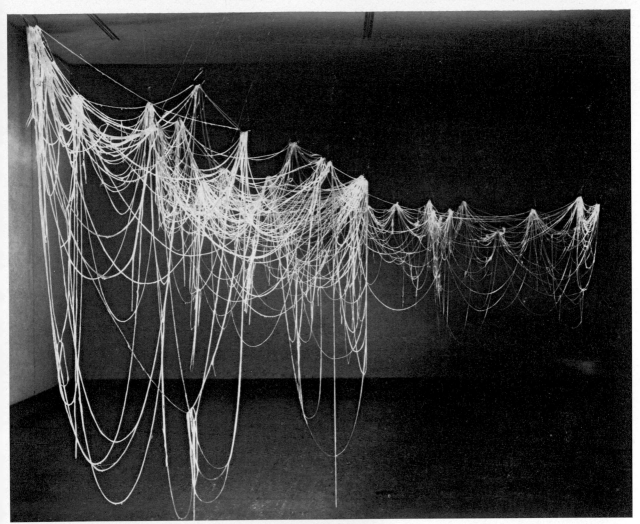

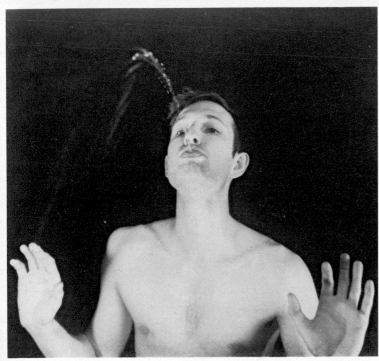

297. Eva Hesse: Right After,
1969. Fibreglass. *Milwaukee
Art Center*

298. Bruce Nauman: Self
Portrait as a Fountain, 1966.
Colour photograph. *New
York, Whitney Museum of
American Art*

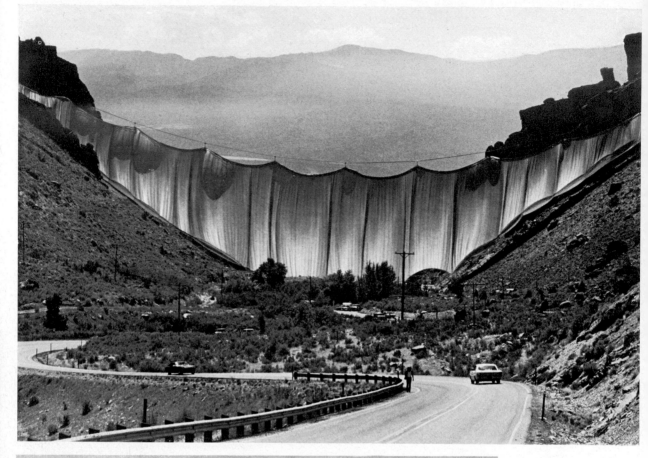

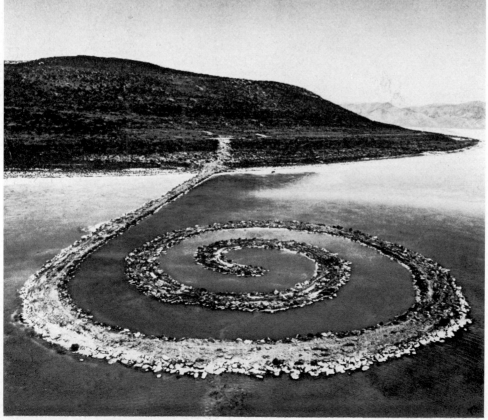

299 Christo: Valley Curtain, as erected at Grand Hogback, Rifle Gap, Colorado, 1971–2. Nylon polyamide and steel cables

300. Robert Smithson: Spiral Jetty at Great Salt Lake, Utah, 1970. Stone

INDEX

Numbers in *italics* refer to plates. Principal references are in **bold** type. References to the notes are given to the page on which the note occurs, followed by the number of the chapter and the number of the note; thus 259(24)[1] indicates page 259, chapter 24, note 1. References are also given to entries in the bibliography (pp. 283–302), where artists' dates of birth and death are to be found.

A

Abbey, Edwin Austin, 283

Abbott, Berenice, 283

Abstract expressionism, 177, 196, **201 ff.**, 215, 216, 217, 223, 224, 226, 230, 231, 232, 234, 235, 259(24)[1], 260(24)[21], 262(26)[1,6], 263(26)[19], 267(30)[2]

Academies, galleries, schools, and societies of art

Académie Julian, Paris, 170, 215

American Academy of Fine Arts, 48, 161

American Art-Union, 78

An American Place, 173

Apollo Association, 78

Art Club, Providence, 164

Art Students League, New York, 145, 193, 208, 210, 215, 219, 233, 237

Association of American Painters and Sculptors, 170

Barnes Foundation, 219

Bauhaus, Chicago, 233

Bennington College, 207

Black Mountain College, 215

Boston Museum School, 232

Carnegie Institute of Technology, 225

Carnegie-Mellon Institute, 219

Chicago Art Institute, 182, 193, 226

Chicago, University of, 212

Cleveland School of Art, 184, 231

Columbian Academy of Painting, 61

Cooper Union, New York, 142, 149

École des Beaux Arts, Paris, 137, 150, 191, 221

Eight, The, 169, 170, 172, 173, 175, 179

Intimate Gallery, 173

Kansas City Art Institute, 215

Lowell Institute, Boston, 164

National Academy of Design, 48, 68, 70, 81, 109, 115, 142, 145, 156, 161, 166, 170

New York School of Art, 145

New York University, 68, 227

Pennsylvania Academy of the Fine Arts, 77, 118, 137, 139, 140, 141, 142, 155, 165, 169, 171, 180, 181, 186, 219, 254(18)[8]

Princeton University, 232

Rhode Island School of Design, 164

Royal Academy, London, 38, 40, 42, 48, 49

Rutgers University, 227

Sacramento City College, 218

Society of American Artists, 145, 156, 166

Ten, The, 156–7, 165

Two Ninety One, 173, 177, 178, 180, 190

Wisconsin State College, 218

Yale University, 231, 235

Acconci, Vito, 236, 268(30)[20]

Achenbach, Andreas, 89

Action painting, 216, 233, 262(26)[1]; *see also* Abstract expressionism

Adam brothers, 54

Adams, Ansel, 173, 283

Adams, Henry, 150, 154

Adams, John (J. Browere), 72, 73; *81*; (Greenough), 107

Adams, John Quincy, 49, 55

Adams, John Quincy (Greenough), 107; (Powers), 108; (Southworth), 71, 72; *80*

Adams, Marian Hooper, 150

Adams Memorial (Saint-Gaudens), 150; *183*

Adams, Samuel (Copley), 39

Adena Mound (Ohio), 11

Aetatis Suae Limner, **22**, 23; *16*

African sculpture, 178, 212, 258(22)[22]

Agee, James, 187

Alaska, 11

Albany (N.Y.), 22, 23, 25, 61, 102, 153, 161

Albany Institute of History and Art (*Aetatis Suae* Limner), [22]; *16*; (anon.), 25; (P. Vanderlyn), [23]; *17*

Albers, Josef, 215, **230–1**, 232, 235, 283; *290*

Alberti, L.B., 3

Albright, Ivan, **185–6**, 228, 231, 283; *233*

Aldrin, Edwin, 10

Alexander, Cosmo, 49

Alexander, John White, **158**, 283; *197*

Allendale (S.C.), 215

Allison, Archibald, 79

All-over painting, 222, 262(26)[6]

Alloway, Lawrence, 265(29)[1]

Allston, Washington, 43, 44, 59, 61, **64–7**, 69, 75, 76, 107, 115, 116, 138, 152, 161, 162, 206, 251(15)[2], 283; *69–73*

Amalfi, 228

305

C